Fishler

The Art of Written Forms

THE ART OF WRITTEN FORMS
The Theory and Practice of Calligraphy

Donald M. Anderson / University of Wisconsin

HOLT, RINEHART AND WINSTON, INC. *New York Chicago San Francisco*

Atlanta Dallas Montreal Toronto London Sydney

ABCDEFGHIJKLMNOPQRSTUVWXYZ
abcdefghijklmnopqrstuvwxyz
abcdefghijklmnopqrstuvwxyz

Preface

Reproduced above are the fragile signs used in the art of writing, one alphabet in three forms: capital, minuscule, and italic. These signs have been in the process of development for some five thousand years, since a man first scratched a figure in the mud and called it a word. Assuredly the set of signs seen above and on the following pages is the most important system of symbols ever devised by man. It has been my purpose in writing this book to enlarge our generally diminished knowledge of these alphabetic signs and to present for professional graphic artists, students, and interested general readers a comprehensive survey of the history, theory, materials, and techniques of calligraphy, typography, and constructed letters.

Most of us are aware that the story of writing is sequential in development. In this sense *The Art of Written Forms* arranged its own order. It has seemed reasonable to discuss Roman writing before the Book of Kells is mentioned. Yet, in seeking within the history of writing the signs and evidence of developing practice and style, I have not found it possible to adhere to strict chronology as a system of organization. Rather, I have looked for parallels and analogies among historical examples of writing, and while generally such comparisons fall within regular chronology, certain of those that have appealed to me most do violate absolute historical order. For instance, in Part I, "The Origins of Writing," a number of reproductions feature the work of American Indians. Several of these have aged less than a hundred years since execution, but they are discussed in relation to parallel ideas originating thousands of years before the Christian era. As we get closer to our own period in this book, these chronological anomalies become less apparent; but, still, the writing in Chaucer manuscripts of the fifteenth century was medieval in character, while Florence vibrated with new ideas, in tune with our accepted notions of the Renaissance.

Because I have wanted the book to be comprehensive, I have kept very much in mind the needs of the person—student or professional—who will wish not only to examine the history and theory of writing but also to work creatively with pen and brush and with types. At the same time, I have found in my own work and in working with students that however original one's approach to letters and writing, the results are more successful and satisfying if informed by an awareness of the great tradition in written forms, both in the West and in other cultures. Within this context, I have written a practical or laboratory section but made

it relatively brief and placed it as Part IV, between the sections on the Western tradition and those on non-Western writing.

Since writing is experienced visually, there is no way to learn about its historical role in communication except to see examples in reproduction. Thus, much of the labor in the preparation of this book has centered on obtaining the required material from the various centers housing original manuscripts and in devising a layout for the book that would place text and illustrations in a close visual relationship with each other. In terms of sources of reproductions, the paleographers have offered the richest array of materials. Edward Johnston's *Writing and Illuminating and Lettering,* published in 1906, contained only 24 photographic plates devoted to fine historical examples, but six years later Edward Maunde Thompson's *Introduction to Greek and Latin Palaeography* contained 250 reproductions on the writing hands of the Greeks and Romans. Thus I have drawn heavily and with much gratitude on many of the fine paleographic studies published in the last hundred years. Also, I have thought it sensible to include in the back matter some of the published works that might aid the understanding of written forms. The reader will therefore find the bibliography full, if not absolutely comprehensive.

I want to offer my very special thanks to Arnold Bank, Professor of Graphic Arts at the Carnegie Institute of Technology, and to Professor Lloyd Reynolds of Reed College, both of whom read the manuscript and worked very hard to improve it. Professor Edward Catich of St. Ambrose College in Davenport, Iowa, provided professional commentary, valued material on the Trajan inscription, and several pieces of his own execution. Skilled calligraphers Warren Chappell, Raymond F. DaBoll, James Hayes, Egdon Margo, and Maury Nemoy generously lent their talents. Heather Child and Nicolette Gray are among the many residents of England who graced this volume with talent; and Eric Lindegren of Askim, Sweden, and Hermann Zapf of Frankfurt am Main, Germany, deserve mention for their generosity.

It would be quite impossible to assemble a volume on writing without the cooperation of a large number of museums and libraries. I owe acknowledgment to a rather long list of persons, but those associated with the British Museum, the Victoria and Albert Museum, and the Laurentian Library in Florence have provided help without stint. I must also thank James M. Wells, Associate Director of the Newberry Library in Chicago, whose many courtesies aided work in that great collection.

At the University of Wisconsin I am indebted to friends in various areas of study. Professor Murray Fowler of the Department of Linguistics read parts of the manuscript. Professor Paul MacKendrick of the Department of Classics aided when asked. I should also like to thank Professor Louis Kaplan, Director of University Libraries, for his courtesies and those rendered by his staff. Dorothea von Elbe, student and friend, assisted in the final months of this project in all its phases including translations. To my wife, Marjorie Elizabeth Anderson, I express my gratitude for her skills in organization and management that did much to bring about the completion of a difficult and complex project.

Madison, Wisconsin Donald M. Anderson
October 1968

Contents

Part *I* THE ORIGINS OF WRITING

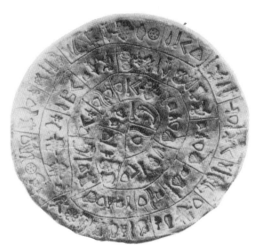

The Phaistos Disk. Heraklion Museum, Crete.

Chapter 1 Signs and Meaning

Writing can be described roughly as the assignment of speech forms to graphic signs. We human creatures managed to live without a form of writing for many thousands of years. A fully developed system of speech-sign communication has emerged within the last five thousand years. If this figure is set against those given for man's emergence as a toolmaker, it can be seen that writing is a recent development in the chronology of man's achievements.

Indeed, one might be curious about the fact that races of the Magdalenian culture left a record of high sophistication in terms of drawing and painting thousands of years before writing was practiced. An example of this sophistication is seen in Figure 1, a bison from the cave at Altamira in Spain. Whether such marvelous animals enlivening the walls of caves in France and Spain were created out of pure joy in the

3

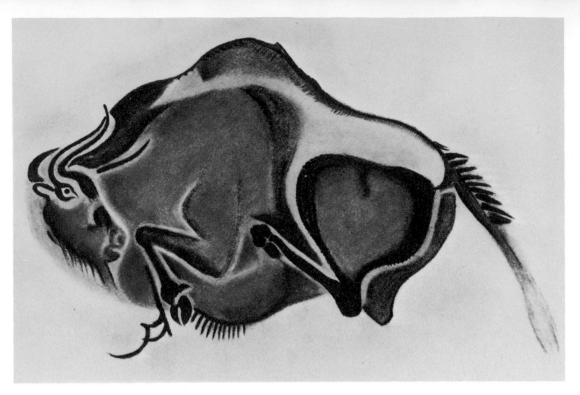

1. Rendering of a bison in the cave at Altamira, Spain. Henri Breuil, *The Cave at Altamira*, by permission of the Real Academia de la Historia, Madrid.

act of painting or whether they were meant to implement a community need for psychic domination of the animal, it is certainly clear that manual skills for the creation of writing signs were not lacking. And when, in looking at these great examples of cave art, we search for specific information communicated, it is curiously lacking. There is no clear record of the number of animals killed, no indication of time or sequence, no record of personal achievement or ownership, no storytelling.

The attempt to communicate specific information represents the first stage in the development of writing. In this first prewriting stage, esthetic qualities are neglected in favor of recording objects and events. Seen in this light, the great cave art of Lascaux and Font-de-Gaume, fully developed in terms of color and grace of conformation, is the exceptional product of primitive peoples. Most of the graphic works found around the world, ranging in time from the Paleolithic period to the present day, are of a more cryptic nature.

Prewriting records have been termed *pictographs*. The word, from its roots, means 'picture writing,' but this is misleading, for the signs do not stand for speech values. And since *pictograph* is also used in connection with such writing systems as Egyptian and Chinese, there is danger of confusion. However, because the term is in wide use it will not be dropped here. *Petroglyph* is the word used to designate those signs carved in stone, and *petrogram* has been suggested for those painted or drawn on stone. Beyond that, the materials by which and on which signs are inscribed proliferate to such a degree as to make specific terminology a burden.

Aside from what they tell of a culture in terms of its technology and its religious and social habits, painted, carved, or drawn pictographs are important to the development of writing in several ways. First, in a somewhat uneven manner they exhibit a strong tendency toward abstraction or extreme simplification of natural form. When alphabetic signs were developed they reflected this same sparseness in graphic form, a necessity in graphic communication, particularly in the keeping of records. It is obvious that to record the ownership of forty sheep by drawing the image of a sheep forty times is too complicated, that some economy of means is required, and that this is incompatible with the method of Figure 1. Thus esthetic considerations were secondary for the most part, though today pictographs are admired for this content in a degree that would not have been possible in the nineteenth century.

The second important tendency in the pictograph message is the effort to establish a sequence of order. In certain Paleolithic cave works, tribal episodes were drawn one on top of another, while in significant works by American Indians the events were drawn in sequence, one event next to another, and these could be "read" for a specific meaning. Random order and specific meaning are as incompatible as cat and dog, and our system of

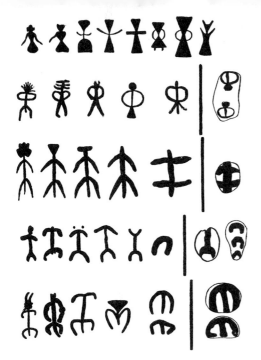

2. Post-Paleolithic stone drawings from Spain (left) and France (right) illustrating a direction of abstraction in which communication and esthetic considerations become disengaged. Max Ebert, *Reallexikon der Vorgeschicte,* Vol. VII.

3. Enigmatic rock painting from Santa Barbara County in California reveals elements that indicate trading in blankets and furs. Garrick Mallery, *Pictographs of the North American Indians.*

writing reflects this: when we write or print we make one sign at a time.

A third development in pictographic communication involves a thorough understanding of sign and meaning. A hungry Eskimo cannot afford any misunderstanding in his signs that are meant to read "nothing to eat."

Some of these tendencies in the pictographic arts will obviously point up the fact that communication is a social phenomenon. Where two people can agree on the meaning of a sign message, the inclusion of a third requires the education of that person and subsequently of many others. The breakdown of communication is inherent here. Indeed, it is the complexity of society that forces the abandonment of picture methods. The number of people involved, the number of transactions to be recorded, the number of names to be given signs, the number of events to be commemorated—these are the factors that eventually produce systems of writing that can be translated and passed on to the various civilizations in our recent past.

ABSTRACTION

The tendency toward abstraction in pictographic communication can be seen in Figure 2. Here Hugo Obermaier's copy of post-Paleolithic petrograms from Spain (the figures on the left) demonstrate that later forms from France (on the right) are quite divorced from the natural form, originally quite explicit. Thus communication can

survive a change in signs, and while there is no difficulty in following the thread of meaning as it is passed on to succeeding generations within the culture, it does present a problem to scholars of a later day, who may be left with an abstraction hanging in time without a before and after to explain its original meaning. Thus many enigmatic configurations appear that suggest pure invention, possibly holding dark meanings promoted by shamans. In all probability the figures in Figure 3 had a rather specific origin and meaning to the people who made them.

Stories in Pictures

While prewriting graphic forms exist throughout the world, those executed by the North American Indians are particularly rich in storytelling techniques. Some examples are also interesting for their artistic form, although we are more concerned here with the ideas presented. Fortunately, some of the most interesting examples of Indian graphics were executed in comparatively recent times, when, during the process of Indian extermination by removal of their economic base, the cultural context produced examples uncontaminated by European traditions. Here was an opportunity to observe and secure paintings and to interview those members of the tribe who were pertinently involved with production and meaning. Such studies in the second half of the nineteenth century as Henry R. Schoolcraft's *Historical and Statistical Information Respecting the History, Condition, and Prospects*

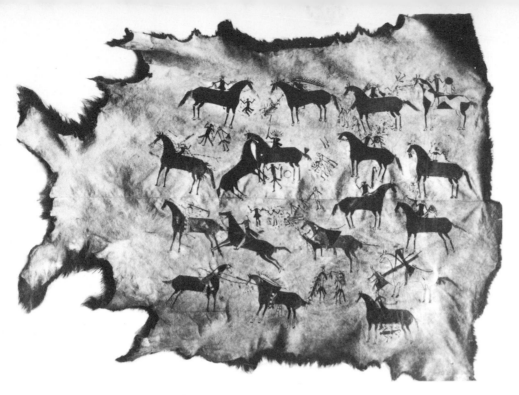

4. Life events of an American Indian chief painted on buffalo skin. A time sequence is lacking. State Historical Society of Wisconsin.

of the Indian Tribes of the United States (Philadelphia, 1851) and Garrick Mallery's *Pictographs of the North American Indians: A Preliminary Paper* (Washington, D.C., 1886) and *Picture Writing of the North American Indians: Tenth Annual Report of the Bureau of Ethnology* (Washington, D.C., 1893) were quite valuable.

Mallery reports that "bragging biographies of chiefs and partisan histories of particular wars delineated in picture writing on hides or bark were very common." The example of such a biography in Figure 4 is from a photographic survey made for the United States Department of the Interior by W. H. Jackson in 1877. It is a painting on buffalo skin depicting the principal events in the life of a prominent chief. Intriguing in form, it represents a midpoint in abstraction between the realism of Figure 1 and the stick figures of Figure 5. It is interesting to note that the painter shows greater knowledge of the shape and anatomy of animals than he does about the shape and anatomy of humans—a rather common phenomenon in primitive art. Figure 4 encompasses a quite complete idea in terms of telling a story, and even some truth, since it is clear that the chief committed murders with some frequency and survived to commission this monument to his prowess. As a record, however, it exhibits a lack of order, and no sequence in the events is discernible.

In pointed contrast to the chieftain's bragging biography is the cryptic message communicated in Figure 5, an Alaskan notice of a hunting trip reported by Mallery.

The story proceeds from left to right in this manner: (a) speaker indicates himself and points a direction; (b) speaker holds a paddle, indicating method of travel; (c) speaker denotes one night's sleep; (d) speaker draws an island with two huts; (e) same as (a); (f) another island; (g) speaker indicates two nights' sleep; (h) speaker holds a harpoon and gives the sign for a sea lion; (j) shooting with bow and arrow; (k) boat with two persons, paddles extending downward; (l) speaker's habitation.

In this example, abstraction is quite complete, and there is an orderly sequence in the presentation of the message. All superfluous details are omitted, as are esthetic considerations. On looking at this figure, it is clear that in terms of efficiency stereotyped signs are indispensable to the orderly presentation of large amounts of material to a large group of readers. It should be said, however, that notable exceptions to the rule of efficiency occur throughout the history of writing. It is also apparent that, in general, as soon as a system of writing becomes current, esthetic considerations are reestablished, not on the old basis of picturemaking but on esthetic grounds involving the form of the letters and the space these letters occupy.

Mnemonic Functions of Pictography

Another kind of orderly record is seen in Figure 6, Lone Dog's Winter Count. The Dakota Indians furnished several of these sign calendars, and they are completely described

in Mallery's account of 1886. The reproduction seen here is from a copy made by H. T. Reed, who discerned its meaning, while the very detailed account of this work was written by Dr. William Corbusier. Both were officers in the United States Army. This record provides a graphic sign for each winter beginning with 1800–1801 and extending for 71 years. It is not a boasting account—a most memorable event is chosen for representation, and it is a sequential record of the tribe's struggle for survival.

Signs of this kind, prompting the memory of an event or place, are called *mnemonic devices,* and we shall see several examples of this type. A detail from Battiste Good's Winter Count is seen in Figure 7. This particular count started with the winter of 1700–1701 and was known to the Oglala and Brule Dakota tribes. The detail shown iden-

tifies the winter of 1826–1827 and was known as the "ate-a-whistle-and-died winter." The story as understood by Corbusier and recorded in Mallery's account goes like this:

Six Dakotas on the war path (shown by bow and arrow) had nearly perished with hunger, when they found and ate the rotting carcass of an old buffalo, on which the wolves had been feeding. They were seized soon after with pains in the stomach, the abdomen swelled, and gas poured from mouth and anus and they died of a whistle or from eating a whistle. The sound of gas escaping from the mouth is illustrated in the figure.

Thus the picture recalls details of an event that had occurred sixty years before this verbal account. The belly-ache sign occurs a number of times in Good's count, and

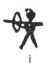

a b c d e f g h i j k l

5. Cryptic message of an Alaskan hunting expedition. Garrick Mallery, *Pictographs of the North American Indians.*

6. Lone Dog's Winter Count, a kind of chronicle of events used by Dakota tribes, featuring a memorable happening for each year of the tribe's existence. Copied c. 1877. Garrick Mallery, *Pictographs of the North American Indians.*

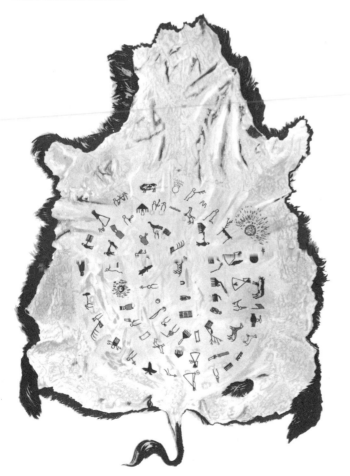

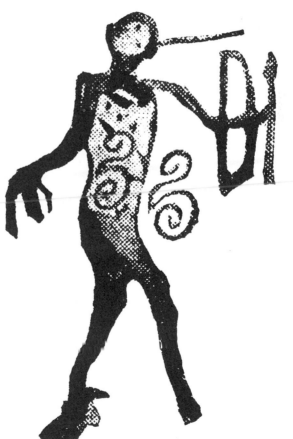

7. The year 1826–1827 from Battiste Good's Winter Count, starting in 1700. The sign for the fatal ailment is repeated and is a word sign in this limited context. Garrick Mallery, *Pictographs of the North American Indians.*

Signs and Meaning 7

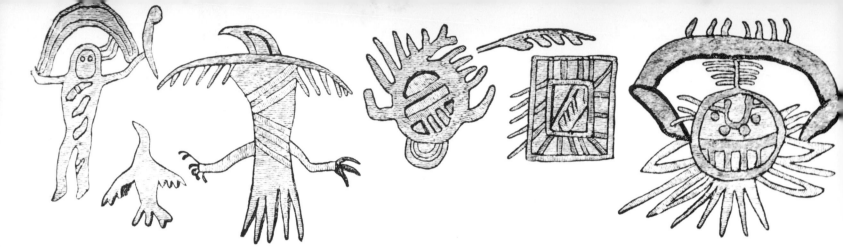

8. Mnemonic devices used by the Ojibwa Indians
to recall traditional poetry. Garrick Mallery,
Pictographs of the North American Indians.

it is always executed in the same manner. Again a stereo-typed sign identifies the same object or phenomenon, and thus we approach that condition where a sign stands for a word, the real key to advanced systems of writing.

The purpose of the mnemonic characters in Figure 8 is to preserve the remembrance of Ojibwa Meda (priest) songs. These pictographs do not suggest exact words but rather give a general interpretation of the song. The words of the songs are memorized. The following interpretation from Mallery's account corresponds with the figure on the right: "The great Spirit filling all space with his beams, and enlightening the world by the halo of his head. He is here depicted as the god of thunder and lightning, I sound all around the sky, that they can hear me." It will be observed that graphic signs that have a verbal counter-part, vague though this latter may be, point in the direc-tion of a more direct connection between graphic signs and speech.

Signs of Identification

The Oglala Roster provides an example of a mnemonic graphic device serving a different purpose in communica-tion. In this roster a pictorial device identifies each of 84 heads of families in the clan of Chief Big-Road, one of five principal leaders in the Northern Oglala tribe. Each chief and family head is graphically named by a device with which the individual is associated. Chiefs and subchiefs hold the insignia of office in the right hand. Here in Figure 9 Chief Big-Road, holding a pipe designating his high office, is represented in name by the device above his head, a road with tracks on each side. The bird repre-sents swift travel, a good quality. Similar name designa-tions are found in Red-Cloud's Census, a graphic record of some of the individuals (289) giving allegiance to this very powerful chief. Red-Cloud's census was prepared in the Dakota Territory in 1884 and sent to Washington.

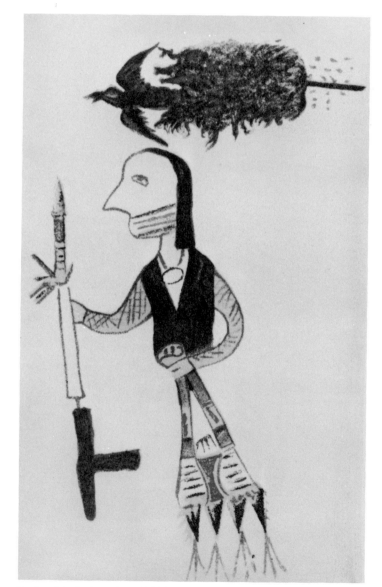

9. Graphic designation of Chief Big-Road of the Oglala tribe. Garrick Mallery, *Pictographs of the North American Indians.*

8 *The Origins of Writing*

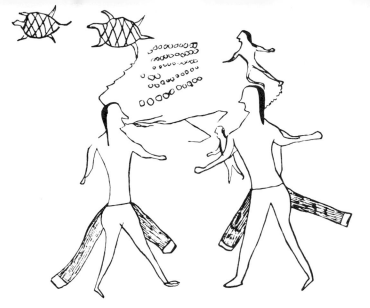

10. The Cheyenne Letter, a message without words. A father wants his son to collect $53 from the agent and come home for a visit. Garrick Mallery, *Pictographs of the North American Indians.*

It is an interesting sidelight that names from these compilations persist in time. The name Dog-Eagle appears in Red-Cloud's Census, and the author and one Franklin Ambrose Dog-Eagle, a descendant, were fellow collegians for a time. Here again signs for names of individuals come ever closer to the matching of signs with speech elements.

The Involved Message

For an example of a rather complex story told through graphic signs we can study the Cheyenne Letter, in Figure 10. This pictograph was sent through the mail from a Southern Cheyenne named Turtle-Following-His-Wife, living at a western agency, to his son. The letter was ad-dressed to Little-Man, Cheyenne, Pine Ridge (Dakota) Agency. Drawn on a half-sheet of writing paper without words, the message was obviously clear to Little-Man, since he called upon the Indian agent, Dr. V. T. McGilly-cuddy, to collect $53 for use on a long trip. The artist's name is indicated by the two turtles; the name of the other figure is indicated by a drawing of a little man. Another little man is seen being pulled by speech emerging from the mouth of Turtle-Following-His-Wife. This part of the drawing means "Come to me." Money signs totaling $53 are seen in the small circles.

The Cheyenne Letter is a strong example of the poten-tialities and limitations of communication by graphic

11. Detail of the Bayeux Tapestry depicting the conquest of England in 1066. Town Hall, Bayeux.

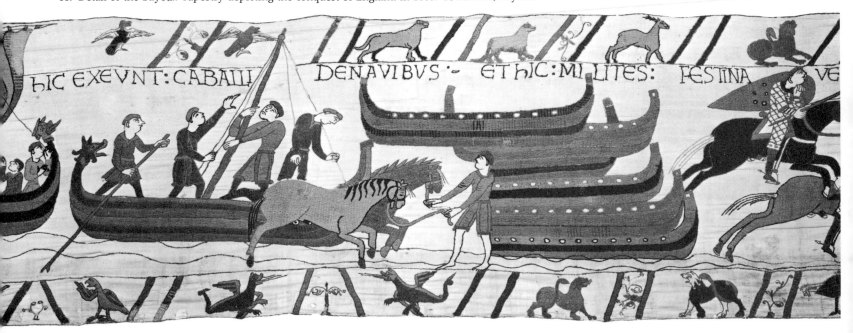

device. This method of communication conveys more than one might think possible with the means at hand. It is made possible by the existence of a rather small society with intimate knowledge of the meaning of the graphic signs and by some care in the repetition of images, as described by Mallery in the following:

One very marked peculiarity of the drawings of the Indians is that within each particular system, such as may be called a tribal system, of pictography, every Indian draws in precisely the same manner. The figures of a man, of a horse, and of every other object delineated, are made by everyone who attempts to make any such figure with all the identity of which their mechanical skill is capable, thus showing their conception and motive to be the same.

Nevertheless, it will be noted that the father depositing a credit to his son wrote the dollar sign as many times as needed, while we write it 53, the sign 5 standing for the number of 10s and the sign 3 supplanting individual marks. This is an important distinction in the development of writing and counting.

Contemporary Usages

While pictographic communication represents a primitive stage in the development of true writing, it is not to be assumed that the art died abruptly with the adoption of more efficient methods. Indeed, our civilization still makes good use of wordless pictorial devices. Some examples of the technique of continuous illustration are the frieze of the Parthenon, the Column of Trajan, recording that emperor's victories on the imperial frontier, and the Bayeux Tapestry (Fig. 11), an eleventh-century embroidery detailing the Norman conquest of England in 1066. In more recent times, Lynd Ward's wordless wood-cut books (*Vertigo* among others) and George Baker's *Sad Sack*, the wartime comic strip executed without benefit of blurbs (those lettered speeches emerging from the mouths of comic-strip characters), carry on the tradition.

The use of identifying mnemonic signs also continues. In ancient times masons and potters used cryptic signs to put the mark of their workmanship on their products. Similar signs of ownership have been used throughout history. Cattle brands are an example of this graphic usage. Heraldic symbols were used to designate the families of nobility. Growing out of this tradition are the symbols that enable us to read at a glance the rank of military personnel and the branch of service to which they are attached. During World War II Washington, D.C., housed an organization of heraldic designers totally occupied with making insignia for the proliferating military units.

The Los Angeles Rams, a professional football team, uses a pictorial device deriving from a ram's horns on

their helmets. Uniforms of the St. Louis Cardinals are decorated by a red bird. College band members can often be identified by the lyre sign. And lofty citadels of higher learning are associated with such animals as groundhogs, badgers, wolverines, and gophers.

Graphic forms are still used in the streets to identify certain business establishments. In England appropriate signs often mark that venerable institution, the pub; and in Paris one can occasionally see the gilded horse's head that identifies a special kind of meat market. In the United States some regret the passing of the red- and white-striped pole that marked a barber shop, of the large tooth in front of a dentist's office, and of the three balls of the pawnshop. But there are others that remain—glasses, keys, and clocks among them. Figure 12 shows a device of this kind.

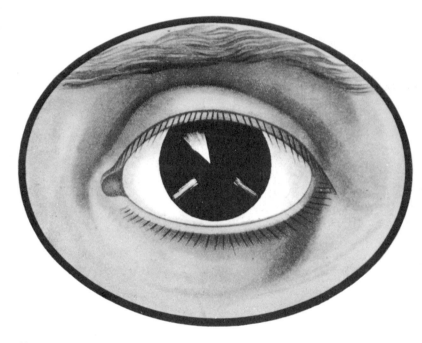

12. Contemporary designation for a business establishment.

Graphic devices identify many fraternal organizations and trades. In large businesses the design of an appropriate identifying mark is a serious enterprise. A good deal of effort is expended in this field of design, since a striking image successfully imprinted on the minds of the young can mean millions of dollars to a company. Lucky indeed is the Prudential Insurance Company of America, whose graphic device is the Rock of Gibralter and has been since 1896. Many identifying devices, strong in visual impact, are made from letter forms. Some of these will be seen in a later part of the book.

WORD SIGNS

The second stage reached in man's search for efficient systems of communication through cryptic signs is that in which graphic mark and spoken word are equated. As in other corners of the cultural milieu, new does not supplant old absolutely in sign communication. We still use £ for 'pound,' while ℞ stands for 'prescription' and $ for 'dollar.' Signs that stand for one or more words in a language are called *logograms,* and all of the great historical systems of writing—Sumerian, Chinese, Egyptian, Proto-Indic, Cretan, Proto-Elamite, and Hittite—seem to have passed through this stage of language development. Because the sign-word system of writing implies the equivalence of a sign with sounds or segments of speech, it is called *phonetic.* In all the great systems of writing, of course, speech preceded pictographic means of communication. Gradually, through a process of conventionalization, a pictograph would come to be associated with a specific object or person, and most individuals within the group would learn this association, together with many other sets. And of course those taught in this way could themselves engage in writing.

It is by no means to be assumed that the several systems under our immediate scrutiny will look alike. Different civilizations in the various geographic areas of the world developed different materials and tools for use in writing. Figure 13 shows a Chinese inscription on a bronze vessel of the Western Chou dynasty, c. eleventh century B.C. Although inscribed on bronze, the example shows a cursive tendency more characteristic of the brush, that tool so marvelously exploited by the Chinese in writing and painting up to the present time. It may be useful here to state one of the important guiding principles in the formation of the style of letter forms throughout history. Generally speaking, forms cut in stone or other difficult materials tend to be stiff, simple, and geometric. The method inhibits the free-flowing forms so prevalent in brush or pen writing, where arm, wrist, and finger motions act on a known form and create style. Thus when forms cut in stone become cursive and flowing, one can suspect the influence of a more flexible writing tool. Language scholars, more interested in meaning than in means, tend to neglect this area of visual form, while artists take a great interest in it.

If we look closely at the signs in Figure 13 we can discern the pictographs for 'man' and for 'eye.' In the lower right there is a compound sign of a hand holding an object, most probably a brush, so that the sign means 'scribe.' The Chinese writing system is basically a pictographic word-sign system, and such compound signs are frequently encountered.

Figure 14 is an example of Sumerian word signs from Uruk. Sumerian records are in clay for the most part, and therefore have a distinctive look. Here at the top are seen a ledger tablet, obverse and reverse, with corresponding diagrams below. This is a record of cattle delivered to various people. The number of cattle to be received is indicated by an indented semicircle on the obverse side, and a personal name sign is included within each compartment. Totals of cattle being sent are registered on the reverse side and indicate 54 oxen and cows. Besides the name signs, obscure at this late date, we can see an indented circle for the word *ten,* used in recording the number of cattle. This is a more efficient form than that seen in Figure 10, which recorded $53 in 53 separate marks. Two sexes of cattle are indicated in the sender's record

13. Chinese writing from a bronze casting inside a vessel dating from the Western Chou period of the eleventh century B.C. British Museum, London. T. H. Tsien, *Written on Bamboo and Silk,* copyright © 1962 The University of Chicago Press.

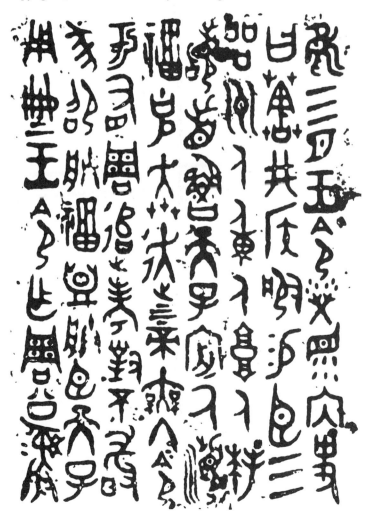

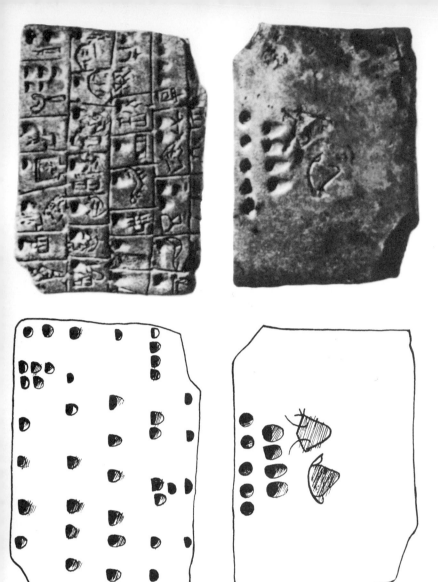

In early Chinese, 'woman' plus 'broom' means 'wife,' 'woman-woman' means 'quarrel,' and 'woman-woman-woman' means 'falsehood.' T. H. Tsien furnishes the example in Figure 15, a combination sign of mother and child meaning 'suckling.' Seen here is that inherent talent of the Chinese for creating signs that meet the need for economy of means and grace of expression in one swift action. Most early writing systems use the most visually significant part of human creatures, animals, and objects—that is, the profile view. Early Egyptian stonecutters freeze the view in perpetuity, but the Chinese seem to capture essence of character in movement in a way that must be discouraging to students of drawing.

In the early stages of writing, many signs are added that appear to be arbitrary inventions because of their geometric nature. The Egyptians used a circle to mean 'to go around.' Quite likely the sign grew out of a drawing action—a stick moving in the dirt. In some early writing systems a vertical sign stands for the number 1. We still use this system in counting points in games, with four vertical signs meaning 4 and a diagonal line through the series making 5. This idea may have originated in simple sign language, in answer to a question such as, "How many did you kill?" One or more fingers held up could give the answer.

We have seen in Figure 14 that a circular indentation meant the number 10, while the number 1 was indicated by a semicircle. In ancient Chinese a semicircle meant 'above' or 'below,' depending on its orientation. In Sumerian a circle meant 'all.' In Hittite a vertical line and a

14. Uruk ledger of cattle delivered to various persons, with author's diagrams below. The total, seen on the right, is 54.
A. Falkenstein, *Archaische Texte aus Uruk.*

of the transaction, but they are not so differentiated on the receiving end.

Besides the direct sign-word relationships seen in the early history of writing, meaning is expanded through other connotations closely allied with the original one. I. J. Gelb, in *A Study of Writing* (Chicago, 1963), lists several of these examples. In Sumerian, the word sign for 'sun' also stands for 'white' and 'day.' The word sign for 'star' in Sumerian also means 'deity,' while in Egyptian it means 'hour.' The word sign for 'mountain' in Sumerian also means 'foreign country,' an extension of meaning.

Meaning is also expanded by the exploitation of more than one sign. In Hittite, the combination sign 'man-man' means 'to agree.' The ancient Sumerians used the signs for 'male' and 'mountain' together to mean 'male slave.'

15. Early Chinese sign for the word 'suckling.'
Drawing after T. H. Tsien, *Written on Bamboo and Silk.*

semicircle meant 'to return.' This kind of sign proliferates as needed.

At first glance the word-sign system would seem to be ideal—one sign, one word. Yet it can quickly be demonstrated that the method has serious limitations. There are 26 words in the sentence that opens the discussion on word signs, the same number as the letter signs in our alphabet. In a strict logographic approach to writing we would have to develop separate signs for those 26 words and for all the other words in Webster's or the Oxford Universal or any other dictionary. Clearly, as a language group moves its economic base from hunting and agriculture to trade and manufacturing, with the attendant features of urban living, the number of words needed in communication increases sharply.

If we think about this problem for a moment, it will seem astonishing that the Chinese, whose language has been least affected by radical changes, at the present time contend with and practice a written language involving, on outside limits, fifty thousand graphic characters. The number of logograms in the Shang dynasty (1765–1123 B.C.) has been estimated to have been about twenty-five hundred. The complexities of civilized living have forced the additional number of signs in present-day Chinese. Of course, as in our language group, ordinary persons in Chinese-speaking areas do not encounter fifty thousand word signs daily, nor any small fraction of that number. However, even a smaller total of necessary signs is a handicap in a number of ways to national dreams of complete literacy. The burden of learning by rote is considerable, though perhaps not insuperable. The design of a type font imposes a greater problem. It is generally recognized that literacy and the expansion of knowledge depend on the cheap production of books. Book production becomes difficult when the number of characters required in a font is too great. Then, of course, if an arbitrarily small number of characters is chosen to represent the language in print, richness and subtlety of expression are lost.

Phonetic Transfer, or Rebus Writing

We have seen that the number of word signs in Chinese expanded from twenty-five hundred to a figure twenty times that large in the course of its development. It is estimated that early Sumerian utilized two thousand different signs. In the later Assyrian period the number of signs had been reduced to six hundred. Egyptian used about seven hundred signs, while Hittite used four hundred fifty. It is well known that these civilizations were far beyond hunting cultures in terms of complexity of social organization and of activity in such areas as manufacturing, trade, religion, living comforts, and the

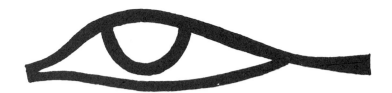

16. Eye drawn in the Egyptian manner. In the principle of phonetic transfer such signs were used in words and syllables of similar sound.

development of large cities. It was the principle of *phonetic transfer* that enabled these various languages to halt the proliferation of word signs and even to reduce them. According to this principle, existing word signs are used to express words of like sound for which there is no sign. Phonetic transfer is the most important principle in the complex history of writing, and all modern alphabetical languages are dependent on it.

Figure 16 shows the Egyptian sign for 'eye.' Now suppose we are using a word-sign system and get the bright idea of substituting the eye sign for the pronoun *I*, for which we have no sign. Of course the sign will then have two functions: it will still be a word sign for 'eye,' but it will also stand for the pronoun *I*, which happens to be one of the handful of vowel sounds in our hypothetical system of logography. While we are at it we might as well go the whole way and substitute the eye sign each time the diphthong written *I* appears where we have no appropriate word sign. In respect to the double function of the sign, context tells us how to read it.

The principle of phonetic transfer is often called the *rebus principle*. A rebus is a pictorial device that substitutes pictures for words or syllables. Readers may be familiar with the device through rebus puzzles published in newspapers for the benefit of children, and in television celebrity games produced for adult audiences. Perhaps the first such puzzle published in America was by Benjamin Franklin and was entitled *The Art of Making Money Plenty*. This short book, published around 1810, some years after Franklin's death, contains advice on getting and keeping money. The page reproduced in Figure 17 contains this statement: "2: Spend one shilling every day less than thy clear gains. Then shall thy pockets soon begin to thrive." The substitution of a pictured bee for the sound *be* and a pictured eye for the long *i* sound are quite inevitable in rebus puzzles. Notice that the pictured awl in the word *shall* is in our time a slightly inaccurate substitution, but it may serve as a reminder that the early stages of writing presented no sudden and clear victory of a fully phonetic system over pictographic methods. Sometimes clear expression is possible by luck.

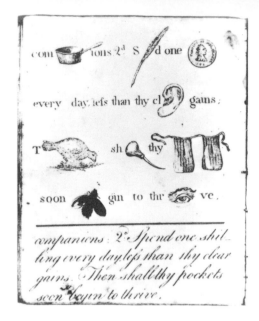

17. An early rebus puzzle for children, from *The Art of Making Money Plenty*, by Benjamin Franklin, illustrating the rebus principle, or the principle of phonetic transfer, basic to the formation of many ancient languages. Rare Book Division, New York Public Library.

We would have no difficulty substituting logograms for the Rose Bowl.

Particularly noticeable in the rebus example of Figure 17 is the fact that many words and syllables still have to be represented in letters. What happens in the early stages of writing when no pictographic word sign is available for substitution for certain sounds, such as *com* in the first line of Figure 17, for example? These are simply left out in early writing. Meaning is spliced together out of limited context, established word signs, and suitable substitutions of word signs for syllables.

Phonetic transfer, the important third stage in the development of writing, is thought to have been forced by two main considerations within a general pattern of increasingly involved social problems: record keeping and the designation of proper names. To go back for a moment to the Oglala Roster, we find such name designations as the following: Low-Dog, Iron-Crow, Little-Hawk, Red-Horn-Bull, and White-Tail. For the most part these names can be described by the method of pictorial assemblage already described. Because the North American Indians were dependent on pictographs for describing proper names and did not happen to stumble upon the rebus principle, persons foreign to the cultural milieu were given Indian names. Great-White-Father referred to the President of the United States. Indian patterns of identification were ingeniously fitted to environmental phenomena.

Foreign names and those involving abstract qualities seem to have forced the development of the rebus principle. Gelb points out that a name such as Enlil-Has-Given-Life poses a problem to the pictographic method. We should also have some difficulty in describing the word *freedom* by pictorial methods.

The rebus principle of word-sign substitution in situations where there are like sounds was discovered by a number of diverse civilizations. Although they never fully exploited it, the Mayan and Aztec cultures in Central America sometimes used the rebus principle in describing proper names. In our culture this would be analogous to substituting pictures of an ox and a ford for *Oxford*, or the picture of a thistle or burr upon a barrel or tun for *Burton*. It was in this latter way that Prior Burton in the Middle Ages playfully identified himself in graphic form.

The Mayan language (Fig. 18) is pictographic in nature and still puzzles scholars. Aztec pictography is clear and well defined in its manner of execution. In Figure 19, an embroidery, it is quite easy to tell that the footprints indicate various journeys. In the lower right is a river, and in the center right a chieftain appears to be shedding

18. Mayan pictographs carved in stone. F. Duane Godman, ed., *Biologia Centrali-America*.

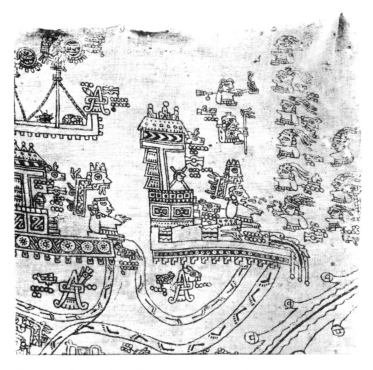

19. Aztec pictography and name signs executed in embroidery. Journeys are depicted by a typical device. *Codices Mixteco Lienzo de Zacatepec.*

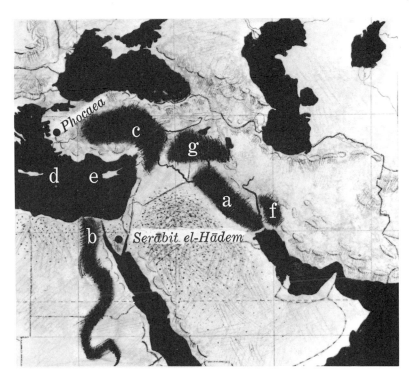

20. Location of writing systems in use prior to the alphabet: (a) Sumerian and Akkadian, (b) Egyptian, (c) Hittite, (d) Cretan, (e) Cypriote, (f) Proto-Elamite, and (g) Hurrian.

tears. Off to the right are the names of various tribal heads, and it is from this kind of record that scholars have discovered the phonetic elements of the Aztec language. Occasionally specialists are able to find in place-names such as *Teocaltitlan* (meaning 'temple personnel') the following word signs: 'lips' (beginning with *te*), 'road' (beginning with *o*), 'house' (beginning with *cal*), and 'teeth' (beginning with *tlan*). Only the syllable *ti* is unaccounted for by a word sign.

SUMERIAN WRITING: THE SYLLABARY

To a people known as the Sumerians goes the honor of having developed the first adequate phonetic system of writing. In Sumerian writing the graphic signs and speech sounds are so codified as to permit reasonably accurate translations after a span of four or five thousand years. It should be added here that the great scholarly breakthroughs in the decipherment of ancient languages occurred after 1800. Chinese, Greek, Latin, Arabic, and Hebrew were never lost to us. The language spoken by the ancient Romans is almost as well known to us as that spoken by our own ancestors at the Battle of Bunker Hill, and with our abbreviated and abridged system of history it is easy to assume that all ancient cultures were intimately associated in time and space. Our Roman ancestors were, in years, more remotely separated from the early Sumerians than we are from the time of Augustus.

It is only fairly recently that archeological evidence about the Sumerian culture began to accumulate. The diggers were looking for the sites of Assyrian and Babylonian cities mentioned in biblical and Greek literature. Some of the great finds from nineteenth-century archeological enterprises in Mesopotamia have come to rest in many museums throughout the world.

The geographical extent of the Sumerian culture can be located in Figure 20. It constitutes the area at the head of the Persian Gulf into which flow the famous Tigris and Euphrates rivers. Five thousand years ago the plain of these rivers was a barren land without trees or minerals. In this harsh and forbidding environment the Sumerians built the first advanced civilization. They developed the baked clay brick and built cities, channeled the waters of the two great rivers and created gardens in the desert, developed the first codes of law and originated regional government. In Sumer, trade surpluses in grain were exchanged for metals and other needed materials. The effect of the Sumerian culture was felt from India to the Mediterranean in its time, and most of it was passed intact to the Babylonian culture that succeeded it. It is supposed

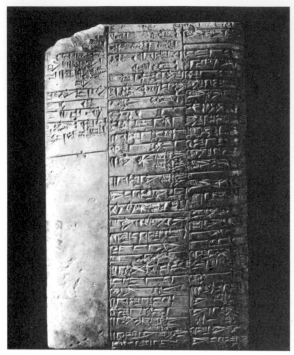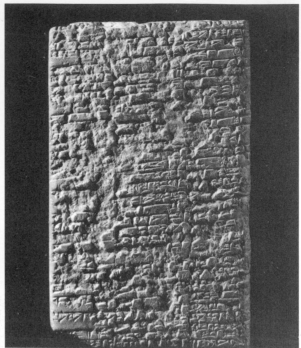

21. Sumerian cuneiform medical tablet. Museum of the University of Pennsylvania, Philadelphia.

that the Sumerians moved into the area sometime before 3000 B.C., and the era came to an end in 1720 B.C., when Hammurabi, the Babylonian king, was able to capture control of the area.

Because the Sumerians were a vigorous, inventive people, interested in exploiting the land, they have been likened to the restless pioneers who settled the American West. And because of their achievement in writing, we might well ask the question, "Who were these people and where did they come from?" Specialists do not know. Samuel Noah Kramer of the University of Pennsylvania had this to say in "The Sumerians," an article in *Scientific American* (October 1957):

The dates of Sumer's early history have always been surrounded with uncertainty, and they have not been satisfactorily settled with the new method of radiocarbon dating. According to the best present estimates, the first settlers occupied the area some time before 4000 B.C.; new geological evidence indicates that the lower Tigris-Euphrates Valley, once covered by the Persian Gulf, became inhabitable land well before this date. Be that as it may, it seems that the people called Sumerians did not arrive in the region until nearly 3000 B.C. Just where they came from is in doubt, but there is some reason to believe that their original home had been in the neighborhood of a city called Aratta, which may have been near the Caspian Sea. Sumerian epic poets sang glowingly of Aratta, and its people were said to speak the Sumerian language.

The Sumerian medical tablet seen in Figure 21, dating c. 2000 B.C., is markedly different in outward appearance from that seen in Figure 22, an Uruk record some 1300

years older. The older document should serve as inspiration for students working in clay, since it is an elegant piece of work. Moreover, it presents a technical problem that instructors in this area will observe at a glance: the number of edges required to impress the marks in this figure is quite impressive since few seem to be scratched in by a single stylus, and because the pictographs are so carefully rendered. If teachers in the area of working in clay could calculate the time involved in rendering this piece, it might give the scholars some clue to the reasons for the significant change in method seen in the Sumerian tablet.

It seems apparent that the detailed method of the Uruk figure required too much time. The Sumerians, the original keepers of records, had to find a quicker writing method. Thus all Sumerian writing came to be interpreted through a few shapes that could be cut from the end of a native reed. These were wedge-shaped, and original pictographs, subtle in curve formation, were reinterpreted through the use of a few tools stamped into clay in a number of positions. The result is apparent in Figure 21. The vertical direction of the writing in the Uruk figure has been changed to horizontal, and the word signs have been shifted 90 degrees counterclockwise to accommodate the change. Of course, a great amount of scholarly effort has been devoted to the structural content of Sumerian writing, but a number of studies also have been devoted to attempts to cut the exact form of the stamp styluses used by the Sumerians and the peoples inheriting their method. Because of its method, Sumerian writing is

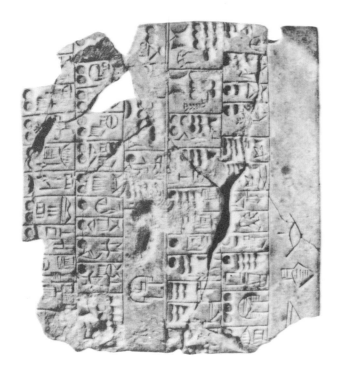

Left: 22. Sumerian record from Uruk. A. Falkenstein, *Archaische Texte aus Uruk.*

Right: 23. Cherokee syllabary. Henry R. Schoolcraft, *Historical and Statistical Information Respecting the History, Condition, and Prospects of the Indian Tribes of the United States.*

Cherokee Alphabet.

D a	R e	T i	δ o	O u	i v
S ga O ka	F ge	Y gi	A go	J gu	E gv
ha	P he	hi	F ho	Γ hu	hv
W la	C le	P li	G lo	M lu	lv
ma	O me	H mi	δ mo	y mu	
O na t hna G nah	A ne	h ni	Z no	nu	O nv
T qua	O que	P qui	V quo	quu	E quv
U sa O s	4 se	b si	R so	su	R sv
L da W ta	S de T te	J di J ti	A do	S du	dv
S dla C tla	L tle	C tli	tlo	V tlu	P tlv
G tsa	V tse	h tsi	K tso	J tsu	C tsv
G wa	we	O wi	wo	wu	6 wv
ya	B ye	yi	h yo	G yu	B yv

called *cuneiform*, from the Latin *cuneus* 'wedge' and *forma* 'form.'

Some of the clues to the decipherment of Sumerian writing were provided by the famous Behistun Inscription. Found by European scholars on the cliff of Bisutun (and mistakenly called Behistun) in a mountainous area northeast of the site of the Sumerian civilization, this huge rock contained inscriptions in three related languages: Old Persian, Neo-Elamite, and Akkadian. The latter term is used to identify the language and culture of the Semitic Babylonians and Assyrians, who followed the Sumerians in the Tigris-Euphrates Valley. Old Persian was deciphered first, and that accomplishment, after the deciphering of Neo-Elamite, enabled scholars to tackle Akkadian, which in turn furnished clues to the earlier Sumerian writing, going back to its inception.

Scholarship on Sumerian writing, still very much alive, produced the idea that the Sumerian symbols were not alphabetic but rather syllabic and logographic; that they were derived from non-Semitic words; that many Sumerian words were monosyllabic; and that Sumerian words were composed of signs ending in a vowel or a consonant.

By the rebus principle, the original logograms in Sumerian writing (about five hundred in number) came to stand for syllables. We can follow this idea by substituting the logogram for 'ox' for the first syllable in *occidental*. When such a phonetic substitution is fairly complete, the system of writing is called a *syllabary*. The Sumerians achieved this in principle. In a rough equivalent it is as if we had separate signs for the vowel-plus-consonant combinations *ab, ac, ad, af, ag,* and so on; and for the consonant-and-vowel combinations *ba, da, fa, ga, ha,* and so on. Historically, the advantages of this system are beyond calculation, since it provides a method of recording foreign names, words, and objects in interculture trading and of inventing new words. Also, the total number of graphic signs involved is reduced to a number that can be handled in printing processes and in teaching. To reinforce a point made earlier, Chinese newspapers cannot be printed by means of a linotype machine. News reporting involves some seven thousand characters, and these cannot be coded on a keyboard machine but must be set by hand. In contrast, the Cherokee Indian syllabary, seen in Figure 23, was invented in modern times to reproduce Cherokee sounds. The number of signs needed is about 80. This is more than our 26 but still manageable.

It should not be supposed that any of the syllabic systems of antiquity reached perfection. In Sumerian, a sign ending in a consonant of known value could be preceded by any one of several vowels, and a sign ending in a vowel could be preceded by one of several consonants, for example, *ga* for *ga* and *ka* or *qa*. We who speak and write English are in equal fault, for we use one sign *a* to stand for the sounds uttered in *fate, fat, father,* and *fall*. Speakers of Spanish, taught that *a* means only one sound, have some difficulty in expressing the others. We put up with these imperfections because it is felt that a minimum of signs will do. Scholars are quite sure that this principle of economy in signs was an important factor in the structure of early syllabic writings.

24. Egyptian sculpture with hieroglyphic writing. Gaston Maspero, *The Dawn of Civilization—Egypt and Chaldea*.

EGYPTIAN WRITING

A thousand miles west of Sumer, the fabled Nile River flows into the Mediterranean. The great Egyptian civilization (marked *b* in Fig. 20) was fed by the Nile, and on the banks of the river appear the architectural monuments familiar to all students of historical art. Familiar, too, are the stone and wood sculptures produced by the ancient Egyptian civilization. Some of these rank with the fine productions of other civilizations. The Egyptians also produced a system of writing that remained in use for thirty-five hundred years. And some of the sounds used in the ancient Egyptian spoken language can be heard today.

The term *hieroglyphic* denotes the Egyptian writing that is carved in stone; it derives from Greek words meaning 'sacred inscriptions.' This version of the Egyptian written language is best known because it was often a part of Egyptian architecture. The deeply incised, pure contours of Egyptian hieroglyphic remain distinctive, oddly without imitators, and with strong esthetic qualities. From this chiseled style sprang two cursive styles, the *hieratic* and the *demotic*. These latter forms were pen-written. Hieratic writing developed through imitation with a pen of the forms carved in stone. Demotic writing developed later as a kind of shorthand version of hieratic. Figure 24 shows an example of hieroglyphic writing accompanying storytelling sculpture.

Egyptian writing developed around 3000 B.C., in a period when Sumerian influence was strong. The potter's wheel was an import from the Mesopotamian Valley, and

the brick architecture found in Egypt had its origins in the Sumerian civilization. Some scholars have come to believe that the origin of Egyptian writing may owe something to Sumerian developments. Delineated with a technical sophistication, hieroglyphic may seem to be more than pictographic in content, but in the earlier phases of Egyptian writing it was just that. However, the Egyptians discovered the rebus principle, and in accordance with a general rule that proper names are the first to be given phonetic equivalents, the Narmer Palette (Fig. 25), from the First Dynasty, is presumed to record the name of King Narmer, in the area between the horned figures of Hathor, by the device *n[e]r* 'fish' and *mr* 'chisel.' The central figure is of course Narmer himself smiting the enemy. Other persons are portrayed with their names or titles appearing near their heads. This is essentially the same kind of identification used by natives of the Western hemisphere.

While language forms carved in stone are seen throughout most of the long march of Egyptian history, surviving changes in central authority, two inventions appeared that shaped the history of writing most profoundly. These were the pen and papyrus, a writing surface. A wedded development, these two items of writing equipment changed the world. They made writing portable and relatively inexpensive. A history of world events seldom dwells too long on what might have been. It is difficult enough to separate fact from myth and speculation. But one can imagine how cultural exchange might have been frozen had it been a perpetual necessity to move pieces of stone around to the various corners of the world. The

Mayan peoples found that the cultivation of corn drained the land of its productivity, and they were forced to move every several years, leaving behind their records cut in stone and starting anew in other locations. And if the memorable love epistles of record had needed execution in stone, certainly their number would have been smaller than it is.

In making the art of writing available to those of lesser affluence, the Egyptians delivered it from the exclusive possession of the priestly and ruling classes. Potentates generally lose no time in commissioning monuments carved in stone recording their great deeds, and we should be thankful that these records have endured. But perhaps the cheaper means of writing is the more important to progress, even if they are more fragile. To have placed the means of writing in the hands of merchants and traders meant the spread of the art of writing; to have placed the means of writing in the hands of leaders of great religious movements meant the preservation of valued cultural material over a large span of time and geographical distance; to have placed the means of writing in the hands of common people meant infinitely more than the possession of weapons. Had the means of writing been a trifle more expensive, Abraham Lincoln's qualities might have been lost. This should suggest the importance of portable and inexpensive writing equipment to the warp and weft of historical development. Certainly if the Egyptians had not developed the pen and a suitable writing surface, some other people would have.

The pen was cut from a reed growing in wet ground, and it was essentially the same as the pens cut today from bamboo stems. To observe the kind of stroke these pens made, it is only necessary to sharpen a pencil into a wedge and see what happens in drawing objects or letters.

The writing surface was made from the papyrus plant, *Cyperus papyrus*, which grows in the Nile Delta. Sir Edward Maunde Thompson, the great authority on Greek and Latin paleography (the study of ancient writing systems), writes in *An Introduction to Greek and Latin Palaeography* (Oxford, 1912):

Papyrus rolls are represented on the sculptured walls of Egyptian temples; and rolls themselves exist of immense antiquity. . . . The manufacture of the writing material, as practiced in Egypt, is described by Pliny, Nat. Hist. XIII. 12. His description applies specially to the system of his own day; but no doubt it was essentially the same as had been followed for centuries. His text is far from clear, and there are consequently many divergencies of opinion on different points. The stem of the plant, after removal of the rind, was cut longitudinally into thin strips (*philyrae, scissurae*) with a sharp cutting instrument described as a needle (*acus*). The old idea that the strips were

peeled off the inner core of the stem is now abandoned, as it has been shown that the plant, like other reeds, contains a cellular pith within the rind, which was all used in the manufacture. The central strips were naturally the best, being the broadest. The strips thus cut were laid vertically upon a board, side by side, to the required width, thus forming a layer, *scheda*, across which another layer of shorter strips was laid at right angles. The upper surface thus formed became the *recto*, the under surface the *verso*, of the finished sheet; and the *recto* received a polish. Pliny applies to the process the phraseology of net or basket making. The two layers formed a 'net,' *plagula*, or 'wicker,' *crates*, which was thus 'woven,' *texitur*. In this process Nile water was used for moistening the whole. The special mention of this particular water has caused some to believe that there were adhesive properties in it which acted as a paste or glue on the material; others, more reasonably, have thought that water, whether from the Nile or any other source, solved the glutinous matter in the strips and thus caused them to adhere. It seems, however, more probable that paste was actually used. The sheets were finally hammered and dried in the sun. Rough or uneven places were rubbed down with ivory or a smooth shell.

These sheets were connected together by means of glue into the form of a roll. The height of the roll varied throughout time, beginning in early Egyptian history at about 6 inches and ranging up to 18 inches in later times. The length of the roll could be over 100 feet, although such are rare. Papyrus served lands around the Mediterranean until it was supplanted by paper from the Far East through Arabia. Papyrus may have been manufactured in Egypt as late as A.D. 1050. It served the Greeks and Romans as a writing material, although in Latin literature it was gradually replaced by vellum as a writing surface. By the fourth century of the Christian era animal skins were used for most of the writing in Latin hands. The use of papyrus lingered on in Europe until the eleventh century. Egypt was not the only place where it was manufactured. Many papal documents were written on it in this later period. Figure 83, written in 892, is sufficient proof that quality papyrus was still in good supply at this date. Papyrus was in use for some four thousand years, and many ancient records of literature, commerce, and government are in existence today because of this useful material. However, it could not survive damp climates. Libraries in some institutions have examples of papyrus, locked away of course. Facsimiles are more frequently found.

As we have seen, the Egyptian language came to be executed in three different forms. The hieroglyphic form was indeed a "sacred" form, used to confirm the thoughts and deeds of priests and royal persons. This form was sometimes imitated in painted versions. The more cursive hieratic followed the hieroglyphic rather closely in time sequence and became the common form used for keeping

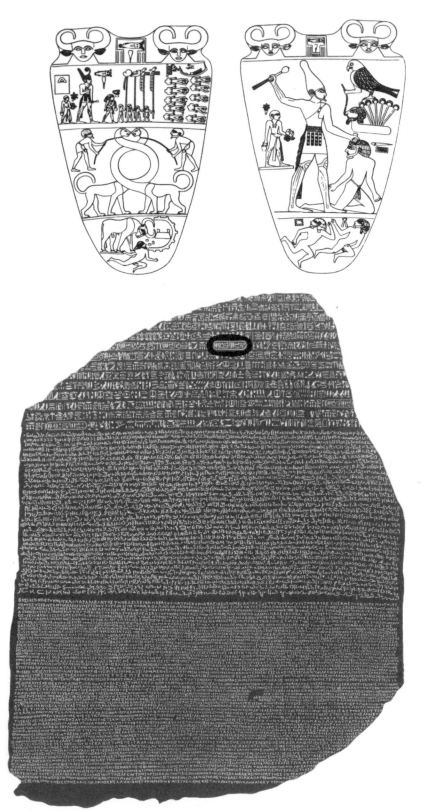

records and for recording a growing literature. Numbers very much like our own were developed. Demotic emerged around 700 B.C. and was used for books. Professional scribes were trained to execute these pen hands, and this activity is well documented in Egyptian illustration. None of the forms supplanted the others, for each had its purpose. In Greco-Roman times all three were used. It is not quite a parallel example, but today we use letters carved in stone, rapid pen writing, and shorthand. The Egyptians thus initiated a great period of reed-pen writing, with professional scribes and fixed apparatus and procedures.

It was Napoleon who indirectly provided the clue to the decipherment of Egyptian, a lost language for 1500 years. In 1799 Lieutenant Boussard, one of the soldiers Napoleon had sent into Egypt, discovered a rock bearing some strange language forms. One of Boussard's superiors, General Menou, took possession of the now-famed Rosetta Stone and arranged to have it shipped to his private residence. But Napoleon heard of the discovery and ordered the stone sent to Cairo for examination by Parisian experts. Menou argued that the stone was his personal property, but he finally had to give it up. Meanwhile the British defeated Napoleon in 1801 and wrote a special clause in the treaty of capitulation to gain possession of the Rosetta Stone. Beginning in 1805 engraved reproductions of the material recovered from the French began to be published in Britain under the title *Egyptian Monuments*. In company with this document was a small four-page publication documenting the recovery. Among the objects recovered was the sarcophagus of Alexander the Great, a priceless relic.

The much-traveled Rosetta Stone can now be seen in the British Museum, where it has resided since 1802. Inscribed on this stone are three versions of the same text: one in hieroglyphic, one in demotic, and one in the Greek tongue and script. The stone records a decree of 196 B.C. defining honors to be rendered Ptolemy V. Scholars tried their hands at deciphering the hieroglyphic inscription quite soon, and Thomas Young, an Englishman, recognized the name of Ptolemy (circled in Fig. 26). But that was all.

However, on September 22, 1822, a young French scholar of Egyptology burst into a room of the French National Institute in Paris, where his brother was working, and cried out, "Je tiens l'affair," or "I've got it." He then collapsed. Jean François Champollion had indeed cracked the code. The story is continued in the *UNESCO Courier* of March 1964:

A few days later when he had recovered, Champollion announced the great news in a letter to Monsieur Docier, the secretary of the Académie des Inscriptions et Belles Lettres, in Paris.

Top: 25. The Narmer Palette. Egyptian Museum, Cairo. J. E. Quibell, *Zeitschift fur Agyptische Sprache*

Above: 26. The Rosetta Stone. British Museum, London.

. . . In 1821 Champollion made a capital discovery. Counting hieroglyphic signs on the Rosetta Stone and the words of the corresponding Greek text, he found that the hieroglyphs outnumbered the Greek words three to one; thus it took several hieroglyphs to form a single word. Using a demotic script written on papyrus, he confirmed the hieroglyphic form of the name Ptolemy and, in 1822, succeeded in deducing and writing with almost perfect accuracy the name of Cleopatra. He now had 11 letters as a basis for future decipherment. His findings were confirmed when he deciphered the name of Thutmosis, and he thus opened the way for a complete understanding of hieroglyphics, the key to ancient Egyptian history. . . .

Champollion was of course looking for signs that designated sounds. A remnant of sound structure existed in Coptic, the language of the Christian Egyptians, and working through a list of proper names in many manuscripts, he finally confirmed enough phonetic signs to read whole sentences. Sir Alan Gardiner, in *Egyptian Grammar*, states that ''. . . Egyptian hieroglyphic writing did not attempt completely to replace pictorial elements by sound-elements; throughout the entire course of its history that script remained *a picture-writing* eked out by phonetic elements.'' The Egyptian syllabary, the phonetic part of the language, consisted of 24 signs of a single consonant plus any vowel, and about 80 signs with two consonants plus an admixture of vowels between and after. Egyptian writing influenced the cousin languages Phoenician, Aramaic, Hebrew, and Arabic, which were originally without vowel signs. During the medieval period, the latter three languages acquired vowel signs in the form of auxiliary marks to consonant signs.

Figure 27 shows the vigorous pen calligraphy of Egyptian hieratic. Hieroglyphic is written in a number of complex word orders, but this example, dating from the reign of Sesostris I, reads from right to left and is part of a contractor's record of the construction of a temple.

The demotic example in Figure 28 is from a trial transcript c. 175 B.C. It too reads from right to left, and is part of a document containing lines of considerable length. (Several documents are listed in the Notes and Bibliography so that students can find more examples of the fine Egyptian writers.) Professional scribes appeared early in Egyptian history and are pictured in relief sculpture and in sculpture in the round. Their palettes have been found, and the apparatus indicates a long tradition of skills that were not matched until the Middle Ages in Europe. Much of the European tradition—ruled lines, flush margins, large initial letters—stems from Egyptian writing. It is to be regretted that more of this splendid tradition is not available to students of calligraphy, for there is great vigor and variety in the individual hands.

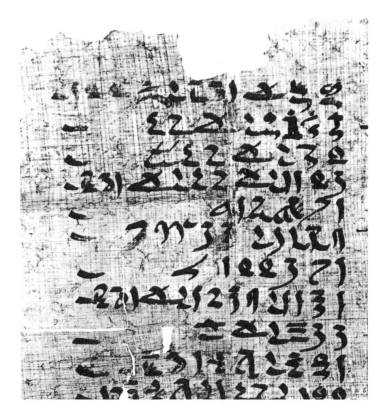

27. Egyptian hieratic writing executed on papyrus. The strokes indicate a reed pen similar to those now used. Museum of Fine Arts, Boston.

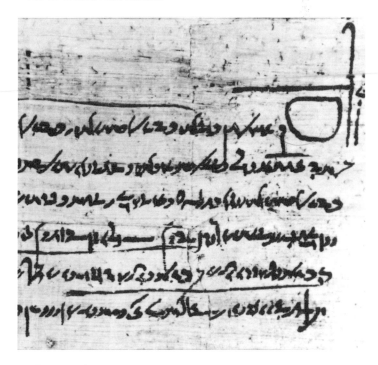

28. Egyptian demotic writing, reed pen on papyrus. Demotic was a kind of shorthand version of hieratic. British Museum, London.

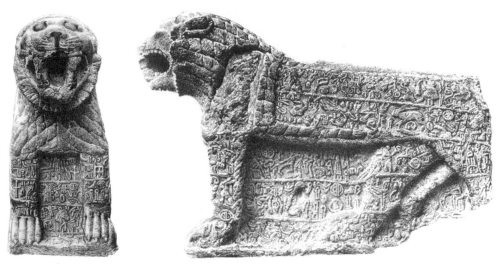

29. The Marash Lion. Archeological Museums, Istanbul. William Wright, *The Empire of the Hittites*.

THE HITTITES

The name *Hittite* is familiar to those in our culture who have read the Bible (Genesis 23).

And Sarah was a hundred and seven and twenty years old: these were the years of the life of Sarah. And Sarah died in Kirjath-arba; the same is Hebron in the land of Canaan: and Abraham came to mourn for Sarah, and to weep for her. And Abraham stood up from before his dead, and spake unto the sons of Heth, saying, I am a stranger and a sojourner with you: give me possession of a burying place with you, that I might bury my dead out of my sight.

The sons of Heth were the Hittites. Descendants of Abraham were to see the Hittites again, for they were one of a number of peoples who surrounded the ancient Israelites with walls of power. Hittite power was to the north (marked *c* in Figure 20). In this general region the Hittites developed a word-syllable system of writing called hieroglyphic (though it is in no way related to Egyptian writing), which was in use from 1500 to about 700 B.C. It was of course pictographic in origin and cut in stone, as is observable in Figure 29.

Initial discoveries of the Hittite civilization were made in the nineteenth century. Credit for the first discovery goes to Johann Ludwig Burckhardt, who in 1822 devoted a few lines to a curious rock he had seen in earlier travels in Syria. This stone was covered with strange figures of an unknown kind. It was rediscovered in 1870 by an American consul-general, J. Augustus Johnson, and an American missionary, Rev. S. Jessup. They and others were subsequently thwarted by hostile natives in attempts to copy these "Hamah inscriptions," then inset as part of a later

structure. Magical powers were attributed to one of the stones. In 1872, two Englishmen—W. Kirby Green, the consul at Damascus, and William Wright, D.D., author of *The Empire of the Hittites* (1886)—were invited on a journey to obtain the Hittite inscriptions. Wright explains the invitation in these words: "The Sublime Porte, seized by a periodic fit of reforming zeal, had appointed an honest man, Subhi Pasha, to be governor of Syria." This latter proposed the expedition. The undertaking, however, was rather dangerous, since the natives threatened to destroy the stones before seeing them removed. It took the promise of money, the threat of violent reprisal, and the fine art of diplomacy to quiet the natives. Wright describes the final success of the expedition:

The removal of the stones was effected by an army of shouting men, who kept the city in an uproar during the whole day. Two of them had to be taken out of the walls of inhabited houses, and one of them was so large that it took fifty men and four oxen a whole day to drag it a mile. The other stones were split in two, and the inscribed parts were carried on the backs of camels to the *Serai*. As the shrill-voiced Moslems were summoning from the minarets the faithful to prayer at the set of sun, the last stone was, to our great delight, deposited in safety.

The party then made two sets of plaster casts of the inscriptions. They were sent to the British Museum and to the Palestine Exploration Fund. Thus the Hittite language came to the attention of interested scholars.

Of interested scholars there were many. A young Welshman, Archibald Henry Sayce, made the first important contribution to the understanding of Hittite. Before Sayce went to Oxford he had mastered Latin, Greek, Egyptian, Persian, and Sanskrit, and was well equipped.

Sayce succeeded in giving a correct reading of a silver plaque now called the Tarkumuwa Seal. The Hittites used two related languages and two scripts. Hittite "hieroglyphic" is picture writing in physical forms and seems to have ties with forms originating in the Aegean area. Cuneiform Hittite borrowed its method from the cuneiform of the Mesopotamian Valley. Thus the seal under consideration was a kind of bilingual fragment, and the already considerable knowledge of Sumerian-Babylonian-Assyrian texts was focused, in the person of Sayce, on the mysterious Hittite.

He produced a phonetic reading that said: "Tarkumuwa, king of the land of Mera." In Wright's book Sayce published a list of Hittite characters with some logographs, some syllabic values, and some determinative signs, such as a prefix to signify divinity and signs to identify plurality and racial origin.

Bedřich Hrozný, a Bohemian expert in Semitic languages, established, in an account of his studies on Hittite to a meeting of colleagues in Berlin in 1915, the fact that, in structure and to some extent sound, Hittite possessed affinities to the Indo-European language group (of which English is a member). In one inscription Hrozný read a logogram for 'bread' and following that the phonetic reading, -an ezzateni, wāsar-ma ckuteni. What should follow bread? For ezzāteni Hrozný recalled the Greek edein 'to eat,' the Latin edere, and the old German ezzan. And for wāsar Hrozný remembered the Old Saxon watar. Then by context ekuteni meant 'to drink.' We know now that the word father is essentially the same in all Indo-European languages and can be recognized from the United States eastward to Northern India. Hrozný published his findings in 1915.

The work of interpreting Hittite scripts continued. Piero Meriggi applied statistical methods to the Hittite hieroglyphic and gave the final push that enabled Emil Forrer, Helmuth Theodor Bossert, and Ignace J. Gelb to wade through the difficulties of Hittite writing and put its interpretation on a sound footing. Gelb's Hittite Hieroglyphic Monuments (Chicago, 1939) contains an account of his travels in the Near East and numerous reproductions of Hittite inscriptions. With many essential words rendered in logographic signs, with word endings and other grammatical structures understood by the rebus method, the syllabic part of Hittite consisted of about 60 signs, each beginning with a consonant and ending with a vowel. The number of word signs is about 450, in comparison with Sumerian's 600 and Egyptian's 700. Greater economy in number of signs used is not to be found in ancient writing, but can be achieved in syllabaries especially designed for a specific language, like that

developed to fit the Cherokee Indian sound structure in the nineteenth century (Fig. 23). Here we see that in contrast with the older systems logographs are eliminated, and invented signs stand for syllables needed to record the spoken language—a sharp break in method.

THE ISLANDS OF CRETE AND CYPRUS

Another center of ancient writing was Crete, an island situated in the Mediterranean between Greece, Turkey, and Africa (d in Fig. 20). Endowed with deposits of metals, and being a natural steppingstone between continents, Crete was in a manner of speaking a predestined stage for Bronze Age culture. There is still speculation about the peoples who acted their parts here.

Heinrich Schliemann, discoverer of Troy and of the priceless historical material interred at Mycenae, had his eye on Crete as an archeological site but was unable to obtain permission to dig there. The digging on Crete was done by an Englishman, Arthur Evans, who purchased the site. Evans, Keeper of the Ashmolean Museum at Oxford, had been struck by similarities between inscribed seals from an area in Greece and those of Hittite origin. It was not known then that there was any such cultural connection, although it is now well established. Evans went to Greece in the spring of 1893 to look around and collect specimens from the resident population. Schliemann, unfortunately, had died only three years before.

Evans discovered that some of the Greek women wore ancient amulets about their necks to ensure their being good mothers. These amulets contained pictographic elements that interested Evans, and in 1895 he published Cretan Pictographs and a Prae-Phoenician Script. A reproduction from this publication of a four-sided red carnelian is seen in Figure 30. Evans also discovered a system of abbreviated carved signs that he called linear, and in the 1895 publication he made some comparisons between these linear signs and other language signs found in the Mediterranean area. From this material and on the basis of external evidence, for which he had a sharp eye, Evans suggested that the pictographic system of Crete was related to the Hittite "and it must in all probability be regarded as a sister system, with distinct points of affinity. . . ." Evans also quoted Diodoras of ancient Greece to the effect that the Phoenicians had not invented writing characters but only changed the shapes. "We may further infer from the Cretan contention recorded by Diodoras that the Cretans themselves claimed to have been in possession of a system of writing before the introduction of the Phoenician alphabet." In these contentions Evans

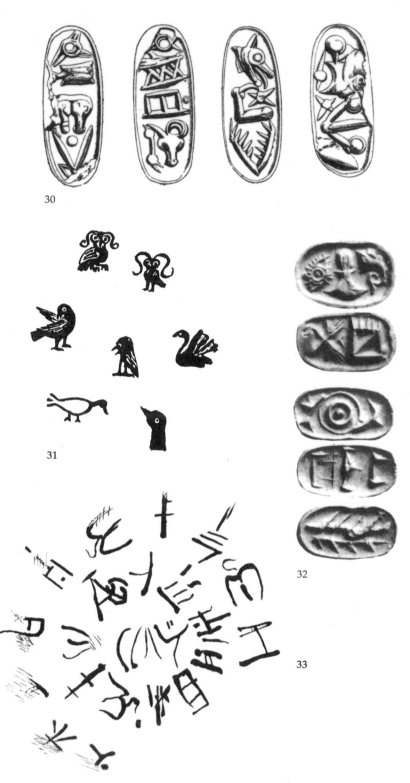

30

31

32

33

30. Red carnelian with Cretan pictographs. Ashmolean Museum Library, Oxford, England.

31, 32, and 33. Bird signs, Linear Class A seals, and Linear Class A signs executed with a crude reed pen. Arthur J. Evans, *Scripta Minoa I.*

was essentially sound. His suggestion that the source of alphabetic writing could or might be found in the Aegean area rather than the Syrian area was incorrect; but the notion of involvement between the northern invaders of Greece and the Semitic peoples of the eastern Mediterranean is a live subject today.

But there was more to come, for Evans was determined to dig on Crete. In 1895 he purchased a share in the property, "but it was not till six years later, after encountering every kind of obstacle and intrigue, that [he] finally succeeded in purchasing the whole site." Evans began digging in March 1900. He uncovered the "House of Minos" and gave the Minoan civilization its name and place in history. On March 31 Evans' group of diggers uncovered a clay tablet with incised signs of the linear type he had seen before, and this was the beginning of a flood of Cretan documents. In 1909 he published the first volume of *Scripta Minoa*, a review of his findings. This book contained a catalog of pictographic signs together with suggested derivations and meanings. Typically these consisted of animals, on the principle of *pars pro toto*, parts of animals, plants, human anatomy, and so on standing for the whole object. Some of the bird signs are seen in Figure 31.

The Cretan pictographs that Evans discovered were products of the very earliest stages of the Minoan civilization, perhaps as early as 3000 B.C. Evans later identified two kinds of conventionalized scripts, which he termed Class A and Class B. Both were pictographic in character. The script of Class A was developed in 2000 B.C., while the Class B script made its appearance some two hundred years later. These early forms of Cretan writing came to be written in a more cryptic or abstract fashion near the close of the Middle Minoan III period (1700–1550 B.C.). In his account of the Knossos dig, Evans marked the change, which he described as a widespread catastrophe in the palace and its environs. Thereafter the older scripts took on a new form and were termed Linear Class A and Linear Class B. The former was in use up to about 1450 B.C., and the latter disappeared around 1200 B.C. A few of the older signs typical of Linear Class A writing can be seen in Figure 32.

After the debris of the Middle Minoan disaster had been cleared away, Evans found two cups with ink-written signs of the Linear Class A script appearing on the inner surfaces. The writing that resides in one of these cups appears in Figure 33. The specimen should have some interest for students of calligraphy, since it appears to be executed by a reed pen before the final firing of the clay. This bespeaks a connection between the Aegean area and Egypt or Syria. The "pen" used was undoubtedly

frayed at the tip, imparting to the instrument some of the character of a brush. It was not the sharp chisel-edged tool the Latin writers began using in the third century B.C.

The first volume of *Scripta Minoa*, which was based on the tablets of the fabulous Evans dig, contained many reproductions of Linear Class A material and only a few documents of the Linear Class B material out of some twenty-eight hundred specimens Evans had uncovered. The second volume of *Scripta Minoa* appeared in 1952, eleven years after Evans' death. This left scholars starved for material on Linear Class B, such as that seen in Figure 34.

34. Linear Class B signs. Arthur J. Evans, *Scripta Minoa II.*

In 1939 the American Carl W. Blegen discovered six hundred clay tablets of Linear B at Pylos on the mainland of Greece. These were taken to the United States on the last boat to leave the Mediterranean before World War II, and thus another source of Linear B writing was available to scholars.

Minoan Linear Class B

The brilliant decipherment of Linear B is a tale too long to relate here. Ernst Doblhofer tells part of it, and the part played by Michael Ventris has been related in various journals. Youthful experts Emmett J. Bennett and Alice J. Kober made valuable contributions. Kober died in 1950 and Ventris, too, lived only half a lifetime (1922–1956). At the age of 14, Ventris had heard a lecture by Evans, and at 18 had tried to prove that the Cretan writings were Etruscan. He abandoned this idea later and introduced Greek phonetic values into a hypothetical grid system of vowel and consonant signs. This worked, and the system was confirmed in 1952 by another brilliant young Englishman, John Chadwick.

Thus seven hundred years before Homer there was a Greek language in the Aegean area. On recent evidence by Bennett, Minoan Linear B consists of a syllabary of 89 phonetic signs, each expressing a vowel or a consonant plus a vowel.

By identifying Linear B as Greek, Ventris and his colleagues helped to cement a revision in Aegean history. Mainland Mycenae was not an offshoot of Minoan civili-

zation. Rather, Mycenaeans (now considered to be Greek) invaded Crete sometime after 1450 B.C. and supplanted Linear A with Linear B. It is presumed that there were cultural and linguistic affiliations between the Mycenaean Greeks and other Indo-Europeans in Anatolia (Turkey), especially the Hittites. Mycenaean domination of the Aegean area ended with the invasion of Dorian Greeks about 1100 B.C. The illiterate Dorian Greeks introduced a "dark age" into Aegean civilization, and writing had to be reintroduced by way of the Phoenician Semitic alphabet several hundred years later.

Minoan Linear Class A

Almost fifty of the signs in Minoan Linear B can be traced back to Linear A, and these emerged from the earlier signs cut in stone. It is generally presumed that Linear A is not a Greek language, but it has yet to be deciphered. In 1956 a Swede, Arne Furumark, suggested that Linear A had roots in an Anatolian language of Indo-European affiliation. However, Cyrus Gordon of Brandeis University contends that Linear A is a Semitic dialect, related to Ugaritic, Phoenician, and Hebrew (see *Scientific American*, Feb. 1965). He argues that Greek and Semitic cultures were interwoven to a degree suggesting common origins, and that the Minoans of the great palaces and of Linear A were Phoenicians who came to Crete around 1800 B.C. Both theories cannot be right, and so we wait for later word.

The Phaistos Disk

In 1908 an Italian team digging at Phaistos on Crete uncovered a remarkable clay disk containing 241 total signs and 45 differing signs, printed into the clay by means of a stamp or punch (see Fig. 35). Lacking in ancestor or progeny, the disk represents a unique object in terms of its physical form. It dates about 1700 B.C. by archeological methods, and judging from the number of its signs, it represents a syllabary. Gelb declared that the syllabary was Aegean on the basis of word groupings, after a number of theories had been published on its geographical origin. Although some have claimed to have read parts of the Phaistos Disk, it is generally placed in the undeciphered category and may well be indigenous to Crete. The direction of writing is from right to left, and the signs always face to the right.

The Cypriot Syllabary

Pockets of migrant Greek civilization appeared on Cyprus as early as 2000 B.C.; but no writing forms predate 1500 B.C. and these Bronze Age inscriptions die out c. 1150 B.C. None of this early material was discovered before

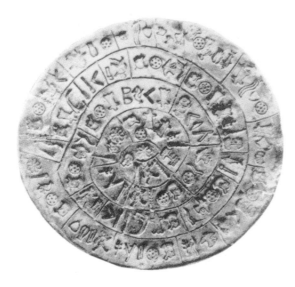

35. The Phaistos Disk. The other face may be seen on page 3. Heraklion Museum, Heraklion, Crete.

1850, and Duc de Luynes, a Frenchman, seems to have been the first to have introduced this material to the scholars of Europe in 1852. Arthur Evans, in the fourth volume of *The Palace of Minos*, established the fact that on the basis of signs the early writings on Cyprus were related to Crete, and the relationship was corroborated by comparisons in artifacts.

The classical Cypriot syllabary dates from a later period (700–100 B.C.). The gap in time between the older writing and the newer has not been explained, but it is clear that there is a connection with Cretan signs.

The later, or classical, Cypriot syllabary was deciphered in the latter half of the nineteenth century. Ernst Doblhofer records this scholarly hunt in *Voices in Stone* (London and Toronto, 1961). Lacking subtle distinctions, the late writing on Cyprus consists of 56 signs, each expressing a syllable ending in a vowel. It was designed to express the sounds of a non-Greek language and was then used to express Greek. In effect it spelled Greek words in an archaic manner: *a-to-ro-po-se* was, in effect, the spelling of a modern word as short as *atropos*.

Even as the Cypriot syllabary was in development, alphabetic writing was being passed to the Greeks via the Semitic Phoenicians. In spite of geographical proximity, Cyprus was, for a time, bypassed by the new development in writing.

OTHER ANCIENT SYSTEMS OF WRITING

Another old and undeciphered form of writing appeared in ancient Elam, in the southwestern part of what is presently Iran. Some maps may label this area Persia. The center of the Elamite culture was Susa (see *f* in Fig. 20). Its language, called Proto-Elamite, exists in its earliest form on several hundred clay tablets dating some time after 3000 B.C. Since the number of signs used in the writing runs to several hundred, it is presumed that the writing is pictographic-logographic. Not one of the signs has been read. Proto-Elamite thus joins Minoan Linear Class A and the writing of the Phaistos Disk in a limited number of writings that still defy the best efforts toward decipherment.

Influenced by neighboring Sumer, Elam discarded the method of its earliest writing and borrowed the Akkadian cuneiform method and language c. 2500 B.C. Akkadian was borrowed by a number of other cultures and became the *lingua franca* of the Near East. Later the people of Elam used the cuneiform method of sign production to express their native tongue, which was neither Indo-European nor Semitic. This language, Neo-Elamite, was preserved by the Persian invaders of Elam and is one of the languages appearing on the famous Behistun Inscription.

Another syllabic system using cuneiform signs dates from c. 1500 B.C. and was developed by the Hurrians in the vicinity where Syria, Iraq, and Turkey meet (*g* in Fig. 20).

Ancient Ararat, familiar as the mountain where Noah's ark became stranded, was the site of yet another ancient kingdom and language. Powerful in 800 B.C., Urartu controlled the lands around Ararat, a 17,000-foot peak near the confluence of boundaries separating the USSR, Turkey, and Iran. Urartu held territory between large lakes in each of these countries, expanding into central Turkey and to the Mediterranean during its brief period of influence. The Urartians also used a cuneiform system of signs.

The Ring of Languages

Figure 20 shows that the developments of languages in word sign and syllable sign resulted in a circle of language systems that surrounds the eastern end of the Mediterranean now occupied by Israel, Jordan, and Syria. To the southwest across the Red Sea is the area of Egyptian writing. To the east is the Mesopotamian Valley, with its Sumerian cuneiform followed by Akkadian cuneiform, the languages of the Babylonians and Assyrians. In northern Syria and Turkey are areas of the Hittite, Hurrian, and Urartian languages. Then to the east are Greek-Minoan Linear B, Minoan Linear A, and the Cypriot languages. To the south and east lie the great deserts of Syria and Saudi Arabia, where the lack of population centers inhibited the development of writing. Somewhere within this ring of languages on the eastern end of the Mediterranean Sea alphabetic writing had its beginnings.

Fifth century B.C. Greek coin.

Chapter 2 The Alphabet to Rome

The alphabet represents a change in principle from syllabic systems of writing, which feature a unique sign for every syllable needed in a given language. In English, for instance, we should need separate signs for *ab, ac, ad, ag,* and so on. Syllabic systems represented a great step forward in expanding language potential. They furnished a ready method of spelling foreign names and of borrowing foreign words, as well as a method of connecting words to signs coined out of the verbal milieu — important to trade and commerce. But syllabic systems of writing are clumsy compared to alphabetic systems and require three or four times as many signs.

The development (or invention) of an alphabet involves a single principle: one sign for each vowel and one sign for each consonant. It is widely accepted that a Semitic people in the geographical area de-

36. The Baal of Lebanon. Louvre, Paris.

scribed previously did in fact develop alphabetic writing; however, a slight gap between theory and fact must be mentioned at the outset. The theory calls for a script designating vowel signs, but in fact Proto-Semitic and the related languages deriving from it—Phoenician, Aramaic, and Hebrew, among others—did not have signs for vowels. Even at the present time Hebrew is written with consonant signs with auxiliary marks to indicate vowels. These facts are the basis of an argument among philosophers of language on the question of what the radical signs of the Phoenician system mean and what they should be called. Because vowels are not indicated by major signs, some scholars contend that the Greeks developed the first true alphabet, because they *did* indicate their vowels with signs equal in visual content with those used to indicate consonants. The argument is not based on a trivial technicality, but the controversy is difficult to document and is certainly beyond the scope of this text. The earliest Semitic "alphabetic" writing used 28 consonant signs, and these were later reduced to 22. In general intent early Semitic leans to the economy of alphabetic writing as we have learned it, and our terminology will reflect this.

Alphabet is Greek in origin, merely *alpha* and *beta*, Greek names for the first two letters. At the eastern end of the Mediterranean these letters were *alef* and *beth*, the words for 'ox' and 'house.' The continuity of Semitic scripts is demonstrated by a word like *Bethlehem* 'house of bread.' Signs used to represent the consonant values of the earliest Semitic alphabet were borrowed from remnant word signs in the area. There remains a peripheral subject: Why was the word *beth* and its sign chosen to stand for the second sound in the alphabet? The picto-

graphic content 'ox' had been shed, as well as the word content, and no doubt there were many words beginning with *b* that could have served as well. Perhaps the manner in which the words were selected is reflected in the method of flyers in World War II, who used *Able* and *Baker* to stand for *A* and *B*.

The order of the alphabet and reasons for it are obscure, though various acrostic passages in the Old Testament suggest an order that is confirmed by Greek usage. G. R. Driver presents a detailed argument on this subject in *Semitic Writing* (London, 1948).

When we speak of the Arabic alphabet or the Latin alphabet or the Russian alphabet we are referring in essence to only one alphabet, for all have a single origin. The alphabet used to express the sounds of the English language is essentially that used by the speakers and writers of Latin. Adaptations of the alphabet in Asia are so extensive that only the idea exists.

Studies in England have revealed that English sounds need 45 signs for perfect clarity but the "Latin" of India, Sanskrit, seems to have achieved this state of perfection long ago.

Since 1500 B.C. the idea of alphabetic writing has surpassed all other systems. While it is true that military power, missionary zeal, and commercial elan have combined to make it stick in areas of nonconformity, the idea of alphabetic writing seems to have constituted a relentless force in its own right. Many an historic battle seemed to have changed the course of events, but the alphabet survived and became more firmly established. Once trailing in the footsteps of power, the alphabet now has strength in its own right on the grounds of efficiency and flexibility.

EARLY THEORIES ON THE ORIGIN OF THE ALPHABET

Theories of the origin of the alphabet have been many. Herodotus, the Greek historian (c. 484–425 B.C.), states:

Now these Phoenicians . . . brought in among the Hellenes many arts . . . and especially letters, which did not exist, as it appears to me, among the Hellenes before this time; and at first they brought in those which are used by the Phoenician race generally, but afterwards, as time went on, they changed with their speech the form of the letters also.

Pliny, who lived in Rome during the first century A.D., credited the Phoenicians, in *Natural History*, with the invention of the alphabet. The Phoenicians occupied an area of the eastern Mediterranean coast to the north of ancient Palestine, a territory now included in the Syrian nation. As is well known, these Semitic people were addicted to travel by sea, and the marks of their passing are to be seen throughout the Mediterranean and beyond. In the *Annals* of Tacitus (A.D. 55–120) we read:

The first people to represent thoughts graphically were the Egyptians, with their animal-pictures. These earliest records of humanity are still to be seen, engraved on stone. They also claim to have discovered the letters and taught them to the Phoenicians, who controlling the seas, introduced them to Greece and were credited with inventing what they had really borrowed.

No new material on the origin of the alphabet was added in the years between these early writers and 1900. In the nineteenth century the first alphabetic writings were confirmed as Phoenician through archeological findings. An example of Phoenician writing is seen in Figure 36 on a bronze cup from Cyprus called the Baal of Lebanon. This example, c. 800 B.C., received its first important publication in volume one of *Corpus Inscriptionum Semiticarum* (Paris, 1881). The volumes comprising this important work on Semitic writings established the continuity of Phoenician inscriptions found in the Asia Minor homeland and those in Cyprus, Greece, northern Africa, Sicily, Sardinia, Marseilles, and Spain. With its local derivatives, the Phoenician language thrived and then faded out of use between 1000 B.C. and A.D. 300. It will be recalled that Carthage, in Africa, with its memorable encounters with Rome, played a part in the history of the Phoenicians.

Another famous example of early Semitic writing is the stela known as the Moabite Stone, now in the Louvre (Fig. 37). The stone was discovered in 1868 about 25 miles east of the Dead Sea and dates from c. 850 B.C. This stela tells the story of a rebellion against the Israelites from the

37. Moabite Stone. Louvre, Paris. Severely damaged, this early Semitic inscription is reprinted from M. Lidzbarski, *Ephemeris für Semitische Epigraphik,* a copy made before 1902.

point of view of Mesha, the king of Moab. The other side of the story is related in the Bible in III Kings and begins, "And Mesha king of Moab was a sheepmaster, and rendered unto the king of Israel a hundred thousand lambs, and a hundred thousand rams, with the wool."

Because of an essential continuity between early Semitic writings and Semitic tongues of the present day, it was possible in the nineteenth century to establish the signs and phonetic values of the Semitic alphabet. The alphabet (Fig. 38) consisted of 22 consonant signs, varying with the locality, and was used for various local languages of peoples who were related but had different ways of living and separate histories. Thus, although the Phoenicians, occupying a coastal site 20 miles wide and involved in business pertaining to the sea, are credited with the

⟨	Aleph
⟨	Beth
⟨	Gimel
⟨	Daleth
⟨	He
⟨	Waw
⟨	Zayin
⟨	Heth
⟨	Teth
⟨	Yod
⟨	Kaph
⟨	Lamed
⟨	Mem
⟨	Nun
⟨	Samekh
⟨	Ayin
⟨	Pe
⟨	Sadhe
⟨	Qoph
⟨	Resh
⟨	Shin
⟨	Taw

38. These 22 consonant signs became fundamental
to the written Semitic languages used by related peoples
at the eastern end of the Mediterranean. The signs
were nowhere standard. The names are modern Hebrew
of direct lineage.

spread of the alphabet to the West, they cannot be given credit for its invention. The signs used, if derived from pictographs, hardly reflect Phoenician concerns and habits.

In the nineteenth century it was a popular assumption for various reasons—domination of the area, continuity of culture, a seeming similarity of signs, and a consonant syllabic system—that Egypt was the source of early Semitic writing. It was Champollion who suggested hieroglyphic as the source of Semitic letters. In 1859 E. de Rouge derived the Phoenician signs from the Egyptian hieratic. This date can perhaps be regarded as the beginning of serious study on the subject of the connection between Semitic and Egyptian writing. Subsequently other theories linked Semitic with Egyptian hieratic and demotic. However, ancient theories were also revived to connect Phoenician writing with some of the other ancient systems of writing previously discussed. French historian Gaston Maspero, in *The Struggle of the Nations* (London, 1896), wrote: "It is no easy matter to get at the truth amid these conflicting theories." These words are equally true today. That there is a connection between Egyptian and early Semitic is recognized; but it is also recognized that neither invented the first alphabetic writing.

Proto-Sinaitic Alphabetic Signs

In 1905 Flinders Petrie, leading a British team of archeologists on the Sinai Peninsula—the area between the Nile River and the ancient Holy Land—discovered some enigmatic inscriptions that were quite unlike Egyptian hieroglyphic. The site of these marks is Serābit el-Hādem, seen in Figure 20, a temple of the Egyptian goddess Hathor. Some of these signs are seen in Figure 39a, taken from the original publication *Inscriptions of Sinai* (London, 1917), by Alan H. Gardiner and T. Eric Peet. The photograph in Figure 39b shows three of the signs from these inscriptions, spelling *tnt* or 'gift.' In this example the letter forms are quite like our own, and one can see the pictographic origin of the letter *N*, 'snake.' In terms of artistry the Petrie discoveries were not much to look at, and they were tucked into the back of *Inscriptions on Sinai* under the heading "Foreign Inscriptions"; but they were to cause spirited exchanges among scholars for 35 years.

The Proto-Sinaitic inscriptions in early years were dated as old as 1850 B.C., but since 1950 a date this side of 1600 B.C. has gradually been accepted.

In 1915 Gardiner announced a theory that the writings from Sinai were a link between Egyptian and early Semitic, and held that the writing was alphabetic, based on the acrophonic principle of using the first syllable of a

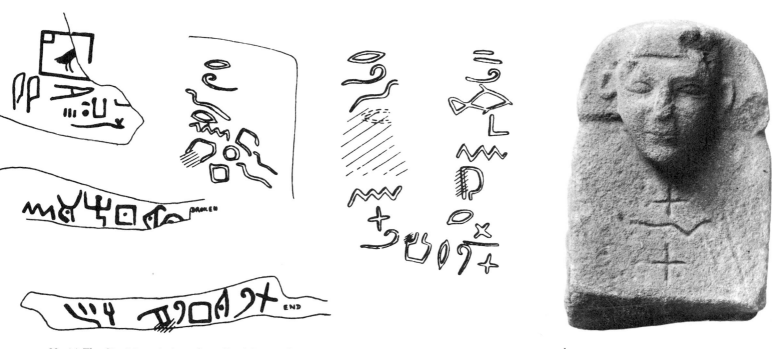

39. (a) The Sinai inscriptions from Petrie's expedition of 1905.
At right (b) is a part of the inscriptions reading *tnt*, 'gift.'
Musées Royaux d'Art et Histoire, Brussels.

a b

logogram as a phonetic value. Gardiner, using known Semitic phonetic values on a series of signs, deciphered the word *Ba'alat*, the Semitic designation of the goddess Hathor, which resulted in the reading, "belonging to Ba'alat." Gardiner said at the time, "Unfortunately, however, I have no suggestions for the reading of any other word, so that the decipherment of the name Ba'alat must remain, so far as I am concerned, as unverifiable hypothesis." Despite Gardiner's modest disclaimer, his ingenious reading has generally been accepted over the years. The difficulty here is that Egyptian and early Semitic are rather well-known languages, so that an inability to interpret a language purporting to link the two tends to cast doubt on the premise. And of course another language could be involved.

Martin Sprengling, in 1931, called the language of the Proto-Sinaitic inscriptions Serite and held that the Serites, living between the Dead and the Red seas, spoke a language rooted in Canaanite–Phoenician. Sprengling projected that the alphabet had been devised by a Semitic foreman of a mining operation under the direction of Egyptians during the reign of Amenemhet III (1850–1800 B.C.). There were turquoise-mining operations near Serābit el-Hādem, and Sprengling reasoned that the alphabet was devised for the purpose of keeping mining records. It has been argued that miners were hardly the type to have devised a radically new kind of writing, with its rather systematic selection of signs and phonetic values, since with all the time and talents available, the civilizations of the Nile and the Mesopotamian valleys had failed to turn this particular trick. But as to miners, why not? We have indeed seen that the very beginnings of writing (Fig. 14) had to do with the keeping of records.

In 1948 William F. Albright, advising an expedition sponsored by the University of California, was able to study the Proto-Sinaitic inscriptions, the number of which had grown since the 1905 discoveries. Albright, clearing away some of the errors of his predecessors (and his own), produced such readings as: "Thou, O offerer, O foreman of our mine, an offering prepare for Baalath for the sake of our brother." The number of scholars contributing to these convincing decipherments are too numerous to mention here. After Albright's work, 19 out of 25 to 27 signs were identified.

Albright's general conclusions were along these lines: The signs were alphabetic and were written in a Canaanite dialect; Gardiner's partial decipherment was correct; and the inscriptions dated from the early fifteenth century B.C. For an interesting account of Proto-Sinaitic writing, see Alan H. Gardiner's *Legacy of Egypt* (London, 1942).

Could the alphabet have been invented at Sinai? At one time it was exciting to think so. But if we speculate on the total number of records made and on the number that have been lost to us, it is obvious that scholars are dealing with but a few fragments of the visible part of an iceberg of written records, and that the chances of having

The Alphabet to Rome 31

40. The sites of experimental writing in ancient Canaan. All of the discoveries in this area are fragmentary but tend to fit a pattern of sign similarity and suggest related efforts toward alphabetic writing.

obtained that one essential key to enlightenment on the origin of the alphabet is slim. David Diringer in *Writing* (London, 1962) put the situation this way:

It must be remembered, however, that our position in regard to the history of the alphabet in the period 1800–1200 B.C. is rather like that of travellers flying high over a mountain range on a cloudy day. Here and there a peak or a plateau juts out of the mists, and it is comparatively easy to determine their relative heights; yet, to picture in the imagination the topography of the entire range—the precise geological relationship of peak to peak—is impossible.

Experiments in Canaan

The Canaanites were a people who inhabited the lower part of the eastern Mediterranean shore. They were neighbors of the ancient Israelites and were mentioned by them frequently. Discoveries of Canaanite writing date mainly from the 1920s. Some of the sites can be seen in Figure 40. The Gezer Potsherd (a ceramic fragment) was found in 1929, the Shechem Stone Plaque in 1934, and the Lachish Dagger in 1934. These fragments (containing only ten separate signs) date from the eighteenth to the fifteenth centuries B.C. and push back alphabetic writing two centuries. Some of the signs are the same as those occurring in Proto-Sinaitic writing. These are prototypes of Hebrew *beth, yod,* and *resh* (our *B, I,* and *R*).

Canaanite writings from other sites descend in time toward our own and tend to establish a community of writing with related tongues. Lachish has yielded several documents from the thirteenth century, and Beth-shemesh and other sites have produced fragments almost as old. Megiddo yielded a gold ring dating 1300 B.C. It seems likely that writing was widespread in the area before the Hebrew invasion in the thirteenth century B.C.

A Cuneiform Alphabet from Ras Shamra

In 1928 a farmer discovered a subterranean vaulted cavern in Ras Shamra, a tiny village near Latakia on the Syrian coast. Described as one of the greatest archeological finds of all time, the site was that of ancient Ugarit, a thriving city. The earliest stratum went back to the third millennium B.C., and from that early point the diggers peeled off the history of peoples from three continents. From the point of view of the philologist, the most startling finds were a large number of clay tablets with cuneiform letters. Thus the records bear a physical similarity to the method of sign productions used in the Mesopotamian Valley but were quite illegible to scholars who knew Akkadian. The example seen in Figure 41 is reproduced through the courtesy of Claude F. A. Shaeffer of Paris, who with his

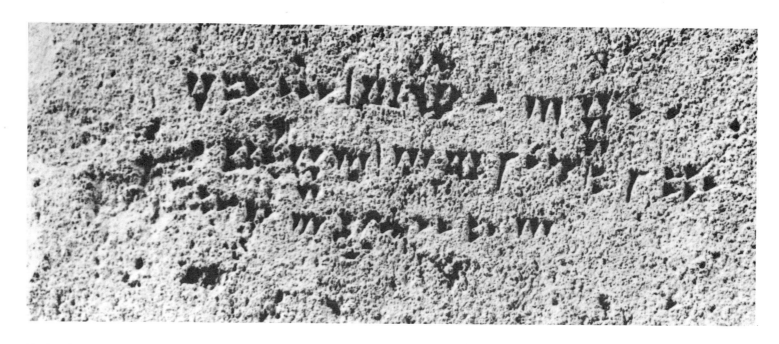

41. A stela from Ras Shamra directly recognized as a cuneiform rendition of a Semitic alphabet with several vowel signs. Louvre, Paris, and C. F. A. Shaeffer.

colleague G. Chenet headed the original team who explored the site, beginning in 1929.

Charles Virolleaud, director of Syrian researches in archeology for France, published the original documents. They were immediately deciphered. Virolleaud had noticed 27 signs and deduced that the writing was alphabetic. Hans Bauer, a leading specialist in Oriental languages, guessed that the language was Semitic. In a remarkable tour de force, Bauer established many correct phonetic values in the course of just a few days. Edouard Dhorme, working in France, added to Bauer's work, and between them they worked out phonetic values for 25 signs. Virolleaud added important details. The Ugaritic writing consists of 30 signs. Of these, 27 are consonants, in the usual Semitic manner; but there are three signs for emphatic vowel sounds *a, i,* and *u.*

The Ugaritic writing dates from the fourteenth century B.C. and is closely related to Phoenician and Hebrew. From a technical point of view this writing may be classed as the first true alphabet, since signs for vowels were invented and used. There was little impact on the environment, for the experiment was local. No doubt the ingenious writers of Ras Shamra will eventually receive the accord due them.

In terms of method of execution, the stamp of the stylus on clay did not need to be perpetuated or revived, since other writers in the area were using crude pens to scribble signs on pots or on whatever material came to hand. A static society like Egypt's could afford to keep its records carefully; but the Semitic peoples at the eastern end of the Mediterranean were on the move, about to become teachers and sea travelers, and needed a method of writing that could be performed with speed and in all locations, in sand if necessary.

The Byblos Syllabary

Beginning in 1929, Byblos began to produce tablets of another unknown writing. Dhorme was present at the site when excavators found two stelae, two bronze tablets, a few spatulas, and miscellaneous fragments, all with unknown signs. These and subsequent findings were published by Maurice Dunand in 1945, and a year later Dhorme presented a decipherment. He recognized about seventy signs and concluded that the writing was syllabic in character. There were too many signs for alphabetic writing, too few for logographic writing. Dhorme got his first four consonants by guessing correctly the signs for "in this year," and this started a chain reaction. According to Dhorme the language is Phoenician and dates from the fourteenth century B.C. This writing is often referred to as "pseudo-hieroglyphic" or Gublitic, this latter from *Gubla,* a Semitic name for ancient Byblos. The Hebrew name for Byblos was Gebal.

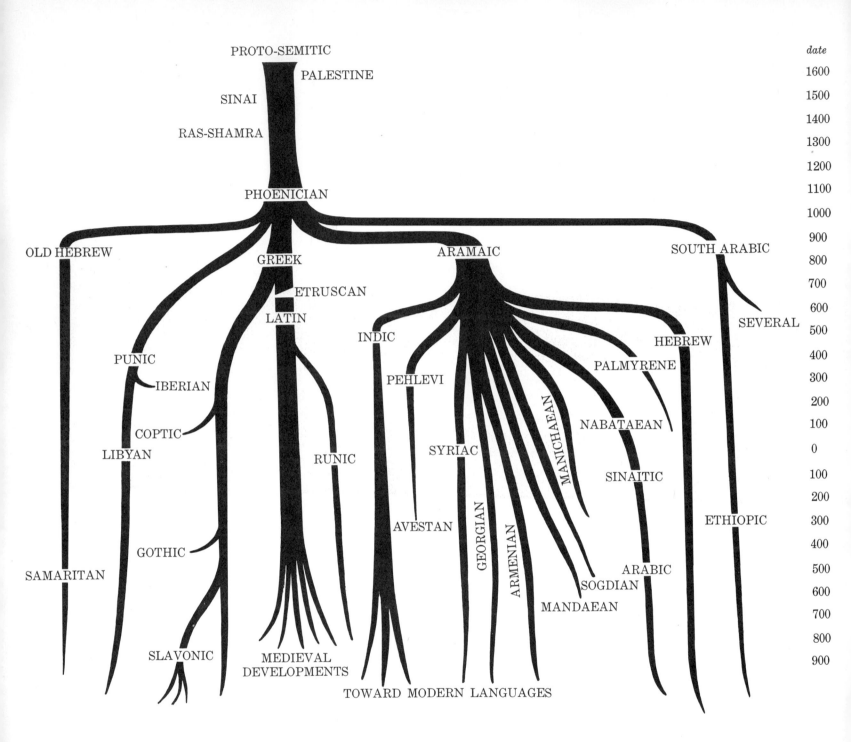

PROTO-SEMITIC

PALESTINE

SINAI

RAS-SHAMRA

PHOENICIAN

OLD HEBREW GREEK ARAMAIC SOUTH ARABIC

ETRUSCAN

LATIN

INDIC SEVERAL

PUNIC

HEBREW

IBERIAN

PEHLEVI PALMYRENE

COPTIC

NABATAEAN

LIBYAN RUNIC SYRIAC MANICHAEAN

SINAITIC

GEORGIAN

SAMARITAN AVESTAN ARMENIAN ARABIC ETHIOPIC

GOTHIC SOGDIAN

MANDAEAN

SLAVONIC MEDIEVAL DEVELOPMENTS

TOWARD MODERN LANGUAGES

date

1600
1500
1400
1300
1200
1100
1000
900
800
700
600
500
400
300
200
100
0
100
200
300
400
500
600
700
800
900

42. A relationship of languages, chiefly through the origin and development of alphabetic writing and not through structure, leading up to modern times. Thus it may not be assumed that Etruscan is structurally related to Greek or Greek to Coptic. The dates are approximate. In the case of Gothic the work of Ulfilas is fairly well defined in time; but the date of the introduction of Phoenician signs to Greek speakers is still in debate and awaits new evidence.

THE ALPHABET IN ACTION

The eastern end of the Mediterranean has produced many fragments containing signs. Some of these go back to the third millennium B.C. and may be owner's marks. There are also undeciphered fragments of writing from Syria, Jordan, Israel, and Egypt that seem to offer further confirmation of the great experiment toward alphabetic writing in this area. A potsherd with a few written signs is literally one piece of a jigsaw puzzle. Scholars examining the writings of this area first have to decide what picture the fragment belongs to. The pieces gathered that date roughly after 1800 B.C. form the pattern of Semitic peoples attempting to interpret their related tongues with a series of signs representing consonants. The Bible suggests part of the problem: Semitic peoples were by no means a political or national entity, and those who moved with the seasons probably had no method of sign production that could last.

In this area methods of writing that last are the product of residing in settlements, towns, or cities where a stonecutter or a potter could make a living. Byblos was one of these places, and a series of inscriptions dating c. 1000 B.C. seems to have established a date for a reliable method of writing Semitic languages. These writings from Byblos center around the inscription on the tomb of King Ahiram of the Phoenicians. From the writings an alphabet of 22 consonant signs (Fig. 38) emerges, used for Phoenician, Old Hebrew, Canaanite, Aramaic, and other closely related languages of lesser fame. Aramaic came to be written with the now-familiar set of signs c. 1000 B.C., and carried by a vigorous and resourceful people, eventually dominated the Near East. Jesus and his disciples spoke Aramaic.

Before leaving these Semitic writings to follow the alphabet to Greece and Italy, note the chart of Figure 42. This shows the general framework of important languages developing out of Proto-Semitic. A very rough date of 1000 B.C. can be given for the branching out of Old Hebrew, Aramaic, and South Arabic. It will be noted that Hebrew stems from Aramaic. When the Israelites returned to their homeland from their enforced stay in the Mesopotamian Valley, they were to use the Aramaic script. An interesting and most informative account of the peoples, languages, and writing in ancient Palestine can be found in William F. Albright's *The Archeology of Palestine* (London, 1949).

Figure 38 exhibited a series of consonant signs that were basic to the new Semitic writing in the Near East. Although the diagram of Figure 42 shows that Aramaic uses the language and script that influenced many peoples, Aramaic is now a dead language except for a few speakers in isolated communities in the Near East. For scholars in Europe and the United States, Hebrew was the priceless contact with the ancient scripts of Sinai, Palestine, and Phoenicia, because it was preserved by a religion that insisted that language and signs were essential to continuity. Figure 43 gives the relationship of modern Hebrew signs (second from left) to the Phoenician signs as they might have looked when passed on to Greek speakers. The alphabet used by English speakers is seen on the left and is included in order to give the reader a point of contact with the unfamiliar signs of the Semitic alphabets. The order is roughly the same, and the signs used in our Roman alphabet are for the most part derived from the Phoenician. This is as much as should be assumed, for the letters do not perform the same functions in the separate languages.

It is necessary to put in a qualifying word for the column of Phoenician letters. In the early stages of this writing, inscription sources are not abundant, and while there was a general agreement on sign configuration, no two writers would execute the *alpha* letter in precisely the same way. A few letters executed in different localities might exhibit strongly differing features. Thus there was no official Phoenician alphabet (at least none has been found), and so no Phoenician alphabet can be presented in this way. The signs here are similar to the letters seen in various Phoenician inscriptions found in the early centuries of the first millennium B.C. In later centuries, after it had been passed to Greek lands, the Phoenician script became more impressive in its style and in its continuity.

As to the order of the alphabet—A, B, C—no archeologist has been lucky enough to uncover a complete alphabet by any method of execution in any of the languages under discussion. Only one or two inscriptions present a sequence of signs in order, and the longest of these contains the Semitic equivalents of *B, D, G,* and *H.* While there is sufficient evidence that there was an order in the signs employed in the several Semitic languages, the reasons for it are far from clear. An interesting discussion of this subject can be seen in Godfrey R. Driver's *Semitic Writing* (London, 1948).

In the right column of Figure 43 can be observed the pictographic origins of the signs used in alphabetic writing. A few of these are derived from Egyptian signs, while others were borrowed from word signs existing in the area. Letters *G, J, U, V, W, X, Y,* and *Z* are later developments (see Fig. 55).

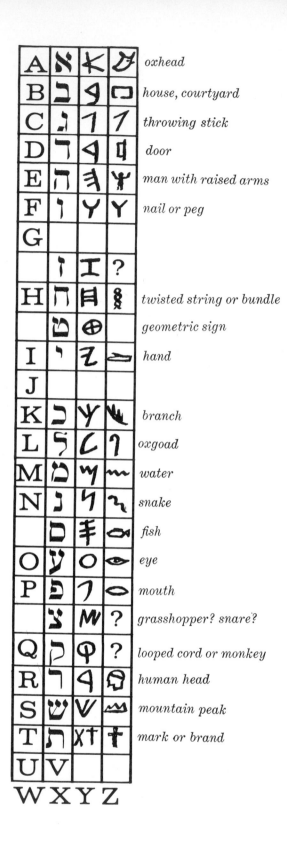

A	𐤀	K	𐤀	*oxhead*
B	𐤁	𐤁	𐤁	*house, courtyard*
C	𐤂	𐤂	𐤂	*throwing stick*
D	𐤃	𐤃	𐤃	*door*
E	𐤄	𐤄	𐤄	*man with raised arms*
F	𐤅	Y	Y	*nail or peg*
G				
	𐤆	I	?	
H	𐤇	𐤇	𐤇	*twisted string or bundle*
	𐤈	⊕		*geometric sign*
I	𐤉	Z		*hand*
J				
K	𐤊	Y	𐤊	*branch*
L	𐤋	𐤋	𐤋	*oxgoad*
M	𐤌	𐤌	𐤌	*water*
N	𐤍	𐤍	𐤍	*snake*
	𐤎	𐤎		*fish*
O	𐤏	O	👁	*eye*
P	𐤐	𐤐	𐤐	*mouth*
	𐤑	M	?	*grasshopper? snare?*
Q	𐤒	𐤒	?	*looped cord or monkey*
R	𐤓	𐤓	𐤓	*human head*
S	𐤔	V	𐤔	*mountain peak*
T	𐤕	Xt	𐤕	*mark or brand*
U	V			

W X Y Z

43. A comparison of alphabetic signs of common derivation: Roman, Hebrew, and ancient Phoenician.

The Alphabet to Greece

If for no other reason, the Greek alphabet is assumed to have been derived from the Phoenician because the names of the letters (*aleph : alpha, beth : beta*) are utterly meaningless in the Greek language. (In review, the Semitic meanings were *aleph* 'ox,' *beth* 'house,' and so on.) Then, too, the resemblance in signs is unmistakable. The earliest Greek inscriptions date after 800 B.C., when Phoenician writing in the new manner was well established. And the ancient Greeks themselves referred to alphabetic letters as Phoenician writing.

As noted earlier, the Greeks possessed a system of writing in the second millennium B.C. This was the Minoan Linear B syllabic system, which was deciphered by Ventris and others; and as we have seen, the stage was shared by a people using the Minoan Linear A syllabary, which has yet to be deciphered. Successive waves of Indo-European invaders from the north had infiltrated Greece, the coast of Asia Minor, and the Aegean islands from c. 2000 B.C. Although some of these invaders left a trail of blood, the fusion of peoples resulted in a great period in the history of mankind. The last of the northern invaders, the Dorians, could not be absorbed, and the Mycenaean culture was destroyed, scattering the resident population to the northern Peloponnesus and Asia Minor. This invasion occured in 1100 B.C. and brought on a "dark age" in which writing became a lost art. Thus the Phoenician system of sign writing penetrated Greek-speaking areas without invasion, because the Greeks were receptive to a new writing system.

A number of sites have been suggested for the first contact of Phoenician letters with the Greeks. Some cogent reasoning on this subject is found in Lilian H. Jeffery's *The Local Scripts of Archaic Greece* (Oxford, 1961). Jeffery holds that the most likely places were those where Greek and Phoenician peoples mixed and where bilingual speech patterns in families resulted. In this environmental situation Phoenicians could have taught the use of letters to the Greeks. Likely places for the existence of such an environment were on the coastal strip around the northeast corner of the Mediterranean. There were several Greek trading colonies within this Phoenician area.

The date for the exchange has long been debated. Greek and Roman tradition credits Cadmos of Thebes with having brought the letters out of Phoenicia. This date could be c. 1300 B.C. In recent times strong support for this date has been given by the late B. L. Ullman, a distinguished professor of Latin at the University of Chicago. His short book *Ancient Writing and Its Influence* (New York, 1932) is a good review of developments in

writing. Rhys Carpenter has been the protagonist for a much later date. In an article published in 1933, he favored a date as late as 720 B.C. Each of the centuries between these outside limits have been favored by one or another respected scholar.

Argument about the introduction of Phoenician letters to the Greeks exemplifies first-rate scholarly reasoning, because by necessity the evidence is circumstantial. There is no Greek alphabetic writing prior to the eighth century B.C. Indeed, even this date is in some dispute, but there is no doubt about the gap of several hundred years between the time when the Phoenicians were capable of transmitting the alphabet and the earliest Greek writing. If a later date is accepted for the earliest Greek alphabetic writing, it means that certain records, such as Homer's epic accounts of events purported to be historical, long lists of names, and the like, were perpetuated through memory. If this is hard to believe, we have only to recall the fabulous capacity of politicians for remembering names.

The record of silence, in terms of Greek writing, is compelling. While the definitive answer may well be interred in obscure gravel, the ninth-century date for the introduction of letters into Greece seems reasonable. Jeffery, in the latest full review of the subject, favors a date c. 750 B.C. This date could be coincidental with Homer's epic. Jeffery's date has reference to a communication of a simpler kind.

The form of the earliest Greek writing is seen in Figure 44, a vase from Dipylon. It is written from right to left in a stark linear style, typical of writings cut in stone, but with a few curved letters, suggesting that handwritten Phoenician documents were responsible for early Greek letters. Movement of the fingers and a desire for speed usually combine to make pen-written letters more cursive in form than those incised in stone. It will be noted on close inspection that the letter *A* lies on its side in the Phoenician manner. A modern Greek alphabet may be seen in Figure 401, and the classical version may be examined in the chart in Figure 55.

Semitic letters *beth, gimel, daleth, zayin, kaph, lamed, mem, nun, pe, resh,* and *tau* expressed sounds occuring also in Greek. *Aleph* was a weak consonant unknown to the Greek tongue, so the Greeks disregarded the consonant and used the vowel sound that was *a.* Ullman suggests the analogy of a Cockney dropping the *h* sound in *hear* and pronouncing *ear,* the vowel sound. Semitic *he* became the vowel *e* (short sound); *waw* produced two Greek letters, because early Greek needed both the consonant and the vowel sounds. Thus the sixth spot in the Greek alphabet was once occupied by *digamma* (that is, *double*

44. A Dipylon vase showing early Greek writing, eighth century B.C. Forms are similar to Phoenician. National Museum, Athens.

gamma, after its sign resemblance to *gamma*), the consonant form of *upsilon.* This letter ceased to be pronounced and was dropped, but the sign continued as number 6. The vowel derived from the Semitic *waw* was transposed to the end of the alphabet and is the vowel *u, upsilon. Heth* became long *e. Teth* became the Greek sound *th,* while *yod,* a semivowel, became the Greek vowel *i.* In an exchange of signs and sounds, the Semitic *samekh* became *xi,* with the value of *x. Ayin,* a Semitic guttural consonant, became the vowel *o, omicron;* for the long *o* the Greeks devised another sign and placed it at the end of the alphabet. Semitic *sadhe* appeared as *s* in some early Greek alphabets but was dropped later. *Qoph* became a distinctive sound in some early Greek dialects but was eventually dropped. The sign survived as number 90. The *sigma* sign is derived from Semitic *sadhe,* but the Greek sound *s* is derived from Semitic *shin.*

The Greek language had a few sounds that could not be derived from the Semitic. Signs were devised for these and placed at the end of the alphabet after *upsilon. Phi,* pronounced *fee* and standing for the sound *ph,* was followed by *chi* to express the *kh* sound. *Psi* became standardized for the *ps* sound and became the next to last letter before *omega.*

This aspect of Greek letters, signs, derivations, and phonetic content is a complex one. In the beginning there was fumbling and experimentation. Standardization of signs and phonetic content was delayed by the existence of many local dialects, each with a slightly different version of alphabetic writing. No doubt this sifting process was slowed by the political disunity of the Greek-speaking people. The Ionic alphabet finally won out over rival versions and was officially adopted at Athens in 403 B.C. In the following fifty years most of the Greek communities followed along.

Form and style in Greek inscriptions are vividly seen in the beautiful Lemnos Stela (Fig. 45), from the sixth century B.C. As previously mentioned, the writing on the Dipylon Vase is from right to left, following the Semitic practice. In the Lemnos Stela the writing alternates from right to left and then left to right. This manner of writing is called *boustrophedon* (meaning 'as the ox turns in

avoid smudging wet letters. While the direction of Greek writing was stabilized before the dates of pen-written documents, it is possible that right-handed penmen could have decided the issue. In the case of Semitic letters the direction was stabilized as right to left before right-handed penmen could put in a word. It is unfortunate that literature pertaining to this interesting subject is scarce, because these early decisions must have affected the form of later writing, particularly in such Semitic branches as Hebrew and Arabic.

In considering the history of Greek letters, we can see that a rather severe style developed in inscriptions. This is apparent in the fifth-century example in Figure 46. Individual letters are conceived and cut in pure elements of geometric form without any ornamental flourishes. Strokes lack variety in thick and thin quality and generally are abruptly straight or simply curved. Letters are deliberately spaced with no hint of crowding and are aligned vertically—a feature seldom found in the history of writing. This method of composition, called *stocheidon*, gives Greek inscriptions a serene and balanced appearance. Our modern sans serif letters, developed in Germany in the 1920s (Fig. 269), were probably inspired by Greek inscription letters. The German designers sought a similar esthetic in their letter forms. We will see Roman sans serif letters between the time of ancient Rome and the Renaissance, but the Greek style is unique.

The earliest Greek pen manuscript dates from the early fifth century B.C. A few examples on now-darkened papyrus date from the fourth century. This leaves a gap

45. Lemnos Stela, sixth century B.C., before Greek writing settled on a left-to-right direction.
National Museum, Athens.

plowing'). Symmetrical letters such as *O* are not affected in the change of direction, but the others face left and then right depending on the direction of reading. In the sentence now being read, the eye scans from left to right and the prongs of *E* face right; in boustrophedon alternate lines are scanned from right to left and the prongs of *E* would face left. After 500 B.C. the direction of writing is always from left to right.

For a sculptor inscribing letters with a mallet and chisel it matters little whether the writing proceeds from left to right or right to left. The direction is more critical to a right-handed person using a pen. If the writing is from left to right, a scribe can see where he is going and can

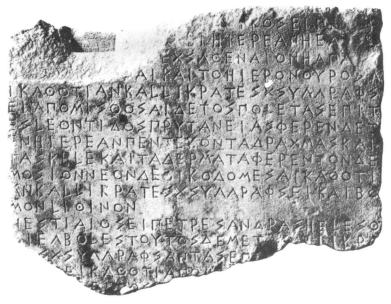

46. Stocheidon composition, fifth century B.C.
Otto Kern, *Inscriptiones Grecae.*

of about two hundred years before the first Roman pen writing. In the fragment seen in Figure 47 the scribe has generally followed models cut in stone, but there is a curving of the stems of some letters. The slant of the pen is more than 45 degrees counterclockwise, because the vertical strokes are thinner than the horizontal strokes. In early Greek writing there is a remarkable continuity of the pen letter styles for almost a thousand years. Codex Sinaiticus, one of the three great Greek Bibles, dates from the first half of the fourth century A.D. and is, in general feeling, as close to the measured style of early Greek inscriptions as pen letters can get. For a comparison in the styles see Figures 46 and 403 a and b.

Before recessing the study of Greek letters, it will be useful to look at an inscription from 427 B.C. (Fig. 48). Here again is the marching style of Greek inscriptions, a kind of stately texture, but there is also a hint of pen letter strokes that in our own letters we call a serif. This is an influence from pen letters, where a vertical stroke may be started with special emphasis or where vertical and diagonal strokes overlap slightly, giving a different graphic content to the corners and endings of letters. There is also a definite tapering of some of the strokes in the inscription under study, with *K, kappa,* a conspicuous example. This marked tendency in Greek letters can be traced to a sculptor's formalization of the pen's ability to change the thickness of a stroke. *Epsilon, E,* will be seen to be directly copied from pen letters, especially in the horizontal strokes. The top of some *alphas* are derived from a slightly double-stroked pen letter. A more self-

conscious inscription style based on the tapered strokes is seen in later centuries. There seems to be little interest in this wedge-stroke style among modern designers.

Finally, let us look at an inscription from the second century A.D., Figure 49. The sculptor has given up the strict vertical alignment of the letters, so that one line contains 31 letters and another contains 36, but the monumental character remains. Also remaining are the tiny serif endings that may have been derived from pen-letter suggestions of an early date that are undiscovered. As we shall see, the Roman serif was devised by another writing tool. The brief serifs of the Greek inscription style are not found in contemporary letters with any frequency. Copperplate Gothic, a typeface used today, is an extreme form of the idea. In the Roman style of writing, and in our own tradition, serif endings play a greater part in the esthetics of letters. This brief discussion should help to point up the differences and similarities. The similarities between Greek and Roman inscriptions are very great if the two are compared with Arabic or Chinese. But little things mean a lot, and the qualities of formal Greek letters have never been captured by either Renaissance-oriented letter designers or the more recent sans serif school.

An interesting side note is the method of learning the Greek alphabet devised by Herodes Atticus, a wealthy Athenian of the second century A.D. He had a son who could not learn the signs of the alphabet as quickly as others. So he equipped 24 servants with the alphabetic signs *alpha, beta, gamma,* and so on, and required them to parade endlessly in front of the young man.

47. Early Greek pen writing showing an affinity to inscription letters. Bodesmuseum, Berlin.

48. Greek inscription, fifth century B.C., showing tapering strokes and a hint of serif endings. Epigraphical Museum, Athens.

The Alphabet to Rome 39

49. Greek inscription, second century A.D., inviting comparison to the mature inscriptions in Latin. Otto Kern, *Inscriptiones Grecae*.

50. The Marsiliana Abecedarium, a writing tablet inscribed with the Etruscan alphabet. Museo Archeologico, Florence.

Etruscan Letters

A date for the introduction of alphabetic writing to the boot-shaped peninsula of Italy is the seventh century B.C. Geographically Italy could not be missed by sea travelers, and Herodotus stated that ships of fifty oars traveled the Mediterranean from Phocaea in Asia Minor (see Fig. 20) to Etruria and elsewhere in the Mediterranean. Indeed, shortly after 700 B.C. a strong trade developed between the Greeks and the Etruscans. The latter were then the dominant people on the Italian peninsula. This trade provided the conditions for the transfer of the alphabet: two peoples in intimate contact long enough for bilingual speech habits to form. Cumae, a Greek colony near present-day Naples, is now accepted as the site for the transfer of the alphabet from the Greeks to the Etruscans c. 675 B.C. Rhys Carpenter's account of the circumstances surrounding the exchange ("The Alphabet in Italy," *American Journal of Archeology*, Oct.–Dec. 1945) is quite interesting.

The most complete example of the earliest Etruscan alphabet is the Marsiliana Abecedarium (Fig. 50), named for the site of its discovery. Letters of the alphabet are inscribed from right to left on the ivory edge of a writing tablet thought to have been used for schooling. Such an abecedarium is simply a mnemonic device; but this find is especially enlightening because it provides evidence that once the alphabet was put down it went through the various cultures intact, being taught as a permanent instrument. The Etruscans had no use for some of the letters and did not employ them, but all the signs were kept. *B, D, O,* and *X* were not used, and in the early stages of Etruscan writing the signs *K* and *Q* are infrequently seen in Etruscan inscriptions. *K* was used only in front of the sound *a*, and *Q* (an identical sound) was used before *u*.

In other situations the Greek *gamma* was used for the *k* sound.

About 400 B.C. the Etruscan alphabet began to achieve its final form. At various times it had three signs for *s*. No local Greek dialect had more than two signs for this sound; so it is assumed that the Etruscans accepted too much advice from friendly foreigners who were already divided on which Semitic *s* sign to use.

It is generally believed that the Cumae Greeks were from a western part of the Greek sphere of influence and used the western version of an east-west divergence in the Greek alphabet. The differences were not great, but the alphabet that came to the Etruscans was not quite the same as the version that won out and became official in classical Greek times. In the classical Greek alphabet the order of the last letters is φ, χ, ψ, or *phi, chi, psi*; while in western Greek it is χ, φ, ψ, *chi, phi, psi*. This explains the discrepancy in the order of letters in the Marsiliana Abecedarium and in the chart in Figure 55. It is useful to remember that, as mentioned earlier, the alphabet was given to the Etruscans some two hundred fifty years before the Greek alphabet became standardized.

The direction of writing in the Marsiliana Abecedarium, as already noted, is from right to left. A few Etruscan inscriptions are in boustrophedon, or serpentine, but the majority are written from left to right. Through the Etruscans the alphabet was passed on to other peoples of the Italian peninsula with various linguistic affiliations. The alphabet went to Etruscans living in the northern part of the peninsula, to Oscans in the south, to Umbrians in the north central portion, and to Faliscans north of Rome, among others. Etruscans spoke in a language that was not Indo-European, and it has not yet been deciphered. Almost nine thousand Etruscan inscrip-

51. An Umbrian inscription featuring a typically stiff and angular letter construction. Stelio Bassi, *La scrittura Greca in Italia*.

52. The Franks Casket, an Anglo-Saxon inscription with runic letters. British Museum, London.

tions exist; most of them short. One long piece of Etruscan writing is preserved on a linen mummy wrapping and contains thousands of words. Even this long record has not helped very much in the understanding of the Etruscan language, in spite of great efforts in this respect. Thus the Etruscan language is still part of the greater mystery of the identity and history of the Etruscans.

The Etruscans were the dominant people in Italy for 250 years. Then in 509 B.C. the Latin-speaking people of Rome drove them out and power swung the other way. Etruscan inscriptions died out in the first century of the Christian era, and although the Etruscan language continued to be used for centuries, an unfortunate lapse in Roman scholarship has left us no record of it.

In style, Etruscan, Oscan, and Umbrian letters are stiff and angular. As previously mentioned, most primitive stone-inscribed letters are usually this way until cursive tendencies from pen letters intrude. At their best the inscription letters under discussion take their merit from extreme stiffness and make something special out of it. This can be seen in Figure 51, an Umbrian inscription of the second or third century B.C.

The alphabet traveled out of Italy and into northern Europe by way of the North Etruscans. Thus the Etruscans, themselves a people of mystery, contributed to yet another mystery—that of the meaning and origin of runic writing, which used the alphabetic forms of the Italian peninsula to implement the early Teutonic tongues. The word *rune* is derived from a word meaning 'mystery.' Tomes have been written on the subject of runes, including much amiable nonsense. In the latter category is one claim that a stone with runes was found in Minnesota. The earliest runes are from the third century of the Christian era, and of the 4000 inscriptions in existence, most date from before the twelfth century. Only a handful are pen-written; the rest are worked into wood, metal, ivory, bone, and other materials.

According to Rhys Carpenter, the Etruscan alphabet was transmitted to northern Europe before the time of Julius Caesar but not earlier than the second century B.C. Apparently runes in several varieties became the national scripts of early Germanic tribes. A few runic inscriptions have been found in Germany, some fifty in the Denmark-Schleswig area, the same number in England, and about sixty in Norway. About twenty-five hundred runic inscriptions have been discovered in Sweden, and other discoveries dot the map of Europe as far as Greece and the Black Sea. Never a major vehicle for the recording of literature, runic writing was dislodged by the Roman alphabet, armored in its movement by religious and political power. In pseudo-magical functions, runic characters are preserved into recent centuries.

In its centuries of existence as an adjunct to cultural enterprise, the style of runic writing remained as similar as the ticks of a clock. Certain writings can be dated on archeological evidence, but what can scholars do with a style that has remained very much the same regardless of when or where it was done? Figure 52 shows one side of the Franks Casket, executed in England c. A.D. 700. The name *Franks* refers to Augustus Franks, an English antiquarian, who acquired the work around 1860 and who later presented it to the British Museum. This Anglo-Saxon casket was carved out of whalebone, and both the inscription and the text concern the theme of Romulus and Remus. It is one of the finest pieces using runic letters, since many runic inscriptions are stiff and dull. It is clear that runic forms were never influenced by cursive tendencies derived from pen letters.

Alphabet Rides with Power

With the expulsion of the Etruscans from Rome in 509 B.C., the Latins began the great parabolic arc of ascent and descent in world power. When the Latin-speaking people started their move, they had already acquired the alphabet from the Etruscans in the seventh century B.C., when the latter dominated central Italy. The alphabet, then, was carried to success through the ideas, tenacity, organizational capacity, and military power of Rome. In the history of the alphabet this phase might be called "Alphabet Follows Empire," as other phases of its history can be headed "Alphabet Follows Religion." When we observe that Roman writing tools (as well as inscriptions) have been found in England, we realize that the Romans carried the art of writing with them in their adventures in empire building, and so put their mark on the speech and writing habits of the present day.

As is well known, Latin replaced the native languages in Italy, Spain, France, Portugal, and Rumania, producing the five languages associated with these countries. Latin itself, kept alive by the Roman Church, also served in legal and intellectual enterprises into Renaissance times. It was the international language in a changing world. Thus after A.D. 1066 Latin was the third tongue of England, bridging a communication gap between the French-speaking Normans and the Anglo-Saxons. Latin was preserved in Catholic ritual until 1964. Of course, institutions of higher learning still preserve Latin, since it is fundamental to several areas of scholarship and because its roots are found in derived languages.

Western European countries that did not use the Latin tongue—Germany, Denmark, England, Scotland, Ireland, Sweden, Norway, Finland, Belgium, Holland, and Switzerland—were converted to the Roman alphabet. Through colonization ("Alphabet Follows Commerce") the Roman alphabet was carried to Iceland, Greenland, North America, South America, Australia, New Zealand, and parts of Africa. This book, along with perhaps 95 percent of the books and magazines published in the United States, utilizes a Roman alphabet in three versions: capitals, minuscule, and italic. The latter two are derived from Roman brush and pen forms via a route of some complexity; but the capitals are almost identical with certain inscription forms used in the Roman world two thousand years ago, a rather incredible fact.

Early Latin Inscriptions

The earliest inscription in Latin is found on the Praeneste Fibula (Fig. 53), a gold brooch dating from the seventh century B.C. The letters of the inscription are:

IOSA MUN DEKAHFEHF DEM SOINAM

It reads from right to left and in translation says, "Manius me fecit Numerio" or "Manius made me for Numerius." Thus *D*, *E*, *K*, and *F* face left in this earliest Latin inscription. In Latin inscriptions featuring boustrophedon, these same letters face left and right in alternate lines. This is mentioned again because in some comparison charts both forms of these letters are shown; this is unnecessary if the reader understands why two forms of the same letter were used.

The early history of Roman letters is scarcely the noble enterprise we might have been led to expect. It was longer in its development than its Greek counterpart. There are a few Roman inscriptions dating c. 300 B.C. One, the *cippus* found in the Roman Forum, is written in boustrophedon. A few inscriptions from the fifth and fourth centuries are still written from right to left. In third-century inscriptions the writing begins to have a familiar look: the direction is from left to right, and the individual letters become oriented to that direction. In Figure 54 is the Lex Spoletina, a third century B.C. inscription preserved at the Civic Museum in Spoleto, Italy. Again it can be presumed that right-handed persons using a pen or stylus script determined the final direction of the lines, and those of our own writing; however, there is no direct evidence for this. The curves of *B*, *C*, *D*, and *R* suggest the cursive qualities of finger movements creeping into the stiff tradition of the stonecutter's straight lines and angles; but since no Roman pen writing exists from this early period, there is no way to prove the case.

Top: 53. The Praeneste Fibula. Hermann Degering, *Die Schrift.*

Above: 54. The Lex Spoletina. Il Museo Civico di Spoleto.

A Comparison of Letter Forms

Since it can be observed that the Latin alphabet of the third century B.C. seems to have settled into a recognizable pattern, it is perhaps a good time to present a chart of sign derivations together with a few notes on some of the letters, especially in regard to Latin adaptations. Figure 55 shows a comparison of letter forms from early Semitic to Greek and Latin. The Semitic signs appear in the left column. As noted, these signs were carried to Greek speakers by the Phoenicians. The names of the Semitic letters are known through Hebrew, and these are seen in Figure 55 along with early Hebrew pen letters c. 100 B.C. An examination of the chart will reveal that the Semitic alphabets do not correspond in precise detail with the Greek alphabet. Nor is there perfect correspondence between Greek and Roman alphabets. Some of the changes in signs and sounds can only be explained through auditory means of communication, but the notes that follow will cover some of the essential points.

Semitic *A* was converted to a vowel by the Greeks, and Latin writers continued the practice. Letter *B* is a consonant in the several languages.

In early Latin, letter *C* was used for two sounds: *k* and *g*. In a move attributed to a decree of 312 B.C. by Appius Claudius Censor, a small upright stroke was attached to the bottom end of *C* to denote the hard *g* sound. The precedent of *gamma* in the third position of the Greek alphabet had no influence, and *C* for *k* took the third place in the Roman alphabet. A new position was needed for *G*. The sixth letter in the Greek alphabet is *zeta*, but Latin speakers had no need for this sound and put *G* in place of *Z*. In the first century A.D., Latin writers found they could not do without *Z* after all and they placed it last in order after *Y*, which was introduced at about the same time. *Z* was called by its Greek name, *zeta*, and was used to spell Greek names. Even today *Z* is by no means overworked.

In the Praeneste Fibula, sound *f* was expressed by use of Greek *w digamma* (a sign like *F* which derived from *waw*, the sixth letter in the Phoenician and Hebrew hierarchy of signs) plus *H*. In Latin this use of *H* was abandoned, leaving *F* to stand for sound *f*. *Digamma* received its name through a sign resemblance to *gamma*. Greek speakers found they had no need of *digamma* and it was thrown out of the Greek alphabetic order and finally took up position at the end of the Greek alphabet, where it is only seen in scholarly texts demonstrating its early usage as *w*.

Semitic *yod* gave rise to Greek *iota* and Roman letter *I*. Sound *y* disappeared early in Greek history, and *iota* now designates vowel *i*. In Latin, *I* had to express consonant *j* and the vowel sounds of long and short *i*. For a time, c. A.D. 50, *I* was carved or written taller than the other letters. This *I longa* form designated the long *i* sound, but the idea failed to become permanent in Latin manuscripts. In the Middle Ages the consonant function of *I* began to be designated through the expedient of a longer stroke, or descender. By 1600, *J* was recognized in most areas of literacy.

The Semitic alphabets ended at letter *T*, and the Greeks and Romans added letters after *T* to round out their respective phonetic systems. Greek *upsilon* was derived from Semitic *waw* and was placed at the end of the Greek alphabet before the invented signs *phi, chi, psi* and was used as a vowel. Our Roman *V* derives from *upsilon* and was used for both consonant and vowel sounds *w* and *u*. Readers may be familiar with this usage because it is preserved in modern inscriptions in English, wherein *V* appears where *U* should. We can read these texts as easily as the citizens of Rome did, but beyond this feeble intrusion into the area of pedagogy the practice lacks merit. In the book hands of the Middle Ages this versatile letter *V* came to look more like lowercase *U*; but the dual function remained, and sign separation for the consonant *V* and the vowel *U* became fixed after the Renaissance.

Letter *W* was never seen in Roman times. It derives from the manuscript *V* written more like *U* and written twice to express a needed consonant sound in the late Middle Ages. First written *uu* and then connected through a national practice of pen calligraphy, the *W* finally developed enough power to eliminate a rival Anglo-Saxon sign in England in Renaissance times. Anglo-Saxon writers had invented the *W* in the seventh century.

Roman letter *X*, derived from Greek *chi*, was used to express the Latin *ks* sound. At one time, c. A.D. 50, it was the last letter in the Latin alphabet. Of course it is also seen as number 10. It was a late addition and was not used in early Latin texts.

Letter *Y* was introduced into Latin writing in the first century of the Christian era to stand for a vowel similar to the French *u*. The sign is derived from Greek *upsilon*. In some early book hands in Latin, *Y* may look like *V*.

Greek *phi* and *theta* were not needed in Latin, but Roman signs for 1000 and 100 derive from them. The *phi* sign was cut in half to obtain the sign for 500. *Chi* furnished the sign for 50. These developments are interesting but a little too involved for our present pursuits.

There were early attempts to change the alphabet we now call Roman. In the second century B.C. there were experiments in double consonants and double vowels. We are familiar with this practice, but the double vowel did

Figure: A comparison of letter forms showing some relationships in Semitic, Greek, and Roman alphabets.

#	early Semitic signs	early Hebrew pen letters	modern Hebrew names	early Ionian signs	classical Greek signs	modern Greek signs	modern Greek names	Etruscan signs	Latin signs	contemporary Roman capitals	possible derivations
1	↰	א	Aleph	⊿Δ	A	A	Alpha	A	AΛ	A	oxhead: Greeks used it as a vowel sign
2	⅌	ב	Beth	𐌁ꟼ	B	B	Beta	B	B	B	house, courtyard; similar sign in Egyptian writing
3	𐌂	ג	Gimel	⅂ꓥ	Γ	Γ	Gamma	⟨	C	C	throwing stick; Latin k sound; becomes soft c sound in 6th century
4	△	ד	Daleth	◁ꟼ Δ	Δ	Δ	Delta	D	D	D	door
5	⋺	ה	He	⅌F	E	E	Epsilon	Ɛ	E	E	man with raised arms; short e sound in classical Greek
6	ꟼ	וו	Waw	ΥꟵV	Υ			F	F	F	nail or peg; digamma in early Greek, later dropped
									CG	G	an addition to C; attributed Appius Claudius Censor in 312 B.C.
7	⟂	ו	Zayin	I	IZ	Z	Zeta				? not used in early Latin
8	HⒽ	ה	Heth	⊟H	H	H	Eta	⊟Ꞗ	H	H	twisted string or bundle; sign and sound of Egyptian origin, long
9	⊕	ט	Teth	⊕⊙	Θ	Θ	Theta	⊕			geometric sign, not needed in Latin and became number 100
10	⇃	יי	Yod	⟩	I	I	Iota	I	I	I	hand; Greek vowel i, Greek sound y; disappeared in prehistoric times
										J	from I; differentiation in sign occurs in the Middle Ages
11	ꓥVꓬ	כ	Kaph	⅄K		K	Kappa	K	K	K	branch; dropped in Latin, revived in middle Europe in the Middle Ages
12	ᒪL	ל	Lamed	∠ꓠꓥ	Λ	Λ	Lambda	L	L	L	oxgoad
13	ᙏ	מ	Mem	ᙏᙠ	M	M	Mu	ᙏ	ᙏM	M	Egyptian sign for water
14	ꓬ	נ	Nun	ꓨꓠ	N	N	Nu	N	N	N	snake
15	⧧	ס	Samekh	⧧	Ξ	Ξ	Xi	⊞⋈			fish; Greeks changed sound
16	O	ע	Ayin	O	O	O	Omicron	OꙨ	O	O	eye; became Greek vowel o, long o sound in eighth century
17	⌐	פ	Pe	⌐Γ	Π	Π	Pi	Ρ	Ρ	P	mouth; Latin shape from rho
18	ᙏ	צ	Sadhe	ᙏᙗ				ᙏ			grasshopper? snare? not used in Greek or Latin
19	Φ	ק	Qoph					Φ	Q	Q	looped cord or monkey; not used in classical Greek, left out of early Latin
20	⊲	ר	Resh	◁ꟼ	Ρ	P	Rho	Ρ	R	R	human head
21	W	ש	Shin	Ɛ	Σ	Σ	Sigma	꟣Ɛ	S	S	mountain peak
22	✝X	ת	Taw	T	T	T	Tau	✝	T	T	mark or brand
					Υ	Υ	Upsilon	Y	V	V	used for consonant and vowel in Latin
										U	from V; differentiation in Middle Ages
										W	literally a double U; Anglo-Saxons used a runic sign displaced c. 1280
					Φ	Φ	Phi	X			arbitrary Greek invention; sign came to mean 1000 in Roman counting
					X	X	Chi	Φ	X	X	arbitrary Greek invention
					Ψ	Ψ	Psi	Ψↆ			arbitrary Greek invention
					Ω	Ω	Omega				another form of ayin
					F		Digamma	8			a dropout from the sixth letter
									Y	Y	from waw and upsilon; a late addition to the Roman alphabet
									Z	Z	from Greek zeta; used by Latin writers to spell Greek words

55. A comparison of letter forms showing some relationships in Semitic, Greek, and Roman alphabets.

not become standard at the time. Emperor Tiberius Claudius, in power A.D. 41–54, instituted a number of reforms. He proposed a new reversed *C* for the *ks* and *bs* sounds, and an inverted *F* for a *w* sound. These and other suggestions prevailed for the limited time of his reign but were not followed later. In comment on the inverted *F*, B. L. Ullman in *Ancient Writing and its Influences* (New York 1932), states that Claudius was fifteen centuries ahead of his time.

The Development of Latin Inscription Letters

Roman inscriptions continue with a monoline approach to inscriptional forms—the heritage of an ancient trade—well into the third century B.C. The beginning of a changed style is seen in Figure 56, an inscription dating from 216 B.C. There is no doubt that thick and thin parts occur in the letters. A close study of *C*, *O*, and *S* reveals a heavy stroke on the left and right, with the axis slightly off vertical to the left. A square-tipped pen or brush is probably responsible for this change. There is a hint of specially drawn endings on the *C*, and a hint of thick and thin strokes on the top *M*. No doubt calligraphy in the form of pen or brush letters is entering into the form of Roman letters at this time.

The mysterious infusion of calligraphic content into the art of the stonecutters continues in a votive inscription of the second century B.C., now preserved in the Vatican Museum (Fig. 57). There are definitely hook-shaped endings, or serifs, to many of the strokes. The right stroke of the left *V* in line 7 and the endings of the horizontal strokes on most *E*'s and some *T*'s definitely establish a calligraphic tool as the source. Either a brush or pen style is being copied from manuscripts unknown to us, or the stonecutters are using some other source. Scale is a key to the mystery here. It is unlikely that stonecutters of the period, patently inept, would gain much from pen letters drawn ¼ inch high. Directly bearing on this problem are the brush-drawn writings from Pompeii, an example of which is seen in Figure 58, an election appeal written on a wall in Pompeii with a square-tipped brush. Such writings are not strictly dated, but all were executed prior to A.D. 79, the year of the city's destruction by the historic eruption of Mount Vesuvius.

Thus embalmed, Pompeii revealed these brush-drawn wall signs that would otherwise have disappeared completely. Apparently the sign-writer's skill was well established at the time, from which fact we can presume something of a tradition. It will be noted that the brush is set at an angle counterclockwise to a signal degree from vertical, so that horizontal strokes are quite thick in comparison to the vertical strokes. This style, *scriptura vulgaris*,

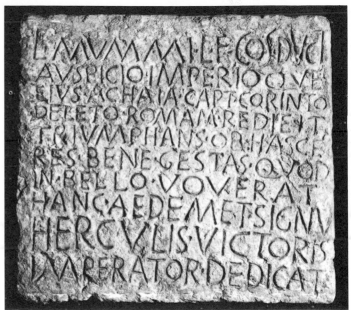

Top: 56. Roman inscription, third century B.C. Thick and thin strokes in development. Musei Capitolini, Rome.

Center: 57. A votive inscription, second century B.C., showing primitive serifs on the endings of many letters. Vatican Museums, Vatican City.

Below: 58. Wall writing from Pompeii. Stelio Bassi, *La scrittura Greca in Italia.*

The Alphabet to Rome 45

VOCONTIO

COSS VERBA FECERVNT DE DESIDERIO AMICORVM IVLIAE RI
CANICVQVI PETVNT EVTEI PERMITTATVR IN PROV AFRICREGIONE

VTEGLA FRIANEE XCOLEREM TITVLI SQ RELINQVM
VIVOS VT HOC FACEREM FATA DEDERE MIHI

P NERONI CLAVDIO DIVI CLAVDI F G

P LVCILIOP

59. Inscription letters. Emil Hubner, *Exempla Scripturae Epigraphicae Latinae.*

60. Tomb of centurion M. Caelius. Reinisches Landesmuseum, Bonn.

written with a square-tipped brush, is the foundation of Roman letters. In this rather extremely canted version it is perpetuated in a pen-written style called rustic, reproduced later in two versions, and so it lived on into the times of Charlemagne and beyond.

The intimate connection between *scriptura vulgaris* and the stonecutters is seen in a number of inscriptions (Fig. 59) taken from Emil Hubner's *Exempla Scripturae Epigraphicae Latinae* (1885). This fine collection of drawings of Roman inscriptions does not show subtle details but is quite valuable for giving an impression of the range of Roman letter carving in terms of both style and geography. Here we see the unmistakable mark of brush writing and can observe the principal angle of attack as it moves well to the left of vertical in Figure 59. Thus it seems certain that in some Roman inscription writing after c. 200 B.C. the carver follows a contour sketched on the surface with a brush. There is no other way to account for the complex endings attached to major strokes and for the tapering of strokes. In this commentary the principle concern is with those models of epigraphy that were important in the development of the capitals we now use. Many Roman inscriptions defy any kind of analysis in terms of the instruments of calligraphy, including some in which the carver simply began to cut some letters. It is by no means possible to establish clear and definable links between calligraphy and epigraphy in every instance. The best discussion on these problems and those of terminology is furnished by Joyce S. Gordon and Arthur E. Gordon in "Contributions to the Paleography of Latin Inscriptions" (*University of California Publications in Classical Archaeology,* Vol. III, 1957). This team also produced the definitive volume *Album of Dated Latin Inscriptions* (University of California Press, 1958–1965). Father

Edward Catich has scheduled his *Origin of the Serif* to appear in 1968, and this publication should be valuable to any detailed study of Roman letters. The volume will be issued by the Catfish Press, Davenport, Iowa. Catich is a gifted stonecutter, and this is an invaluable aid in this area of research.

During the first six centuries of its existence, Roman carving was not especially skillful. While the votive inscription seen in Figure 57 has fine graphic content in total, the letter forms themselves, if reduced to black and white, would not be especially noteworthy. It is not until the beginning of the Christian era that stonecutters commence to compose and execute their letters with authority and finesse. There are many fine inscriptions from the first century, and in this time the classical Roman alphabet receives its final graces and becomes an alphabet of dignity and style. This is apparent in the inscription of Figure 60 from the tomb of the centurion M. Caelius, dated A.D. 9. Worthy of particular notice is the ingenious composition of letters around the *O* in the top line. If our impression of *littera monumentalis* is gathered only from contemporary type faces, our thinking about the form and composition of letters is going to be static from the outset. The kind of ingenuity seen in the tomb of Caelius is typical of many Latin inscriptions of the Middle Ages and points up the fact that our modern habits are conservative if not fearful. We are afraid to break a tradition that never was.

It should not be deduced that Roman letters were accompanied by a sepulchral dampening of the spirits; it should be noted that Roman usage, as in our own day, encompassed many facets of life. Messages to friends, games, schools, stamps and seals, coins, jewel boxes, tickets, grants, decrees, laws—all these made use of letters.

THE TRAJAN INSCRIPTION

In England the United States the inscription seen in Figure 61 is the most celebrated piece of writing in the history of written language. The version presented here is a photograph of a cast prepared by Edward Catich for the R. R. Donnelley & Sons Company, a printing firm in Chicago. It records the dedication of the column erected in Rome in A.D. 113 as a memorial to the victories of the Emperor Trajan on the imperial frontier. The peak of a later building intrudes, and photographs show stain damage. Printed below is the Trajan inscription text with implied material in brackets.

```
     SENATUS · POPULUSQUE · ROMANUS
IMP[ERATORI] · CAESARI · DIVI · NERVAE · F[ILIO] · NERVAE
TRAIANO · AUG[USTO] · GERM[ANICO] · DACICO ·
   PONTIF[ICI]
MAXIMO · TRIB[UNICIA] · POT[ESTATE] · XVII ·
   IMP[ERATORI] · VI · CO[N]S[ULI] · VI · P[ATRI] · P[ATRIAE]
ADDECLARANDUM · QUANTAE ALTITUDINIS
MONSET · LOCUSTANTIS OPERIBUS SIT · EGESTUS
```

The inscription begins: "The senate and people of Rome to the Imperial Caesar, Divus Nerva Trajan, son of Nerva, Augustus," followed by the Emperor's titles and years he held them. *Altitudinis* refers to the height of a hill that was removed in order to build the column. The version of the column in Figure 62, from *L'architettura romana* (1830–1840) is without the triangular flaw caused by the erection of the addition that mars the monument. In overall dimensions the Trajan inscription is 9 feet wide and 3 feet 9 inches high. Vertical dimensions of the letters are about 4½ inches. This small scale of the letters deserves some comment. Certain sculptural pieces have minor importance because they are paperweight in concept. They may have size but not the strength of form to support that size. In the Trajan letters we are not aware of a scale, and we can imagine them at any size we wish. In typeface ¼ inch high or in inscription letters two feet high, these letters seem to possess essential graphic content that speaks of stature. Certainly historical accident plays a part in the preservation of these letters, as we shall see, but they have merit on their own. Structural elements

61. Cast of the Trajan inscription in Rome prepared by Edward Catich for the R. R. Donnelley & Sons Company of Chicago. This recent cast is the first accurate rendition of this notable inscription and supersedes renditions based on the cast in the Victoria and Albert Museum in London.

62. The Column of Trajan, in Rome, as it appeared in a volume published in 1845. *L'architettura antica.*

are balanced between those strokes derived from stiff inscription practices and a mediating calligraphic tool that imparted curves and graceful shading for variety.

Influence of the Trajan Inscription

Though the Trajan inscription is celebrated in England and the United States, it has not been reproduced in survey books emanating from the Continent. Emil Hubner published part of it, but the Trajan inscription was only one of hundreds of examples reproduced in 458 pages devoted to Roman inscription letters. Only one student of letters in the Renaissance regarded the Trajan inscription as worthy of special attention and publication, and this effort has only been seen recently by a very few people.

It so happened that Napoleon III, in power in 1852, ordered that an iron cast be made of the entire Trajan column. This monumental undertaking (the column is about 145 feet high) was in appreciation of the famous spiral reliefs that sweep around and up the column, and only included the inscription as an incidental part of the enterprise. A plaster cast taken from the French metal form was acquired by the Victoria and Albert Museum in London in 1864. Lloyd Reynolds and others believe that the shallow-cut serifs were faulty in the casting. Then, too, the pieces of the cast were crudely joined, which distorted some of the letters. Even after 1900, when the Trajan inscription took on new meaning, nobody bothered to obtain new material from the original in Rome. Between 1880 and the Edward Catich studies of 1935–1939, a rough rubbing by Ernst Detterer of Chicago (made in the early 1920s and now residing in the Newberry Library in Chicago) may have been the only effort in this direction. The Trajan cast may have had some influence on scholars. Toward the end of the century some of them knew and stated in print that Roman inscription letters were first drawn on stone with a brush and then chiseled along this drawn image.

W. R. Lethaby, an admirer of Ruskin's and a young friend of William Morris', became influential in teaching, and in 1899 asked Edward Johnston to start a class in "illuminating" at the newly formed London School of Arts and Crafts. In 1901 Lethaby and Johnston moved to the Royal College of Art. For teaching purposes Lethaby is said to have acquired casts of the Trajan inscription, and these were certainly known to Johnston and his students. Johnston's book of 1906, *Writing and Illuminating and Lettering,* was principally devoted to calligraphy, but it contained two reproductions of the Trajan inscription. Lethaby wrote an editor's preface stating the principles of method of Roman inscriptions in these words:

The Roman characters, which are our letters today, although their earlier forms have only come down to us cut in stone, must have been formed by incessant practice with a flat, stiff brush or some such tool. The disposition of the thicks and thins, and the exact shape of the curves, must have been settled by an instrument used rapidly; I suppose, indeed, that most of the great monumental inscriptions were designed *in situ* by a master writer, and only cut in by the mason, the cutting being merely a fixing, as it were, of the writing, and the cut inscriptions must always have been intended to be completed by painting.

The incised letters were indeed painted with minium, a red lead native to Italy.

Eric Gill, a brilliant student and friend of Johnston's, worked with the latter on inscription letters in 1903, and Johnston's *Manuscript and Inscription Letters* (London, 1909), a portfolio book, contained some plates by Gill inspired by the Trajan letters (Fig. 63). This book was intended for use by students and craftsmen. Other versions of the Trajan letters intended for sign painters and other commerical tradesmen appeared in 1903, 1904, and later. In this manner knowledge of, and interest in, one particular Roman inscription became widespread through Britain's art schools, trade schools, and out into the arena of public usage. Trajan-based inscriptions can be seen all over London (see Fig. 153).

Knowledge of the Trajan inscriptions in America came by way of Johnston's book, and many a veteran teacher saw the famous letters for the first time in slides made from this book. Naturally, too, some teachers traveled and were able to see the Trajan letters at the original site in Rome.

Figure 63 shows an early version of Trajan-based capitals designed by Eric Gill. They are fine letters and capture the grace and dignity of the Trajan letters, but Gill never meant to copy them exactly. Gill's role was that of an artist; he was not performing a scientific study.

James Mosley, writing in *Alphabet 1964,* (Birmingham, 1964) tells the story of the Trajan revival in England in some enjoyable detail. Father Edward Catich of St. Ambrose College, Davenport, Iowa, made a very thorough study of the Trajan inscription at the site in Rome in the latter part of the 1930s. His book *Letters Redrawn from the Trajan Inscription in Rome* (Davenport, 1961), accompanied by 93 portfolio plates, is a most valuable addition to a classroom library. It would be advisable to obtain two copies of Father Catich's volume. The plates reproduce all of the available Trajan letters in outline, and one volume could be used to obtain machine facsimile prints, which could be blacked in and used in the classroom.

Ideas born in the Renaissance and reinforced by centuries of type designers have tended to leave the im-

63. Eric Gill's capitals based on Trajan letters, first published in 1909 in Edward Johnston, *Manuscript and Inscription Letters for Schools and Classes and Craftsmen.*

pression that the Roman inscription letters were strictly codified and that each letter was always identical. This is not quite the case, as Father Catich has proved. The proportions of mainstroke to height vary a little, and mainstrokes are not strictly parallel; they bend a little and taper at midpoint. Further, today's capital alphabets tend to suggest that many of the letters possess interchangeable parts, like cylinders in automobile engines. The bowls of *P* and *R* appear as twin members today, but originally the lower arc of *P* was not connected to the stem. *B* and *S* were narrow, *C* was cut rather square, *N* was wide, and *I* sometimes soared above the top line, as did *T* on occasion. These individual qualities make the Roman inscriptions worth studying. They embody some good thoughts on letters not seen in many of the letters we use today.

Scriptura Communis

Roman writing was the basis for the great manuscript writing of the Middle Ages, and so it will be instructive to examine some of the styles produced in terms of Roman influence. The majestic letters of the Trajan monument took a long time to execute. Texts of like kind, recording the exploits, virtues, and deaths of the powerful and wealthy are properly recorded for history but reveal nothing of the role of letters in the more spontaneous demands of ordinary living. But if Pompeii is a good example, writing was a popular art in Roman towns. Pompeii, across the Bay of Naples from Cumae, was an old town existing in the seventh century B.C. It came to be

directly governed by Rome in 80 B.C. and became a vacation resort for wealthy Romans. In its own right, Pompeii's cultural heritage was substantial, and its population was perhaps 35,000. Literacy is assumed to have been high. Election notices written by professional scribes have received special attention because of their contribution to our knowledge of Roman institutions. Even the names of candidates are known. But the *graffiti* on the walls of Pompeii reveal the way in which the alphabet was used in common transactions of every kind, by people representing every condition of life. News, gossip, notices, messages, quotations from Vergil, Ovid, and Lucretius, school alphabets, earthy comments, amorous doggerel, and more are recorded on the walls of Pompeii. The comment, "Epaphra is no ball player," is typical. Adding another insight as to Pompeii's unique contribution to our knowledge of Roman letters is this quotation from a respected nineteenth-century scholar: "The cultivated men and women of the ancient city were not accustomed to scratch their names upon the stucco or to confide their reflections and experiences to the surface of a wall; we may assume that the writers were . . . not representative of the best elements of society." A prime illustration of this is a graffito from Pompeii reading, "Everybody writes on walls but me."

So with a cheerful disregard for spelling and grammar, and with a penchant for quoting great writers but only a fair regard for veracity, the citizens of Pompeii, through the accident of Vesuvius, left us the best record of Roman writing of two specific types: professional sign writing and common cursive. In Pompeii, most pen-written documents were destroyed, of course, but Roman pen writing is exceedingly rare in this first century for other reasons. The indoor-outdoor mode of living and the wet-dry, hot-cold climate tended to destroy papyrus. Also, there were no continuing institutions devoted to the preservation of documents. These came into existence after the decline of Roman power.

Our concept of Roman pen writing and cursive writing in general must be projected backward in time through circumstantial evidence. As mentioned, the carved parts of Roman inscriptions seem to indicate a degree of calligraphic influence in the third and second centuries B.C. Then too, Plautus, an early and influential playwright (c. 254–184 B.C.), left us a significant comment in *Pseudolus* (translated by Paul Nixon, Loeb Classical Library, Cambridge, Mass.: Harvard University Press, 1959), one of twenty plays that delineate Roman life in ribald and humorous terms. In the following dialogue from Act I, Calidorus has received a letter from his "girl friend" and asks the assistance of Pseudolus, his crafty slave.

CAL *(still hesitant, then tragically)*. Take these tablets *(handing them to him)* and from them tell yourself what misery and solicitude subwhelm me!

Ps. Anything to oblige *(examining the writing)*. But what's this, for heaven's sake?

CAL. What do you mean?

Ps *(chuckling)*. I judge these characters are after children, the way they climb on top of each other.

CAL *(wounded)*. Joking now, you jester?

Ps God, sir! The Sibyl may be able to read this, but I don't believe anyone else can make it out.

CAL *(rapturously)*. Ah, why do you disparage the dainty writing in dainty tablets indited by a dainty hand.

Ps. Lord save us! Have hens got any hands? For it surely was a hen wrote this.

CAL. You annoy me! Read the letter, or give it back.

Ps. No, no. I'll plough through it *(preparing to read aloud)*. Give me your sole attention.

CAL *(sighing heavily)*. My soul is not here.

Ps. Well, summon it.

CAL. No, not a word from me! Summon it yourself from the wax there *(indicating the tablets)*. For it is there my soul is now, and not within me.

Ps *(with a start)*. Oh, I see your girl friend sir!

CAL *(excitedly)*. Where? For heaven's sake, where?

Ps *(pointing to her name and guffawing)*. Look! At full length on the tablets, lying in wax.

CAL *(feebly indignant)*. Ugh. May all the powers above——

Ps *(interrupting cheerfully)*. "Preserve me," of course, sir.

CAL *(tragic again)*. Like the summer grass I flourished but for the moment: quickly I sprang up and, ah, quickly did I wither!

Ps. Hush, sir, till I read these tablets through.

CAL. Then why not read?

Ps *(with due sentimental stress)*. "Phoenicium to her lover Calidorus, through this medium of wax and wood and letters, sends her dearest wishes, and longs to have her own dearest wish from you, longs for it with tears in her eyes, with mind and heart and soul all tremulous."

The writing method referred to is that in which wooden tablets are coated with wax on which letters are scratched with a pointed stylus. At least we know that personal handwriting was well established in the time of Plautus, and if some of the writing was as bad as the playwright indicates, he must have had the personal experience of seeing more legible hands.

The Four Tools of Roman Writing

Roman methods of writing during the first century of the Christian era can be compared in terms of the tools used. Each of these methods of execution added something to our own ways of using the alphabet. All forms created at this time were derived from angular carved letters of archaic inscriptions.

Figure 64a, the previously discussed Caelius inscription of A.D. 9, shows brush-written letters stiffened in the carving process. Figure 64b shows a pen-letter style written on papyrus in A.D. 48. Pompeii contributes the brush-written election notice of Figure 64c and the graffito of Figure 64d.

Figure 64b shows the Roman capitals written with the hand rotated to the left and with some condensation. This style is accentuated and polished at a later date and called rustic. A few other papyrus fragments from the same period show the letters in a wider format, a tendency seen later in a formal book hand called *quadrata* or square capital. Professional sign writers using the brush, as in Figure 64c, contributed to and reinforced the slanted form of rustic pen letters. This same slanted form is seen in pen, brush, and inscription letters. Held more vertically, the brush contributed the subtleties seen in the Trajan capital alphabet. After this contribution, writing with the square-tipped brush became a forgotten art until 1890 in Chicago, when sign painting became important.

Already exuberant in form after a more cautious beginning, the Pompeian graffito of Figure 64d results from emphatic movement guiding a pointed tool. It takes an effort to scratch a line into a hard surface, and once in motion the stroke continues. The strokes are of equal value in any direction, in contrast to the thick and thin reed-pen strokes of Figure 64b. The first three examples of Roman writing shown exhibit some restraint, and the casual observer can name the letters without effort. Identifying the letters in Figure 64d is more difficult.

Popular Cursive

There are several reasons for the difficulties in reading Figure 64d. We are not so familiar with these forms as we are with the forms of the formal capitals we use daily. Then, too, casual renderings of amateurs are not likely to be models of legibility. Of course the flamboyant strokes interfere to a degree; but above and beyond these difficulties is the fact that the writing represents a kind of shorthand, and some of the letters depart from the capital prototypes.

For purposes of comparison, the same inscription is written in capitals:

```
C COMINIUSPYRRICHUS · ET
L · NOUIUS · PRISCUSETL · CAMPIUS
PRIMIGENIUSFANATICITRES
APULUINARSYNETHAE
HICFUERUNTCUMMARTIALE
SODALEACTIANOANICETIANI ·
SINCERISALUTIOSODALIFELICITER
```

64. (a) Tomb of M. Caelius. Reinisches Landesmuseum, Bonn.
(b) Pen letters c. A.D. 47. Biblioteca Nazionale, Florence.
(c and d) Pompeian wall writing and a graffito similar to stylus forms executed on wax tablets. J. Mallon, R. Marichal, and C. Perrat, *L'Écriture de la capitale romaine.*

A similar monoline style is found on waxed tablets from Pompeii and on the Dacian tablets a century later. In these a pointed stylus moving on a waxed surface makes curved lines easily. This begins a tendency to curve all letters, to connect letters at will, to reduce the number of strokes to a minimum, to continue strokes above and below the lines originally drawn to contain inscription letters, to invent new abbreviations and contractions, to add fancy strokes, and to give free rein to self-expression generally.

The thread of popular cursive as executed by nonprofessionals on walls cannot be followed to the end of the period of Roman power because it has been destroyed. Pompeii was a little window on the panorama. But popular cursive was taken up by professional scribes writing with a pointed pen on papyrus, and this became the "document cursive" that continued on into the later Middle Ages.

Popular cursive of the monoline type is also found in a few early papyrus rolls, such as the *Orationes Claudii, Imperatoris,* a part of which is seen in Figure 65. This papyrus dates from the middle of the first century A.D. There is a point of punctuation after each word. A transliteration of the first three lines follows:

TENNUISSE · CAUSSAM · PETITORI · EXPEDIAT
HAE · NE · PRO · INTERCEDANT · ARTES · MALE · AGENTIBUS·SI
VOBIS · VIDETUR · P · C · PATRES CONSCRIPTI DECERNAMUS · UT · ETIAM ·

One could wish for a decree ordering all scribes to write in the manner of the inscriptions, but alas. The monoline construction here was achieved by a pointed reed pen. Letters *D, E, G, H,* and *Q* are curved—certainly the precedent for the curved uncial letters we shall see shortly. *B* has a long cursive ascender with the small loop like our *b,* but the loop is on the left side of the stem. *R* is similar to our *r* but with a long descender. The piece is cryptic and not much can be said for its style. However, this popular monoline cursive was taken up by professional scribes, who brought skill and life to the writing. This more spirited style is seen in Figure 66, dated A.D.

65. Pen-written document c. A.D. 50, reflecting the influence of letters executed with a stylus on wax and of graffiti. Aegyptische Museum, Berlin.

66. A receipt for goods written in A.D. 167. British Museum, London.

October 7, 167. In this example the writing possesses qualities of speed and confidence, marks of a professional scribe. Bernard P. Grenfell, in *New Classical Fragments* (Oxford, 1897), offers this opinion on the status of the writer: "The difficulties are augmented by the badness of the Latin, which suggests that the writer was not a person of high station; possibly he was only a copyist." Grenfell remarks that the last word, *consulatus*, is quite clearly written. Notice that *U* and *L* are joined, and that a two-stroke *A* is joined to *T*, which connects with *U* and *S*. This example is typical of pen-written documents of the period. Emerging from various centers of an expanding empire, the cursive capitals do show variety in alphabetic forms. But these are well documented, and a gifted neophyte with a knowledge of Latin can catch on quite rapidly.

Fortunately the kind of writing seen here in its formative stages was accepted for official purposes and survives in brilliant cursive documents sponsored by the Church after the collapse of the Roman Empire.

Alphabet Follows Religion

At its height the Roman Empire stretched from the Atlantic Ocean to the Caspian Sea and from northern England through Egypt. Under Hadrian's able rule (A.D. 117–138) there were 75 millions of people dominated by Roman power. At this pinnacle who could have guessed that a despised handful of Christian believers would survive the decline and collapse of Rome? The Christian believers not only survived the Empire but succeeded it. It is ironical that, having condemned Roman culture and having been condemned by it, they were left to continue it in barbarous lands until an appreciation of learning slowly revived. In A.D. 500 the population of Europe was composed of a swarm of tribes. Perhaps the new vigor was needed, for as one writer puts it, the Romans "lost their nerve." But it was as if the American Indians had continued their victory over Custer with the conquest of Chicago, St. Louis, Pittsburgh, Philadelphia, New York, and Washington.

To shorten the defense line the last Roman troops left England in 407, after more than three hundred years of occupying the country (they had first appeared in England in A.D. 43). Within a generation, swarms of Angles, Saxons, and Jutes from northern Germany and Denmark invaded England, devastating the native Celtic peoples and erasing any signs of Roman civilization. As the Germanic tribes came to power in Europe there was a decline of literature, learning, and writing. Christian

monasteries served to preserve these foundation stones of civilized life during the centuries that followed the eclipse of Rome. How did this happen? No complete review is possible here, but several important events may be mentioned for those students whose studies in history are in some other era or area. St. Paul, a contemporary of Jesus' (the two did not meet), was instrumental in establishing the principles upon which a universal religion was possible. This helped early Christians to persist in the face of rival doctrines. Roman power, cutting emphatic marks on the map of Europe, was unable to cope with the landless and the unemployed. On this fertile ground the Christian weed grew faster than the methods devised for its eradication. Marcus Aurelius, who reigned from 161 to 180, was a relentless foe of the Christian doctrine, and a campaign against the Christians was initiated by Decius in 249. The last of the intermittent purges was carried out by Diocletian in 303. In 311 Emperor Galerius issued an edict of tolerance, and in 313 Constantine, in the Edict of Milan, gave the Christian movement official status. In the following decades state support of the Christian Church increased while patronage of pagan temples dwindled, and in 395 Emperor Theodosius made Christianity the official religion of the empire. Thus freed from its defensive position, the Church strengthened its internal structure and came to assume secular responsibilities in the vacuum left by the decline of Roman power.

Part II THE GRAND AGE OF MANUSCRIPTS

Lindisfarne Gospels. British Museum, London.

Chapter 3 Missionary and Monastery

Religious movements progress and grow by obtaining converts. Perhaps this was the only objective of early adherents to the Christian movement, but as the Church grew in numbers and power some of its leaders grew in learned achievements, and these were needed to spread the doctrine. For example, one of the earliest missionaries to the Germanic tribes was Ulfilas (c. 311–381). He spent 40 years among the Visigoths, translating the Bible into Gothic and inventing an alphabet (see Fig. 405) for a people who had no system of writing. This alphabet did not take root in the environment, but the effort was significant. St. Patrick, born in Britain in 389, was another important figure in early missionary work. Although his formative years were spent as a monk in Gaul, St. Patrick's main work took place in Ireland, where the Church obtained a strong foothold. Irish monks, with a zest for missionary work, went to Scotland, Gaul,

and Italy, and enjoyed a good measure of success. Columba was one of the great leaders in Irish missionary work.

Pope Gregory the Great was another important figure in the Church who encouraged missionary work. In 596 he sent a mission to England headed by St. Augustine. Its purpose was the establishment of the Church among the Anglo-Saxon peoples. St. Boniface of England, still another strong missionary, spent 35 years among primitive tribes in Germany.

The Christians did not invent the monastic way of life. Men had chosen a life of isolation and self-denial long before the birth of Christ. Christian monasticism developed in the third century under eastern leaders of the Church. Generally where missionary work succeeded, monasteries were established. By the sixth century many monasteries had been established in the several parts of Ireland, like Kilmacdugh, Clonard, Bangor, Clonmacnois, Moville, Durrow, and Derry. Activities conducted within these monasteries constituted the peak of civilization during these trying times. They were the centers of learning, teaching, and writing. Other monasteries came to dot the map of western Europe: Jarrow and Wearmouth in England; Luxeuil, Corbie, and Tours in France; St. Gall in Switzerland; Bobbio and Monte Cassino in Italy were but a few of the important centers, as the map in Figure 67 shows.

Most of these institutions of learning established *scriptoria,* writing centers, wherein the greater proportion of the books of the Middle Ages period were produced. It should be emphasized here that up until 1450, all European books and documents were handwritten (*manuscript* means 'handwritten'), with only a few woodcut books appearing before that date. Pens were cut and sharpened, skins were contracted and prepared, inks and pigments were ground and mixed, apprentices were trained in specific styles, and the arts of scholarship and writing went forward in these islands of civilization in spite of the turmoil and ignorance of the outside world.

Between 400 and 900 many of the *scriptoria* developed unique hands. It was a matter of experimenting with the few book hands developed in the times of Roman power. The unique qualities of the historic pages produced in the scriptoria are due to the unique qualities of human spirit and expression. In running documents of history such as *The Annals of Inisfallen,* an Irish record, paleographers are able to discern when one scribe retired from duty and another took over through individual interpretation of the script in use. We study these manuscript pages and base practice sessions upon them with the full knowledge that we cannot duplicate another's style. Instead we try to analyze those qualities of letter form and spacing that go into the spirit of the writing. This process may furnish a personal interest and direction for the contemporary student of letter forms. If the writing of the Middle Ages teaches anything it is this: the art of writing was not rigidly fixed and was open to personal views, as any art form should be. From the decline of Rome to the Renaissance there were not just a few carefully cultivated styles, but scores of them. E. A. Lowe in *Codices Latini Antiquiores,* which covers Latin manuscripts to 800, uses dozens of designations for these various styles. Lowe himself was somewhat dismayed at this proliferation of terminology. There was a brief respite from these manifestations of prolixity during the Carolingian reform, starting in Charlemagne's reign (768–814) and lasting for a century afterward. Then diversity of style again became the order of the day until the apparatus of type design induced something of a "freeze" on alphabetic change. The Middle Ages was indeed a rich period for writing styles. Unfortunately even Johnston's *Writing and Illuminating and Lettering,* a kind of Bible for calligraphers trained earlier in this century, revealed less than a tithe of this treasure. And perhaps as a consequence we have tended to push students toward the mastery of only a few styles. There is more to it.

During the Middle Ages there was a lively exchange of personnel between monasteries. A peasant was often stuck on the same plot of ground from birth to death, but a cleric enjoyed more freedom of movement, and writing styles were planted in foreign soil through this mobility. We know very little about the individual scribes or about their working day. Strict silence was maintained in the scriptorium, but conversations between scribes could be carried out in writing. Occasionally a scribe would reveal something about himself or some of the conditions surrounding the production of the book in the *colophon* (a page at the end of the book containing titles, dates, and other pertinent matter). Copyists sometimes wrote interesting notes in a *gloss* (words inserted between lines of an official text, often in the vernacular or native tongue). Or again a scribe might put some personal idea into the *marginalia* (notes inserted in the margin). Thus through glosses we may see two styles of writing in intimate juxtaposition. W. M. Lindsay, in the second volume of *Paleographia Latina,* quotes this interesting entry in a manuscript written in 823:

I, Baturicus, bishop at Ratisbon, in the name of God had this book copied for the salvation of my soul. It was written in seven days and revised on the eighth in the same place, in the seventh year of my episcopate and the year 823 of our Lord's Incarnation.

Moreover, it was copied by Ellenhard and Dignus, while Hildiun supervised the correctness of the writing. Pray for us.

Insertions of this kind are all too rare, for they furnish an insight into what the scribes thought about their work. As we can understand, a certain quality of pride or vanity sometimes shines against the dark cloth of humility. A well-known scribe at St. Gall, active in the eighth century, wrote this passage in a colophon:

Here ends the book which Winitharius, a sinner and a priest undeservingly ordained, wrote. With God's help he brought it to completion by the labour of his own hands; and there is not here one leaf which he had not secured by his own efforts, either by purchase or by begging for it, and there is not in this book one *apex* or one *iota* which his hand did not trace.

Reginbert, the librarian at Reichenau from 821 to 846, was also a skilled scribe. In the books that he copied he inserted 12 lines concluding with this thought written in Latin: "Observe, sweet friend, the copyist's heavy toil; take, open, read but harm not, close, replace."

We are quite aware of the fact that books have a way of disappearing. In the Middle Ages a fairly common entry in the colophon named the monastery or library owning the book. Appended to this kind of entry we might find a verse putting a curse on any person committing thievery. One ninth-century manuscript has an *ex libris* note indicating that the book belongs to Lorsch, and a couplet is added that reads something like this:

> Whoe'er this book to make his own doth plot,
> The fires of Hell and brimstone be his lot.

EMERGENCE OF THE BOOK

The signs and characters of writing have been placed on a wide variety of materials: stone, skins, silk, metals, clay (stamped and brushed), bark, leaves (as in India), and farther east, bone, paper, and wood. Homer's mention of a message carried by Bellerophon refers to a wooden tablet, while Livy states that the ancient records in Roman history were recorded on linen. Two of these materials seem pertinent to our study of writing after the decline of Rome. One of these, papyrus, has been discussed; but skins were also used in ancient times. Leather was used in Egypt earlier than 2000 B.C., and this material may also have been used in Assyrian and Persian writing. Herodotus mentions that skins were used by the Ionians when papyrus was scarce, and adds that barbarous peoples used skins extensively. Frederic G. Kenyon, in *Books and Readers in Ancient Greece and Rome*, includes the Syria-Palestine area in this regard, and we know that the Hebrew Dead Sea scrolls, discovered in 1947 and dating

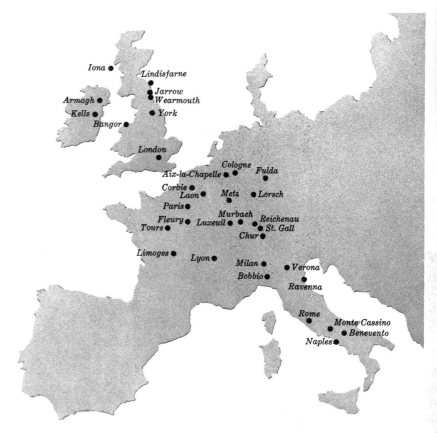

67. Map showing some of the principal European writing centers in the Middle Ages.

from the first century B.C., were written on leather. According to the Talmud, Hebrew law must be written on skins. Papyrus is assumed to be the writing surface in Greece for that period previous to extant manuscripts of the beginning of the fourth century B.C. As mentioned, papyrus was made into sheets that became long rolls, varying in length and width. The *Harris Papyrus* (Egyptian) in the British Museum is 133 feet by 17 inches, but Greek manuscripts are of more modest dimensions, some being as small as 2 inches in height. We have also seen that papyrus was used in the Roman era. Rollers were attached to the ends of the papyrus, and some of these rollers had ornamented knobs. Papyrus was usually written on only one side, and this, in part, prohibited the containing of any large document on a single roll. A 30-foot roll might hold a text as long as the Gospel of Matthew, but that was about the limit. A long work such as the *Odyssey* would have to be written on a number of rolls. This limitation or a desire to produce an entire work such as the Bible is believed to have led to the *codex*, or folded-sheet, method of book production and to the predominant

use of skins, which made the method possible. It should be mentioned here that paper was a later introduction from the East into Europe. The knowledge of paper-making, a Chinese invention c. A.D. 100, moved west. Arabs learned the art in the eighth century and introduced it to Spain and Italy in the twelfth century, whence it spread to the rest of Europe. By the fourteenth century it became the dominant medium for writing and vellum began its decline, though still used for books commissioned by wealthy Renaissance figures and for high proclamations issued by kings and emperors.

If Roman historians are to be believed, the use of skins for writing became noticeable about 200 B.C. Accounts of this can be followed in Sir Edward Maunde Thompson's *An Introduction to Greek and Latin Palaeography* and in Kenyon's study previously mentioned. Skins were in general use in the first century A.D. but had not superseded papyrus. The earliest extant examples dated from c. A.D. 100. From the fourth century onward the use of papyrus declined, and skins came into predominant usage as a medium for writing. Sheep, goat, and calf skins were in greatest use, although other animals also lent their hides to culture. The Latins referred to skins by the single word *membranae*, but over the centuries the word *parchment* came to stand for the ordinary quality of skin obtained from sheep and goats, while *vellum* referred to a finer quality of skin obtained from a calf, a kid, or a lamb. The younger the animal the better, and some skins are said to have been obtained before birth. The terms have not always been used accurately, but vellum is the material of the superb books of the Middle Ages. The processing of the skins became an industry, and since they were written on both sides, one of the principal steps in their manufacture was the careful removal of hair. Washing, lime treatment, scraping, stretching, rubbing with chalk and pumice—these operations were carefully handled. Hair-sided skins are sometimes most obvious in facsimile and at times give trouble in reproduction, the coarser texture obscuring fine pen strokes. Vellum was expensive, since an animal contributes his skin but once, and this sacrifice provided but a few pages. This mundane economic factor affects style, since it forces a tendency toward more characters to the line, more lines to the page, and smaller letters. We cannot follow this tendency from one manuscript to another, but we shall have to consider it seriously in the development of the cramped black letter. We see this factor at work today in newspaper headlines, where a vertical letter is used in order to get more words into a set horizontal format; and in newspaper want-ads, which may be set 13 lines to the inch.

The Roman word *caudex* (later *codex*) is derived originally from a word meaning 'from the bark of a tree.' In Greek and Roman times two or more wooden writing tablets could be coupled together with rings or thongs, and *codex* was used to describe such a communication on a series of surfaces or leaves. The name became generalized to apply to the more complex methods of book construction in leaves (as opposed to the roll form). Thus Codex Alexandrinus is the name given to a famous Bible in the British Museum featuring the Greek uncial style of letter form. Some of these codices are famous throughout the civilized world, and the history of various codices involves some of the best cloak-and-dagger material one can find anywhere. As to the question of their monetary value, Codex Sinaiticus, for example, was purchased from the Russian government in 1933 for £100,000. An American group then offered to pay £200,000 for it but failed to obtain it.

The codex, or early form, of our book, was made up of a series of *gatherings*, or *quires*. If a sheaf of four sheets of paper are folded once, the result will be eight *leaves*, or a quire. By modern count a quire gives 16 pages, but pages were not numbered in those early days. The term *quaternio*, as is obvious, meant a folding of four sheets, but it became a generic term for any gathering, or quire, without regard to the number of sheets. Quires of three sheets (six leaves) are in existence as are some of six sheets. Codex Vaticanus, a famous Greek Bible in the uncial style, is made up of ten-leaved quires. The usual practice was to number or *sign* each quire at the end leaf in a lower inner corner, but sometimes this sign is at the beginning of the quire. The sign *Q*, for *quaternio*, was often used, with an accompanying number to designate the quires in sequence. Such signs were the origin of the modern term *signature*, which indicates a grouping of 8, 16, 32, or 64 pages. Book design is intimately concerned with the way paper folds. The facing pages of the center of any gathering of sheets is a continuous piece of paper. The center of the gathering is the ideal place to print a piece of art that stretches across the folding place, or *gutter*.

If four sheets of paper are marked *hair* on one side and *flesh* on the other, and arranged so that when folded and opened a double page is of the same quality, the method of the early codex will be clear. In vellum the hair side is slightly darkened and yellow, while the flesh side tends to be nearer white. Two facing pages, then, presented something of a unified appearance. There is no unanimity in early methods as to whether the flesh or the hair side of a piece of vellum would face down or up in beginning a quire. E. A. Lowe says:

In our oldest manuscripts the outside quire is flesh-side as a rule. In the later manuscripts the hair-side is preferred. . . . The practice of leaving the first and last pages of each quire blank, treating them simply as jackets . . . throws fresh light upon the methods pursued in classical times in the production of books.

To mark off space between lines the vellum leaf was pierced by an instrument known as the *circinus* in vertical order down the page. In this way the front and back sides of the leaf could be ruled for letters with the same visual cue. Lines and margins were ruled with a sharp (but not cutting) tool, which pressed a mark into the skin. These marks could be seen on the reverse side. Different habits of pricking and ruling manuscripts interest scholars in that they help to identify the locale of the writing and in some instances help in dating it, a very difficult subject.

The vellum codex demonstrates the principal method of book production in the Middle Ages. Papyrus was not entirely out of the picture, but it did completely disappear about the time that paper made its appearance in western Europe at the beginning of the twelfth century. As previously mentioned, vellum was doomed to a decline, but that is another story. Vellum is still in use, and it is suggested that readers examine the material and use it, if only for a few letters.

A Note on Pens

Early Egyptian scribes used pens made from a rush plant. The solid stems of the plant could be made into a brush by sharpening a point and fraying the end fibers. When pointed, these rush stems could be used as a drawing tool, and when shaped to a wedge, served as a pen. Sometime in the late stages of the Egyptian civilization scribes began using pens made from the hollow reed *Phragmites Aegyptia*, which was cut with a slit and produced sharply defined thick-and-thin contours. One authority who has examined original Egyptian manuscripts closely, feels that the introduction of this hollow reed pen should be dated 600 B.C. It is interesting to note that John Howard Benson, one of the most distinguished calligraphers to represent the United States in this century, advocated pens made from *Phragmites communis*, a hollow reed growing in swampy ground in the northeastern United States.

Latin writers began to employ the reed pen c. 200 B.C. Museums exhibit metal pens used in Roman times, and some of these derive from the occupation of Britain. The experiment with metal pens did not survive, and the instrument cannot be precisely associated with existing manuscripts. The quill pen was the principal writing tool of the great manuscripts of the Middle Ages, though there is very little literature on its introduction.

Quill pens were made from the large flight feathers of various birds. Hollow and tough, quills resemble pens made of reeds, the principal difference being that water-soluble inks cannot penetrate the horny material of quills as they penetrate vegetable fibers. Reed and quill pens can produce written forms so identical that it is virtually impossible to certify the instrument used in specific manuscripts of the Middle Ages.

The compatability of quill pens with parchment surfaces suggests that quill pens began to displace reed pens when parchment began to replace papyrus c. A.D. 200. Our word for pen is derived from the Latin word for 'feather,' *penna*. It is certain that both the quill and the reed pen were used in the Middle Ages and that the quill pen became the dominant tool employed in book hands, legal writing, and personal scripts until the introduction of the metal pen in England in the eighteenth century.

Early Book Hands

There are three important or famous book hands that carry over from Roman developments: square capital, rustic capital, and uncial. The first two are limited in historical development, so we shall take them up first.

Square capital is a remarkable book hand in a number of ways. If the example in Figure 68 is compared with the Roman inscriptions already reproduced, it will be apparent that there is an attempt here at a direct transcription from the stone to the pen letter. This does not work too easily, and the manuscript letters are laboriously assembled, with an attempt to reproduce the serifs of the large-scale letters on the smaller scale. The principal pen slant is from vertical to slightly left of vertical, and yet the thin strokes, going from upper right to lower left, are thinner than would be expected, meaning that the scribe turned his hand to the left to make the slanted strokes. From an esthetic point of view the page has great dignity. It looks important.

As a book hand square capital is actually something of an anomaly: there is no existing precedent for it, nor are there any descendant styles. In fact, the fame of the style rests principally on just two manuscripts, one at St. Gall and the other in the Vatican. Paleographers know the designations by memory; the latter manuscript is Codex Vaticanus 3256 (also designated as Vat. Lat. 3256, meaning, obviously, that it is a Latin manuscript belonging to the Vatican Library). A piece of this manuscript is in Berlin. Both of these deluxe pieces of writing (and a few other fragments in the same style) are devoted to the works of Virgil. Perhaps at some time in the fourth century there was an idea that this poet should be honored by the

commission of these special editions, and one can specuate that others of the series may have been lost.

There is nothing special to be noted about the letters. The elongated *L* is common in inscriptions of the classical kind, while the *F* is common in inscriptions closer to rustic capital. As we know, *L* remained a tall letter when it came through the various minuscule versions to our lowercase, but this style is not responsible for it. There is no space between words at this time, but a point (or period) is used occasionally, as in inscriptions. So that the reader may follow Vat. Lat. 3256 letter for letter, the first four lines are given here:

> Atq[ue] alius latum funda iam verberat amne[m],
> alta petens, pelagoq[ue] alius trahit umida lina;
> tum ferri rigor atq[ue] argutae lammina serrae,
> nam primi cuneis scindebant fissile lignum,

While there are many forms of pen capitals seen in the Middle Ages none is quite like the square-capital style. And in the Renaissance, when Roman inscriptions were studied again and scribes made pen capitals based on the inscriptions, the forms achieved did not have quite the same effect as the square capital. The function changed too. In the Renaissance, pen capitals were used for titles. For these reasons the term square capital retains its specific connection with the manuscript discussed. It is not recommended that readers try this alphabet at once; but sooner or later it should be attempted. It is a good challenge and can be done fairly well, as seen in Figure 69, a student work.

Rustic capital has a precedent in brush form, in carved capitals, and in pen letters, as we have seen. The chief ingredient in this style is an extreme shift in the slant of the pen. The hand is about 75 degrees counterclockwise from vertical, so that vertical strokes are thin and horizontal strokes are thick. Our present Roman alphabet is based on a more moderate pen slant, so that rustic capital may seem strange to the eye. Modern typeface styles Barnum and Playbill (derived from nineteenth–century typefaces) are constructed on the same principle.

The manuscripts written in the mature rustic capital pen hand are not numerous. The style is seen in what can best be described as a sporadic continuity from the first century A.D., so when it does reach maturity, it is a genuine pen style with the pen describing the letters in a natural way. Very little of the personality of the writer comes through, but the pen and the surface meet in harmony.

The reproduction seen in Figure 70 is from Codex Vaticanus 3225, an illustrated edition of the *Aeneid*. Perhaps due to the fact that it is illustrated, the manuscript has no large or decorated letters; the first letter of each page is slightly enlarged. Different parts of the book start out with three lines in red. There are fifty colored illustrations in this important fourth-century production, and a facsimile edition may be found in some libraries (see Notes and Bibliography). As can be seen, the writing with its deliberate spacing communicates a quality of dignity but retains warmth. The letters, especially *M* and *N*, are broader than some rustic-capital specimens. *F* and *L* rise slightly above the line, and the scribe uses high, medial, and low inscription points (or periods) to indicate various pauses.

Another version of the rustic-capital style is seen in Figure 71, Codex Palatinus 1631 in the Vatican Library. This example, too, is presumed to have been written in Italy, in the fourth or fifth century. Here the scribe adds more sophistication and grace than is evident in the previous example, pushing the style to its natural conclusion. Some may not prefer the pretentious qualities of this writing, with its repetitious cursive elements (somehow the previous example seems more honest); yet a page of it is most impressive, and the expert scribe permits himself extra flourishes in the strokes only at the top and bottom lines (not present in the page reproduced here). Such self-restraint, in this case in the face of such an awesome task as preparing an edition of a Virgil text, is admirable and is a lesson in good manners. It will be noticed that the *flush left style* (that is, holding the left margin steady), with lines seeking their own end on the right, is not a late invention to accommodate modern poets.

A few other small points: *B*, *E*, and *F* rise above the line; the ending stroke of *G* is inward rather than down; and *R* and *P* are quite compressed. It is only since the Renaissance that *B*, *P*, and *R* have been designed to have a wider countenance and look as if they had interchangeable parts, as in a modern motor. *P* at one time possessed its own mark, but this has been lost, in the belief that all letters with bowls should conform.

Unless there still are undiscovered manuscripts, the rustic-capital style enjoyed no continuity into the centuries after the fifth; but it was known and revived for subtitles in the Carolingian Renaissance, around the end of the eighth century. It is seen in the title function in subsequent centuries.

The uncial style of Latin letters has a longer tradition of usage than either square capital or rustic capital. Letters under this designation were used from the fourth to the ninth century in the various European writing centers. It became an international style in the limited terms described in the map in Figure 67. In early uncial we can see the emergence of a new style of writing, primarily de-

ATQ·ALIVSLATVMFVNDAIAMVERBERATAMNE
ALIAPETENSPELAGOQ·ALIVSTRAHITVMIDALINA
TVMFERRIRIGORATQ·ARGVTAELAMMINASERRAE
NAMPRIMICVNEISSCINDEBANTFISSILELIGNVM
TVMVARIAEVENEREARTESLABOROMNIAVICIT
IMPROBETDVRISSVRGENSINREBVSEGESTAS

Above: 68. The square-capital manuscript Codex Vaticanus 3256. The quadrata is found in this form in only two manuscripts, devoted to the works of Virgil. Vatican Library, Vatican City.

Right: 69. Student work on square capital.

Below: 70. Rustic-capital style. Vatican Library, Vatican City.

Bottom: 71. The rustic-capital style in its most polished form. Vatican Library, Vatican City.

PVLVERVLENTACOQVATMATVRISSOLESIA
ATSINONERITTELLVSFECVNDASIPVM
ARCIVRVMETLVISATERITSVSPESVLCO
ILLICOFFICIANTLAETISNEFRVGTBEBAE
HICSTERILEMEXIGVVSNEDESERHAREN
AETERNISIDEMIONSASCESSARENOLIS
ETSEGNEMPATIERESITVDVRESCERECVM

SEMINAABAETHERIOLAGRATISNARIB·IGNEM·
ILLORVMDICENTEPATRIQVOSDAEDALACIRCAE·
SVPPOSITADIMATRENOTHOSFVRATACREAVIT
TALIBVSAENEADONISDICTISQVELATINI·
SVBLIMESINEQVISAEDIVNTPACEMQVEREPORIANT
ECCEAVTEMINANCHIISSESEREFEREBATABARCIS

EXTINCTVMETSVBITOMENTETVRBATADOLORE·
SECAVSAMCLAMATCRIMENQVECAPVTQVEMAIORVM·
MVLTAQVEPERMAESTVMDEMENSEFATAFVROREM·
PVRPVREOSMORITVRAMANVDISCINDITAMICTVS·
ETNODVMINFORMISLETITRABENECTITABALTA·
QVAMCLADEMMISERAEPOSTQVAMACCEPERELATINAE·
FILIAEPRIMAMANV·FLAVOSLAVINIACRINES·
ETROSEASLANIATAGENASTVMCETERACIRCVM·
TVRBATVRITRESONANTIATEPLANGORIBVSAEDES·

DITIONEMUNDIPEREA
QUAEFACTASUNTINTEL
LECTAASPICIUNTURE
TERNAQUOQ·EIUSUIR
TUSETDIUINITAS
hUIUSITAQ·DIUINITATIS
CORPORALISINXPOEST
NONEXPARTESEDTOTA
NEQ·PORTIOESTSEDPLE
NITUDOITACORPORALI
TERMANENSUTUNUM
SINTITAUNUMSUNT
UTADONONDIFFERATDS

TRACTANTESSUPERIORE
LIBRODEINFERENTINA
TURADIPATRISETDIFILI
ETIDQUODDICTUMEST
EGOETPATERUNUMSU
MUSDEMONSTRAN
TESNONADSOLITARIU
DMPROFICERESEDAD
UNITATEMINDISCRE
TAESECUNDUMGENE
RATIONEMDIUINITA
TISDUMNEQ·ALIUNDE
QUAMEXDODSNATUS

72. The uncial manuscript *Hilarius de Trinitate,*
a classic of the early uncial book hand. Bibliothèque Nationale, Paris.

pendent upon Roman capital form but throwing off the elaborations of serif construction as seen in square capital and rustic capital. The square-tipped pen and its movements begin to dominate the letter form. Then too, there is a principle of economy of movement at work in the formation of the uncial style. *A* comes closer to a two-stroke letter, *L* is executed in one stroke, and so on. *D* is a new form; *E* and *M* become curved and are essentially new forms. In uncial there is also the beginning of what we now call *ascenders* (parts rising above the line) and *descenders* (parts dropping below the line). We have seen a few such letters before, but in this book hand the practice becomes more fixed and permanent. To be sure, there are changes in the uncial style as time goes on, but there are five hundred uncial manuscripts extant, and these tendencies can be observed in most of them. *I, F, N, P, Q,* and *R* drop below the base line slightly, while *H, L,* and *D* rise above it. In these descenders and ascenders we see the great ancestor of our minuscule, or lowercase, alphabet.

The uncial example in Figure 72 is a famous manuscript, *Hilarius de Trinitate,* now in the Bibliothèque Nationale in Paris. If a student is looking through Lowe or any of the other facsimile editions of ancient manuscripts, this excellent piece of writing will be identified as Paris, Bibl. Nat. Lat. 2630. It was probably written in

Italy in the fifth or sixth century. There are no decorated letters in this example, and this is typical of early uncial manuscripts. In the Hilarius codex, the first line of a new part of the manuscript is written in red, while new paragraphs are marked by a slightly enlarged letter in the margin. The two-column style of page layout is typical of other early uncial examples, although the width of column can vary. Many single-column pages can be seen also.

The name *uncial* orginated as a term of derision. St. Jerome vented some scorn on persons who wanted ancient texts written in gold or silver on purple parchment or using *literae unciales*—inch-high letters. It is still unclear what books or book hands were under indictment, since no examples of the uncial letters remaining measure over ⅝ inch in height. In a literal sense the term is meaningless. Uncial was certainly developed before the fourth century, and some of the early signs of it were produced in Africa. Earlier examples of this classic book hand do exist, but a number of them are too obscured for proper reproduction. Others are *palimpsest* documents. This term refers to a parchment containing a form of writing that has been scraped off and used for a later text.

If there is any secret to the formation of the early uncial style, it resides in the large quantity of white space captured inside the letters. *N* is wider than high in rec-

ognition of this fact, and often *C* and *G* follow the same pattern. Then too the round qualities of the letter must be maintained. In an entire page these large, captured white spaces alternate with vertical strokes, and the result is a texture of grace and dignity. This quality cannot be captured without a close study of these details. A novice will almost immediately try to condense the letters of the uncial script; and while his effort may result in an interesting line or page, it misses the central point made by the scribes who initiated this book hand. These scribes knew what they were doing, and the longevity of the hand reinforces this.

Uncial Migration

Although Latin writing was thoroughly practiced in England during Roman occupation, there is no scrap of a written document existing from that or the subsequent period of Saxon domination. Writing in England during the sixth and seventh centuries was disseminated from the great Irish centers of learning, and these styles became important in both countries, as we shall see later. However, the uncial script came to England in a separate historical development and flourished, with changes, in a number of writing centers as scribes became more knowledgeable and skillful. Rome returned to England in 597, according to Bede's *Historia Ecclesiastica Gentis Anglorum*, and uncial was in the baggage of this original Christian mission from Rome. A second wave of missionaries arrived in 669 with more literature, and Anglo-Saxon pilgrimages to Rome brought still another supply. According to Bede, one Northumbrian brought back a quantity of "books of all sorts." It is a safe assumption that uncial (and other hands) arrived in England through travel, seeking, and acquiring.

Figure 73 shows a restoration by a seventh-century Anglo-Saxon scribe of a manuscript originally written in southern Italy in 547. It demonstrates that the Italian manuscript must have been in England and that the Anglo-Saxon scribe mastered the uncial style quite well.

73. The early uncial hand as copied by an Anglo-Saxon scribe in the seventh century. Universitätsbibliothek, Würzburg.

His spacing is off at times, which may indicate that he was not familiar with Latin; and curiously, where the original had no space between words, the restoration does. Reading letters strung together without that small white space between words is not as difficult as might be imagined and is paralleled in speech patterns:

First Speaker. Didjaketcheny?
Second Speaker. Fewpurch.

Obviously when a reader is confronted with a text in Latin written in a continous flow of letters there is some feeling of discomfort, since he feels entitled to discern words even if he is unable to read them. Of course in English the spelling of words is so peculiar that a space between words is a blessing. There is no definite rule on this, but a separation of words began to gain favor after the year 600. In hand scripts and typography the least amount of space between words is the most acceptable.

A landmark in letters produced in England is seen in Figure 74. This is a dedicatory verse from Codex Amiatinus, the earliest complete Latin Bible, now in the Laurentian Library in Florence. It was written at the twin abbeys of Wearmouth-Jarrow sometime before 716. The man who initiated this monumental undertaking, Abbot Ceofrid, died in France in September 716, on his way to St. Peter's in Rome with the volume as a gift. We have it on Bede's authority that he had ordered the writing of two other Bibles, one for Wearmouth and one for Jarrow, and a few leaves of one of the Bibles can now be seen in the British Museum. These and other manuscripts confirm a distinctive type of uncial script used in England in the Wearmouth-Jarrow area for about a hundred years, starting sometime prior to 700. The pages of the Amiatinus codex are imposing in format, over 13 inches wide and almost 21 inches high.

In the example reproduced here the scribe had some difficulty in lines 1, 2, and 5; but the style can be seen in all its vigor and dignity in the last six lines. Here the spacing of words became very sensitive, almost an ideal model. In line 10, at the end of the first word there were two vertical strokes to contend with, so he gave them a little room. He was a little tight with *IN* at the beginning of the second word, but otherwise the dynamics of the individual letter forms do not interfere with the continuity of the line—a most important principle. In the last line there is little space between the second and third words, because the height of *L* marks the beginning of a new word. Facsimile books are useful in the classroom because an individual student can be asked to examine a specimen for mistakes. This is invaluable in the progress of student writing.

+ CENOBIUMAD EXIMII MERITO

UENERABILES ALUXTORIS

quem cÁpuT ecclesiÁe

ÒEÒICÁT ÁLTÁ fiÒES

PETRUS LÁNGOBÁRÒORUM

EXTREMIS ÒEfiniB· ÁBBÁS

ÒEUOTI ÁffECTUS

PIGNORÁ MITTO MEI

MEQUE MEOSQ·OPTÁNS

TÁNTI INTERGÁUÒIÁ PÁTRIS

INCÁELIS MEMOREM

SEMPER HÁBERELOCUM ·

74. Dedicatory verse from the great uncial Bible Codex Amiatinus. It was written at the twin abbeys of Wearmouth-Jarrow before 716. Biblioteca Laurenziana, Florence.

In terms of shape, Codex Amiatinus is within the general format of the uncial letters we have seen, but difficult endings, like the serif endings of square capitals, are put back into the style. The pen, as a guess, was cut from upper left to lower right, with a slit to the left. This cut enables the scribe to use the sharp left corner to describe the endings seen in the loop of *A* and the descender of *G*, and the kind of serifs seen in *E, L,* and *S*. The pen was held at a vertical angle, as can be seen in the example. This subtly reinforces the horizontal parts at the top and bottom of the letters, and gives a horizontal stability to what is essentially a curved alphabet.

There are some remarkable specimens of writing in this late uncial style, perfectly disciplined letter forms prevail in some examples, and it is tempting to reproduce

some of these. However, they can be seen more completely in E. A. Lowe's *English Uncial* (Oxford, 1960). If a criticism of late uncial is to be made, it would have to center on the fact that it contains a reiteration of the fussy endings of square capital, after scribes of early uncial had thrown these encumbrances out the window.

We turn now to a writing style that seems to fix the role of ascenders and descenders in certain letters and reshapes our thinking about capital letters. In this style, half-uncial, so many letters have changed, when seen in comparison to carved Roman capitals, that we seem to be well on the road to our own minuscule alphabet. When the reader examines this next specimen of writing, he should remember again that the alphabet seen is the alphabet for this particular monastery or area. There is no distinction between a capital, a minuscule or an italic alphabet. Although most authorities accept the name, half-uncial perpetuates the misleading meaning of uncial without adding anything new. Early minuscule would be a more appropriate name. This matter aside, we can see in Figure 75, a sixth-century manuscript probably originating in Italy, that many letters are changed from the Roman inscription capital and the uncial alphabets seen previously. These changes are of cardinal importance to the development of letter structure in subsequent centuries. In Figure 76 the top line shows an interpretation of the alphabet as seen in Roman carving. The second line features letters based on the uncial letters found in the manuscript of Figure 72, while the third line features an alphabet based on the forms seen in Figure 75, Basilicanus D. 182, which was written before 510. The forms in the second and third lines are not to be considered as standard alphabets for the time. There are too many variations in the alphabetic forms from the period to be able to assume that one version is the most "correct." For example, the scribe who created the script of Figure 75 rendered the bowls of *a, b, d,* and so on as open, while other writers drew these letters with closed bowls, much as we see them today. Furthermore, calligraphers of the day did not bother to render the letters identically at each appearance, so some care must be taken when we choose a representative alphabet. In other words, teachers and students can trust original manuscripts over contemporary versions, and Figure 76 is presented here as a teaching aid to reveal tendencies.

In reference to our current minuscule, or lowercase, alphabet, the bottom line of Figure 76 reveals that by the sixth century *b, d, f, h,* and *l* had acquired permanent ascenders and much of their present form. Letters *f, g, p,* and *q* had gained descending parts, three of which remain today. The relative size of letters *c, e, i, m, o, r, t,*

INPONIT CUIUIRDIUINITATIrpLENITUDOHABITET INXPO
riueropatrirertedocequomodocorporalyter
haecineoinhabitetplenitudo· rienimcorpoly
modopatreminfiliocredit· paterinfiliohabitan
NDNexTabitinrete· riueroquodertpotiurcorpo
ralyterineomanentdiuinitatenaturaeineo
dr exdo ritnificat ueritatem·dumineodrent

ABCDEFGHILMNOPQRSTVXYZ

ABCDEFChILMNOpqRSTUXrZ

abcdefghilmNOpq rrtux

Top: 75. An early minuscule hand (half-uncial) written before 509 in Italy. Archivo della Basilica di S. Pietro.

Above: 76. A comparison of classical inscription capitals with the early uncial pen hand and the early minuscule, or half-uncial, alphabet.

and *u* had been established as well as the essentials of shape. And the initial and terminal strokes of these letters begin to exhibit hook shapes at the top and bent feet at the bottom, important in later calligraphic developments. Letters *b, d, h,* and *l* show clubbed ascenders, which are important details in manuscripts emerging from middle Europe through the Carolingian Renaissance. These clubbed ascenders are rendered with a stroke up and then down. The *l* in the bottom line of Figure 76 shows this feature quite clearly. This kind of stroke, natural to Roman cursive and to our own handwritten letters, is technically difficult for wide-nib pens used in the Middle Ages. It means that in rendering the upward stroke the pen is going "against the grain." This is the principal reason why clubbed ascenders, a remnant of cursive writing, was destined to die out in favor of hooks or wedges at the top of ascending strokes, as featured in the writings that stem from Ireland and England. It is interesting to note that early uncial is based on strokes that are entirely natural to the wide-nib pen, and that is why it remains a classic among the formative alphabets.

Still in reference to the bottom line of Figure 76, a few notes on individual letters may have relevance here, in spite of the fact that our eyes catch obvious changes in forms used in the writing of Latin.

a: an uncial form featuring a closed bowl lower on the stem is eventually most influential.

b: features an ascender and bowl, which are permanent.

c: essential form undisturbed through time.

d: has a vertical ascender and bowl. This form is the eventual winner over the uncial *d* seen in the second line.

e: essentially permanent in form, although interesting variations occur in the Middle Ages.

f: roughly permanent in form, with descending appendage eliminated finally in Renaissance times.

g: develops out of Roman cursive rather than uncial—upper parts become closed before the descender. Several forms in this development are shown in a later figure.

h: continues but with details changed.

i: eventually acquires a dot.

j: does not appear at this time.

k: is not needed in writing Latin.

l: essentially permanent in form—the foot becomes shortened in minuscule alphabets of subsequent centuries.

m: relative size determined—the initial stroke is in for minor changes.

n: the capital form is retained here, but is rarely seen in minuscule hands after 800.

o: unchanged.

p: essentially the same as now.

q: cursive writing changed the capital *Q*—almost final as seen here.

77. An early minuscule hand mixing uncial and popular cursive. Biblioteca Nazionale, Naples.

r: the bowl of *R* has become detached from the stem and the change has been perpetuated.

s: the long *s* is observed here; contemporary readers will see this form in quaint usage and in certain vintage alphabets from Germany. This form has occasioned a confusion with *f*.

t: has not changed very much.

u: is quite the same today.

v: does not appear at this early date.

w: is not essential to Latin manuscripts except as two consecutive *u* forms.

x: features a descending part here, but this is permanently dropped in Renaissance writings in Italy.

y: seldom seen in Latin documents; when it does appear the descending stroke shows a tendency to bend to the left.

z: gradually assumes two minuscule forms—one similar to the Roman Z, the other featuring a descending part still seen in revival styles in Germany. In early Latin documents *z* is hard to find since it is not essential.

When put in this form it is clear that in this early minuscule we have the blood ancestor of our minuscule letters. In terms of elegance the writing lacks something, but it does possess an honest vigor. It is a continuation of the pen-oriented tendencies of early uncial, and it does avoid the strict virtuosity of late uncial. This style is seen mainly in Italy and France in the fifth and sixth centuries. This line of influence is important, because early minuscule became embedded in the manuscript styles of writing in the sixth, seventh, and eighth centuries in Europe and

thereafter, with a gradual separation of function between minuscule and majuscule. In book hands the distinction between minuscule and majuscule is not based on size. In particular the styles developed in Ireland and Britain show a difference. The majuscule tends to be written between two guide lines, as in square capital, rustic capital, early uncial, and late uncial, while the minuscule needs four guide lines to mark ascenders and descenders. It is a little dangerous to make a generalization of this kind, and perhaps the meaning of minuscule and majuscule is best learned through examples to be reproduced.

Another form of early minuscule, often referred to as quarter-uncial, is seen in Figure 77. This is an Italian work of the fifth century, and its exuberance speaks of an acquaintance with popular cursive. The pen is cut fine and the writing is confident and skilled. Paying little attention to ruled lines, the scribe creates the form as he goes: in the tradition of popular cursive no letter is done the same way twice. One gets the feeling that the writer was going along at a good clip and enjoying himself. Speed is an essential part of a writing style; those who are interested in learning new writing styles should approach the activity in the same way as the original scribe, with swiftness, rather than devote too much time to slavish copying. Quite often the mysteries of a style will disappear when speed is applied, and the writer will quite often add his own valuable stamp to it.

Franks and Merovingians

Scholarship and writing seem to survive and prevail in the Middle Ages as a sort of underground movement of intelligent moles, sheltered away from the high winds and hail. Yet periods of political power could reflect on the quality and quantity of writing. After the period of vacuum following the Roman decline and fall, two continental power movements should be noted. The second and more notable was that brief and brilliant renaissance of Charlemagne, and this will be commented upon later. The first power movement involved German tribes called the Franks, who lived along the Rhine. Under Clovis, king of one important group called the Salians, a movement of conquest began. In 486 Clovis moved into Gaul and threw out the last vestige of Roman authority. In ten years of fighting, the Franks subjugated several rival groups and drove the Visigoths out of southern Gaul. At this early date Clovis was the only ruler in western Europe who was a Christian—through his marriage to a Burgundian princess who was a church member. The conversion of Clovis in 496 was of historical importance for western Europe, because the ambitious Franks pressed the Christian faith on all peoples who could be brought under the sword.

Clovis and his successor have been termed Merovingians. In former years Merovingian was considered the national book hand of French areas under Frankish domination, but art historians and paleographers have segmented the arts and writing of the area into that performed by specific cultural centers. An early minuscule written in Burgundy (a broad area around the Rhone River) is seen in Figure 78. This sixth-century document was written on papyrus and shows the influence of Roman

popular and formal cursive. A discussion of the latter is yet to come, but the reader can see at a glance that a new element has entered the writing under study. Perhaps a comparison with the English uncial in Figure 74 will point up the contrast. This cursive is active. The length of ascenders and descenders becomes a special mark of the book hands of French writing centers, and the vigor remains. If a generalization can be made about the difference between the writing in Italy and in the French-German area, it is perhaps that Italian writing is a little more severe and unobtrusive. Italian uncial and minuscule book hands show a taste for quiet legibility; northern writers bite into the surface with personal emphasis.

While the last example reflected a tendency to use the narrow-cut pen of Roman cursive, resulting in an almost monoline effect, Figure 79 shows a wider cut to the pen and a turn of the writing hand to the left, with thin verticals. The origin of the writing is unknown, but Lowe believes it to be Luxeuil. There is a degree of influence from, and similarity to, Irish minuscule (see Fig. 89), undoubtedly due to the fact that Luxeuil was founded by the Irish, bringing their advanced culture back to the Continent. But there is a swing to this writing that speaks of an influence not from the cultivated and stylized book hands (square capital, rustic capital, and uncial) but from Roman popular cursive—not confined, let us remember, to Italy. For readers interested in following the Latin a few transliterated lines are provided. Note the ligature for *et* in line 4. This is our ampersand sign.

Omnia opera eorum. Numquid super isto non
commovebitur terra, et Lugebit omnes habitator
ejus, et ascendit quasi fluvius universus, et eje-
crietur et defLuet quasi rivus Aegypti. Et erit

78. A specimen of French Merovingian writing, dating from the sixth century. Bibliothèque Nationale, Paris.

79. A seventh-century Merovingian document resembling manuscripts from Luxeuil. Bibliothèque Nationale, Paris.

Later Roman Cursive

The monoline Roman cursive in popular usage became increasingly free of inscription influence in the first centuries of our era. It developed its own letter forms and evolved curves, loops, and ligatures in exuberant fashion. Never static, never settling into a rigid pattern like rustic capital, Roman cursive has been neglected by the important writers on writing in this century. It is presumed that Johnston and his successors simply did not know what to do with it. But the style should be studied as an aid in our own efforts to develop cursive writing, for many personal letter writing styles are difficult to read and hard on the eyes. At the same time, our professional cursive writing has leaned heavily on Spencerian writing and is mannered, stiff, and mechanical. With all its curves, the professional cursive of today looks as if it had come out of a computer. But Roman cursive has style and freshness. Some modern writers go all out, as if in a contest to see who can produce the wildest looking page, and much of this is quite illegible.

Figure 80 shows a letter to a Roman governor. Written on papyrus, it dates before 362. The historical importance of this kind of writing can be judged from the fact that it is an official document. Thus popular cursive grew into an official cursive used in legal documents, edicts, and Church pronouncements. This is fortunate in that many of the documents were preserved, while popular writing

in the Middle Ages is hard to find. Then too, it is clear that Roman cursive was the incubator for later minuscule forms that resulted in our minuscule, or lowercase, letters. So that the reader can follow this development for himself, the first few lines of Figure 80 are transliterated below:

| Domino | suo | | Achillio |
| | | | vitalis |

cum in omnibus bonis benignitas tua sit praedita, tum etiam scholasticos et maxime, qui a me cultore tuo hono rificiente tuae tradunturm quod honeste respicere velit

While there is an indelible trace of Roman cursive in the book hands after square capital, rustic capital, and uncial, the cursive writers go their own way, and charter hands constitute a tradition apart down through the centuries. The reason for this is apparent. Books were created for reading, and so the letters were stereotyped, separate, and clear. Legal documents were a showcase for power and were not meant primarily to be read—hence a tradition where the form of letters was used to create this sense of solemnity or the appearance of power. One can suspect that this kind of challenge leads to moments of inspiration in the history of calligraphy, but there are times when the penman falls considerably short of the mark. There is in fact a tradition of absurdity in official documents, which speaks more of pomp and less of power.

An excellent series of documents in Roman cursive comes out of Ravenna in the sixth century. Seen in Figure 81 is part of a deed of sale of land, written on papyrus

80. Roman cursive written before 362. Certain minuscule forms emerge from cursive. Bibliothèque Nationale et Universitaire, Strasbourg.

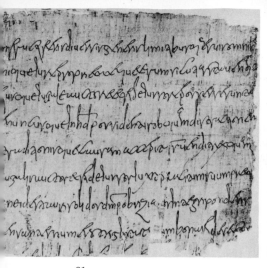

81

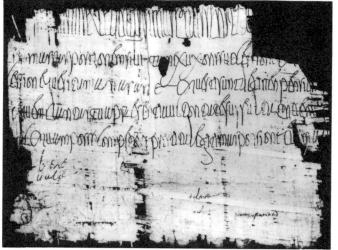

82

Für das Jahr 1965

alle guten Wünsche Best wishes for 1965

Gudrun und

Hermann Zapf

Frankfurt am Main · Bernhard Mannfeld Weg 24

83 84

81. Roman cursive c. 600. British Museum, London.

82. A sixth-century document from a provincial chancery.
Bibliothèque Publique et Universitaire, Geneva.

83. A papal document dated 892. Vatican Library, Vatican City.

84. Cursive writing by a contemporary, Hermann Zapf, Frankfurt.

and dating c. 600. Writing with a genuine authority, the calligrapher joined letters (ligatures) as the spirit moved him, invented as needed, while preserving a unity in the whole. In other words, the writer was an artist.

This spirited writing is again seen in Figure 82, a sixth-century document from a provincial chancery. The elongated letters at the top are found in many charter documents in subsequent centuries. It is an attempt to give importance to titles, names, and places without making an outline capital letter and filling it in. It is all done with the single mark of a pen. Again some lines are transliterated for the benefit of the reader—these beginning with the cursive writing below the elongated letters:

> Ciana massas portionem sibitam ex uxoris successione
> cessione quesitam a Nasane questi sont detineri
> bension

It is tempting to go on with this powerful and free cursive style, but more of it may be seen in *Chartae Latinae Antiquiores* (Lausanne, 1954), a facsimile edition of Latin charters prior to the ninth century.

Roman cursive was absorbed and changed as the years passed. It influenced the minuscule book hands of western Europe, and in the next example we see that some of the calming disciplines of the book hands had to come back to cursive writing. Since this example in Figure 83 was written c. 892, it is hardly proper to call it Roman cursive,

but there is still a spark to the style. This papyrus document has been published in an elephantine edition measuring 25 by 35 inches, and the columns of writing are about 25 inches deep. Its formidable title is *Formosus Servodei Gerundensi Episcopo*.

Roman writers made frequent use of abbreviations and elisions. It made more sense in the versions cut in stone than in legal documents. The reader will notice a few of them here in the transliteration of Figure 83.

> servod[e]i s[an] c[t]ae gerundenesis eccle
> siae episcopo et per te eade[m]
> ven[erable] ecclesia in perpetuum

Thus Roman cursive lived in its own way for a time, leaving a mark on official writing at least a thousand years beyond the fall of Rome. And in the streets of Europe cursive writing continued in the same carefree way in which it had started in the old towns of Italy. As a result there is an unbroken line of cursive writing down to the present day. Never easy to read, Roman cursive became more complicated and illegible and was finally banned in thirteenth-century decrees by Frederick II of Germany.

A modern work by the great contemporary German calligrapher Hermann Zapf is seen in Figure 84. Here one can see some of the drive and spirit inherent in Roman cursive, and a suggestion of the way in which those who care to might approach it.

85. The Book of Kells. Trinity College Library, Dublin.

WRITING IN IRELAND

It is generally forgotten that Ireland was never a part of the Roman Empire. However, when St. Patrick, born in Britain and trained in Gaul, undertook his work in Ireland, there were already some converts in the land. Scholars find that St. Patrick's actual work in the establishment of the Church in Ireland is difficult to assess. But in the century following his death (c. 461) numerous monasteries were established. Undisturbed by foreign arms, the Irish were able to assimilate the Church within established cultural patterns, and according to M. L. W. Laistner, in *Thought and Letters in Western Europe* (London, 1931), the monastery became the religious and educational center of the clan, which elected the abbot. Laistner writes:

It is beyond dispute that from the sixth century the Irish monasteries cultivated both secular and theological learning and that for three centuries they produced a series of remarkable men who exerted a profound influence on thought and letters in Western Europe. . . .

Appropriately, the thought and letters of this high culture were carried by high skills in the arts of writing

and illumination. Some of the works produced by the Irish writing centers during the seventh, eighth, and ninth centuries are high points in writing and bookmaking.

It is certain that Irish scribes and book-production specialists learned part of their skills from the Continent through imported manuscripts. The particular manuscripts are not known, but paleographers assume that the manuscripts brought to Ireland during the fifth and sixth centuries were of the type seen in Figure 75, wherein the ascenders and descenders were already in development. It must be assumed on the visual evidence of Irish writing that the simpler uncial writing of the fifth century never reached Ireland. However obscure the origins of Irish writing and illumination, these skills are seen full-blown in the wondrous Book of Kells, now in the library of Trinity College, Dublin. (A facsimile edition has been published by Urs-Graf-Verlag, Berne, Switzerland, 1951.)

The Book of Kells, executed c. 800, is a gospel book containing the lives of Matthew, Mark, Luke, and John, and also other material, written in Latin. It dates from the eighth or ninth century. There are 340 leaves, whose present size is approximately 9 by 13 inches. About 165 years ago a bookbinder trimmed the pages, and some margins may have lost an inch. Pages filled with writing normally contain 17 wide lines, but some pages contain 16 or 18 lines. The vellum is strong and well prepared, with black or brownish-black ink. In some parts the scribe has used red, blue-black, and purple ink alternately.

Also known as Codex Cenannensis, the Book of Kells was probably written at Kells (formerly Cenannus), an important writing center about forty miles northwest of Dublin, although it may have been begun at Iona. Part of the writing center there traced its origin to Columba (Columcille), the sixth-century Irish churchman. The manuscript has led a rather tame existence, staying at Kells except for one short interval. An account written in 1006 reveals that this "chief treasure of the western world" was stolen from the western sacristy of the great stone church of Cenannus. When found buried in the ground some two months later its gold cover was missing.

The great book was apparently given into private ownership during the dissolution of monasteries directed by Henry VIII in 1539. Richard Plunket, the last abbot at Kells, was the first owner. A kinsman, Gerald Plunket, was the second, and the third was the scholar and Archbishop of Armagh, James Ussher (1581–1656). The latter, one of the founders of Trinity College Library in Dublin, used the volume in his researches. It was bequeathed to Ussher's daughter and finally given to Trinity College by Charles II.

Figure 85, one of the ornamented pages, gives ready evidence of the overwhelming graphic content of the Book

of Kells. Zoomorphic forms are intertwined with the geometric, while great curved letters, generously decorated, flow into stiffly oriented capital letters. There are gospel scenes and evangelists with their symbols, and there is not one of the 680 pages without color and ornamentation. It is quite believable that the intent of the volume was to impress the uninitiated with the mystery and glorious power of the Deity.

The writing itself is termed Irish majuscule and is perhaps to be preferred over Irish half-uncial, used in some commentaries. As can be seen in Figure 86, the style leans strongly to ligatures, and occasionally whole words will be connected together. In the resulting loops, spaces, and voids the scribe, at whim, inserted bits of color. In view of the fact that words are designed according to the needs of line composition and personal preference, it is difficult and perhaps misleading to present a fixed alphabet. Letters change to accommodate the environment, as should be. Nevertheless a basic table of letters is given in Figure 87 to help readers get started on the anatomy of this strange and difficult book hand.

The Irish majuscule is written between two guide lines, as in uncial. On seeing it for the first time one might well receive the impression that the letter forms are strange and exotic; but a comparison between the alphabets of Figure 87 and that in the bottom line of Figure 76 reveals a close correspondence in basic forms. The Irish hand shows an uncial *d* and *R*, but these features are not unusual for manuscripts of this date. The pen used in the Kells manuscript was a quill, in use from a rough date of 200. In uncial the pen was held in a map direction of northwest, natural for right-handed penmen, but in the Irish majuscule the pen is directed north or a few degrees to the west. A clue to this pen slant resides in the flat strokes atop *b, h,* and *l*. These initial strokes and those of *i, m, n, u,* and so on are executed by two separate strokes, with the left profile of the letter described in the first move of the pen. In the Irish majuscule these wedge-shaped initial strokes are an essential part of the style. They remain today, modified, curved and trimmed down, in written minuscule letters and the printed lowercase. Church leadership in Ireland was energetic, establishing monasteries and writing centers in the British Isles and on the Continent. Hence Irish scribes and their writing methods were influential.

It would seem presumptuous for a student to attempt anything along this line, but luckily students sometimes lack awe and hesitation in the face of impressive or difficult historical documents. The student who executed the piece seen in Figure 88 simply took a look at the Book of Kells in facsimile and then proceeded to execute a piece of his own desire.

86. The writing style of the Book of Kells. Bits of color were sometimes painted inside the letters. Trinity College Library, Dublin.

87. An alphabet of letters from the Book of Kells.
The basic forms are remarkably stable, but the art of ligature is everywhere present. Trinity College Library, Dublin.

88. Student effort inspired by Celtic scribes.

89. The Bangor Antiphonary. Biblioteca Ambrosiana, Milan.

Irish Minuscule

Irish scribes developed another good book hand, called the Irish minuscule. An example of this is seen in Figure 89, an excerpt from the Bangor Antiphonary, written at Bangor in the north of Ireland in the period between 680 and 691. The manuscript is now in Milan, by way of the great monastery at Bobbio, which was founded by the energetic Irish monk Columba c. 614. The writing swings along nicely, and here it is appropriate to quote E. A. Lowe: "The Irish scribe often behaves as if the written line were something elastic, not a fixed and determined space which has to be filled in a particular way. He seems often guided by whim and fancy. The English scribe, by comparison, is balanced and disciplined." Indeed, the writers of Britain learned and copied their letters from the Irish, and for a time the writings of Irish and Anglo-Saxon scribes were almost identical and can be distinguished now only with great difficulty. The spirit of the work sometimes gives the clue, although in this "international set" it is not always possible to identify the locale of the writer.

The writing seen in Figure 89 puts us a little closer to our own minuscule by one or two concrete steps. Certainly the a, n, r, and t look a little more familiar, and one has the notion that had the scribe been a bit more sensitive about our habits in separating words, the passage could be read. On tall letters the double-stroked serifs prevail, and these are seen on the initial strokes of i, n, m, p, u, and r. A word of caution—d, n, r, and s may have two forms.

Irish writing possesses spirit and continuity. In the latter part of the Middle Ages the Irish minuscule became somewhat fixed and continued on as a national habit until recent times. Of a number of Irish annals (historical records), the most complete is that in the Annals of Inis-

fallen. These were written in continuity from c. 1100 to 1321, and cover the significant historical events in southern Ireland. A small island in the Lake of Killarney is the source of these records, and the column seen in Figure 90 was written in 1191. A more complete record can be seen in the facsimile published by the Royal Irish Academy in 1933. The scribe, equipped with a sharply cut quill pen, seems to have behaved in the manner described by Lowe, wobbling a little but leaving a mark of genuine authority. Readers will discern that the scribe cut a new pen after line 14 and that the nib was not quite as wide.

Still later Irish minuscule is seen in Figure 91. This is part of a column from the Senchas Mār, now in the library of Trinity College. A fascimile of this manuscript was published in Dublin in 1931. This writing dates from c. 1300. Scholars find it difficult to date Irish manuscripts between the twelfth and fifteenth centuries on the basis of the writing, as much of it is quite similar. There is no doubting the vigor and boldness of this minuscule, which might look more impressive without the gloss or notes between lines added later. The writing of these centuries generally suffers from compression or crowding of the letters, and one cannot fail to note that the Bangor manuscript seen previously is more relaxed in this respect. Irish writing can be seen in the Cathach of St. Columba, the Schaffhausen Adamnan, the Books of Dimma and Mulling, the Book of Armagh, and the Stowe Missal.

90. Excerpt from the Annals of Inisfallen. Bodleian Library, Oxford.

91. Detail of the Senchas Mār. Trinity College Library, Dublin.

ANGLO-SAXON WRITING

With their zeal for missionary work, Irish monks were instrumental in the establishment of Christian centers of learning, and with them writing centers, in Britain and on the Continent. Columba went to Scotland around 565 and founded a famous monastery on the island of Iona, given to him by a local chieftain. From this seat many monastic centers grew. Columba, a strong and controversial person, led a group of monks into Gaul. Arriving in Burgundia around 590, the group created a center at Annegray, and from this the abbeys of Luxeuil and Fontaines were established. In trouble with Frankish authorities over his uncompromising attitude on court life and Church disciplines, Columba had to retreat to northern Italy, where he founded the great monastery of Bobbio. One of his followers took up residence in the Alps, and the great writing center of St. Gall emerged from this modest beginning. The first abbot at Corbie in northeast France, founded in the middle of the seventh century, was a Columban man.

In the seventh century the Irish were also busy in northern England helping the local rulers convert and reconvert those who had lapsed into paganism. The Celtic Church was based at Lindisfarne (now Holy Island; see Fig. 67), established c. 635 from Iona by Aidan, a pupil of St. Columba. Other centers of Celtic culture were also established with Iona and Lindisfarne as a base. Rome-based influence crept up from the south of England and mingled with the Celtic in Northumbria. The controversies between the two branches of the Church are outside the scope of this study, but E. A. Lowe's commentary in *English Uncial* (Oxford, 1960) on the cultural aspect of the fusion is significant:

Roman influence, paramount in the south, slowly makes itself felt in the north, and in Northumbria the two streams meet and combine, with remarkable results. The seventh century is a blaze of activity. Scribes writing side by side in Roman and in Irish styles seem to vie with each other, spurred on to great deeds. One masterpiece of calligraphy follows another. . . . A folio-size Bible of over one thousand leaves, beautifully prepared, well penned and accurate, would be a credit to any age; actually three such were produced under Abbot Ceolfrid at Jarrow; and at the same time in the neighboring Isle of Lindisfarne such works of art as the Lindisfarne Gospels and the Codex Epternacensis came into being.

Thus the Celtic styles just seen merge with the uncial style (Fig. 74) in the north of England, and in some manuscripts they are seen combined, with pages of Celtic–Anglo-Saxon wrapped with pages of uncial. All the texts were in the late version of Latin, and in some cases scholars can by no means determine the national origin or linguistic affiliation of the scribe. In these cases manuscripts may be described as Insular (majuscule or minuscule), at least limiting the area of origin to the British Isles. At the outset of this fusion, the Irish monks taught the Anglo-Saxon scribes exactly how it was to be done, and this is why Anglo-Saxon writing, later to emerge on its own after the departure of the Irish, was at first a copy.

What we see next, in Figure 92, is a page from the Lindisfarne Gospels, one of the great documents of

92. A page from the Lindisfarne Gospels. British Museum, London.

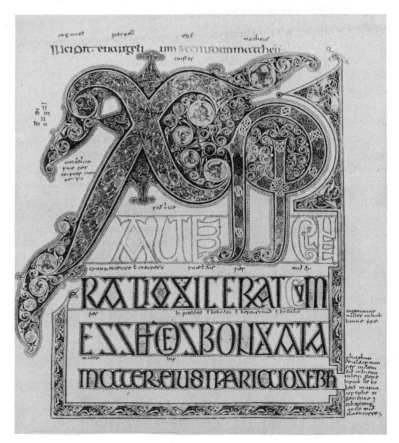

93. Two-column writing from the Lindisfarne Gospels. The end of line 1 is notable. British Museum, London.

Anglo-Saxon history. Now in the British Museum, it was written and illuminated at Lindisfarne between 698 and 721. St. Cuthbert, bishop of the island center, had died in 687 and the gospels were written in his honor. A facsimile was published by Urs-Graf-Verlag in 1956.

The manuscript, recording New Testament gospels, consists of 259 leaves. There are two columns to the page and 24 lines in each column. It was written by one scribe, Bishop Eadfrith, who headed Lindisfarne during the dates mentioned. The illumination is in the Celtic manner, and slides from the zoomorphic to the lacy arabesque to the geometric without hesitation. The capital letters are quite original.

A sample of the writing of the Lindisfarne Gospels is reproduced in Figure 93. Between the lines of Latin a gloss in Anglo-Saxon appears. These lines were added in the tenth century. There is no need to dwell on the obvious similarity between this book hand and that of the Book of Kells. The letters in the Lindisfarne work are a little thicker and wider, and their symmetry and precision bring to mind E. A. Lowe's earlier remarks. In spite of similarities, the Lindisfarne hand and others like it identified as having been written by natives of Britain are

termed Anglo-Saxon majuscule. A number of fine manuscripts were executed in this style during the eighth century. But at the end of the century the style was almost extinct. Of course the style was known to Edward Johnston, and contemporary interest in it stems from his works.

Anglo-Saxon minuscule also started out as a copy of Irish. The sample seen in Figure 94 invites comparison with the Celtic hand of Figure 89. Figure 94 is from Bede's famous *Historia Ecclesiastica Gentis Anglorum*, now in the British Museum. The Venerable Bede, a great scholar of the period, carried his *Ecclesiastical History of the English People* to the year 731, and the writing in Figure 94 dates from a few years later. It has a cursive tendency, and the pen slant is well to the left, with double-stroked initial strokes. The scribe has not been generous with the space between words, and the period usually means an abbreviation.

The Anglo-Saxon minuscule style has a much more extensive history of longevity and influence than the majuscule. First, there were connections between the British Isles and the Continent; and in these neighboring centers, sometimes affiliated in terms of race and lan-

94. Late eighth-century Anglo-Saxon writing. British Museum, London.

95. Anglo-Saxon writing of the tenth century. British Museum, London.

guage, the Insular hands had their effect. Then too, the Anglo-Saxon hand persisted in England against the later invasion of Carolingian minuscule, which became the international book hand of the ninth, tenth, and eleventh centuries in Europe. In England, when Carolingian became the book hand for Latin texts, the Anglo-Saxon minuscule was used for texts in the vernacular and then in primitive English. Thompson states that in some charters of the period, the two hands are seen side by side, with the body of the document written in Carolingian-style Latin, and the property boundaries expressed in Anglo-Saxon minuscule.

A later version of the Anglo-Saxon minuscule hand can be studied in Figure 95, a tenth-century document now in the British Museum. The distinctive look of the page can be traced to the spiky serifs and the sharp descenders. Speaking romantically for the moment, this vigorous hand seems eminently suited to our notions about a vigorous people. This is the last we shall see of it in full flower, for the Norman invasion was a knife's edge to its growth, and scholarly enterprise is needed to trace its decline. England's revival of interest in calligraphy for this century proceeded as if this hand had never existed.

Anglo-Saxons on the Continent

Early invasion from the Continent had made Britain a savage land, but the darkness of these events had been penetrated by missionaries of Roman influence. Pushing north in England, this branch of the Christian faith had not only to survive the hostility of heathen rulers but also to deal with the problem of rival Irish monks. Clan participation in church structure in Ireland was described briefly in Laistner's comment, and the Celtic monks practiced certain customs that were unorthodox. They shaved their heads in a different manner and calculated the date of Easter by an outmoded method. These differences symbolized independence of Roman discipline.

A jurisdictional dispute over the Midlands area of England was decided at the Council of Whitby in 664, where council members voted against the Irish. The church in Britain was to be organized under papal discipline, and the Celtic churchmen withdrew from Anglo-Saxon territory. Contacts were not lost permanently, as we have seen in the transfer of the Celtic writing hands to Anglo-Saxon writing centers.

But the Irish church then lost its contact with the Con-

tinent. Monasteries on the Continent that had been founded by Irish missionaries were no longer permitted to go their own free way, and by 700 Anglo-Saxon monks had superseded the Irish as leaders of the missionary effort in central Europe. There were strong leaders heading this cultural invasion across the channel and into lands held by German tribes. Willibrord led a successful drive to convert the Frisians inhabiting the estuary of the Rhine beginning in 690. Another important figure in this movement was a West Saxon monk named Winfrid, later St. Boniface (680–754), who created a unified ecclesiastical system for major parts of France and Germany. In this movement east, old monasteries were reformed and new monasteries were established. A jewel among them was Fulda.

Upon the establishment of these new religious centers scriptoria were set up, and quite naturally the scribes were English and employed the Anglo-Saxon minuscule. In the eighth century the style became entrenched in the various centers, and E. A. Lowe, in *Codices Latini Antiquiores*, identifies more than a hundred European manuscripts executed in Anglo-Saxon styles. This does not mean that Anglo-Saxon minuscule dominated the Continent, because other local styles were already well established.

The writing seen in Figure 96 represents a kind of fusion between Anglo-Saxon habits of letter formation and those practiced on the Continent. In this authorative script the pen slant is considerably left of vertical, and descending end strokes bend to the left. These features are typical of Anglo-Saxon minuscule hands. The long club-shaped ascenders, executed with an upstroke and a downstroke, are closer to the habits of continental penmen. This remnant of Roman cursive prevails on the Continent and will be seen in the Carolingian minuscule hand, which became dominant in Europe after 800.

96. An Anglo-Saxon hand in a German center. Deutsche Staatsbibliothek, Berlin.

CAROLINGIAN WRITING

The Merovingian line of rulers in central Europe declined in power and talent after a high point under Clovis, who died in 511. A new line of rulers among the Franks was established by Charles Martel, who defeated a Saracen army at Tours in 732. Martel's son obtained a sanction from the pope to declare himself the ruler of the Frankish nation, and this event saw the establishment of the Carolingian line. In these times Gaul and surrounding territories were united in one government, from 751 to 888. The grandson of Martel was a shining sun over the "slough of despond" in this period of the Middle Ages. The great triumphs of Charlemagne, who took power in 771, are not to be measured in terms of conquered territory, although his lands, encompassing France, Germany, part of the Baltic, and half of Italy, were not to be surpassed until the campaigns of Napoleon at the turn of the nineteenth century. Charlemagne had a zeal for education as well as conquest and brought many scholars to his court in Aachen and Aix-la-Chapelle, a favorite residence.

Charlemagne turned to Alcuin (735–804), an Anglo-Saxon and the former head of the scriptorium at York, for leadership in matters of scholarship. Alcuin became the editor of a large publishing establishment featuring deluxe books, and corrected editions of biblical texts. Our interest in this is primarily focused on the reformation and standardization of handwriting and its resultant minuscule, the Carolingian, also known as Caroline.

The development of this important minuscule took place in the last quarter of the eighth century and was based on the pre-Carolingian minuscule hands executed in the various important writing centers in Europe. But especially it included that performed at St. Martin's in Tours, which had been an important writing center a century before Alcuin's time. A sample of this pre-Carolingian writing appears in Figure 97. Now in the British Museum, it was executed at Tours in the eighth century, sometime before Alcuin arrived at Charlemagne's court.

This hand, like other European hands, evolved from the early Roman minuscule (half-uncial). Early Carolingian involved some influences not seen in this example, because uncial forms of G and N were preserved for a time as well as the older form of A. Clubbed ascenders (a stroke up and down), seen in this example and a widespread central European habit, were also saved. More sharply executed serifs, as performed by Celtic and Anglo-Saxon writers, had not penetrated the key area of influence at this time.

97. Pre-Carolingian writing at Tours. British Museum, London.

Alcuin and his staff, interested in establishing a legible book hand, decided that ascenders and descenders were to take up the same vertical space as the main body of letters. Thus the script was written between four equally measured lines. This decision eliminated the absurdly long ascenders and descenders found in Merovingian and charter writing, and has influenced our own feelings in this matter. Today it is difficult to find a book typeface that employs excessively long ascenders and descenders. No doubt a sense of economy of means was functioning then as now.

Alcuin's group also ruled out the random use of ligatures. Each letter was to be seen clearly, except for a few happy marriages. This clarifying tendency is also seen today in printed reading matter. Some early designers of typefaces in Italy tried to accommodate every ligature possible to penmanship (see Fig. 228), but this failed over the years from inherent inefficiency.

The example of Carolingian minuscule exhibited in Figure 98 is a Latin Bible executed in the second quarter of the ninth century. It is reproduced in this way because of the impossibility of showing the document in its actual noble state since it is quite large, the columns consisting of fifty lines. Here we see only part of the left column of a right-hand page. No doubt by now readers will be able to recognize most of the letters, except perhaps for the now archaic form of S. This would seem rather surprising in an art that can change very rapidly. The writing was executed over 1100 years ago. It is, however, the direct ancestor of our minuscule, or lowercase, alphabet, and the reason for this lies in the fact that it was chosen as a model during the Renaissance. Clarity and grace are its chief

98. Carolingian minuscule, uncial, and inscription capitals in a monumental document. British Museum, London.

99. Detail from the Paris Psalter. Bibliothèque Nationale, Paris.

100. A Terence play, ninth century. Vatican Library, Vatican City.

characteristics—if it is possible to characterize a style in two adjectives. Between words we see just enough space to suffice. This should be studied carefully by novice calligraphers, because at the outset they always want to use more space between words than is necessary. The eye welcomes a small space between words because we do not read one word at a time but rather scan whole groups of words in a single glance. In this respect it is well to remember some general rules for composing. The page takes precedence over the column; columns are more important than paragraphs; the latter, likewise, are more important than lines, and lines, finally, are more important than words. What the scribe does with the individual letters is his own business; but he must make the line a continuous flow of signs so that it holds up as a horizontal form. Fortunately there are both esthetic and psychological reasons behind these statements. For example, if one line is full of small words and the next is composed of long ones, an imbalance will occur if the writer allows normal spacing between words in the first line. This will result in a disturbance in the even flow of black and white, and make the piece illegible and ugly. We must admire the scholars and scribes of Charlemagne's school for their grasp of these principles, for in spite of modern technology their example in this respect stands as a model.

Carolingian scholars and writers, working in harmony as their work shows, also codified the use of other writing styles in a manner that had never been done before. Large inscription-based capitals were used for titles. This can be seen in the current example and in Figure 131. Roman inscriptions were to be found throughout the Carolingian world. The earliest collection of Roman inscriptions occurred at Tours at the end of the seventh century.

Uncials of the late type, previously seen in Figure 74, were used for subtitles, as our current example shows,

and they were also used to begin paragraphs and sentences. In this manuscript (but not shown here) verses were marked by a capital form in the margin, as in manuscripts featuring early uncial. At times rustic capital was used for headings or subtitles, showing that the scholars under Charlemagne seem to have been aware of styles that had lapsed into obscurity.

The number of individual letters or characters in a line of this Carolingian excerpt averages about 38. This appears to be about ideal for the size of the letter and agrees with modern ideas about the proper number of characters per line. To emphasize this point, the manuscript in Figure 99 is offered as a contrast to the previous example. This is from the Paris Psalter, dated c. 1030, and is typical of Carolingian minuscule found in English writing in both Latin and Old English. Here the length of line is obviously too short, and reading is made difficult.

When on Christmas Day in 800 Pope Leo III crowned Charlemagne emperor of the Romans, it marked a high point in European unity. But after the emperor's death in 814 a decline set in, and Charlemagne's great "Roman Empire" disappeared in the tenth century. Carolingian minuscule, made official in a decree of 789, went on to become an international script of great importance between 800 and 1000.

Other Carolingian Specimens

The manuscript sample appearing in Figure 100 is a portion of one of Terence's plays executed early in the ninth century and is known as Codex Vaticanus 3868. A facsimile edition was published in 1929 and features some very interesting illustrations of characters in the plays. Note here that rustic capital is used to identify speakers in the play. Considered as a whole the lettering looks good, although the line is a bit long.

Left: 101. Eighth-century manuscript from Verona. Bibliothèque Nationale, Paris.

Right: 102. Visigothic writing. British Museum, London.

103. English Carolingian, early eleventh century. British Museum, London.

An expert scribe is seen at work in Figure 101, a manuscript created at Verona shortly before 800. Here the initial strokes of *n, m,* and other letters are slightly curved, while the same strokes in Figure 98 are carefully shaped in a wedge. Notice that the two forms of *d* appear, the contemporary type and the uncial.

The early writing of Spain is called Visigothic after the fast-moving Gothic tribe that captured Rome in A.D. 410. A few years later these West Goths moved into the Iberian Peninsula and held it until the Moslem invasion of 711. The sample of Visigothic writing seen in Figure 102, a Passional from the diocese of Burgos dated 919, contains the same double forms of *d* seen in the previous example. The writers of this area favored long ascenders and descenders, and serifs were rather sharply executed, as in Anglo-Saxon writing. Visigothic writing and the later manuscripts of the Iberian Peninsula are not strictly speaking in the Carolingian line. For this reason further information on them has been relegated to the Notes and Bibliography.

An interesting marriage of styles can be observed in the Latin gospels reproduced in Figure 103. This manuscript was written at New Munster, Winchester, early in the eleventh century. Well-schooled in Carolingian traditions, the writer here also shows his Anglo-Saxon background, and the rather stiff rendition together with a yearning for ligatures echoes Kells and Lindisfarne. The initial strokes of the ascenders are not quite so smoothly clubbed as in the Continental manner nor so sharply drawn as in the Anglo-Saxon manner.

Changes in Carolingian Minuscule

If a comparison is made between the classical Carolingian example observed in Figure 98 and the Latin gospels of Figure 103, one can see that the original Carolingian is comfortably relaxed, while the writing in Figure 103 appears more crowded. Roughly speaking, the life of Carolingian can be said to start c. 800 and end c. 1200. It would be better to state that Carolingian writing gradually immersed its identity in new forms of writing that took over the Continent and Britain. One of the changes was a thickening of the stroke. The precise reason for this change is obscure. It was practiced during the eleventh and twelfth centuries in various European countries. The pen was cut with a wider nib. An example of this stronger pen stroke is seen in Figure 104, written in England at the end of the tenth century. The manuscript, Harley 2904, a Psalter, resides in the British Museum. Its letters are built on the Carolingian model, and they are separated, using ligatures only tastefully. Rustic capital, somewhat altered from the original, is used here in the manner of Charlemagne's scribes. By the time the manuscript was written this Roman book hand was a thousand years old, venerable indeed! The uncial letters used in Figure 104 are embossed in gold.

Esthetically the writing is important because the ascenders and descenders have been brought into harmony with the main body of the minuscule. Early versions of Roman minuscule (half-uncial) demonstrated that the script had two origins, uncial and popular cursive, and it has always bothered estheticians of letters that the stylistic unity of the early uncial writing (Fig. 72) was not approached again during the times we have covered. Roman cursive traced its own course, created its own spatial environment and reason for being; but its intrusion into the geometric unity of early uncials has disturbed many students of writing. In Harley 2904 we see that the two styles of antiquity have been successfully blended. It is a good piece of calligraphy—one of the rare times when a penman creates a statement for posterity.

104. British writing earlier than 1100. British Museum, London.

105. Italian writing c. 1100–1150. British Museum, London.

The example of writing in England from the Harley manuscript is hardly typical of developments in the north of Europe; rather, it is similar to the style of writing that developed in Italy. The use of the heavier pen is also observed in Figure 105, a book of homilies written in Italy in the first half of the twelfth century. The writing here also has the short ascenders and descenders of Figure 104, giving the line the kind of unity seen in early uncial. It is held together in the same way — a harmonious flow of round and vertical shapes with impeccable spacing of the letters, particularly noticeable in the short word sequences. This piece of penmanship has been greatly admired, and Edward Johnston's comments in *Writing and Illuminating and Lettering* (London, 1906) are well worth hearing: ". . . it has all the qualities of good writing in a marked degree, and I consider it, taken all round, the most perfect and satisfactory penmanship which I have seen.''

The writing in the book of homilies shows the Carolingian line of influence at its best, and scripts of this kind were to influence Renaissance scholars seeking legible styles. Succeeding generations of scribes made changes in this late Carolingian hand, and it suffered seriously from compression, rigidity, and superficial sleight of hand in technique, as we shall see. However, these later writers preserved a valuable inheritance from the Latin uncial book hands: the constant interplay between vertical and round forms. Thus Italian rotunda letters, which emerge from the late Carolingian, embody graphic qualities that still interest students of calligraphy.

Wienhausen Embroidery II. The Wienhausen, Hanover.

Chapter 4 Writing in the Late Middle Ages

Successful in all ventures, Charlemagne once believed that he could assail the Moslem area of Spain, but his expedition of 778 was defeated. On the return journey rear-guard units of the Frankish legions were ambushed by Christian Basques at the pass of Roncevaux. The event remained with the survivors and was perpetuated through an art form called *chansons de geste*, or 'songs of great deeds.' Finally written down in French in the latter part of the eleventh century, the *Song of Roland* is not only a fine piece of literature in its own right, but suggests, in implication, the limited functions of writing in the Middle Ages.

Roland's demise at Roncevaux, perpetuated vocally, reminds us that many European peoples of the time, like the Greeks of Homer's day, were without the art of writing. The great majority of the peoples of Europe did not speak or understand Latin, and the adaptation of the

Roman alphabet to the native languages was painfully slow. Much of the resident literature was irretrievably lost for all time. Though celebrated, the runic writing was insignificant.

Thus we see that the great manuscript hands were devoted to biblical texts, classical texts, a few chronicles, and very little original material in scholarship or literature. The thin line of Latin-speaking and -writing monks was not enough; and to worsen matters, Viking raiders began their systematic attacks in the eighth century and for a hundred years destroyed every monastery they could find. In England and Ireland most of these old centers of learning were looted and burned. The Vikings raided the Continent too, but the damage was particularly serious in Anglo-Saxon territory in England, where the Roman alphabet was being introduced as a vehicle for the Anglo-Saxon language, not only for religious texts but for secular purposes.

The decline of cities and towns is one aspect of the Roman decline, but in the twelfth, thirteenth, and fourteenth centuries many new towns were founded. This meant that industry, trade, and commerce were beginning to flourish and with these a fresh impetus in educational movements. In the twelfth century there were only four universities in Europe: those in Paris, Oxford, Bologna, and Salerno. The word 'university' stems from *universitas*, used to describe a guild of teachers in Paris. Seventeen universities were founded in the thirteenth century and 35 new universities in the fifteenth century.

There was no sudden spurt in vernacular literature or secular usage of the alphabet. The Domesday Book, a survey of manor evaluation in England, was ordered by William I in 1086. The eleventh century also marks the appearance of Anglo-Saxon literature in some substance. *Beowulf*, the diamond in Anglo-Saxon literature, brings back the days when the heathen Germanic tribes behaved in the manner of the Vikings.

These few notes on the development of literature in the late Middle Ages must be felt rather than seen in the reproductions that follow. Significant changes in manuscript styles were expressed in documents emanating from religious centers and were followed by secular documents.

BLACK LETTER EMERGES

The eleventh century marks the erosion of the Carolingian style into heavier and more compressed styles. We have seen two excellent examples of wide-nib writing, but this tendency was also accompanied by a desire to compress the letters, to achieve more letters in a line. In northern Europe, England, France, and Germany, rounded letters were squeezed into a vertical format. The original impetus for this development was probably economic, a desire to get more letters into a line. The classic Carolingian was a relaxed hand—highly subsidized, it could afford to be. But book production became a commerical enterprise in the later Middle Ages, and competition became a factor in forcing a compressed style. Other reasons can only be suggested pending a complete study.

The compressed styles have various generic titles. The best is black letter, but they have also been called Fraktur, Gothic, Old English, and in modern typefaces, Text. The latter title derives from contemporary Latin names for the style: *textura, textus prescissus, textus quadratus*. In the present discussion concerning the northern European book hands of the later Middle Ages we will use "black letter" as a generic term, with *textus prescissus* and *textus quadratus* standing for versions of the style.

The strong seeds of the change in Carolingian seem to have taken root in the twelfth century. The first example for study (Fig. 106) is from a document written c. 1136. Here we see that there is plenty of space between words, but the pen is cut wide and turned to the left, so that initial strokes on such letters as *m* and *n* begin to be rather heavy. At times the visual impact of the script becomes sharply angular, marking a significant change from the flowing Carolingian. Spaces inside the letters are reduced, another significant change.

Some of the tendencies of change from Carolingian can be observed in the next illustration, Figure 107, a missal executed in 1170. The original is in the Newberry Library in Chicago. The American calligrapher James Hayes, in his excellent study *The Roman Letter*, refers to this sample as a St. Gall style, typical of the heavy manner of this influential scriptorium. Notice that the white

106. Document showing changes in the Carolingian minuscule c. 1136. Bibliothèque Nationale, Paris.

space inside the letters is about as wide as the stroke (less in some cases) and that the letters begin to feel more vertical as a result. Since the letters themselves are somewhat reduced in horizontal content, the space between them follows along, resulting in numerous ligatures—the penman was swinging along and did not bother to slow down his momentum. Also notice the word *humilitatis* in the last line. Here is an example of the fatal tendency to make all letters look alike. This tendency was the Achilles heel of the black-letter style, which reached a high level in terms of majestic appearance.

With a condensation of the horizontal space, the letters become somewhat square, as the *n* in Figure 107 demonstrates. To establish a more satisfactory proportion, the letters went up vertically, and in northern Europe the new style was thus on its way. With shortened ascenders and descenders, lines of lettering were placed closer together. And with the decreasing quantity of white in the line, the page became blacker with passing years.

The best discussion of this strange development in letter forms occurs in Stanley Morison's *Black Letter Text* (Cambridge, 1942), indispensable in this area of study. Morison traces the life story of the black letters and reproduces many examples. Figure 108, taken from Morison's book, is a part of the Lesnes Missal, written in England c. 1200. The style is an early example of the variety of black letter called *textus prescissus*. It is a difficult letter form if it has to be written with a pen cut straight across the nib or tip. The initial strokes of the main body of *i*, *m*, *n*, *u*, and so on show a pen slant to the left, and yet the feet of these same letters do not show a similar slanted ending. Rather they are flat-footed, and this requires some manipulation of the pen. To finish off the stroke at the foot of the letter the pen hand may assume a more vertical position on the down stroke, or the foot can be finished by filling in with the left corner of the pen. Some manuscripts show that scribes moved the pen from left to right at the foot of these letters, giving the base a kind of serif. No precise explanation fits every manuscript. Serifs on ascenders and descenders in this example begin and end flat. Neophyte calligraphers should not worry about these complications. If enough pages are written, they will begin to understand, and an affinity will develop between them and the original manuscript.

In the years after its introduction *textus prescissus* came to be written with increasing care and neatness, as its name suggests. In the thirteenth century it became the liturgical script of deluxe editions in England. Highly skilled work was performed in this script during the fourteenth and fifteenth centuries.

Another version of black letter was developed during the thirteenth through fifteenth centuries. It was called

107. Lateral condensation in Carolingian letters as shown in a missal dating 1170. Newberry Library, Chicago.

108. The Lesnes Missal. Flat endings result in a style termed *textus prescissus*. Victoria and Albert Museum, London.

109. The Mons Lectionary. The black-letter style with bent feet is called *textus quadratus*. British Museum, London.

110. The Metz Pontifical, a French manuscript of the *textus quadratus* style. By permission of the Syndics of the Fitzwilliam Museum, Cambridge.

textus quadratus and looked like Figure 109, an early (1269) Flemish version of the Mons Lectionary. In *textus prescissus* only *c*, *e*, *l*, *s*, and *t* had curved feet—a remnant from Carolingian and even older scripts; but in *textus quadratus* nearly all the endings are broken at the foot, sometimes sharply and sometimes in a curve. As can be seen, many ligatures result. Another version of this hand is the Metz Pontifical, Figure 110, a French work executed early in the fourteenth century. Such scripts were written with a pen cut at a slant at its nib, which makes it easier to manipulate the left corner for fine lines. Here one begins to see the essence of solemn dignity for which textus quadratus is famous. The constant repetition of heavy vertical strokes lends power to the line and blackness to the mass of the column.

A typical black-letter page of these Gothic years would show a page in which the lettering was cramped and crowded into a format dominated by huge ornamented capitals that descended from uncial forms or by illustrations (illuminations) or by leafy vines of decorative vegetation crawling up, down, and around the writing. There is no question that this form of vine decoration was influential in the calligraphy of William Morris, who initiated an interest in older forms of writing in the latter part of the nineteenth century (Fig. 271).

In the example in Figure 111, the first page of a coronation service for an English king, written c. 1308. The calligraphy clearly dominates. The flat-footed version of black letter prevails in this document of French detail that shows the work of a master calligrapher.

The first typeface printed in Europe was based on black letter (see Fig. 215). Writing masters of the fifteenth and sixteenth centuries had to provide a version of it in their copybooks since the writing was still extant, but its use declined and disappeared from copybooks in the eighteenth century. Versions of black letter in typeface

are seen today in Germany—perhaps the only country in the world where it is still used as a reading face.

Some scholars, like Morison, believe that black-letter scripts resolved the conflicts in Carolingian and its several ancestors, and at its best was a most logical kind of writing, with harmony among the various letters. That black-letter script achieved this is obvious from the examples seen. It was perhaps best before mechanization of its various parts took its toll. This process resulted in all letters beginning to look alike, a fatal occurrence for a book hand or a book face. Certainly one can say that for the deep tones of Old Testament prose it was magnificent. Today, black letter has a limited function in the world of letters. It is occasionally seen at the top of page 1 implementing the name of newspaper. The ancient letters are also seen in hymnbooks, wedding announcements, and on the labels of beer and liquor bottles. In this latter connotation age or Germanic origin is the intent.

A large volume could be written about the subject of black letter. But since it would be unfeasible to do so here, we will leave the subject after seeing what two great designers did with these forms. The first design, seen in Figure 112, is the minuscule and capital alphabet devised

111. English coronation document written by a French scribe c. 1308. British Museum, London.

112. Black-letter alphabets designed by Albrecht Dürer.
From Dürer's *On the Just Shaping of Letters*, 1525.

by Albrecht Dürer and printed at the end of his *On the Just Shaping of Letters* published in 1525. The minuscule contains the double-stroked diamond serifs at the shoulders and feet of the letters. It is probable that the *z* at the end is a proper decoration for the end of the set and not meant to fit the other letters. Versions of *z* with a descender fit the character of the alphabet better.

There were several kinds of large letters appearing with black-letter minuscule. Some of these, decorated uncial forms, were only remotely connected with black-letter minuscule in terms of likeness of form. But there were constant attempts to devise large letters that were stylistically akin to the small heavy letters. Dürer's version is rather unique, and in the opinion of this writer, good —although an exception is filed on the Z. It should be observed (and this comment holds equally for other black-letter capitals) that these large letters fulfilled a decorative function and were not used together. Even in titles of short length one can scarcely stand so much flamboyance, and this certainly places a limitation on modern usages of black letter, even for calligraphers and typographers of courage. Also, it is difficult to find large letters of alien vintage that can go with the solid minuscule.

The second design, presented in Figure 113, is the work of Frederic W. Goudy. Goudy was the Frank Lloyd Wright of American calligraphy, and like Wright he enjoyed a full career and an international reputation. Seen in Figure 113

is Goudy's drawing for the black-letter minuscule in type—or in the language of type, the lowercase. This and more of Goudy's designs and commentary are available in *The Alphabet* (University of California Press, 1942). The same material has been issued by Dover, New York, in a photocopy edition of 1963, available in paperback. Goudy's version is close to *textus prescissus* but preserves some of the double-stroked feet—out of context, historically. Notice that this master sticks to the difficult kind of *x* (contrary to Dürer) but holds it in tight so it will compose well with the other letters. As to the numbers, Roman numerals would fit the style better. The so-called Arabic numerals fit into other letter styles more sympathetically. This can be seen in Goudy's numbers, where there is more air, or white space, surrounding the digit signs that in the minuscule.

113. Black letter by Goudy. Frederic W. Goudy, *The Alphabet*.

abcdefghijkln mopqrstuvxy wz1234567890

Is black letter a dead letter? Is it too limited for our time and place? Perhaps we have suggested an embalmment before the demise. Consider the example of Figure 114, a heading for an ad appearing in a New York newspaper for a firm manufacturing sweaters.

The albatross of tradition hangs heavily about the neck of both typographer and art director. Some nerve and imagination were required to use the lettering seen here, as the subject is neither liquor, religion, or a German subject, but sweaters for women. It is perhaps no coincidence that the version seen here stems from French models of the black-letter hand.

114. Black letter in contemporary usage. Helen Harper Sweaters.

"It ain't whatcha got but whatcha do with it."

[Beneventan script manuscript image]

115. Beneventan script. Archivo della Badia, Monte Cassino.

Beneventan Style

Another condensed style in book hands emerged from the area near Naples, Italy. Fierce Lombards, a Germanic people, had poured into Italy in A.D. 568 and established a powerful kingdom, which endured until 774. Charlemagne conquered the Lombards and assumed the title of king of the Lombards, but the areas under northern domination ended somewhere between Rome and Naples. Below this line cultural developments continued apart. In this area lay the monastery of Monte Cassino (wickedly destroyed in World War II), La Cava near Salerno, and other centers of learning and writing. Monte Cassino had been established by St. Benedict c. 520, and it was here that he composed the rule that was to dominate religious life in the West. Monte Cassino was refounded in 718 and 949, and thereafter enjoyed two centuries of power and influence. During the eighth and ninth centuries Monte Cassino was the center of southern Italian culture and produced the writing discussed in E. A. Lowe's *The Benevantan Script* (Oxford, 1914) and *Scriptura Beneventana* (Oxford, 1929).

The example seen in Figure 115 is from an eleventh-century document from Monte Cassino. Since it is a palimpsest (reused) manuscript, the previous uncial writing has been painted out for this reproduction but none of the Benevantan writing has been disturbed. Here the pen slant is noticeably swung counter clockwise, and the downstrokes of the minuscule, so architectural in black letter, are thin. The entire script seems to be supported by the heavy intital strokes and endings. It recalls rustic capital in its pen slant, and shows some resemblance to the Celtic Anglo-Saxon line in its angular treatment of the initial strokes of letters such as *p* and of the tapered descenders. The *a* and *e* are also from the British Isles, but the club-shaped ascenders derive from middle Europe. Exhibiting itself above all is the Italian predilection for curved letters. The typical Beneventan script is perhaps faulty in that it is condensed both ways—vertically and laterally.

A column of Beneventan writing is seen in Figure 116, a twelfth-century manuscript reproduced from the original in the British Museum. There are changes of color in the page, and letters that begin sentences are filled in with color, as in the Book of Kells hand. It should not be forgotten that there were many Irish scribes in Italy at an early date. After its peak in the eleventh century the Beneventan style went downhill and disappeared in the thirteenth century. Rotunda became the dominant book hand of Italy, displacing this unique and rather isolated contribution.

116. Beneventan style in the twelfth century. British Museum, London.

Rotunda

The tendency toward condensation of letters in northern Europe was also a force in Italy in the late Middle Ages, but it never quite reached the point where a line of lettering looked like a picket fence. Rotunda was a distinctive style during the thirteenth, fourteenth, and fifteenth centuries, and was converted into a typeface. It was based on the thickened pen letter of Carolingian origin already studied in Figure 105. Since the Italian tradition in letters is especially important to our own, a part of the homilies page is again reproduced in Figure 117 without the background. As an aid to the complete understanding of this pen style, a transliteration follows:

> cruce · Tamquam novellus vitulus · p[ro]
> peccatis p[o]p[u]li voluntariae mactatus in
> passione · Et sicut aquila vehemens · re-
> cepto corpore de tumulo surgens · stri-
> cto secans aerem · omnium lapsu calca-
> vit · et super cherubin ascendit · et vola-
> vit · qui ambulat super pennas vento-
> rum · Ascendit in celum · cui est honor
> et gloria in secula seculorum · amen ·

This piece of literature ends with *seculorum* and *amen*. It is followed by three lines of writing devoted to the *explicit*, a late Latin word used to indicate the end of a literary work and containing some of the information that in a longer work might be found in the *colophon* at the back of the book. Then we see one line devoted to the *incipit*, a term used to describe the beginning of a new work. From the word *amen* on, these lines are written in a late version of uncial letters.

Concerning the structure of the homilies letters, we can see here the two forms of *s*, the dual function of *u*, and a sign attached to *e* translated *ae*. Otherwise we should have little trouble in sign recognition.

The cut of the pen used in this piece appears to be a trifle wider than its Carolingian predecessor, but it preserves the relaxed feeling inherent in the best of the Carolingian hands while condensing a line in moderation. Spaces inside the letters are generous, as in early uncial manuscripts, with the exception of the vowels *a* and *e*. In early printing these curved forms, seen in clarity in this calligraphic model, tended to become filled in and had to be enlarged later. In terms of spacing it is remarkable that fine printing of the present age so closely resembles the spacing seen in Figure 117. Words can be discerned as separate entities, but space between words is held to a minimum so that the line preserves a continuity. Ascenders and descenders are short and fit the contours of *m* and *n* to perfection. In the absence of long ascenders and

117. Early twelfth-century Italian homilies. Superb writing, with sufficient space inside and outside the letters to facilitate reading. British Museum, London.

descenders, ensuring a generous space between lines, the scribe has added an extra space, or *leading*, between the lines. In the language used by typographers the specimen seen here could be described as existing on 16-point body with 6-point leading, making 22 points for each line. For purposes of comparison, some early printers in Italy might employ something close to a 16-point body with 1 or 2 points leading, making about 17 or 18 points for each line. Many contemporary textbooks and novels are in 10-point sizes with 2-point leading between lines.

In our current specimen the length of the line is another pertinent consideration. An Anglo-Saxon specimen of Carolingian minuscule reproduced earlier (Fig. 99) demonstrated that the character of the writing and line brevity worked against a pleasing conclusion for readers. In the script employed for the homilies a longer line, by one or two words, could have been maintained without any difficulty.

Many of the principles governing clarity and legibility in usage of the Roman alphabet can be discerned in the script of Figure 117. And it is fortunate for us that Renaissance scholars discovered manuscripts of this type and became interested in them.

Rotunda stems from the fine writing we have just seen. In development it involves the stiffening of some of the curved letters of the late Carolingian hand, with *m* and *n*, for example, being made more vertical and with less white space inside the letter. More black is inserted into a given area. Some curved or bent feet are retained from the older forms. These are seen on the terminal parts of *l*, *t*, and *u*. Letters *b*, *c*, *e*, *d*, *g*, *h*, *o*, *p*, *q*, *r*, *s*, and *z* retain curved parts, and this saved the rotunda from the excess of the northern European hands, that is, from interchangeable parts. Although rotunda suffered from certain faults at times, its practioners managed to retain that interesting play between vertical and rounded elements.

Our first example of rotunda, Figure 118, is of a work of the Latin writer Horace. The manuscript was written in 1391. Although the hand is strong, its beauty is apparent, for the Italian scribes of the thirteenth, fourteenth, and fifteenth centuries executed their work with skill and a feeling for elegance. To point out a few details: the *r* is seen in two forms, one without the arm; there are two froms of *d*, one the ancient uncial; square initial and terminal strokes (unnatural to the pen slant) are filled in; and the serif on *p* is double-stroked. Seen here is the admiration of the Italian writers for an extreme difference in thick and thin strokes. These writers cut their pens very sharp and were equally fastidious in their execution of the letters. The resulting fine lines are called *hairlines* and are particularly noticeable in the *a* and *e*. Minuscule

118. A Horace manuscript executed in 1391. British Museum, London.

a was a particular victim of this practice and was left weak in an environment of sturdy letters. In this example, joined letters are frequent and interesting—*ta, ho, pe, de, od, gn,* and so on. No doubt the calligrapher will want to spend some time on this alphabet, and it is suggested that he follow the practice of the scribes and connect the letters when the spirit moves him to do so. If the examples shown here do not contain all of the letters of the alphabet, so much the better. The student can then invent the needed ones. To do this requires a degree of analysis, thought, and trial not usually produced when all of the characters are given. Modern texts also use marks of punctuation that may not be seen in historical scripts, and these too require an act of discrimination on the part of the student.

One reason the Horace manuscript is included here resides in the excellent set of initial letters that start each line. In many documents of the Middle Ages such letters were carefully drawn and filled in, resulting in a disparity in style. Here the scribe develops a set of initial letters that are technically and esthetically suited to the small letters, and his success deserves a note of admiration. They are neither rigid nor fussy and possess a kind of calligraphic veracity that professionals seek in contemporary work.

If the northern European black letter was tailor-made to the solemnity of the Old Testament, rotunda was a more versatile hand. It was used for secular purposes, for documents of the Church, and it was used in all sizes. In Figure 119 the script is seen in small size and retains

119. The rotunda style in small scale. Biblioteca Nazionale, Florence.

120. The texture of the rotunda style. Bibliothèque Nationale, Paris.

121. The rotunda style in detail. Author's collection.

its character of elegance; but it is also strong in clarity. When seen in whole pages, the possible excess here in length of line disappears. The initial letter in the first line is filled in, a different tradition and one that will be discussed in the section on large letters.

In the Horace manuscript the writer used fairly short ascenders and descenders, and the handling of these seems ideal for the letter structure. Note that space between lines is reduced from that seen in the homilies. By now the reader should be able to recognize certain ground rules of calligraphy. With shortened appendages the minuscule can be tightened vertically, and in the next example, Figure 120, the white space between lines is reduced to a minimum. In this thirteenth- or fourteenth-century manuscript in the Bibliothèque Nationale the scribe has also reduced the space between words. Otherwise the rotunda script is quite intact.

Frankly it is difficult to assess what has been lost in legibility. No doubt the manuscript suffers in this respect, but the uniformity of the script, along with the massing together of the lines, creates its own special visual quality, a kind of powerful texture of straight lines and curves. That fraction of the manuscript seen here is part of one column of a much larger page with generous margins. With this "massed" script, the document presents a picture of awesome dignity.

On the whole, rotunda changed very little in several centuries of existence. Perhaps the differences are revealed more by changes in size than by any remolding of the letters. The example in Figure 121, from a manuscript purchased in the streets of Florence in 1963, is of a size frequently encountered in large missals. It is extracted from a page measuring 16 by 22 inches. The pen used, of course, was cut very wide at the nib and exceedingly sharp. While rotunda is still a handsome letter form at this size, the hairlines, as fine as in specimens ¼ inch high, seem too weak for the main strokes. This illustrates the fact that an alphabet is not always effective at all sizes. Typefaces are not simply reduced for use at smaller sizes but redesigned to put more white space inside the letters. In rotunda the relationship between stroke and hairline is acceptable in smaller letters but appears to be a superficial affectation in the larger version.

In Italy, rotunda provided a link between the late Carolingian hands and the new writing of the Renaissance. Humanistic scholars did not like it, but scribes in religious service kept the hand alive in the fifteenth century. It was employed in many type fonts designed in the fifteenth century and then declined in usage. In its late stages it was damaged by rigidity of form and by execution of such perfection that the pages seem untouched by the human hand. In the Horace manuscript the writer inscribes the choices open to him in a spontaneous manner. Contemporary calligraphers feel that rotunda is well worth a closer study when approached in this manner.

Bastarda Scripts

As we have seen, the late Middle Ages produced some heavy and condensed forms of writing. There were always free cursive hands, and when the formal book hands were crossed with cursive, some interesting kinds of writing resulted. Esthetically each style left good marks, but neither could be given an *A* for legibility, and this goes for their offspring as well. In most of Europe black letter and cursive became mingled through contact and gave life to whole families of styles, called *bastarda*.

First let us examine a specimen of French verse and prose written c. 1445. French and Flemish penmen were particularly inclined toward the bastarda style of writing, and while it added unique qualities to the historical record, it also set a new record in illegibility. Of course the specimen seen in Figure 122 was deliberately chosen to demonstrate the maximum amount of crowding found in this style. Thompson's comment that "it is not a pleasing example of writing . . . [and] degenerates into coarseness" does not quite cover the subject, but his addition that such writing furnished the basis of early typefaces in France and England is worth a notebook entry.

The next example, Figure 123, more moderate in spacing, was written in France about 1481 and is perhaps less objectionable. That the writing was executed by a skilled calligrapher is undeniable. The piece has graphic power. Readers will see the flexible pen at work here in the fattened and tapering strokes. It should be noted that

122. Page from a book of romances, given to Margaret of Anjou on her marriage to Henry VI. The penman is French. British Museum, London.

123. A French hand c. 1481. Thickness in stroke is varied by use of a flexible quill pen. British Museum, London.

124. Typical Chaucer. Samuel A. Tannenbaum, *Handwriting of the Renaissance.*

the date is a bit late for writing of the Middle Ages, but these are the remnant scripts that prevailed before developments of the Italian Renaissance entered the picture.

A related kind of writing was developed in England about the same time, the fourteenth century. Some early examples of it can be seen in *Piers Plowman* and the Wycliffite Bible, both dated around 1380. Figure 124 is a page from Chaucer's *Legend of Good Women*, dating about 1450. The letters are small and crabbed. This piece has style too, but it should be apparent why this and related scripts, the basis for some early type fonts in England, had to go. We will see another Chaucer manuscript later on.

Cursive Hands

The monastery scribe was the star calligrapher of the Middle Ages. Pronouncements issued by kings and popes did not always employ the book hands devised in religious centers, but the Anglo-Saxon minuscule used for secular writing was identical to that used for biblical texts, and much the same can be said for Carolingian writings. In the later centuries of the Middle Ages secular demands on the art of writing increased as commerce revived, and legal institutions became more firmly established and began to keep records. Personal handwriting seems to flavor this area of demand, and the variations are too numerous to be categorized. There were no centers devoted to teaching a proper hand for scribes in legal service. Sources for the cursive hands are not numerous, but one of the best is Vincenzo Federici's *La scrittura delle cancellerie italiane* (Rome, 1934).

Figure 125 reproduces a part of *Charte de Ferry duc Lorraine*, dated 1263. It is dangerous to generalize about the legal documents of the period, but readers can expect to see small and cramped minuscule letters with flourishes on ascenders and descenders. But there are times when unexpectedly a scribe can record an event with genuine authority, as seen in Figure 126, *Registro dei signori di notte al criminale de venezia*, dated March 20, 1290. This authoritative script does not depend on contemporary book hands and echoes the bold Roman cursive of Ravenna.

Another example of cursive writing is seen in Figure 127, from *Notes brèves de notaire*, written 246 years later than the previous example. This brings us into a time of celebrated developments in Renaissance writing in Italy but the scribe of Figure 127 is seemingly unaware and pursues his own course in a manner suited to his own tastes. It appears that he had no time to waste.

125. A French charter cursive dated 1536. Bibliothèque Nationale, Paris.

126. A document from Venice dated 1290. Archivo di Stato, Venice.

127. *Charte de Ferry duc Lorraine*. Bibliothèque Nationale, Paris.

ABCDEFGHIJKLMNOPQRSTUVWXYZ

abcdefghijklmnopqrstuvwxyz

abcdefghijklmnopqrstuvwxyz

THE ROLE OF LARGE LETTERS

We are quite familiar with the three standard forms taken by the Roman alphabet today: capitals, minuscule or lowercase, and italic. These are reproduced above once again to reinforce this familiarity.

Italic at present represents the middle ground between the minuscule and cursive alphabets. By now it should be clear that the minuscule emerged out of Roman capitals and Roman cursive in a lengthy development covering 1500 years. Our Roman capitals stem directly from Roman inscription letters of A.D. 1. The value in preserving the graphic forms of an alphabet so old is that any set of alphabetic signs that have weathered the ages has merit by that measure. On the other hand it is possible to state that for simple purposes of communication, one set of signs is enough. We have all seen poetry printed exclusively in minuscule letters and not been unduly disturbed. It is more perplexing to consider whether we would as willingly accept the Magna Carta or the Gettysburg Address in minuscule letters? After reading this section, readers may wish to examine the roles played by our three alphabets a little more closely.

Our thinking on these subjects will be more to the point after a review of the emergence of large letters during the Middle Ages. We will be able to examine some of the ideas that failed to endure, and gain some perspective for criticism of our present methods.

Examples of Roman inscription letters reproduced earlier show that the first letter of the text was no larger than the other letters of the line. The end of an expression was often marked by use of an incised point before the text went on to new material, but the first letter of this new material was the same size and style as all the other letters in that particular line. A review of our specimens of Latin book hands, however, reveals a slightly altered condition. In the reproduction exhibiting the square-capital style, the first letter of the text is greatly enlarged, even decorated, while no other letter is so honored. From the emphatic manner of the presentation it is certain that the idea was not invented for the Virgil text. The idea is suggested in Egyptian pen manuscripts and presumed in pre-Christian Latin manuscripts, but there do not seem to be any that point to an origin or a tradition, however fragmentary.

In a page of a text implemented by rustic capitals, the first letter might be slightly enlarged. In manuscripts written in the uncial style, letters marking the beginning of new material, biblical verses for example, were slightly enlarged. These were placed in one of two positions, inside the line representing the left margin of the column or just outside it. Greek uncial manuscripts also featured an initial letter outside the column. A variation of this idea can be seen in the Horace manuscript recently discussed, wherein all the initial letters are outside the column of minuscule letters and are separated by white space, a mannerism perpetuated in Italy after the introduction of printing. The initial letter outside the column is an attractive idea.

In areas dominated by Roman traditions the enlarged letters marking major changes in text content were derived from uncial letters, with some admixture of Roman inscription forms. The development was modest and did not offer any spectacular diversions to the reading of the text.

Celtic scribes and artists, in an indigenous development, created a new role for letter forms: pictorial art. The full extent of the peculiar genius of the Celts can be seen in the amazing Book of Kells. Letters were given a large variety of forms and decorated brilliantly in a fantastic display of color and intertwining forms. Some forms seen in the Book of Kells do not derive from any known tradition and are thus pure invention, though many symbols and designs are pagan and come through a Celtic tradition existing before the Christian era. The independent Celtic church had its element of paganism, and there were none who cared to restrict the imagination of the men who created the Book of Kells.

Anglo-Saxon scribes and artists followed their neighboring craftsmen with great enthusiasm and produced many excellent manuscripts in which letters were bones of legibility hidden in a visual feast of color. The manuscript known as the Lindisfarne Gospels represents the high point in Anglo-Saxon manuscripts, and while Celtic

influence dominates without question, some restraint is exercised. Writing in *Decorative Alphabets and Initials* (New York, 1959), Alexander Nesbitt puts it this way: "There is visual evidence, though, of a greater feeling for the page—the designs do not tend to explode in all directions. Apparently the scribe, Bishop Eadfrith, began to consider the architecture of the page." For this reason there is a deep respect for this great manuscript. In Figure 128 we see some of the letters that appear in the Lindisfarne manuscript. These are taken from Thomas Astle's book, *The Origin and Progress of Writing* (London,

1803), perhaps the first modern book to reproduce ancient book hands in great detail. Anglo-Saxon scribes carried the message of exuberant ornament to areas in Germany, and the continental scribes responded.

On the Continent, in areas of Roman and Latin influence, title letters and letters beginning verses were cast from more conservative molds. In the Middle Ages there were no title pages as we know them, and often pertinent information about the manuscript was contained in the colophon at the end of the book. It is dangerous even to hint that there was a set form for such letters, because

128. Thomas Astle's reinterpretation of forms of letters and of decoration found in the Lindisfarne Gospels.

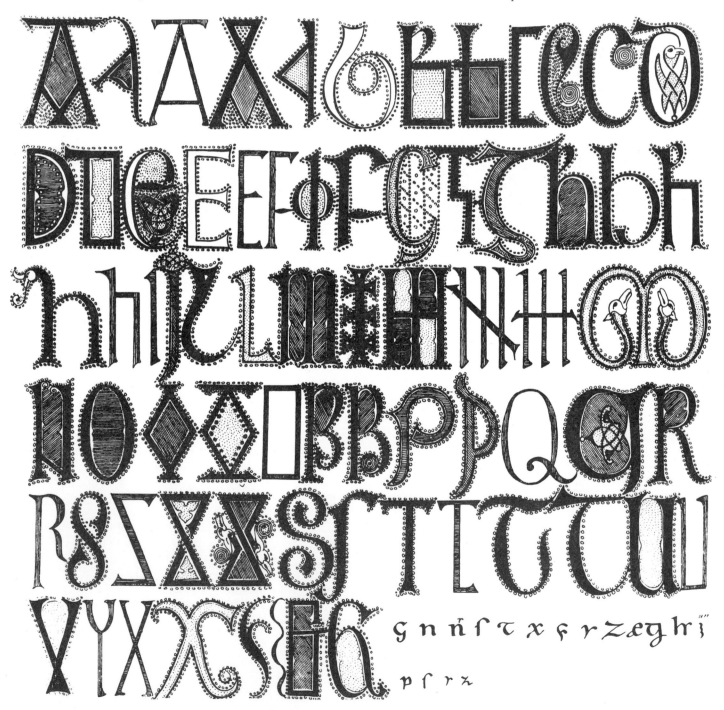

the scribes and illuminators of the Middle Ages changed details to suit the manuscript on personal whim. In Figure 129 we observe a group of letters used in uncial manuscripts. These are not much more than enlarged uncials written with the same pen.

129. Enlarged letters from various Latin manuscripts. Many are slightly enlarged versions of the text style.

When even larger letters were needed, a different method of execution was evolved. In these letters the writer used a pen with a narrow point and drew the outlines of the letters and the serifs and then filled in the spaces between the outlines. These spaces could be filled in with the same ink used in the main body of the manuscript; they also could be filled in with a brush carrying colored pigment or with gold leaf. This change in principle was simple, but the effect was profound and permanent. The seemingly simple change from a calligraphic letter to a drawn letter was one of the developments that led to the separation of minuscule and majuscule letters in our alphabetic signs and to the preservation of Roman inscription letters in the Middle Ages.

The key graphical presentations in the case are contained in Figure 130. Figure 130a shows the sophisticated Roman carved versions of *A*, *B*, and *T*. The compound brush strokes necessary to form the letters are suggested in Figure 130b. Father Edward M. Catich presents a most elegant set of these brush strokes, but one suspects that the Roman sign writers were not as skilled as Catich. Now, if, as can be observed in Figure 130c, a stiff reed pen is cut to the proper width at the nib to execute letters on the same scale, details will vary in obvious respects. However, if the calligrapher uses a pointed pen and fills

in the letter (Fig. 130d), he can again follow inscriptional models quite closely or invent new versions of them. Contemporary versions of the Roman alphabet—Old Style Roman (Fig. 130e) and Modern Roman (Fig. 130f)—cannot be executed with a calligrapher's pen except in crude terms. It is perhaps time that calligraphers made it quite clear that there is an essential difference in the origin of minuscule and capital alphabets, and explained that their execution really requires a different set of tools.

With uncial, inscription capitals were a major inspiration for large letters in the Middle Ages, and the Carolingian scholars and writers were most careful to maintain the integrity of the carved forms in transferring them to constructed manuscript signs. This debt to inscription capitals can be observed in a late eighth-century manuscript written at the command of Charlemagne (Fig. 131).

a ABT

b ABT

c ABT

d ABT

e ABT

130. Graphical presentations of the change from a calligraphic letter to a drawn letter.

f ABT

131. Drawn and filled letters from a Carolingian manuscript, late eighth century. Bibliothèque Royale, Brussels.

It is a stroke of luck that the short title contains 16 different letters. Visually the most striking element is the homage paid to inscription letters; but in the details the pointed pen begins to enforce its own rules. Notice that vertical strokes taper and that endings show a pen grammar. Other peculiarities, such as the odd cross-stroke in *A*, the square *C*, and the small inserted letters, speak of Byzantine influence. These and other habits of letter construction, unfamiliar in contemporary practice, will be seen in reproductions that follow, but it should be emphasized that Charlemagne's writers anticipated the adaptation of Roman inscription letters for our contemporary capital alphabet and may have influenced the decision through presentation.

Pen letters and inscription letters maintained parallel courses during the Middle Ages, and in inscription letters there is no counterpart to most of the minuscule book hands developed during the period. (For the record, it should be noted that uncial was committed to stone.) But there was a considerable exchange of forms between the two methods, as one might expect.

Figure 132 shows an inscription on stone from S. Sebastian, Via Appia, Rome, that dates between 366 and 384. While this inscription preserves the main features of classical Roman inscription forms, certain interesting changes are evident. The bifurcated serifs seem to imply the influence of a pointed pen, the mark of which was observed in the previous example. There are also some interesting joined letters, such as *TE, AV, HR, NT, VA,* and *NE*. Letter *T* is sometimes tall, with adjoining letters

tucked under the crossing stroke, a good idea that can be seen in many Roman inscriptions. Perhaps a number of contemporary typographers who have had to contend with Caslon's wide *T* would like to see this idea revived. Small inserted letters are particularly effective in the inscription under study, with the *CO* especially worthy of notice. At the present time there is renewed interest in this kind of usage.

The right-handed brush stroke, imbedded in classical inscriptions such as that on the Trajan column, is lost in the present example, and the emphasis of strokes is more vertical, as in the Bodoni font. Strength in the bowls of *P* and *R* is missing, which adds weight to the idea that this example is a curious mixture of ideas. In certain respects it resembles the square capital of Figure 68.

Some inscription alphabets from the eighth, ninth, and tenth centuries are seen in Figure 133. These are the work of Nicolette Gray of London. Her most definitive research on this subject is "The Paleography of Latin Inscriptions in Italy", in *Papers of the British School in Rome* (1948), and a more recent article, "Sans Serif: A Study of Experimental Inscriptions of the Early Renaissance," *Motif* 5 (1960), is recommended reading. As can be seen, many of the letters are subject to variation in form. The crossing of the *A* is observed in several variations; *C* is sometimes executed in square form; *D, E, H, M,* and *N* take on the curved uncial form; *G* often takes the curled ending; and *Q* is often distinguished by an internal mark.

A heavier inscriptional capital was also developed in the Middle Ages, and an example of this tendency can be

EVTYCHIVSMARTYRCRVDELIAIVSSATYRANNI
CARNIFICVMQ·VIASPARITERTVNCMILLENOCENDI
VINCEREQVODPOTVITMONSTRAVITGLORIACHRISTI
CARCERISINLVVIEMSEQVITVRNOVAPOENAPERARTVS
TESTARVMFRAGMENTAPARANNESOMNVSADIRET
BISSENITRANSIEREDIESALIMENTANEGANTVR
MITTITVRINBARATHRVMSANCVSLAVTOMNIASANGIS
VVLNERAQVEINTVLERATMORTISMETVENDAPOESTAS
NOCTESOPORIFERATVRBANTINSOMNIAMENTEM
OSTENDITLAEBRAINSONTISQVEMEMBRATENERET
QVAERITVRINVENTVSCOLITVRFOVETOMNIAPRESTAT
EXPRESSITDAMASVSMERITVMVENERARESEPVLCRVM

132. Roman carving of the fourth century. Church of S. Sebastian, Via Appia, Rome.

133. Carved letters from the eighth, ninth, and tenth centuries.
Nicolette Gray, "The Paleography of Latin Inscriptions in Italy."
Papers in the British School in Rome, XVI, 1948.

134. Heavier letter forms, Rome, eighth century.
Angelo Silvagni, *Monumenta Epigraphica Christiana*.

135. Mosaic letters. St. Mark's, Venice.

studied in Figure 134, dating from the eighth century. The writing in this figure tends toward a single-strength stroke with a diminution of thick-and-thin characteristics. Reminiscent of our Gothic and sans serif alphabets, the artists here are creating a Roman alphabet with a distinctive visual thrust. It has power and texture. Such examples were by no means isolated, and they contributed to a history of letter forms that has been neglected.

Another influence on inscription letters of the Middle Ages is found in Byzantine mosaics. The example of Figure 135 can be seen in St. Mark's in Venice and dates from the eleventh century. Byzantine letters, meeting ground of pen letters and inscription letters (Greek and Roman), but with some accommodations due to the difficult technique, are a source of inspiration because they defy the rules of lettering: the strong vertical strokes make the curved endings on *R*'s seem absurdly small; letters are cramped; both capital and uncial forms of *E* and *M* are included; the uncial *H* seems out of place; and some peculiar ligatures are used. In spite of these oddities the lines speak the language of art. It is this kind of inventive approach to letter forms that seems to have inspired the eminent Ben Shahn, and we include one of his pages from *A Partridge in a Pear Tree* (New York, 1951). Shahn is sensitive to letter forms and likes to include them in his work. His book *Love and Joy about Letters* is excellent.

In the later Middle Ages the inscription capitals of Italy took on even more of the curved uncial character and were blended into a highly sophisticated style. Next we see a rubbing (Fig. 137) taken from a strip that runs around the base of the Duomo in Florence by Brunelleschi (1377–1446). Certain ornamental features, such as the flag or banner on uncial *D*, should be noted. It is obvious that the craftsman was deeply involved in an esthetic state-

ment so different from that of the Trajan inscription that it hardly seems possible both could stem from the same national area.

The decorated style of inscription letter seen in Figure 137 held on well into the fifteenth century, but at this late date it was an "out" mode, classical Roman models being "in." Figure 138 shows an inscription on the tomb of Cardinal Pietro Stefaneschi (1417). Maestro Paolo, a Roman *marmorarius*, or marble-cutter, executed the tomb. Some extremes make this sample of the decorated style less satisfactory than the Duomo piece. (An aside may be appropriate here. For many years photographic prints of sculptural and architectural monuments—and more incidentally, inscriptions—were furnished by either Anderson or Alinari, European firms. Now these negatives are held by Fratelli Alinari, in Florence. Fine photographic prints may be obtained at a very modest price by citing a description from a reference.)

This late inscription style, with its manuscript forms and curious endings, is fascinating, and we are only able to hint at its wide usage. Unfortunately this line of letter development came to a halt with the inception of Renaissance ideas on alphabetic reform. This took the shape of a classical revival, and inscriptions such as that seen on the Column of Trajan were restudied, to become the basis for inscription letters, that is, large letters or capitals used in manuscripts and type fonts. Concerning inscription letters in the classical revival, these noble letters were again executed with masterly understanding and superb skills, but unfortunately they cut the growth of the indigenous styles. Nicolette Gray, writing in *Motif 4*, states: "The Renaissance letter is very beautiful and very sensitive, but one cannot but regret that its evolution brought an end to a fascinating period of experiment."

ON THE SECOND DAY OF CHRIST-
MAS MY TRUE LOVE GAVE TO ME
TWO TURTLE DOVES AND A PARTRIDGE
IN
A
PEAR
TREE

136. Drawing and letters by Ben Shahn.
Selected by Ben Shahn, from *A Partridge in a Pear Tree*, copyright 1951 the Museum of Modern Art, New York.

✠ S· IACHOPO · DIGANNI · GVI
CHAPERO·OLO· AFRANCESCHO · DIBORGIN

137. Author's rubbing from the Duomo, Florence.

CAROIIIGVM TRIBVIII VIRTVS ETATIIG VIRGIITII
ASPICG AVM IAIORIIIIS LGATOR QVO MARMORG ALAVSVM
IMPIA MORS RAPVIT AORMAM IIATVRA IIITGIITGM
AIIGGIICAM D GD GRAIII SAPIGIIS GT DOOTVS IIIOIIII
PRGAVIT ALOQVIO IIIIVLVM AVI SAIIATG DGDISTI
AIIGGLG PGTRVS GRAT IIOMGII SIIIATIIIGA PRIMA
DG SIIGPHAIIGSAIS IIATGRIIO AARDIIIG IIATVS
AVVSIII AB HAIIIBALG MAM LOIIGI TRAMIIIIS GVO
OSSA IIGRII IIGLLVS AIIIMG SIIIGIII GLORIA AGIO

138. Inscription on Tomb of Cardinal Stefaneschi. Sta. Maria in Trastevere, Rome.

Meanwhile, back in the scriptorium, large letters were produced in the filled-in manner of Figure 131. Generally speaking they were based on inscription capitals but were shaped with a certain freedom. These large letters are sometimes called versals (for letters beginning a verse), but they were more than that since they were also used alone or with illustrations ahead of the minuscule text. The collection of large letters in Figure 139 is dated c. 1100; the rest of the text was in a late Carolingian minuscule. The more notable features of these capitals are a curve or taper on every major stroke, a free interpretation of serifs, and a vertical orientation on the endings of horizontal strokes in *E* and *S*. Some pages on versal letters can be seen in Johnston's book, and a study by Father Catich is reproduced in Figure 298.

The importance of these letters should be emphasized. Student calligraphers generally fear the capital alphabet, and with reason, since typefaces seem to stress rigidity, uniformity, and interchangeable parts, suggesting a formidable barrier in tools and execution. But the calligraphers of the Middle Ages developed letters in free interpretation. Sometimes, as seen in Figure 139, the scribe cared very little about maintaining a uniform size. Why, then, should we put on this straitjacket? Perhaps the neophyte should simply cut a reed pen, narrow at the nib, and draw some letters. Scribes of the Middle Ages

139. Extracted and rearranged title letters c. 1100.

paid their respects to inscription capitals by breathing new life into tradition.

Contemporary designers of type fonts are willing students of earlier traditions, but they often find that period pieces or revivals may be unusable because of their quaintness. Many typefaces have been designed on pre-Renaissance models, and type houses that have commissioned such efforts deserve admiration, since few revival fonts succeed commercially, due to limited usage. One design that preserves some of the qualities we have been studying is Weiss Initials Series III by the Bauer Type Foundry. Figure 140 presents these strong letters, which preserve several features of versal designs.

A manuscript counterpart to the letters seen in the Duomo inscription of Figure 137 was also developed in the late Middle Ages. These curved letters, leaning heavily on uncial forms, were used for initial decorated letters all over Europe, but only in northern Italy was there an intimate connection between manuscript and inscriptional forms. These letters are known as Lombardic capitals, after the peoples who fled the Danube region and invaded northern Italy in the sixth century. The term *Lombardic,* while not appropriate, is easy to remember and does no particular damage, though some professionals now prefer Stanley Morison's term *Uncialesque.* Lombardic capitals were most often brush-painted in color or goldleafed or both. Here again there is no fixed alphabet, and the forms vary considerably from one manuscript

140. Weiss Initials Series III by the Bauer Type Foundry.

DESIGN C64

to another. Frederic W. Goudy was fond of these as well as other letter forms of the Middle Ages, and the letters in Figure 141 were done by him. In *The Alphabet and Elements of Lettering* (University of California Press, 1942) he shows an awareness both of Lombardic's weak and strong points: "Lombardic Capitals do not combine well in words or sentences, although they are frequently so misused. Occasionally, where the decorative quality sought is of more importance than easy legibility, they offer an opportunity for richness difficult to attain with other forms." Figure 142 is taken from a late fourteenth-century Florentine choirbook and illustrates Goudy's suggestion that the legibility of Lombardic is not of the highest order but that the letters decorate the space well.

It is impossible in so brief a chapter to explore all the ramifications of decorated capitals as they occur in the manuscripts of the Middle Ages. Zoomorphic forms were quite widespread, and although the Celtic and Anglo-Saxon scribes demonstrated a special talent for fusing

141. So-called Lombardic letters by Goudy. Frederic W. Goudy, *The Alphabet.*

142. Fourteenth-century Florentine letters. Pierpont Morgan Library, New York.

144. Title letters from eighth-century France. Bibliothèque Nationale, Paris.

143. Christian symbol. Bibliothèque Nationale, Paris.

145. Letters from an eighth-century manuscript from Canterbury. British Museum, London.

animal forms into their complex designs, Continental writers were good at it too. A fine example is seen in Figure 143. This peacock capital *D* appears in a late eighth-century uncial manuscript, possibly Italian in origin. This kind of initial letter also occurred in areas now defined as French and German. Fish were quite popular as letter devices; the left stroke of an *A* might be a fish, as could the middle stroke of an *E*. On occasion an entire line of capitals might be made out of fish forms.

In Christian art the peacock is a symbol of immortality. The fish in Christian symbolism is equated with Christ, because the Greek letters that make up the word *fish* are the initial letters in ''Jesus Christ God's Son Saviour.'' Fish also play roles in Christian allegories and lore in a proliferation of symbolic content.

When fairly straightforward inscription capitals were written, they were quite often given interior decoration. There was no particular rule about this either, and sometimes whole letters were made in different colors or individual letters might change colors internally on an arbitrary basis. Something of this can be studied in Figure 144, an eighth-century manuscript written in eastern France. Quite often the spaces between the letters were used to enhance the visual effect of the entire line.

Figure 145 is an example of this kind. It was produced in Canterbury or the surrounding area in the eighth century. Little comment is needed here, for the piece speaks quite well on its own behalf. But it should be noted that the internal play between positive and negative areas anticipates the modern cubist movement by a considerable number of years.

In Figure 146 we see part of a manuscript written in Cologne in the ninth century. Like many another piece of writing of these centuries, it seems to have originated under a different set of rules than we employ today. It thumbs its nose at justification (the holding of margins), consistency in size, or any other quality of proper letters, and it is delightful. Notice that some letters are placed on a shading which shifts the plane in which the letter appears. This and the previous example exhibit some of the qualities of space and design that appealed to Paul Klee and other artists of this century. We will see some of these more recent innovations in a later section of the book.

The Spanish talent for invention can be observed in Figure 147, from a manuscript dated 954. There are a few manuscripts like this but each is unique. A transliteration is provided below for those who wish to follow the Latin

146. Decorated title. Ninth Century. Dom Bibliothek, Cologne.

of this inventive piece of calligraphy. The long ascenders are a curious holdover from Roman inscription forms.

LIBELLUS
DE VIRGINITATE
S[ANC]TE MARIE ANTI
TRIAPISTOS ID [E]ST
CONTRA TRES INFIDELES
ORDINE SINONIMARUM
CONSCRIPTUS

Thus we find that in the Middle Ages the larger letters provided the greater scope for personal expression; for in plowing through leaf on leaf of minuscule letters the scribe was sincerely bent on those minute subtleties of form that, seen in a line, make it legible and that, seen as a page, make it serene and complete in texture. By turns sensitive and crude, infused with genius, lunacy, and inexplicable experimentation, pre-Renaissance writing is indispensable source material for all students of art.

It is well to remember that until the development of printing from movable types, every record—the sale of a sheep, the footsteps of Exodus, the decrees of emperors—was written or carved by hand. And all accompanying forms—illustrative, symbolic, or decorative—were executed in like manner. The Book of Kells and the Lindisfarne Gospels rank with the great expression of any epoch, and in these we find that words and graphic content were inextricably wedded, for whole pages were designed and executed by the mind and hands of one individual. In the present century this idea has again gained force in important workshops and teaching centers. We no longer believe that a student should be taught to set type and be unable to create his own images. Neither should we believe it productive to train students to draw and paint and then hire someone to make letters for them.

147. Spanish letters. Tenth century. Escorial Museum, El Escorial (Madrid).

Part III THE ORIGINS OF MODERN LETTER FORMS

Medal honoring the Duke and Duchess of Ferrara,
1473. British Museum, London.

Chapter 5 Renaissance and Change

Jacob Burckhardt, in *Die Kultur der Renaissance in Italien* (1860), wrote:
"We must insist upon it as one of the chief propositions of this book, that
it was not the revival of antiquity alone, but its union with the genius
of the Italian people, which achieved the conquest of the western world."
Burckhardt's reference to genius must include Dante, Petrarch, Boccaccio,
Cimabue, Duccio, and Giotto—all important figures in the transitional
period preceding the full voice of the fifteenth-century Italian arts and
scholarship.

Renaissance advances in literature, the arts, learning, and scholarship
occurred on a solid foundation of prosperity. This foundation was laid
in the twelfth and thirteenth centuries by merchants, industrialists, and
traders, who were central to the establishment of great urban centers
like Genoa, Venice, Milan, and Florence. The latter city became the chief

107

148. Tomb of Pope Nicholas V, c. 1455, showing late remnants
of inscription styles of the Middle Ages. Grotte Vaticane, Vatican City.

banking center of the period, in spite of Church opposition to trade in money. Commercial prosperity in northern Italy produced a class of people who could afford to sponsor the arts, who could afford to produce books and buy them. Where, previously, libraries were maintained by the Church, private persons of means could now indulge in collecting books.

Foundation stones of learning and scholarship were laid by the Humanist movement. In a narrow sense this movement was devoted to the philosophy and literature of Greece and Rome, and writers strove heroically to write Latin in the style of Cicero and other great classical authors. One important aspect of this awakened interest in antiquity was its spread and popularity. Another facet was that some early Humanists broke out of Latin "bondage" and wrote in Italian dialect after the practice of Dante. Petrarch, who gave Humanism early momentum through his voluminous and polished Latin writings, met the now-immortalized Laura in 1327 and wrote sonnets on the subject in a Tuscan dialect. Boccaccio's scandalous masterpiece, the *Decameron*, was also written in the vernacular, although Boccaccio became partly reformed to important scholarly pursuits after meeting with Petrarch in 1350.

Petrarch's Laura was flesh and blood. Boccaccio's memorable effort mirrored what he had seen in the side streets of Naples and Florence. This "realism" of course is an important feature of the Renaissance outlook, but primary to our particular interests is the fact that literature came to be written in the prevailing tongue and not in Latin. In England the work of Geoffrey Chaucer (1340–1400) helped make the Middle English of London the literary language of the country, while French and Latin prevailed in court and religious circles. The triumph of vernacular tongues in literature meant that books were accessible to a larger number of people. Prosperity, the new scholarship of the Humanists, and the emergence of dominant vernacular languages—these were the germs of Renaissance letters and lettering. In these times, the forms and roles of our capital and minuscule letters became very firmly established. Today we assault these foundations in experiments, like ants crawling over the Alps. The Renaissance period also saw the emergence of a semicursive writing that we call italic (the third part of our Roman alphabet) and the development of printing, which helped to freeze calligraphic letters for a time but left the way open for new technical approaches and new experiments with alphabetic forms.

INSCRIPTION LETTERS

A renewed interest in antiquity pressed scholars to reach for proper Roman models in literary form, and the design of inscription letters reflected this aim. There were other letters used in Renaissance inscriptions, but classical letters of the Trajan-inscription type came to dominate these activities in Italy for centuries after c. 1425.

Design and execution of the Roman inscription letter reached a very high level in the second half of the fifteenth century, at the same time that the first type fonts were drawn and cut in Italy—a coincidence of considerable importance to the entrenchment of our capital alphabet. The excellent inscriptions of this period drew on the highly skilled artisans of northern Italy. This pool of talent had been growing in the area from the late Middle Ages, and from it emerged brilliant personalities whom we study and admire today. Behind these silhouetted figures lay a solid background of workmanship and skills, commercial houses, if you will, that could design, build, and cut almost anything in stone. Sometimes these businesses flourished over generations and employed many workmen. As a result, some of the fine inscriptions were produced by persons unknown.

149. Carved alphabet derived from the work of Luca della Robbia, c. 1431–1438. František Musica, *Krásné Pismo*.

In inscription letters, the period of transition between the older styles and the revival was marked by clean experiment rather than by mixtures. There were a few mixtures, however, and one is shown here (Fig. 148) to demonstrate a tenable marriage. In this figure we have the deliberate classical letter crossed with edited letter habits of the Middle Ages. This inscription appears on the tomb of Pope Nicholas V, who aided Cosimo de' Medici in the acquisition of manuscripts now in the Laurentian Library in Florence. Nicholas died in 1455. Gerald S. Davies in his book of 1910 had this to say of the tomb: "The sarcophagus, with the rudely carved figure of Nicholas and its inscription by Mafeo Vegio, is a clumsy work by a second-rate Roman *marmorarius*." This is a tough review for a work so vigorous.

Letters designed by the celebrated sculptor Luca della Robbia show a late and perfected transient style that reflects medieval tendencies rather than a strict adherance to the classical models of Rome. There is even an echo of Greek inscription letters in the composite alphabet of Figure 149, derived from works executed by Luca della Robbia between 1431 and 1438. Tapered strokes instead of serifs are used to give finality. Other Florentine inscriptions reveal a similar cut between 1425 and 1450. A modern typeface, Pascal, issued by Typefoundry Amsterdam, is a tribute to these experimental inscription letter forms that failed to hold their ground.

Classical Forms

History, shunting mixed efforts onto a side track, shows a Renaissance inscription letter with a high mark in stability, with details left to the individual designer. In Figure 150 we examine the inscription on the Roman tomb of Giovanni della Rovere, who died in 1483. While *S* and *P* are quite similar to the same letters in the Trajan inscription, other letters are cut on a wider format—*O*, *T*, and *X* for example. A few remnants of medieval composition remain in this unusual piece. These older habits do not prevail in the letters on the tomb of Cardinal Gian Jacopo Sclafenati (Fig. 151), who died in 1497. His tomb is from the workshop of Andrea Bregno, a northerner from Carrara who operated a most successful *bottega* in Rome in the last quarter of the fifteenth century. Here the designer is more faithful to classical models: *B*, *S*, and *P* are in a narrow frame, and the bowl of *P* is not connected to the stem. This individual characteristic of *P* has since been lost. Letter *E* is cut a little wider than the Roman model and is closer to present practice. The tail of *Q* provides another slight excursion, and this is frequently seen in Renaissance inscriptions and in written examples. Again it must be said that the Roman letter designed with this kind of skill is quite impressive.

The casual observer may see fine inscriptions all over Rome. He can see some of the originals at the Forum, or on the Pantheon (A.D. 120), or on the base of the Trajan column. He may also see examples of the Renaissance revival—some of the fifteenth-century tombs perhaps —or the facades and fountains dating from the sixteenth and seventeenth centuries. A visitor would certainly see St. Peter's, where there are fine five-foot letters high up on the entablature. In short, the revival was widespread in terms of time and geography, and occupied the attention of many fine architects, sculptors, and calligraphers. In Figure 152 we see the excellent letters on Fontana Paola in Rome. This structure is dated 1612 and was designed by Flaminio Ponzio. Except for the details on a few serifs, these letters follow the example of the Trajan letters quite faithfully. The reader will remember that inscribed letters were often painted. Those on the Pantheon were filled with brass sometime late in the nineteenth century. These practices enhance the dramatic and esthetic possibilities of inscription letters.

150. Tomb of Giovanni della Rovere, who died in 1483. The principal inspiration is classical. Sta. Maria del Popolo, Rome.

151. Tomb of Cardinal Sclafenati, who died in 1497. S. Agostino Cloister (Ministery of Marine Reale), Rome.

110 *The Origins of Modern Letter Forms*

PAVLVS·QVINTVS·PONTIFEX·MAXIMVS

AQVAM·IN·AGRO·BRACCIANENSI
SALVBERRIMIS·E·FONTIBVS·COLLECTAM
VETERIBVS·AQVAE·ALSIETINAE·DVCTIBVS·RESTITVTIS
NOVISQVE·ADDITIS
XXXV·AB·MILLIARIO·DVXIT

152. Classical letters in the Fontana Paola, Rome.

153. London letters with pictographs.

An earlier section explained some of the circumstances of a second revival of Roman letters, in England at the turn of the century. The practice of Roman letters, once entrenched in the trade schools and in stonecutting workshops in England, is fading in its strict application, according to James Mosley, in *Alphabet 1964*. Mosley's fine article "Trajan Revived" is principally concerned with Renaissance developments, and he does not attempt an evaluation of the revival in England. It should be said, however, that it came on the heels of some gross nineteenth-century developments in letters and may have given a needed stability to the practice of letters at a time when the vigorous twentieth-century art movements of Europe assaulted the past and were willing to throw out baby and bath water together.

At the present time one can wander about London and see genuinely distinguished Roman capitals gracing many buildings of commercial nature. One needs no antiquarian bias or sentimental attachment to the past to feel that these letters contribute a valuable quality to the panorama of the city. Letters as good as those in Figure 153 are quite common.

MARTINS
BANK
LIMITED

THE HUMANISTIC SCRIPTS

The story of the Humanistic scripts begins again with the early Humanists, for it was this band of scholars who began to collect ancient manuscripts. Petrarch (1304–1374) led the way in this endeavor, and it was his concern for the form of letters, as well as for literary content and attendant scholarly problems, that seemed typical of later Humanists. Today, except for paleographers, few scholars exhibit any interest in the form of writing or of typefaces. Petrarch took some pride in his handwriting, which was based on late Carolingian examples in his own collection. A third of Petrarch's library of 46 manuscripts were written between A.D. 900 and 1100. Boccaccio also wrote in a legible hand.

Coluccio Salutati (1330–1406), the learned successor to Petrarch as the leader of Humanist scholarship, was deeply involved in letters, in both the broad and narrow meanings of the term. And as chancellor of Florence, his influence was important. According to the count of B. L. Ullman, Coluccio's library contained over one hundred volumes, and a third of these were dated between A.D. 800 and 1100. Ullman concludes that Coluccio was familiar with the graceful Carolingian hand in several of its aspects and tried to model his handwriting on these letters. In exchanging opinions on writing, the Humanist scholars admired these letters, called *lettera antica,* and rejected other models of the later Middle Ages. Perhaps the key factor was legibility rather than esthetic judgment, although an admiration for old as opposed to contemporary letters could have been involved.

Before continuing, it will be of help to review the Carolingian development in writing, with particular regard to the legibility of the late Carolingian as seen in Figures 104 and 105. What the Renaissance scholars were rejecting can be seen in Figure 109 and in the contemporary rotunda, Figures 119 and 120, the popular letter of Florence. While the pre-Renaissance letters of Italy did not suffer the extreme condensation seen in the black-letter styles of northern Europe, Figure 120 shows that they could be bad enough. We can well imagine what an aging scholar with failing eyesight might wish to say about these cramped styles when they have been written small.

What did the term *lettera antica* mean, in terms of age, to the coiners of the phrase? Antiquity admired for its own sake was a mark of the times, and one modern proposal inclines to the idea that Renaissance scholars believed that the Carolingian manuscripts were classical. The most recent views on this express doubts that the Humanists could have believed them to be that old, but the question is unresolved. Collected manuscripts were in Latin, and Renaissance scholarship was not ready to distinguish age on the basis of language structure, letter style, or the nature of the writing surface. Paper was in contemporary usage, but the library collections consisted of manuscripts written on skins; and while the preparation of the latter reveals much to twentieth-century research, the subject made no impact then.

Poggio Bracciolini (1380–1459), known simply as Poggio, was another scholar who devoted most of his adult life to letters. He was born in a town near Arezzo and went to Florence to study Latin under John of Ravenna. He became a disciple of Coluccio's and developed excellent skills as a calligrapher. These scholarly and manual skills were acquired early, and at the age of twenty-three Poggio left Florence for employment in Rome. On Coluccio's recommendation he was secretary to a cardinal for a short time but then entered the service of Pope Boniface IX in the capacity of a writer of documents. A man of many parts, Poggio wrote a history of the people of Florence, found many ancient manuscripts, some of which were very important, translated and transcribed (rewrote) many of these, delivered weighty funeral orations, and wrote some vigorous material against the clergy. Not quarrelsome by nature, Poggio carried on a long literary duel with Francesco Filelfo in which both exhausted the Latin language for invective.

About 1418 Poggio went to England to search for manuscripts. He found only one that interested him, so his trip was a disappointment. In later writings he commented on the curious ways of the inhabitants but wrote favorably on their polite manners. He also wrote:

When I was in England, I heard a curious anecdote of an Irish captain of a ship. In the midst of a violent storm, when all hands had given themselves over for lost, he made a vow, that if his ship should be saved from the imminent danger which threatened to overwhelm her, he would make an offering at the Church of the Virgin Mary of a taper, as large as the main-mast. One of the crew, observing that it would be impossible to discharge this vow, since all the wax in England would not suffice to make such a taper—"Hold your tongue," said the captain, "and do not trouble yourself with calculating whether I can perform my promise or not, providing we can escape the present peril."

This, a quite modern joke, will perhaps show how close we are to the people of Renaissance Florence. It was Poggio who created the first modern minuscule book letters. These letters cleared new ground in terms of a redefinition of the minuscule letter without compromises with cramped contemporary book hands, although Poggio knew how to write the rotunda too. Ullman believes that Poggio made this breakthrough c. 1400. We see a sample of his hand in Figure 154, dated 1402–1403. It will be immediately apparent that the script owes a great deal to

mei laboribus de me non licere quod ad melio
ra studia quo dam quasi modo surripere me
no queam quo tue more geram uoluntati ut
tibi satisfaciam immorabor. & tecu tractatu
de uerecundia quo pateat an sit uirtus insti
tuam. Iuuat etenim rem istam siue sit simplex
passio siue uirtutis habitus de quo te dicis
ambigere paulo latius agitare. non quo licet
famam esse confirmes michi nihil moralis

154. Poggio's hand, c. 1402. Biblioteca Laurenziana, Florence.

European Carolingian from the eleventh and twelfth centuries. Poggio discovered books from this period and was certainly familiar with the writing.

The new hand that Poggio created, *lettera humanistica*, we now call Humanistic minuscule, and it is this style that is the heart of our Roman minuscule, or lowercase, alphabet. There was no sudden rush to emulate this new style, and it existed alongside rotunda and its cursive variations, the bastarda scripts, for the better part of a century, with these latter scripts in steady retreat in books.

Another important feature of Poggio's writing was his pen version of ancient capitals, seen in Figure 155, dated 1406. After he went to Rome he became more involved in inscription capitals of the kind just discussed, and began to study and collect them. He published a small collection of these inscription letters, based on ancient models, in *Sylloge* in 1429. As in the Carolingian period, Renaissance scholars of the fifteenth century became interested in the use of inscription capitals for majuscule letters to begin sentences and for titles. But whereas the Carolingian majuscule letter was drawn and filled-in, Poggio's manuscript shows the majuscule in a size appropriate to the minuscule, and with both created by the same pen. Poggio's early efforts are decisive here, because this marriage of Humanistic minuscule and calligraphic inscription capitals drove out the other large letters of the late Middle Ages and became entrenched in our cultural line in the development of typefaces in the second half of the fifteenth century. In 1453, Poggio followed Coluccio and Leonardo Bruni as chancellor of Florence, after a long tenure in the Chancery in Rome. When he died, an honored man, the citizens of Florence erected a sculptural piece in his memory; but perhaps it would be correct to say that his fame is better preserved in the structure of our Roman alphabet.

There were many other scribes occupied with copying manuscripts in the fifteenth century, and quite a number of them made contributions to the new style. A callig-

155. Cicero manuscript by Poggio dated 1406. Biblioteca Laurenziana, Florence.

posse non arbitrabar: ea dicta sunt a te: nec minus pla_
ne q dicuntur a graecis: uerbis aptis. Sed tempus est si
uidetur: & recta quidem ad me. Quod cum ille dixis_
set: & satis disputatum uideretur: in oppidum ad pom_
ponium perreximus omnes.
.M.T. CICERONIS DE FINIBVS BONORVM ET MALORVM
LIBER QVINTVS FELICITER EXPLICIT.
Absoluit autem scriptor postrema manu. ad. IIII. kal. iunias:
uerbi anno incarnati .m. cccc sexto.

156. Writing by Niccoli dated 1427. Biblioteca Laurenziana, Florence.

rapher might even say that the fifteenth century was the century of the scribe. Vespasiano da Bisticci (1421–1498), an important Florentine book publisher who promoted the new script, employed 45 scribes under him and delivered 200 volumes to Cosimo de' Medici in 22 months. (The elder Medici, a gifted penman, made such memorable contributions to the accomplishments of the Renaissance that this brief mention of him demands an apology.) Federigo, duke of Urbino, employed 30 or 40 scribes, according to Alfred Fairbank. Scholars and wealthy patrons were high in the pecking order and were at least on speaking terms. Lower were the *scrittori*, full-time professional copyists who might know Latin or Greek, and *copisti*, perhaps needy teachers who could be trained to write in one of the accepted styles. In this century many manuscripts were delivered to sponsors in other European areas (in this historical period it is difficult to name national states), and foreign scribes were trained as Italian writing centers grew in prestige. The latter made no immediate impact where older native forms were solidly entrenched, but a substantial body of Italian manuscripts found their way into private collections (now public) in England, paving the way for an important fad of Italic writing that occurred after 1500.

As a consequence of the vigorous commerce in handwritten books a star system developed in which a number of fine performers are known by name. Other manuscripts of quality are by anonymous persons.

Niccolò Niccoli (1363–1437) was another early writer of Humanistic minuscule. A Florentine scholar of inherited wealth, Niccoli exhibited a special enthusiasm for collecting old manuscripts. He spent his fortune on this enterprise, collecting eight hundred volumes. It was Niccoli who supported Poggio and others in the search for manuscripts in the older libraries and monasteries of Europe. As we have seen, the early Humanists, Niccoli

and Poggio among them, expressed a strong preference for *antica* letters, and since there were no scribes who could be entrusted with the task, they simply wrote the new style themselves. It is a curious fact that despite close personal ties, the two scholars interpreted *antica* quite differently. The handful of contemporary scholars interested in Renaissance writing are too busy to investigate this subject, so for the present the difference must be put down to personality.

In Figure 156, Niccoli's script, devoted to a text by Celsus, the Roman expert in surgical practice, is seen in a manuscript dated 1427. This style contrasts with Poggio's strong and upright hand. Niccoli also wrote in a more formal hand than that seen here, but it too showed cursive tendencies. While Poggio's script exhibits a tendency toward careful method, Niccoli's is obviously written with some rapidity. It leans a little, and there are times when he did not bother to lift the pen on ending a stroke. While it is possible to compare letters one by one, it is hardly necessary, since the two examples impart separate graphic qualities en masse. Niccoli simply let his personal handwriting style enter in, and it is this intrusion that led to the style we call Italic. Thus Poggio and Niccoli established rival tendencies in the interpretation of the Humanistic minuscule that became two distinct styles later in the fifteenth century.

Florence rather dominated the writing scene in the first half of the fifteenth century. Among the early professionals were Giovanni Aretino, who could write several styles, Giacomo Curlo, and Antonio di Mario, active from 1417 to 1456. Di Mario's earlier work drew heavily on Poggio's example. This is seen in Figure 157, dated 1427, one of 41 manuscripts signed and dated by Di Mario. This considerable body of work makes Di Mario an important figure in the development of Renaissance letters. In talent he was surpassed by some other scribes,

no disgrace in the century under discussion. The writer's colophon was typical; he always identified himself and dated the piece.

Giacomo Curlo, a Genoese, began his scribal activity in Florence and copied two books for Cosimo de' Medici. Later he was a writer for the king of Naples. His death occurred about 1459. The example seen in Figure 158 is of a work by Cicero copied for Cosimo in 1423. Curlo's minuscule had a distinctive curvature in the vertical strokes, which at times made the body of writing appear to be seen through water.

There were too many good writers in the second half of the century to cover here, due to the spread of Humanistic writing. Gherardo del Ciriagio was the dominant scribe in Florence in the third quarter of the century. Ciriagio began copying manuscripts in 1447 and continued in this occupation until his death in 1472. Ullman lists 34 manuscripts of certain origin, all but one on parchment, many of which were commissioned by members of the Medici family. Ciriagio, an excellent writer with a fine taste for spacing, is represented here by an example dating from 1453, executed for Giovanni de' Medici, Cosimo's son (Fig. 159). The use of Latin capitals in the manner observed in the right margin is unique

158. Writing by Giacomo Curlo. Biblioteca Laurenziana, Florence.

159. Sample script of Gherardo del Ciriagio. Biblioteca Laurenziana, Florence.

157. Antonio di Mario's hand. Biblioteca Nazionale, Florence.

160. Sinibaldi's early minuscule hand. Biblioteca Laurenziana, Florence.

quidem possibile est cum multitudine orare. Plurimi
uo cum uno solo unanime fratre congruentius orant
paucorum uero ualde est solitaria oratio. Si cum mī
titudine psallas. purgatissimam et ab omni materia
remotam orationem offerre non poteris. ceterum pro
exercitatione mentis ea que canuntur eloquia tūc
speculare. uel rursus dum. ut uersum proximis fi
niat expectas intentius ora. Nihil dum oras imisce
orationi decet. siue ad inutile sit et ociosum. siue uti
le et necessarium sed orationi et operi distribuenda
sunt tempora. Quod manifeste docuit isq magnū
antonium erudiuit angelus. Probat quidem au
rum fornax sed studium et caritatem in deum.
monachorum probat orationis intentissime quali
tas. Explicit gradus xviii. Incipit De cor
poralibus uigiliis. et qua ratione arripiende sint
gradus. xix.

ERRENIS quidem ac mortalib'
Regibus qui adstant. alii experiti ac
nudi fere sunt. alii fasces alii clipeos.
alii gladios tenent. Est autem ingens at
q incomparabilis priorum adsequentes differen
tia. Quippe illi proprie cognati regis esse atq fa
miliarissimi solent hi uo serui et ministri. et ista
quidem ita se habent. Age uero iam nos quoq, q
nam modo in uesptinis. diurnisq conuentib' et ora
tionibus deo et regi nro adsistimus. sollertius inspi
ciamus. Quidam uero in uesptinis p noctationibus
expeditissimi et ab omni cura nudi. puras ad oratio
nem extendunt manus. Alii cum psalmorum mo
dulatione in hac adsistunt. Alii lectioni magis in
cumbunt. Quidam p opus manuum ex infirmi

161. A page from Didymus
Alexandrinus, written in 1488.
Pierpont Morgan Library,
New York.

and gained no followers. Through Poggio, Di Mario, and Ciriagio, it is possible to see the heritage of Carolingian minuscule quite clearly, and perhaps Ciriagio understood its message of grace and legibility as well as any writer in the century.

Antonio Sinibaldi was born in 1443, and his first manuscript was dated 1461. While Ciriagio's father was a silk dyer, Sinibaldi's father was a silk merchant, which indicates the changing origin of writing talent. Sinibaldi worked sporadically in Naples but returned to Florence about 1480 and remained there the rest of his life. Ullman states that Sinibaldi made a tax declaration of poverty in 1480, claiming that the invention of printing had so reduced his work that his clothing was barely adequate. Most of Sinibaldi's manuscripts date after this low period, and the last, dated 1499, is an appropriate epitaph to the passing of a century devoted, in a sense, to a new era of writing.

Sinibaldi's minuscule hand is seen in Figure 160, dated 1461. It is his first dated work, executed when he was eighteen years old. Later he increased the space between lines. The example seen here is closer to printing models seen in contemporary books. Sinibaldi also wrote the cursive hand, without doubt the most masterful version of its time (see Fig. 166).

An entire page of the sophisticated Humanistic minuscule is reproduced in Figure 161. This is a page from Didymus Alexandrinus, written in Florence for the king of Hungary in 1488. It is reproduced in order to summarize the kind of writing that influenced so much contemporary practice in the use of letters. It is this kind of writing that inspired the first Roman type fonts and that influenced our ideas about spacing words and lines. It is also this kind of page design that is most used in contemporary book printing; and it is this era of calligraphy that brought on the contemporary revival and interest in all of the letter forms of the past.

The legacy of Humanistic minuscule was carried down to our times by type fonts. With the demise of the large Renaissance scriptorium around 1500, attention centered on cursive writing, that is, Chancery cursive; and when Humanistic writing made its impact in England after 1500, it was the cursive hand that was practiced. In the modern revival, it is again the cursive hand that is most admired, although the Humanistic upright letter forms have been studied by many contemporary calligraphers, each in his own way.

Poggio was the first Renaissance scribe to develop a pen version of classical inscription capitals for use in titles, initial letters, and colophons. He made fresh studies of inscriptions, while his predecessors, like Petrarch, were dependent on manuscripts and their capitals exhibited a mixed derivation. By 1450 pen-letter versions of classical inscription capitals were widely used in the manuscripts of northern Italy, and scribes became so familiar with the forms and with pen adaptations that they were able to relax from the labor of strict copying and reach for style and grace. This freedom was enhanced by the fact that Renaissance pen capitals were not used as a text alphabet, like the square capital of an earlier day. Thus pen-written capitals of the period often show a deliberate spacing of the letters and an elegant graphic content. Bartolomeo Sanvito was an excellent penman on all counts, and his colophon page of 1509 is seen in Figure 162. Aside from its pleasing calligraphic style, the piece serves the reader well because it contains 20 of the 26 letters of our alphabet.

The use of pen inscription capitals (they were also drawn and painted) became an inseparable part of Humanistic writing at a key time in history. Printing began in Italy in 1465, and the first superb Roman types were used in Venice in 1470. Editors and designers based their type designs on Humanistic writing styles, and the inscription capitals were included and thus perpetuated to our own times.

162. Sanvito colophon dated 1509. Mrs. E. M. Davson, London.

As suggested by Niccoli's example of Figure 156, the semicursive scripts of the early Renaissance were based on letter forms deriving from late Carolingian models but strongly influenced by the writer's personal tendencies in handwriting. It is neither the sober book hand of Poggio nor the free cursive we have already seen in legal documents.

It is difficult to draw the line between personal cursive (handwriting) and Humanistic cursive, but technically the distinction lies in the number of times the pen is lifted. The best hands of the fifteenth century preserve something of the isolated letter, but this tendency was never seen in formula until the first cursive types were cut c. 1500, and the cursive hand was first exhibited in woodcuts in 1522. In both kinds of presentation joined letters were either technically impossible or very difficult.

Our first example after Niccoli is by Pietro Cennini, a Florentine scribe whose dated work falls between 1462 and 1474. This manuscript of a work by Plautus (Fig. 163) is written on paper. (Although the wealthier patrons disdained paper and insisted on vellum, paper made considerable headway in the fifteenth century.) Cennini's hand is not a set one; letters are randomly joined, and strokes show a pleasant variation in the angle.

Marcus de Cribellarus was an expert Venetian writer. His Humanistic cursive is reproduced in Figure 164, dated 1478, a funeral oration by Petro Marcelli. The writing has a genuine flow, obtained by speed in the

164. Writing by Marcus de Cribellarus. The author's colophon has been moved up on this page. British Museum, London.

execution; the confidence of the writer is seen in every line and expressed in the bold colophon, "Written by Mark of Venice; flying pen."

The presence of such a fine writer in Venice attests to the fact that after 1450 Florence could not dominate in areas of scholarship, teaching, and writing. Capabilities matched sponsorship all over northern Italy and down to Naples. Bartolomeo Sanvito, a Paduan, is the next calligrapher under consideration. We are indebted to the late James Wardrop for greatly enlarging the information available on this fine scribe, and students can read about Sanvito in *The Script of Humanism* (Oxford, 1963). Sanvito was born in 1435 and was still alive in 1518. With some 35 manuscripts credited to him, Sanvito was one of the leading calligraphers before and after 1500. Most of his activity centered in Rome, where he may have been influenced by the excellent cursive writing of scholar Pomponio Leto and colleagues. Sanvito also had connections with the Veronese architect and epigrapher Fra Giovanni Giocondo, which may be why he wrote capitals so well. Sanvito's writing in Figure 165, the Chronicle of Eusebius, dated 1478, is interesting because it shows minuscule,

163. A Plautus manuscript by Pietro Cennini. Houghton Library, Harvard University, Cambridge, Mass.

ROMA
NORVM IVDAE
ORVM

VII. Tiberius multos Reges ad se p blandicias euocatos nunq̃ VII.

remisit: in quibus Archelaum Cappadoce̅ cuius Regno

in prouinciam verso Mazeam nobilissimam ciuitate̅

Olympias.cc. Cæsaream appellari iussit.

VIII. Pompeij Theatrum incensum. VIII.

Tiberius Drusum consortem regni facit.

IX. Drusus Cæsar veneno perijt. IX.

X. Q. Aterius promptus & popularis Orator usq. ad .xc. X.

prope̅ annum in summo honore consenescit.

XI. + Seruius Plautus corrupti filij reus semet in iudicio XI.

Olympias. cci. interfecit.

XII. Philippus Tetrarcha Pancadem in qua plurimas ædes XII.

construxerat: Cæsaream Philippi uocauit: & Iuliadem

aliam ciuitatem.

XIII. Pilatus procurator Iudeæ a̅ Tiberio millitur. XIII.

XIV. Votienus Montanus Narbonensis Orator in Baleari XIIII.

bus insulis moritur: illic a̅ Tiberio relegatus.

Herodes Tiberiadem condidit & Liuiadem

XV. Iohannes filius Zachariæ in deserto iuxta Iordane̅ XV.

fluuium prædicans CHRISTVM filium Dei in

medio eo℞ adee̅ testatur. Ipse quoq. Dominus

IHESVS CHRISTVS hinc in populos salutare̅

uiam annunciat: signis atq; virtutibus vera

comprobans esse quæ diceret.

Computantur in præsente̅ annu̅ idest. XV. Tiberii Cæs.

A secundo anno instaurationis Templi: quæ facta

est sub altero anno Darii Regis Persa℞ Ann. DXLVIII.

A Solomone au̅t & prima ædificatione Templi Ann. I̅.lx.

165. Bartolomeo Sanvito's hand, c. 1478. British Museum, London.

166. Writing by Antonio Sinibaldi.
Biblioteca Laurenziana, Florence.

seen in some book scripts and develops into a rather set hand with a pen lift after almost every letter. The slope of the letters became rather rigid and compressed. A group of scribes employed in the pope's business office, the Chancery, were probably responsible for these changes in the cursive script. Compared to what we have seen, they wrote alike, and unfortunately this rather narrow interpretation has received the strongest attention in the modern revival. James Wardrop suggested that compression of writing in the early decades of the sixteenth century was a result of economic necessity, since vellum was scarce and expensive. Historically this had been the compelling force behind other compressed styles, but some papal briefs show wide margins and plenty of space.

Nonetheless, some of the characteristics of the Chancery hands can be seen in the book cursive of one of the most famous of the Vatican scribes, Ludovico Arrighi, called Vicentino, who died 1528. While Arrighi is a permanent fixture in the history of letters, it is a curious fact

167. Writing by an anonymous scribe dated 1490.
Houghton Library, Harvard University, Cambridge, Mass.

capital, and cursive versions of his hand. Essentially these are the three alphabets we use today. In contemporary times, the styles of Sanvito are considerably hardened and show less flexibility. Designers of type fonts had to segregate these alphabets, and modern calligraphers are compulsive on the subject of stylistic unity. Thus Sanvito's example in Figure 165 is unique.

As mentioned previously, Antonio Sinibaldi developed a fine cursive style. His *veloci calamo* is seen in Figure 166, dated 1481. Notice that the ascenders are slightly clubbed to the right, the descenders to the left. This is in contrast to the hooked or plain endings of Sanvito's style. Sinibaldi's manner of handling letters became an important feature of the more formal and standard cursive alphabet, being more exaggerated and requiring two distinct strokes in the execution.

The next example of Humanistic cursive dates from 1490 (Fig. 167). The anonymous scribe exhibits a few interesting peculiarities. His pen is finely cut and reveals little thick-and-thin content. And although the hand is disciplined, letters are joined at will, with very few lifts of the pen. Some of the capital letters are given free reign, which is a precedent to the development of cursive capital alphabets appropriate to the cursive minuscule. Some of these alphabets will be seen later.

The first Roman typeface of a cursive nature was cut in 1500. Whether this affected the course of cursive writing is not clear, but in the succeeding twenty years it can be

168. Writing attributed to Arrighi. British Museum, London.

Papal documents employed the Humanistic cursive before Arrighi's tenure, but he was responsible for publicly giving the hand a new name. He was not above using his Vatican connection for commercial purposes, and on the title page of his *Operina* he refers to himself as *da imparare di escrivere littera Cancellarescha*, thus using his role as writer of apostolic briefs to enhance his reputation. In our times the hand is known as Chancery cursive. In England c. 1500 the hand was known as *Italic*, after the name of the country of origin. This usage survives in our *italic*, the term used to designate type styles that derive from these Renaissance developments.

The hand enjoyed a great vogue in the non-Teutonic countries during the sixteenth and seventeenth centuries, although this development involved mainly learned, wealthy, and royal persons. In Italy all the great scribes and writing masters gave it a good working. Some of these were Giovanbattista Palatino, Giovanantonio Tagliente, Sigismondo Fanti, Ferdinando Ruano, Vespasiano Amphiareo, and Giovanni Francesco Cresci. In Spain the celebrated writing masters who used the Chancery cursive were Juan de Yciar, Francisco Lucas, and later, Andres Brun. We will see some examples of their virtuosity in the next chapter. Fine sets of cursive capitals were executed by Amphiareo, Palatino, and Gerard Mercator (the engraver of maps), who first published his manual in 1540 in Flanders. A good review of cursive styles can be seen in *Renaissance Handwriting*, by Fairbank and Wolpe (London, 1960).

Although it influenced many people to write well, Chancery cursive became a formula. Its vigor is main-

169. A letter by Michelangelo dated 1508. British Museum, London.

that his actual writing exists in only a few manuscripts. Arrighi's *Operina*, the first writing manual, appeared in 1522, but its letters were printed from wood blocks, and in 1524 the calligrapher turned printer. We can examine Arrighi's cursive in Figure 168, a portion of the *Apologues* of Pandolfo Collenuccio, a volume presented to Henry VIII.

Unquestionably, Arrighi was good. The proportions seen are about 1 : 1 : 1 for the main body of the minuscule, ascender and descender, ensuring adequate space between lines. It will be noticed that ascenders are bent to the right and descenders to the left, and that most letters are separated. Also minuscule *g* has been redesigned to fit the cursive style. These features became standard in later cursive hands.

170. A letter by Cellini to Michelangelo. British Museum, London.

tained for our generation by "amateurs" like Raphael, Michelangelo, and Cellini. In Figure 169 we see the hand of Michelangelo in a letter. The natural vigor of this piece is immediately apparent, and it is perhaps a better model for the reader than some of the work of clever professionals. In recent times the bold hand of the late Aldrich Menhart shows this influence. Figure 170 shows that Cellini, in a letter to Michelangelo dated 1561, put plenty of energy into his writing. Alfred Fairbank's comment is appropriate here: ". . . Cellini writes as one can imagine he talked." It is a bit random, perhaps, but there is a graphic quality here that may grow more appealing after we examine some of the superficial writing of subsequent centuries.

Numerous Italian manuscripts found their way to England in the latter part of the fifteenth century, and at least one Italian scribe, Petrus Carmelianus, worked in England. But the real swing to the Chancery cursive came after 1509, the year Henry VIII became king of England. In fifteenth-century England the prevailing book hand was a bastarda, that cross of black letter and cursive seen all over Europe. All of the fifteenth-century editions of Chaucer were written in some form of this hand, seen in Figure 171, which dates from the last quarter of the fifteenth century. The bastarda of England developed in the fourteenth century and proved hard to displace. Hilary Jenkinson is the authority on this subject, and the reader can see other and numerous offspring of cursive and black letter in his writings. Some of these special "secretary" hands can also be seen in a facsimile edition of the 1574 *A Newe Booke of Copies* (Oxford, 1962).

No one would want to quarrel with the writing used in the Chaucer manuscript of Figure 171 in terms of visual character. But on the count of legibility all that can be

said of the numerous Chaucer manuscripts is that each is more difficult to read than the previous one.

The scholars, secretaries, and teachers around Henry VIII wrote the Chancery cursive hand. Katherine Parr, his last wife, wrote it quite well. Henry Fitzroy (1519–1536), a son of Henry VIII and Elizabeth Blount, wrote an amazing Chancery hand at the age of seven (1526). Princess Elizabeth wrote a fine hand before and after she became Queen.

Lady Jane Grey, queen for nine days and executed in 1554 at the age of seventeen, was already a marvelous writer of cursive at the age of fifteen. The earlier teachers around Henry VIII had learned the cursive hand independently of the printed work of Arrighi (1522), but the royal hands of 1550 show a knowledge of Tagliente, of whom we will deal at greater length later.

Roger Ascham, a Greek scholar who wrote letters for Cambridge and became tutor to Princess Elizabeth in 1548, was one of the masters of the cursive style. This is seen in an example written by Ascham in 1542 (Fig. 172), which shows a rather disciplined version of the hand, as dictated by Italian masters. Not all of Ascham's writings are this rigid, but Figure 172 demonstrates that he understood what the standard Italian cursive could do in terms of dignity, grace, and legibility.

Bartholemew Dodington (1536–1595) was a professor of Greek at Cambridge. A very skilled scribe, Dodington also wrote letters for the University at a time when such documents were meant to communicate quality. When one sees the Dodington manuscripts, one is reminded

171. A Chaucer manuscript. British Museum, London.

Above: 172. Writing by Roger Ascham dated 1542. By permission of the Masters and Fellows of St. John's College, Cambridge, England.

Right: 173. A document from Cambridge University by Bartholemew Dodington dated 1561. Public Records Office, London.

that the typewriter is a limited instrument. Notice the factor of dignity in his page of 1561 (Fig. 173). He has very little space between lines, and this enables the viewer to see the page as a mass. This means, of course, that descenders and ascenders are competing for the same space, contradicting Arrighi's model. This makes for an interesting game in solving problems as the writing proceeds and is highly recommended for students of calligraphy, because in practice they will observe that the form of the letter is not sacred. It is constructive to see how the scribe solved his problems in this respect and where he ran into trouble.

Figure 174, a list of benefactors and scholars of Trinity College, Cambridge, was written in 1563. The capitals show the same calligraphic treatment as can be seen in the Carolingian example of Figure 131. Their execution pays tribute to the Roman inscription model, but this is not confining, and the change in size and style of the capitals reveals a calligrapher so well-versed and confident in his craft that even the Italian masters would have to admit him to the club. These English scholars called their writing *Italic*, and this is a third name for the same writing. Humanistic cursive is the foundation name; Chancery cursive refers to the calligraphic tradition emanating from Venice and Rome c. 1490–1500 into modern times, and *italic* is the name given to historical and contemporary typefaces based on this tradition in cursive letters.

The craft, or art, of printing originating from Germany around 1450 and rapidly spreading to the city centers of Europe quite naturally cut the ground from under the professional scribe who wrote books. Wardrop mentions a letter by a copyist and miniature painter, Giovanni Martinengo, complaining of unemployment in 1471. Except for wealthy patronage the manuscript book was doomed by the printing press, and any lament must go unheard in a civilization so patently built on the accessibility of cheap books.

174. List of benefactors and scholars of Trinity College, Cambridge, England, dated 1563. Public Records Office, London.

175. Jacopo de Barbari's painting of Fra Luca de Pacioli and his patron studying
Euclid. Museo e Gallerie Nazionale de Capodimonte, Naples.

CONSTRUCTED LETTERS

Renaissance interest in past achievements led to a study
of ancient inscriptions. Carvers, as we have seen, seemed
to have absorbed the ancient capitals without benefit of
scholarship. In the latter half of the fifteenth century they
drew and rendered the ancient capitals with remarkable
accuracy, although in some details the versions differed.
In this same period scribes and illuminators of manu-
script capitals threw off the last remnants of the Middle
Ages and rendered the inscription capitals with fidelity.
Poggio Bracciolini's manuscript capitals (Fig. 155) were
based on the ancient letters, but they were rendered with
a pen, with attendant changes. Painted letters executed
in the decades before 1500 followed the inscription capi-
tals quite closely. Precisely where these practitioners got
their models is unknown. There was no copybook de-
riving from a central source, and it is quite possible that
the head of a *bottega* might spot a likely inscription source

on his way to work and order his men to go over and make
a few drawings of some of the letters.

There are a few *sillogi* (collections) of ancient inscrip-
tions in the Renaissance. These are listed in G. B. de
Rossi's *Inscriptiones Christianae Urbis Romae Septimo Sae-
culo Antiquiores* (1861–1888). Poggio's *silloge* can be seen in
W. Henzen, *Corpus Inscriptiones Latinarum,* and in De
Rossi's work. The location of the manuscripts is indicated
in E. Walser, *Poggius Florentinus.*

Ciriaco of Ancona (1391–1452) was one of those inter-
ested in collecting drawings and tracings of ancient
inscriptions. He was a merchant and in this capacity
traveled widely in Italy, Greece, and Asia Minor. *La Roma
antica de Ciriaco d'Ancona,* by Christian Huelsen (Rome,
1907), shows some of Ciriaco's versions of the ancient
ruins with their inscription letters. Giovanni Marcanova
of Padua, Fra Giovanni Giocondo of Verona, calligrapher
Bartolomeo Sanvito, and the painter-engraver Andrea
Mantegna (both from Padua) were several Renaissance

Feliciano

Newberry
Anonymous

Da Moyle

Schedel

176. A panorama of constructed capitals of the Renaissance. John M. Wing Foundation, Newberry Library, Chicago.

figures interested in inscription letters. The studies they produced were interesting for preserving what the monuments said, but in most cases inscription letters were inaccurately represented and could not have served as models for stonecutters. Thus Sanvito's letter rendering of Gioconda's *silloge*, showing the lettering on ancient monuments, is a tribute to Sanvito's skill with the pen but hardly met with approval from tough nineteenth-century scholars like Mommsen, Huelson, and De Rossi, who wanted the actual form of ancient inscriptions. Sanvito's calligraphic interpretations can be seen in *The Script of Humanism*, by James Wardrop (Oxford, 1963).

It is apparent that the early studies of inscription letters were of a mixed assortment. Certainly the scholarship of these enterprises suffers in some part because of the revival inscription letters carved in Rome at that time. Carvers in the workshops were interpreting the ancient capitals in a marvelously effective way. Did they need scholarship? No, but they got it anyway. Certain curious people began to investigate the Roman capitals on a theoretical basis and to impute to the ancient letters an origin of correct or divine proportion. Thus began an international game of reconstructing the Roman capitals with rulers, straightedges, and compasses, and an international dialogue on proper ratios of letter parts. Woven into the fabric of the studies we are about to examine are these several Renaissance preoccupations: antiquarianism, an interest in ideal form, and geometry. The reader should pay particular attention to how the tools are used. The methods have not changed very much.

The first constructed alphabet was by Felice Feliciano of Verona (1432–1480) in a manuscript version c. 1463. In a century richly populated with geniuses and volatile personalities, it would be difficult to attain a reputation as a first-class eccentric, but Feliciano succeeded easily. His brother condemned him in terms reminiscent of

Prince Hal's description of Falstaff, ending: ". . . wherein good but in nothing." Apparently Feliciano was a moonstruck tramp who could not do anything right. He did have a vivid imagination though, and followed Ciriaco in his interest in bizarre calligraphy, colored inks, and tinted vellum. As a calligrapher (he was also an alchemist, prospector, and poet) Feliciano wrote ancient capitals quite well, often in a rather free interpretation, which reflected his knowledge of them.

Feliciano was a friend of the painter, Andrea Mantegna, who liked to use the inscription capitals in his paintings, and on occasion the two went out to the country to copy inscriptions. One such perfect day is described in Paul Kristeller's *Andrea Mantegna* (Berlin-Leipzig, 1902). The company toured the shores of Lake Garda, visiting ruins, taking a boat trip, and waxing cheerful through wine and song. They obtained 22 inscription copies before giving way to social pressures.

Figure 176 shows a panorama of constructed letters based on Roman models. Readers are reminded here that we will see only one or two letters by each artist and that the examples are in most cases changed from original size. Feliciano's alphabet, filled in with colored inks, is represented here by letter *P*. His method shows that his letters were meant for stonecutters. Feliciano said that he measured the ancient letters, and no doubt he did, because in certain respects his proportions agree pretty well with Catich's studies of the Trajan inscription. The main stroke of Feliciano's capitals was one-tenth of the height of the letter or one-tenth of a square. Feliciano's basic premise, that the ancients based their capitals on the square and the circle, was wrong. Especially curious in Feliciano's reconstruction was his idea that the thin parts of *O* and *Q* were on a 45-degree angle. This idea was certainly inconsistent with models like the Trajan capitals. These curved letters lack unity of conception in compari-

Pacioli

Fanti

Torniello

Arrighi

Dürer

son to the other letters in Feliciano's alphabet, which suggests a rather sudden application of a personal "theory." Letters executed by Renaissance *bottegas* fail to confirm Feliciano's interpretation, and of course the subtleties of serif construction, which Feliciano knew about, were completely disregarded. How did contemporary letter carvers solve this problem? They simply drew the serifs. With no profound theory to back them up, they observed and they drew. Thus Feliciano's reconstruction is a confounding proposition; it reflects a Renaissance need to explain a human endeavor in rational terms.

It is not possible to state how many versions of ancient Latin capitals made with new Renaissance instruments were based on direct measurements (original research) and how many were based on copying the methods of predecessors. It is quite probable that the authors of many versions would be exceedingly vulnerable to nineteenth-century German scholarship, but many others can plead amnesty on the grounds of artistic or scholarly achievement in other areas.

The next example, the letter *R*, is from an anonymous and undated manuscript in the Newberry Library in Chicago. This exceedingly sophisticated model was not printed but exists in a single copy (it awaits a completed study and publication by the Newberry Library). It is mentioned here because the complex method of constructing this model could hardly be applied to wood blocks. It therefore shows more detail than any printed version of that era could. Another obvious reason that printed versions were simpler is that they were meant to be a practical guide to architects, stonecutters, and calligraphers, among others. The construction of the *R* seen here is unique in the subtle curvature of its tail, identical with that in Pacioli's printed capitals of 1509.

The first printed version of constructed capitals is by Damiano da Moyle of Parma, c. 1480, seen here in letter

C. There is no known connection between Da Moyle and Feliciano, so the idea that the ancient letters were based on the square and the circle had some common currency among interested parties. Damiano came from a family of calligraphers and was also a printer for a time. Only a few of his printed works remain. Damiano's treatise was discovered fairly recently (1924), and the facsimile was published in Paris in 1927 with notes by Stanley Morison. (Morison died in October 1967. His contributions to the history of calligraphy and printing are without parallel in this century.) The efforts of these early theorists to bend the ancient capitals into a preordained mold is interesting. Feliciano made a very wide *D* and a very wide *Z* to make these letters fit a square. Classical *C*'s, as our earlier illustrations show, were rather oval with square arms—indeed, some models were based on the angular Greek *gamma*. In Damiano's model the *C* follows a circular orbit. The width of Damiano's main stroke was one-twelfth of its height.

Letter *A* is taken from an alphabet acquired by Hartmann Schedel, a German humanist, c. 1482. Schedel had studied in Italy and was acquainted with some of the work of Ciriaco. He was the first to take the knowledge of constructed letters into northern Europe.

There is a curious time lag between these early constructions, which may date fairly close to one another, and the next by Fra Luca de Pacioli, published in 1509. Pacioli, a Franciscan, is quite well known through his treatises on arithmetic, geometry, and algebra. He was better known and admired in his own time, holding several professorships in important universities. The reproduction in Figure 175 is of a painting by Jacopo de Barbari and shows Pacioli with his patron, Duke Federigo d'Urbino, accompanied by Euclidian apparatus.

The judgments of time are harsh, and Pacioli's achievements in mathematics are not so honored today as they

Verini Tory Tory Tagliente

were then. It may be that his constructed alphabet of 1509 stands now as his major achievement. This alphabet was included in a tedious work on practical geometry entitled *De divina proportione*. Pacioli's printed alphabet, represented here by capital *Y*, was consistent and rational. A compass was used as much as possible, and like a good teacher Pacioli gave each letter a paragraph of explanation. But letters like *Q*, *R*, and *S* show signs of very complicated curves, which could only be explained in original studies like the anonymous model in the Newberry Library. In the woodcut version that was published, a simple compass method was pushed as far as it would go. Pacioli insisted that main strokes were 1 : 9 with height.

Pacioli's methods, completed just before 1500, established a kind of routine method for rivals and followers. As mentioned, the woodcut technique of reproduction placed definite restrictions on virtuosity. Had lithography been available three hundred years earlier, we might have enjoyed some extravagant letters in this vein.

Sigismondo Fanti followed Pacioli with his *Theorica et Practica de Modo Scribenda Fabricandique Omnes Litterarum Species* in 1514. This was printed in Venice by Joannes Rubeus from wood blocks. An original exists in the Newberry Library, and there was only one edition. Seen in letter *R* here, Fanti's version is fully geometric and holds to a rather thin interpretation for the width of vertical strokes, 1 : 12. The complicated structure of the tail of *R* has disappeared.

Another version of constructed capitals was printed in Milan in 1517. This alphabet is represented here by letter *B*. Francesco Torniello is the author of this version, which appears to follow Pacioli's proportions of 1 : 9. In this example one can see that the bowls of *B* are delineated by a method of arbitrary geometry unconfirmed by ancient or contemporary practice.

The first printed writing manual, Arrighi's *Operina*,

did not contain Roman capitals, but his second, *Il modo di temperare le penne*, published the next year (1523), did. There is no method of construction given. Arrighi's proportions give a sturdy letter with the relationship 1 : 8. Letter *X* shows evidence of a penman's hand in a freely drawn interpretation. The hand of the penman can also be seen in the serifs, a compromise between those endings achieved by pen and the same endings as altered by a wood block carver. In detail, the serifs in Arrighi's capital alphabet are unlike the original Roman and unlike those drawn with a compass—a mongrel kind similar to those of our era. This is important to remember. Our Roman capitals in typeface are a mixture of methods and do not follow pen letters or compass letters precisely, but rather reflect both methods plus the forms of direct engraving.

Albrecht Dürer's constructed alphabet was published in 1525 in Nuremberg. In the panorama of constructed letters seen in these pages, Dürer is represented by letter *A*, one of the alternative solutions he presented for a number of letters. Dürer's alphabet is now available in a reasonably priced reprint of a deluxe book of 1917 using a 1535 edition of the third volume of his *Applied Geometry*. The section devoted to constructed letters was titled, "On the Just Shaping of Letters."

Dürer spent some time in Italy, visiting Venice in 1494, 1495, and again in a period covering 1505–1507. Many printers and artists in Venice were concerned with letters, and Dürer undoubtedly absorbed some of the lore of theory from his visits. He decided on a ten-part division of the square, and the stems of his letters are therefore 1 : 10 with their height. He may have had a more involved theory, but by the time the wood blocks were cut there were discrepancies between the instructions and the letters. Proportions were as likely to be 8 or 9 : 1.

Dürer's models show a little more reliance on freehand drawing and less reliance on the compass. The *A* here

Neudörffer

Palatino

Fugger

Wyss

shows the tip constructed above the square, which is in accordance with modern ideas on optical illusions. To make a pointed letter like *A* look like it is on the same line as the horizontal stroke in *T*, the former should be slightly above the line. Dürer's famous book also shows a method for constructing black letter, the prevailing style in German areas. Of course black letter was, and is, a pen letter, and the idea of applying geometric techniques to calligraphic forms now strikes us as absurd. It must be put down as a sign of the times, because there were other attempts in the same vein. Such artists as Dürer and Mantegna regarded letters as a normal part of the landscape of forms. It never occurred to them that their creative impulses might be stifled by a study of letter forms.

Another constructed alphabet saw the light of day in 1526. This was by Giovanni Battista Verini of Florence. His work *Luminario* starts out with careful instructions on the construction of squares and circles. The method is rather complete in terms of instruction, both written and graphic. Verini was strong with the compass, and his entire alphabet can be seen in a facsimile edition (see Notes and Bibliography). In this edition the letters are reconstructed after Verini's models.

Verini's handsome *S* shows a top bowl of slightly less volume than the lower bowl. The difference is subtle but quite significant for appearances. Most modern designs for this letter show similar features.

Geoffroy Tory's alphabets of 1529 have very little in them that is new in terms of principles, but his volume is interesting in its analogies and in what he says about other extant versions. Tory, an important French printer, published his work on alphabets in *Champ Fleury: L'art et science de la proportion des letterres*. Most of the men previously discussed had some trait of practicality, but Tory was immersed in mystical lines of reasoning and

contradicts our notions of the Renaissance man. He seems to embody a reversion to medieval reasoning at its worst, but this may not do him justice, since it is possible that he was unreasonable in his own right. The ordinary aspects of Tory's alphabet are as follows. He stated that capital letters should be fashioned after the three most perfect figures of geometry—the circle, the square, and the triangle. Then he divided a square into ten parts on a side, making a square with one hundred parts within, and formed his alphabet within this grid. The main stroke of the letters was then 1 : 10. His *A, D, H, K, O, Q* (without tail), *R, V, X, Y,* and *Z* (seen here) were resolved within a square; *M* was 13 units wide, *N* was 11, *G* was 9½, *T* was 9, *C* was 9, *E* and *L* were 7½, *F* was 6, *C* was 9, *B* and *P* were 7, and *S* was 5¾. There was nothing new in any of this except perhaps the grid.

One of Tory's alphabets (represented by *K*) suggested a parallel between the structure of letters and that of man. If this idea is unsound it is at least within an understandable framework of Renaissance ideas.

Tory criticized Dürer's letters at some length and said that the German had ". . . gone astray in the proper proportions. . . ." (The harshness of Tory's comments on Dürer's letters was tempered by an admiration for the man as an artist.) Nor did Tory have anything good to say about the constructed alphabets of either Fanti or Arrighi, but Pacioli's work drew the heaviest barbs. Tory repeated a rumor allegedly from Italian sources to the effect that Pacioli had stolen his alphabet from Leonardo da Vinci. Tory's comments make interesting reading, but the Renaissance vendetta often cut deeper.

It is in Tory's notes on the various letters that we find his strangest train of thought. His proportion of 1 : 10 for main stroke and height came from the nine Muses, with Apollo considered as a tenth. Here are Tory's comments on the letter *Q*:

Yciar

Ruano

Cresci

Horfei

This letter *Q* is the only one of all the letters that goes below the lowest line, and I have never been able to find a man who could tell me the reason therefor; but I will tell it and set it down in writing. I have thought and meditated so much on the shape of these Attic letters that I have discovered that the *Q* extends below the line because he does not allow himself to be written in a complete word without his trusty comrade and brother *V* (*U*), and to show that he wishes to have him by his side, he embraces him with his tail from below, as I shall draw him hereafter, in his turn.

In time sequence, the capital alphabet of Tagliente came next. This great writing master included a set in his *Lo presente libro insegna la vera arte dello excellente scrivere de diverse varie sorti de litere,* cut in wood in 1530. Letter *H* seen here is taken from the edition of 1531. There were no diagrams of construction method, and the alphabet as a whole is similar to Arrighi's, although not cut as well.

Palatino, the third of the great champions of Chancery cursive, published his writing manual in Rome in 1540. Palatino's title, a bit long, is generally known as *Libro nuovo.* It contained a capital alphabet without construction marks. The letter *R* reproduced here is from a manuscript in the Kunstmuseum in Berlin that comprises some of Palatino's original work sheets bearing the dates 1543, 1546, 1549, and 1574. Palatino was also involved briefly with stonecutting problems, but nothing of that tradition filtered into his constructed alphabet, which was mostly a review of past efforts.

Johann Neudörffer, one of the greatest writing masters of all time, was born in 1497. His first important book on writing was published in 1538. It did not contain an alphabet of constructed Roman capitals. But Neudörffer's disciple, a Nuremberg printer named Wolfgang Fugger, printed a superb treatise on letters, *Handwriting Manual,* in 1553, and a special section of it was devoted to a method of constructing the Roman capitals. These capitals (letter

D) are presumed to stem from Dürer through Neudörffer, who presumably knew Dürer's work and had no direct contact himself with Roman letters, to Fugger and his skilled engraver. The technique is worthy of mention: letters were cut in relief on soft metal.

The changes from Dürer's alphabet (the *D* seen here is more symmetrical than the artist's lopsided version) have not yet been fully studied. Neudörffer's studies were left in 46 sheets of parchment. These were the basis of a publication by Johann Hoffman entitled *Basic Fundamentals of Johann Neudörffer the Elder* (Nuremberg, 1660) These are reproduced in a facsimile from Leipzig in 1956. Thus Neudörffer's constructed alphabet, in formation c. 1440, was not seen in printed form until 1660. By this time the copper intaglio technique was quite sophisticated, as letter *B* demonstrates. In this version of *B* the midstrokes have almost disappeared. Although this seems rather unusual, Lloyd Reynolds has asserted that there is precedent for it in many imperial inscriptions in Italy. Fugger's constructed capitals were used by stonecutters for several centuries.

Urban Wyss published his second writing book in 1549 in Zurich. Entitled *Libellus Valde Doctus,* it contained a Roman capital alphabet with some strange features. Stems were unusually thick, serifs were rather wedge-shaped, and a number of letters were drawn quite wide. Thus the Wyss *O* seen here is wider than its height. There were no construction lines given.

Juan de Yciar published his *Arte subtilissima* in Zaragoza, Spain, in 1548. Yciar, born c. 1522, has been described as the patriarch and founder of Spanish calligraphy, and his book is very impressive. He was a master in the art of writing. His woodcutter, Jean de Vingles, was especially skillful. Yciar's constructed capitals were derived from Dürer and present no original features. He called them *letra latina,* and his version of letter *N* is seen in the spread

Rossi

Antonozzi

Grandjean

Catich

of letters accompanying this discussion. Like many a master penman except Palatino, Yciar lacked interest in Roman capitals and only published a version of it because it was thought necessary to a successful book on the art of writing. The writing book of Vespasiano Amphiareo (1554) contains a good set of Roman capitals but little instruction on the method. On the other hand, Ferdinando Ruano's *Sette alphabeti* of 1554 did contain a good set of constructed capitals with sturdy stems and cross-strokes, as can be seen in his letter *E*. The proportion of stroke to height is 1 : 8. Francisco Lucas published a set of capitals in his 1577 writing manual. This work contains two handsome pages with white letters on a black ground, a habit of the day. Serifs are quite wide and sharp. Lucas' countryman Andres Brun also included a set of capitals in his manual, but these are routine and based on old material. Sebastiano Serlio's version in connection with *The First Book of Architecture* is also routine.

Giovanni Francesco Cresci, a Vatican scribe from Milan, was a master calligrapher who made important changes in the Chancery cursive hand. His first appointment in Rome lasted from 1556 to 1572. During this time he held the posts of *scriptor latinus* to the Vatican Library and also *scriptor* to the Sistine Chapel, and published his first writing book, *Essemplare di più sorti lettere* (1560). In the section on Roman capitals, "Trattato sopra le eccellentissime maiuscule Romane antiche," Cresci printed and outlined the best thinking on Roman capitals in the sixteenth century, except for that of some of the stonecutters. James Mosley, writing in *Alphabet 1964*, points out that Cresci's knowledge of the ancient letters was very good and his judgment unmarred by a devotion to any particular inscription.

Some of the capitals by those who copied Arrighi's examples have been included here to show what can happen to a tradition when calligraphers copy one

another. Something like this happened in the herbals (plant drawings) of the Middle Ages. Instead of looking at the plant, each new artist based his interpretation upon a previously published version, and in time the drawings became abstracted to the point where it is impossible to tell a rose from a skunk cabbage. It is good stuff but not very instructive where information is needed.

Cresci rejected the inherited myth that the classical letters were based on the square and circle, that there was one divine proportion, or that all letters should be constructed with a compass. He did not condemn the use of the compass altogether, but his advice to students was to draw the curved letters freehand over and over. This is the best advice that one can find. Ability in letters is based on the ability to draw. If one can draw a tree or a fire hydrant well, one should be able to draw capital letters.

The 1560 alphabet was sturdy, with a 1 : 8 proportion of stroke to height. Cresci's second alphabet, contained in *Il perfetto scrittore* (Rome, 1570), had a proportion of 1 : 10. This alphabet is represented here by the letter *O*, which is a little higher than it is wide. The technique is interesting; it was cut in wood by a superb craftsman, Francesco Aureri of Crema. Cresci's alphabet is unlike other woodcut versions of fancy geometry, because when Cresci states that the proportion is 1 : 10, that is what it measures. Cresci liked the idea of clarity in letters, and so he decided to print his alphabet twice. One printing was lightly inked to produce the greatest clarity (as in letter *O*), and the other heavily inked (for certain friends who were not quite as sensitive to form). Students of calligraphy may be sensible of his problem. Cresci had apparently observed that in the process of getting the ground areas black, the pressure of the press could cause the ink to squeeze over an important line, distorting the original intention. The solution arrived at by Cresci

—printing everything twice—is a splendidly impractical idea. Inking of plates is still an art, not a science, and many a printer could wish for a second chance. Contemporary printmakers often make numerous trials before deciding on the gamble. Cresci, gaining stature as the leading figure of his times in terms of thought, sensitivity, and technical knowledge, did not include all the subtleties hidden in inscription letters. Perhaps no man could have done this in one alphabet. But his alphabet of 1570 is reproduced at the end of this discussion because it is a splendid model for our times.

Among Cresci's many students was Luca Horfei da Fano, a priest who worked as a scribe in the Vatican. Horfei played a part in the building program of Pope Sixtus V (1585–1590). His designs appear on an obelisk erected in St. Peter's during this period. According to both Stanley Morison and James Mosley, Horfei's letters were adaptations of Cresci's examples, somewhat crudely handled in detail but still strong and vigorous.

The theory behind the Vatican inscriptions was worked out in a constructed capital alphabet in an original manuscript recently discovered by Carla Marzoli in the recesses of the Vatican Library. It is not yet in print, but Horfei's capitals appeared revised in an edition printed in intaglio from copperplates. This edition is extremely rare, and Horfei's letters are almost unknown. A few of them may be seen in *Calligraphy 1535–1885*, by Marzoli (Milan, 1962). The *Q* in the present layout is taken from original material in the Newberry Library.

Readers will notice the new intaglio technique that was to be the principal printing method of the manuals of writing masters from 1600 to 1800 (marking the date of the introduction of lithography) and well beyond. The first such writing book in Italy dates 1571.

Marco Antonio Rossi was the head of a flourishing *bottega* of printers in Rome until 1640. A number of important engravers worked in this shop, and its accumulation of editions, plates, and blocks is in the Calcografia Nazionale, a national heritage. One of Rossi's important editions (all intaglio copperplate) is the *Giardino de scrittori*, dated 1598. Rossi shows a very good Roman minuscule in this edition, and the engraving technique is superb. One is tempted to admire his examples because the technique of intaglio was so much more incisive than that of earlier relief printing, beset by problems of insufficient press pressure and overinking. But Rossi's capitals (represented by letter *D*) are stiff and symmetrical, and although he tries to impart a calligraphic character to *B* and *R*, he is only partly successful. The *B* is good, but the *R* suffers from technical method. By Rossi's time, however, the author's intention and the printer's technique

have been brought into harmony, and the reader can trust the method given. As can be seen, Rossi publishes a rote square and a circle with every letter, thus preserving a myth that had little meaning in its origin.

There is no need to go beyond 1600 in discussing the formal study made by Renaissance scholars and artisans, except to note that Leopardi Antonozzi, a writer in the Sistine Chapel, published a version of the Trajan letters in Rome in 1638. A personal version of the capitals was also included that gave Renaissance versions of the letters (shoulders on *M* for example) not included in the inscription source. Antonozzi, a well-known calligrapher, was born in Osimo and was in Rome painting miniatures for Pope Urban VIII in 1629. *De' caratti*, Antonozzi's writing book, contained the usual club-ended Chancery cursive. The panorama compares Trajan letters by Catich and Antonozzi. The latter was also a good calligrapher.

Antonozzi's is the first and last Renaissance effort devoted to a specific set of ancient letters. Antonozzi states that in the opinion of all experts the Trajan letters are "the most beautiful in all the world." It is coincidental that a plaster model of the Trajan inscription was acquired in London in the nineteenth century to serve in the revival study still felt today. Certainly there is no recorded connection between these expressed interests so separated in time. It could also be set down as a coincidence that Antonozzi, a Roman (from Osimo), chose his model from something down the street that natives passed every day.

The final pursuit of method can be observed in letter *G* of Figure 176. A full alphabet in this manner derives from *La reforma de la typographia royale sous Louis XIV* by Phillipe Grandjean (1665–1714). Some of the signed plates date c. 1700. Here in the letter *G* the square is divided into 2304 smaller squares for more subtle and accurate adjustments, presumably toward a perfect capital alphabet. The accommodation of detail was a brilliant conception, but major structures were contaminated by the method and emerged weak and without vigor. The dichotomy seems to pervade every area of letter formation, if not every area of art and life.

An essential element of taste and refinement seems to reside in the Cresci alphabet seen in Figure 177. Curiously, every letter in Cresci's twice-printed capital alphabet appears on a separate page, with one exception. This means that all the letters except one can be photographed and retouched for accurate black or white reproduction. Letter *Q*, it turns out, has scholarship by the tail. In the original printed work letter *Q* begins on a left-hand page, descends into the gutter, and continues on a right-hand page under *R*. The exact contours of the tail of *Q* must therefore be redrawn.

177. Cresci's beautiful alphabet of 1570. The Victoria and Albert Museum issued the alphabet in
a *Book of Alphabets*, 1958. In this version the tail of *Q* was abbreviated. When James Mosley,
of the St. Bride Printing Library, published Cresci's alphabet in *Alphabet 1964* he restored
Q's noble tail. Mosley's material is rearranged here to fit the page.

Woodcut portrait of Juan de Yciar.

Chapter 6 Writing Masters: Brilliance and Decline

As we have seen, many Renaissance scholars, patrons, and artists **were** vitally interested in the forms of writing as well as in the literary **content.** The foremost consideration was that of legibility, and in this sense **the** book hands of Poggio and Di Mario are rather plodding. It can be **argued** that beautiful writing and legible writing are the same thing, as it **can** be argued that a beautiful house is one that functions well. If faced **with** difficult and illegible forms of writing, most calligraphers and typog-raphers would retreat to a rather hard position, but lacking a challenge, most critics would prefer to allow a little leeway for individual interpre-tation or even for a bit of excess. Thus for many critics the calligraphy **of** the second half of the fifteenth century is slightly more interesting **than** that of the first half; there is a little more grace and a little more **ego** enlivening the pages, and the imprint of personality is most interesting.

But this golden era of Renaissance writing was not to last. The introduction of printing changed the method of book production. As the manuscript scribe disappeared from view, manuals on writing sprang up as if to fill the void. Arrighi's first writing manual of 1522 was a model of taste, but the proliferation of writing manuals led to contests in technical virtuosity, which eventually brought on a decline in the art of writing. The movement is imperceptible in single examples, but the slide can be felt in examples covering a century. On the other hand, all writing needs were exposed. Type designs carried what remained of Latin texts and the growing native literatures, but commercial, legal, and private writing needs became evident in the manuals. In this sense the age of the writing master was one of experiment to meet new requirements. If the writing of the period shows a decline in esthetic qualities, this must be weighed against its service to an expanding commerce. Readers can make up their own minds about this aspect of writing styles. The flamboyant exhibitions can be absorbed with interest, but the stereotype is hard to take.

The age of the writing master can be said to date from Arrighi, but it is impossible to give a closing date. Austin Palmer (1859–1927) developed a cursive writing method for business and public schools, centered in Cedar Rapids, Iowa, which netted his heirs a half-million dollars. The author of this study, a passive victim of the Palmer Method around 1929, trusts a scholarly verdict will vindicate his hope that Palmer was the last of a long line. A phenomenal commercial success in an era of the typewriter, Palmer deserves a major study as a curious remnant of the heritage of the writing master. If there is no end date for this tradition, it can be stated that its most flourishing period was between 1600 and 1800. In some decades of this period a new writing manual was published almost every year.

THE GREAT PENMEN OF ITALY

Early writing manuals stressed the Chancery cursive (Italic) style but very soon included all of the important styles of a given country. If the authors of these manuals were possessed of noble motivation, its pure essence was diluted in an ocean of commerical necessity. The publishers meant to sell the writing books, and one of the best ways to accomplish this end was to exhibit the virtuosity of the master. While this principle led to frequent violations of good taste, it also led to innovation, as master writers sought to outdo one another in exploiting the various letter forms. The first writing books were cut on relief wood blocks, a most difficult enterprise. Even when

superbly accomplished, the Italic hands show some differences between the woodcut relief version and pen letters, particularly in a thickening of normally thin parts. This was corrected with the burin and copper plate intaglio (dug-in) method first used in a writing manual in 1570. In this method of printing, very fine lines are possible, and pen letters were quite accurately transcribed and even refined. Intaglio printing itself had a considerable influence on letters during this period. New alphabets were developed that were half pen and half burin; capital alphabets were rendered with hairline parts, and new, fully cursive hands were made that were pure burin letters.

Operina (1522) was not only the first writing manual but also one of the most simply and elegantly constructed. In Figure 178 we see one of Arrighi's pages alongside the same page as executed by the late John Howard Benson, the distinguished calligrapher and student of writing. Every student of calligraphy should try to own the Benson book since it contains a facsimile of the *Operina* and Benson's version of it in English.

Arrighi's second writing book was printed in 1523 in Venice rather than in Rome. It was called *Il modo de temperare le penne,* and contained, among others, the alphabet that Arrighi said he used in papal briefs. It was a somewhat compressed Chancery cursive.

The third writing book published was by Giovanantonio Tagliente and was entitled *Lo presente libro insegna la vera arte dello excellente scrivere de diverse varie sorte di litere.* This was produced in Venice in 1524, and according to Alfred Fairbank, went through at least 30 editions. Tagliente had been a skilled scribe and teacher for some 30 years: a manuscript in his hand is dated 1491, and he was a superb penman then. Tagliente's hand shows a love of ornament that is usually held within bounds, but luckily, not always. Having seen some developments in the Chancery cursive, readers may be interested in seeing the conservative set of Tagliente's capitals designed to accompany the sloped minuscule. The capitals (Fig. 179) are a union of inscription capitals (plus manuscript uncials) with the "flying pen." Tagliente is the inspiration for the calligraphic game played in Figure 180. There are many fine sets of capitals designed to accompany contemporary italic minuscule in type. The font called Weiss italic (Fig. 181) is especially handsome and shows a direct affinity with Renaissance calligraphy.

A third great penman of the Italian Renaissance, Giovanbattista Palatino, printed his first great writing manual in 1540. Palatino, a native of Calabria in southern Italy, was apparently proud of the fact that he was a citizen of Rome. *Libro nuovo d'imparare a scrivere* was published

Ultra le'retro=
scritte' cinque' littere' a c d g g
ti fo intendere'
che' anchora quasi tutte' le' altre' lre'
se' hanno á formare' in questo :: qua=
dretto oblungo et non quadro per
fetto □
perche' al occhio mio la littera
corsiua ouero Cancellarescha'
vuole haucre'
del
lungo & non del rotondo: che' rotonda'
ti veneria fatta qua=
do dal quadro
perfetto
& non oblungo la formasti

Understand
then that not only the above
five letters a c d g g
but almost all the other letters are'
formed in this :: oblong parallelogram
and not in a perfect
square □
because to my eye' the cursive
or Chancery letter ought to
partake of the'
long
& not of the round: which roundneß
would come if made'
from a perfect
square
& not an oblong parallelogram

178. A page from Arrighi's first writing book, with Benson's version. Copyright 1954 by John Howard Benson.

in Rome in 1540 and was revised in the 1545 and 1566 editions. Palatino was skilled in various hands. He gave a good explanation of rotunda, that remnant of the late Middle Ages which remained a strong force in Renaissance writing through sponsorship by the Church. The capitals of this alphabet are a little artificial, and manuscript models of an earlier date are far superior (see Fig. 117). If Palatino, prominent in the intellectual circles of Rome, saw these letters, he gave no sign of it. But the Chancery cursive was the alphabet he knew best, and in this he was a superb craftsman with an excellent sense for spacing. The sample reproduced in Figure 182 is typical of Palatino's talent for composition. It must be emphasized that what we see here is not precisely the hand-

script of this master but a woodcutter's version of it. A certain incisive character is imparted to the piece through the action of the chisel, so that it is actually in part an engraver's piece and an engraver's method. This should not be construed as being a mutilation of Palatino's hand but rather as a contribution to our heritage in letters. We see the carver's art in many of our typefaces, sharp and clear even in small sizes. The carver's art can be seen in almost everything done by Rudolph Koch, the great twentieth-century German master, and perhaps the reader will see it in Lydian Cursive (Fig. 183), designed by the distinguished American designer Warren Chappell. Besides the family relationship of Renaissance cursive inherent in Palatino and Chappell, one can also observe

the relationship of method. Both their models impart a carver's vigor.

Arrighi, Tagliente, Palatino—these names flow well on the tongue, and they are inseparably bound together for our time in a facsimile edition, *Three Classics of Italian Calligraphy* (New York, 1953).

Writing manuals by Ugo da Carpi and Sigismondo Fanti in the third decade of the sixteenth century add little to our knowledge, since they used old material. Da Carpi cut Arrighi's blocks. Ferdinando Ruano's *Sette alphabeti di varie lettere formati* of 1554 featured an attempt to construct the calligraphic italic by rule and measure. Ruano, a Spaniard, worked as a Vatican scribe between 1541 and 1560. His curious attempt to define italic minuscule in geometric terms is no more absurd than Dürer's attempt at black letter. Perhaps Dürer escapes the charge of absurdity because many inscriptions in stone and metal were executed in black letter, while few stonecutters followed Ruano's example. In any case, Ruano was a superb calligrapher.

Vespasiano Amphiareo (1501–1563) was from Ferrara in northern Italy, famous for its production of marble for architectural purposes. A member of the Franciscan order, Vespasiano was a fine calligrapher who produced an excellent writing manual in Venice in 1548. The world-famous model of Vespasiano's italic (Fig. 184) is from a 1554 edition in the Newberry Library.

Cresci's editions of 1560 and 1570 have already been mentioned in connection with two superb renditions of

Above: 180. Author's calligraphic game.
Below: 181. Weiss italic capitals.
Bottom: 182. Writing by Palatino. Newberry Library, Chicago.

179. Cursive capitals by Tagliente. Newberry Library, Chicago.

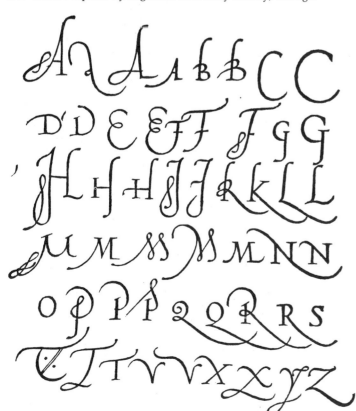

Writing Masters: Brilliance and Decline 137

abcdefghijklmnopqrstuvwxyz

the Roman capitals. His rendition of the Roman minuscule, seen in Figure 185, is equally distinguished. The example shown is from Cresci's edition of 1560. As noted, the method is difficult: wood-engraved intaglio and printed relief. In order to obtain sufficiently heavy inking to print the block black, letters may suffer some distortion. Cresci actually preferred a lighter inking. His minuscule shows a discerning mind in terms of elegant structure, legibility, proportion, and composition. Cresci's rotunda blocks show similar qualities: an appreciation of simplicity and a fine sense of composition. Italic alphabets by Cresci were also effective, and he started a new trend in cursive writing by narrowing the tip of his pen and clubbing ascenders. This latter habit is seen clearly in Figure 186, from *Il perfetto scrittore* (1570). Notice that the traditional thick and thin of pen-letter models is dis-

appearing into a composite style in which the engraver plays an equal role in letter formation.

Cresci's model of the italic is followed in the writing book of Giulantonio Hercolani, *Lo scrittor' utile* (Fig. 187). This manual was the first printed in the copperplate intaglio method. The plates were cut in 1571, a year after Cresci's wood-block manual was issued, and one can see that in the space of one year italic changed from a pen letter to a burin letter. The burin cutter was able to produce finer lines than any obtained by craftsmen using end-grain woods. Cresci disapproved of engraving and its distortions, but the immediate effect of his cursive writing was a rather bitter quarrel in print between him and Palatino. Palatino revised his edition to conform to the new style (Cresci called it *cancellaresca testeggiata*) and accused Cresci of various crimes. Cresci in turn

184. A page from Amphiareo's book of 1554. Newberry Library, Chicago.

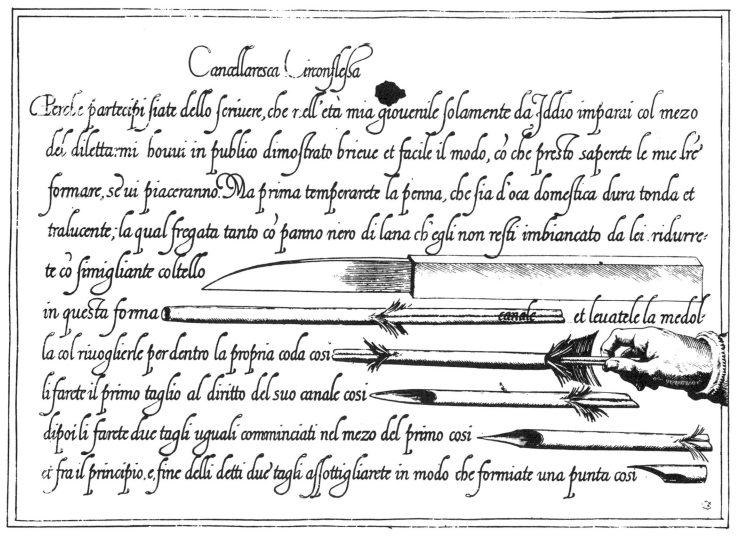

Above: 185. Cresci's Roman minuscule. Newberry Library, Chicago.

Above: 186. Cresci's italic writing. Newberry Library, Chicago.

Below: 187. Hercolani's method for quill pens. Newberry Library, Chicago.

accused Pàlatino of copying. Cresci's son took up the sword after the original participants were dead.

Subsequent to the models of italic by Cresci and Hercolani, many writing manuals in Italy featured the same script: fine lines with clubbed endings on ascenders and descenders. The mannerism is quite tiresome, as can be seen in an example included in the manual of Conretto da Monte Regale, published in Venice in 1576 (Fig. 188). This is cut in wood and is outstanding in terms of workmanship. Other examples of this mannered cursive can be seen in writing manuals by Marcello Scalzini (1581), Luca Horfei da Fano (1589), Cesare Picchi (1598); and many others, spilling over into the next century.

Thus the Humanistic cursive, a hand disciplined by a pen of moderate cut and interpreted by woodcutters, gave way to Baroque penmanship executed by a pointed, flexible pen and by the burin. Thick-and-thin strokes could occur anywhere in the letters, and it became common practice to use the alphabets as a showcase for virtuoso mechanical talents. The cursive hands we have seen led to cursive alphabets in which all letters were joined. Calligraphers, engravers, and type designers pooled their efforts in this direction, and round hand and Spencerian penmanship resulted, along with a tradition of type fonts we now call scripts: Commercial Script, Bank Script, and so on. The formal cursives that developed out of Baroque italic continued in practice into this century, and the flexible gold pens in use at the end of the nineteenth century still turn up from time to time. It is a tradition generally neglected by calligraphers, for no apparent reason. When compared with Palatino's script, the last few examples reveal an historical trend.

Writing masters loved to show off in a number of ways. There were elaborations on the letter forms themselves, geometric games of the pen, calligraphic riddles in which the line of writing wound around in an elaborate pattern, and calligraphic renderings of objects, humans, and animals. These latter are something of a neglected innovation, since the forms represented were seen as transparent, with lines describing contours and details of the subject in depth. Many of these were carried to absurdity, of course, but a few exhibit enough restraint to be instructive. This fish design, Figure 189, from Francesco Periccioli's writing book, written in Siena and engraved in Naples in 1619, shows something of this calligrapher's game of continuous-line drawing.

Geographically, we have spent a couple of centuries wandering about the great museum pieces of Italian letters, and it is time to move on. Carla Marzoli's book gives more examples of the Italian writing manuals and furnishes a valuable bibliography.

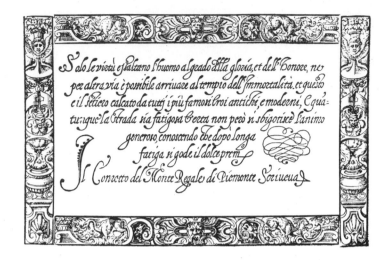

Top: 188. A page from the writing book of Conretto da Monte Regale, featuring a typical border.

Center: 189. Fish from the writing book of Francesco Periccioli.

Below: 190. Dutch Apocalypse and Bible of the Poor. A number of block books were produced in Germany and Holland before the development of movable type.

Writing masters in the German-speaking area concentrated on black letter, or bastard versions of it, and on the hands of official documents. A heavier letter than italic, black letter looks impressive in woodcut models, and in the northern European areas the art of making books, letters, and illustrations from wood blocks dated c. 1423. Thus the pool of talent for woodcut writing manuals may have been established in the northern areas a century earlier than in Italy. A piece of one of these early block books is seen in Figure 190, a Dutch print of the Apocalypse produced c. 1435. These block books were printed by rolling the relief up in ink and rubbing the reverse paper surface with a piece of smooth wood, bone, or a stuffed leather ball. In recent times the method has been revived with the bowl of a spoon as the tool.

Important writing manuals were produced in northern Europe by Johann Neudörffer (Nuremberg, 1538 and 1544), Gerard Mercator (Antwerp, 1540), Urban Wyss (Thurgau, 1544), Johann Kleiner (Zurich, 1548), Mathais Wassenberger (Cologne, 1548), Caspar Neff (Cologne, 1549), and Cristoph Stimmer (Cologne, 1549). These were followed by greater editions by the same masters and by the editions of others. Mercator's efforts were notable for his skill with italic, and his page of capitals shows a master's touch. Through Mercator, maps and italic letters are closely associated to the present time.

Johann Neudörffer (1497–1563) was the greatest of the Renaissance writing masters in the north. A facsimile edition of his work was published in Leipzig in 1956 with notes by Albert Kapr. Neudörffer's masterwork, an engraver's version of his accumulated work in calligraphy, is impressive in many ways. It contains three beautifully designed pages on the cutting of quill pens. One of these is seen in Figure 191.

The next illustration, Figure 192, features a baroque letter *A* by Neudörffer. Amphiareo's writing book of 1554 carried a similar set of letters wildly ornamented through strokes made by a broad-edged pen and with faces, angels,

191. One of three pages by Neudörffer on cutting a pen.

193. Letter *J* from
Paulus Franck's alphabet.

192. Neudörffer's baroque letter *A*.

and animals added with a narrow-cut pen; all this was left to the wood-block cutter, who undoubtedly felt that a few additions of his own design would not impair the proceedings. These calligraphic exercises were full-blown in the sixteenth century, but their origins belong to the fifteenth century.

Master penmen and master engravers collaborated in producing baroque letters, but in the end they were a showcase for intaglio skills. This can be seen in letter *J* (Fig. 193) from an alphabet produced by Paulus Franck in Nuremberg in 1601. The entire set can be seen in Alexander Nesbitt's *Decorative Alphabets and Initials* (New York, 1959). Because the problem of legibility has been abandoned, we are free to enjoy these baroque letters for inherent graphic content, and they are indeed visual wonders.

Neudörffer furnished a number of fine bastarda blackletter alphabets and some fine cursive styles. All of these suffer in the matter of legibility, since they do not benefit from the new air of clarity flowing out of Italy. Except for a few pages, Neudörffer's book is thoroughly German. In terms of spacing and design, his pages are superb and should be studied carefully.

Modern calligraphers and type designers spend a good deal of time on trial efforts. Neudörffer made a game out of this kind of exercise, and a page of his decorated blackletter capitals is presented in Figure 194. Here the master

194. A page of capitals by Neudörffer.

195. Fugger's art of joined letters.

196. Fugger's italic with a national flavor.

penman turns an exercise into a brilliantly unified statement.

Wolfgang Fugger, a printer in Nuremberg c. 1551, published an important handwriting manual in 1553. Fugger was a protégé of Neudörffer's and the 1553 manual is supposed to be based on Neudörffer's material. The Fugger manual was cut in relief on soft metal, and the technique is excellent. Since Fugger was a printer, much of Neudörffer's baroque penmanship was left out, and a number of alphabets, including black-letter minuscule and capitals, rotunda minuscule and capitals, Lombardic capitals, and Roman versions, were presented as type specimens rather than as examples of penmanship. Thus many of the letters shown are abrupt and self-contained, and Fugger's pages of tied letters (ligatures) clearly indicate that the manual was intended for punch cutters and printers — certainly the earliest manual of its kind. The flavor of German letters permeates Fugger's manual, and modern designers in that area of Europe are quite aware of their heritage, a marriage of calligraphy with type design. Caught between the virtuoso penmanship of his teacher and the practical necessities of his trade, Fugger's compromise, seen in the rotunda ligatures of Figure 195, is a classical example of the tight discipline imposed on the calligrapher by the mechanics of type. Fugger's solution is good. Because he was a printer, his book is entirely different from that of Neudörffer, and a comparison study of the two facsimile editions is quite instructive. Fugger's Roman minuscule is unusual in that it is heavy, vertical, and condensed. It is no model of beauty but deserves a careful look by those interested in a condensed Roman style. Fugger's italic minuscule has very little white space inside the letters but is a sharply

designed calligraphic alphabet well worth a close look because it is a good example of the Teutonic imprint on the graceful style of Italy. This alphabet is reproduced in Figure 196. Fugger gave the italic a good effort, but in his text he spoke a national tongue when he said, "German does not look well written in Roman letters." This view is significant. Roman type styles deriving from Humanistic book hands made no headway among German speakers until the nineteenth century. Germans preferred the indigenous black letter or variations of it.

Other important writing masters are Perret (Antwerp, 1571), Houthusius (Aachen, 1591), Boissens (Amsterdam, c. 1616), Roelands (Vlissingen, 1616), Van den Velde (Rotterdam, 1605), Strick (Rotterdam, 1618), Carpentier (Haarlem, 1620), De la Chambre (Haarlem, 1649), Overheide (Braunschweig, 1665), Grahl (Dresden, 1670). Examples of these masters and others can be seen in books by Peter Jessen, Werner Doede, and Jan Tschichold (see Notes and Bibliography).

SPANISH WRITING MASTERS

Spanish scribes of the late Middle Ages produced some excellent writing in the Carolingian style. Some of it was remarkable for its clarity (see Fig. 102), and if the early Renaissance scholars of Italy had seen any of it, they might well have been impressed. One of the outstanding features of Spanish writing was a tendency to use long ascenders and descenders in the minuscule.

Spanish writing seems more closely affiliated with Italy than with any other European area, and this connection is apparent in the manuals published in Spain in the sixteenth century. If any generalization of difference

letra antigua.-

spes Vnica

Qual es el varon
dixo vn sabio
tal es su pla
tica

a.b.c.d.e.f.g.h.i.l.
m.n.o.p.q.r.s.
s.t.u.x.y.z,

Joannes de Yciar Scribebat.

197. A page from the writing book of Juan de Yciar.

is possible, then some Spanish letter forms exhibit a tendency toward heavy strokes and a connection with Gothic calligraphy.

As mentioned, Juan de Yciar produced the first Spanish writing manual in 1548, with subsequent editions in 1550, 1553, 1555, and later. Born in 1522 in Durango, Yciar became a skilled calligrapher while quite young. He knew the work of Arrighi, Tagliente, and Palatino, and his *Arte subtilissima* shows the influence. It contained specimens of Chancery cursive, large rotunda, which Yciar called *letra formada,* and a set of Roman capitals. *Arte subtilissima* is one of the finest of the writing manuals, and students of calligraphy are urged to obtain the facsimile edition. Part of the book's brilliance is due to the woodcutting of Jean de Vingles, a master engraver from a French family of printers. Yciar furnished the cal-

ligraphic specimens, but De Vingles invented much of the decoration. Some of the pages are signed by both men.

Figure 197 is a reproduction of the kind of minuscule Yciar said he liked best, Humanistic minuscule, which he termed *Antigua,* as did many before him. This is what he said about it:

This Antique lettering is the most pleasing of all the minuscules and in my opinion, the most beautiful. And so I have done it in all the ways that I could and have embellished it as best I knew how. The perfection of it is that it is very even and goes well together and that it has very good white spaces, as can be seen here.

In fact, however, Yciar spent little time on it.

Francisco Lucas was the second of the great Spanish writing masters. He was born in Seville c. 1535, and arrived in Madrid in 1570. The first Lucas manual was published in Toledo in 1571. It had a long title, and the Madrid edition of 1577, called *Arte de escrevir,* is the title associated with Lucas and his works. The last edition appeared in 1608. Over the years, Spanish scholars have given Lucas credit for the development of minuscule letters called *bastarda.* As previously noted, this title belongs to the offspring of the union of cursive with black letter. Lucas executed a Chancery cursive very much in the style of the trio of Italian masters already seen. The Lucas bastarda was really a more serene version of the flourished Chancery cursive. He redesigned the Italian cursive minuscule, giving it more space inside and outside the letters. More important, Lucas got his plate cutters to understand the meaning of cursive letters. The sharp, jerky qualities seen in Palatino's Chancery and duplicated in Yciar's version, disappear in the Lucas manual. A page of the Lucas is seen in Figure 198, and it is still a good model for modern calligraphers.

Pedro Diaz Morante was a celebrated Spanish calligrapher who lived from c. 1565 to 1636. Morante settled in Toledo and after many years of study and practice developed a new method of writing so successful that his enemies assumed it had diabolical qualities and turned him in to the Inquisition. Morante left Toledo and went to Madrid, where he opened a school of calligraphy. He was one of the first in a long line of writing masters to establish schools. Morante, like Yciar and Lucas, also tutored the royal children, in this case Ferdinand, son of Philip III. His *Arte neuva,* published in four parts, was finished in 1631. His Chancery cursive was of the variety developed by Cresci and Hercolani, with the popular clubbed ascenders and descenders. Some Spanish critics condemned Morante for using this "degenerated" form, but then Spanish critics were imbued with an enthusiasm for Spanish writing, to the exclusion of outside influences.

In one forthright statement, the Spaniards were called the *mejores escribanos del mundo*.

Andres Brun, a native of Zaragoza, produced his first writing specimens in 1583. His manual of 1612 is considered his major work, and this publication exhibits some excellent italic specimens cut by the intaglio method on wood planks. The letter specimens are cut below the surface but printed in relief. The observer sees white letters on a ground of dark ink. Two methods of cutting and printing—black letters on a white ground and white letters on a black ground—were often seen in the same manual. Brun cut his own wood blocks, the largest seen in writing manuals. Pages are about 12 inches high and 8½ inches wide. Although his italic alphabet is quite beautiful, its similarity to Lucas' italic is embarrassing.

Among other important Spanish writing masters were Jose de Casanova, who published a writing manual in Madrid in 1650, and whose baroque italic specimens are quite impressive; Father Luis de Olod, who produced his specimen book in Barcelona in 1768; and Francisco Xavier Palomares, who produced a major work in Madrid in 1776. Palomares' manual, *Arte nueva de escribir*, contains some fine calligraphic specimen pages in italic. These pages also show the clubbed endings, a mannerism exhibiting no change two hundred years after its appearance. The Palomares manual contains 12 pages devoted to Oriental alphabets, with 18 pages showing medieval alphabets.

Still another famous Spanish writing book was produced by Domingo Maria de Servidori. His writing manual, *Reflexiones sobre la verdadera arte de escribir*, appeared in Madrid in 1789 and had an international flavor, reproducing specimens by Lucas, Cresci, Paillasson, Rossignol, Shelley, Bland, Champion, Torio, and others. Torio, a famous critic, had published his *Nueva arte de escribir* in 1783, and several other volumes followed, with the last in 1804.

Manoel de Andrade should also be mentioned. His first work was published in Madrid in 1721, but his reputation rests on his *Nova escola*, issued in Lisbon in 1722. His calligraphic specimens have much baroque ornamentation, geometric and figurative, a mark of the times.

Yciar and his followers were aware of the developments in Italy and tried to be up to date. The chief import to the Iberian Peninsula was the Chancery cursive—in current terminology, italic. Spanish writing masters preserved this hand into the nineteenth century, long after its decline in other European areas. Later in the same century italic was rediscovered in England on a basis of Renaissance antiquity. Italic made some kind of impression on most of the European areas. Humanistic minuscule, the basic alphabet of our contemporary reading

198 The Lucas Chancery cursive. Alfred Fairbank and Berthold Wolpe, *Renaissance Handwriting*. Copyright 1960, Faber and Faber, London.

texts, and Roman capitals were somewhat overlooked by writing masters in all countries. Humanistic minuscule made its way to prominence through type fonts and printing. In Spain, the upright minuscule of Yciar and his followers was greatly influenced by official writing of the late Middle Ages. In spite of Yciar's quoted admiration for the Humanistic minuscule, in practice he used scripts that showed his respect for the traditions of his native land. This was typical of writing masters all over Europe; they preserved national writing.

The success of italic and the failure of Humanistic, or Roman, minuscule in writing manuals is a fact that has not been thoroughly explained. Roman minuscule, abrupt and functional, presented a meager landscape for virtuoso penmen. Then too, there was a cursive tradition in every area of Europe, harking back to Roman times. Perhaps the cursive italic was an importation that could be tolerated.

FRENCH WRITING MASTERS

Geoffroy Tory's *Champ Fleury* of 1529 is the seminal publication of French calligraphy. Another Paris publication of Tory's dates from 1549. Both feature as part of their complete titles the words *art* and *science*, the first time the latter word is encountered in connection with letter forms. As hinted previously, Tory's suggestions on the background of Roman capitals were highly spiced with personal interpretations of classical mythology, and the word *science* in the title is used where *method* might be more appropriate. *Champ Fleury* contains a vigorous bastarda, both capital and minuscule, and the perfection of this native style is at the heart of most writing manuals of French issue.

Some of the better known French writing manuals were produced by Jacques de la Rue (Paris, 1569), Pierre Hamon (Paris, 1561; Lyon, 1580), De Beaulieu (Montpellier, 1599), Jean de Beaugrand (Paris, 1601), Lucas Materot (Avignon, 1608; Paris, 1628), Francois Desmoulins (Lyon, 1625), Louis Barbedor (Paris, 1640, and others), Louis Senault (Paris, c. 1650, and others), Nicolas Duval (Paris, 1670), Jean Allais (Paris, 1680), Estienne de Blegny (Paris, 1691), Nicolas Lesgret (Paris, 1694), and Nicolas Duval, Jr. (Paris, 1725). The list goes on well into the nineteenth century, but the sixteenth and seventeenth centuries established the flavor of French writing. It was strong on the cursive alphabets and on the decorations that took advantage of the thick-and-thin strokes of the flexible quill pens and the high skills of burin engravers.

L'art d'écrire, by Allais, in 1680 is signed by both Allais and the engraver, Senault. This fact is rigidly typical of the union of skills—calligrapher and engraver—that went into the writing manuals seen by the public. The manual by Allais is remarkable in this period because it is essentially a treatise on calligraphy with instructions (see Fig. 199), and accompanying decorative elements are held to a minimum.

Engraving, an intaglio method of printing, came out of late Middle Ages metalcraft. Advantages for the repro-

199. Drills and instruction by Allais.

duction of images were seen early in the fifteenth century. As noted, the method was first used in writing books c. 1570 in Hercolani's *Lo scrittor' utile*. Wood-block cutting, intaglio or relief, was doomed by metal plates and the burin. This method of reproducing complex imagery held its dominance until the method of surface chemistry, or lithography, gave it stiff competition, beginning in 1800. The intaglio method declined in use during the nineteenth century, and photoengraving methods developed in the last quarter of the nineteenth century also doomed handwork on stones. Lithography, featuring fine handwork, did survive the turn of the twentieth century; but since 1940 the use of lithography has been reduced to mapmaking, music printing, and other specialized areas of communication.

The point in this discussion is that engravers became so good that their interpretations of calligraphic models took the human element out of calligraphy. Human beings and pen and paper come together in a believable way, and those seeing calligraphy interpreted by burin engravers are apt to miss the point in a mass of conformity and common virtuosity. A modern book on letter forms must stress the manuscripts of the Middle Ages, not only to trace developments in writing but to demonstrate that writing is a human art and suffers when it is turned over to technicians to copy. It cannot be denied that the engraver of the seventeenth, eighteenth, and nineteenth centuries created some dazzling and hypnotic letter arrangements, but the act drained the art of its humanity.

Since the importance of original manuscripts is being stressed, it should be mentioned that these were lightly regarded in the era of the writing masters. Calligraphic models were furnished to the engraver, and nobody cared what happened to the models after the plates were made. This practice is religiously followed today: original graphic material is considered expendable once it is engraved and printed.

The italic models of Cresci and Hercolani came to be imitated in French writing manuals and existed side by side with upright and cursive minuscules of national origin. In writing italic the tip of the pen was often cut at a slant, with the left corner more forward than the right. In writing rapidly, it is natural for letter endings such as occur in *m* to *n* to sweep into the next letter. By 1600 letters in italic were naturally connected by "joins." Since Italic developed out of Humanistic minuscule, certain letters, such as *b*, held out against the kind of connected minuscule that seemed inevitable. It is difficult to assign credit here, but Louis Barbedor seems to deserve a share. Barbedor (c. 1589–1670) was a very gifted calligrapher commissioned by the king to write *lettres françaises* for the people. (The number of calligraphers who knew kings in those days is remarkable.) An example of Barbedor's connected alphabet is seen in Figure 200. The technical problem involved is much more difficult than Barbedor's effort suggests, because he disguises the whole in fancy footwork. Barbedor's successors improved the method of connecting letters considerably.

The continuous cursive became known in France as *ronde*, in England as round hand. It was very popular and remained so until about 1900.

French master penmen, no different than the others in showing off, found a good many different ways to do it. Père Sanier published a work in Paris dated 1811 that contained over twenty-three hundred monograms. One of the 32 copperplates is reproduced in Figure 201, a fascinating piece of work.

200. Cursive writing by Louis Barbedor in his book of 1659.

201. Monograms by Père Sanier, a showcase for the engraver's art.

202. The "Italique hande" from England's first writing book.

ENGLISH WRITING MASTERS

The first writing book published in England, *A Book Containing Divers Sortes of Hands,* was by John de Beauchesne and John Baildon, and appeared in 1570. It was an English version of Beauchesne's Paris book of 1550, and its sixty plates were cut in wood. Until its appearance Italian writing manuals filled the need; Tagliente and Palatino were fairly well known. The "Italique hande" from the 1570 editions is seen in Figure 202, and it is obviously based on the Italian work. It is nicely designed, if one can discount the hideous initial, and is quite well cut, although the capitals show an element of uncertainty. *A Newe Booke of Copies* by French-born Thomas Vautroullier, an important scholar and printer, followed in 1574. This work is available in a facsimile edition.

Caxton had introduced the new art of printing into England in 1477, and the old art of calligraphy, with almost a thousand years of tradition behind it, suffered a decline. The first writing books in England signaled a renewal of interest in writing, and once the flame was rekindled it burst out like a prairie fire. Writing masters became skilled, wealthy, important, and vain. Less skilled in literary arts in a country used to excellence, the writing masters plastered one another with invective. An early "trial of penmanship" took place in 1595 between calligraphers Peter Bales and Daniel Johnson. Proper judges were to ascertain the winner of the tournament and award a "Golden Pen of Twentie Pounds." Johnson, the young challenger, lost and published a manifesto claiming a packed jury. Bales printed and circulated a broadsheet denouncing the accusation.

According to Ambrose Heal, many of the great masters of the eighteenth century—Shelley, Snell, John Clark, Snow, and Ollyffe—instead of dueling, created something in the nature of a "general Melee," with each denouncing one of the others in a preface or even in the public press.

Benjamin D'Israeli took note of these capers and wrote an essay on the subject. This excerpt requires no further preface:

Never has there been a race of professors in any art who have exceeded in solemnity and pretentions the practitioners in this simple and mechanical craft. I must leave to more ingenious investigation of human nature to reveal the occult cause which has operated such powerful delusions on these "Vive la Plume" men, who have been generally observed to possess least intellectual ability in proportion to the excellence they have obtained in their own art. I suspect that this maniacal vanity is peculiar to the writing-masters in England; . . . Writing-masters or calligraphers, have had their engraved "effigies," with a Fame in flourishes, a pen in one hand, and a trumpet in the other; and fine verses inscribed and their very lives written! They have compared "The nimbly-turning of their silver quill" to the beautiful in art and the sublime in invention; nor is this wonderful since they discover the art of writing, like the invention of language, in a divine original; and from the tablets of stone which the deity himself delivered, they traced their German broad text or their running hand.

While we calligraphers recover from this massive thrust we might as well consider some of the factors that led to the success and vanity of the English writing masters. Their prosperity paralleled England's rise in power. From 1500 a rising middle class found few barriers on the road to commercial success, and a gradual increase in sea power led to the defeat of the Spanish fleet in 1588 and control of the seas a century later. In the seventeenth century, English merchants established posts in India. The merchant marine was given incentive as early as 1485, and decrees of 1651 and later stating that all goods entering or leaving England should be carried in English vessels were instrumental in its phenomenal increase in number.

Sixteenth-century England saw a sharp upward trend in foreign commerce, leading to its dominant position in 1800. Industrial production increased, based on coal and new inventions, and money and banking flourished.

As we know, the ownership and management of trading, business, and finance were held by a relative few. Equally well known is the fact that the country laborer who moved into the city to man the mills of England's prosperity suffered a tremendous decline in dignity, family, health, and culture. Nevertheless, upward commercial trends created a new middle class, some of whom had to be trained to keep the records and ledgers of the new business society.

Double-entry bookkeeping was developed in the fourteenth century. In the fifteenth century most public and private accounts in Italy were kept in this way. Luca Pacioli, discussed earlier in connection with his con-

structed Roman capitals, wrote the first theoretical treatise on double-entry bookkeeping. By 1600 the method was well known in western Europe and had thrust aside any personal or qualitative considerations in order to show a hard balance in cash. Early produce and stock exchanges and the emergence of insurance companies increased the need for a class of worker who could do sums and write well.

There is not much indication of events to come in sixteenth-century copybooks, and in looking back these early manuals are the "art" books of that century. Neudörffer did a page of bookkeeping dated 1546, but this is not seen in his manual. However, English writing manuals of the seventeenth century and thereafter do reflect the commercial milieu of the country. A system of shorthand was published in 1642 by one Jeremiah Rich. It was entitled *Semography*. William Addy (1618–1695) published a book entitled *Stenographia, or the Art of Short Writing* in 1684. The same author published a Bible in shorthand several years later, and a number of later writing manuals were devoted to the teaching of shorthand.

When two people are concerned in a common study, the most likely outcome in England is the formation of a school. Early addiction to this practice meant that many of the leading writing masters in England ran their own schools. Writing was the principal subject taught. Day students were sought, but board was commonly furnished. Writing schools flourished beyond commercial necessity, attracting the elderly toward acts of philanthropy. One of these schools, Christ's Hospital Writing School, was founded in 1577 and continued until 1800. In 1694 the number of pupils was a "little less than 400." A liberating suggestion was brought up in 1692, uncovered by Heal's reading of the school's record:

1692. John Smith urged upon the court the desirability of giving instructions in Drawing to certain pupils in the Writing School. This proposal was supported by letters from Sir Christopher Wren and Samuel Pepys. William Faithhorne junr. was appointed drawing master but the experiment was not a success and the committee came to the conclusion that Mr. Faithhorne's instruction had "been of noe advantage to the House in any respect whatever" and recommended to the Court that the drawing class should be discontinued.

For once, the art of writing came out ahead. It is too bad that the compliment came from such a misdirected faction.

Edward Cocker (1631–1676), one of the important early writing masters in England, was also one of the most prolific and versatile. Cocker put together some 24 writing books. He was also an engraver of calligraphy and a skilled teacher of arithmetic. In addition, Cocker became noted for his lacy penmanship, a calligraphic game called "striking." In this unique contest a "striker" achieved his pen-written ornaments by a continuous motion of the pen's nib: the pen cannot be picked up to start a new stroke. This particular method of making animals and human figures, previously illustrated and seen in many writing books, must have impressed amateurs, for many have tried it. Cocker's specimen reproduced here (Fig. 203) is from his *Pen's Transcendencie* of 1657. We had the "flying pen" earlier and now we have the "fluttering pen." With such a provocative designation it is too bad that the writing is not more distinguished, but then Cocker was one of the most interesting of the English writing masters, not the best.

After 1600 the English scribes began to rework the italic into a more cursive style. As seen in Figure 204, an example by David Browne, the "speedy Italian writing" had its problems. This figure is reproduced from Browne's *Introduction to the True Understanding of the Whole Arte of Expedition in Teaching to Write*, dated 1638. As Barbedor's example demonstrates, a running cursive hand is not easy to design, even by expert calligraphers who are good at other styles. Some native cursive is mixed in Browne's example, which does not help. Still this kind of development led to the round hand of high perfection, which became almost a synonym for English writing.

John Ayres is given a good deal of credit for developing the running cursive called round hand. Ayres flourished from 1680 to 1705 and was the most eminent writing master of his time. His first book, in 1680, was *The a la Mode*

203. A page from Cocker's book of 1657.

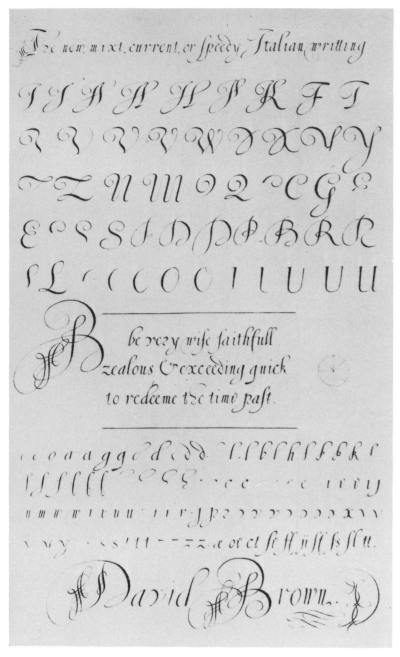

204. Browne's speedy Italian writing.

Secretarie. Ayres had a school, the Hand and Pen, where one could be furnished the best in steel pens. There is a fine portrait of Ayres in Heal's book (see Notes and Bibliography). Stuffed with lace and arrogance, he can easily be believed capable of this view on a competitor: "And the great pitty that a collection of famous Copy books should be Castrated and Mangled to serve the Ambition of a Mountebank pretender."

150 *The Origins of Modern Letter Forms*

Round hand, a product of many penmen and engravers, reached perfection in the years after 1700. The hand of Gabriel Brooks is seen in Figure 205, which dates from 1737. Although not as well known as some other penmen, Brooks did contribute nine plates to the *Universal Penman*. The piece under study here was partly chosen to preserve the valuable literary content, which expresses a rare sentiment for one of the wigged gentry so gifted at "popping off."

It is apparent that in Brooks' example the *joins*, or the connections from one letter to the next, were worked out in detail, and the method is about the same today. As noted, contemporary calligraphers do not like formal script or formal cursive. It is not the true calligraphy. All the more reason for suspecting a prejudice and doing something about it in teaching calligraphy.

In this period, remnants of the "true calligraphy" are hard to find in the copybooks of the writing masters. This is partly because the penmanship of the seventeenth, eighteenth, and nineteenth centuries is dominated by the flexible pen and the engraver's burin in cursive styles. In truth, it is a tiresome panorama. L. C. Hector's book *The Handwriting of English Documents* (London, 1958) shows that behind the façade of superficial techniques encountered in the writing manuals of England, official documents preserved something of England's perverse insistence on individuality and tradition. The English do not have to explain this dichotomy because they live it. One of the legal hands is seen here in a piece on Abbreviations, by Thomas Ollyffe, dated around 1715 (Fig. 206). In 1713, Ollyffe had published *Practical Penman* and noted these sample hands: engrossing, text, secretary, great court, small court, common Chancery, and set Chancery, plus a small specimen of the Abbreviations in court hand. Although somewhat mutilated by the engraver, the example shows that the long tradition of English calligraphy did survive.

The next example, Figure 207, is one of documentation. It is by Samuel Thomas, dated c. 1690, and shows the striker's game. The title reflects the need for workers skilled in writing and arithmetic. Black letter, Roman, and three varieties of cursive are shown on this trade card, preserved in Samuel Pepys' collection of calligraphy.

Another symptom of the times is preserved in P. Roberts' *A New Set of Copies for Ladies*, published in 1772 at Putney Academy, a portion of which appears in Figure 208. According to Ambrose Heal, Roberts was born in 1760. At the time of publication he was in his thirteenth year. Heal, the scholar stating facts, can only indicate that Roberts flourished (or was active) c. 1772. The format is French, and it is probable that Roberts received a lot

These are many shining Qualities in the Minds of Men, but there is none so useful as Discretion; it is this indeed which gives a Value to all the rest, which sets them at Work in their proper Times and Places, & turns them to the Advantage of the Person who is possessed of them.

205. A commercial homily by Gabriel Brooks.

206. Writing by Thomas Ollyffe c. 1715.

207. Trade card of Samuel Thomas.

of help from the engravers, and from writers too, if one can judge from these adjoining lines:

> Then let the Fingers whose unrivall'd skill
> Exalts the Needle, grace the noble Quill.
> An artless Scrawl ye blushing Scribbler shames;
> All should be Fair that beauteous Woman frames.

In all cursive writing of these times, the Roman alphabet survives. In the latter part of the eighteenth century, engravers and typographers made revisions in the Humanistic minuscule, straightening curves and removing the calligraphic curves from serifs. These changes led to the style called Modern Roman. One early revision is seen in the next example, Figure 209, from William Elder's *A Coppy Book*, published around 1690. A sharp mechanical feeling is imparted to the ancient inscription capitals in this ancestor of similar contemporary faces. The change in Roman is due to the effect of fine-line pen and burin techniques.

In a rising commercial atmosphere like England's it was obvious that the writing manuals would stress examples of accounts, bills, orders, and the like. Charles Snell is the author of the page seen in Figure 210. Snell (1667–1733) was one of the great figures in master penmanship and operated schools in various parts of London. His first book was *The Penman's Treasury Open'd* (1694). The example seen here is from his *Art of Writing in Its Theory and Practice* (1712) and is composed and framed rather nicely. Snell must have developed the art of invective along with his calligraphy, for both talents appear at an early age. At twenty-three Snell wrote about "the starch'd affected Flourishes, and illiterate copies that senseless Pretenders have impos'd on the World. . . . Such Empericks, by their barbarous Copies, both Written and Printed, have led Youth into a Labyrinth of Errors." This master's answer to the flourished owls and apes of such rivals as George Shelley was to put writing under a set of rigid and meticulous rules, and a vitriolic running debate ensued between Snell and John Clark, another worthy foe.

Servidori, the great Spanish critic, thought very highly of Snell, saying that the English master never published any examples that were not *suelta, graciosa y correcta*. The great publication of this period is the work of George Bickham, Sr., whose dates are roughly 1684–1758. Bickham's substantial undertaking was called *The Universal Penman*, which appeared in 52 parts between 1733 and 1741. It presented the work of 25 contemporary masters of the writing art in 212 folio-engraved (intaglio) plates. These superb engravings can be seen in a facsimile edition published by Dover (New York, 1941), and the reader is urged to find it. Joseph Champion, a fol-

208

210

212

ABCDEFGHIKLMNOPQRSTUVWXYZ.
a b c d e f g h i k l ll m n o p q r s ſ t u v w x y z æ &.
1 2 3 4 5 6 7 8 9 0.

209

208–211. Windows on seventeenth- and eighteenth-century writing in England by P. Roberts (208), William Elder (209), Charles Snell (210), and George Bickham (211). 212. An example of the Spencerian hand.

lower of Snell's, was one of the principal contributors to the Bickham opus, doing 47 out of the 212 plates. He wrote that Bickham's skill at engraving was so complete that he could cut letters directly through the waxed plate without the previous step of tracing. Evidence shows that Bickham was also an excellent calligrapher. Eighteen plates from his master work were products of his own hand.

Bickham's *Bills of Exchange* (Fig. 211) is a token of what can be seen in *The Universal Penman*. It is not different from what we have seen, but it puts a period to an era of skill impressive on all counts, an era that furnished a national portrait through the graphic forms of writing. The literary content in the manuals of the English writing masters is quite a few cuts below that of Shakespeare, but there is good advice on almost every

page. The United States inherited much of the calligraphic achievements just discussed, and some Americans of a generation ago wrote in a style like that perfected by English masters. The old round hand of England became Spencerian in America and flourished in the latter part of the nineteenth century. The example seen in Figure 212 is typical of hands executed by schooled writers.

In terms of scholarship there are large gaps in our knowledge of writing master manuals. Any library may contain gift items of nineteenth-century manuals that may one day be listed in the card catalogs. Older original books may reside in rare-book rooms. But since a student is primarily interested in volumes he can see, purchase, or lay his hands on in one way or another, some facsimile versions of early writing books are listed in the Notes and Bibliography.

152

211

Part IV THE ALPHABET IN TYPES

 typography

Type in three stages: pied, composed, and proofed. Setting by Walter Hamady.

Chapter 7 The Heritage of Gutenberg, Jenson, and Griffo

In the first figure above, pieces of type lie in random order. Letters of the alphabet have been cut in relief on these chunks of metal. Although they are meaningless in the casual order of their initial appearance, observe what happens next. In the second figure a printer has gathered the pieces and arranged them in proper order for printing. On a smooth glassy surface the printer worked a rubber roller over hard, sticky black ink until it was evenly charged with the black material, and then he rolled it over the pieces of type. If everything worked right, the letters in relief received a deposit of ink. The printer then placed a piece of smooth paper over the pieces of type and applied pressure to the sandwich by a mechanical device called a press. Ink held by the pieces of type was transferred to the paper, and the third figure shows the result. These are the simple principles of the complex craft and art of printing.

155

This method of obtaining identical images is also used in printing woodcuts or linoleum prints and is generally known as *relief printing*. In this method of reproduction the parts of a surface that are to take the ink are left untouched while the rest is carved away, drilled away, or eaten away by acid. On the plate or body of type the image is always backward or illegible so that the printed image will be correctly oriented and legible. One of the first things an apprentice printer must get used to is seeing the letters of the alphabet facing left instead of right. The specific term for commercial relief printing is *letterpress*, and types are the backbone of this method of reproduction. Most of our contemporary alphabet styles and the skills for designing them are intimately associated with type and letterpress, and that is why type is studied in classes concerned with making and using letters. Then too, images obtained from type are used in the other principal methods of reproduction.

Intaglio is the generic term for the method of reproduction in which the ink rests *below* the surface of the plate. That part of the plate which is to furnish the image must be carved away or eaten away by acids—just the opposite of relief principles. A letterpress halftone cut (perhaps processed from a photograph) can be printed in two ways. Properly rolled up with ink, the image will appear as intended; but if the less sticky intaglio ink is pressed into the recesses of the plate and the surface wiped clean, the image will come out with the values reversed and looking like a negative.

The intaglio method has already been discussed in connection with the writing master manuals, and it was an important hand method for several centuries. In colleges and universities it has become the most widely used method among printmakers and their students in the last twenty years. In these circles the method is sometimes called *etching*.

In commercial printing the intaglio method does not count for much if quantity is the criterion. It is capable of very subtle gradations in the black and white scale but exists in a society that is careless of these qualities. The formerly honored method has a hard way to go. The technical terms are *gravure* or *rotogravure* for plates on a cylinder.

Planographic printing processes refer to those methods not depending on a raised or lowered surface. The parts of the plate that hold ink are on the same plane with areas that do not print. *Lithography* is one of these processes. In the nineteenth century lithography became a hand method of great importance. In that century and well into this one, Bavarian limestone was used as the plate. It could accept a greasy image and hold it by chemical action while retaining water in the areas not to be printed. Thin metal plates have replaced stones in commercial printing and are beginning to replace them in college printmaking circles. Stones will shortly become museum pieces. This book is printed by means of the lithographic process. Just a few years ago the text images for this book would have been derived from proofs of metal type, but recently perfected photosetting machines provide the images used in the text presently scanned by the reader. The full impact of this particular change in technique cannot be assessed here, but college departments needing letterpress equipment may be able to acquire presses as the photographic method makes them obsolete in commercial printing.

Collotype, another planographic process, is used for fine reproduction of art pieces. Some of the reproductions in this book are taken from facsimile editions in collotype. The method is practically unknown in college courses but deserves study. A related method, *mimeograph*, is well known, and secretaries would be amazed to see what army technicians were able to do with this medium during World War II.

Serigraphy is sometimes mentioned with planographic methods but perhaps deserves a category of its own, since its ways are unique. A fine-mesh silk screen is used to filter paint, and various stencil methods are used to block out the parts that do not transmit the image. In college art departments serigraphy has become an important medium for printmaking. Commercial serigraphy seems to have an amazing ability to print images on any kind of surface, but the screen texture rather precludes the method as one that could specialize in printing tiny letters.

TYPE IN DEVELOPMENT

The idea of movable type—separate relief letters that can be put together in various combinations—probably stemmed from woodcut letters. Since the Chinese had an early history of woodcut reproduction, it is perhaps logical that the first notions of movable type should be recorded from that area. Pi Sheng of the Sung dynasty is reported to have made movable letters of clay and glue about 1045. There is no record of the printing, if any. Wooden type was mentioned in China in the thirteenth century, but again there are no extant examples.

In Korea it is certain that some kind of metal types existed in the middle of the thirteenth century. A letter written in 1239 states: "This edition is a reprint (in block) of the preceding edition which was printed with cast type." It is believed that cast metal type was developed in

development was the *punch*. Goldsmiths made punches, carving relief initials or trademarks on steel rods that they struck into their finished products. This left an intaglio image in the metal. Gutenberg used this idea. He carved letters on the rods of hard metal and struck them into softer brass, thus creating the *matrix*, or mother image, for casting letters identical to that on the punch. Locking pieces of metal provided an inch-deep orifice over the brass intaglio letters to form a mold into which molten metal could be poured. The inch depth allowed a man to manipulate the finished pieces of type with his thumb and forefinger, setting them in an order appropriate to the text. The physical form of the handcut metal punch is seen in Figure 214.

Johann Gensfleisch zum Gutenberg was born to a patrician family in the years between 1394 and 1399. His trade in Mainz was that of goldsmith, and he seems to have begun experiments in movable type c. 1440, when he was a political exile living in Strasbourg. Gutenberg returned to Mainz sometime before 1448 and by 1450 needed capital to go into production. A lawyer, Johannes Fust, invested 800 guilders in Gutenberg's enterprise and in 1452 obtained a partnership to secure another advance of 800 guilders. A foreclosure was initiated by Fust in 1455, and most of Gutenberg's types and equipment went to Peter Schoffer of Gernsheim, who had close ties with Fust and who later married into the family.

What remained to Gutenberg after the decimation of his holdings is uncertain. He may have retained the types of the 42-line and 36-line Bibles and a smaller font used to print the *Catholican*, which he issued in 1460. The smaller font and the popular subject matter, an encyclopedia compiled in the thirteenth century, pointed the way to a wider usage of the printed word. Gutenberg's production ended in 1460, and from 1465 he was aided by a pension.

213. Kemija type. Library, Seoul National University.

Korea around 1200. The first bronze types from this area date before 1430, and an example is seen in Figure 213.

Woodcut books were seemingly late in Europe, in view of the Chinese development of relief printing, but these were separate developments. The earliest block books (Fig. 190) date no earlier than 1420. But the demand for volumes must have been pressing in these times, because a number of experimenters tried to develop an easier way. The man who fought through the technical difficulties and began to produce books was Johann Gutenberg of Mainz, Germany. Book production called for very large quantities of identical letters, and Gutenberg, a goldsmith, was able to make brass molds for accurate casting of individual letters. Another key to the

214. Punches for Baskerville's Canon Roman, cut by John Hardy c. 1754.

The Heritage of Gutenberg, Jenson, and Griffo 157

215. Lines from Gutenberg's 42-line Bible.

In 1440 Gutenberg was one of a number of experimenters in the new method of book production. This involved letter design, punch cutting, matrix fitting, typecasting, composing, preparation of paper, preparation of inks, and the conversion of wine presses to the needs of printers. Gutenberg brought the new techniques and resident skills together and produced the famous 42-line Bible, in process from 1452 to 1456. A part of a column of this memorable achievement in printing is seen in Figure 215. The style is an imitation of black-letter book hands of the era. Initial letters were drawn by hand in color. A facsimile edition of this truly great edition was published in Leipzig in 1913.

Not differentiated in the early years of printing, punch cutting, matrix fitting, typecasting, composing, inking, and printing remain the essential processes in letterpress today. Techniques have become more sophisticated, the manufacture of paper has acquired a more scientific base, and inks are more dependable, but principles have not changed.

Between Gutenberg's initial experiments around 1440 and his death in 1468 lay a period of time sufficient for the training of a number of printers, and by 1485 presses were established from Sweden to Sicily and from Spain to Hungary. For calligraphy students and collectors the incunabula period of printing (before 1501) is the most interesting, because it encompasses a vital period of experimentation with local scripts, all remnants of the later Middle Ages. One of these is seen in Figure 216, the *Biblia Bohemica Prima* by Johann Kamp (Prague, 1488), a skilled rendition of northern European calligraphy. Some collectors are interested in only the first twenty-five years of printing, but some historians feel that the period of experimentation can be roughly dated 1450 to 1550. In any case, after the initial efforts a standardization took place, based principally on the models of Italy derived out of Humanistic book hands.

According to Daniel B. Updike, the destruction of the city of Mainz in 1462 accelerated the flow of printing talent to other places. Conrad Sweynheym and Arnold Pannartz set up the first printing press in Italy at Subiaco, a monastery near Rome. The partners printed three books at Subiaco, the first being Cicero's *De Oratore*. The lines in Figure 217a are from the *Opera* of Lactantius printed in 1465. At first glance it would seem that this first Roman typeface is a deliberate mixture of Humanistic minuscule and the black letter of northern Europe; but an enlargement of a number of these letters (Fig. 217b) reveals that it was indeed intended to be an imitation of Italian letters. No doubt there are some echoes of gothic heaviness in these letters, but a part of the ponderous quality is due to tight spacing and over-heavy inking. This first effort by Sweynheym and Pannartz, although historically important, certainly does not represent the best Roman face cut before 1500. But the effort is certainly held in respect. C. H. St. John Hornby and his famous Ashendene Press had the original face restudied and redesigned in 1902,

216. Lines from *Biblia Bohemica Prima*, 1488.

Sed neqʒ adepti ſũt id quod uolebãt : & operã ſimul atqʒ índuſtriã pdíde-
rũt : quia ueritas ideſt archanũ ſũmi dei qui fecit omnia íngemio ac ꝑpriis
ſenſibus nõ poteſt comphédi : alioquin nihil ínter deũ homínéqʒ diſtaret ſi
cõſilia & diſpoſiciones illius maieſtatis ęternę cogitatio aſſequereᷓ huma-
na. Quod quia fieri nõ potuit ut homíni p ſe ipſũ ideo diuína noſcere : non
eſt paſſus homínem deus lumẽ ſapientę requírentem diucius errare : ac ſine
ullo laboris effectu uagari per tenebras ínextricabiles : aperũit oculos eius

ſapientę requí tenebras ínext

217. (a) Lines from the Sweynheym and Pannartz edition of Lactantius, the first book printed in Italy,
and (b) an enlargement revealing an attempt to understand Italian letter forms.

Quell' anima lassù che ha maggior pena,
 Disse il Maestro, è Giuda Scariotto,
 Che il capo ha dentro, e fuor le gambe mena.
Degli altri due ch' hanno il capo di sotto,
 Quei che pende dal nero ceffo è Bruto :
 Vedi come si storce, & non fa motto :
E l' altro è Cassio, che par sì membruto.
 Ma la notte risurge ; ed oramai
 E da partir, che tutto avem veduto.
Com' a lui piacque, il collo gli avvinghiai ;
 Ed ei prese di tempo & loco poste :
 E quando l' ali furo aperte assai,
Appiglió sè alle vellute coste :
 Di vello in vello giù discese poscia
 Tra il folto pelo e le gelate croste.

perhaps to show what the pioneer partners really in-
tended. A portion of Dante's *Inferno* in this special face
is seen in Figure 218.

Before 1500 printing had been established in some 75
Italian towns and cities. One earlier authority identified
1680 distinct typefaces cut during this fifty-year period,
and the count is doubtless higher at the present time.
Some forty printing houses were operating in Rome at
some time during this period. And because the Human-
istic minuscule was judged to be the most appropriate
style for the scholarly editions the printers wanted to
produce, there were numerous attempts to use the hand-
script forms in types. Other alphabets were cut—black
letter, rotunda, bastarda, and varieties in between—but
for the moment our attention centers on attempts to
transfer Italian calligraphy, for which there was no set
model, into type.

Venice became the important center for the effort to
transfer Italian calligraphy into type. In September 1469

Left: 218. An interpretation of the Subiaco types in 1902.

Below: 219. Printing by Wendelin of Speyer in 1471.

dicto precedenti in legato. quia teſta
tor quod legabat erat appoſitum ad
amplianduʒ legatum legatarij.ut ha-
beret precioſius quod eligeret. ſi non
ſit aurum in peculio.non tamen im-
peditur eligere legatarius đ alijs.con
cordat cú hoc.ſ̄.de legatꝰ.p.l.ſi cui fui.
in prin.⟨ Si autem nó ſint reſtricti
ua nec ampliatiua. quia nil ꝓceſſerit
quod uideri poſſet augeri uꝉ reſtrigi

debeatur.& ita inuit dictio q̃q̃ ibi po-
ſita.que implicat. Rationem huius
puto.quia ſatis ſalua ratione recti ſer
monis.poſſunt contineri uina de am
phora. ⟨ Suppoſito tamen ítellectu
glo.intelige quod dictũ eſt de ea det-
minatione.que tantum ſit demóſtra
tio.ſed que demonſtrat ſub dicta ſpe
cie.& ideo non uideo quare magꝰ de
beatur legatum ubi nullas habet am

LVCII IVNII MODERATI COLVMELLAE REI RVSTI/
CAE LIBER DECIMVS. EXORDIVM.

ENIO NVNC AD TVTELAM PECV/
dum filueftrium & apium educationem:quas`
& ipfas Publi Siluine uillaticas paftiones iure
dixerim. Siquidem mos antiquus lepufculis
capreifq; ac fimilibus feris iuxta uillā plerunq;
fubiecta dominicis habitationibus ponebat ui/
uaria:ut e confpectu fuo claufa uenatio poffi/
dentis oblectaret oculos:& cum exegiffet ufus

220. Jenson's printing in 1472. By permission
of Mr. and Mrs. Jacob Lateiner, New York.

the College of Venice granted John of Speyer an exclusive contract to print editions of Cicero and Pliny. Speyer, a town midway between Mainz and Strasbourg, had apparently been the training ground for John and his brother Wendelin. The two brothers quickly produced a number of editions of Cicero and Pliny. John died in 1470, so his promise was cut short; but Wendelin continued to print. The example by Wendelin in Figure 219 dates from 1471. By modern gauges of measurement, types measure about 15 points high. The entire page measures 11½ by 17½ inches, and the vertical dimension of the type page is 12 inches; so the space between the columns is by no means as absurd as it might appear. Beset by various problems concerning paper preparation, inking, worn type, and so on, early printers can exhibit within one edition a variation in visual qualities that is both interesting and disturbing—disturbing because it is difficult to know which version of a particular type font shows the letter structure most honestly. Scholars of early printing are often bent on discovering who got there first, and collectors may be willing to fill in gaps with leaves from any printed version that has the proper pedigree. Students can see the problem for themselves in Figure 219, which shows that the right-hand column is more heavily inked than the left. Of course, contemporary printed pages exhibit variations in blackness (*color* in the printer's terminology), and this is as it should be in any craft or art where personal preference can be decisive. In the future, photographic methods may ensure absolute fidelity of alphabet images and this intriguing game will end.

In comparing the types of the brothers of Speyer and those seen in the example from Sweynheym and Pannartz at Subiaco (Fig. 217a), it will be apparent that the former show more understanding of the Renaissance minuscule hand. There is more space inside the letters, and the space outside is expanded to conform. Wendelin later tried a smaller 12-point Roman font, but its design was inept.

Jenson

The city of Venice could offer many inducements to printers. It had large libraries and many educated collectors of manuscripts. Skilled calligraphers were present, and paper was of excellent quality. A Frenchman, Nicolas Jenson, moved to Venice in 1470. Jenson had acquired the requisite skills in some German center of printing and was well prepared on his arrival in Venice. He began production in 1470, and his Roman face is reproduced here in two examples: Figure 220, dating 1472, and Figure 221, dating 1476. The first is a Latin text, *Scriptores Rei Rustuae,* while the second is a Latin text translated into Italian, a part of *Historia Naturalis* by Pliny the Younger. The type page of Figure 221 measures 6¼ by 11 inches, and the margins are quite generous, so it is apparent why Jenson's pages are seldom seen in full. A variation in inking can be seen in Jenson's originals, but his design of Renaissance letter forms could stand it without a total destruction of the page. He opened up the space inside the letters. Only the closed loops of a lowercase *a* and *e* were vulnerable to being filled with an excess of ink. The example in Figure 221 contains 19 capitals of sturdy design, and it will be noticed that a capital form is seen at the beginning of every sentence. The emphatic *Z* has more width than height, an exaggeration of Renaissance tendencies to make it square. Jenson died in 1480. His press produced about 150 books, and he was successful and admired in his own time. The presswork of his shop was not the best of the period, yet the beauty of his pages seems unapproachable today, and the reason for this fact seems to defy a precise answer.

It is generally assumed that the Roman types of Nicolas Jenson were unexcelled in the incunabula period. William Morris maintained that Jenson carried the development of Roman type "as far as it can go." Golden Type, a face designed by Morris for his Kelmscott Press, was based on

Nyctipolon:perche di nocte di lontano riluce.El Meliloro nafce per tutto:ma nobilif
fimo e in Actica.In ogni luogho recente & non biancheggiante & fimile al gruogho:
benche in Italia ha piu odore & e biancho.La Viuola biancha e el primo fiore che an
nūtii la primauera.Et ne luoghi tiepidi piu āchora nel uerno efcie fuori.Dipoi quella
che e chiamata Porporina.Dipoi laFiameggiante laquale e chiamata Flox.Et e folam
te faluaticha.El Codiamino e due uolte lanno: laprimauera & lauctunno. Fuggie el
uerno & laftate.Piu ferotino de fopradecti e el Narciffo & el giglio oltra amare.& in I
talia chome habbiamo decto per le Rofe.Et ī Grecia e piu ferotino lo Anemone.Que
fto e fiore di Cipolle faluatiche & altro che quello che diremo in Medicina.Seguita E
nanthe Melanthio & de faluatichi Helichryfo.Dipoi Anemōe laqual e chiamata Ti
monia.Dipoi el gladiolo cioe coltelluccio acompagniato da Hiacinthi. Lultima e la
Rofa & prima mancha excepto che laDimeftica.El Hyacintho dura affai & la uiuola
biancha & lo Enanthe:Ma quefta fe fuelta fpeffo non fi lafci femézire.Nafce ne luo
ghi tiepidi.Ha lodore de fiori delle uiti & indi pigla el nome:perche Enanthe fignifi
ca fiore diuino.Del Hyacintho e doppia fauola cioe che fia nato o di Hyacintho fan
ciullo amato dApolline:o del fangue daIace:perche in quello fi ueggono uene che fa
no figura di greche lectere quello fignificāti.Lo Helichryfo ha fiore aureo la fogla fot
tile & el gambo anchora fottile:ma duro.Di quefto fi fāno le ghyrlande eMagi fe pi
glono lunguēto di uafo doro elquale chiamano Apyron & credono che gioui alla be
niuolentia & alla gloria della uita.Quefti fono fiori di primauera. Gliftaterecci fono
el Lichno elfioī digioue & unaltra fpecie digigli .Item Typhon & lo Amaracho decto
Phrygio:ma molto bello e el Pothof.Quefto e di due fpetie: Vno elquale ha elfiore
del Hyacintho.Laltro ha fiore biancho:elquale molto nafce in monti. Et Irif fiorifce
laftate.Nellauctunno e la terza fpetie del Giglo.Gruogho & Orifi di due fpetie:uno
fanza odore & laltro odorifero. Tutti efcon fuori nelle prime pioue. Quegli che fāno
le ghyrlande ufano anchora el fiore dellafpīa:Ma & le tenere meffe della fpina fi met
tono tra edilicati cibi.Quefto e lordine de fiori oltra amare: Ma in Italia alla uiuola
fuccede laRofa & inanzi che laRofa manchi uiene el Giglo.Dopo laRofa uiene el Cy
ano & dopo elCyano lo Amarantho.Impero che la Vinchaperuinca fempre fta uerde
circondata di frondi in modo di linea & con nodegli. Quefta e herba Topiaria cioe la
quale nelluogho doue e fi conduce in uarie figure & alchuna uolta fupplifce al man
chamento de fiori.Quefta da greci e decta Chamedaphne cioe Lauro terreftre. La ui
uola biancha e di lunga uita:perche dura tre anni & dopo quel tempo traligna. laRo
fa ne potata ne arfa dura cīque anni:Ma potata ho arfa fi rinnoua.Dicemo che el ter
reno ha affai affare:Imperoche in Egypto fanza odore fono tuttu quefti & folamente
el Myrtho ha optimo odore.In alchuni luoghi fono prima quefte cofe due mefi.Ero
fai fi lauorano quando comīcia Zefiro & dipoi nel folftitio.Ma bifogna che tra quel
tempo fieno purgati & puri.

CVRA DI PECCHIE ET PASTVRA ET MOR
BI ET RIMEDII CAPITOLO .DVODECIMO.

a Glorti & alle ghyrlade fono conuenienti le pecchie(chofa fructuofa). Per rifpe
cto di q̄fte bifogna porre Thymo Apiaftro.Rofe.Viuole.Gigli.Cithyfo.Faue.

221. Jenson's type of 1476.

Jenson's work, and Jenson's alphabet has been the inspiration for a number of distinguished designs in this century. One of these was by the talented American Bruce Rogers, an acknowledged master of book design in this century.

In designing Centaur, Rogers took samples of Jenson's pages and had them enlarged photographically, placed tracing paper over the enlargements and made drawings from them. One of his working papers is reproduced in Figure 222. Here the Jenson type is at the top and Rogers' blacked-in letters are at the bottom. Centaur, of course, is more than a tracing of Jenson, and the work seen in Figure 222 simply illustrates a method of study. There were many other fine printers in Venice, and the contemporary type designs based on their fifteenth-century models are termed Venetian.

222. Bruce Rogers' worksheet for Centaur.

Manutius and Griffo

Aldus Manutius (Manuzio) was one of the most famous and influential of the early Italian printers. Born in 1450, Manutius was a Renaissance man, a scholar, and a doer. He set up a printing establishment in Venice in 1495 and immediately began to print books in Greek. There were no Greek types, so Manutius directed the first reasonable effort in this direction—a formidable task, since, according to his count, the completed font needed six hundred separate characters. He went ahead anyway. The early printers were devoted to manuscript styles, and in attempting to reproduce them in type they were caught in a trap. They felt the necessity of making characters of every ligature, accent mark, abbreviation, and mark of punctuation occurring in Greek or other manuscripts. Gutenberg had to design almost three hundred different letters, ligatures, and abbreviations. Today we use about forty characters in the lowercase, with seven or less ligatures. The ampersand is the only abbreviation.

Manutius also prepared texts for Humanistic scholars writing in Latin and published a tract by Pietro Bembo in 1495. In this effort he had the aid of a remarkably talented workman, Francesco Griffo of Bologna. Griffo designed the letters and cut the punches. This first effort in Roman letters was not cut too well, but it was the ancestor type of a family called Old Style Roman or Old Face Roman. After a series of cuttings, Griffo succeeded in producing the example seen in Figure 223. This is from the famous *Hypnerotomachia Poliphili,* by Francesco Colonna, which was published by Aldus Manutius in 1499. Griffo's font was sturdy and composed well, as the sample shows. His capitals were derived from inscription sources, after the manner of his time. He succeeded in getting them down to size so that their inclusion in a line of lowercase letters did not upset the even flow of black and white in the line, although their domination is more apparent in this example than in modern types of similar design.

While Griffo had undeniable talent in interpreting the Humanistic minuscule in type, Jenson was better, and so was Erhard Ratdolt. The latter came from Augsburg to set up shop in Venice in 1476, and his ten-year stay in that center was marked by excellent type designs and excellent editions. In terms of technique, Ratdolt probably ran the best shop, and his Roman types have been honored by imitation or inspiration during the present century.

In terms of history, Griffo was luckier than the others, because his employer, Aldus Manutius, ran editions that sold all over Europe, and in this manner Griffo's font became known and copied in other countries. The style was known as Aldine, after the publisher, but Spaniards called it *letra grifa.*

ti ſpeculi,& aurei diſcerniculi nelle ſue delicate mano , & candidi uelami
ni di ſeta plicati , & balneare interule offerentime portitore, recuſabonde
mi diſſeron. Che il ſuo acceſſo ad queſto loco era perche ueniuano al ba-
gno. Et immediate ſubiunxeron· Volemo checum nui tu uengni. Il qua
le coſti dinanti e, oue funde una fontana, non tu quella uedeſti? Io riueré
temente riſpoſi, Venuſtiſſime Nymphe. Si in me mille & uarie lingue ſi

223. The Griffo Roman employed in 1499.

Th 345
torn
plead

224. Poliphilus, a deliberate imitation
by the Monotype Corporation, Ltd.

abcdefghijklmnopqrstuvwxyza
ABCDEGHJKMNQRSTWX

225. Bembo, an excellent design by the Monotype Corporation, Ltd., based on Griffo's work.

All Old Style Roman fonts, the heart of our reading types today, derive from Griffo's models. He made subtle changes in Jenson's letters, and followers made subtle changes in those of Griffo. Jenson's slab serifs were derived from pen letters. Griffo reinterpreted these letter endings and cut them down. Most Old Style Roman faces pay homage to the original pen letters of Human-istic minuscule, but the serifs were altered by the carving of the punch cutters. One suggested reason for these alterations lies in the fact that knife-edged serifs cut the paper.

The original designs of Griffo are current in two inter-pretations. One is called Poliphilus, which was cut in 1923. This version is called a copy by the manufacturer, and attempts to duplicate the uneven punch cutting of the earlier day. An example of this is seen in Figure 224. It is by no means meant to be used at the size seen here, which is shown for purposes of instruction. Most Old Style Roman faces are available in large sizes for use in titles, but their principal function is to provide legibility, even color, and dignity in small sizes. Another type, Bembo, designed in 1929, was based on Griffo's original work of 1495, but it is a lightened reading of Griffo's intention, cutting sharper corners on serifs than those executed by punch cutters of the period. Bembo is seen in Figure 225, again in a larger size so that details of its structure can be studied.

Italic

The Aldus-Griffo team also produced the first italic type, in 1500. It is believed that the necessity for a smaller book forced this development. The first types in Roman letters were large, about 16 points. Every line took up almost ¼ inch. This resulted in a fairly large page and book. Sales of some of these large books were disappointing, and Manutius was willing to try any move that would increase the use of books. He decided on a small book that could be put in a pocket, and his first edition, a work of Virgil's, came off the press in April 1501 and measured about 3½ by 6 inches. The example of Aldine italic seen in Figure 226 is from an edition of Statius dated 1502 using the same small format and the original types. In style it was derived from Humanistic cursive hands, and it was designed on a metal body about 12 points high, roughly ⅙ inch. Ascenders and descenders were long, and so the *m*'s and *n*'s were quite small by modern standards. Another innovation in this original alphabet is the use of small capitals (*small caps* in printing terminology). They are smaller than letters with ascenders. Notice, too, the small white space between the capitals and the rest of the line, a feature common in Italy (see also Fig. 118).

Aldine italics were very shortly pirated by several printers in Lyons and Florence. One of these described himself as "the honest bookseller." Manutius complained,

T *alia iactanti crudelis Diua seueros*
A *duertit uultus· inamœnum forte sedebat*
C *ocyton iuxta· resolutáq; uertice crines*
L *ambere sulfureas permiserat anguibus undas*
I *licet igne iouis lapsísq; citatior astris*
T *ristibus exilijt ripis· discœdit inane*
V *ulgus· et ocursu domnæ pauet· illa per umbras,*
E *t caligantes animarum examine campos,*
T *ænariæ limen petit irremeabile portæ·*
S *ensit adesse dies· piceo nox obuia nimbo*
L *ucentes turbauit equos· procul arduus Atlas*
H *orruit· et dubia cœlum ceruice remisit·*
A *rripit extemplo Maleæ de ualle resurgens·*
N *otum iter ad Thebas· neq; enim ueloctor ullas*
I *t'q; reditíq; uias· cognatáq; Tartara mauult·*
C *entum illi astantes umbrabant ora Cerastæ,*
T *urba minor diri capitis· sedet intus abactis*
F *errea lux oculis· qualis per nubila Phœbes*
A *tracia rubet arte color· suffusaueneno*
T *enditur· ac sanie glissit cutis igneus atro*
O *re uapor· quo longa sitis, morbíq; famésq;,*
E *t populis mors una uenit· riget horrida tergo*
P *alla, et cœrulei redeunt in pectore nodi·*
A *tropos hos, atq; ipsa nouat Proserpina cultus·*
T *um geminas quatit illa manus· hæc igne rogali*
F *ulgurat, hæc uiuo manus aera uerberat Hydro·*
V *t stetit, abrupta qua plurimus arce Cytheron*
O *ccurrit cœlo· fera sibila, crine uirenti*
C *ongeminat signum terris· unde omnis Achæi*
O *ra maris late, Pelopeiáq; regna resultant,*

226. Griffo's italic in an edition of 1502.

. . . in the City of Lyons, books are fraudulently printed under my name. These books do not contain the name and place of the real printer, but are made in imitation of mine, so that the unwary reader will believe them printed in Venice. . . . Their paper is inferior and has a bad odor. The types do not displease the eye, but have French peculiarities and deformed capitals. The letters are not connected, as mine are, in imitation of writing.

Manutius pointed out the mistakes in the texts and the counterfeiters promptly corrected them, an affront of a model kind. Instead of calling the type Aldine they called it italic, since they could not admit the source of their inspiration. Manutius was wrong on one count—the imitations did hurt the eye.

The Aldine italic hurts the eye, too. It is no great artistic success, but at that time it was a difficult problem,

and punch cutters and printers suffered with it for many years. Arrighi designed a typeface for his writing manual of 1523, a continuation of the wood-block writing manual of 1522, and it succeeded in imitating his own formal Chancery hand. This first typeface was an attempt to encompass Arrighi's calligraphic descenders and ascenders, and it did not compose well. The second typeface, Figure 227, was a great improvement. Arrighi, on good advice, gave up his familiar flowing ascenders and descenders and put on the hooked serifs of Humanistic minuscule (except for *f*). The artistic success of this face was due to a skilled goldsmith and engraver named Lautitio di Meo de Rotelli, a Perugian. Cellini spoke

227. Arrighi's second italic design.

LIB. III

N *atiuam eripiunt formam indignantibus ipsis,*
I *nnutasque iubent alienos sumere uultus·*
H *aud magis imprudens mihi erit, et luminis expers*
Q *ui puero ingentes habitus det ferre gigantis,*
Q *uam si quis stabula alta, lares appellet equinos,*
A *ut crines magnæ genitricis gramina dicat·*
P *ræstiterit uero faciem, spolia et sua cuique*
L *inquere, et interdum proprus rem prodere uerbis,*
I *ndiciisque suis, ea sint modo digna Camœnis·*
R *es etiam poteris rebus conferre uicissim,*
N *ominibusque ambas uerisque, suisque uocare·*
Q *uod faciens, fuge uerborum dispendia, paucisque*
I *ncludas numeris, unde illa simillima imago*
D *ucitur, et breuiter confer· ne forte priorum*
O *blitus sermonum alio traducere mentem,*
I *nque alia ex aliis uideare exordia labi·*
I *amque age uerborum qui sit delectus habendus,*
Q *uæ ratio, nam nec sunt omnia uersibus apta·*
O *mnia nec pariter tibi sunt uno ordine habenda·*
V *ersibus ipsa etiam diuisa, et carmina quantum*

E *iiii*

228. Janiculo's type sheet, demonstrating the formidable problem of proliferation. British Museum, London.

highly of Rotelli, who engraved the intaglio matrices for wax seals of cardinals. Cellini in his *Treatise on Goldsmithing* allows Rotelli to explain his method in direct quotation. This is found in C. R. Ashbee's translation of 1898.

Figure 228 shows the entire font of the second Arrighi-Lautitio types. Berthold Wolpe, writing in *Renaissance Handwriting* (London, 1960), explains how this came about. These details do not appear in the standard histories of type and are given here because the typesheet of Figure 228 presents the problem of translating calligraphic hands into typefaces clearly. Arrighi printed a number of books for the poet Gian Giorgio Trissino (1478–1550). The two came from the same town, and when the poet left Rome to return to Venice, he took with him a set of matrices in order to set up Tolomeo Janiculo as his printer. Thus the typesheet of Figure 228 is Janiculo's printing of the font. A few Greek letters were added at the suggestion of the poet, who was interested in spelling reform. This shows the number of characters in Arrighi's second italic, and the effort is impressive to typefounders. Modern alphabets contain only a few ligatures, and Updike points out that italic became successful after designers threw out all this baggage and stopped trying to imitate calligraphy. Modern designers of italic are therefore faced with the problem of designing 26 letters, every letter of which is to be molded in isolation and must look good with every other letter.

Italic, after its laborious trials, was a successful type for books for perhaps one hundred years. Whole books would be printed in italics. Today italics are a standard part of almost all Roman printing fonts—which consist of capitals (sometimes small capitals), lowercase, and italics. Every effort is made for these several alphabets to appear homogeneous in design so that they can be used together on the same page, for italic now plays a subsidiary role in typography, where it is used for titles of books in the running text, for foreign words, and sometimes for captions.

229. Frederic Warde's Arrighi design.

typography

Modern designers of italic sometimes go back to original models for inspiration. The italic seen in Figure 229 was designed by Frederic Warde in 1925. It is called Arrighi and is based on that writing master's second typeface. The founder suggests that it be used with Centaur but probably hopes that it will be used on its own merit, and it has been. Another italic face was designed by Alfred Fairbank and is used to accompany the upright Bembo. This design was based on a Tagliente type of 1524, according to the London Monotype Corporation; but Fairbank has added that certain features of the design stem from Lucas, the Spanish writing master.

The Heritage of Gutenberg, Jenson, and Griffo 165

Round Gothic

The familiar and rather ancient rotunda style was converted to typeface rather early in the history of printing. In Figure 230 we see a specimen sheet issued by Erhard Ratdolt's shop in 1486. Ratdolt came from Augsburg and began to print in Venice in 1476. His famous type-specimen sheet of Figure 230, originally 13 inches high, is a remarkable document in the history of printing. It certainly demonstrates that the Italian writing styles of the fourteenth century were far from extinct and that Ratdolt understood the style perfectly in its inherent structural compatability with the technical demands of type processes. As noted, his Roman types were very well designed; but the round Gothic is seen in ten different sizes, and this suggests that Ratdolt was well equipped to handle many kinds of printing needs. In contrast, Jenson's fame resides in one Roman style in one size. In terms of taste one might prefer the crude power of the Subiaco pages; but in terms of sophistication Ratdolt's type sheet, printed 21 years later, shows a century of progress.

Rotunda was also popular in Spain, and early books printed there featured the round Gothic style of letters. The example of Figure 231 is taken from a facsimile edition of *Fábulas de Esopa (Aesop's Fables)* originally printed in Madrid in 1489, doubtless by a German. Technically the printing is excellent: the hairlines of *a* are clear and few counters (spaces inside the loops of *e* for example) are susceptible to filling with overinking. It is a fine example of Spanish printing of the incunabula period, and the woodcuts illustrating the fables are composed on the page in a simple and direct way. The early printers in Spain were Germans who became assimilated in the same way twentieth-century Germans have become assimilated in the culture of Mexico City: they learn the language immediately, go into business, and intermarry with the Mexicans. The round Gothic gradually died out, and there is little interest in, or use for, it today. William Morris (1834–1896) came close to the style in his Troy Type of 1892, but the problem was too subtle for him.

Above: 230. Ratdolt's specimen sheet of 1486, reduced in size. Although round Gothic versions dominate the page, Ratdolt's excellent Roman design is seen in the right column.

Right: 231. Lines from the first edition of *Fábulas de Esopa*, printed in Madrid in 1489.

FRANCE AND GARAMOND

Printing was introduced in France in 1470. Three Germans, Freiburger, Gering, and Kranz, set up a small shop in the shelter of the Sorbonne. The first type was a clumsy Roman face based on a version by Sweynheym and Pannartz. These partners had improved by 1469, but the first Paris types cut by Freiburger, Gering, and Kranz showed a lack of familiarity with Roman letters. Their round Gothic of 1473 was better but still badly cut, and the 1478 Roman type of Gering (his partners had returned to Germany) was heavily larded with Gothic elements. The first artistic success in French printing was published by Pasquier Bonhomme in 1477. This was an imitation of the French Gothic style of calligraphy, which we have studied under the name of bastarda, or in the French of the day, *lettre bâtarde*. The results were good, as can be seen in Figure 232. Round Gothic was introduced in 1481, and it was very well cut and composed. After the initial effort, Roman types were not used again until the century was near its end.

In the second quarter of the sixteenth century the important man in French printing was Geoffroy Tory, whom we have met before in his curious discourse on the construction of the Roman alphabet and through his intemperate comments on the authors of such alphabets, Pacioli in particular. But in spite of these curious pronouncements, Tory was a man of many talents. He was not only a poet, translator, artist, and critic, but was influential in establishing a norm for French spelling. Also a publisher and printer, Tory was chiefly responsible for the successful reintroduction of Roman types, which he used in his famous *Champ Fleury*, published in 1529. Updike regards this book as one of the important landmarks in the history of printing, although the types used are by no means up to the early standard set by Jenson.

Tory was given the *imprimeur du roi* for his efforts, and French printing flourished and acquired a reputation for a native elegance in the sixteenth century. Roman types of Old Style Roman and italic were designed and printed with great skill. In the midst of this success for the Roman types, Robert Granjon, a name perpetuated in contemporary type specimens, introduced a cursive type named Civilité, c. 1557. This was a new attempt at establishing a native *bâtarde* as the national cursive type. A version of it remains in a type book as late as 1742. Figure 233 shows its original form, and the Monsen typefoundry features a version of it in a recent catalog.

Claude Garamond (1480–1561) was one of the first to devote his efforts to the design and production of type following a period in which the function of typefounder, printer, editor, and salesman often resided in the talents

232. *Lettre bâtarde*, from the first book printed in French, c. 1477.

233. Granjon's Civilité of 1557.

of one or two men. Garamond is renowned for his efforts in designing fonts for other languages. His Greek types were especially important. He designed his Roman type around 1540, and it was based on the efforts of Griffo. Among Garamond's clients was the famous French publishing house of Estienne. Roman designs by Garamond were picked up by the famous publishing house of Christophe Plantin in Antwerp. Garamond had a skilled student in Robert Granjon, and their types were also used by the house of Elzevir in Amsterdam. Through the efforts of these publishers, the Garamond style became known throughout Europe, including Italy, and by the end of the sixteenth century it had achieved a dominant position in book production.

When Garamond died his equipment and fonts were scattered to the winds, and scholars doubt that a complete review of his work is possible. Most of the designs perpetuated in Garamond's name were created by Jean Jannon, who added a note of elegance, particularly to the

The Heritage of Gutenberg, Jenson, and Griffo 167

La découverte de l'imprimerie sépare le monde ancien du monde moderne.

La découverte de l'imprimerie sépare. le monde ancien du monde moderne.

a

234. (a) Roman and italic as designed in France. Some of the flavor is due to Garamond, but Jannon added polish to an interpretation of wide influence; (b) Garamond by Stempel, Germany.

italic. Jannon's versions were designed between 1615 and 1620, and examples are seen in Figure 234a. In this century every major typefounder has created a version of Jannon's letter shapes in type. Most of them are called Garamond, though a few bear the name of Granjon.

In book faces Garamond (Jannon) has been one of the most popular typefaces of this century, but it has lost favor in the last twenty years. *Liber Librorum,* an international project celebrating Gutenburg after five hundred years, found only two of fifty contributing printers using a version of Garamond. Oldrich Hlavsa, in *A Book of Type and Design,* suggests a way in which Garamond could be given new vitality:

Another characteristic of the Garamond type is that they show, in their designs, something of the softness of the written letter and this lends them a peculiar grace, particularly desirable wherever this type meets, in modern production, with illustrations drawn with equal ease and swiftness in pen, pencil or chalk. It is to be regretted that in recutting this type most of the typefounderies have failed to reproduce precisely this fine detail.

In other words, the pantographic method of type reproduction missed something that original punch cutters put in, and there has been more effort expended in recapturing the vigor of early Venetian printing than of early French. Morris F. Benson produced one of the standard Garamond designs in 1917 for American Type Founders, U.S.A. The version by Stempel-Germany is seen in Figure 234b, still a beautiful Old Style Roman alphabet.

The French style of sixteenth-century typography penetrated Germany but could not win. In other European centers it put down Gothic remnants and perpetuated the Roman letter forms of Jenson and Griffo.

b

ABC
DEFGHIJKLMNO
PQRSTUVWXYZ
abcdefghijklmnopqr
stuvwxyz&ffftæ

235. Caxton's type from *Dictes or Sayengis of the Philosophres.*

ENGLAND: CAXTON AND CASLON

The first printer in England was not a foreigner but a native, William Caxton, who was a mature businessman before he learned anything about printing. Caxton was, in effect, already retired when he started learning the printing trade in Cologne in 1471–1472. He set up his own press in Bruges in 1473 to print literature of his own choice. Caxton moved back to England in 1476, and in 1477 produced *Dictes or Sayengis of the Philosophres,* the first book printed on English soil. Caxton's vital contribution lay in the fact that of some 90 editions attributed to him, 75 were printed in English. Caxton translated about 20 books himself, and brought out two editions of Chaucer's *Canterbury Tales* before his death in 1491. His successors published three more editions of this famous work.

In describing Caxton's type forms, historians and critics are not inclined toward admiration. One critic has remarked that Caxton used his own crabbed handwriting as a model for the punch cutters, but it was the prevailing style of the land (see Fig. 124), and Italian hands were known only in remote corners of the culture. The version of Caxton's type reproduced in Figure 235 is from an edition of *Dictes or Sayengis of the Philosophres.*

Form and Reform

At about the time Caxton was publishing books a curious little habit developed in English printing. When the Anglo-Saxons dropped runic characters and began to write in Latin letters, they carried over several runic signs for special sounds. One of these was a sign for *th,* called a *thorn.* It looked like a cross between a *p* and a *y,* except that it had a short ascender with a cross-stroke on it. Printers in England for some reason did not cut a special character for this ancient sign and began to substitute *y.* The word *the* in print appeared as a *y* with a tiny *e* on top of it. At the time every reader knew what it meant, but subsequently it came to be pronounced incorrectly. The *ye* of Ye Olde Tea Shoppe and other quaint usages are remnants of this confusion, a last echo of runic signs.

The point here is that early editors and printers tried to get by with the basic Latin alphabet, and this tended to unify languages and dialects. The technical proliferation seen in Janiculo's type sheet is not based on any effort to accommodate other Italian dialects but was an attempt to duplicate the handwriting of one man, Arrighi. The poet Trissino included some Greek letters to show the difference in vowel sounds, but this did not catch on. His suggestion to printers that they use *i* and *u* for vowel sounds and *j* and *v* for consonants was more successful. In France, Robert Estienne of the famous printing house established the use of acute and grave accent marks and of the apostrophe around 1530, but generally after the establishment of printing, reformers tried hard but had little success. For many years the *Chicago Tribune* substituted different spellings for *through* and other vulnerable words. The fact that this influential newspaper was afflicted with Anglophobia has little to do with its failure in the area of spelling reform.

In the Middle Ages scribes tended to spell in a phonetic manner, trying to reproduce what they heard. As a result there could be a number of versions of the same word. Early editors had to decide how many characters to cut, how to spell the words, and which word among several choices was most suitable. An important edition could be decisive in determining standards for a series of related languages. Two quite distinct literary languages existed in Germany during the Middle Ages, but Luther's Bible, a skilled blend of High, Middle, and Low German, helped set a standard German language that all could learn at least to read. In a similar manner key publications in Italy made the Tuscan language standard over rival dialects. In England, Caxton is given credit for a unification of the puzzling Middle English dialects around the London version of speech.

As an example of the choice that Caxton had to make, according to S. H. Steinberg in *Five Hundred Years of*

The Heritage of Gutenberg, Jenson, and Griffo 169

Printing (Harmondsworth, England, 1961), he told a story of a London merchant who asked a Kentish woman for some "eggys" and "the good wyfe answerde that she coude speke no frenshe." Another man asked for "eyren" (an Old German word) and she "sayd she understood hym wel." This word for "eggs" was lost, so was *cleped* for "named," and many others. Perhaps television has pointed out the gains. In live telecasts emanating from places in the southern United States, from New York City, from London, from Scotland, and from Wales, whole sentences are sometimes lost and could never be understood in rural Mississippi. And yet inhabitants of these various places can all read the same newspaper.

There is no question that printing solidified the language wall between peoples, but in many cases languages were preserved by printing. Welsh would certainly have disappeared without a printed version of the language, and the same can be said for the small national tongues around the Baltic.

Rulebooks for typesetters and rulebooks used by publishers have the weight of tradition on their side, and reformers of the language have a hard way to go. For purposes of instruction in the lower grades, a special alphabet has been in limited use in England for a number of years. This is seen in Figure 236, which shows symbols for 44 sounds deemed essential in English speech. Figure 236 may suggest why early reformers wanted to add characters to the Latin alphabet and why others wisely resisted the temptation to add even one.

236. Special alphabet used in England for instructing schoolchildren.

Quousque tandem abutere, Catilina, patientia nostra? quamdiu nos etiam

Quousque tandem abutere, Catilina, patientia nostra? quamdiu nos etiam furor

237. Caslon's Roman and italic, 1734. Victoria and Albert Museum, London.

Caslon

English printers were dependent on European type-founders up to the time of William Caslon (1692–1760). He learned engraving and metalwork as a gunsmith, and also cut punches for bookbinders. On advice from a printer he set up a shop about 1720 and devoted his efforts to punch cutting and foundry production of types. Caslon's specimen sheet of 1734 established his reputation and severed England's dependent tie with European type-founders. His chief imprint on the typography of the present day lies in his rendition of an Old Style Roman. In Caslon's times the tradition had a considerable patina, going back through Van Dyck, the house of Louis Elzevir, and Cristophe Plantin (great figures in printing in the Netherlands), Granjon and Garamond in France, and back to Griffo. An example of Caslon's style is observed in Figure 237. Caslon's Old Style Roman and italic, outside of its debt to previous models, is considered to possess a certain English character, legible and saturated with common sense. Modern versions reflect this quality, perhaps, but it is difficult to assess typefaces in terms of national characteristics. Caslon's faces are still a part of the daily scene of printing, still contributing fine pages and good headings after other faces have been rejected. The typographic pun of Figure 348 features Caslon forms.

In the early days of printing, all of the calligraphers' strokes had to be interpreted in a manner more bold than the original. Manuscript styles could employ fine hairlines, but early punch cutters could not cut them, and papers, uneven in various batches, could lose fine lines quite easily. In early Roman types the difference between the thick and thin strokes was never severe. Engravers in copper could cut the finest lines, and their alphabets no doubt had an influence on the printers. John Baskerville (1706–1775), the famous English printer, had made a partial redesign of Roman and italic faces using thinner elements in the letters and less angular serifs, particularly in the italic. He also used smoother grades of paper. These letters were greatly admired on the Continent and contributed to the somewhat radical reworking of the three Roman alphabets—capital, lowercase, and italic. Chiefly responsible for the designs we call Modern Roman were Giambattista Bodoni (1740–1813), who worked mainly in Parma, and Pierre and Firmin Didot, brothers who headed a large printing establishment in Paris. Francois Didot (1689–1757), grandfather of the latter two, had started the family work in printing and allied enterprises and headed a flock of Didots who made printing history in France. Pierre (1761–1836) designed the types and operated the foundry. This is by no means the end of it. Firmin had two sons, Ambroise Firmin and Hyacinth Didot, who carried the family tradition into the nineteenth century, when the house name was Firmin-Didot. After listing a few more Didots, Updike makes the remark: "These are the chief members of a learned race of printers, publishers, typefounders, papermakers, authors, and inventors—whose family reunions must have resembled a meeting of the Royal Society!"

Below: 238. Didot designs from 1799.

Above: 239. Letters from Bodoni's manual of 1818.

INTERMISSA, Venus, diu

Rursus bella moves. Parce, precor, precor!

Non sum qualis eram bonæ

Sub regno Cinaræ. Desine, dulcium

Mater sæva Cupidinum,

Circa lustra decem flectere mollibus

Iam durum imperiis. Abi

ABCDEFG
HIJKLMNO
PQRSTV

*ABCDEFG
HIJKLM*

We are concerned now with Firmin Didot, who designed the types for his generation of Didots, and with Bodoni. The two were rivals in a sense. Didot's reworking of the Roman alphabet is seen in Figure 238, published by the brothers in 1799. Bracketed serifs have disappeared into thin lines, thick-and-thin characteristics are accentuated, and the pen-letter base for Old Style Roman has almost evaporated. It is clear, logical, and cold.

Bodoni's work is represented in Figure 239 from the famous type catalog *Manuale tipografico*, published in 1818, five years after his demise. A facsimile edition is listed in the Bibliography. It is regretted that limited space permits only a hint of what these great designers accomplished. The styles of Bodoni and the Didots were very popular in Europe and the United States in their own time, and remained so well into the nineteenth century. These forms have been reinterpreted by twentieth-century typefounders and remain a standard part of the printer's repertoire. We shall see some of these interpretations later. In the United States most of the tradition is carried in Bodoni's name, and every possible variation has been designed. Joh. Enschedé en Zonen, a firm in Haarlem, whose name was established in 1771, purchased a series of original Didot matrices in 1860 and have been casting fonts from them down to the present day.

The Heritage of Gutenberg, Jenson, and Griffo 171

Advertising began to play a key role in type design around 1800. The carefully cultivated Roman types, the product of three centuries of trial and error, could not provide what was needed in terms of visual power and emphasis. In the search for alphabets that could seize the eye and deliver a memorable image, typefounders began to experiment with existing type styles to see if more power could be extracted from them. Seizing on the Bodoni-Didot model we now call Modern Roman, type designers began to strengthen the principal anatomical features of the letters. These were held together with the same thin lines used in the much smaller reading sizes. An example of this kind of letter is seen in Figure 240, a peace edition of the *Albany Argus* of February 21, 1815. This cutting of Modern Roman is in good taste if consideration is given to the more bloated versions of this alphabet seen in the same period. Bodoni designed some quite heavy versions of his typeface, but the subtle qualities he imparted to it were lost in gross imitation. These heavy and brutal versions have been termed *fat face*, and the term serves well. With other type styles they enjoyed (or suffered) much internal decoration during the nineteenth century. Black-letter types, the ancient letters used by northern European calligraphers and by Gutenberg, were also given a trial effort in providing power. These letters were redesigned with their principal anatomical features thickened.

Perhaps the most original type design of the century was the square serif. Two versions of this style appear in lines 2 and 4 of Figure 241, a New York ad piece. The first line of this reproduction is the fattened Modern Roman of acceptable design, while the third is black letter. Line two represents the classical variety of the square serif letter, wherein shaded strokes are absent and strokes in any direction are given equal weight. Serifs are unbracketed (without curves) and have the same weight as the main stems of the letters. This is a rough description of the appearance of a square serif alphabet. In the designing of the letters some variation in the weight of the strokes is necessary, particularly when a curve enters a vertical stroke.

Square serif types appear early in the century. Robert Thorne cut the first square serif type in England c. 1806; within a twenty-year period many versions appeared and the species became a mainstay of nineteenth-century typefounders and printers. The variations on this theme are truly astonishing in the century, and some revivals stem from this period.

In the early part of the century the square serif types acquired the name Egyptian. This title has a connection with Egyptian monuments brought back to England and France in the early part of the century and is reflected in such current titles as Memphis and Karnak. In these early days of the nineteenth century the square serifs were also called Antique.

Still another kind of design developed in the early years of the nineteenth century is that now called *sans serif*. As the name implies, the design lacked serifs and was a geometric alphabet in which each stroke was of equal strength. The type first appeared in a specimen

240. Modern Roman with strengthened strokes.

241. An ad piece using several styles; lines 2 and 4 are square serif.

242. The first sans serif type, 1816.

243. From an advertising page in New York, 1854.

book by William Caslon IV in 1816, and the single line appears in Figure 242. It acquired various names, such as Doric, Gothic, and Grotesque. Figure 243 offers a more condensed version of the style printed in New York in 1854. The lateral condensation of the Lord & Taylor title permits more characters in a given line dimension (*measure* in the language of typographers), and this is particularly suitable for headings in newspapers, where both weight and vertical structure would be desirable. In the first decades of its use the sans serif faces featured only capitals. The lowercase (Fig. 241) appeared earlier in Germany and the United States than in England, where it was not cut until 1870. Terminology for this genus of faces now follows the *sans surryphs* coined by Blake and Stephenson of Sheffield, England, in 1833. Both versions, wide and condensed, have been redesigned in the twentieth century, and the wide sans serif enjoys a current vogue among graphic designers.

Script, or Cursive

Script or cursive typefaces derived from attempts to translate intaglio cursive into the sculptured technique of punch cutting. If one observes the difference between Arrighi's formal handwriting and his woodcut books, it is possible to get some feeling of the difficulty involved.

The copper engravers, as we have seen, made the cursive styles seem easy, once they had worked out a formula for connecting the various letters.

In the sixteenth and seventeenth centuries there were a number of attempts to convert national cursive hands into type; Civilité was one such typeface. In the urge to preserve national cursive hands in type there were formidable technical problems. None of the faces that resulted from experiments in this direction have survived. Toward the end of the eighteenth century some progress was made toward a truly cursive style in type. It was based on italic as interpreted by copper engravers. Perhaps the French

LETTERFOUNDER

punch cutters solved this problem first, c. 1800. Cut on individual pieces of metal, every letter must have its ending connect with the initial stroke of the next letter; thus every letter of the alphabet must be provided with a beginning and an ending of identical structure. The example seen in Figure 244 is from *Grammaire Egyptienne* (Paris, 1836), printed by the firm Firmin Didot Frères. This face was not used in the body of the book but in a letter of dedication contained in the front matter. Didot termed the face Anglaise. Notably different from the brutally heavy faces of the day, the formal script added a note of grace and quality to the printing scene. Some contemporary formal scripts are very similar to the example seen here; but there have been many attempts to inject separate visual content into cursive type fonts, including some that intend to communicate a casual sense. It is a little like trying to impart a carefree attitude to a group of marching soldiers.

244. Firmin-Didot cursive type, 1836.

Vos doctes leçons ont dirigé dans la carrière de l'érudition orientale les premiers pas de l'auteur de la **𝔊rammaire 𝔈gyptienne;** *vos souvenirs vous rappellent le jour où j'eus l'honneur de vous le présenter et de le recom= mander à vos bontés; cette première entrevue a laissé dans votre esprit de profondes impressions; quinze années plus tard, votre suffrage, hautement exprimé, a récompensé ses efforts et sa persévérance, en accréditant dans le monde*

Above: 245. An Ionic-Clarendon face in the word *Carriages.*

Below: 246. A line of decorated styles.

Ionic-Clarendon Types

Ionic-Clarendon faces are a cross between Roman and square serif types. They possess the heavy square stroke on the serifs but preserve the thick-and-thin characteristics of pen-derived Renaissance letters started by Poggio and perfected by Cresci and many others. Antique, or Egyptian, alphabets were developed early in the nineteenth century, and Ionic became still another name for these faces. Henry Caslon used the Ionic title for his square serif Roman in 1843. A more condensed version of the new development was issued by William Thorowgood in 1845. Thorowgood had purchased Robert Thorne's business upon the latter's demise in 1820. Clarendon was the title used by Thorowgood. In addition to other Roman characteristics, a bracketed or curved serif led the main vertical stroke into the sturdy terminations at top and bottom.

In the period between 1800 and 1850 printers in the United States were seizing on any and all typographic ideas that would lend variety to pages devoted to product advertising, and of course the new style was copied almost immediately. The example seen in Figure 245 is included not only because the word *carriages* shows good design and good punch cutting, but because the type is used to frame the woodcut. A very condensed version of the Ionic-Clarendon types survives in revivals designed in this century. In this style, sometimes called Italiennes, the vertical stem of the letter is light in comparison to the horizontal strokes—reminiscent of the ancient Roman rustic hand.

Decorated Types and Formats

The foregoing brief sketch of some of the variations of the Roman alphabet that were developed in the nineteenth century and that are very much alive today should not obscure the peculiar flavor of nineteenth-century typography. Typefounders and printers were seeking answers to the problem of "display" faces, roughly those sizes of type over ¼ inch in height that could attract reader interest. Decorated types were in use on the Continent in the eighteenth century, but in England and the United States, 1800 is a fair date for initial usage. After a slow start, the issuance of decorated types became epidemic in proportions. The Gothic revival had its influence in the typographic area. Writing in 1938, Nicolette Gray explains the impact of the revival in this way:

We habitually underestimate the nineteenth-century Gothic revival. . . . It was not a style but a language; like scholastic philosophy, a world in which the mind could move freely. Having established first principles consonant with reason, and reached convenient solutions to the main problems of construction, the philosopher or designer could concentrate on the grandiose or gambol in the infinite ramifications of detail. . . . It is indeed the only European style in which the whole range of human experience, scientific, intellect or flights of imagination, has found expression. And the early Victorians needed a world for their imagination.

Tennyson's version of the Arthurian legends was published in 1842. *Wuthering Heights* and *Jane Eyre* were accepted for publication in 1847. The business sense of the nineteenth century was thus injected with a romantic and extravagant flavor. Designers and punch cutters were caught up in the atmosphere. It must not be forgotten that these skilled performers were artists too.

There were outline styles in which the middle of the letter was left white, shaded styles wherein letters were made to look gray by hatching, shadow letters in which the designer gave the letters the illusion of three dimensions, and even rustic letters made to look like pieces of trees. Some alphabets reversed values with white letters on a black ground. The treatment of serifs was pushed to its limits, and the curved serifs of late Roman inscriptions (see Fig. 132) were given a strenuous reworking. A few of these designs can be seen in Figure 246, and more can be seen in volumes listed in the Notes and Bibliography. The New York Public Library has an important collection of nineteenth-century typefaces in the Robinson-Pforzheimer collection, and Rob Roy Kelly has been planning a book on this subject that should be very worthwhile. Many of the nineteenth-century faces were cut on wood, and Kelly points out that rural printers may still have some.

ZIGZAG STREAM SHADY SPILLED ETCHING MIDSHIPS

ABCDEFGHIJKLMNOPQRSTUVWXYZ
abcdefghijklmnopqrstuvwxyz

247. Ornamented font from the late nineteenth century. New York Public Library (Astor, Lennox, and Tilden Foundations).

Only one new idea from the second half of the nineteenth century seems to have survived the years. This was a wedge-shaped serif on a heavy Roman body, and type-specimen books use the title *Latin* for these styles. In the last quarter of the century a different kind of ornamented letter was developed. It was generally based on the architecture of Roman fonts, but had ornamental features difficult to describe and even more difficult to name. Alphabets similar to that seen in Figure 247 appear frequently in books of this period. No new faces like this have been cut recently, but television designers and magazine art directors have shown a considerable interest in such designs lately. Nineteenth-century typefaces are a new mine for exploration.

Several features of nineteenth-century composition are noteworthy. One of the most humorous and pleasing features of nineteenth-century typography in the United States was a tendency to use every font in the printer's repertoire in each piece of advertising. Thus all styles were thrown together on the same page. Unity and careful matching of type designs has been, and is, a painful part of the typographic arts, and a great deal of thought and toil are given over to the subject. It is such a sensitive matter that designers are a little fearful and tend to repeat combinations that have been successful. Many printers in the nineteenth century, sheltered by an umbrella of ignorance, threw in everything they had. There were no educated art directors planning the pages in those days. The compositor was given a piece of paper with a few words on it, and he composed the piece without further ado. This kind of advertising piece is seen in Figure 248, from the *Wisconsin Farmer* of 1860. The Bodoni face used in the words *dry goods* appears to be quite nicely designed, although the letter spacing may be too deliberate. Given enough white space, this gross mixing of styles was often surprisingly pleasant. The idea has intrigued many contemporary designers, and the successful pieces in which styles are mixed often feature a good deal of space between the lines.

Figure 249 also features the symmetry of nineteenth-century typography. The compositors of the period did not invent this method of representing letters, but the long-

248. An ad from the *Wisconsin Farmer*, 1860.

$25,000 WORTH OF
SPRING AND SUMMER
DRY GOODS:
AT THE NEW FIRM OF
MENGES & BARTELS,
No. 2, United States Block,
MADISON, WISCONSIN.
Our MR BARTELS has just returned f om NEW YORK and BOSTON, where he has purchased the best assorted Stock of
STAPLE AND FANCY DRY GOODS!
EVER SEEN IN THIS CITY.
As their DOMESTIC GOODS have been bought for CASH exclusively, they are able to compete in prices with MIL WAUKEE and CHICAGO, and they invite
COUNTRY MERCHANTS & FARMERS
To call on them, before purchasing elsewhere.
We also keep on hand a Good Assortment of
Yankee Notions!

249. Part of a nineteenth-century title page.

A
UNIVERSAL
ALPHABET, GRAMMAR, AND LANGUAGE:
COMPRISING
A SCIENTIFIC CLASSIFICATION
OF THE
RADICAL ELEMENTS OF DISCOURSE:
AND
ILLUSTRATIVE TRANSLATIONS
FROM THE
HOLY SCRIPTURES AND THE PRINCIPAL BRITISH CLASSICS:
TO WHICH IS ADDED,
A DICTIONARY OF THE LANGUAGE.

The Heritage of Gutenberg, Jenson, and Griffo 175

winded titles of the day put a burden on the method that it could not support and a quality of boredom set in. This can be seen in Figure 249. The idea of perfect symmetry has also intrigued contemporary designers but they seek solutions that do not put the reader to sleep.

Tasteful usage of ornamented types may be observed in Figure 250. The types used here suggest a quality in the music to be heard and are in suitable contrast to other elements in the design, deliberately severe in the lower lines.

Figure 251 tells a story about nineteenth-century typography in the United States. It is a document that exhibits the fantastic proliferation of styles and sizes available to printers in the latter half of the century. Although our society is presumably more affluent today, few contemporary printers can match the array seen here. In style the piece communicates a dazzling vulgarity quite in keeping with the entertainments announced, and in this sense nineteenth-century typography reflected life on the frontier—brashly improvised. It is true that printers lost their connection with great literature and distinguished type pages of the past, and on these counts the century represents a low point in the typographic arts. Nor were clients of the rising middle class in any position to establish standards of taste. Yet when we review the typography of the century and contemplate the wonder of Figure 251, it is difficult to say that it was all bad.

Below: 250. Ornamented types in contemporary usage. New York Baroque Ensemble.

Right: 251. Types in proliferation. *Design Quarterly,* Minneapolis, Minn., and Rob Roy Kelly.

176 *The Alphabet in Types*

Part V THE TWENTIETH CENTURY

The mark of the Kelmscott Press.

Chapter 8 Morris, Dada, and Bauhaus

At the turn of the century that curious movement known as Art Nouveau held the stage in several areas of the arts. In its sources Art Nouveau was a strange mixture, and letter forms were difficult to fit into its flowing iconography or its bucolic baroque quality. Individual artists like Lautrec and Bonnard could draw or paint letters that were at home in the plastic environment of Art Nouveau, and in this sense it was a period of interesting experiment in a particular type of integration. Every man went in his own direction, and as a movement in letter structure Art Nouveau led nowhere. In the area of graphics hand-lettered titles could be tortuously drawn to fit the molasses patterns of the day, but these suffered a loss in terms of legibility. For type designers it was a difficult time. A number of fonts were cut and used in printing, but they in no way enhanced the art of letter structure.

Several fat and rubbery type designs were executed in a delayed commercial reaction to the movement, but these are best forgotten.

Restless and crawling, the graphic content of Art Nouveau needed a calligraphic tradition like the Arabic (Fig. 252) to fulfill its needs in letter structure but never quite got it. One can observe the fulfillment in the Moorish architecture of Spain. Roman inscription models and the Renaissance minuscule could not be reworked to fit the graphic need, and the decorated styles of the nineteenth century were rejected *in toto* — one decorative sect prohibiting another. In contemporary practice, especially in commercial printing and television, sufficient time has elapsed, and borrowing from these traditions is now acceptable and profitable.

252. Arabic calligraphy by Hafiz Osman, 1642–1698. Topkapi Saray Museum, Istanbul.

THE REVIVAL OF FINE PRINTING IN ENGLAND

Nineteenth-century efforts in type alphabets have been presented in terms of exuberant experiment and a vulgarity of cheerful texture excused by frontier ignorance. In truth that element was present, but the decline in taste was a serious matter. Today we are amused by the nineteenth-century title page that exhibits eight or ten different fonts of type, with indifferent spacing in the lines. But the calligraphy of the Middle Ages and the calligraphy and typography of the Renaissance furnished models of clarity and elegance that were lost in the nineteenth century, and the story here involves something of the efforts to regain lost values. Initially the effort required men of strong conviction plus money. Both were necessary to pioneer new type fonts and to pay for them with little hope for any financial return. The concern was entirely esthetic.

Perhaps the degree of concern in such matters as selection of typeface, spacing, inking, papers, and strength of impression can be gained from two quotations from

Pi, by Bruce Rogers. Rogers relates part of the story of his work on the Oxford Lectern Bible — perhaps the most noble book production of this century. The completed Bible contained 1238 pages. Rogers was very careful about word spacing and had made many trial proofs. In conference, John Johnson, Oxford's printer, had this to say: "What protection am I to be given against Rogers in the matter of spacing? If he has his way throughout, none of us will live long enough to see the end of this book." And with regard to paper selection, Rogers tells this story:

Some time before the Bible was even contemplated I had discovered at the Hayle Mill of Messrs. J. Barcham Green & Sons a small lot of very beautiful paper which they had made a number of years earlier from fibre imported from Japan. For whatever reason no more had ever been produced and this experimental lot was all there was in existence. When work on the Bible was well underway I recollected this paper, and I found on investigation that there was enough to print a single copy, provided that no more than twenty or thirty sheets were spoiled in process. After considerable persuasion the Messrs. Green agreed to sell me the lot, and it was shipped to Oxford just before the printing began. I may say here that owing to the watchful care of the press men not a single sheet was damaged thruout the printing.

The single volume was given to the Library of Congress.

The people who make fine books deserve some comment, but their products are imbued with subtle visual and tactile qualities that do not come across in reproduction. It is possible to learn something from black-and-white reproductions of the types of Gutenberg and Jenson because they are historically important, but most fine printing must be seen in the original. The art is actually degraded in the process of reproduction. Our interests here will center on alphabetic design and efforts to arrive at new forms appropriate to literary content.

The Kelmscott Press

There were private presses before the time of William Morris and his famous Kelmscott Press. But Morris is chiefly responsible for the twentieth-century resurgence in activities and interests involving fine printing. After 1900, private presses mushroomed. Printing is an ephemeral activity, and the average life span of a press is less than that of a cat. Yet a number of private presses have lasted for decades and have become renowned for the beauty of their books.

Morris started his work in calligraphy around 1870 and developed some ideas about type. He discussed these ideas with a friend, Emery Walker, an excellent printer. The Kelmscott Press was finally established in 1891. *News*

HE seuenth comandement is that thou shal do no thefte. This comandement forbedeth to take away other mennes thynges what someuer they bee, without reson, ayenst the wyll of them that owe or make them. In this comandement is defended Rauayne, vsure, robberye & deceyte, & begylyng other for to haue theyr hauoyr or good. And he that doth ayenst this comandement is bounden to make restitucion and yeld agayn that he hath so goten or taken, yf he knowe to whom he ought to rendre it. And yf he knowe not, he is bounden to gyue it for goddes sake, or doo by the counseyl of holy chirch. For who reteyneth wrongfully & without reson other mennes good agayn theyr wyll, synneth dedely, yf he paye not where as he

Of the Hys-
torye of
Moyses

a

that he made, but that he ran faste out of the hool, and he was there cratched & byten, and many an hool had they made in his cote and skyn, his visage was alle on a blood and almoste he had loste his one ere. He groned and compleyned to me sore, thenne asked I hym yf he had wel lyed. He sayd: I saide lyke as I sawe and fonde, and that was a fowle bytche wyth many fowl wyghtis. Nay, eme, said I, ye shold haue said: fayre nece, how fare ye and your fair chyldren which ben my welbelouid cosyns? The Wulf sayd:

b

WHEN she awoke it was broad day, and there was someone going about in the chamber; she turned, and saw that it was Aloyse. She felt sick at heart, and durst not move or ask of tidings; but present- ly Aloyse turned, and came to the bed, and made an obei- sance, but spake not. Goldi- lind raised her head, & said wearily: What is to be done, Aloyse, wilt thou tell me? for my heart fails me, and, meseems, unless they have some mercy, I shall die to- day. Nay, said the cham- bermaid, keep thine heart up; for here is one at hand

Now
comes
to her
Aloyse

c

253. Three type fonts used by the Kelmscott Press: (a) the Roman face Golden Type, (b) Troy Type, used in 1893; and (c) Chaucer Type, used in 1895.

207

from Nowhere, which Morris began in that year, was first printed in existing type, but the Kelmscott Press is especially noted for productions using three type fonts especially designed by Morris and his technicians. These are reproduced in Figure 253. The example set in Roman type is taken from Voragine's *The Golden Legend*, pub- lished in 1892, and is called Golden Type, after the title of the book. Morris admired the types of Nicolas Jenson, c. 1470, and Golden Type is based on Jenson's work, though it is by no means a copy. As in the Roman hands of Edward Johnston, a slightly medieval quality seems em- bedded in the design. Larger type is used in part of a page from Caxton's *Reynard the Foxe*, which the Kelm- scott Press issued in 1893. This type is called Troy Type, after another book title, and was based on types made by Erhard Ratdolt and others in the round Gothic. Here again the Morris version is no copy and remains a rather

unique contribution in the history of letter forms. A third type is called Chaucer Type, and the sample seen here is a complete type page from *Child Christopher and Goldilind the Fair*, written by Morris and published in 1895. This too has echoes of the late Middle Ages. In all, the Kelmscott Press issued 53 books. Rather good reading on the Kelmscott Press is furnished by Morris himself in *The Art and Craft of Printing* (1902). This was issued by the Elston Press. The contents include "Notes on the Founding of the Kelmscott Press." Unfortunately, the volume is fairly rare.

If it gets down to fine points, it is possible to be critical of the William Morris typography. Golden Type is not by any means the shining model that Jenson gave the world, nor is it the equal of Centaur or many others; yet it must be said that a large page of Troy Type is rather impressive when seen in marriage with texts selected by Morris.

Ubi est dialectica? ubi astronomia? ubi sapientiæ consultissima via? Quis, inquam, venit in templum, et votum fecit, si ad eloquentiam pervenisset? quis, si philosophiæ fontem attigisset? Ac ne bonam quidem valetudinem petunt: sed statim, antequam limen Capitolii tangant, alius donum promittit, si propinquum divitem extulerit: alius, si thesaurum effoderit: alius, si ad trecenties HS. salvus pervenerit. Ipse senatus, recti bonique præceptor, xxxix

254. King's Fount by the Vale Press.

The Vale Press

But Morris had an opponent in his own times who was much tougher on him than subsequent critics. This was Charles Ricketts of London, who established the Vale Press in 1896. Morris hated the Renaissance. The Mackail biography states that around 1873 Morris rejected a proposal to visit Rome with these words: "Do you suppose that I should see anything in Rome that I can't see in Whitechapel?" Ricketts, on the other hand, was fascinated by the Renaissance and admired the sunlit pages issued by Venetian printers. Although their life spans overlapped, the Ricketts attack on the Kelmscott typography and book production did not appear until 1899, several years after the death of Morris. It is highly unlikely that Ricketts' "A Defence of the Revival of Printing" would have changed any views held by Morris. The distinguished Vale Press used three type fonts designed by Ricketts: the Vale Fount, an impressive large Roman type; a smaller Roman face that was called the Avon Fount; and a truly strange alphabet called the King's Fount, one of the first experiments toward an uncial alphabet in modern typography. A few lines of King's Fount are seen in Figure 254. Decorative blocks made by Ricketts were lost in a fire, and the punches, matrices, and types were destroyed after the last book issued in 1904.

The Ashendene Press

C. H. St. John Hornby of London established the Ashendene Press in 1895. Early books featured types by Caslon and Fell. Later a version of the Subiaco types of Sweynheym and Pannartz was designed. This type is seen in Figure 218. It was first used in 1902 in a production of Dante's *Inferno* and then in Ashendene's complete edition of Dante in 1909. This latter is rated by some experts as one of the finest books of the century. The author possesses a few pages of the *Faerie Queene* from Spenser's

Minor Poems published in 1925. Dimensions of the page are 12 by 17 inches, and the type page is 8½ by 12. Seen in this kind of format, the peculiarly Gothic quality in the types is quite imposing. Another special Ashendene font, a Roman crossed with pre-Renaissance calligraphy, was used in certain books like *Les Amours pastorales de Daphnis et Chloë* (1933). This peculiar type does not seem very successful. Updike does not bother to mention it. The Ashendene Press closed in 1935.

The Doves Press

The famous Doves Press came into being in 1900. It was established by Emery Walker, a Morris associate in the Kelmscott Press, and Thomas James Cobden-Sanderson, who had founded the Doves Bindery in 1893. This team, high in skills and with well-founded ideals in type design

EVELYN Hope

BEAUTIFUL EVELYN HOPE IS DEAD
Sit and watch by her side an hour.
That is her bookshelf, this her bed;
 She plucked that piece of geranium-flower,
Beginning to die too, in the glass.
 Little has yet been changed, I think—
The shutters are shut, no light may pass
 Save two long rays thro' the hinge's chink.

255. Doves Roman (slightly reduced).

and book production, produced some memorable books before it ceased production. Books issued by the Doves Press generally show a rejection of the idea of decoration, illustration, and ornamented initials, and the type communicates directly to the reader. To accomplish this the Press needed a good Roman type that could stand the pressures of this aim, and it accomplished this goal. A sample of the Doves Roman is seen in Figure 255, from Browning's *Men and Women*, published in 1908. The paragraph sign, originally in green, was hand-flourished by Edward Johnston. The Roman type used by the Doves Press was about 15 points in height and served in many capacities. It looked good in poetry, as can be seen, and was the type used in the most memorable production of the Press, the excellent Doves Bible produced in 1903, one of the honored books of the century. The Doves Roman was also based on Nicolas Jenson's Roman types, "freed from the accidental irregularities due to imperfect cutting and casting." The *y* of the lowercase drew critical comment from Updike, who said its harsh line was an intrusion into the general conformation of the lowercase. Its beauty was perhaps too coldly conceived to approach Jenson's pages.

Emery Walker withdrew from the Doves enterprise in 1909. According to Updike, Cobden-Sanderson, "with considerable elegaic ceremony, brought its work to a close a few years later." This may refer to a happening of 1916 when Cobden-Sanderson is reputed to have taken the Doves punches, matrices, and type and drowned them in the Thames.

The Essex House Press

The Essex House Press was established in 1898 by C. R. Ashbee at Essex House in London. Upon the death of Morris his types were held in estate, and 664 wood blocks cut by Morris went to the British Museum on condition that they were not to be used in printing for one hundred years. As of this writing, the centennial will be coming up in 29 years. On the closing of Kelmscott, the plant was acquired by the Guild of Handicraft, which Ashbee founded. Essex House Press issued its last book in 1917. It used Caslon types for a time, but Ashbee designed two new faces for his press. Endeavor, one pica high, was produced in 1901, and Prayer Book, named for the King's Prayer Book, appeared in 1903. Both were ugly, and the best work by the Essex House Press used Caslon.

The Eragny Press

Lucien Pissaro learned to draw under the tutelage of his father, the well-known French painter. A French review commissioned the young man to illustrate a story, but the editor received a flood of unfavorable comment, said to stem from pens wielded by students in the atelier of a "well-known painter." Rebuffed in this effort of 1886, Pissaro crossed the Channel from his home in Normandy and settled in England. Pissaro's Eragny Press was established in 1896 and ceased in 1903. *A Brief Account of the Origin of the Eragny Press* was issued in 1903 and was carried by a good Roman type designed by Pissaro and called Brook Type.

The six presses just discussed were the heart of England's major contribution to the revival of fine printing. Another strong effort was made by the Gregynog Press, which operated between 1922 and 1940. If the "pseudo-Gothic" type designs appear quaint, perhaps one or two of the book titles have already suggested that they were in part designed to implement a "neo-Romantic" literature. Yet Kelmscott's production of Chaucer, no matter what one thinks of the Burne-Jones illustrations, deserved to be shown in a type that reflected something of the heritage in terms of native manuscripts. Repeated, and finally successful, attempts to redesign the Roman alphabet meant that private presses were bent on exhibiting contemporary literary efforts with some dignity. This was an important gain.

THE SPREAD OF INTEREST IN FINE PRINTING

Dublin's Cuala Press was established in 1902. It was operated by two sisters of William Butler Yeats, a powerful figure in the Irish literary revival. The Cuala Press printed works by Yeats and his associates or translations of early Irish legends. Besides Elizabeth and Lily Yeats, the work force consisted of eight girls. They printed with an Albion press employing only 14-point Caslon Old Face on a domestic rag paper.

Nordisk Antiqua

256. Zachrisson's Roman, c. 1906. Erik Lindegren, *ABC of Lettering and Printing Types.*

Europe

In Sweden the Morris influence was absorbed by the distinguished Göteborg printer Waldemar Zachrisson (1861–1924). Monthly pamphlets, set in a round Gothic type, featured the Morris style of decoration and propogated the Morris ideal. Around 1906 Zachrisson also pioneered a Roman type that he felt would particularly suit the Nordic languages. An example of this strong alphabet, called Nordisk Antiqua, is seen in Figure 256. In Sweden the impetus provided in the early years of the century continues.

Reform efforts in Germany centered on the strong efforts of Carl Ernst Poeschel (1874–1944), one of the distinguished printers of the century. Poeschel began publishing in 1902 and with Walter Tieman founded the Janus Press in Leipzig in 1907. In the same year the Grand Duke Ernst Ludwig von Hessen established the Ernst Ludwig Press in Darmstadt to encourage the art of fine printing. In 1910 the critical journal *Der Zwiebelfisch*, published in Munich, began its influential period. In 1912 the famous Insel-Verlag of Leipzig published the facsimile of Gutenberg's 42-line Bible. Karl Klingspor, E. R. Weiss, and Rudolph Koch were a few among many pioneers in the printing reformation in Germany.

The United States

In the United States, Daniel Berkeley Updike started the Merrymount Press in Boston in 1893. The type known as Merrymount was a collaboration between Updike and Bertram Grosvenor Goodhue, an architect who had designed the Cheltenham fonts that are still in the type repertoire. Around 1895 Updike and Goodhue designed a heavy Roman type. The team was seduced by the black types of William Morris and produced the type seen in Figure 257. It was used in *The Altar Book* (1896) and in an

DOMINE omnipotens, Deus patrum nostrorum Abraham, et Isaac et Jacob, et seminis eorum justi, qui fecisti cœlum et ter⁄ ram cum omni ornatu eorum ; qui ligasti mare verbo præcepti tui; qui conclusisti abyssum, et signasti eam terribili et laudabili nomine tuo; quem omnia pavent et tremunt a vultu virtutis tuæ, quia importa⁄ bilis est magnificentia gloriæ tuæ, et insustentabilis ira comminationis tuæ super peccatores; immensa vero et investigabilis misericordia pro⁄ missionis tuæ: quoniam tu es Dominus, altissimus, benignus, longaminis, et multum misericors, et pœnitens super malitias hominum. Tu, Domine, secundum multitudinem bonitatis tuæ promisisti pœnitentiam et remis⁄

257. Goodhue's Merrymount type.

edition of Tacitus' *Agricola* (1904), both in folio rather than bound in signatures. It is a regal piece of letter design and deserves a monumental production.

Updike was interested in the Roman type styles of Herbert Horne of England in the latter's periodical *The Century Guild Hobby Horse* (1886–1892). Horne was acquainted with Morris but did not share Morris' zeal for the medieval. Horne designed several Roman faces, the first of which, Montallegro, was cut by E. P. Prince, a Londoner who cut the punches for the Kelmscott Press, the Doves Press, and other presses of the period. Here was one bricklayer who was as important as the architects. A feature of this period involves the design efforts of well-meaning amateurs. Punch cutters like Prince had to interpret these designs. The Montallegro font was first used by the Merrymount Press in 1905 in Condini's *Life of Michelagnolo Buonarroti.* An example of this type, open and clear, is shown in Figure 258.

Theodore Low De Vinne (1828–1912) was instrumental in the founding of the Grolier Club of New York in 1884. This organization, devoted to the production of fine editions of important and neglected works, was the predecessor of the limited editions clubs that have become influential in more recent years. The Grolier Club sponsored the beautiful edition in 1933 of Fra Luca de Pacioli's work, featuring the famous set of constructed capitals. Of 79 books sponsored by the Grolier Club, 51 were printed by De Vinne's press. Beyond this, De Vinne's writings and influence were important in the United States.

Frederic W. Goudy started his Village Press in Park Ridge, Illinois, in 1903. As an infant Goudy was present when Lincoln's body was brought to Springfield, Illinois.

Goudy's story is strong in pioneer quality: youth in South Dakota, contact with Indians who fought Custer, and riding broncos. The *Hyde County Bulletin* of September 3, 1887, reported that "Fred Goudy killed a rattlesnake Sunday morning. . . . It measured three feet and eight inches and was as large as a man's wrist. It had eleven rattles."

Despite these rustic origins, Goudy could recognize quality, and the first book issued in Park Ridge was an essay, *Printing*, by Emery Walker and William Morris. Goudy moved to Hingham, Massachusetts, in 1904; to New York in 1906; and to Marlborough (near Newburgh) on the Hudson River in 1922. This was near the property where Dard Hunter had established his replica paper mill in 1913. After many years of hard times, Goudy's success in 1911 with a type design called Kennerly Old Style enabled him to print with a degree of security. Goudy drew the capitals and lowercase for the Kennerly types in one week, and his great success in this area was due primarily to inherent abilities to draw with style and an almost occult sense of what the types would look like on the printed page, a gift that more learned designers lacked. A part of *A Christmas Carroll* by George Wither is reproduced in Figure 259. This was issued by the Village Press in 1915 and features the Goudy design called Kennerly italic. *The Story of the Village Type* was issued by Goudy in 1933 under the imprint of the press of the Wooly Whale. It contains a list of Goudy's type designs to that year. Goudy's Village Press was severely damaged by fire in 1908, and in 1939 it was completely destroyed by fire—equipment, the hand press, matrices, and many drawings and type designs were lost. Certainly a hard blow to a man of seventy-four.

And if you set him beneath as good a man as him self at the table: that is against his honour. If you doe not visite him at home at his house: then you knowe not your dutie. Theis maner of fashions and behaviours, bring men to such scorne and disdaine of their doings: that there is no man, almost, can abide to beholde them: for they love them selves to farre beyonde measure, and busie them selves so much in that, that they finde litle leisure to

S O NOW IS COME our ioyfulst Feast;
Let euery man be iolly.
Each Roome, with Yuie leaues is drest,
And euery Post, with Holly.
Though some Churles at our mirth repine,
Round your forheads Garlands twine,
Drowne sorrow in a Cup of Wine:
And let us all be merry.

Top: 258. Horne's Montallegro design.

Above: 259. A Goudy italic, 1915.

Notes on Private Presses

E. K. Lieberman's *The Check-Log of Private Press Names* (White Plains, 1963), lists about seventeen hundred names used by private presses. It is impossible to mention all of the notable private presses, but London's Fanfrolico Press and Jack Lindsay published 37 volumes between 1926 and 1930. This was an admirable venture. The Black Cat Press of Chicago published a *Bibliography of Material Relating to Private Presses* in 1937. The Golden Cockerel Press started publication in 1920 and produced many fine editions. By definition a private press is one that lacks commercial connections. The Spiral Press, established in 1926, defies the rule, since Random House distributes books produced by this press. Very high standards are maintained, and the books are available to more readers than would normally be the case.

Most private presses operate on a shoestring. It is unfortunate that the operators are unable to experiment with their own type designs, but the great expense precludes this. The victory of the Morris movement lies in the fact that thousands of people care about fine printing. Commercial presses are not indifferent to the subject, but the private press tends to keep them honest.

To conclude this discussion it is appropriate to see the work of a veteran printer who has studied the various traditions of the twentieth century. The page in Figure 260 was conceived and printed by Henri Friedlaender of the Hadassah Apprentice School of Printing in Jerusalem. In alternate lines the Hebrew reads from right to left and the German in the opposite direction.

260. Printing by Henri Friedlaender of Jerusalem.

תפלה למשה איש־האלהים:
EIN GEBET MOSCHES, DES MANNES GOTTES.

אדני
Mein Herr,

מעון אתה היית לנו ׃ בדר ודר:
du bist, du Hag uns gewesen / in Geschlecht um Geschlecht.

בטרם הרים ילדו ׃ ותחולל ארץ ותבל:
Eh die Berge wurden geboren / Erde kreißte und Welt,

ומעולם עד־עולם ׃ אתה אל:
von Zeiten her bis in Zeiten / Gottheit bist du.

תשב אנוש עד־דכא ׃ ותאמר שובו בני־אדם:
Bis zum Mulm lässest den Menschen du kehren / und du sprichst: Kehrt zurück, Adamskinder!

כי אלף שנים בעיניך ׃ כיום אתמול כי עבר:
— Denn tausend Jahre sind dir in den Augen / wie der gestrige Tag, wenn er vorbeizog,

ואשמורה בלילה:
oder eine Wache in der Nacht.—

זרמתם שנה יהיו ׃ בבקר כחציר יחלף:
Du ergießest sie / ein Schlaf ists, da sie werden / am Morgen treibts dann wie Gras:

בבקר יציץ וחלף ׃ לערב ימולל ויבש:
das am Morgen blühte und trieb / am Abend wirds gesichelt und dorrt.

כי־כלינו באפך ׃ ובחמתך נבהלנו:
Ja, wir vergehen in deinem Zorn / durch deinen Grimm sind wir verstört:

שתה עונותינו לנגדך ׃ עלמנו למאור פניך:
du stellst unsre Fehle dir gegenüber / unsern Hehl vor deines Angesichts Leuchte.

כי כל־ימינו פנו בעברתך ׃ כלינו שנינו כמו־הגה:
Ja, in deinem Aufwallen wenden all unsre Tage / wir lassen unsre Jahre wie einen Seufzer vergehn.

ימי־שנותינו בהם שבעים שנה ׃ ואם בגבורות שמונים שנה:
Die Tage unsrer Jahre sind für sich siebzig Jahre / und wars in Kräften, sinds achtzig Jahre,

ורהבם עמל ואון ׃ כי־גז חיש ונעפה:
und ihr Ungestüm ist Mühsal und Harm / wenns mäht, eilends, entfliegen wir.

מי־יודע עז אפך ׃ וכיראתך עברתך:
Wer erkennt die Macht deines Zorns / und, wie du zu fürchten bist, dein Überwallen!

למנות ימינו כן הודע ׃ ונביא לבב חכמה:
Unsre Tage zu bestimmen, laß es recht kennen / daß ein Herz der Weisheit einkomme uns!

שובה יהוה עד־מתי ׃ והנחם על־עבדיך:
Kehre um, Du! bis wann! / lasse es leid werden dir deiner Knechte!

שבענו בבקר חסדך ׃ ונרננה ונשמחה בכל ימינו:
Zum Morgen sättige mit deiner Huld uns / daß wir jubeln und uns erfreuen / in all unsern Tagen!

שמחנו כימות עניתנו ׃ שנות ראינו רעה:
Erfreue uns, / den Tagen gleich, da du uns beugtest / den Jahren, da wir das Arge sahn.

יראה אל־עבדיך פעלך ׃ והדרך על־בניהם:
Sichtbar werde deinen Knechten dein Wirken / dein Glanz über ihren Kindern!

ויהי נעם אדני אלהינו עלינו ׃
Meines Herrn, unsres Gottes, Mildheit / sei über uns!

ומעשה ידינו כוננה עלינו ׃
Das Tun unsrer Hände richte auf über uns,

ומעשה ידינו כוננהו:
das Tun unsrer Hände, richte es auf!

APOLLINAIRE AND EXPERIMENTATION

Guillaume Apollinaire, the poet, must be given credit for the spark that set off the inventive tendencies of later writers and artists in Europe. The heritage of Apollinaire's experiments in letters pervades the present with thousands of followers, some of whom are not aware of it.

Wilhelm-Apollinaris de Kostrowitski was born near Rome in 1880. His mother was a Polish woman whose father had been a colonel in the papal guard. The poet and another son were sired by persons unknown to the record. In 1902 Apollinaire worked in a Paris bank and lived with his mother. He had read extensively and wrote in his free time. While becoming acquainted with artists and writers—Picasso, Vlaminck, and Marie Laurencin, among others—the poet adopted the name by which he is best known and founded a literary review, *Le Festin d'Esope*. His reputation grew as the originator of a new vocal repartee. In 1914, Apollinaire was a leader in avant-garde writing, café life, and discussion. Since he had inherited Italian citizenship, the poet might have evaded French participation in World War I, but he elected to go into the trenches and continued to write until wounded in the head in March 1916. After two operations he returned to Paris and continued his literary career, assembling his second important volume of verse, *Calligrammes*, and finishing a play, *Les Mamelles de Tirésias*, one of the first Surrealist works for the stage. Finally married in May 1918, Apollinaire enjoyed a few happy months in his apartment on Saint Germain in Paris but died of a flu virus on November 9, two days before the armistice celebrations in Paris.

Left: 261. Graphic pun, c. ninth century. British Museum, London.

Above: 262. Calligram by Jacques Cellier. *Verve*, Vol. 1, No. 3, Paris.

Calligrams

The kind of calligraphic games played by Apollinaire were not new in graphic history, as we observe in Figure 261, a work from the medieval period. Such "calligrams"—visual puns if you like—appear in the record from time to time, although they are not numerous. The calligram seen in Figure 262 is by Jacques Cellier of Reims and is dated 1585. Most readers will remember the typographic description of the mouse's tale in *Alice in Wonderland*. In a recent facsimile edition, this clever page may be seen in the author's handwritten version, *Alice's Adventures under Ground* (New York, 1965).

As a poet, Apollinaire was primarily interested in the sound of his words, but he also thought that their arrangement on the page could convey shades of meaning. In his composing, the poet possessed an offhand wit that showed genuine brilliance. Figure 263 shows one of his

pieces. Many of these were scribbled on casual bits of paper and of course offered great difficulties to those who wished to publish formal editions set in type. Yet some of these editions were fairly successful. A few are listed in the Notes and Bibliography. In spite of the technical difficulties inherent in his *Calligrammes,* Apollinaire seemed to think like a typographer. For the most part the works were conceived in terms of small Roman letters or ordinary handwriting, and artful calligraphy was absent. Most of the graphic statements in *Calligrammes* are at once charming and idiotic; the former quality probably pleased his many friends in the art colony of Paris, while the latter quality was most admired by the Dada group. Apollinaire's imagery in poetic terms was most admired by those in the Surrealist movement, which grew out of Dada.

263. Apollinaire's drawn calligrams were inspirational to experimental typographers. Apollinaire, *Calligrammes.*

KARAWANE

jolifanto bambla ô falli bambla
grossiga m'pfa habla horem
égiga goramen
hıgo bloiko russula huju
hollaka hollala
anlogo bung
blago bung
blago bung
bosso fataka
ü üü ü
schampa wulla wussa ólobo
hej tatta gôrem
eschige zunbada
wulubu ssubudu uluw ssubudu
tumba ba- umf
kusagauma
ba - umf

264. A poem by Hugo Ball, 1917. *Dada Gedicte* (Zurich, 1957).

Dada

There is no time here to explain the Dada movement, with its splits, factions, and declared and undeclared members. It grew out of disgust and despair, and was bent on the destruction of a diseased society through the means of ridicule. In political terms the Dada group could not have elected a dog-catcher, but it sharpened its darts and flung them at the portraits of the Establishment. German poet Hugo Ball, a refugee from conscription, founded a café in Switzerland in 1916, the Cabaret Voltaire, which attracted a number of sympathetic artists, including Tristan Tzara, a young Rumanian poet who became the Dada leader in 1918. Paris was the focus for the several international centers of dissent.

Hugo Ball gave recitations of his work and also had them set in type (see Fig. 264). While no expert opinion is available, the work would appear to emphasize the sound patterns of several national tongues as remembered by the author. This phase of poetry has a respectable heritage, and given the voice of Dylan Thomas, one might become quite carried away. Ball follows the Dada dictum of self-destruction in the last line, just in case he has constructed anything of beauty. Typographically the content is interesting, because it forces the reader into a different

265. A page composed by Tristan Tzara for a Paris Dada publication, 1920.

266. *Komisches Tier,* a Dadaistic work by Kurt Schwitters, 1919. Marlborough-Gerson Gallery, New York.

interpretation of each line whether he likes it or not. In reading this poem aloud, a genuine effort is required to disregard the visual cues inherent in the several forms of the lowercase alphabet.

Tristan Tzara, whose logical dictum, "The true Dadaist is against Dada," proved too severe for some of his colleagues, had a genuine talent for arranging type. Figure 265 shows a page of advertisements designed by Tzara. This piece, dated 1920, speaks for itself. In the nineteenth-century manner, the work employs many different typefaces, but the graphic content is uniquely twentieth century in spirit, purposefully inane, while many examples from the previous century achieved this quality unintentionally.

Dada was an international movement, and each country furnished talent to the dissident convocation in Paris. Germany was the original homeland of many talents attracted to the nihilism of Dada, including several poets. Max Ernst, whose early collages traced the absurdity of nineteenth-century morality in its own ink,

was one of the great men to come out of Germany. Kurt Schwitters (1887–1948), upon whose efforts we will now dwell, was not only a great collage artist but also wrote poetry. He coined the word *MERZ* for his collages and also used the term for his writings and excursions into three-dimensional works. In 1919 a volume of Schwitters' MERZ-writing was published in Hannover, the city of his birth, with the title *Anna Blumé.* The work contained slogans, extracts from posters, pieces of ads, and snatches of popular tunes mixed in with cliché expressions. The official Dadaists disapproved of this work, and for a time Schwitters was denied membership in the sect.

Schwitters was interested in the sound of words and in their appearance. Figure 266 dates from 1919 and shows a use of stamps. The manner is reminiscent of Apollinaire and somewhat foreign to the main body of Schwitters' efforts in composition. Another Schwitters collage is seen in Figure 267, dated 1922. In this figure, found objects of word content predominate, and the poet of disparate imagery gives way to the "painter" of disparate

imagery. The piece looks like what a concentrated dose of city noises might sound like.

Typography was one of Schwitters' side interests, and he worked at it off and on, publishing an article on "Creative Typography" in 1928. In spite of these early suggestions, Schwitters was by no means a Dadaist in terms of composition, since he was not against it. His collages demonstrated a fine sensitivity to classical balance and careful control of the forces operating within the picture plane.

For those interested in letters, Dada and peripheral groups are well worth studying. In the area of word arrangement the work was provocative and perhaps more constructive than hard-line followers would have intended. If the Dada brotherhood fostered an irreverent attitude toward typography, that area of the graphic arts deserved it, for it has always suffered from the ministrations of the dull hand and the precious mentality. Although Apollinaire did not live to see the experimental flame he may have ignited, he did speak to the point: "Typographical artifices worked out with great audacity have the advantage of bringing to life a visual lyricism which was almost unknown before our age. These artifices can still go much further and achieve the synthesis of the arts, of music, painting and literature."

267. *Mz407. Lia,* a collage by Kurt Schwitters, 1922. Kunsthalle, Hamburg.

BAUHAUS LETTERS AND SANS SERIF

William Morris died in 1896. In that same year the Arts and Crafts Movement, of which he was a principal formulator, began to attract the attention of thoughtful Germans. German industry, it was argued, had been living in the past and needed new views on design and new training programs. The Bauhaus, conceived as a consulting center for industry and trades, was established in 1919 at Weimar, and the brilliant young architect Walter Gropius became its first principal. The institution had a short history in Germany, existing for only about 13 years before the Nazi movement became strong enough to close it. Gropius left in 1928, and many of the teachers in the Bauhaus moved away from Germany and influenced schools in other countries. A school in Chicago was particularly strong, and the Bauhaus momentum is still felt by most of the middle-aged population in the design field.

It is well known that the Bauhaus artists believed that nineteenth-century art and architecture was abhorrent to view and dishonest in its use of materials. Eschewing decoration, they proposed to create buildings in which esthetic considerations were embedded in the structural qualities of concrete, glass, and steel, and in which the forces of gravity and its opposition were not hidden but stated openly for all to see. In the Netherlands, architects, and also artists like Theo van Doesburg and Piet Mondrian, were motivated by similar views. Bauhaus designers examined the practice of typography and found that a new broom was in order. In typical fashion they swept out the nineteenth century and with it the reform movement of William Morris, which had made some headway in Germany. New thoughts centered on a new alphabet we now call sans serif, and on new ideas concerning the relationship of bodies of type to the field on which they are seen. An entire page of this book is devoted to sans serif alphabets, and readers are invited to examine these forms for a better grasp of the subject under discussion. Bauhaus composition is a feature of Figure 268.

Sans Serif

The redesign of sans serif really began in Germany in 1898, and several new types were designed and cut in the early years of the century in Germany and in England. And in 1916 the London Underground Railway (famous for its long-lived series of posters extolling the virtues of this mode of transportation) commissioned Edward Johnston to execute sans serif alphabets that could be used in transport signs and publicity. The

268. A Bauhaus ad. Museum of Modern Art, New York.

charge to Johnston included formation of letters that would have "the bold simplicity of the authentic lettering of the finest periods" and belong "unmistakably to the XXth century." Johnston's alphabets were called block and were successfully used in the large sizes employed by the Underground Railway. His new ideas for sans serif alphabets included expanded white spaces inside the letters commensurate with white space outside the letters. This was a result of Johnston's academic training in the legible manuscript hands he had examined. Thus these geometric forms could be spaced properly, an elemental feature lacking in nineteenth-century efforts in a similar context. Because of World War I, Johnston's efforts were not noticed in Germany until 1924.

Johnston's designs were meant to be seen in posters and were not adapted to type fonts, but the Germans were intent on this enterprise. The first commercial version of postwar sans serif was designed by Jakob Erbar and cut by Ludwig & Mayer in 1924. Erbar was a teacher at Cologne and was influenced by the Bauhaus at Dessau.

Bayer's Alphabet

Several of the Bauhaus teachers added impetus to the new typography, but a young instructor named Herbert Bayer did most of the drawing-board work and presented the arguments. Bayer later moved to the United States and established a splendid reputation in the graphics-printing area. He now pursues these activities as an elder statesman in Aspen, Colorado. Bayer drew the alphabets for his universal type in 1925, and these are seen in Figure 269. Had they been seen, Johnston's ideas would have been rejected anyway, because these were solidly based on past traditions. Bayer's efforts centered on one alpha-

bet intended to replace the capitals, lowercase, and italics used in Britain, France, and the United States (to mention a few of many countries), and to replace the descendent alphabets of black letter still used in half the books produced in Germany. Residual habits in German writing structure were formidable to any such consideration. In most countries capitals are used sparingly; but in Germany all nouns begin with capital letters, so Bayer and the Bauhaus took on the establishment of letter usage with great odds against them. David and his slingshot would have been a better wager. Bayer called his alphabet Universal Type, and its structure was to be accomplished with "a few arcs, and three angles." Bayer supported his earlier views in articles published in the United States and established a verbal framework for his thinking. In brief his principles were: (1) geometric founda-

269. Herbert Bayer's Universal Type.

tion of each letter, resulting in a synthetic construction out of a few basic elements; (2) avoidance of all suggestion of handwritten character; (3) uniform thickness of all parts of the letter and renunciation of all suggestions of up-and-down strokes; and (4) a simplification of form for the sake of legibility—the simpler the optical appearance the easier the comprehension.

Bayer's notes state that the Bayer type was produced by the Berthold Type Foundry, but there is no evidence that these types received much use. However, in 1925, Bauhaus publications began to appear in print using lowercase sans serif alphabets exclusively and an essay, "Die neue Typographie," by Jan Tschichold (Berlin, 1928), confirmed some of the beliefs held by this sect of typographers. Tschichold later recanted and returned to an interest in the fine aspects of traditional typography. A new Roman typeface designed by Tschichold has very recently been released.

The Impact of Sans Serif Types

Commercial typefoundries in Germany could not go the ambitious route on the single alphabet proposed by the Bauhaus, but they proceeded to make the sans serif available to printers in capitals, lowercase, and oblique styles (to match italic). After the effort by Erbar, Paul Renner became fascinated with the new experimentation in letter forms, and in 1927 the first fonts of his famous Futura were produced. By 1930 the several variations (both capitals and lowercase were included) were available in a complete range of sizes. And about this same time Rudolf Koch designed Kabel, named for a transatlantic cable. In England the stonecutter-philosopher Eric Gill set out to design a sans serif alphabet for The Monotype Corporation, and the first types were produced in 1927, with related variations coming along in the following years. The Gill sans serif, sometimes called Gill Sans, was based on Johnston's work, and some of Gill's letters showed unique features that the German mystique prohibited. German designers insisted on pure cold forms based on measurements and on the logic of the compass.

The reception of the new designs varied from country to country, depending on the kind of vacuum found. Swiss graphic designers (*graphikers*) helped make the new designs look good with marvelous presswork. In the United States there was a need for condensed sans serif faces in newspapers, but the clear message of Futura is best seen in its original wide design, which requires plenty of horizontal space.

In terms of artistry the new types were accompanied by new concepts of the page or the field on which the

270. A page from the *Frankfurter Allgemeine Zeitung,* August 15, 1964.

types appeared. Renaissance typography, like Renaissance architecture, was symmetrical, in that columns of type and titles were held within fixed margins. This symmetry became more fixed in subsequent centuries, and in the nineteenth century, title pages could look like a Rorschach test. Dada designers had no use for this convention and placed bodies of type all over the page, making use of margins that had furnished a stage for the presentation of letters. In this sense they followed artists who painted right up to the edge of the canvas. Bauhaus typographers accepted this lead, and in these terms perhaps the best example is the work of Piet Mondrian, who helped create new kinds of quiet areas. No doubt the end result is a kind of architecture of the page, in which small letters appear as bricks and larger letters appear as cantilevered structural members. As such it has become a designer's method and a designer's playground.

A considerable number of years have passed since the Bauhaus ideas were first presented, and missionary zeal has declined with passing time. One German newspaper, the *Frankfurter Allgemeine Zeitung*, implements these ideas in daily publication and in so doing functions as a kind of laboratory experiment for the rest of the publishing world. Whole pages of ads employ related sans serif typefaces, and the result can be seen in Figure 270. This example will undoubtedly appear strange to English-speaking readers, who are more used to a newspaper landscape of interesting errors and to a marriage of type styles of appalling proportions. In the United States anyone can design an ad for a business and can walk into the newspaper office and get it printed. In the German newspaper illustrated here, there is some control exercised, and it seems probable that the newspaper employs a staff for layout.

Evaluation

Some writers expressed great hopes for the cold elegance of Bauhaus letters. P. M. Handover, the English critic, quotes one of these enthusiastic reviews in *Monotype Newsletter 69*: "A glorious sunrise dispelled the cold grey sky that overshadowed the real modernism in typography." The basic difficulty in sans serif alphabets is their illegibility in small sizes. Greek inscription letters, suggested as the ancestor alphabet for sans serif types, were cut large, and natural lighting cast shadows that helped to reveal their form. Greek manuscript letters, as shown in Codex Sinaiticus and other manuscript styles, exhibited a deliberate order in the spacing of the letters, and since they were pen letters, the forms were not quite mechanical. It seems in the Futura, Kabel, and similar sans serif letter styles the constant repetition of vertical and circular forms causes some kind of confusion in the scanning apparatus we employ to identify objects. Sir Cyril Burt, a British psychologist, has stated that "for word recognition, a sans serif type face was the worst of all." This has been known or felt for a long time, and new efforts are being made to create sans serif alphabets that will prove more legible in small sizes and yet preserve the dynamic architectural qualities seen in the best of Bauhaus pages. Adrian Frutiger, Swiss by birth and training, joined the firm of Deberny & Peignot in Paris in 1953. He has designed Univers, and Hermann Zapf of Frankfurt has designed Optima. Both designs feature a marriage of Roman and sans serif. Zapf's design is particularly sensitive. Going back to the Luca della Robbia sculptured model (Fig. 149), Zapf has given the vertical strokes a tapered contour, and the result is a handsome series of related type fonts that may well excel as bookfaces.

A page from Edward Johnston's *Writing and Illuminating and Lettering.* Copyright © Sir Isaac Pitman and Sons, Ltd., London.

Chapter 9 Calligraphy in Revival

Earlier commentary has established that handwritten books and pen skills declined because of the development of printing and the intaglio method of reproduction. Handwriting, always in use for legal documents and private correspondence, maintained individuality at all times, and the published correspondence of nineteenth-century authors shows no sharp decline in vigor. Public letter usage was quite another matter, and in typography sensitivity was lost in the search for novelty and strength. Hand lettering came to be dominated by the cursive round hand, at first taught to daughters of the wealthy but later taught to everyone entering the chain schools of Spencer and Palmer and the like. The beginnings of this cursive have already been explored. It became an exercise in cold technique and pervaded the art of letters. Other Victorian penmen used a formal Gothic, carefully drawn and filled in.

by Arrighi's *Operina* in his possession. If the writing seems cramped in this example, it is appropriate to note that the original page is 11½ inches wide. Obviously Morris was a good penman. Perhaps his admiration for the great manuscript pages of the Middle Ages and the Renaissance, and his determination to infuse these values into his own cultural milieu, led him into certain errors. In the example seen here, the page undoubtedly contains too much. A rather elegantly conceived title at the top is accompanied by vine decoration, elaborated initial letters, and gilded capitals in the text. The Celtic scribes and illuminators of an earlier day put in more flourishes and escaped censure, but no scholar can tell exactly how the excess became great art. Certainly it involved a culture and a tradition—Morris was but one man.

Morris was a man of wealth. Some of the achievements of his Kelmscott Press depended on this resource, but in the area of calligraphy the cost was trifling. Yet Morris executed his own manuscripts in the strong belief and knowledge that it was his responsibility to prove the point that writing was important. Today responsible men of wealth feel that personal involvement is a luxury that society denies them. Morris began his work in calligraphy around 1870. One of his notable efforts was a rendition of *Beowulf*.

The initial interest in calligraphy attracted a number of followers, and the study of ancient manuscripts quickly followed. Poet Robert Bridges became addicted to it, and his wife published *A New Handwriting for Teachers* in 1899. A few persons began to use the old styles in personal correspondence, as calligraphers do today.

EDWARD JOHNSTON

Edward Johnston (1872–1944) began a systematic study of medieval and Renaissance manuscripts. Sir Sydney Cockerell, a former associate of Morris' and an important collector, encouraged Johnston and lent him many fine manuscripts that had been acquired on the basis of taste, since scribes and dates were mainly unconfirmed at the time. Through a friend, possibly Bridges, Johnston was also acquainted with the early publications of Edward Maunde Thompson, the great scholar of Greek and Roman paleography.

Johnston's hard work was aided by excellent collections in the libraries of institutions of higher learning in the British Isles and by the great collections in London: the Victoria and Albert Museum and the incomparable British Museum. It should be added that scholarly paleographers were hot on the trail of ancient writings all during the nineteenth century, and Britain's world inter-

271. A Morris manuscript. Bodleian Library, Oxford University.

MORRIS THE PENMAN

William Morris, the great thinker on social reform, cut through some of the superficiality and vulgarity of nineteenth-century letter practice and restored the arts of typography, calligraphy, and illumination to a level of dignity through the study of past achievements. Thus the Morris hand of Figure 271, from *Odes of Horace*, is based on the manuscript cursive styles produced in Italy in the second half of the fifteenth century, possibly influenced

ests were a part of the picture. Thomas Astle's *Origin and Progress of Writing* was published in 1803, and the author possesses a volume entitled *Oriental Penmanship* by Duncan Forbes (London, 1849), which demonstrates how to write Sanskrit (in the Devanagari alphabet) and Persian Ta'lik, with illustrations of the cut of reed pen employed for each. Thus a tradition of scholarship existed. But paleographers are not noted for issuing information on technical matters embodied in the writings they study, and this is where Johnston dug in and persisted. His famous book *Writing and Illuminating and Lettering* (London, 1906) contained the first collection of useful information for calligraphers on procedures. A recent book edited by the Rev. C. M. Lamb adds to the technical information on calligraphy, as dozens of other books extend our knowledge of various facets of the arts of letters. But Johnston's book, with a patina of sixty years and plenty of thumbprints, is still consulted. Students may never see an early edition, because an instructor would be foolish to let it out of his sight.

Johnston's Writing

Johnston's foundation alphabet was based on the sturdy late Carolingian alphabet seen in Figure 104, a tenth-century manuscript executed on native soil. He could not have done better. Johnston renewed an interest in the wide-nib letter found in this example, and his interpretation is still preferred to later suggestions on fundamental alphabets, many of which are easily learned but possess

272. Johnston's basic hand
in *Writing and Illuminating and Lettering*.
© Sir Isaac Pitman and Sons, Ltd., London.

273. A manuscript by Edward Johnston.
Victoria and Albert Museum, London.

no style. Johnston's execution of a foundation hand is seen in Figure 272, taken from an early edition without retouching. Many paleographic facsimiles had the benefit of large size, fine paper, and first-rate collotype reproduction, but Johnston got his points across within a small format and very limited means in terms of printing techniques. Yet in respect to ideas and information the book is still exciting.

While interested in medieval styles, Johnston did not neglect the heritage of Renaissance Roman and did many pieces in that inherited tradition. Generally calligraphers try to maintain a purity of style, but Johnston often rendered the Roman alphabet with medieval overtones. This can be seen in Figure 273, in which the Roman is condensed, with black-letter echoes or perhaps, in the spiky serifs, a suggestion of Anglo-Saxon hands. Johnston had mastered most of the historic hands, and bits of this knowledge crept into his work in a natural and graceful

way. A certain piece will at first glance seem to be Renaissance Roman; but something different strikes the eye, and a closer study will reveal that there is a strong element of Celtic minuscule running through the page. Johnston was not only a good student of writing styles and a gifted expository writer, but a master calligrapher. This is sometimes overlooked because of the international impact of his book and the number of important calligraphers who studied with him.

Johnston's Students

Johnston's teaching began in 1899, when W. R. Lethaby initiated a class in "Illuminating" in the original London Central School of Arts and Crafts. The first class numbered less than ten but included Eric Gill, one of the great men in the art of letters in this century, and a year later Graily Hewitt and Percy Smith joined the class. Both were to do important research and to write influential books. In 1901 Lethaby, appointed Professor of Design at the Royal College of Art in South Kensington, invited Johnston to start classes in that institution. Apprentice systems of learning had prevailed in the typographic arts and in stone carving, while commercial schools taught writing. This innovation by Lethaby and Johnston was historic in the sense that the study and practice of letters was now to be included in a curriculum of art education.

William Graily Hewitt succeeded Johnston in the post at the Central School of Arts and Crafts in 1901. Hewitt counts as one of the genuine pioneers in the revival of calligraphy when it is noted that he was born in 1864 and died in 1952. Hewitt taught the ancient letters at the same school for thirty years. He was a late arrival with reference to his own work, having studied law and turned to the practice of letters after a brief and unsatisfactory try at the bar. Hewitt was particularly interested in Renaissance writing with a book format and carried out many detailed experiments on gesso, in gold leaf, and in the kindred arts of illumination. His book *Lettering*, published in 1930, is still a standard for technical information. Heather Child, writing in *Calligraphy Today*, states that Hewitt and his assistants came near to the medieval concept of a scriptorium in terms of book production and the technical skills involved in the many reproductions already studied.

Eric Gill was born in Brighton in 1882 and died in 1940. His original direction was toward architecture, but in his leisure time he took up lettering and stone-cutting with Edward Johnston. Sharing quarters for a time, the two had a relationship that was based on professional kinship. As a letter cutter Gill set a modern standard for excellence. His workmanship in end-grain

274. Wood engraving and types by Eric Gill.

wood engraving showed a sense of graphic power that made some revival illuminations seem merely quaint. Gill's work in Figure 274, a page from *The Four Gospels* printed by the Golden Cockerell Press in 1931, shows several facets of Gill's personal expression. First, the graphic content and the arrangement of the type go hand in hand to create an original statement for the page. Converted to the Catholic faith in 1913, Gill spent much of his energies working on books that reflected the strength of his personal involvement. Then, too, the typefaces seen in Figure 274 are his. A superb craftsman in stone letters, he understood the intimate connection between stonecutting and typography, and he designed a number of distinguished typefaces. Perpetua and Gill Sans were outstanding; these date from 1925 and 1927. Gill also wrote some notable essays on typography. Not only was Gill sensitive to the quality of stone, but as an engraver and type designer he was equally sensitive to paper as a carrier of his graphic enterprises.

To show Gill's understanding of letter structure and his skill as a carver, we reproduce one of his alphabet stones in Figure 275, executed about 1938, near the end of his career. A worker, a craftsman, and a thinker, Eric Gill was also a wonderful individual. For those who

either teach or are studying calligraphy his *Autobiography*, published in 1940, is a rewarding experience.

Morris, Cockerell, Bridges, Lethaby, Johnston, Gill, Smith, and Hewitt—these men, as well as scholars of paleography and nameless librarians of the great collections of London, were all linked together in the revival of calligraphy, in the inscription arts, and in typography. Morris, born in 1834, began studying letters in 1870; and Hewitt died in 1952. This shows the span of the revival; and many of their students are still alive and spread the gospel of this original inspiration. One or two of the names mentioned were personally radical in disposition, but as a movement (if it can be called that) it was conservative in the sense of conserving the past, an idea closely associated with British tradition.

275. Alphabet stone by Eric Gill. John M. Crawford, Jr., New York, and the Walters Art Gallery, Baltimore.

SO FLEHTEN SIE. ES HUB DA AN ZU KL GEN DER ARME HI RICH IN DES HERZ NOT DER HOFFNU LIEBER WOLLTE ER ENTSAGEN ALS SI

16. ¹/₃ der Originalgröße. Fragment. Mit der Rohrfeder groß schreiben. Rücksicht auf die Material- und Werkzeugsprache.

der Buchstabenschenkel — kann übrigens leicht zur Folge haben, daß diese Massen für das Auge zusammenfließen, daß aber gleichzeitig an dieser Stelle anstatt schwarz ein grauer TON empfunden wird, daß also überdies die Schwarz-Weiß-Kontrastwirkung verloren geht. □

Man verwechsle nur ja nicht das Erfassen des Baues des Buchstaben und seines charakterisierenden Gerüstes, ich möchte sagen: das Studium der Anatomie des Buchstaben mit der geometrischen Konstruktion von Schrift. □

□ Zu ersterem kann der Schüler nicht genug angehalten werden, vor dem Schriftkonstruieren dagegen ist er zu warnen. □

□ Mit eiserner Strenge dringe der Lehrer auch

276. A page from the Von Larisch manual, 1906.

DEVELOPMENTS ON THE CONTINENT

A pioneering spirit in calligraphy in Europe was provided by Rudolf von Larisch. Born in 1856, Von Larisch began his teaching career in 1902 at the Vienna School of Art. The dates reveal a late start in the academic arena, but Von Larisch had held several posts in royal writing centers as an archivist. He was Keeper of the Hapsburg Records, for example. In several jobs he was in close contact with historical manuscripts and absorbed a sense of the changes that had occurred over the centuries. Somewhat appalled by hand scripts of late vintage, Von Larisch gathered ammunition for an assault on bad writing, and began to speak and publish on the subject. One of his pamphlets led to his appointment as a lecturer in lettering, and he continued this late-born career for many years. He died in 1934. *Unterricht in ornamentaler Schrift*, a manual on decorative writing, appeared in 1906 (the same year as Johnston's book) and was quite influential in German-speaking areas. A page from the Von Larisch manual is reproduced in Figure 276.

After years in the archives and having begun a teaching career at the age of 46, one would guess that Rudolf von Larisch should have exhibited some signs of rigidity or calcification of the teaching arm, but instead he moved in all directions. While the revival in England stressed the tradition of pen letters, Von Larisch encouraged his students to invent with any number of tools and to work in many different materials—wood, metal, clay, textiles. Von Larisch felt the mood of Expressionism and believed

that an artist using letters should show the thumbprint of his own personality and that a page or a whole book should communicate a unity of emotion.

Von Larisch's wide interest in letters is reflected in his calligraphy and in his designs for printing. He designed a heavy Old Style Roman face, Plinius, in 1903. He also designed a script for paper money and vouchers, and a fine double-line Roman used for high pronouncements of the kaiser.

The philosophy embodied in Von Larisch's teaching methods tended to encourage the student to become accomplished in many different phases of letter activity. A person in letter design might be a calligrapher but also a carver, or he might be interested in type design, even to cutting punches of his own design. Thus a close and fruitful link between calligraphy and typography was established in Germany and surrounding areas, where the tradition continues to the present day in such persons as Hermann Zapf of Frankfurt.

Perhaps the experimental nature of the Von Larisch school can be seen in the graphic form of Figure 277. Note what it says. This piece was executed by Charles Mackintosh, a Scottish architect, in 1901 and published in *Beispiele kunstherischer Schrift* by Von Larisch in 1902. Von Larisch had studied the graphic effect involved in crushing letters together into a tight square and had, in 1899, designed a personal bookmark embodying this idea. For purity of style, equal margins were used, and the effect was that of a square within a square. But the Mackintosh piece illustrated another idea that Von Larisch was interested in. This was the total invasion of the page by design and letter elements; many works issuing from the Vienna workshop echoed this intent. As mentioned, this idea was central to format conceptions developed by the Dada typographers, by Mondrian and by the Bauhaus teachers.

277. Piece executed by Charles Mackintosh in 1901.

278. Writing by Anna Simons. Herman Cohen, New York.

Anna Simons

Anna Simons was another important European figure in the revival of letter arts in this century. Born in Prussia in 1871, she went to study at the Royal College of Art in London, because women art students were banned in her native land. She became one of Johnston's most proficient students and in 1905 returned to Germany to begin teaching a lettering course in Dusseldorf. In subsequent years these courses were very successful. Simons also produced a translation of Johnston's book in 1910, followed by a translation of his portfolio on *Manuscript and Inscription Letters* in 1912. In this latter year Johnston went to Dresden to deliver a lecture on his researches and Anna Simons translated his remarks. Johnston's blackboard demonstration is reported to have created a sensation, so Simons' difficult contribution may have been overshadowed. That she was a master calligrapher in her own right is apparent in Figure 278. Anna Simons was one of many caught in a web of irony when bombers from England destroyed her house and collections during World War II.

It is not certain if Anna Simons was the first woman professional involved in the modern revival of calligraphy, nor is it established that her enrollment in England broke any barriers. Most likely it did not. There is no study available on the reasons for the important contributions made by female calligraphers in England. Many women were attracted to the study of calligraphy, and many of them acquired skills of professional level.

279. Koch's Sermon on the Mount. Oskar Beyer, *Rudolf Koch*.

Rudolf Koch

It one were obliged to name the outstanding man of letter design in this century, it would have to be Rudolf Koch (1876–1934). His early years were difficult: his father died when he was ten, and his mother's tiny pension precluded any thoughts of formal training. As a youth Koch went into vocational training in a hardware factory and then became an apprentice in metalwork. In the evenings he studied drawing. At twenty Koch entered the Applied Arts School in Nuremberg with hopes of becoming an instructor in drawing but failed the examination. He found a job in Leipzig but gave it up to search for one in London. Again he was unsuccessful. He came to the conclusion that his talents lay in book design and obtained a position as illustrator in a bindery in Leipzig, where he stayed for three years.

Koch was a kind of universal man of the alphabet. He worked with pens (*Schrift*), and with metal, fabric, and blockbooks (*Handwerk*), encompassing almost every kind of tool and material used in making anything. Here one man encompassed more of the Morris ideal than any

group within Morris' lifetime. Koch became immersed in the technique of printing and designed many typefaces for the famous Klingspor foundry in Offenbach, an association that started in 1906. Oskar Beyer's book *Rudolf Koch* (Kassel and Basel, 1953) shows the master working on punches. He cut the punches for three of his typefaces himself. His discipline in terms of workmanship and his zeal for work were indeed remarkable for a man whose physique was fragile.

Deeply religious, Koch did not hesitate to communicate this quality in his work; in this and every other sense he let his personal feelings flow into his work, giving it a validity over and above technical command. One of his calligraphic pieces, the Sermon on the Mount (Fig. 279), shows a use of letters that we have not seen previously.

Of course, Koch immersed himself in the black-letter versions of the alphabet. It was a natural interest, since the tradition was still very much alive in Germany. Writing in *Alphabet 1964*, Walter Plata states that in 1928, 57 percent of new books were set in black letter in German-speaking areas, while 43 percent used Roman letters. (Hitler, originally sympathetic to the national letter form, later decided that it had a Jewish aura and banned it for official documents.) Koch used black-letter versions in his carved block books and also in his pen-letter work. Coming from his hand, black letter was seldom a stiff resurrection; it was always a fresh approach, with Koch's personal stamp upon its features. Surely this idea comes across in Figure 280, a vigorous pen-letter interpretation.

Koch's cursive also was his own (Fig. 281). Active and spirited, it reminds one of the old Roman cursive and disregards the rather sterile tradition of nineteenth-century cursive letters. Of course Koch understood spacing and legibility, but he knew when to leave it and let the letters speak their own graphic language. Few calligraphers can proceed without trial and error, but Koch's work has an unrehearsed look—right the first time. His

280. Koch's black letter. Oskar Beyer, *Rudolf Koch*.

281. Koch's cursive. Oskar Beyer, *Rudolf Koch.*

knowledge of letters was so completely assimilated that he could disregard the mechanical baggage at any time. Readers should look into the Koch bibliography if they wish to observe a creative man using letters.

In 1918, while Koch was heading the lettering work at the School of Arts and Crafts at Offenbach, the Offenbach Penman became an organization. This grew into a workshop community, or *Werkstattgemeinschaft*, which was not a class in the ordinary sense but a group of people working, singly or in teams, to produce books, tapestries, or whatever project came to hand. Koch was the leader, but talented students came up to an associate level whenever ready, and in some enterprises the former student got top billing. This happened when Fritz Kredel executed the woodcut flowers for *Das Blumenbuch* between 1922 and 1929.

On Training

Newcomers to the workshop got a thorough training in letters before they moved on. A number of Koch's students attained reputations on their own: Kredel, Berthold Wolpe (writer and designer in London), Ernst Kellner, Henri Friedlaender (Fig. 260), now doing important teaching and printing in Jerusalem, and Warren Chappell (Fig. 293) of Norwalk, Connecticut. The latter designed the series of typefaces named *Lydian:* Lydian, Lydian Italic, and Lydian Cursive. These have been a useful and graceful part of the American type scene for thirty years. A thoroughly professional man of letter design and a former student in the Koch workshop, Chappell's views are interesting to consider. Although he is a professional calligrapher and book illustrator, Chappell maintains that type design is a carver's art, involving the sculptor's method of cutting material away. Since many calligraphic practices from the time of the early Middle Ages involve filling in, using double strokes, and adding on, the thinking is different. In this sense, calligraphy and type design involve different materials and a different set of tools; the evolution of types can only be thoroughly grasped when the method of execution is experienced.

Chappell expresses no enthusiasm for classrooms, grades, scheduled hours and the rest of the normal teaching apparatus. In the United States, many of these clichés of pedagogy are beginning to disappear in graduate areas of study. The kind of integrated workshop that Koch formed is within the reach of many institutions, but a requirement of specialization imposes a serious problem. Perhaps the most fruitful prospect lies in the integration of the traditional printmaking methods: relief, intaglio, lithography, and serigraphy with counterpart photographic means and calligraphy, typography, papermaking, and bookbinding. The possibilities are quite inspiring, and one day Koch's idea of cross-pollination may be realized.

ITALIC REVIVAL IN CALLIGRAPHY

English students and scribes were responsible for the revival of interest in the formal kind of pen-letter cursive practiced by Arrighi and the other great Italian writing masters. As we have seen, admiration for these letters, which were in formation in the fifteenth century, perfected in the sixteenth, and in decline thereafter, spread to many lands. Johnston's book reproduced an excellent example, but he devoted only a few pages to "semiformal" writing and did not favor this hand in his personal projects or commissions.

Alfred Fairbank

One of Johnston's followers, Alfred Fairbank, can be given much of the credit for the revival of interest in italic. Fairbank, born in 1895, did not study under Johnston but rather attended evening classes at the Central School of Arts and Crafts from 1920 to 1922. Graily Hewitt and Lawrence Christie were his teachers.

During the 1920s Fairbank became interested in the italic hand and has done countless pieces in variations of it. The double page of Figure 282 is from a manuscript book of Catullus executed by Fairbank around 1929. Here he preserves the Italian Renaissance habit of leaving a little space after the capitals. The gilding in this book is credited to Madelyn Walker, with illuminations by Joan Kingsford. In many books Fairbank performed his own gilding and often collaborated with illuminator Louise Powell. The distinguished sponsor and collector St. John Hornby, who provided great service to twentieth-century calligraphy and typography, acquired many of the books written by Fairbank. These are still in the Hornby Estate collection.

Of course the calligraphy of Figure 282 is obviously heavily influenced by Renaissance hands. Fairbank is

282. Alfred Fairbanks' italic. Mrs. St. John Hornby, London.

reported to have admired the work of Tagliente and Lucas especially; yet the work is not a copy of either master scribe, and Fairbank added his own details. Fairbank's contribution to type design is seen in the handsome narrow italic face accompanying the Venetian-based Bembo executed in 1928.

Long in civil service, Fairbank did most of his teaching, lettering, and research into Renaissance letters in his spare time. He taught the italic hand to hundreds of young calligraphers and published a number of works, the titles of which can be found in the Notes and Bibliography. His collaboration with Berthold Wolpe produced *Renaissance Handwriting* (London, 1960), the best source on cursive calligraphy of the period and indispensable in the lettering laboratory.

Though many have learned the italic hand independent of Fairbank's efforts, he is chiefly responsible for the wide interest in italic scripts in Europe and America. The Society for Italic Handwriting was founded in 1952 as a subgroup of England's Society of Scribes and Illumina-

tors. The Committee for Italic Handwriting, sponsored by the Rochester Institute of Technology, publishes a newsletter from time to time that is quite informative.

The strong schools of lettering in London and other British cities produced a rather impressive list of fine calligraphers, and the tradition continues with new research and new books. It is impossible to attempt to list all of the expert English scribes. The work of some of them is reproduced in Heather Child's *Calligraphy Today* (London and New York, 1963). A native of Winchester, Heather Child studied at the Chelsea School of Art under Mervyn C. Oliver, an important calligrapher and teacher. Since 1948 she has been a free-lance designer specializing in botanical books, decorative maps, and heraldry. A hint of her superb artistry can be seen in Figure 283, dated 1958 and written in a sturdy upright italic. Her decorative maps are large, and the written parts suffer in reduction. One of them can be seen in *Two Thousand Years of Calligraphy* (Baltimore, 1965), one of the best catalogs available on the subject of calligraphy.

Violaceae

a. Upper petal.

b. Lateral petal.

c. Lower petal.

d. Upper stamen. x 6

e. spurred stamen. x 6

f. gynoecium. x 6

Viola tricolor
Common Wild Pansy.

Berdy's Eyes, Bleeding Heart, Buttery Entry, Call me-to-you, Cats' Faces, Face & hood,
Fancy, Flamy, Garden Gate, Godfathers and Godmothers, Heartsease, Herb Trinity,
Jack-behind-the-garden-gate, Jump-up-and-kiss-me, Kitty-run-the-streets, Love-in—
idleness, Love-true, Meet-her-i'th'entry-kiss-her-i'th'buttery, Monkey's Face, Pansy,
Pink-o'-my-John, Tickle-my-Fancy, Two-faces-under-the-Sun, Trinity Violet, Wild—
love-and-idle. From a Dictionary of English Plant Names; Britten and Holland, 1886. ❖

Dicotyledon: **The Violet Family**
A Family limited in Europe to the single genus Viola.

VIOLA TRICOLOR
Heartsease, Pansy,

A most variable plant, but easily recognised by the branching
stem, the large leaf-like stipules deeply divided into several
linear or oblong lobes, the central or terminal one the largest,
broadest, and most obtuse, and by the style thickened at the
top into an almost globular oblique stigma. The plant is
glabrous or slightly downy. Leaves stalked, from narrow
oblong to ovate or cordate, always obtuse and slightly crenate.
Flowers purple, whitish, or yellow, or a mixture of these colours;
the two upper pairs of petals slightly overlapping each other,
and usually more coloured, the lower petals always broad-
est, and generally yellow at the base.
On hilly pastures and banks, in cultivated and waste
places throughout Europe and Asia and abundant in—
Britain, especially as a weed of cultivation.
Flowers from spring till autumn.
This is the most variable of all our Violets, and has been
divided into more than a dozen species.

"Yet marked I where the bolt of Cupid fell: It fell upon a little western
flower; Before milk-white, now purple with love's wound,
And maidens call it Love-in-idleness." A Midsummer Night's Dream.

283. Double opening from *A Shakespeare Flora* written by Heather Child. By permission of the artist and Dr. J. Shulman, Coventry.

CALLIGRAPHIC INTEREST SPREADS

The movement of interest in the history and practice of calligraphy can be likened to the situation in the Middle Ages when small pockets of learning and technique were established and then a thread of this talent would be traced to another pocket and so on. In this century London was the first strong center for the new skills. It should be emphasized that the pioneers were forceful, and many of the followers who took up the work had to be forceful, too, as they were often working alone in "heathen" lands. Perhaps that is why so many of the teachers and practitioners in the field of calligraphy seem possessed of a missionary zeal to convert anyone they can lay hands on.

Some isolated individuals were first introduced to modern calligraphy through Johnston's book or some later book, and many have been self-taught, at least in early development.

It is apparent that information on developments in Ireland is hard to obtain. Tom Gourdie of Scotland is well known, and his work is seen in important exhibitions featuring calligraphy. His writing manuals are worthy of study, and his itinerary for lectures includes Ireland and Wales. Little information is available on Welsh calligraphy, but the author has seen a remarkable illuminated manuscript devoted to the work of Dylan Thomas and executed by W. Emlyn Davies, a retired schoolteacher. Perhaps there are other efforts worthy of notice.

202 *The Twentieth Century*

The German tradition is a great one. Early leaders were Otto Echmann, Koch, Walter Tiemann, Fritz Helmuth Ehmcke, Emil Weiss, and Ernst Schneidler. Ehmcke's work is noted in the Notes and Bibliography. Weiss (1875–1942) was a pupil of Anna Simons'. A poet and a painter, he became interested in book forms and formats through authorship. He later became a master of type design, and produced a fabulous number of alphabets that show a keen sense of the carving art of the punchcutter. A few of the Weiss alphabets are seen in America, issued by Bauer Alphabets of New York. Alphabets by Weiss have already been seen in Figures 140 and 181.

Jan Tschichold is perhaps better known in the United States and England through several important books. As noted previously, Tschichold published *Die neue Typographie* in 1928, and it reflected the Bauhaus ideas in typography. Tschichold studied in Leipzig and Dresden, and taught lettering and typography in Munich. His break with the limited and severe Bauhaus typography is well known, and his designs and books exhibit a thorough study of the best historical examples. His latest book, *A Treasury of Alphabets and Lettering* (New York, 1966), is valuable in this respect and continues his wide international influence. Tschichold's books are so good that his personal output in letters is generally overlooked.

Imre Reiner studied graphics with Ernst Schneidler in Stuttgart. His type designs and calligraphic inventions are well known internationally. Max Caflisch studied with Tschichold and Reiner and has been a consultant and teacher in Zurich. Walter Kaech, a graphic artist in Zurich, has compiled some fine books on calligraphy and typography.

Hermann Zapf

Not to be overlooked is the incomparable Hermann Zapf (1918——) of Frankfurt. It is difficult to believe that Zapf taught himself to letter with Johnston's book and Koch's work. It is also difficult to believe that Zapf could be as young as he is with so much accomplished. Gudrun Zapf-von Hesse, Zapf's wife, is also a professional, having received a degree in bookbinding in Weimar. She taught lettering in Frankfurt up until 1954 and has produced a number of fine typefaces for the Stempel typefoundry. Among these are Diotima. The italic version of this face is considered a masterpiece. Year by year the December-January festivals are marked by a card from the couple, and it is probable that most recipients save them carefully, for they always contain some thoughtful idea in letter usage. One of these has been reproduced in Figure 84, and another is seen here in Figure 284.

It will be recognized that this piece is rendered through type, and Zapf is closely associated with type-

284. A greeting card by Hermann Zapf of Frankfurt.

285. Zapf calligraphy from *Feder und Stichel*.

design enterprises. In 1938 Zapf began working for the famous Stempel typefoundry and has produced a great many type alphabets, including Michelangelo, Palatino, Aldus, Melior, Virtuosa, and Optima. This latter face was cut and cast by Stempel in 1958. The lesson contained in it has begun to be absorbed by typographers in England and the United States. If a young instructor in printing had only five fonts to buy on a limited budget, Optima might well be one of them, as it eliminates the icy cold anatomy of classic sans serif alphabets and may be useful at all sizes. Figure 284 is arranged with Optima. *The Art of Written Forms* is set in Palatino and Palatino italic, one of Zapf's best designs.

Zapf, as mentioned, started out as a calligrapher and practiced diligently in his spare time. Writing in *Über Alphabete*, he stated that his father complained about the heavy electricity bills caused by night work. In 1960 Zapf lettered the preamble to the Charter of the United Nations in four languages—a remarkable piece of composition. Many pieces of calligraphy are contained in Zapf's *Feder und Stichel (Pen and Graver)*, printed at Stempel in Frank-

furt in 1950. The plates were cut by the master engraver August Rosenberger of Stempel. It was limited to an original edition of five hundred copies on handmade Fabriano paper, plus eighty copies on Japan paper. But popular demand ordered an edition in English using the same plates, the same Zapf typeface (Palatino), and the same Fabriano paper. The book is a landmark in modern calligraphy and printing. Figure 285 is reproduced from this remarkable publication. This italic writing possesses a genuine pen characteristic and a vigor one seldom sees in italic renditions. Hermann Zapf, an acknowledged leader in letter design, continues the tradition of Von Larisch and Koch in skills that encompass calligraphy and types.

Other European Figures

Space does not permit mention of the many fine type designers in Germany. A book, *Aventur und Kunst* (Frankfurt, 1940), should be mentioned. This large and elegant volume is a history of printing and bookmaking to 1940, the date of its publication. The type is a kind of Round Gothic, and the pages are as majestic to typographers as the Tetons or the Alps are to lovers of scenery. This remarkable volume was compiled by Dr. Konrad F. Bauer, who started work for Bauersche Giesserei, Frankfurt am Main, in 1928. Bauer has been the artistic director for the firm since 1948.

In Czechoslovakia the great man of letter design was Oldrich Menhart (1897–1961). Menhart, a native of Prague, learned part of his trade from his father, a goldsmith. He embraced all of the letter arts in his time, for he was a calligrapher, a book designer, an illustrator, an engraver, and a punchcutter. A basic letter style, the ancient uncial, was the basis for Menhart's Manuscript typeface, which had both capitals and lowercase. These designs were based on his remarkable handwritten version of Kytice, a Czechoslovakian classic that was published in facsimile in Prague in 1940.

Student typographers will find an excellent book on typefaces in *A Book of Type and Design* by Oldrich Hlavsa, printed in Prague in 1960 but available from a New York outlet. His 1965 book on the work of Apollinaire fills a big gap in our understanding of this talented man. Mention should be made of Jiri Rathousky of Prague, an exceedingly ingenious designer with letters, color, and paper folds.

Akke Kumlien (1884–1949) became the artistic head for P. A. Norstedt and Sons, an important Swedish publishing firm. Kumlien, a thorough scholar of letter forms, greatly influenced the course of book design in Sweden through his lettering and typographical ideas. Karl-Eric Forsberg, born in 1914, succeeded Kumlien as artistic director for Norstedt and is conceded to be Sweden's foremost lettering artist and graphic designer. His type design Berling Roman is an elegant version and was used in a superb Rembrandt Bible. Forsberg's drawings for the types Carolus and Ericus are excellent. Samples of these designs can be seen in volume C of Erik Lindegren's *ABC of Lettering and Printing Types,* recently printed in Sweden and available through Museum Books Inc., New York. In this fine trilogy Lindegren makes an understandable error in understating his own skills. An example of Lindegren's artistry is reproduced in Figure 286.

Bror Zachrisson, director of the Graphic Institute and Institute of Advertising of Stockholm, has been very influential in the printing and design areas. Zachrisson's book *Skriftens ABC* made a valuable contribution to the study of handwriting. His portfolio volume, *Liber librorum*, is very instructive. In this project many fine printers were invited to print a passage from the Bible, and varying ideas in composition, type, and paper selection make the volume quite valuable in the teaching laboratory.

In Denmark, Bent Rohde's calligraphy has been influential and his book *Bredpenkursiv (Broad-Pen Cursive)* has helped many students in a start to good letter formation.

Jan van Krimpen, one of the great modern pioneers in Holland, was born in 1892 and died in 1958. After a schooling in lettering at the Hague in which Simons' translation of Johnston's book proved inspirational, Van Krimpen became a professional designer of letters. This phase of his life started in 1912. In 1923 Van Krimpen became associated with Enschedé en Zonen, the famous typefoundry in Haarlem. He designed many beautiful types for this firm, in a capacity which lasted 35 years. The italic writing of Palatino and other Renaissance masters influenced Van Krimpen, and he became a fine calligrapher in this direction and executed many commissions. His interests in calligraphic practice carried over into his type design, and the italic versions seen in Lutetia, Spectrum, Cancelleresca Bastarda, Romulus, and Romanee attest to his taste. With a great skill in bookbinding as well, Van Krimpen continued the tradition of the all-around man of calligraphy, type, and book design. John Dreyfus wrote *The Work of Jan van Krimpen* in 1952. Although death indeed ended Van Krimpen's career as a calligrapher, his type designs are still widely used in Holland and Britain, and in this way his work may be seen for decades to come.

S. H. de Roos (1877–1962) is another grand man in Dutch typography. He turned to type design after a career of free-lance work as lithographer, painter, and furniture designer. His type designs are too numerous to mention, but Erasmus, Egmont, and Libra received wide acclaim and distribution. Libra is a single alphabet based on

PATER NOSTER
qui es in caelis/sanctificetur nomen
tuum·Adveniat regnum tuum·Fiat
voluntas tua sicut in caelo/et in terra·
Panem nostrum supersubstantialem
da nobis hodie·Et dimitte nobis debita
nostra/sicut et nos dimittimus
debitoribus nostris·Et ne nos inducas
in tentationem·Sed libera nos a malo
A M E N

286. Writing by Erik Lindegren of Sweden.

uncial styles and represents a great deal of thought and experience.

Chris Brand, a very talented calligrapher, was born in Utrecht in 1921. He taught himself calligraphy, with the aid of Johnston's book, and worked in Brussels from about 1948 to 1953 doing calligraphic work for government agencies. He exhibits internationally and has recently been teaching in the Netherlands. In association with Ben Engelhart, Brand has produced a number of fine books on writing. Heather Child reports that this team has produced a wonderful series for primary schools called *Ritmisch Schrijven*, and a page is reproduced in Child's *Calligraphy Today*.

Walter Kaech, a graphic designer in Zurich, is a fine calligrapher who has published a number of excellent books. *Rhythm and Proportion in Lettering*, published in Switzerland in 1956, is one of his best.

Italian efforts in calligraphy appear to be minimal, although they are strong in the fields of graphic design and printing. Alessandro Butti (1893–1959) was one of the great leaders in type design for Nebiolo, a type house in Turin. Butti, an excellent punch cutter, designed very fine faces himself and collaborated with Aldo Novarese on a number of distinguished faces. Novarese joined Nebiolo at the age of sixteen and became artistic director in 1952. This team produced some wide sans serif faces, which fit modern Italian graphic practices perfectly. These should receive more attention in the United States.

Hans Mardersteig, responsible for much of the fine printing in Italy, was born in Weimar in 1892. Mardersteig founded the famous Officina Bodoni, near Lugano, in 1922, which briefly used the original matrices of Giambattista Bodoni. This firm has published facsimile editions on Arrighi, Brun, Celebrino, Feliciano, Mercator,

and Pacioli, along with hundreds of fine books featuring the best types available: Centaur, Bembo, Times Roman, and so on. Mardersteig's contributions in scholarship and printing are indeed remarkable, and many critics believe his firm has executed the best printing in the world today.

In France, where calligraphers seem scarce, attention is mainly directed to other phases of letter design. Adrian Frutiger is a notable designer for the famous type house of Deberny & Peignot. Frutiger studied at the remarkable Kunstgewerbeschule in Zurich. Among many type designs his Univers is attracting international attention.

287. An early American headstone.
By permission of Mrs. John Howard Benson.

THE UNITED STATES

In the Colonial and post-Revolutionary periods the United States borrowed its ideas in letter formation from Europe. This is not to say that these early periods are not worthy of study, for native talents at times did appear. In carving the United States has some distinction, and a complete study of this field is needed. A hint of this native genius is revealed in the thousands of careful gravestone rubbings made by Ann Parker and Avon Neal from New England burial grounds. (A few rubbings obtained by this team can be seen in the July-August 1963 issue of *Craft Horizons*. Readers also will enjoy *Early New England Gravestones*, by Edmund Vincent Gillon, Jr., published in

288. A gravestone by John Stevens II.
By permission of Mrs. John Howard Benson.

289. A page by Francis Portsline. Native talents in brilliance.
Free Library of Philadelphia.

1966.) In New England at this early time, and across the rapidly expanding continent, technical skills were lacking, and amateurs of several callings were thrust into the stonecutter's trade. The results were often powerful and frequently touching in terms of symbolic and written content. Letter cutting was often primitive, and mistakes in spelling were frequent; but these flaws do not obscure character, and early headstones often show powerful cutting, as can be seen in Figure 287, executed by an anonymous craftsman. Among these sturdy Roman letters the use of *y* for *th* is observed in the first line. One of the early professional shops for stonecutting and lettering was started by John Stevens of Newport, Rhode Island, in 1705, and was continued by his survivors. The last Stevens died in 1900; the shop was eventually rejuvenated by the late John Howard Benson. A stone by John Stevens II is seen in Figure 288, which gives an idea of the skills developed in this family of carvers. The field of grave-

yard stonecutting is still wide open to research, since most graveyards in the United States have never been examined for design and letter structure. Photographs could be one product of original research here. Crude rubbings could be made with ordinary butcher's paper and soft graphite. A more sophisticated technique of rubbings involves an ancient Oriental method using heavy rice paper, silk pads, and heavy-bodied inks.

The Pennsylvania Dutch

Certain ethnic groups within American culture have produced other original forms in design and lettering. One of these groups is the Germans who settled in Pennsylvania. They produced a native style of illumination in the latter part of the eighteenth century that continued well into the nineteenth. The writing is usually based on cursive versions of black letter, perhaps dimly remembered. It was often drawn with a fine-line pen and

290. Satirical comment by Saul Steinberg from *Passport*.
Copyright © 1954 Harper & Row, Publishers.

THE FABULIST

NUMBER 3 AUTUMN
1921

Myself, I hope to live in a land that I have made out of potsherds and broken bits. It is not a well-articulated country, and it is not different from a many that other people have made. There are old things in it, but it is not old. I manage to have arched masonry dug out of Rome, and Greek fragments of marble, but the colonists from Greece have forgotten their fatherland, and pasture their cattle under the columns. There are glints from the East in the land if there are really no Easterners there. I use words to furnish this part of the country— Samarkand and Ispahan. They do as much as real colonists would, and much more musically. I do not need real things in this part, I choose rather invocations of memories or imaginings. All the claptrap of Oriental imagery serves me very well,—dust and sun and faded bright colors. There are no cities, and there are only the more picturesque sorts of merchants. How the inhabitants live I am not too much inclined to ask being overclose to the problem myself in this part of the world. But they are mostly countrymen and work in the soil

You will see that the country is hopelessly romantic, hopelessly to you, I mean. For a time back I was ashamed of its nearness to ruined Rome and hid its existence. Now I have grown careless about your opinions & am inclined to live in whatever land I please.

D.

1

291. Script by William A. Dwiggins. By permission of Dorothy Abbe, Hingham, Massachusetts.

painfully filled in. On intrinsic merits the writing in these documents would not be much admired today, but the essence of the pages lies in the innocent and inventive way in which the letters are combined with other graphic elements. A sample of this indigenous talent can be observed in Figure 289, which appears to carry a date of 1819. It is not enough to state that this piece, a record of birth and baptism, has a refreshing charm. Most modern calligraphers are commissioned to execute documents that begin, "Be it resolved . . ." or "In token of 45 years of faithful service . . ."; these signs of special occasions, however beautifully rendered, embody few elements of humanity or of personal meaning. Perhaps a solution to the problem of impersonality in calligraphy can be found by studying more of the tradition represented by Figure 289. A satirical comment on ceremonial documents is provided by Saul Steinberg in Figure 290. This is a superb piece of calligraphy and ornamentation.

Some hints on nineteenth-century letter practice have already been given. Copybooks and other writing methods derived principally from England and the German-speaking centers. Ray Nash of Dartmouth is investigating the writing masters of the United States, and his *American Writing Masters and Copybooks* (Boston, 1959) covers the field through Colonial times. If Nash finishes his formidable task, we will know more about the nineteenth-century writing masters in the United States.

Goudy, Rogers, and Dwiggins

In the United States there was no counterpart to England's William Morris, but many individuals made contributions to a review of practices in lettering, type design, and book layout. Three individuals deserve special mention: Frederic Goudy (1865–1945), Bruce Rogers (1870–1957), and William A. Dwiggins (1880–1956). They all enjoyed long and fruitful careers.

Goudy began drawing alphabets for type in 1896, the same year Morris died and, as already noted, established The Village Press in 1903. A typefoundry was added later. Goudy studied medieval letters carefully and produced some fine alphabets based on these studies. We have already seen one of his black-letter designs in Figure 113. Goudy also studied Renaissance letters and designed many alphabets based on these traditions. His ideas, independent, were greatly reinforced by the writings of Theodore Low de Vinne, first in an article in *The Book-lovers Almanac* (New York, 1896), and later in De Vinne's *Notable Printers of Italy during the Fifteenth Century* (New York, 1910), an important book. An exact count of Goudy's type designs is unavailable, since he drew many that were not actually cut, but there were over a hundred. In a field where a career can be made by one or two original or successful faces or by both, Goudy's output was fabulous. In teaching, his career at the Art Students League in New York City influenced many students. In 1920 Goudy became the head designer for Monotype Corporation in the United States, and produced a great many designs still in the catalogs. Among so many it is difficult to mention only a few, but Goudy Text (the black letter) was an important design as were Kennerley, Veneziana, Goudy Old Style, and Deepdene. In spite of fads, many fine printers still turn to Goudy types, and in this writer's opinion the Goudy Deepdene italic is one of the best. Any critical comment on Goudy's work would have to take note of the fact that some of his designs lacked the carver's incisive mark.

Goudy's *The Alphabet and Elements of Lettering* was first published in 1918, and it is now available in an inexpensive edition. But Goudy wrote considerably more than this, and a few of his titles are included in the Notes and Bibliography.

Bruce Rogers has been mentioned in relation to the Centaur type design based on the types of Nicolas Jenson. To many young printers Rogers is known only through this one design. Fresh critical appraisal of Centaur is heard each year, so it is easy to believe it was a recent enterprise; in reality, however, Rogers developed the idea in 1914.

Rogers began his career as a newspaper illustrator but became interested in the excellent production of books with very careful control of type selection, setting, margins, paper, front matter design, covers, and binding. Rogers was the art director of several outstanding presses in the United States and directed the "typistry" (a Rogers coinage) for a number of outstanding books published in England. He directed presswork for both Cambridge and Oxford Universities at different times. The Oxford Lectern

Bible (Oxford, 1935) is one of the better books designed by Rogers. For a book designed by Rogers on a lettering subject, look at *Fra Luca de Pacioli* (New York, 1933) by Stanley Morison. Here in one place we have one of the interesting constructed alphabets of the Renaissance (with a translation of Pacioli's notes), written by one of the greatest of modern scholars and writers on calligraphy and type, designed by one of the finest of designers, and printed on a beautiful handmade paper (Batchelor's). As should be expected, it was printed in a limited edition of 390 copies.

William Addison Dwiggins, who studied with Goudy, was in the German tradition in that he was good at everything: lettering, illustration, designing with type, and type design. His typefaces were based mainly on his personal lettering in the Renaissance tradition. One of his handwritten pages is seen in Figure 291, reduced from actual size. A busy man, Dwiggins was willing to go to some pains to understand the relationship of calligraphy to type. Careful exercises, such as that seen here, helped to give his typefaces a warmth that made them very popular in the United States. Most of Dwiggins' work in this area was performed for Mergenthaler Linotype, and such faces as Caledonia, Eldorado, Electra, and Metro are still found in type cases all over the United States. The page seen in Figure 291 was executed for the wholly imaginary Society of Calligraphers, which Dwiggins founded for his personal amusement. Dwiggins designed books and covers for the New York publishers Alfred A. Knopf, Inc., for over thirty years.

Important Figures in the East

John Howard Benson was another splendid figure in the American resurgence of the letter arts. Benson was born in 1901 and died in 1956. In view of his abilities and contributions, he died too soon. Benson was born in Newport, Rhode Island, and after his schooling in New York, returned to Newport, where he revived the John Stevens shop. Here he practiced stonecutting, calligraphy, and allied arts. He was a student of letters for 35 years and could write all of the historic hands for his students at the Rhode Island School of Design. We are indebted to Benson for his transcription of Arrighi's *Operina*, Figure 178. His collaboration with Arthur G. Carey resulted in *The Elements of Lettering*, a fine text that influenced many teachers in the United States. Philip Hofer, the eminent collector, librarian, and scholar at Harvard, wrote of Benson's work in *Typophile* in 1957. Since Benson was a superb carver, his alphabet stone in Figure 292 is reproduced to demonstrate that the art of stonecutting is not yet dead. Stencils and sandblasting have erased some of

292. Benson's stone alphabet. By permission of Mrs. John Howard Benson and the Walters Art Gallery, Baltimore.

the personal involvement in this art. Benson's wife and his son, a fine carver himself, continue this line of work.

Alexander Nesbitt was born in Paterson, New Jersey, in 1901. Like Benson, Nesbitt studied at the Art Students League in New York, but he received some impetus in letter design from travel and study in Germany. He worked as a designer, typographer, and calligrapher in New York for many years and taught in several important schools there and in the Rhode Island School of Design. Among several fine books by Nesbitt is *The History and Technique of Lettering* (New York, 1958 rpt.). Other books by Nesbitt are listed in the Notes and Bibliography.

Oscar Ogg is another honored veteran in the fields of letter design, teaching, and writing. Born in 1908, Ogg worked as a typographer and art director. He founded the School of Calligraphy at Columbia University in 1946. His book designs and book jackets have won many awards. His best-known books are *The 26 Letters* (New York, 1948) and *Three Classics of Italian Calligraphy* (New York, 1953), which reproduces early block books by Arrighi, Tagliente, and Palatino. Ogg's contribution here is important, because we need to see reproductions of the work of writing masters that are as close to the original as possible. No healthy writing tradition can be based on thirdhand variations of original scripts. It might be argued that a book should show more of Arrighi's own writing and less of versions by woodcutters and punchcutters, but aside from a few examples, this material is nonexistent.

Still another veteran calligrapher and type designer is Warren Chappell of Norwalk, Connecticut. Born in

1904, Chappell studied at the Art Students League, with Boardman Robinson in Colorado, and with Koch in Germany. His designs and commentary have been dealt with in earlier sections of this book. In Figure 293 we reproduce part of a letter by Chappell. Sometimes it is better to see good calligraphy in this form than in diploma hands. Chappell's piece is in the style of Roman cursive and the fine personal writing of the Renaissance. Vigorous and elegant, this example shows us what handwriting can be.

Crimilda Pontes, born in 1926, studied with Benson at the Rhode Island School of Design. A talented calligrapher and printer, Pontes designed, set, and printed *The Instruments of Writing*, translated by the Rev. Henry K. Pierce and printed by the Berry Hill Press in Newport, 1948. (It was later reproduced by Meriden Gravure, 1953, for the Chiswick Book Shop in New York. Incidentally, students of calligraphy and printing should receive the Chiswick list of available documents in the area of letter design.) Pontes worked at the Yale University Press and has recently accepted a post as designer for the Smithsonian Institution in Washington, D. C.

293. Fine writing by Warren Chappell.

Edward Karr, born in 1909 in Connecticut, has been a strong figure in design and calligraphy in Boston since 1945. He has had a long career as a teacher at the Museum of Fine Arts School in Boston.

In the New York area, Paul Standard has been one of the pillars of calligraphy and graphic enterprises. He was born in Ellenville, New York, in 1896; since 1926 he has been engaged in designing, lettering, teaching, translating, and writing—all concerning the practice, definition, and place in the society of letter structure. Standard's list of credits is simply too long to relate here, but one book should be mentioned: *Calligraphy's Flowering, Decay, and Restoration*, published by the Chicago Society of Typographic Arts in 1947. The book is not easy to find now. Standard's training at Columbia led him into an

294. Arnold Bank's *Alphabet Study*.

295. Expert calligraphy by James Hayes.

early career in journalism, but his enthusiasm for letters diverted him. His writing and teaching has featured skills and knowledge of italic hands, and he has converted a number of schools to the practice of this elegant hand.

Marjorie Wise, a teacher, published *The Technique of Manuscript Writing* in 1924, and in twenty years the book sold twenty thousand copies. Frances M. Moore, who studied with Graily Hewitt, was also an influential teacher. She published *Handwriting for the Broad Pen* in 1926. George Salter, a superb calligrapher and teacher, has been active in the New York area for many years. He has been one of the strong persons in the revival of calligraphy in the United States. Other important craftsmen associated with the New York area are Hollis Holland, Philip Grushkin, Jeanyee Wong, Martin D. Oberstein, and Fridolf Johnson. Hopefully the new federal program in support of the arts will one day recognize these and other important American artists with appropriate publication.

Arnold Bank is another very influential calligrapher and teacher. Bank was born in New York City in 1908, and he received his early training there. He has taught in most of the principal schools in the New York area and has been visiting fireman in schools all over the United States and in England, where he was a Fulbright Senior Fellow and Lecturer in the letter arts from 1954 to 1957. Bank has been at the Carnegie Institute of Technology since 1960. His work is full of vigor and often contains some experimental piece of decoration that is quite his own (Fig. 294). The following excerpt from Marvin Newman's article on Bank in *News Letter No. 5*, Rochester Institute of Technology, is a comment on the man and his teaching:

His criticism of students' work ranged from soft-spoken suggestions to clamorous outbursts, depending on the crime perpetrated against his close friends, the letters of the alphabet. An ugly serif might provoke a "No! No! No!" uttered in complete disgust, whereas poor spacing would bring his fist down on the table, creating a noise loud enough to startle the students in the painting class next door.

Chicago and the Newberry Circle

Ernst Frederick Detterer (1888–1947) may now be considered one of the pioneers of calligraphy and allied subjects in Chicago. Detterer studied with Edward Johnston in 1913, and his early calligraphic work maintains Johnston's line of thought, showing a sturdy Roman, slightly condensed. Detterer regarded Johnston as one of the greatest calligraphers in history, so it is natural that he should have patterned some of his practices after the "master." Detterer held important teaching posts in Chicago; one at the School of the Art Institute of Chicago lasted from 1921 to 1931. Detterer had a sound knowledge of letter forms and insisted that his students acquire a part of it through hard study and hard practice. He was a tough teacher, but those who survived were able to make their own way as designers and calligraphers. In 1928 Detterer initiated the first drawings for a fine typeface for the Ludlow Typograph Company. It was named Eusebius and was based on the work of Venetian printers of the decade of the 1470s. R. Hunter Middeton developed the font in following years.

Detterer became curator of the distinguished John M. Wing Foundation of the Newberry Library in Chicago in 1931. This area of the library has a truly outstanding

within reach. But it is not so. Painters, draughtsmen, potters, and their kin show the calligraphers and typographers how to glide and soar above the earth. Of course when they need to have a catalog designed and printed, they have to leave their wings at the door and walk in like anybody else.

SCRIPTURA VULGARIS

Not all worthwhile writing is done by professionals. As the panorama above shows, there is spirit in the spontaneous writing of people of all ages and descriptions, and if one's eyes are attuned, there are many interesting pieces of lettering that can be seen during a walk about town or a drive into the countryside with stops at small villages. The amateur writing at Pompeii is quite as fascinating as the professional examples, and more's the pity that amateur documents have not been preserved in greater quantity through history. Unless the man was famous, the writing found its way back to the dust. In the early history of writing, many of the stone-carved letters were executed before professional skills had been acquired, and often this work shows a vigor that was lost somewhere in later developments. The early Roman inscriptions possessed a crude power that was impressive, as we have seen, and that in no way implies that the Trajan inscription is not great writing. Then too, technical skills can become so elaborate and refined that original aims are lost and the product becomes superficial and lacking in honest graphic content. This happened in the later stages of the era of writing masters, when engravers became so enamored of their own skills that they forgot the content of what they were writing and produced silly monuments to manual dexterity. This cannot be the case when an immigrant shoemaker saves up enough to rent a small space and writes his name and occupation in the window fronting the street.

The Trap of Conformity

There is no question but that the danger of losing honest graphic quality exists with professional calligraphers and typographers. In attempting to show that letters must be arranged properly, a designer may have a title reset a half-dozen times. Caught up in the game of perfect design, perfect spacing, correct paper, and careful inking, the designer may forget that refinement has its hazards. Early printers often produced pages badly overinked, but such pages often contained a graphic content that made them more interesting than perfectly executed pages.

Teachers of calligraphy are caught in the same trap. Often they spend so much time getting students to make the letters correctly and space them correctly that the students are out of school and gone before the teachers can admit that there are other qualities that should be considered. Emotion and personal vitality can be effaced. A standard italic is taught instead of the better Renaissance models or the personal handwriting of some of our best calligraphers. The vigorous hand of Chappell, Figure 293, is pertinent to this point.

To state the case another way, examine the sign language of Figure 312. This shows the opening bars of Purcell's "Golden" Sonata, dated 1683. It preserves some personal quality we should expect to find in the music. Turned over to a professional copyist, the work would be coldly mechanical and only worthy of attention because of its strange code. Perhaps this is the quality that Rudolf Koch was able to preserve—a personal communication which contains his own mark. Even in type design Koch achieved this, and his Neuland typeface contains a primitive accent that was all his own. It defied the proper canons of typography. Perhaps the one important lesson to be learned from the curious warp and woof of innocent calligraphy is that the individual performer, no matter how inept, preserves an identity. In the face of a society that threatens to bury identity, this is an achievement of importance and well worth study.

Amateur Daring

Even the most ardent students of letter styles, those who make the study a life work, are also members of the human race and would not wish to avoid the fact that letters do

312. Opening bars of Purcell's "Golden" Sonata, 1683. British Museum, London.

313. A trade sign in New York City.

314. Sign, New York City.

reveal the human condition. This is obvious in Figure 313, an interesting piece of composition. It says what it ought to say the way it is. By turns absurd, touching, dignified, and bizarre, amateurs reveal themselves where professionals tend to hide behind the walls of various traditions.

At times amateurs in a zeal to be creative leave the professional gasping. What is one to think about the letters of Figure 314? In terms of legibility the piece is outrageous in every respect. Yet in terms of graphic content it has amazing power and variety. To see these qualities, forget the readability of the forms; turn the book upside down and see what happens in terms of decorating the space. Visually the dynamic quality is compelling, and a professional might have to admit that he would like to have solved some problems in this way but had never thought of it.

The example of Figure 315 is just plain good. It is the work of a college student (obviously elsewhere than in an art school). The silkscreen printing job would not pass in the printmaking area but helps to make the piece interesting. The derivation of the letters will defy the most discerning critic of historical manners in letter formation. Is it crossed with Hebrew or Arabic?

Amateurs are often unaware of stylistic unity of form. The example of Figure 316 exists in the town of Harrison, Idaho. Everything about the sign is unique. *R*, *E*, and the

G's are wide with large interior spaces, but the two *A*'s are narrow. Unique endings on the *G*'s contrast with the square serif endings, and these are seen on the *A*'s but not on *R* or *E*. Notice the *R*, a monoline letter except for a part of the bowl. Who would have thought to make this sudden change in letter structure? This *R* is worthy of some attention.

Good calligraphic projects can be done even by those who cannot letter but who may be good with a camera. One might do an interesting portfolio on the lettering on mailboxes. This kind of study is quite unique, since scholars and historical societies care very little about such matters. Foreign-speaking neighbors might offer some unusual specimens. Industrial areas often hold some fine examples of utility letters executed with stamps and stencils. The best material comes from the older areas of industrial enterprise. Railroad yards are good too, as Figure 317 demonstrates. Numbers appearing below have been shattered by the stencil process and possess a unique graphic content. The beautiful numbers at the top show a very subtle stencil method, uniquely joined, and with an unintentional crackle finish. These fine wide Clarendon numbers are a remnant of a special tradition in engine lettering. Designed wide and deliberately spaced, these letters were meant to be read as the cars rattled down the track. Some enterprising reader ought to design a book on this special subject.

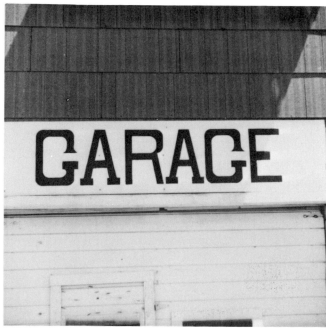

315. Student sign, Madison, Wisconsin.

316. Sign, Harrison, Idaho.

The most moving examples of popular lettering occur when there is a wide gap between the professional and the amateur. Those in between usually produce ugly letters, which remain useless in any connotation. An exception to the rule is seen in the fences that college students write on. One of the tools they use is the spray can, and it has become a standard part of the student tool kit in efforts to amuse one another or to reform the state or to do both. The graphic content of the spray gun has been available to professional designers for many years through the airbrush, but these effects have been shunned like the pox. This is one case where the amateur is going to force the issue and the spray can will be smuggled into the classroom. Calligraphers and typographers respect one another, but in some respects they do not room together. In regard to the spray can, the two areas of letter discipline will have to huddle together like sheep in a blizzard.

Taken in small doses, teachers can learn something from the walls that students write on. In Figure 318 is a part of a book on undergraduate *graffiti*, printed by a graduate student. Shots were made in high contrast and processed for black and white and run on a small lithographic press. The letter styles are peculiar enough, with inside shapes varying from round to square, but they possess considerable energy and power. If such walls are studied carefully, they reveal a healthy variety in kinds of alphabets never seen before and present a kind of vulgate tongue in refreshing contrast to the vegetable and meat pages in our daily newspapers, which are genuinely vulgar. It is certainly strange that television can show the alphabet in new and different ways with good ratings, while newspaper presentation, seen by the same audience, lags far behind.

317. Stencil letters on the side of a freight car.

318. Campus fence, freely decorated and shot in high contrast.

319. Business sign by F. Glau.

Perhaps it is the inability to conform that is truly exciting. We are surrounded by professional nonconformity at every turn. People work at it, and it becomes tiresome. In Figure 319 we observe a statement by a person who simply cannot conform, and while we are inclined to be skeptical of ad writers who say "The Welcome Mat is Out for You," in this graphic piece the word *welcome* seems believable because guile is nowhere in evidence.

The graffiti of our time may be quite the equal of that produced by any age. Our appreciation of it is perhaps a matter of developing a keener perception of the poetic impact to be found in amateur statements. In our own time Ben Shahn has developed a capacity for absorbing rustic letter forms and reforming these in unique fashion. Certainly Shahn's *Love and Joy about Letters* (New York, 1963) shows us something of our cultural heritage that some of us may have missed. If professionals and students have acquired any semblance of snobbishness in regard to proper letter forms, a cue should be taken from the paleographers of Roman writing. These scholars do not select their examples on the basis of excellent craftsmanship, correct spelling, or good rendering of Latin grammar. They study every example of Roman writing that can be found.

319. Business sign by F. Glau.

A frame from the NBC/TV identification mark.

Chapter 10 Graphic Design and the Alphabet

In the nineteenth century, advertising pages were put together by a printer. There were standard illustrations for various objects in the environment; but if the printer did not happen to have one that was appropriate, he substituted something that came close. As to the typographical accompaniment, the printer used his own taste. In the twentieth century, in the larger cities, the demand for more careful supervision of these affairs led to advertising agencies and art directors. These latter were drawn from art schools that specialized in illustration, and if the art director did not know anything about type, he could at least draw some lines that represented type and then consult and learn. Dwiggins had a rare talent for illustration and typography, but most of the art directors were self-taught in one or two areas. Through caution, and often in the best of taste, they preserved the traditional separation

225

between art and letters. New teaching methods and new experimental techniques have broken down this old formula. The designation of "art director" is still necessary because advertising agencies need a man who can correlate ideas and implement them with talents scattered around the city or country. Increasingly these needs are being met by the independent graphic designer who can handle all aspects of any communication problem. The *graphiker* has become a businessman with an experimental attitude toward every aspect of communication, and the illustrations we are about to see encompass ideas and technical mastery that would have been impossible a generation ago. Above all, the contemporary *graphiker* dispenses with any traditional ideas that get in his way and concentrates on using available technology to enhance communication potential.

321. An advertisement designed by Herbert Spencer, London.

320. A student work.

PHOTOGRAPHY

Most people watch television, where we see letters in animation—moving, bouncing, and changing in size. Pieces of letters in large sizes are flashed on for visual impact, and scrambled letters are reduced to legible order in a split second. Advances in photographic techniques mean that designers are not limited to the letters that can be drawn or that can be obtained from typefaces. A piece of lettering that is out of focus can change the quality of the communication, and hard forms can be turned to rubber or go around corners. Typographers and calligraphers have their respected traditions; but photography has penetrated the area of letters, and the phenomenon is here to stay.

Figure 320, a student work, is used here to symbolize sharply what has been a rather gradual and subtle contri-

bution to the art of letters in communication. This participation in the creative area of letters has grown out of a need to have graphic pieces copied, and before the modern facsimile machines (still questionable in regard to reliability) photography was the answer.

A simple example will illustrate the value of photography in graphic design. Let us say that a designer wants to experiment with the word *repetition*. He could get a typist to copy the word ten times or so, or he could get a printer to set the word in type and run off any number of identical impressions. With a little practice the designer could draw the word on a mimeograph stencil and get the required number of copies in that way. He could also paste up letters cut from alphabet sheets or magazines or type manuals (heaven forbid) and reproduce them on a copying machine, or have a photographer furnish a number of contact prints. If the designer is willing to use an existing typeface, the answer is simple; but if the original is hand-lettered, he had best go to a photographer for exact copies. It is this kind of need that has brought about the collaboration between the designer and the photographer.

As a second example, let us say that an art director wants to exploit the sequence *large, larger, largest* in graphic terms. A printer can furnish the words in 18-, 24-, and 36-point type. If the director wants anything in between, he must take a type proof or a hand-lettered original to a photographic service, where he can get reproductions in any size desired.

If a designer had to cope with a piece involving the word *echo*, he might choose in his first sketch to reproduce the word in its simplest form but accompanied by a grayed version of the word reading backward. Or perhaps he sees the word surrounded by superimposed images in differing sizes. What about a version in perspective, receding into the distance? In these thumbnail case studies the designer cannot resolve the matter without the help of a skilled photographer. Long involved in routine copy work, photographers are now actively hooked into the creative process. They have much to contribute.

An original work by London designer Herbert Spencer is seen in Figure 321. It features a Clarendon alphabet in overlapping images and gives the impression of motion like a newspaper coming off the press. Something similar can be obtained by carving a word in linoleum and printing lighter impressions above or around the blacker one. Multiple images can communicate the idea of continuity

322. A cover designed by Franco Grignani, Milan.

Crunch.
Crunch.
Crunch, crunch.
Crunch, crunch. Crunch, crunch, crunch. Crunch.
Crunch, crunch, crunch, crunch, crunch, crunch, crunch,
crunch, crunch, crunch, crunch, crunch, crunch, crunch, crunch,
crunch, crunch, crunch, crunch, crunch, crunch, crunch, crunch,
crunch, crunch, crunch, crunch, crunch, crunch, crunch, crunch,
crunch, crunch, crunch, crunch, crunch, crunch, crunch, crunch,
crunch, crunch, crunch, crunch, crunch, crunch, crunch, crunch,
crunch, crunch, crunch, crunch, crunch, crunch, crunch, crunch,
crunch, crunch, crunch, crunch, crunch, crunch, crunch, crunch,
crunch, crunch, crunch, crunch, crunch, crunch, crunch, crunch,
crunch, crunch, crunch, crunch, crunch, crunch, crunch, crunch,
crunch, crunch, crunch, crunch, crunch, crunch, crunch, crunch,
crunch, crunch, crunch, crunch, crunch, crunch, crunch, crunch,

323. An advertisement designed by Hal Riney
of Batten, Barton, Durstine and Osborne, Inc., San Francisco.

or destroy the picture plane and create the illusion of spatial depth. The example under study here accomplished both of these tricks.

Dramatic possibilities inherent in distortion through photography can be seen in Figure 322, an experimental piece from the vital school of graphic design in Milan. The Milanese designers are not occupied in debating which of several inherited traditions of the past ought to be followed, but in cutting new ground as fast as technical processes can be mastered. We do not know yet how to use such imagery effectively, but the potential is there and we have to think hard. If an image of this kind were to be blown up and put on a wall, it would destroy the vertical plane completely.

TEXTURAL CONTENT

Readers seeing these pages will observe that small letters set in rows not only convey information but also act as a texture, with tiny shapes of black mixing with areas of white to form masses of gray. Such a gray texture varies with the style of alphabet, spacing, and so on. Sometimes a designer will choose to make use of the textural content of letters by repeating the same set of words over and over. If the viewer elects to read the piece, he will absorb the literal content, but otherwise the letters are experienced as a shape with a textural quality. The shape usually acts to define another area of the field. Such applications appear with sufficient frequency to permit omission of examples here, so we can show a usage of letters with a slightly different twist (Fig. 323). Designer Hal Riney chose a word with a good auditory content and matched it with an alphabet possessing sharp, emphatic graphic qualities. It is more than a designer's piece to please other men of letters, because it is a mirror to a human experience, and thus we feel involved.

Graphic Design and the Alphabet 227

324. An advertisement designed for Stephan Lion, Inc., New York, by Mathew Leibowitz.

325. The cover of a promotional piece for the Columbia Broadcasting System.

WORDS AS PICTURES AND PICTURES AS WORDS

In several examples from the Middle Ages we have observed that letters could also be read as birds or fish and so on. Figure 261 shows such an example. In a conservative Renaissance tradition, most probably reinforced by the development of typefaces and attendant technical problems, word content and pictorial content have tended to be separate; the reader looked at the engraving and then he read the type. Given the right problem, contemporary designers like to substitute images that act as letters. This game of the visual pun is one that students of calligraphy like, and many cheerful pieces of vulgarity come out of neophyte projects in this direction. However, this marriage of letter and symbol is not necessarily a communication of low wit. Figure 324, prepared by Mathew Leibowitz, presents a graphic line of some dignity while giving the firm a memorable trademark. It is quite difficult to forget this particular double play or ploy with the sculptured lion serving as an *I* and also representing the name of the firm. Of course the lion has a position of stature in the animal world, and thus lends a note of dignity to the image of the firm.

After the last war, CBS Radio produced a large number of promotional pieces that set high standards in the trade. The late William Golden was the guiding hand in these publications. The leadership of CBS in design continues. In Figure 325 we see the cover of a brochure by this studio. The letters are extreme in the Bodoni tradition, and an embossed graphic ear has replaced *ear* in the reading. The contrast in forms is arresting. There is some sophisticated technique in the printing of the sculptured ear, but experiments in this area can be started with nothing

more than a hammer, a blotter, and a coin; and almost any collection of found objects or old letterpress plates can be "blind" printed on a press providing the various objects can be presented on a reasonably consistent horizontal plane. Some expert help would be needed here, since we do not want to encourage the destruction of expensive presses.

A more playful version of a double function in letters is seen in Figure 326, the book jacket for *The Hungry Goat*, published by Rand McNally. Abner Graboff did the jacket and illustrated the book. Here the types (green in the original) spell out the title and act as a field of greenery for the omnivorous goat.

SPEECH IN ALPHABETS

At times the designer sees the collaboration between letters and pictorial features as forms of speech. The blurb of the modern comic strip may lack dignity, but it is not a recent convention; and historical examples on biblical subjects were totally serious. It is more difficult to use the device in a solemn context today, since the convention is entirely permeated with banality. However, it is possible to make a point, as Walt Kelly's piece in Figure 327 demonstrates. This illustration is taken from an early Pogo book, and in it we observe the spurious man of the cloth speaking in ancient black letter. Kelly's selection of this alphabet seems a simple enough device, but it is well to remember that the quality of wit seen here is one that would be impossible to obtain on a sound track. No amount of vocal talent or skill could convey the satirical content in Kelly's invention, and the imagination is prodded for ways to beat the author at his own game.

nature of the enterprise, and the joined letters add much to the sense of mobile strength associated with the technique. The sans serif alphabets find a new life in this kind of usage. A standard part of the designer's repertoire for almost forty years, the modern sans serif types need change.

NBC/TV uses an animated version of its identifying letters, with forms spreading and curving from a central core. This is a fine piece of design seen in action, and it finishes with the static image appearing in Figure 334. It identifies the organization by means of a unique sign and demonstrates that a thorough knowledge of alphabets is necessary to accomplishments of this level.

TECHNOLOGY

Types are printed from pieces of metal set in rows, and alphabetic images from these miniature relief sculptures are seen in consecutive order through a familiar law of physics, which states that two entities may not occupy the same space at the same time. Superimposed letters can be obtained by means of hand-drawing methods, but it is seldom done. For reasons unexplored, calligraphers do not care to mar their efforts by drawing one letter through another. Stamping or printing relief letters is a more suitable and satisfactory method of accomplishing this end.

"The Tin Whistle Man" (Fig. 335) appeared on Britain's television as a static image anticipating a program scheduled for a later viewing. The main title was arranged by use of a Letraset alphabet, available on thin plastic sheets. Letters of the alphabet are embedded on the reverse side of these thin sheets and are made to adhere to other surfaces by means of pressure applied by rubbing. "Letraset" is patented in England, and the various styles, available in a limited number of colors, can be obtained in the United States, where they offer good competition to local products, such as Prestype.

The crowded swarm of letters in Figure 335 was produced by "rubber" type—the alphabets available on devices used in grocery stores to stamp prices on the merchandise. In the United States the Will Hoff Rubber Stamp Corporation (Detroit, Michigan) furnishes a catalog of competitive stamp alphabets. As seen here, a commonplace device of commercial necessity was exploited by an alert designer with imagination.

The letters in Figure 336 were obtained by the collage technique of cutting and pasting found images. Sirje Helder arranged the piece, which shows a storm of letters descending to a modest head, which reads: "Caught in the communication blizzard?" Upon seeing this application, others will no doubt come to mind.

Top: 334. The identification mark designed by John Graham for the National Broadcasting Company, New York.

Center: 335. A design used by Rediffusion Television Ltd., London.

Below: 336. Use of collage technique in an advertisement by Sirje Helder of The Marschalk Company, New York.

Graphic Design and the Alphabet 231

337. The cover of the Czechoslovakian publication *Typografia 4/62*.

SHAPE CONTENT

Textural content in letter arrangements changes when the letters are enlarged. Then we begin to see that letters possess distinctive shapes in the same way as trees, automobiles, and humans. In certain alphabets we could play a fine game of curves with the numbers 6 and 9. The number 4 is the only symbol used in Figure 337, the front and back cover of *Typografia 4/62*, a Czechoslovakian publication. Here the artist designed the number 4 on the sans serif model, obtained some copies (probably on transparent film) and proceeded to make shapes with his material until the correct combination fell into place. *Counters*, or inside shapes, are large enough to assume a major role in the design, and some of the smaller typographical elements are tucked inside.

Generally this image reads black (and color), but the black-framed counter spaces read white when the viewer gets inside the design, so the smaller black letters read black on white. In one place the small letters are set flush left, unjustified right; the order is reversed at the left.

Another fine play of letter shapes appears in Figure 338 by Walter Bosshardt of Basel. Here the designer uses letters in the colored title coming down from the top. In massing the letters for effect, some lose their identity; but the German reader may pick up the theme quite rapidly. This striking image would probably never have been made without Dada and Bauhaus precedents. The two movements, contemporaneous in the years 1919–1922, were scarcely compatible in their own times due to substantial differences in points of view; but contemporary designers sometimes create unified works that show traces of both schools of letter usage. In the last two striking designs, shape content is a major feature in the presentations, but the words are legible.

DECORATION AND THEME

In the following two graphic pieces familiar signs are taken out of the familiar context of legibility and used thematically. There are times when a designer feels that letter forms can communicate qualities separate from those observed in word groupings. In Figure 339 the designer drew Greek letters, much employed in mathematical statements, to provide thematic content for the cover of a small book for a research institution. Readers will observe that this form of letter usage is dependent on recognition of familiar signs within a knowledgeable group. Clearly this publication was meant for mathematicians and not for musicians, cooks, or policemen. In designing any piece of calligraphy or printing, one of the factors that determines form is the answer to the question, "Who is going to read it?" While professionals actually benefit from knowledge about prospective readers, neophytes need not let these factors interfere with the creative act. They must please themselves first. Perhaps it is best to assume that a neophyte's "readers" are his peers—those at the same stage of mastery.

The next piece is a folder announcing a summer session course at Radcliffe College (Fig. 340). This group of positive shapes is assembled from peripheral signs

338. Graphic design by Walter Bosshardt, Basel.

Above: 339. Cover design by the author.

Below: 340. Portion of a brochure designed
for Radcliffe College by Walter Lorraine, New York.

that serve as aids to reading. The symbol for infinity appears left center. Again the design is oriented toward a somewhat limited area of reader interest; but in terms of shape and counter space the design of Figure 340 demonstrates the potential inherent in signs most of us do not even think about or observe with any care.

CATEGORIES OF ONE

Under the various headings in this section, reproductions have tended to emphasize certain points, and one or two designs have been shown to suggest that hundreds of designs have been rendered in these various areas of thought on the function of letters. It might be useful to stop thinking in terms of categories now and begin to recognize individual efforts. Figure 341, a unique piece of graphic enterprise, is worth seeing, but readers will recognize that there is no necessity for a discussion under the heading of "Alphabets Printed on Animals." The Ray Johnson piece on the snake has a precedent in the history of the United States in the famous "Don't Tread

on Me" flag; but beyond that the image stands on its own merit. Johnson's exhibitions are quite rewarding.

John Melin and Anders Österlin designed the poster in Figure 342, in Sweden in 1963. It is possible to assume that animation haunted the off-duty pursuits of these designers, and they decided to have a try at it with a series of static images. Here the letters begin the series huddled together like a group of insects, and gradually they assume the regimented order necessary for legibility. It is sometimes useful to see the letters in other than their normal positions so that we can discern their true shapes.

In the close association of alphabets with other graphic material, it is sometimes necessary to make the copy fit tightly into a space. In dealing with type this can sometimes be arranged successfully by choosing the correct size of type and then letter-spacing the line to its desired length. Quite often this proves impossible, and sometimes the designer turns to photographic reduction or enlargement of correctly spaced copy in order to achieve his aim. Figure 343 demonstrates a situation in which the lines have to fit or the idea fails. This design was a cover for *CA* magazine and was produced by the Robert Miles Runyan Studios of Los Angeles. This is a period piece cleverly arranged out of nineteenth-century materials. The joined *CA* on the medal was used as identification on envelopes and other printed material issued by the magazine. The original cover used three colors and black.

Another example of tight fit in relating letters to thematic graphic material is exemplified in Figure 344, a book cover by Don Blauweiss. It is an elegant piece of work and the column idea remains intact; but the letter-spacing in the author's name is expanded to a degree that is slightly out of focus with the spacing of *theories*, which sets the pace for the typographical elements.

Given time, money, and facilities, talented designers can solve difficult problems. Students have limited time, limited facilities, and limited cash; and these factors also exist in the world of production. After students leave school the relationship may change so that there are more facilities and less time. It does not matter—certain barriers

341. Announcement designed by Ray Johnson
for his own show at the Willard Gallery, New York.

Graphic Design and the Alphabet 233

342. Poster designed for a display of the graphic work of John Melin and Anders Österlin at the Museum of Västerbottens Lans in Sweden.

343. Cover designed by Robert Miles Runyan Studios, Los Angeles, for *CA* Magazine.

are constant. On a given problem the student must think, resolve, and act. Imperfections occur, and that is the way we learn.

Knowledge of letter structure is the key to many solutions in the graphics of letters. Figure 345 presents a succinct statement of this idea. Designer Emil Ruder, teacher of typography at the Allgemeine Gewerbeschule in Basel, studied the word he wanted to use and decided to play the vertical components against the circular forms. To exploit the idea for all its worth, he turned the word upside down and obtained the interesting vertical conformation. Ruder's book, *Typography*, is excellent.

Copy or word content is usually handed to the designer in a rather fixed form. Writers and editors generally make hard decisions that preclude changes in word content. Obviously the first act of the designer is to read the copy and think about what it means. The design must

reflect in graphic terms the qualities inherent in the text. Are capital letters fundamental to implementation or would lowercase or italics be more appropriate? To create striking images in problems involving a limited number of words, it is necessary to examine word and letter structure very carefully. How many words are involved? Could these be arranged in one line or two lines or three lines? If a lowercase letter form is to be involved, how many ascenders and descenders occur and where do they appear? If by chance the copy shows no ascenders or descenders, is there a chance for a tighter spacing of the lines? In each case it is necessary to study, count, and measure, for in this way a complete knowledge of the problem is accumulated and sensible solutions become possible. It is natural for editors to assume that designers can distinguish between Robinson the poet and Robinson the baseball player. In this sense college literacy is ad-

Disarmingly simple though solutions may be in appearance, they seldom appear out of the blue. Hard work and many trial efforts go into most solutions. Once in a while a word and an idea flash together in the mind, and the designer's work is then simplified. This does not happen often, and inspiration is unreliable.

Figure 347 presents a piece of pure invention. Herb Lubalin, a prominent New York designer, arranged the word as part of a design for CIBA, a pharmaceutical house. In terms of communication this piece speaks (or coughs) for itself.

The aim here has been to stress the creative aspects of the art of letter arrangement and to integrate letters with other graphic entities. Designers search far and wide to bring fresh ideas to the solution of specific problems. In variety, the solutions seen here and in contemporary journals are far more interesting than those conceived twenty years ago. The individual designer has acquired a a range of skills that is greater than ever before, and if he lacks one or two, he knows where he can obtain the needed collaboration.

344. A book cover designed by Don Blauweiss for the Citadel Press, New York.

vocated. In the case of difficult subjects, questions must be asked. In any event the designer can legitimately plead ignorance about the text, but it is assumed that he knows everything about alphabets, and student designers need to study these quite carefully.

The logo or trademark for the American Broadcasting Company was furnished by Paul Rand, the distinguished United States designer (Fig. 346). His preliminary work is not available to us, but it is clear that the finished product shows a thorough knowledge of letter shapes. In current sans serif alphabets all three of these letters are partly circular in form, but *a* and *b* differ from the versions seen here. The *b* required little change, but for the *a* Rand went back to Herbert Bayer's Bauhaus *a* of 1925 and gave it a circular configuration. These changes resulted in a successful solution, because research by ABC revealed that the viewing public liked the brief identifying statement.

345. Piece designed by Emil Ruder, Basel.

Top: 346. Trademark designed by Paul Rand
for the American Broadcasting Company, New York.

Above: 347. An advertisement designed by Herb Lubalin,
New York. CIBA Pharmaceutical Company.

New solutions to problems in graphic communication do not appear as if by magic or inspiration. Old-fashioned manual skills are still necessary. Thus the solution seen in Figure 347 did not make use of Lubalin's outstanding skill with the pen and brush, but it was there. Basic skills give the designer confidence and free his mind. A sound knowledge of letter structure and the ability to draw are essential to a designer. Techniques and processes can be picked up as the individual matures in his work. In programs made up to train young people for work in graphic communication it is sometimes forgotten that knowledge and the development of skills are not always inherent in projects that are fun to do. The acquirement of basic skills involves a lot of brutally hard work over a long period of time. It is unfortunate in some respects that this kind of work must be accomplished on the college level, where theory, history, and examination of ideas might be thought to be more important. But there is no other way to acquire the needed skills than to get at it.

The Morris revival attracted strong adherents in typography and calligraphy. In former years these adherents were not especially sympathetic to the avant-garde notions of the Dada group nor with the separate and emphatic Bauhaus opinions on the role of letters in communication. At one time the schisms were serious and a student felt the prod of the shepherd's crook on one side of his ribs or the other. The role that the designer has taken in graphic communication has tended to break the force of rigidly held views, because he does not care where ideas come from as long as they are appropriate to the solution he is seeking. Thus today an instructor can start his typography class with an exercise in nineteenth-century types, which would have been an act of heresy in earlier days of the century.

Part VI FORM, MEANING, AND LEARNING

Alphabet Stone by Edward Catich. Los Angeles County Museum of Art.

Chapter 11 Structure

While the history of type alphabets possesses an inherent value, easily as interesting and important a subject as the history of fashions, jewelry, cats, or dentistry, the few notes included here on this subject were selected in order to give some idea of the origin of major families of letters. The generic terms for these major categories serve not only for type styles but for handmade letters, letters available from photosetting machines and typewriters, and those alphabets available on transparent sheets. Terminology will be kept to a minimum here, but some guides are necessary in order to establish a basis of communication about letters. This should enable neophyte calligraphers to get into the creative arena as quickly as possible.

Differences between similar alphabets are like the differences between wines of neighboring hillsides: The perception of them is a subtle

sleep

348. Design by Lester Teich. Aaron Burns,
Typography. Reinhold Publishing Corporation.

Although wines and alphabets have traditional usages developed over centuries of trial and error, experience and talent can override these rules. Winston Churchill was credited with a unique talent for pressing the English vocabulary for words that embellished his meaning and stirred the imagination, but in another context, a soldiers' mess, he is reported to have remarked, "Good grub, ain't it?" Obviously the gifted statesman could match language to any situation and come off well.

An intimate acquaintance with detail is implied in the work of Figure 348 by Lester Teich, who knew that Caslon had the proper configurations in lowercase to communicate a meaning. The gentle shading of the curved portions of the letters helped the idea. Had he used a more mechanical-looking alphabet, the structural components of the letters might have been incompatible with the meaning of the word. In order to see structure more clearly, let us put a classic Old Style Roman font through its paces to see what we can learn.

art with subjective factors. For the beginner it is rather silly to try to distinguish Bernkastler Doktor from other wines of the Moselle region. Perhaps a more sensible approach would be to try to distinguish between whiskey, beer, wine, and gin at first, and then perhaps attempt the problem of sorting out the wines into red and white, sweet and dry, and so on.

Left: 349. An analysis of Roman minuscule letters, grouped according to structural similarities.

Right: 350. Comparisons within the capital alphabet, expressed through Caslon, a standard Old Style Roman font.

bdfhkl

gjpqy ij

abcdegopqs

kvwxyz

minu

flirnhmk

akgvstz

BPRD

CGOQ

FELZ

AKMNV

WXYZ

HIJKLU

FHIKPRTY

&S

In Figure 349 six lowercase letters with ascenders are grouped together. Next, five letters with descenders are grouped together. The two sets together total eleven letters, not counting the dot of *i* in the minor duo of *i* and *j*, which also appears in line 2. Line 3 includes the letters with curved parts: *a, b, c, d, e, g, o, p, q, s*. Letters with angular features are included in the fourth line, and these are *k, v, w, x, y, z*. Curiously, these late additions and refinements of the original Latin alphabet retain an echo of geometric Greek inscription letters, and they are difficult to compose within the group and with other letters. They lend the necessary variety in visual content that makes our lowercase alphabet interesting, but they do not appear often enough. Those who wish to play games with this set of lowercase letters will find that the geometric content is interesting but that very few words emerge.

Line 5 represents a group of lowercase letters similar in structure. Undoubtedly they are too similar in content for good sense, and this will recall certain medieval alphabets in which *n* and *m* were structurally unique. Conformity has hurt this set of *m, i, n*, and *u*, particularly when other letters with interchangeable parts are added. These are seen in line 6. Letters that do not appear to be made of prefabricated parts are seen in line 7, and they retain a kind of vitality of sign content most valuable in the lowercase letters. Grouped in these various ways, the letters allow discerning artists to see solutions to various problems when they examine the letter content of material to be designed.

Since capitals derive from a separate tradition, the groupings are more or less distinct from those of the lowercase letters. The first line of Figure 350 shows three letters, *B, P*, and *R*, which exhibit more facsimile elements now than in Roman times. Line 2 shows four letters tending toward a common structure. In the third line we observe that *F* and *E* show similar features, and in a slight switch, *E, L*, and *Z* follow in exhibiting similar finishing strokes. Lines 4 and 5 show the angular letters *A, K, M, N, V, W, X, Y*, and *Z*. Again these letters present difficulties in composition because of the greater white areas in and around the component strokes. In line 6 we see those capitals that have similar endings at the top; and in line 7 those letters with identical serif endings at the base are aligned in order to accentuate the feature. Letter *D*, with serif endings similar to *B*, is somewhat unique in its structure and is seen at the end of the first line after *R*. This grouping leaves out *S*, so it is included here in the last line with the ampersand, one of a number of word signs still active in our system. Notice that the lowercase

letters have fewer blacks at the top and tend to fall into horizontal patterns. The capitals, clearly more architectural in feeling, complement the small letters. Modern typographers like to play visual games with letters, but the Old Style Roman capitals present a wall of dignity that is difficult to assault. These ancient letters say *ain't* with obvious reluctance.

Legibility in Lowercase Letters

Legibility factors in the lowercase are seen in Figure 351. It is obvious that most of the graphic marks that distinguish one letter from another reside in the upper parts of the lowercase letters. Many of the supporting stems add nothing to sign content. In effect, meaningful features hang on the top line of any string of lowercase letters. This unique feature is also true of Hebrew letters and the modern descendants of scripts associated with Sanskrit. The nature of this phenomenon is open to study and involves fundamental work in culture, tools, and perception. Very little has been published on this subject.

gramofoonplaten

gramofoonplaten

gramofoonplaten

351. A Dutch word split to show that significant sign structure resides around the shoulders of the Roman minuscule rather than in the feet.

An exceptional letter is *g*, which now possesses an identity in the descending anatomy. A brief history of *g* is presented in Figure 352, provided by Frederic W. Goudy in *The Alphabet and Elements of Lettering* (University of California Press, 1942). Letter *g*, an invention of Roman origin, started off as a *C* with a very short descending stroke, smaller than that seen here. Second from the right is a Renaissance form, and Goudy's own version is seen at the right. It is suggested that those seeking reform of the alphabet will need to consider the essential sign forms of those alphabets bequeathed to us. Young instructors sometimes suggest that students invent an alphabet of their own. There is fun in this, but some knowledge of structural inheritance is necessary to any fruitful effort, and perhaps the student's aim should be toward eliminating some present weaknesses. If medical students were asked to redesign the human skeleton into some novel

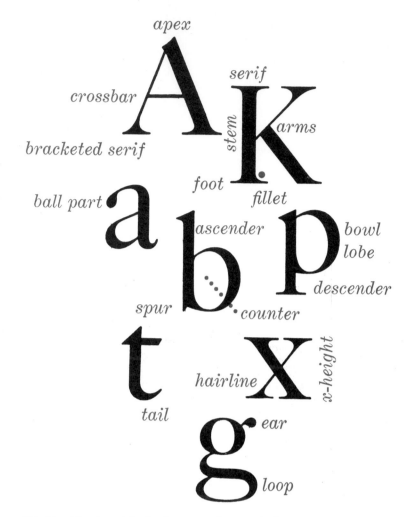

352. Goudy's review of the letter *g*. Frederic W. Goudy, *The Alphabet*.

form, the project might not be worth the time; but if they were asked to engineer a new human skeleton to eliminate sacroiliac troubles, they might do some valuable thinking in the process.

Terminology

Figure 353 presents some of the basic terms used to describe parts of letters. A standard Old Style Roman is used here. The entire curved part of lowercase *b* and *p* and similar letters is called the *bowl*. White spaces enclosed are termed *counters*, while the curved tapering stroke opposite the vertical *stem* is a *lobe*, or *swell*. An initial part of a letter can be called a *head*, while a termination can be called a *foot*. A head or foot may be without *serif*, but those seen here have *bracketed* serifs, which means that they have a curve, or *fillet*, between the serif and the stem. A decorative ending on a capital is named a *swash*, and some Old Style Roman fonts have a complete set of swash, or flourished, capitals. A short term is needed for that height of the lowercase which does not include ascenders or descenders, so letter *x*, having no curved part top or bottom, is a convenient letter for this measure. As can be observed here, the ancient proportion established in the Carolingian minuscule of 1 :1 :1 for ascender, body, and descender is no longer standard. It is believed that factors of legibility and esthetics can be maintained without the expensive historical proportion of fewer lines on a page and more pages in the book. The alphabet in Figure 349 does a good job of proving the point, but Caslon's derivations are not the end of the debate. Lowercase letters seen in this figure would be called long on the body, or x-height. Within the same vertical space, alphabets featuring longer ascending and descending parts would be termed short on the body.

OLD STYLE ROMAN AND MODERN ROMAN

In Figure 354 we see the essential differences between Old Style Roman and Modern Roman, with the latter shown above in each of the four sets. The several differences described here may not apply to single letters, and a number of letters must be contrasted to gain the distinctive visual flavor:

353. Identification of the basic structural parts of a letter.

1. Differences in thick and thin strokes of Modern Roman tend to be more extreme than in Old Style Roman alphabets.
2. The upper terminal stroke of *a* tends toward a teardrop in the Old Style, reflecting pen strokes, while Modern features a round bowl.
3. In Old Style Roman the curved letters show signs of a pen-letter bias (dotted line); but these same curves in the Didot-Bodoni alphabets show an axis strictly vertical and horizontal.
4. Initial strokes on the ascender of *d* show obvious differences, and these are also seen in *n*'s and all letters of similar structure along the waistline.
5. Bracketed serifs appear on the feet of Old Style Roman *n*'s, but the same ending in the Modern Roman features a stem and a hairline serif with no fillet between stem and serif.

These several features will be reflected in the four versions of the two principal Roman styles seen in Figure 354. It is important that readers recognize the essential differences between these styles. They perform different functions in communication. For example, Old Style Roman is seen in books, but the Modern Roman is seldom used for this purpose.

354. Type display revealing the basic differences between Old Style Roman and Modern Roman.

ABCDEFGHIJKLMNOPQRSTUVWXYZ&

ABCDEFGHIJKLMNOPQRSTUVWYXZ&

abcdefghijklmnopqrstuvwxyz

abcdefghijklmnopqrstuvwxyz

ABCDEFGHIJKLMNOPQRSTUVWXYZ&

ABCDEFGHIJKLMNOPQRSTUVWXYZ&

abcdefghijklmnopqrstuvwxyz

abcdefghijklmnopqrstuvwxyz

CLASSIFICATION OF LETTER STYLES

Roman styles such as Centaur and Bembo, based on the work of Nicolas Jenson and other fine printers of the 1470s, are frequently called Venetian. This category will not be used here. The term *transitional*, used to describe Roman styles hovering between Old Style Roman and Modern Roman, is also rejected.

Sans serif alphabets are designed in an upright version and also in a version canted to the right. These slanted versions are incorrectly labeled italic. The reader already knows that italic stands for a version of Humanistic minuscule developed out of pen letters of the fifteenth century in Italy. Slanted versions of the geometric sans serif alphabets hardly qualify, if terms are meant to inform and not confuse. Here we will use the term *oblique* for canted versions of the sans serif alphabets described. These notes aside, a convenient system of letter classification is listed below:

1. Old Style Roman: capitals, lowercase.
 Old Style Roman italic: capitals, lowercase.
2. Modern Roman: capitals, lowercase.
 Modern Roman italic: capitals, lowercase.
3. Square serif: capitals, lowercase, rare oblique.
4. Clarendon: capitals, lowercase.
 Clarendon italic: capitals, lowercase.
5. Sans serif: capitals, lowercase.
 Sans serif oblique: capitals, lowercase.
6. Gothic: capitals, lowercase.
 Gothic oblique: capitals, lowercase.
7. Formal scripts: capitals, lowercase.
8. Informal scripts: mostly hand-lettered.
9. Calligraphic styles
10. Miscellaneous

The latter category is avoided by some writers on this subject, but it contains some interesting and varied matter that cannot otherwise be included without a proliferation of subject titles, which is self-defeating in purpose.

abcdefghijklmnopqrstuvwxyzabcdefghijklmnopqrstuvw
ABCDEFGHIJKLMNOPQRSTUVWXYZABCDEFG
abcdefghijklmnopqrstuvwxyzabcdefghijklmnopqrstuvwxyzabcde
ABCDEFGHIJKLMNOPQRSTUVWXYZABCDEFGHI

abcdefghijklmnopqrstuvwxyzabcdefghijklmnopqrst
ABCDEFGHIJKLMNOPQRSTUVWXYZABCDI
abcdefghijklmnopqrstuvwxyzabcdefghijklmnopqrstuv
ABCDEFGHIJKLMNOPQRSTUVWXYZA

abcdefghijklmnopqrstuvwxyzabcdefghijklmnopqrst
ABCDEFGHIJKLMNOPQRSTUVWXYZABCD
abcdefghijklmnopqrstuvwxyzabcdefghijklmnopqrstuv
ABCDEFGHIJKLMNOPQRSTUVWXYZABCDE

abcdefghijklmnopqrstuvwxyzabcdefghijklmn
ABCDEFGHIJKLMNOPQRSTUVWXYZ
abcdefghijklmnopqrstuvwxyzabcdefghijklmnopqrstuvwx
ABCDEFGHIJKLMNOPQRSTUVWXYZABC

ghijklmnopqrstuvwxyzABCDEFGHIJK
LMNOPQRSTUVWWXYZ

Old Style Roman styles: Garamond, Caslon, Times Roman, Weiss, and Weiss Italic with swash capitals.

abcdefghijklmnopqrstuvwxyzabcdefghijklmnopqrstuvwxyzabcdef
ABCDEFGHIJKLMNOPQRSTUVWXYZABCDEFGHIJKLMN
abcdefghijklmnopqrstuvwxyzabcdefghijklmnopqrstuvwxyzabcdef
ABCDEFGHIJKLMNOPQRSTUVWXYZABCDEFGHIJKLMN

abcdefghijklmnopqrstuvwxyzabcdefghijklmnopqrstuvwxy
ABCDEFGHIJKLMNOPQRSTUVWXYZABCDEFGHIJK
abcdefghijklmnopqrstuvwxyzabcdefghijklmnopqrstuvwxyza
ABCDEFGHIJKLMNOPQRSTUVWXYZABCDEFGHIJK

abcdefghijklmnopqrstuvwxyzabcdefghijklmnopqrstuv
ABCDEFGHIJKLMNOPQRSTUVWXYZABCDEFGHIJ
abcdefghijklmnopqrstuvwxyzabcdefghijklmnopqrstuv
ABCDEFGHIJKLMNOPQRSTUVWXYZABCDEFGHI

abcdefghijklmnopqrstuvwxyzabc
Printed page, conquering world of Euro
abcdefghijklmnopqrstuvwxyzabcdefghijklmnopqrstuvwxy

Refreshing

Modern Roman styles: three weights of Bodoni, Torino Italic, Poster Bodoni Italic,
Ultra Bodoni Extra Condensed, and Craw Modern.

abcdefghijklmnopqrstuvwxyzabcdefghijklmnopqr
ABCDEFGHIJKLMNOPQRSTUVWXYZABCDEF
abcdefghijklmnopqrstuvwxyzabcdefghijklmnopq
ABCDEFGHIJKLMNOPQRSTUVWXYZABCDEF

abcdefghijklmnopqrstuvwxyzabcdefghijklmn
ABCDEFGHIJKLMNOPQRSTUVWXYZAB
abcdefghijklmnopqrstuvwxyzabcdefghijklmno
ABCDEFGHIJKLMNOPQRSTUVWXYZABC

abcdefghijklmnopqrstuvwxyzabcdefghijklmnopqrstu
ABCDEFGHIJKLMNOPQRSTUVWXYZABCDEFGHI

abcdefghijklmnopqrstuvwxyzabcdefghijklmnopqrstuvwxyzabcdefghijklmnopqr
ABCDEFGHIJKLMNOPQRSTUVWXYZABCDEFGHIJKLMNOPQRSTUVWXYZAB

ABCDEFGHIJKLMNOPQRSTUVWXYZABCDEFGH

abcdefghijklmnopqrstuv

1234567890 !?$

abcdefghijklmnopqrstuvwxyzabcdefghijklmnopqrstuvwxyzabcd

Square serif style: various interpretations of Stymie.

abcdefghijklmnopqrstuvwxyzabcdefghijklm
ABCDEFGHIJKLMNOPQRSTUVWXYZA

abcdefghijklmnopqrstuvwxyzabcdefghi
ABCDEFGHIJKLMNOPQRSTUVWXY

abcdefghijklmnopqrstuvwxyzabcdefghijklm
ABCDEFGHIJKLMNOPQRSTUVWXYZABC

abcdefghijklmnopqrstuvwxyzabcde
ABCDEFGHIJKLMNOPQRSTUV

ABCDEFGHIJKLMNOPQRSTUVW

abcdefghijklmnopqrstuvwxyzabcdefghijklmnopqrstuvw
ABCDEFGHIJKLMNOPQRSTUVWXYZABCDEFGHIJKL

abcdefghijklmnop
ABCDEFGHIJ
ABCDEFGH

Clarendon style: rival interpretations.

abcdefghijklmnopqrstuvwxyzabcdefghijklmnop
ABCDEFGHIJKLMNOPQRSTUVWXYZABCDEF
abcdefghijklmnopqrstuvwxyzabcdefghijklmnopq
ABCDEFGHIJKLMNOPQRSTUVWXYZABCDEF

ABCDEFGHIJKLMNOPQRSTUVWXYZ *ABCDEFGHIJKL*
abcdefghijklmnopqrstuvwxyz *abcdefghijklmnopqrstuvwxy*

ABCDEFGHIJKLMNOPQRSTUVWXYZ&

abcdefghijklmnopqrstuvwxyzabcdefghijkl
ABCDEFGHIJKLMNOPQRSTUVWXYZABCD
abcdefghijklmnopqrstuvwxyzabcdefghijklm
ABCDEFGHIJKLMNOPQRSTUVWXYZABCD

ABCDEFGHIJKL
MNOPQRSTUV

Sans serif styles: Futura Book, Gill Sans, Gill Sans Titling, Futura Demi Bold, and Futura Medium.

abcdefghijklmnopqrstuvwxyzabcdefghijklmnopqrstuvwxyzabcdefghijklm
ABCDEFGHIJKLMNOPQRSTUVWXYZABCDEFGHIJKLMNOPQRSTUVWXYZAB

abcdefghijklmnopqrstuvwxyzabcdefghijklmnopqrstuvwxyzabcdefghijkl
ABCDEFGHIJKLMNOPQRSTUVWXYZABCDEFGHIJKLMNOPQRSTUVWXYZA

abcdefghijklmnopqrstuvwxyzabcdefghijklmnopqrstuvwxyzabcdefghijklmnopqrstuvw
ABCDEFGHIJKLMNOPQRSTUVWXYZABCDEFGHIJKLMNOPQRSTUVWXYZABCDEFG

abcdefghijklmnopqrstuvwxyz äbçdéèfgh
ABCDEFGHIJKLMNOPQRSTUVWXYZŒ1234

At the portières of that silent Fauburg St.Germain, there is but brief question, do you deser

SEIT DIE ZEIT GESCHICHTE GEWORDEN ist, begleitet die Schrift den Menschen

abcdefghijklmnopqrstuvwxyzabcdefghij
ABCDEFGHIJKLMNOPQRSTUVWXYZ

abcdefghijklmnopqrstuvwxyzabcdefghijklmno

ABCDEFGHIJKLMNÆKn

Gothic styles: Three sets of Alternate Gothic, the interesting Demi-Grasse by Fonderie Olive, Folio Medium Condensed, Erbar Grotesk, Univers, Bauer Topic Oblique, and Bauer Topic.

abcdefghijklmnopqrstuvwxyzabcdefghi1234567890
ABCDEFGHIJKLMNOPQRSTUVWX

abcdefghijklmnopqrstuvwxyzabcdefghijkl
ABCDEFGHIJKLMNOPQRS

abcdefghijkmnopqrstuvwxyzabcdefghijkmnopqrst
ABCDEFGHIJKL
MNOPQRSTUVW

abcdefghijklmnopqrstuvwxyz abcdefg
ABCDEFGHIJ
NOPQRSTUVW
LMNOPQRSTUVWXYZABCD
GHIJKLMNOPQRSTUVWXYZ1234567890
CDEFGHIJKLMNOPQRSTUVWXY

Formal scripts: Commercial Script, Typo Script, the remarkable Stradivarius, and Diane, a French design.

abcdefghijklmnopqrstuvwxyzabcdefghijklmnopqrstuvwxyzabcdefg

ABCDEFGHIJKLMNOP2RSTUVWXYZ ABCD

ABCDEFGHIJKLMNOP QRSTUVWXY

abcdefghijklmnopqrstuvwxyz

ABCDEFGHIJKLMNOP2RS TUVWXY3& abcdefghijklmnopqrst

abcdefghijklmnopqrstuvwxyzääöüchckßdeenerfffliflltßtzg

aääubcdeeienenterfffliflft ghhchheitijkdckkeit lllmmnnmooöpäurssch

ABCDEFFGHJJKLMNOPQüRSSchSTThUVWXYZÄÖÜÆŒÇ

Der Rosenmontag in Mainz Möbelhaus Anton Rabenstein

After an Apprenticeship as Page and Squire the Knight of the mid

abcdefghijklmnopqrs

ABCDEFGHJKLMNOP

ABCDEFGHIJKLMNOPQRSTUVWXYZ1234567890ÆŒÇ abcdefghijklmnopqrstuvwxyzä

Informal scripts: Brush, Pepita and Swing (both English), three remarkable German designs, Repro Script, and Mistral.

abcdefghijklmnopqrstuvwxyz ABCDEFGHIJKLMNOP

ABCDEFGHIJKLMNOPQRSTUVWXYZ&abcdefghijklmno

abcdefghijklmnopqrstuvwxyzabcdefghijklmnopqrstuvwxyzabcdefghijkl
ABCDEFGHIJKLMNOPQRSTUVWXYZABC

abcdefghijklmnopqrstuvwxyzABCD

abcdefghijklmnopqrstuvwxyzabcdefghijklmnopqrstuvwxy
ABCDEFGHIJKLMNOPQRSTUVW

It showed civilization at a time when it was hardly conceivable that

ABCDEFGHIJKLMNOPQRSTUVWXYZ abcdefghijklmnopq

abcdefghijklmnopqrstuvwxyzabcdefghijklmnopi
ABCDEFGHIJKLMNOPQRSTUVWXYZA

abcdefghijklmnopqrstuvwxyzabcdefghijklmnopqrstuvwxyzabc
ABCDEFGHIJKLMNOPQRSTUVWXYZABCDEFGHIJKLMNO

abcdefghijklmnopqrstuvwxyzabcdefghijklmnopqrstuvw

abcdefghijklmnopqrstuvwxyzabcdefg

Calligraphic styles: Temple Script, Klang, Thompson Quillscript, Libra, Legend, Verona, Bologna, Engravers Old English, Lydian Italic, Lydian Cursive, and Goudy Text.

ABCDEFGHIJKLMNOPQRSTUVWXYZ ABCDEFGHI

JKLMNOPQR& abcdefghijklmnopqrstv

ABCDEFGHIJKLM 1234567890 ABCDEFGHI

12345ABCDEFGHIJKLMNOPQRSTU

abcdefghijklmnopqrstuvwxyz âbçdèëf

EFGHIJKLMNOPQRSTUVWXYZ&

GENERAL MOTORS BI

UVWXYZABCDEFGHIJKLMNOPQRST 123

ABCDEFGHI JKLMNOPQRSTUVW

ABCDEFGHIK

LMNOPQRSTUVWXYZ?

ABCDEFGHIJKLM

☞ ABCDEFGHIJKLMNOPQRSTUV

Miscellaneous styles: Designs for special needs proliferate beyond traditional categories.

355. A type gauge.
The Haberule Company,
Stuart, Florida.

MEASUREMENT IN TYPES

In examining the ten preceding pages of major alphabetic styles or in going through type catalogs, strange numbers and names may be encountered. In a designation such as 10-point Garamond, the number refers to the size, while the title is the name of the type. In calligraphy or hand-lettered specimens there are no unique units of measurement, and in the United States the inch ruler with its familiar fractions is used. For measuring type there is a unique system. Vertical heights of types are measured in *points* (abbreviated to *pts.*). For larger measurements, such as depth or width of a column, the *pica* is used. The relationship between the point, the pica, and the inch is as follows: 6 picas = 1 inch; 12 points = 1 pica. This relationship shows that a point is 1/72 of an inch.

Such a minute unit would seem to indicate that students should require some scientific instruments to determine type sizes, but this is not as critical as it would appear. The landscape of type is small, but people with good eyesight can read 4-point type. Veteran typographers can identify the type size and the amount of *leading* between the lines by eye.

Since type sizes are measured vertically, usually the combined measurement of an ascender-descender combination like *dp* will give the size of the font or come close to it. Convenient scales are available, and one of these is reproduced in Figure 355. While some typefaces are available in sizes below 8 point, the latter size is generally considered to be the lower limit in faces designed for reading. Most book faces are 10 or 12 point. Odd-numbered sizes, 9, 11, and 13 point, are available in

some alphabets. Elegant limited editions can be seen using 14-point types or even larger, and children's books also tend to use larger sizes. Above 12 points, types are designed at discrete intervals of size, and in-between sizes are rare. Generally, *display* sizes—those used for headings, titles, and other matter of strong visual force—begin at 14 points. The larger sizes are 18, 24, 30, 36, 42, 48, 60, and 72 points. A 72-point typeface is an inch high, and everyone has seen letters larger than that; but these are especially designed for the purpose or are enlarged from smaller sizes through photography.

THE RELATIONSHIP OF STYLE TO MEANING

The selection of alphabets for differing communicative functions is the role of graphic designers and typographers. There is no other reason for the proliferation of alphabets, for the pursuit of small detail in design, or for exercises in identification of styles. Many alphabets serve well for Lincoln's "Gettysburg Address." But what is the best alphabet for this memorable speech? This is the kind of difficult question graphic designers have to ask, and students of calligraphy or graphic design must also learn how to approach this problem.

Habits of a society are strong here, and the cliché runs rampant in the area of typography. If one were to make an inquiry of a printer as to a suitable alphabet for a wedding announcement, the odds are good that the printer will exhibit a formal script among other choices. Certainly an Old Style Roman italic might be an excellent choice here, but how often is it seen? Quite often a designer can solve a problem by doing the expected, and at other times he serves himself and the public best by doing exactly what he pleases to do as an artist.

The latter course of action ought to be preferred on its rough definition, but there is more to the situation than this. Frequently the typographic artist finds himself in conflict with public views about layout and letters. Appearing in a communications seminar some years ago, a designer told of persuading a client to have his Thursday newspaper ads reworked. The client was a supermarket whose ads bore some resemblance to that seen in Figure 356, crowded and typographically ugly. The aim, seemingly well-motivated, centered on a clear layout and a sans serif type of the kind already seen in Figure 270, the German newspaper. With well-ordered white space the new pages were quite elegant, but sales fell off. The alarmed client ordered a quick survey to determine the cause of this and found that women were staying away because the redesigned pages carried the impression that the store was too expensive. In contrast, the crowded,

ugly pages seemed to communicate the proper bargain-day aura. This is one case where the designer did exactly what he pleased and lost.

There is no question that acute selection of alphabets and careful spacing of them can make a sales pitch for a fraudulent elixir look like a report from Harvard professors. No person is immune to this form of persuasion, and the only defense against it is knowledge of alphabetic forms and of graphic images. Skill in the handling of words on a page has some parallel in the area of speech. No doubt any assessment of Franklin D. Roosevelt's success as a political leader must include the manner in which the written word was delivered.

The best way to observe the manner in which the forms of letters supplement or destroy the meaning of words is actually to work out some graphic designs. For example, phrases can be cut from newspapers or magazines that in form seem most suitable in expressing the following ideas or phrases:

1. a precision watch
2. figure skater
3. Rutherford B. Hayes
4. May apples bloom early
5. stop—road ends
6. supersonic speeds
7. a little old lady in lace
8. a fragrance from the East
9. a cool drink with a distinguished gentleman
10. dixieland jazz

In classes where an opaque projector is available student notebooks can be projected on a screen and opinions sought. The value in open discussion may well lie in revealing some cliché attitudes held in common or discovering why unorthodox views seem to be interesting. A hidden and important value is that the student has been asked to participate in an act of discrimination. He has been asked to think about the problem; and if suitable follow-up projects can be devised, the student will think about it again and again. This is perhaps more important than discussion or evaluation of initial efforts.

Newspapers and magazines provide a more generous supply of alphabets in variety than any institution can afford to supply in terms of type fonts. In the theoretical area we can learn on free material. The following list of headings can be used for developing the facility to name an appropriate typeface for different subjects. This book or a type catalog can be used for these typefaces.

1. a heading for an article on bear cubs
2. lettering for a poster announcing a circus
3. an announcement of an exhibition of Peruvian pottery
4. a formal invitation from the president of the college

5. letters in a poster for a farm auction
6. the title of an article on the Roman Forum
7. letters in a television ad for hand lotion
8. jacket for a book of poems by Robert Frost
9. construction site sign for a firm of architects
10. program of Bach pieces written for harpsichord

In the classroom it is interesting to tabulate the results of student selection on such items, because it will demonstrate that certain problems tend to be solved in the same or in similar ways. For instance, to implement an announcement of an exhibition on Peruvian pottery at least half of the students will choose a style called Legend. This reflects cliché attitudes in our culture and at the same time poses the problem, If you do not care to do the obvious, what will you do? On the other hand, some subjects will spark a rather wide range of solutions, and it is enlightening to find out why a student selected a particular alphabet. A thorough session on this kind of problem can show that the numerous type styles seem inadequate to deal with certain aspects of communication.

In Figure 357 we see a student work along the lines under discussion. Needless to say, the presentation must be logical and interesting to look at. Of course the problems need not follow the precise contour of suggestions presented here. But the neophyte must be confronted with the ties between styles, meaning, and identification of styles.

Left: 356. A typical newspaper layout.

Right: 357. A student effort to match styles to needs.

Student project using one word.

Chapter 12 Laboratory Experience

TOOLS AND THEIR USE

It will be useful to center a discussion of ideas for calligraphy around a basic set of tools and instruments and see what can be accomplished with them. The set in Figure 358 does not include all the tools used by professionals, but limited means have never hindered beginners. Not pictured here are a T square, a large triangle, and an ordinary ruler. Inks, paints, and other paraphernalia will be mentioned from time to time. From left to right in Figure 358 are (*a*) and (*b*) profile and top view of the author's bamboo pens, (*c*) a bamboo pen by Lloyd Reynolds, (*d*) a turkey-quill pen made by Reynolds, (*e*) a pointed sable brush, (*f*) a flat-tipped sable brush, (*g*) a steel pen and pen holder (*h*) an ink compass, (*i*) a ruling pen, (*j*) a carving tool, and (*k*) a hard lead pencil. A razor blade and steel pens complete the array. Pencils come in degrees of hardness;

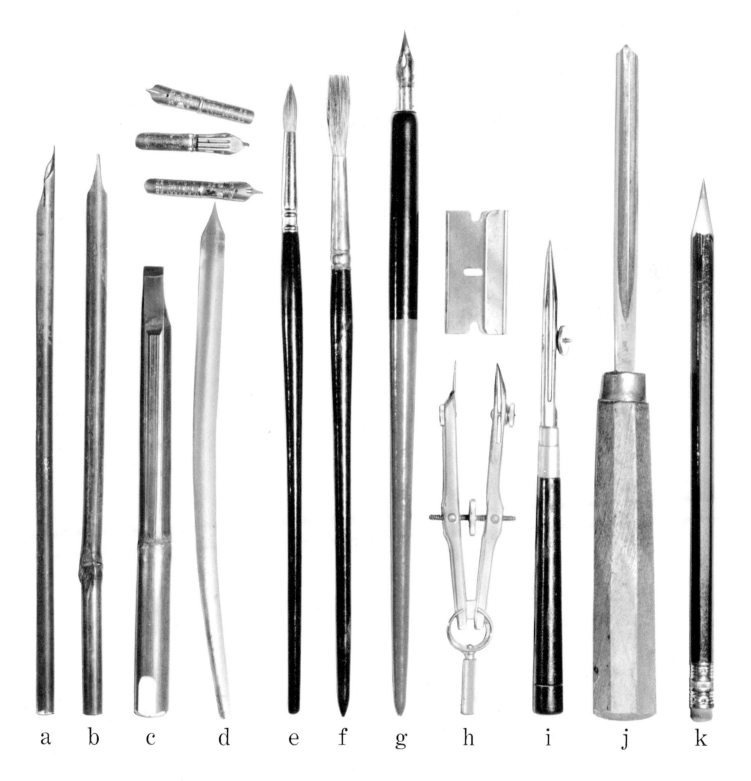

a b c d e f g h i j k

358. A basic set of tools for making the several kinds of letters.

a 1H (hard) pencil allows for erasures. The razor blade is used to sharpen the pencil to the shape observed. Pencil sharpeners do not give the right point and are usually broken or too dull. The razor blade is also useful in collage work. The steel pens seen in the layout are especially designed for small-scale calligraphic work but are also useful as drawing tools. A pen of special nib for left-handed individuals appears at the bottom of the group. Let us dispose of the problem of left-handed persons at the outset.

Early inscriptions, geometric and stiff, frequently cut in stone, did not bear indications as to whether they were done by left-handed or right-handed persons. It is presumed that left-handed individuals could execute this kind of work. As we have inherited them, the forms of the alphabet have been determined by right-handed persons, and all of the great calligraphic hands of Roman times, the Middle Ages, and the Renaissance, and the typefaces reflecting these eras, prove the point. Not all left-handed persons solve their handwriting problems in the same way, so it is difficult to prescribe for them. And in calligraphy left-handed pens sometimes fail to solve the problem. However, many left-handed persons can learn about these historic hands, and on occasion they do fine work (Fig. 390b), although not infrequently they have difficulty with spacing. Some work upside down; others try their right hand. If the problem seems insuperable, their interest in lettering may be channeled to carving letters in linoleum or wood and perhaps printing these specimens if they are designed backward. Or they can turn to working in clay or metal, to photography, to collage, or to research work in the library. Of course on constructed letters left-handed persons perform on a par with their right-handed friends. The problem is a fascinating one. Right-handed violinists finger with the left hand, trumpeters with the right. Some pitchers throw left and bat right. But calligraphers have not succeeded in training the switch hitter.

The Wide Brush

The brush seen in Figure 358f is a Grumbacher Series 9355 No. 8, and makes a stroke about ¼ inch wide. Thus it will make letters about 2 inches or more high. There is something to be said for starting at this scale. The landscape of calligraphy and type is of Lilliputian dimensions for beginners, and while they are used to reading at this size, they are not used to executing drawings in a miniature format. All that is needed for this tool is some black tempera, preferably in tube form, a small container to hold pigment, and some newsprint. Put some tempera in a very small glass or the top of a spray can and add water drop by drop, mixing all the while. A warm-up exercise in which one does long curves and changes in direction is worth a few minutes—abstract calligraphy can get the arm moving. The calligrapher must show the brush who is the master and learn to force the brush wide, making fast, clean strokes. If the arm moves quickly, the brush cannot make a bad stroke.

It may be helpful to beginners to go through the basic Roman alphabets or start off in some other area—uncials, italic, or black letter for example. A page of random italic capitals (not lined up) can make a good-looking specimen. The arm has to move. A wide brush will execute a good rotunda and many other calligraphic styles. Final projects can be executed on paper that is a little more pleasing than newsprint. The paper ought to have a little tooth, because writing on hard and slick papers is like trying to write on glass; there must be a little resistance, something for the brush to catch on, or it will slide off course. Perhaps a few titles or a piece of poetry could suffice as a final project. The piece ought to be composed on newsprint before final execution so that details of spacing, space between lines, indentation, and so on can be tried out. Then the size of the paper that is needed can be determined.

Forms of the alphabet were never standardized in the best book hands of the Middle Ages. Letters touched one another or were joined together in ligature if the union seemed fitting. If the graphic identity of the letter is not totally lost, the calligrapher can do whatever he likes with it. If the arm of *r* puts the next letter too far away, shorten the arm or put it above the next letter, or run it into the next letter if in so doing the identity of *r* can be preserved. The struggle between the calligrapher and the alphabet is one of honor: he must preserve the identity of the individual letter and get his own way at the same time. In this sense alphabets presented to the beginner are something to start with and historical examples show us the way to proceed.

Spacing Letters

Spacing of letters and words is a difficult problem at first, but it works out gradually. The object is to provide a smooth road for the eyes; the less space between words the better, particularly in a line of short words, which sets up a strong possibility of "stuttering" in the graphic content and may provide more white space than other lines. Many calligraphic specimens are contained in this book, and they should be studied very carefully with reference to good continuity and the avoidance of spacing errors. Errors in spacing can occur with even the best of practitioners.

Johnston provided a good model for spacing, but he did not dwell long enough on one of the essential principles: Within an alphabet the space inside the letters must be consistent. This is one of the keys to correct spacing. Thus the counter, or the enclosed white space, in *d* must be consistent with that in *n*, *h*, and *v*. If the two strokes of *n* are closer together than the two strokes of *h*, more black appears in *n* than *h*, and this will upset the balance of the line. Letters are nothing more than strokes of black and areas of white, and we seek to strike a level in the way they appear and to keep this level consistent at all times. In Figure 359 the essential problems are pictured. The shaded areas inside *m* and *a* must be kept consistent in size. For a simple rule to start, try to get the same quantity of white space inside the letters as outside. The amount of white space between *m* and *a* is about the same, but because *a* slides away at the top it must come closer to *m* than to *r*. Letter *r* presents a problem; but in this case we slide the *e* under the arm of *r* and all is well. Letter *e* has an open space, so we must get *t* in tight to prevent the amount of white space from becoming too large. At the end of a word we do not care what happens to the arm of *r*; but if we have to put an *i* after *r*, we must watch the arm of *r* very carefully—it cannot extend or it will create a problem that defies solution. With *i* after *r* we shorten the arm of *r* or put it above the line—anything just so we can begin *i* at the proper place. We could even consider making *r* and *i* a ligature, but it is not a traditional solution to the problem because it could lead to confusion in reading.

Black lines at the top and bottom serve to define the space, and the places where too much white occurs can then be marked out. If the piece is turned upside down, words can be isolated with the hands and then words that are whiter or blacker in the black-and-white content can be identified. A word with a series of consistent stems, like *minimum*, is likely to set the standard, and a word like *wren* will probably have too much white in it. If you can see this point, then it is clear that *wren* will have to be redesigned to get closer to the overall graphic content of *minimum* or the latter will have to be relaxed a bit in its spacing.

Above all, the form of the letter as taught is not sacred. If the cross-stroke on *t* produces a problem, put it on the left of the letter or make a *th* ligature. Sacrifice the form of the letter to produce the word, and sacrifice the word to produce a tranquil line. Condense a line full of short words, with commas, apostrophes, and the like, in order to get an even texture for the whole page. This kind of spacing is sometimes called *optical spacing*, which means that only the human eye can do it well.

359. A start on the problem of spacing letters.

360. Amateur signs exhibit spacing troubles.

It is instructive here to include a sign made by an amateur in order to sharpen the eye for criticism. The maker of the sign in Figure 360 has measured the distance between letters and placed them according to the dictates of the ruler. This is the wrong way. He is all right on *RUS* but the *ST* spacing begins to be troublesome, and the *TY* situation puts it beyond reach. Students can diagnose the problem here quite adequately. The *TY* is difficult in any alphabet. The Roman carvers, designing tight, often put the cross-stroke of *T* above the line to solve some problems of composition, and it was a good idea. In this particular example the designer suffers from the idea that all of the letters should be of the same width. "Consistency," it is said, "is a virtue possessed by those who have no other." Well, if the designer wants to cleave to his original intention, he will have to space *RUS* more deliberately and get *Y* in tight. As the piece now stands, there is five times as much space between *T* and *Y* as between *R* and *U*. Cutting down the cross-stroke of *T* could help. As commented before, the problem of *TY* here is not isolated and exists in many typefaces. Many typographers think Caslon cut his *T*'s too wide.

Among many alphabets that can be drawn with the brush is the italic of Figure 361, which moves along vigorously and is composed well. It demonstrates some of the compositional problems that occur with the most talented beginners. The space between words is a trifle

La strada i piu si fanno col bastone:
altri la guida segue d'un suo cane:
chi canta a pie d'un uscio un'orazione.
e fa scorci di bocca e voci strane:
chi suona il ribechin. chi il colascione:

361. Short words dictate a less deliberate spacing.

too wide, and this coincides with an unlucky accident in word length that creates rivers of white running down the page vertically, destroying the horizontal feeling that lines of writing should embody. It is a frequent problem in setting lines of type. A professional would have run a quick study on the piece to determine problems of this kind and then tried to avoid them in the final effort.

Constructing Letters

We have seen constructed letters before in a number of alphabets stemming from Renaissance beginnings. We construct letters now because several alphabets essential to the contemporary designer were composed in this manner. While the tools advocated here are few in number and do not represent all available to designers, they have aided in the accomplishment of thousands of designs and will suffice for our limited purposes. These tools are a

T square, a large triangle, a ruler, an ink compass, a ruling pen, a pointed sable brush (or a steel pen), and a hard pencil sharpened by a razor blade. It must be sharpened as illustrated (Fig. 358k) and can be tested on the back of the hand. If it does not draw blood it is not sharp enough.

Begin by creating a very complicated Mondrian type of design with the T square, triangle, and sharp pencil. For right-handed persons the T square rides on the left edge of the board and the diagonal of the triangle slants to the right and down. New ruling pens and ink compasses should be carefully washed with soap and water to free them of oils used to prevent rust or corrosion. In using the ruling pen, keep the adjusting knob pointing toward the top of the board for strokes that always travel from left to right. For vertical strokes, twist the body slightly and point the knob toward the left edge of the board. Always make the vertical strokes against the vertical edge of the triangle from bottom to top. Left-handed persons may invert the procedure, with the T square on the right and the triangle reversed.

After a few experimental strokes, try to execute the Mondrian design in ink, putting lines of the ruling pen precisely on the pencil lines. Keep the ruling pen away from the bottom edges of the T square and triangle. A few blobs of ink will occur until you learn the technique.

With a little practice the ruling pen and the compass can be made to behave, and one can then set about learning an alphabet. A fairly simple one is the lowercase of a condensed Gothic seen in Figure 362. This is somewhat

362. A way of constructing a lowercase Gothic alphabet for use in implementing ideas.

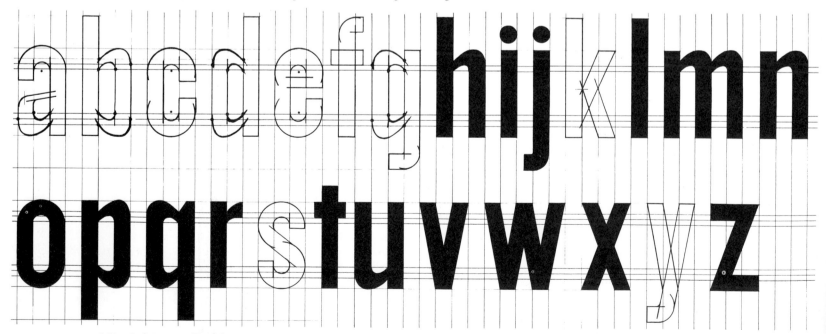

reduced from the size that might be more appropriate for beginners: perhaps 2 inches for the main body of the lowercase, or x-height, and ¾ inch for ascenders and descenders. Vertical strokes and inside white spaces are ⅜ inch. The parabola curves on *b* and *d* are identical, appearing in four different positions. This same curve also appears on the bottom stroke of *a* and on *g*, *h*, *m*, *n*, *p*, *q*, and *u*. The lines of these curves are drawn in with a hard, sharp pencil. Curves on *c* and *e*, the large curve of ascender *f*, the large curve on the descender of *g* and *j*, *o*, and *s* are compass curves. Arrange the point of the compass so that the curves extend above and below the containing guide lines by about $1/32$ inch. This will make the curves and horizontal strokes (the top of *z* for example) appear to be on the same level. If curves are tangent to the top line of *z*, they will appear as slightly below.

Curves on *b*'s and other letters can be filled in with a pointed brush or a sturdy steel pen. Then straight lines can be drawn in with a ruling pen and skeleton letters filled in with a pointed brush. Either inks or tempera can be used in the compass or ruling pen. For filling in, use an extra-dense black ink or a dense tempera mixture. On cheap bond paper the inks may wrinkle the paper slightly, but this does not matter. The first 26 letters can be corrected, and a second effort of 10 or 12 letters will suffice before final projects are discussed. It will be noted that Figure 362 is mechanically spaced, and this should provide ample evidence that this method can never be used in the handling of letters. In final efforts, the project must be sketched out and tested for correct spacing, and then the letters must be constructed at the correct interval. If the sketch is incorrect, it can be cut apart with a scissors and reassembled into the desired format. Final projects should be done on a hard-surface board or paper, which will simplify some of the technical problems. This strictly disciplined procedure should familiarize one with the peculiarities of the tools and acquaint one with just a single alphabet. Next we will need to see what can be done with what has been learned.

Let us assume that a final project could encompass only one word; that the form of the word should describe its meaning, as in *crowded*, where the letters are jammed together; and that the piece should include an element of graphic material that explains the word pictorially. With *crowded* this might be a photograph of sheep, for example. This establishes the principle that word and pictorial device should reinforce one another in some harmony of graphic means—a principle as old as writing.

It is suggested that letters be kept the same size as given, for the sake of convenience; other than this there are no limitations placed on means. Letters could be jammed together or deliberately spaced; or the spacing could change in the sequence of letters, as in a word like *acceleration*. Letters can be positioned unevenly or placed at different angles, upside down, or backward, or both. Color, value, texture can be changed to accommodate the end in view. The Gothic letters have an intrinsic architectural content, but they can accomplish more variety in communication if the project is thrown wide open. The projects seen in Figure 363 show little of the color possibilities but should give a hint as to the total potential hidden in one alphabet. In Figure 363a we see the kind of simple reinforcement that has strong graphic qualities. While there was a lot of original work on the letters, using three values, the image was picked up from a magazine. Figure 363b is another fine interpretation of the same word. The word is hand-lettered once, but the other interpretations were cut out of newspapers. None of the ideas seen here were supervised. The project was presented and work was done outside of class. Most creative work is best done in private. Professionals find the condition of privacy most essential.

Figure 363c shows a direct interplay of letters with other graphic elements, and again the simplicity of the statement calls for commendation. The graphic enterprise in Figure 363d is not complicated but is effective in communicating a feeling about the word used. This piece of work is well done but badly spaced and shows the instructor's marks indicating the principal trouble spots. Figure 363e speaks for itself and represents a rewarding example of youthful wit. Many excellent ideas can come out of a project of this kind.

Having presented the rudiments of a constructed alphabet, the neophyte ought to benefit by constructing an alphabet of his own choice. Perhaps alphabets closely associated with pen letters should be crossed off the list. There is no great point in constructing an italic form or a black-letter form when an understanding of the traditions involved is better achieved through the medium of the broad-edged pen.

An essential point in constructing a modern Roman or sans serif style is to establish the height-to-width ratio. Rulers are not recommended here. Height and width can be marked out on a piece of paper. Disregard the serifs in making a simple rectangle. Then establish the relationship of mainstroke to the inside white space. Within a specific alphabet these relationships repeat themselves. Examine curved letters for midpoints and mark them off. Find out where curves begin and where they end. Do not trust preconceived notions about the method of construction, but look closely to see what the designer had in mind. Examine the alphabet for repeated

a

b

c

363. (a and b) Two solutions to the same problem;
(c) words spell the idea of the game;
(d) good execution, with spacing problems indicated;
and (e) a fine example.

corroded

d

gimmick

e

features and test endings for slant. Does the cross-stroke of *B* come at the midpoint or is it above the midpoint to a subtle degree? Is there a fine-line serif? Keep it fine and do not multiply by three if construction triples the height of the model letter.

This is an exercise in seeing and understanding and is similar to the thought involved in drawing a tree, a fire hydrant, or the human body. Despite the personal inclinations of each worker, certain elements of structure prevail, and it is important to get these right and not disguise gross mistakes of form by a mask of personal expression. It is necessary to preserve essential structural qualities in Garamond Bold or Bodoni in order to see what communicative essence is dormant in them and why they were designed as they were in the first place. Careful examination, precise measurement, and prideful craftsmanship are necessary to achieve an understanding of one alphabet. Most of the essential strokes can be seen in half an alphabet; after these, repetition sets in. If the members of a group of beginners each choose a different style to study and execute, the total knowledge accumu-

lated will be considerably augmented, and final projects will vary enough to provide fuel for discussion.

The letters of Figure 364a were executed in blue on a red-orange ground, so it was felt that the load should be carried through color and the heavy graphic content of the word. This nineteenth-century revival produces interesting shapes in the ground configuration, so the letters were joined where possible. In a conventional sense the letters are incorrectly spaced. Should *V* and *A* have been more crowded too? Or do the spaces between them balance the large spaces between the two *L*'s?

Figure 364b features Old Style Roman capitals in a title that might not need other adornment. In this alphabet, a Caslon, the cross-stroke of *T* is so wide that it causes alarm. The student did a fine job of work here, but notice the open quality of the wide *N* in contrast to the other letters. Did Caslon cut the *N* too wide?

An elongated Modern Roman is the source for the letters in Figure 364c. Each of the letters was executed in a different color, which fit well with the full-color pieces in accompaniment. There is an open space on the right side but this does not seem annoying.

Figure 364d shows the locking of pictorial device and letter structure—in this case a wide square serif—in an architectural manner. An instructor (the author, as it happens) gave the student a B+. It is hoped that the statute of limitations for suing has expired.

The next piece, Figure 364e, is an elegantly constructed word containing some of the baggage associated with nineteenth-century designs. The student designed the letters wide and composed them tightly, which left an amusing problem between *L* and *O*. This is a little like painting yourself into a corner of a room; before you have realized your error it is too late. Preliminary sketches often reveal potential danger spots, and that is why they are advised. In any case, the execution of the piece is excellent.

Initial experiences in constructed letters will produce a greater variety of designs than we have been able to see here. The skills carry over into package design or in layout and typography. Students in one advanced course were given the problem of producing a piece on a musical instrument. Each student chose an instrument and tried to produce a work that reflected some quality associated with the sound, function, or graphic content of that instrument. They were asked to try to express as much of this as possible through the selection and spacing of the letter style. One result was the specimen marked in Figure 365a. Here the student decided that the big, square format, together with the blast of color and the old fat-face letters (an ultra-bold Bodoni), were quite sufficient to

a

b

364. (a) A revival idea; (b) good form for the word, but stems of *N* are flimsy; (c) each letter in a different color; (d) well expressed; (e) an odd problem.

c

d

MELODRAMA e

the purpose, so no additional graphic material was included. The original ground color, a vigorous magenta, was quite good with the black letters. Figure 365b presents still another type of letter, a stencil letter, and it is used well here. As we have seen in the section on twentieth-century developments, the modern graphic designer goes beyond the more conservative practices in both typography and calligraphy, and the graphics man today is not successful if he cannot handle letters in a creative way.

Carving Letters

The carving tool in Figure 358 is designed to carve in linoleum or wood. Sets of these gouges are available, and a well-equipped studio for letter practice should have some of these tools. Good steel is essential. Linoleum or wood blocks are available *type high* (.918 inch), and these should be used if designs are to be printed on a proof press. Finished relief designs are inked with a rubber roller charged with sticky printing ink; for fast experiments in overlapping images a quick-drying, water-soluble ink is available. For limited facilities, spoon printing is quite all right. Here the paper is placed on top of the inked plate and pressure is applied to the back side of the paper by way of a smooth, rounded instrument like a spoon. On absorbent papers, hand or foot pressure may suffice for fast experiments.

A good many things can be learned by carving relief letters. The basic principles of the relief-printing method can be easily grasped. Then, too, in carving letters one begins to appreciate the practice of punch cutting, a key to the origins of typeface production—formerly a carver's art. Type styles will suffer if this element is permanently neglected.

Essential character in individual letters is important. As children we learn the signs, and as soon as we learn to read, the rendering of the letters becomes automatic and the essential graphic content of each letter is lost to consciousness. We can be taught to "see" again if we carve an individual letter and examine its form in many different contexts. Again, the classroom becomes a bank for collective learning if each student picks an individual letter and gives it a thorough workout. In this sense it is surprising what students can teach professionals. Caught up in deadlines, few design studios devote enough time to pure research, and student enterprise can contribute original ideas in spite of the long and honored tradition of printing. For example, see the piece in Figure 366a. Here the student has printed a letter *a* in white ink on a stringy rice paper. It is rather improbable that the idea is entirely new, but where has it been seen lately? And who would suspect that letter *a* was capable of this kind of graphic content?

Figure 366b presents a strong design on the form of a medieval *G*. Many other versions produced by this letter were equally effective. Letter *l* is capable of more than its simple contour would suggest. In Figure 366c we observe a study in repetition that gives the letter a new role to play. Overlapping can present in letters some of the methods used by futurists to create the flux and motion content of a society in turmoil. Figure 366d, based on the capital *M* in the typeface known as Legend, possesses a more poetic version of this idea, perhaps resembling birds in flight. Numbers also find new kinds of existence in printing experiments. The random strokes and voids of number 3 in Figure 366e demonstrate some curious habits of perception. The piece can be grasped as a total of white figures on a black ground; but on closer inspection one can sometimes see curious black figures with white acting as the ground.

Of course two or more letters can be printed in various combinations. Figure 367a has a kind of Japanese flavor. Where the student got his *A* is unknown—perhaps he invented it. So much the better. The principal ingredients used in Figure 367b consist of an *o* and an *i*, with a wedge-serif alphabet being the theoretical base. Here

a

b

365. (a) Fitting form to subject; and (b) stencil letters on an imitation wall.

366. Projects in carving and printing one letter.

a

b

c

d

e

the letters are losing their function as letters and in accumulation build up a graphic image that is perceived as such. Energy content is surprising, considering the limited means.

Entire words that are repeated, overlapped, or variously juxtaposed can also communicate different qualities, depending on the word selected and the style of alphabet used. In this manner an entire page might be given a rococo complexion, and structures can run the gamut from a dignified architecture to banality. It is possible to combine this sort of image with a different sort of image, and of course color can add a strong element to the experimentation. Paper selection is also important, as printers know. There are occasions when a simple statement on the correct paper allows the designer to dispense with some graphic element originally included in the plan. In printing a simple letter style the designer may seek some relief in the form of a textured element, and if the latter is embodied in the paper, the matter may be resolved simply.

In Figure 367c all the letters were printed in black except for the word in the left margin, the word below the bottom margin, and the one above it. These three were printed in a purple ink, which proved quite effective, although the idea may have an odd ring to it. Black was used throughout Figure 367d except for two letters in red. A strong message is seen in Figure 367e. Personal feelings, in this case rather generalized, should enter into these proceedings. The hand image was achieved by cutting into a paper of differing value.

The total possibilities inherent in this introduction to printing methods are very great, since one carved letter or word can be used in so many ways. In addition to this, some of the daring and joie de vivre developed in these projects can carry over into the printing arts if you choose to get into that area. Here we must face the fact that printing traditions are conservative, but see the *Proverbs of Oz Cooper:* "(13) He that calleth me down, saying, Thy judgment on such and such is punk, himself addresseth me on *pink* stationery."

Form, Meaning, and Learning 265

a

b

c

367. (a and b) Carving and printing two or more letters; (c, d, and e) a group of projects involving the use of one word.

d

e

Use of Collage

Magazines and newspapers furnish an ocean of alphabets, in a proliferation of styles, weights, and sizes. It is impossible to let this free source go by without some effort to press it into use as a teaching device. The talent of a scavenger is needed in acquiring the massive backlog of material necessary.

If you are trying to learn the visual language of sans serif alphabets, you can cut out such words and letters and create pages that carry the essential graphic message. It matters little how they are pasted on, although a vertical-horizontal format is perhaps preferable to a completely random arrangement. Such a sans serif page will differ significantly from others devoted to Gothic or Modern Roman or Formal Cursive, and these essential differences can be stamped on the memory. All that is necessary is to see the various pages in purity, perhaps tacked up on a bulletin board. Some editing will be necessary for best effect. An idea of the impact of such a project can be seen in Figure 368a.

The games to be played with collage are akin to Apollinaire's efforts, and various mutations thrive on suggestions of artists and teachers since his time. As a graphic tool in communication, collage finds some new usage almost daily. Figure 368b shows a student work that demonstrates the power of type in a diminishing sequence. In their more potent aspects, type alphabets communicate a sense of shape and architecture possessing a strength capable of competing with other graphic elements, such as illustrations and photographic images of various kinds. The visual quality of types can be graded from a major element to an element welded with the textural content to one that disappears into the white of the margins. Perhaps unwittingly, the student here illustrated these changing visual features of type better than any monologue uttered by an instructor or essay by an expert in typography. Another way of looking at this piece is as a method of centering visual interest on a special area, in which case it is a lesson in design. It is also like a city seen from above, with larger elements dominating the central area and smaller textures standing for suburban or farm areas. Thus the piece begins to act as a work of art, carrying more implications than a casual glance reveals.

Since letter forms do indeed encompass shape factors at large sizes, linear factors at medium sizes, and textural qualities (defining shapes) at smaller sizes, it is obvious that much of the designer's arsenal is at hand. Perhaps the qualities of pure line and massive pieces of color are not found in abundance, but these can be added if needed.

a

b

368. Typographical collages.

asked to present three solutions, each based on quite diverse communicative needs. These projects were to be devoted to (1) a funeral parlor, (2) a child's toy, and (3) farm machinery. Results are seen in Figures 369a, b, and c. Letters could be minimal but had to appear in a form that suited the mood and architecture of the piece. One or two images of subject matter could be employed, but the emphasis was on abstract suggestion, shape, value, size, and so on. Figure 369a was one of many interesting solutions preserving the dignity or serenity required. This one was chosen for its rich poetic quality and nostalgic echoes over others that might have met commercial needs better. Nearly all of these projects followed a format that featured shapes of white and grayed tones, with bright colors missing. It is probable that the words *The Silent Miaow* adds to the piece in a manner defying precise analysis.

Solutions to the part of the project concerning a child's toy varied more widely. That seen in Figure 369b gives free reign to the imagination but bases the imagery on the subject. Abstract elements and typography are closely linked and work together. Contrasts in large and small elements are effective here, and were featured in some other pieces on the subject.

Young experimenters can create a page in which visual interest is spread throughout the entire page without any emphasis on one area. Here they must watch their sizes and placements. In a format of letter forms any unusual feature can dominate interest. Configurations of dogs, coins, or people are best left out. In a page of type a single enlarged letter can attract special attention. Or in a Mondrian format, a single diagonal can dominate.

Following an initial effort to spread visual interest throughout a page, our next problem is to create a page in which emphasis is directed to several different areas of the page. This is accomplished through the use of heavier forms, massing of blacks, colored letters, and so on. The conscious effort to direct visual interest is a counterforce to undirected experiments, which may leave out some of the factors of communication that should be emphasized from time to time.

An emphasis on specific ideas in communication can be sought through an attempt to illustrate by type collages such words as *power, fragrance, mechanical,* and so on. The aim here is to find out how far letter forms can be stretched to cover the idea; but there is no harm in permitting borrowed graphics or drawn forms to supplement letter configurations. In one experiment each person was

369. Use of collage in thematic projects.

a

c

b

370. A typogram.

371. A typogram featuring
an excellent road.

372. A type collage involving
transparency.

373. Numbers game
in three values.

Figure 369c contrasted sharply with other designs on farm machinery. Most of these contained bold forms in the typography, shape, and color. Perhaps this one was selected for reasons of the simple means used to carry out the space and the arresting use of typographic elements. Projects that push thought in different directions while allowing considerable personal freedom will generally reap a dividend in terms of variety of interpretation. With regard to tools, very little is needed beside the razor blade. A scissors might be helpful. For glue, rubber cement will do, but it will not last and often discolors the material. It can be used on thin papers. More permanent collages can be made by using the familiar white polymer glues and stiff boards to prevent excessive warping. The white glues are not easy to remove from the surface, but there is usually no need to do so, although painting over dried polymers presents a problem with some pigments. Polymer paints cover glued areas.

A large variety of projects can make use of the collage method, and several of these are presented here. Figure 370 follows an ancient method of using letters to describe objects in the environment. This was seen in the fish of Figure 261 and in some other areas of the book. If these efforts were called *calligrams*, it might be permissible to call the effort in Figure 370 a *typogram*. The student was smart in using large letters closely related to typewriter faces. Figure 371 shows a road made out of type, and the image turns out to be very attractive. The type road sets up a perfect situation for a stronger image at its termination, and the artist has given us this stronger form at the proper place. If he continues in this line of work, he will think of a better solution than that presented here. Our next example exhibits a graphic idea of considerable complexity. Using some of the techniques of the previous example, the artist of Figure 372 creates a spatial depth and transparency by imposing one fragile image on top of others. In its graphic content the piece speaks for itself and shows a lot of talent. In a literal sense it may remind us of modern communications networks. In its original colors the work possesses a very strong impact.

Textural qualities are again featured in Figure 373, wherein numbers are printed on different shades of rice paper. This piece serves to remind us that various kinds of typewriters exist. Numbers in elite, pica, and bulletin faces are observed here. Rough edges help the design by providing a relief from the monotony of the textured panels. Another numbers game is featured in Figure 374, which is an imaginary life record of an individual.

Collage material is everywhere, and those objects discarded and thrown into the streets or placed in trash

383. Author's method of cutting a pen; like most other methods, it is derived from Edward Johnston.

it can be ground down to ½ inch and sharpened on fine stones. A handle can be made by pressing a good knife handle into clay and filling the resulting mold with an epoxy resin that sets with the aid of a catalyst. When the resin shows signs of hardening, or "setting up," the long steel handle of the straight razor can be inserted and held in position with clay until the resin becomes hard. Whittle out the form as pictured. For a start, use a piece of bamboo about ¼ to ⅜ inch in diameter and try for a nib about ³/₃₂ inch wide. The lower curve seen in Figure 383b is cut first, followed by a second cut more forward. A third cut is pictured in Figure 383a. The inside of the nib should be scraped flat and very thin, using a single-edged razor blade. Then the nib must be cut straight across with a piece of wood supporting the tip. The cut is made with a bevel toward the leading edge (Fig. 383b). If this goes smoothly, then slit the pen up the middle to the depth of ½ inch or so. A single-edged razor blade does this well. The blade must be thin. To keep the pen from absorbing moisture the tip can be given a coat from a plastic spray can. Then a tapered strip of springy metal must be inserted into the barrel of the pen and formed into a well for holding ink (Fig. 383c). This is done with long-nosed pliers. Clock springs were formerly used for the metal strip, but these are rather hard to come by now. Brass shim material used by sculptors in clay-casting work will do nicely. For larger pens, Reynolds employs a springy metal used to wrap packages of nails. Metal laboratories may have some sheet alloys that could serve this purpose. Shim and alloy material can be cut with a scissors.

Those practiced in this minor art often use a magnifying glass to inspect the nib. A glass that does not have to be held but that has its own stand is most preferable. If the nib shows rough corners or a slightly uneven quality, further scraping may be necessary; and since a fine carborundum stone is a requirement for sharpening knives, this can be used for a subtle honing.

For practice sessions an engrossing ink will do, and bond paper offers a suitable surface. You will need a warm-up period to find out how the pen works. Large curves with abrupt changes, fast drawing, or some ab-

stract pattern of curved and straight lines will serve to allow you to observe the graphic characteristics of the pen and ink. If the pen spatters a little on tight turns, it is no cause for concern; the trouble may go away of its own accord or a splintered edge may have to be scraped a little. Thus we are under way.

One of the pleasant fringe benefits of calligraphic practice is the possibility of giving some kind of character or style to personal handwriting. Figure 384 is an offhand rendition of a receipt for books lent to a student. A message of this kind is pleasing to the eye and supports the view that personal handwriting need not lack a degree of taste and should not require a professional decoding expert to

384. A receipt for books by Ann Wharton.

385. Class notes by Ann Wharton.

piece out the text. In Figure 385 we see classroom notes by the same calligrapher. These are in the manner of the Vatican scriptors, condensed to save space. These examples show that good writing, like good manners, can be learned, and both show a respect for the recipient. The author of these two specimens received early training in Saturday classes led by Arnold Bank.

These examples were executed with a fountain pen. Several firms make good pens and good tips. Osmiroid, in England, is a good one. Inks present a problem to some people. To state this problem briefly, it is a matter of the ink's ability to flow, its blackness, its water provability when dry, and its permanence. All these qualities do not reside in one ink. If it is black, it is no doubt a carbon ink and will clog the pen. Cleaning is then a problem. The new Parker Super Quink Permanent Black fits the need fairly well. Pelikan Font India is a fine ink but may deposit enough carbon to cause a stoppage. Carbon inks also clog up handmade pens, but for these Artone Fine Line Black is a good choice for final projects where black is required.

To increase flow and decrease carbon accumulation, some tips have sifted down through the trade. John B. Kiernan uses a product called Photo-flo, a wetting agent

available in photographic supply houses, making a solution of one drop to sixty drops of water and adding half to a bottle of India ink. Sister Michaeline Lesiak, in *Lettering* (Notre Dame, Indiana, 1965), suggests a Pelikan ink diluted with distilled water plus 2 percent ammonia to reduce clogging. This writer also recommends an 8 percent ethylene glycol solution with a bottle of India ink.

It is also necessary to add that perfectly black writing is not necessary in beginners' projects. In fact this black requirement only holds for those who must do diploma work and others who may need to have work reproduced in solid blacks. Furthermore, one of the interesting facets in studying medieval manuscripts is the fact that the inks were not uniform, not solid black, and the viewer can see the ink quality and the surface below.

Working Arrangements

Let us add just a few notes on drawing boards, angles, and traditional methods of protecting writing from fingerprints. Some of the drawing tables available in the United States should certainly be classed among the worst designs of all times. Currently the best table available is made by a Dutch firm called Ahrend. The top can be adjusted to any angle between horizontal and vertical and raised 17 inches. These two factors in positioning the tabletop are controlled through just two large hand knobs, each connected to very efficient braking devices. Scribes of the Middle Ages and the Renaissance are sometimes shown using a supporting surface that is more vertical than horizontal. This was in order to keep the writing surface perpendicular to the line of vision. However, some renderings of the scribal position seem suspect on the grounds that no support is furnished for the lower arm. Johnston sensibly demonstrated that the pen would not work well if its position approached a vertical angle in relation to the writing surface. Johnston and Hewitt advocated a desk slant of about 45 degrees. There is no objection to this angle unless it causes the penman to hold the pen at a true horizontal. The pen ought to slant downward a little. It is often difficult for beginners to accommodate themselves to tabletops set at a 45-degree angle. However, in the long run the angled table will prove less fatiguing than the flat table. Then, too, the 45-degree angle certainly precludes the use of tabletops as a storage device.

On a wooden tabletop the paper receiving the pen may have a tendency to slide. If an angle of 30 or 40 degrees is to be maintained, some other surface must be used on top of the wood to increase friction. Johnston advocated blotter papers such as are presently available in 24-by-38-inch sizes. Then in regard to the writing surface Johnston

NILICITUKMORSESTADNOSNEQUEPERTINETHILUM,
QUANDOQUIDEMNATURAANIMIMORTALISHABETUR.
ETVELUTANTEACTONILTEMPORESENSIMUSAEGRI,
ADCONFLICENDUMVENIENTIBUSUNDIQUEPOENIS,
OMNIACUMBELLITREPIDOCONCUSSATUMULTU
HORRIDACONTREMUERESUBALTISAETHERISORIS,
INDUBIQUEFUEREUTROBUMADREGNACADENDUM
OMNIBUSHUMANISEESETTERRAQUEMARIQUE,
SICUBINONERIMUS,CUMCORPORISATQUEANIMAI
DISCIDIUMFUERIT,QUIBUSESUMUSUNTERAPTI,
SCILICET,HAUDNOBISQUICQUAM,QUINONERIMUSTUM,
ACCIDEREOMNINOPOTERITSENSUMQUEMOVERE,
NONSITERRAMARIMISCEBITURETMARECAELO.

a

386. (a) A student work exhibiting some fidelity to the uncial hand;
(b) a personal interpretation using the uncial as a base;
and (c) a good interpretation of rustic capitals.

AND YOU TOO, JUDGES, MUST FACE DEATH WITH A GOOD
COURAGE, AND BELIEVE THIS AS A TRUTH, THAT NO EVIL
CAN HAPPEN TO A GOOD MAN, EITHER IN LIFE OR AFTER
DEATH. BUT NOW THE TIME HAS COME AND WE MUST GO
HENCE; I TO DIE, YOU TO LIVE. WHETHER LIFE OR DEATH
IS BETTER IS KNOWN TO GOD, AND TO GOD ONLY.
SOCRATES

b

gave this advice: "A tape or string is tightly stretched across the desk to hold the writing-paper (which as a rule is not pinned on)." Whether or not such a device is used, the principle upon which it is based is most sensible. For writing, move the paper but not your arm.

In older days, when vellum was in use, the writing surface had to be protected against the oil imparted to the surface from the hands in the act of writing. Professional calligraphers face this problem in various ways. Clean hands and talcum help; but in hot weather the writing surface below the line of execution must be protected by another surface. Johnston advised pinning the protective paper to the board, but this was not one of his best ideas. A paper with a holding action—a blotter—can do as well, and this can be moved with the left hand as necessary. If the suggestion is not too heretical, perhaps the novice calligrapher ought to forget about this problem and concentrate on learning to write.

Historical Hands

There is no recommendation here on which alphabets the beginner ought to concentrate on first. A chronological order might be followed if materials for such a study are readily available. You might do a quick study of about twenty different styles and then choose a few for closer examination and possible rendering in a final project. If you intend to become a professional, you should see and practice historical hands in order to understand how letters developed in form. For others, this kind of practice is a part of a liberal arts education—a part of history not experienced in history courses or art history courses.

Individual interpretation is always important. Some initiate calligraphers choose to learn a hand in detail, while others disregard the rules and perform a work that is unique. This is seen in the contrast of the next two examples. The Roman uncial was rather deliberately spaced, and the student executing Figure 386a preserved something of this quality. The second example based on the same alphabet, Figure 386b, preserves very little of the spacing habits of Roman scribes but concentrates on massing the letters, providing a blacker image more suitable to the literary content.

Roman rustic was a rather rare hand in books, but the general method, a condensed version of Roman capitals, survived as a titling alphabet well into the Middle Ages. Some beginners may be interested in inspecting its curious pen slant. As seen in Figure 386c, the textural quality of its massed letters is emphasized.

c

SICVIDESIINMEINGENIVDICESQVODSENTIOC
VODSENIOQVAMSIEXLOGVMAVISIQVAEXERCI
TATIODICENDIINQVAMENONOINFITIORMEDIOC
RITERESSEVERSATVMAVTSIQVAHVIVSCEREIRAII
OALIQVAABOPTIMARVMSTVDIISACDISCIPLINA
PROFECTAAQVAEGONVLLVMCONFITEORAEINSN
EAETEMPVSABHORRVISSEEARVMRERVMOM
NIVMVELINPRIMISHICAVLVSLICINIVSERVCLV
MMMEREPETEREPROPESVOVREDEBEINAMQVOA
DLONGISSIMEPOTESIMENSMEAIPERECESPAIIVM
IRAEIERINEMEORIAEMSTEMVIIIMAMBECORDA
RIINDEVSQVEREPIENSHVNCVIDEOMIHIPRINC

Form, Meaning, and Learning 275

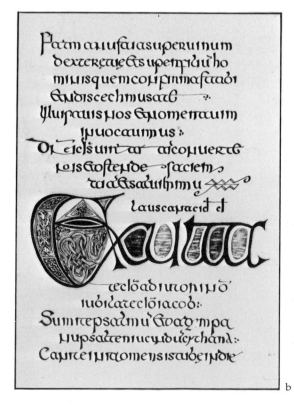

In principio erat Uerbum et Uerbum erat apud deum et deus erat Uerbum. hoc erat in principio apud deum. Omnia per ipsum facta sunt et sine ipso factum est nihil quod factum est. in ipso uita erat et uita erat et uita erat lux hominum et lux in tenebris lucet et tenebrae eam non comprehenderunt. fuit homo missus a deo cui nomen erat Iohannes. hic uenit in testimonium ut testimonium perhiberet de lumine ut omnes crederent per illum. Non erat ille lux sed ut testimonium perhiberet de lumine. Erat lux uera quae illuminat omnem hominem uenientem in hunc mundum. In mundo erat et mundus per ipsum factus est et mundus eum non cognouit. In propria uenit et sui eum non receperunt. Quotquot autem receperunt eum dedit eis po testatem filios dei fieri his qui credunt in nomine eius qui non ex sanguinibus neque ex uoluntate carnis neque ex uoluntate uiri sed ex deo nati sunt.

a

387. Work on the Irish majuscule.

b

Celtic hands are not easy to understand, since the scribes did not see the logically arranged Roman uncial and created a tradition of their own, which runs counter to most of the letters found in any other historical context. Some of the scripts from India are easier to grasp in calligraphic method. The more one studies the *Book of Kells* and other Irish majuscule hands, the more one is convinced that the pages contain an internal logic that is unassailable but to which it is impossible to find the key. Novice writers do not know how tough the hand is or that professionals are perplexed by what to do with it, so they are usually game for a try at it. Figure 387a shows the work of one who composed Celtic fairly well on short acquaintance. Here we might remember Hemingway's admonition on bullfights—that if an observer tries to understand too much, he will not write about it at all. Figure 387b shows a compositional problem that can be tolerated in the original but is hard to swallow in a secondhand version. However, the decorated letters, executed in gold and in many colors, deserve some mention, as they were very striking in the original and the student gets an *A* for effort. Successful attempts at decorated letters are few indeed. Henri Friedlaender, commenting on this piece, remarked that somehow the Celtic decorated letters work, and part of this success is due to the natural texture and color of parchment. Done on uniform modern papers, the effects are often flat, cold, and somehow meaningless. The other aspect of the problem is that much of the Celtic and Anglo-Saxon decoration is so complicated and obscure that a student of letters is almost forced to imitate it. The view here is that if imitation will help the student understand a difficult method in calligraphy, well and good. The choice is up to the student. One cardinal rule stands out in the use of decorated initials and titles: It must be done well or not at all, because a foolish letter can spoil a whole page of interesting writing. And since these are different times and places, there is no reason why we should not think of a decorated letter in contemporary terms if the student has the right feeling for it. By way of learning, it seems reasonable that a novice should get some feeling for an alphabet but should use it to compose a different text, and in scripts from the Middle Ages these are mostly in Latin. Printed Latin texts are not hard to find in libraries, and the beginner can compose the material in a way that suits his purposes. Formulas for space between lines, for margins, and for other details of arrangement should be ignored. The details of composition should be left to your discretion, so that you can think about these problems yourself. However, sometimes a point or two is good to have in mind. For example, if lines are to be un-

justified right, then frequent indentations on the left may give pages a very nervous appearance.

Anglo-Saxon hands are full of spirit, and are not quite as difficult to grasp as the Celtic majuscule. The piece seen in Figure 388 captures the essence fairly well, although the colored letters beginning the text were stark and raw. The curious Beneventan pen slant is seen in Figure 389.

Given a free choice, beginners do not seem to be as attracted by classical Carolingian as are scholars and instructors. Perhaps it is not as exciting as some of the other scripts of this age. The example of Figure 390a is based on a rather late version of Carolingian, before it became too cramped. The student has gambled on a spacing system wherein ascenders and descenders use the same space and has gotten himself into some difficulty. To do this success-

fully, a calligrapher has to make some trial efforts to see where the ascenders and descenders fall. If there is competition for the same space, it is sometimes possible to find a way out of the problem; but here, while the student does well, the middle section becomes cluttered and the horizontal flow of the lines is seriously disturbed. The arrangement also contains a light hole at middle right which does not seem suitable. Figure 390b features a Carolingian too. This is perhaps closest to tenth-century models executed in England. The piece was written by a left-handed student, which proves that they can do fairly good work.

Italian rotunda provides a good challenge for students. It is a little more subtle than its look of disarming simplicity would lead you to believe and requires careful handling of spacing problems to keep from jamming the

Above: 388. Anglo-Saxon minuscule.

Right: 389. Beneventan.

Below: 390. (a) Work related to Carolingian; and (b) a good late-Carolingian hand by a left-handed writer.

a

b

Form, Meaning, and Learning 277

Continua mi-occasionalita-e-insieme-di un vario-sperimentare-di
e tecniche aperto tutto una volta agli echi della grande tradizione
-trobadorica e dantesca alla suggestiva novità del linismo petratrch
esco alle eleganze fionte della poesia musicale al parlato incisivo e
mordente dell angiolieri al gusto dei suggerimenti popolareschi allo
con squallido mitologismo ornamentale dei grammatici preuman-
isti. dire che poi tutte queste ed altre reminiscenze e maniere non si
succedono ma si alternano si intersecano, si mescolano di continuo
e uno stesso autore. alora in un solo componimento si tratta divent-
er. lo piu non di poesia ma di letteratura con letteratura per altro, irre-
quieta e mobilissima che attraversa zione intense e solo verso il finire
del secolo approva ai malinconia di un generico squallore. non diver-
samente nella sezione dei poemi allegorici e didattici vedete come dal

391. Student version of the rotunda style.

392. Two versions of the black-letter style.

a

Als Bewusztsein deines Falles
Unser armes herz durchdrang
Wieder war's geschehn um alles
Wir erbleichten wurden krank
Und die wissender sich deuchten
Fuhlten dasz sie nicht gewuszt
Als sie so verliesz dein Leuchten
Ernst Ubertraf sie der Verlust
Wie du zieltest wie du ranntest
Du Lieszen froh wir dich hinweg
Keinen Blick auf verwanndtest
Die aus Uugen stark und keck

b

Elegie' xvii by John Donne'
Variety

The heavens rejoyce' in motion, why should I
Abjure' my so much lou'd uariety,
And not with many youth & loue' diuide'?
Pleasure' is none', if not diuersifi'd:
The sun that sitting in the' chaire of light
Sheds flame' into what else'so euer doth seem bright,

black strokes together. What made it work originally was fine craftsmanship in cutting pens and superb control on the part of the penman. The student work in Figure 391 captures the textural content of the hand quite well.

If you think of the northern European black letter as a picket fence with space inside letters equal to the stroke and space between letters, you can master the formula fairly well and it has some historical accuracy; but there are other versions not so easy to grasp. More difficult are those old and modern versions in which the inside spaces are wider than the strokes. Black letter becomes an entirely different alphabet with this factor included, and letter structure and spacing problems become more difficult and cannot be solved without special study. The example seen in Figure 392a is subtly wider than many black-letter versions but preserves the sharp graphic quality of the style. Even the unusual treatment of capitals on the left margin is integrated quite well. Guide lines may be seen. Professionals are not allowed to let these remain, but sometimes young craftsmen choose a paper that is disturbed by erasures. Lines also show in some old manuscripts, and it does not detract from them in the least. In fact, if the guide lines are given some thought they can be made part of the page and even emphasized. The example of Figure 392b, executed with a fountain pen, used no guide lines at all, and that takes some doing. If the apparatus of calligraphic practice seems oppressive, see if it can be avoided. Calligraphers who write good hands in personal messages do not use guide lines, and sometimes these messages are to be preferred to their commissioned work, which must exhibit all the neatness and formality of a well-kept graveyard. This is the way we are. Perhaps it is a sign of immaturity in the culture, and certainly it is a sign that calligraphers are not as relaxed as painters presently are. Perhaps we ought to develop a new era of the Roman cursive.

Italic and the Ductus

The italic hand suffers from overexposure and is often presented poorly in *ductus* manuals of writing. Certainly italic is a basic script in Western writing, and it can be an elegant hand. But many exponents of the style seem to feel that if everyone could be persuaded to write in the italic manner, many of the world's ills would disappear. It is difficult to fault missionary zeal when it seeks to get style and grace into ordinary handwriting, but the thought of millions writing in a standardized italic hand is somewhat appalling. Then, too, writing manuals present the *ductus* of italic as if it had come out of a machine that produced ice cubes. One of these "methods" is reproduced in Figure 393a. Obviously this still rendering is not

393. (a) A standard italic in a ductus; and (b) a student piece in italic.

the italic we have seen in the reproductions of Renaissance writing and in those devoted to the modern revival of calligraphy. The student may then ask, Why is italic or any other alphabet presented in this manner?

The *ductus* may be defined as the order and direction of strokes. As used by paleographers, a *ductus* chart seeks to determine with precision the order and direction of each stroke in each letter of any ancient alphabet under study. Thus various studies of Roman writings by Jean Mallon, Robert Marichal, Joyce and Robert Gordon, and others clarify this complex field not only in terms of scholarship—the seeking of truth—but incidentally serve to aid the teaching of calligraphy. But we already know the order of strokes in the Roman alphabet we use. We know, for example, that the first stroke of *B* is the left stroke, and that it travels downward. Then if we are reminded that reed pens cannot move against the grain, we can see why the strokes in Figure 393a are broken down as they are, with the necessary lifts indicated, and can make a *ductus* for any alphabet.

In an extension of meaning, German writing masters used *ductus* in reference to the sweep and style of individual strokes and to their assemblage into a letter of unique character. There is no doubt that one requirement in making good letters is that the hand must know where it is going, and this indicates in turn that the order for strokes must be well etched in the mind. For style, Figure 393a should not be taken seriously, since one cannot learn

O tu che sei di la dal fiume sacro,
volgendo suo parlare a me per punta,
che pur per taglio in era paruto acro,
ricominucio sequenda senza cunta,
di di se questo e vero! A tante accusa.
Tua confessione conviene esser congiunta.
Era a mia virtu tanto confusa,
che la voce si mosse e pria si pense
che dagli organi suoi fosse dichiusa.
Poco sofferse poi disse Che pense!
Rispondi a mi; che le memoire triste,
inte non sono ancor dall aqua offense.
Confusione e paura insieme meste
mi pinsero un tal si fuor della bocca
al quale intender fur mestier la viste.

La Divina Commedia

Form, Meaning, and Learning 279

to write by copying the strokes of a *ductus*. There is not just one style of italic but many: the elegant hand of Arrighi, the crowded style of Palatino, and the bold, wide letters of Michelangelo. For good writing refer to specimens by such masters and enlarge your spectrum by acquiring a few select books.

The student example of Figure 393b swings a little, containing a couple of strange capers, but it also shows some solutions that emanate from spontaneous action, in other words, from thinking and acting like a good calligrapher. Writers practicing the italic letters often use a skewed pen, with the top higher at the left corner.

Minuscule Styles

Humanistic minuscule perhaps deserves some emphasis, since it is the important link between the Carolingian minuscule and our own small letters. The example seen in Figure 394 features quite a generous space between lines, and although not convincingly spaced, the piece does demonstrate that the Renaissance letters possessed more individuality than they do at the present time.

394. A young calligrapher examines Renaissance letters.

395. A sturdy minuscule hand.

Our next example is essentially modern, with some overtones of the Johnston influence. The hand of Figure 395 is sturdy and possesses some dignity.

For modern alphabets the field should be expanded. Some typefaces could serve as fairly good models. Legend has some unique characteristics, and the Lydian series possesses fine calligraphic qualities. With finer pens novices can try some cursive alphabets, or some full pages of italic capitals on the Zapf model in Figure 84. The same narrow-cut pen is used for the outlines of larger filled-in letters after the manner of versal letters. Many versions of Roman and other title letters can be executed in this way. Overlapping letters in different colors is one kind of experiment that can be done, or using the same kind of pen, students can leave the field of letters completely and execute a variety of calligraphic games. One of these is seen in Figure 396, based on letter *z*.

For complete domination of any kind of writing, it is necessary to perceive it and practice it long enough for it to sink in and become a natural rather than a studied reaction to the letters. There is seldom time for this, but it is the way to improve on the examples seen here. Calligraphy in book format has been left out here because of difficulties in reproduction, but forward penmen may wish to execute projects along this line. A large sheet folded twice will give eight pages, and a paper cutter can furnish the proper trim. If these eight pages are followed by another eight, you will become acquainted with the method of book production used since Roman times, when scrolls were abandoned.

396. Fine workmanship on the letter z.

Notes on Paper

Ordinary bond tablets are not very rewarding for final projects. This material can reveal how the pen works in a naked kind of context, and black ink plus bond paper will reveal errors in letter structure and spacing like klieg lights reveal flaws in a human countenance. But painters like canvas because it lends a quality of warmth, and calligraphers and printers like papers that do the same for their enterprises. Students should avoid working on hard-finished papers because it is like working on glass. The pen needs a slight texture to bite into, and a certain resistance is necessary, for in overcoming it good strokes are made. Smooth papers can be made more acceptable by roughing them with pumice or a common kitchen cleaning powder.

Smooth watercolor papers will do well, but here one should try Milbourne or other makers who take pains in producing a reliable product. Papers used in intaglio and other printmaking areas should be investigated. Charcoal papers, available in many tints, will also serve. Many papers made for letterpress and offset printing might do, but these are not generally available in stores. Fake parchment papers are also available and will work quite well, although most of them are offensive to the eye and to the tactile sense, both of which are important to the calligrapher. Cheap construction paper is available in many tones, and there is no reason why it should not be used for certain projects that call for a strongly colored ground,

even though taste might be compromised. There are times when form and text might benefit from the use of an extreme color as a surface for writing.

Following a natural law of perception, deeply toned papers ought to contain letters that have strong structural qualities in the blacks; but even this rule might have its exceptions if one wanted to speak in whispers. Feliciano taught us the use of bizarre ink colorings. These were used to give variety to his contructed capitals. Much might be communicated if colors were used on tinted papers. Experiments are needed to press to the limits of these ideas because few calligraphers are exploring these outer fringes.

Rice papers and other papers having attractive visual or tactile qualities are a question mark as to calligraphic possibilities. Some of these absorbent papers may contain a sufficient quantity of sizing material to deter the spread of ink along the fibers. Watercolor papers may be manufactured with a starchy material that makes these surfaces slightly resistent to pigments carried in liquid form. This can be soaked out, and such surfaces will then accept inks more readily. The sizing in Oriental papers should be left in. They are designed to accept a limited quantity of ink, and the fast brush strokes of Oriental calligraphers are suited to the capacity for absorption. Some of the Oriental papers can be rendered suitable to pen letters by giving them a coat of plastic spray. Crude steel pens will cut the surfaces, and an excess flow of ink should be avoided.

Some Foreign Alphabets

The *ABC*'s of foreign alphabets are not too difficult to learn as regards form. Earlier discussions have emphasized that many other tongues use different shapes for the same sign. Greek *alpha* is a little different from our *A*, but the principle of the alphabet is fundamental to Greek, Latin, English, German, and so on. These foreign scripts are not encased in a shell of mystery; we can write them without knowing what they mean, in the same way that European scribes wrote Latin without knowing Latin. It is not ideal, but it is the best we can do.

Greek uncial is a very unpretentious alphabet. The pen is held almost vertically in reference to the top edge of the writing surface. There are no frills, and the hand must be exploited for its geometric content. Deliberately spaced, vertical and curved parts work against each other to form a texture of quiet dignity. Codex Sinaiticus (Fig. 403) was the inspiration for the page observed in Figure 397. Modern Greek can be written from a base such as Porson Greek, a good contemporary typeface. A table of characters and their names can be found in the large catalog of

XETEΔEAΠOTωNI
ΛNωNΠΑΡΑΛωT
COYCINIΑΡΥΜΑΟ·
EICCYNEΔΡΙΑKAI
ENTAICCYNΔIωE
ΓΔICAYTωNMAT·
ΓωCOYCINYMAP
KAIEΠIHIEMONΑ·
ΛEKAIKACIΛICΑ
XΘHCECΘΛIENE
KENEMOYEICMΑ
TYPIONAYTOICK
TOICEΘNECINOI
TANΔEΠΑΡΛΛωT
YMACMHMEΡIMΛ
CHTEΠωCHTIΛΛ
ΛHCHTEΛOΘHCC
TAIΓAPYMINENE
KINHTωPATIA
ΛHCHTEOYΓAPY
MICECTEOIΛΛΥ
TECAΛΛATOΠΙΝΑ
TOYΠΡCYMωNT·
ΛΛΛOYNYMIΘΑ
ΠΑΡΛΔωCIΔEATE
ΔEΛΦOCΛΔΦHω
EICOΛNATONKA
ΠHPTEKNONKA
EΠΛΝACTHCON
TAITEKNΛETΠI
NICKAIΘANATω
COYCINAYTOYK·
CECΘEMICOYME
NOIYΠOΠΛNTω
ΛΙΑTOONOMAMY
OΛEYΠOMINΑCI
TEΛOCOYTOCCω

ΠEPTONΛIΔΛCKAM
ΛONAYTOYOYΔEΛ
ΔOYΛΟCΥNEΡΤON
KNAYTOYΑΡKETO
TωMAΘHTHINAF
NHTΛIωCOΛIΛAK
ΛOCAYTOYKAIOΔ
ΛOCωCOKCAYTOY
EΙTONOIKOΔECΠ
KEEZEKOYΛEΠEK·
ΛECANTOΠOCωI
MAΛΛONTOYCOΓ
KIΛKOYCAYTOYM
OYNΦOKHΘHTEΛ
ΛYTOYCOYΔENIΑΡΡ
ECTINKEKAΛYMI
MENONOOYKATI
KAΛYΦΘHCETE
ΓNωCΘHCETEOO
ΛETωYMINENTH
CKOTIΔEIΠΙΑTEEN
TωΦωTIKAIOEΤ
TOOYCAKOYETEK
ΡYZATEEΠITωNΛ
MATωNKΛIMHF·
KIEΘEΛΠOTωNΛ
ΠΟKTENNONTω
TOCωMATHNAΥ
XHNMHΔYNAME~
NωNAΠOKTINAI
ΦOBICΘEΛEMΛΛΛ
TONΔYNΛMENON
KAIΨΥXHNKAITΕ
CωMAΛΠOΛECEE
ΓEENNHOYXIΛYO
CTPOYΘIΛACCAPY
ΠΙωΛEIΠEKAIENE

397. An excellent version of Greek uncial writing.

398. A good interpretation of Greek minuscule.

και τις αποθνησκων νοτατ ακοντισατω.
τιμηεν τε γαρ εστι και αγλαου ανδρι μαχεσθαι
γης περι και παιδων κουριδιης τ αλοχου
δνομεσιν θανατος δε τοτ εσσεται, οπποπε κεν δη
Μοιραι επικλωσωσ αλλα τις ιθυς ιτω
εγχος το πρωτον και υπ αοπιδος αλκιμον ητοσ
ελσας ανασχομενος μειγνυμενου πολεμου.
ου γαρ κως θανατου γε φυγειν ειμαρμενον εστιν
ανδρ, ουδ ει προγονων η γενος αθανατων.
πολλακι δηιοτητα φυγων και δουπον ακοντων
ερχεται, εν δ οικω μοιρα κιχεν θανατου
αλλ ο μευ ουκ εμπης δημω φιλος ουδε ποθεινος,
του δ ολιγος στεναχει και μεγας, ην τι παθη.

the Mergenthaler Linotype Company. Such faces are not thoroughly calligraphic, just as Garamond is not pure calligraphy, but they can serve as a basis for learning the Greek forms. With familiarity, a student might dare to try some of the scripts seen in facsimiles. As observed, many of the earlier scribes used a pen of narrower cut. In these foreign alphabets correct spacing will be more difficult, because good spacing always involves taking certain liberties with the letters, and there is some reluctance to take such steps for fear of misrepresenting the sign or creating ligatures that are not a part of the tradition. In Figure 398 the pen slant is well to the left.

Hebrew is a beautiful and stately hand, with a good contrast between stable and cursive elements. The stable element is the strong horizontal that hangs on the top line, and this should not be lost if the flavor of the style known as "Square Hebrew" is to be preserved. It looks best when done with a pen that has been cut quite wide, with a large disparity between thick and thin strokes. The example seen in Figure 399 is a good try but does not quite manage to preserve the strong top line. Incidentally, you can dispense with the vowel markings seen here. One is expected to learn Hebrew well enough to get along without them, and in type versions the extra markings are noncalligraphic. A few peculiarities should be noted. Without vowels many Hebrew words are about the same length. Word groups should be tightly assembled so that space

between words can be minimized, to prevent vertical rivers of white. Words are almost impossible to break apart, so compositions can be unjustified at the left. To accomplish a justification of the left edge in order to present a column it is probably a mistake to use extra space between words. This mistake will be observed in the first line of the example reproduced. It can throw the whole page into confusion. Instead, the strong horizontal line at the top of most signs can be lengthened or shortened according to need. This distortion does not harm the sign function of the character. Some earlier scribes justified lines by making one of the last characters in the line excessively wide. This mannerism, impossible in our alphabet, is not at all objectionable in Hebrew, although modern calligraphers would probably try to distribute needed elongations throughout the entire line. Styles termed rabbinical feature a more curved form on each letter, and this is rather attractive, although lengthy texts tend to become tiresome in the repetition of the same curved form. Informal Hebrew scripts seem to go off in all directions. There are all kinds of versions in all kinds of countries, and it has not been blessed with any kind of tool

Left: 399. A student effort on square Hebrew. Faults occurring here must be shared by the author.

Above: 400. Student transcription of an Arabic manuscript.

Form, Meaning, and Learning 283

discipline or any kind of status, governmental or religious, which might have given it time to rest and assume some cohesive form. Neither calligraphy nor typography has been able to penetrate the informal Hebrew cursive, and experts say it lacks merit. It is presumed that novices know by now that Hebrew is written from right to left. Hebrew is a fine hand for carving on large planks of wood.

Arabic is a calligrapher's hand. Originally a stiff, painted imitation of the carver's art, it was taken over by pen calligraphers and given a beautiful form. In spite of all kinds of elaboration reflecting cultural tendencies, the legible alphabet is still a marvelous collection of forms. With its ligatures it presents a problem to type designers; but even here, with few designers working on the prob-

lem, it reflects something of the calligrapher's art. Like Hebrew, Arabic is written from right to left, and problems of word spacing and allied difficulties are matters for experts. Thus the student effort of Figure 400 looks good; but exactly how legibility and decorative functions of the Arabic alphabet are separated or joined is not clear, because little information is available on the subject. The example of Figure 400 was executed on rice paper.

Beginners are sometimes overawed by seeing examples of the kind exhibited in these pages, but after a few class periods they are ready to try difficult scripts and do as well. Would it not be interesting to form a class of advanced students involving many foreign-born ones, who could teach each other to write the various scripts?

Part VII WRITING: A WORLD ART

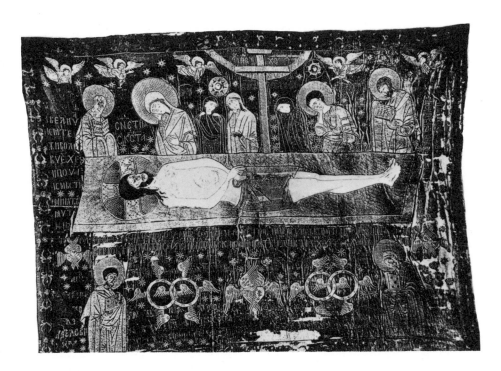

Greek calligraphy in a tapestry. Chilandari Monastery, Athos, Greece.

Chapter 13 Greek Calligraphy

Any study of calligraphy would be incomplete without a brief examination of the writing styles of other cultures. While at first glance a novice might assume that Latin uncial and the hand seen in the Book of Kells were "foreign," through familiarity and classroom experiences these alphabets will be more comfortably observed as intimately related. Indeed, after tracing the alphabet to the times of Roman power in earlier sections of this book, our interests have centered on the styles that branch from Latin alphabets used in writing Anglo-Saxon, early Teutonic, and later national languages. Thus we have followed the scripts most closely associated with our own cultural lineage. But there are other scripts that have been used for recording great literature and historical events. Then too, some foreign scripts are associated with esthetic traditions in which the scribes are honored as important artists.

287

Alpha	A	a	Ⱥ
Beta	B	β	B
Gamma	Γ	γ	Γ
Delta	Δ	δ	Λ
Epsilon	E	ϵ	Є
Zeta	Z	ζ	Z
Eta	H	η	H
Theta	Θ	θ	Θ
Iota	I	ι	ι̇
Kappa	K	κ	K
Lambda	Λ	λ	Λ
Mu	M	μ	M
Nu	N	ν	N
Xi	Ξ	ξ	Ƶ
Omicron	O	o	O
Pi	Π	π	Π
Rho	P	ρ	Ρ
Sigma	Σ	$\sigma\varsigma$	C
Tau	T	τ	T
Upsilon	Υ	υ	Y
Phi	Φ	ϕ	Φ
Chi	X	χ	X
Psi	Ψ	ψ	Ψ
Omega	Ω	ω	ω

401. Modern capital and lowercase Greek letters and Greek uncials.

A generation past, foreign students were fairly rare on campuses in the United States, and foreign-area studies were quite rare. Today many students from India, Egypt, the Far East, and other foreign countries study in our centers of learning. And more of our students are studying Hebrew, Greek, Chinese, and so on. Certainly it is appropriate to open a small vista on the appearance of some of these historic scripts. More of our teachers are introducing foreign hands into the classroom, and it is hoped that the notes that follow will facilitate this practice.

GREEK ALPHABETS AND REVIEW

To begin our discussion we must go back in time and pick up the trail of Greek scripts, alphabetic forms used in the memorable years of classical Greek civilization, during the Byzantine empire, and in contemporary languages.

On circumstantial evidence, Greek writing that made use of Phoenician signs is projected back into the eighth century B.C., a probable date for Homer and his epics. The earliest dates for recovered manuscripts fall in the fourth century B.C., and here we refer the reader back to Figure 47. In style this writing was rather close to epigraphic forms shown in the earlier discussions. Before pursuing the Greek calligraphic hands, the reader is invited to examine Figure 401. Here we see three Greek alphabets and the names of the Greek letters. The two alphabets on the left are majuscule and minuscule letters in use today, while the right column exhibits the Greek alphabet as seen in Codex Alexandrinus.

The best review of the development of Greek pen hands is found in *An Introduction to Greek and Latin Paleography* by Edward Maunde Thompson (London, 1912), but it must be mentioned that the reproductions in the 1965 offset edition suffer in comparison with that of 1912. However, the tables of letters and the commentary remain unimpaired. Paleographers call the early Greek book hand uncial, and it is like the Roman uncial in that both, in formative stages, follow stonecut models as closely as possible, with certain letters becoming curved over the years. It is contended that there was always a cursive form of Greek writing, but this tendency had difficulty in penetrating the conservative nature of Greek scribes. At times elegantly executed, Greek writing tended to be spaced very deliberately, as in the measured stonecut versions already seen. Another convention stemming from carved letters was the single-strength stroke, or monoline, without thick and thin elements. Scribes writing Greek cut their pens narrow at the tip, so that there was only a small difference between thick and thin strokes no matter the direction.

Cursive writing must have developed from common writing. It was approved and preserved through official documents, a kinship observed in the Roman tradition. Ligatures were well established in this area of writing in the third century B.C. In Figure 402, a boxer's diploma dating A.D. 194, we can see that the pen has been given its own way and that a minuscule alphabet is in the process of formation.

GREEK UNCIAL BIBLES

In the better connotation of the word, *conservative* means 'to conserve,' 'to preserve,' and it is in this connection that we study a late Greek uncial hand of the fourth and fifth centuries of our era. This uncial book hand bears a remarkable similarity to the Timotheus hand and points to a very long tradition in the writing of uncial letters.

There are three distinguished Bibles written in Greek uncial. Codex Vaticanus and Codex Sinaiticus date from the fourth century and Codex Alexandrinus from the fifth. The first of the three is in the Vatican Library, while the other two are in the British Museum. Local libraries may possibly have facsimile editions of one or more of these famous Bibles, and the British Museum published a small book on its two manuscripts in 1955. Our discussion here centers on Codex Sinaiticus because it is a most im-

pressive book, because it has an interesting history, and because it was definitive in the triumph of the vellum book over the papyrus roll.

Codex Sinaiticus

Originally each page of Codex Sinaiticus measured 14 inches wide and 16 inches high, so that a double page used up the skin of one goat or one sheep. The manuscript consisted of 730 leaves in its finished state, of which 390 now remain. The design of the pages can be gathered from Figure 403a, while the character of the writing is better seen in Figure 403b. Both reproductions are from the same page of the manuscript.

Codex Sinaiticus was uncovered at the famous monastery of St. Catherine on Mount Sinai, founded in the sixth century by Emperor Justinian. It is not known how it came to be there, but in 1844 Constantine Tischendorf, a visiting German biblical scholar, came upon a basket full of tattered parchment. The librarian of the monastery informed Tischendorf that the contents were to be burned. Two other loads had already been destroyed. Investigating the parchment, the scholar discovered 129 leaves from an Old Testament Greek Bible, which seemed the oldest he had seen. His too-obvious delight aroused the suspicion of the monks, and Tischendorf was only able to carry off 43 pages. These were presented to the king of

402. Boxer's diploma, A.D. 194. British Museum, London.

a

403. (a) A page from Codex Sinaiticus; and (b) Greek uncial letters from the same page. British Museum, London.

b

Saxony, who gave them to the library of the University of Leipzig, where this part of the manuscript now resides, called the Codex Friderico-Augustanus. Tischendorf returned to St. Catherine's in 1853, with no success; but in 1859 he struck pure ore in the form of other parts of the Old Testament, the complete New Testament, and other early Christian works. He persuaded the monks to send the manuscripts to Cairo, where he made a complete copy in the space of two months, and suggested that the original documents be given to the tsar of Russia, his sponsor. They became the property of the library of St. Petersburg. After the 1917 revolution in Russia the British Museum started negotiations toward the purchase of Codex Sinaiticus and was successful around 1932. The British government offered to match funds resulting from the museum's subscription drive, which went well over the mark. The price was £100,000. An American group, unsuccessful in earlier bidding, offered twice the sum, but this offer was declined.

Codex Alexandrinus

Codex Alexandrinus provides a less dramatic scenario but furnishes one good scene. A gift to a king of Britain, the great Bible was in the Royal Library when the building caught fire the night of October 23, 1731. A librarian, clothed in nightgown and great wig, was observed fleeing the scene with a volume of Codex Alexandrinus under his arm. George II gave it to the British Museum in 1757. The style of the writing can be seen in Figure 404.

In its original state Codex Alexandrinus contained 820 vellum leaves. Only 47 have been lost in over fifteen hundred years of existence. The page size is smaller than that of the Codex Sinaiticus, measuring about 10⅜ by 12⅝ inches. Codex Sinaiticus was designed in four columns, while the smaller Bible uses two columns of about fifty lines. The styles of uncial hand in all three of the great Bibles are quite similar. Letters in the Codex Alexandrinus may be a trifle heavier, with a slightly more deliberate spacing. In it paragraphs are marked by an enlarged letter in the margin, a device used in Roman uncial, and it must be assumed that there are ties between Greek and Roman calligraphers in the third and fourth centuries. The pen is held at a more vertical angle in Greek uncial than in the Roman counterpart, and there is some flexibility in this aspect of the Greek writing. For vertical strokes the pen is held perpendicular to the line; but for slanted strokes it is tilted to the left or the left corner of the pen is used. And there is no absolute rule on this, in spite of the fact that the letters look as if they were executed according to rigid standards. Outside of the long vertical strokes on *phi* and *psi*, no flourishes can be seen in the

404. Writing in Codex Alexandrinus. British Museum, London.

Greek uncial letters. The simplicity and dignity of the concept is really quite astonishing, and students of calligraphy will find the hand more difficult to master than many others. In abstract qualities the play of vertical against curved forms is dominant, and the deliberate spacing is equally important to the sense of the page. For further study see the reduced-size facsimile of Codex Alexandrinus by the British Museum (1957).

BORROWING GREEK SIGNS

The split in the Roman empire was started in A.D. 395 by Theodosius and eventually made Greek culture important in the Middle Ages. In the seventh century the eastern Roman empire became the Byzantine empire. This meant many things, for the Byzantine culture was complex; but in the seventh century, Greek replaced Latin as the official language for the army, for edicts, and for the church. Peoples of the Balkan area—Croats, Serbs, and Bulgars—were brought into the Hellenized empire; and in 989 a powerful prince in Kiev was converted to Christian ways and Byzantine customs, and learning penetrated into Russia. Eventually the area of the Balkans and Russia came to use the Greek alphabet. As we shall see, the form of the letters adopted for these areas was not in the best writing tradition.

Codex Argenteus

An early adaptation of the Greek alphabet is seen in the alphabet invented by the Gothic Bishop Ulfilas, who translated the Bible into Gothic in the fourth century. Some fragments of the translation exist in manuscripts of the fifth and sixth centuries, preserved in Uppsala, Sweden. This work, Codex Argenteus, was published in facsimile by the University of Uppsala in 1928, and the page in Figure 405 is taken from this publication. It was originally written with silver and gold on parchment that was tinted purple—a most impressive document. It is clear that the pen was cut wider than for the earlier uncial Bibles and that a majuscule letter is in formation. A bibliography on this short-lived alphabet is furnished in *The Alphabet*, by David Diringer.

Another adaptation of the Greek alphabet, the only one in Africa, was that for the Coptic language. The Copts were the indigenous population of Egypt, common people who practiced a variety of the Christian faith and spoke the eastern variety of the Egyptian language. Surviving the Arabic conquest of 641, Coptic, long thought to be a dead language, was found existing in villages of northern Egypt in 1936. The earliest Coptic inscriptions date from the second century. Our example (Fig. 406) is pen-written

405.
Writing in
Codex Argenteus.
University of Uppsala.

and dates from the fifth or sixth century. These are uncial letters, written with a pen cut wide at the nib. If one or two signs are unfamiliar, it is because 7, in an alphabet of 32, were taken from late Egyptian.

DEVELOPMENTS IN TIME

Although there are many varieties of Greek scripts in the Middle Ages, three main tendencies can be seen in the development of minuscule, majuscule, and cursive letters. Wild cursives are seen in papyrus documents of the fourth century. This writing, like the Roman, came in through common, informal sources into official places, and the scribes in both areas must have come up the economic ladder the same way. Clerk-scribes were not of the educated set and must have been instrumental in the infiltration of free common writing into official documents. The example seen in Figure 407 dates from the fifth or sixth century and is as joyfully wild as the Roman cursive. There is a kinship between the two scripts in these times.

The deliberate tradition of Greek writing can be observed in the New Testament script of Figure 408, dating c. 950. Greek minuscule has by this date been developed as a book hand separate from the earlier uncial. In spite of ligatures, the letters maintain a discreet space for their visual and physical existence. Letters may not be jammed together, and a habit of ligatures with deliberate spacing is unique to Greek writing. Perhaps this idea can be used in your own projects. Greek scribes preserved this quality in their minuscule book hands during the late Middle Ages, avoiding the crowding and blackening tendencies in pages seen in western Europe. Since most books designed for students emphasize those alphabets in the mainstream of our cultural heritage, good or bad, it is important to observe this and other traditions of calligraphy.

Greek minuscule writing was excellent on the whole, but letters maintaining the uncial tradition and developing into the majuscule, or capital, alphabet suffered a collapse in terms of legibility and esthetic qualities. Uncials came to be written with a wide pen, and documents decline after the sixth century. Some of the Greek majuscule alphabets of the later Middle Ages are so absurd that they become interesting. The example of ninth-century Greek writing in Figure 409 will have to stand for the entire tradition, although there are other examples even heavier and more ugly. Most of these alphabets are marked by an extreme contrast in thick and thin strokes.

Greek was the first language to achieve a world status. The New Testament was written in Greek, and its importance far outweighs the modest number of ten million native speakers.

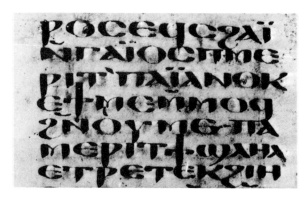

406. Coptic writing. Vatican Library, Vatican City.

407. Greek cursive. Bayerische Staatsbibliothek, Munich.

408. Greek minuscule c. 950. Vatican Library, Vatican City.

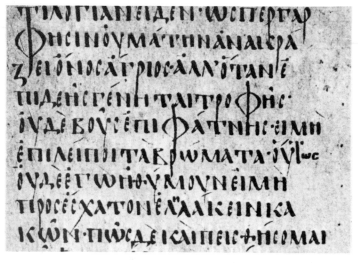

409. Greek majuscule, ninth century. Vatican Library, Vatican City.

Greek Calligraphy 293

Above: 410. Greek writing from *The Universal Penman.*

Right: 411. Johnston's Greek hand. Victoria and Albert Museum, London.

Cyrillic Letters

In the course of a long development, the Greek alphabet was adapted for the Slavic languages in the Balkans and Russia, although Rumanian now employs the Roman alphabet. Cyril, a brilliant Greek missionary, left Constantinople in 863 with a brother, Methodius, to preach among the Slavs of central Europe. These people had no alphabet, so Cyril devised one for them. A revised version of this original Glagolitic (*glagol* means 'word') became known as the Cyrillic alphabet. It needed 43 characters to convey the rich variety of sounds in Slavic speech. The earliest documents date from around the year 1000 and thereafter, and the writing unhappily was modeled on Greek majuscule writing of the ninth century, an example of which we have just observed. Later on, of course, Slavic scribes developed minuscule and cursive forms. Alphabets based on Cyrillic signs expanded over enormous territories, and after the conversion of the Russians in 988 the alphabet took hold in that country.

Greek Letters in Modern Times

During the Italian Renaissance some scholars knew Greek and were anxious to recreate the classical texts in manuscript form, and scribes with the proper credentials were assigned to the work. After the establishment of printing it was inevitable that the written Greek alphabet should have been converted to types. Aldus Manutius cut the

first legible Greek types in 1495. It was a particularly formidable task. As we have seen, Italian scribes such as Poggio separated letters for the most part, and this act, a recognition of the legibility of manuscript styles of the late Carolingian style, enabled printers to get at the problem rather quickly. Jenson created his memorable pages within months of his arrival in Venice. There was no such precedent to be followed in early Greek printing. The models were full of ligatures and accent marks. The first Greek font was anything but a model of legibility or beauty. Claude Garamond, working in France some fifty years later, designed the first elegant Greek font, the Grec du Roi. An interesting engraved version appears in George Bickham's *The Universal Penman* (London, 1743). This Greek cursive is seen in Figure 410. Taken in small doses, the Bickham model goes down well, but it sticks in the craw when consumed in large quantities. Even Arabic, ornate on occasion, has a basis of stable strokes on which to build. For those who might like to try writing a few pages of Greek poetry, a more sedate version of Greek minuscule was presented in Figure 401, and a student work (Fig. 398) has already been seen. Pen slant in the latter is markedly left of center.

A reproduction from the pen of Edward Johnston (Fig. 411) closes this discussion of Greek letters. Johnston executes the uncial Greek with freshness and taste, preserving the dignity of the scribes of Codex Sinaiticus.

Persian map. Walters Art Gallery, Baltimore.

Chapter 14 Aramaic: Syriac, Arabic, and Hebrew

We have observed that the emergence of the alphabet took place among Semitic peoples located on the eastern shore of the Mediterranean. In review, Figure 42 showed the lineage of alphabetic influence stemming from the original experiments. This chart demonstrated that Aramaic was the matrix script for a dozen languages. For various reasons, Syriac, Arabic, and Hebrew are best known. All were intimately connected with religious movements, and calligraphic efforts carrying the language of faith were treasured; but only the Arabs were destined to draw world maps. For a time in history missionary zeal was meshed with political talent and military élan, and the Arabic script was seen on three continents. A Moslem map of the world is reproduced in the figure above. The script is Nastaliq. To a Moslem this map would be upside down.

412. Aramaic pen writing, fifth century B.C. Bodleian Library, Oxford, England.

ARAMAIC AND ITS INFLUENCE

As shown in Figure 42, Aramaic was closely related to Phoenician. The Aramaeans were settled in Syria (particularly in Damascus) and Mesopotamia in the centuries before 1000 B.C. and were one of a number of Semitic peoples, closely related in speech. The Aramaeans never cast great shadows on the stage of history. They were important in the trade between the Mediterranean and the Euphrates Valley, and even after being officially subdued by Assyrian might in 732 B.C. they continued to ply the trade routes all over the Middle East and Asia. Excellent businessmen and scribes, the Aramaeans, using the efficient Phoenician alphabet, moved all over the area. The Aramaic script replaced official cuneiform languages in Babylonia, Persia, and Assyria. Aramaic was carried to India and became a seed of the development of writing in that country. It replaced Hebrew in Palestine, and in the centuries before Christ, Aramaic became the general language of the whole area between the Mediterranean and the Persian Gulf. One scholar writes: "It is still a puzzle how they were able to drive out of general use the Babylonian language and cuneiform writing, which had been to some extent international in the second millennium, and to have their own speech and characters accepted instead."

Aramaic was the tongue of Jesus and his contemporaries. Although it was spread to far places in Asia— among Iranians, Turks, and Mongols—it survived the Middle Ages chiefly as a language of religious sects. A few people still speak Aramaic in remote villages of the Near East. George Lamsa of New York, translator of a Bible from early Aramaic manuscripts, spoke Aramaic as a youth.

The Direction of Semitic Scripts

The script of Aramaic was written from right to left, and most of the scripts of languages deriving from Aramaic are also written in this direction, including Syriac, Arabic, and Hebrew. As we know, Greek-Latin writers reversed the writing direction from that used in Phoenician texts and early Greek and Latin inscriptions. And languages deriving from Greek and Latin, including those that merely borrowed Greek or Latin signs, came to be written from left to right. As has been shown, this reversal was a great advantage to the right-handed person. In our tradition the right-handed scribe was responsible for much of the shape content in Roman alphabets in use today, and the position and shape of initial and terminating strokes were determined by right-handed persons. The direction of writing, then, is an essential factor in the appearance of writing and letters.

When Aramaic and other Semitic languages came to be written by right-handed calligraphers, some stricture in the social milieu prevented them from changing the direction of writing. In writing Aramaic, Hebrew, and other Semitic scripts the right-handed scribe must make indi-

vidual strokes from left to right and then move left past the wet stroke to start another. It has been said that habit is the flywheel of society, and this fact alone may account for the permanent direction of Semitic inscription and manuscript writings. But several scripts were in the service of powerful religious movements, and once the sacred word had been recorded, it was already too late to change. No doubt the shape of letters in Syriac, Hebrew, and Arabic was affected by the necessity of right-handed penmen to move left; but this is a subtle matter best left to paleographers of Semitic scripts.

Passing over inscriptions, the Aramaic pen hand is seen in Figure 412. Written on leather in the fifth century B.C., the letter contains instructions issued by a Persian satrap in Egypt. The pen is cut wide, and the hand is rotated almost 90 degrees left for writing position. This is typical of the writing traditions that stem from Aramaic. A closer inspection will reveal that the pen, generally holding a horizontal line at the top of the letters, makes a dip down and then right before descending, a feature seen in formal Hebrew scripts of today.

Phoenician West, Aramaic East

As Figure 42 demonstrates, Aramaic was the mother of Near East and Eastern alphabets. This can be shown by use of the diagram in Figure 413. The alphabets stemming from Phoenician headed in a westerly direction, while those which derived from Aramaic flowed out to the east. Derived from the Phoenician directly are Old Hebrew, Greek, and Punic. Peoples speaking Punic descended in the Canaanite-Phoenician line and were famed in the wars between Carthage and Rome. These African colonies of Phoenicia probably passed the alphabet to a short-lived Iberian language and to peoples of North Africa speaking Libyan at the present time. The Western Greeks passed the alphabet to the Etruscans, who gave it to the Latins. Alphabets descending from the Etruscan included the Oscan and Umbrian in Italy and the famous runic alphabets of northern Europe. The alphabets descending from Rome in medieval developments include all those of western and northern Europe and the British Isles, and later those of the Americas, in general.

413. Eastern and western flow of alphabetic writing.

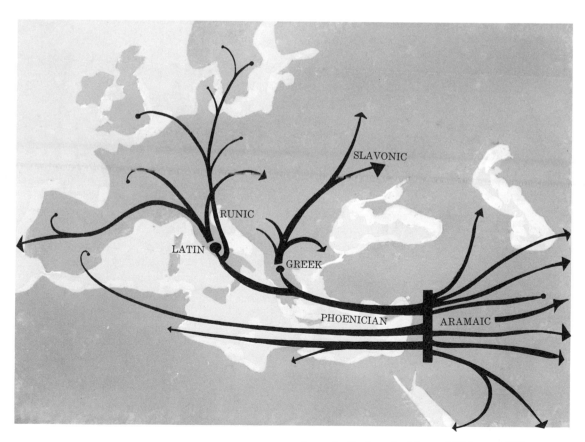

SYRIAC WRITING

Syriac was a direct and important descendant of the Aramaic. It was spoken over large areas to the north and east of Palestine, but the literature centered around a strong national church of Syria, flourishing most strongly in the city of Edessa. The development of the Syriac scripts occurred from the fourth to the seventh century. Syriac, like Aramaic and Hebrew, used the 22 Semitic consonants with some of the names changed. It was written from right to left. The most important of the Syriac scripts was called Estrangela (or Estrangelo). The example seen in Figure 414 is part of a page from Genesis in a version of the scriptures known as Peshitta. It was written in 464 and is the second oldest dated biblical codex in any language. Curiously rounded, the technique seems to involve a pen with a round tip, some double stroking on initial descending strokes, and a generous flow of ink. Dots above and below letters indicate vowels.

Eastern Christendom was riddled with sects and heretical movements. After 431, the Syriac language and script split into eastern and western branches. The western branch was called Serta and developed into two varieties, Jacobite and Melkite. Nestorian was the name given the eastern Syriac, after Nestorius, who led a secession movement out of the Orthodox Church of Byzantium. The Jacobite Christians have survived, and samples of the writing can be seen through the later Middle Ages, some of them on the Estrangela model but very much heavier. These scripts and many others can be seen in *Specimina Codicum Orientalium*, by Eugene Tisserant (Bonn, 1914).

414. A part of Genesis in Estrangela. British Museum, London.

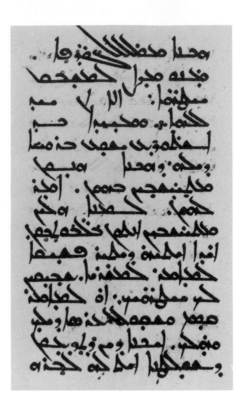

415. Jacobite. Vatican Library, Vatican City.

416. Nestorian writing. Vatican Library, Vatican City.

Exciting calligraphy is seen in Figure 415, a Jacobite religious document dating 1481. Apparent is a shift in the base line from the top, as it is in ancient Semitic scripts, to the bottom. Contemporary typefaces in modern Syriac, a language spoken by about a hundred thousand people in Iraq and adjacent parts of Turkey and Iran, follow the model of Figure 415.

The Nestorian Church flourished in Persia and spread along trade routes deep into Asia, a fact observed by Marco Polo. A Nestorian mission arrived in China in 635, and vigorous missionaries carried the sacred word, language, and script, into Kurdistan, southern India, Turkestan, and Mongolia. Interesting articles on this subject have been written by P. V. Saeki and A. Mingana. A late version of Nestorian writing is seen in Figure 416. It is similar in style to the earlier Estrangela but tends to hold ligatures to a base line.

417. Writing by Hafiz Osman. Topkapi Saray Museum, Istanbul.

ARABIC: THE FLYING QUALAM

The word *calligraphy* is supposed to mean 'beautiful writing,' and in the Arabic tradition it fulfills its meaning. Introducing the subject is the line of writing seen above (Fig. 417), done by the famous Turkish calligrapher Hafiz Osman (1642–1698). In the tradition of Islam, the first thing created by God was the *qualam,* the reed pen, and the humble instrument comes into its own in the manuscripts we are about to see.

The Arabs

In the first millennium B.C. there were Arab settlers in the Fertile Crescent, that great arc from Egypt up the Mediterranean coast, around to the headwaters of the Tigris, and down to the Persian Gulf. They may have drifted into the area from the north, but their origins are not well fixed. It is a familiar fact that they were a wandering people, driven by the seasons. Today they would have to be termed barbarous, for they let blood with frequency, buried infant females, and drank to excess. With this, they loved to tell stories and admired poetry. Even so, it is rather surprising that the Arabs succeeded so magnificently, emerging in the early Middle Ages as one of the chief custodians of world culture.

At first the Arabs used the western Phoenician alphabet; but they picked up Aramaic, the eastern branch of Semitic, during that sweep it made in the first millennium B.C. Arabic writing of the early period, surviving on stone, shows an angular South Arabic style, which held sway to the eve of the Muslim era and then yielded to a North Arabic alphabet, based on Nabataean writing. The Nabataean kingdom, centering on Hijr, Petra, and Busra (Bostra), flourished from 169 to 106 B.C. Numerous writings on stone stem from this kingdom. The letters were linked together, and this was to have an enormous effect on Arabic, one of the greatest of calligraphic writings.

Syriac was the language and script of the Church in this area, and Arabic, being a language neither of ruling peoples nor of a powerful church, had to remain in the background—a language of common people until well after the birth of Mohammed c. A.D. 570.

Mohammed transformed the religious, political, and social organizations of his people. In 622, having received revelations, Mohammed fled his native city of Mecca and went north to Medina. Moslems consider this date as year 1, and the appropriate number of years must be added to dated Arabic manuscripts to put them within our frame of reference. By conquest and persuasion, Islam spread to Spain, through North Africa, the Balkans, Asia Minor, and east through India, with shafts of the faith penetrating China, Africa, and southeast Asia. Again the alphabet followed a religion. World history was changed at the battle of Tours when Charles Martel stopped an army of Moors in 732. For that reason, European remnants of Islam exist principally in Spain. On most accountings Islamic culture was superior to European culture of the Middle Ages.

Calligraphy Admired

Arabic writing is the calligrapher's delight. The act of writing for its own sake was highly developed, greatly admired, and was an art form with high status, not merely accepted but assumed to be a part of civilized life. Treatises on the art of writing were not stuffy and dry but aspired to a form acceptable to the selective ear. Note this example from *Calligraphers and Painters: A Treatise by Qādī Ahmad, Son of Mīr-Munschī,* c. 1606, V. Minorsky, published by the Freer Gallery of Art in 1959. It is worth reading in its entirety because of its technical notes; however, the original Persian was translated into Russian and then into English, so it can be assumed that the flow of sounds here is not what it might have been. This passage is called "On How To Become a Calligrapher."

After I had left the Madrasa
None saw me return there.
I ensconced myself in a corner of my home.
And from the burning of my breast spoke thus to my wounded
 heart:
"Oh my heart! it is better either to say 'farewell' to writing,
And to wash the traces of script off the tablets of the heart,
Or to write in a way that people should talk of it
And entreat me for every letter."
Then I settled down in complete earnest and zeal,
In short, all day till nightfall,
Like a *qualam,* I girt my loins for practice,
Sitting on my heels.
I withdrew from friends, relations and companions.
And finally received encouragement.

Said the Prophet, that king and leader—
And do not turn away from the traditions of the Prophet!—
"For him who knocks at a door in supplication,
That door will open."

The nostalgia of the passage may bring tears to the eyes of veteran calligraphers (and, for different reasons, to the eyes of students) but the issue is clear. Quādī Ahmad spoke the truth.

There are few Arabic manuscripts that predate Hijrah, and early pen writings imitated inscriptions. As observed previously, stonecutters do not invent alphabetic forms but generally follow existing pen or brush models; but these presumed models for Arabic inscriptions do not exist. At any rate, the specimen of Figure 418 is thirdhand in origin. It is a fragment from the Koran and dates from the eighth century. The penmanship is superb, and of course the evidence of a wide, slanted *qualam* of fine cut is most marked. For an artist, the taste inherent in Arabic documents is compelling. The color of the letters is often a deep, rich chocolate with a second color, red, in decorations or alternating in the lines. The effect of these colors against the light tan of subtly textured parchment is stunning and makes some European manuscripts look overdone and cheap. In Arabic, esthetic factors tend toward residence in the writing itself rather than in a division of writing and ornament.

418. A Koran. Egyptian Museum, Cairo.

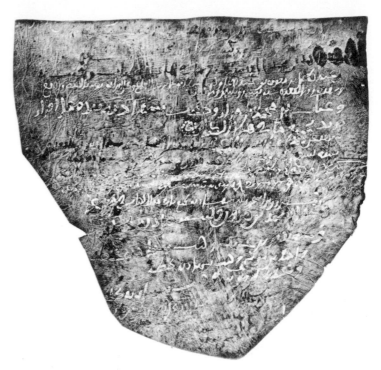

419. Arabic document of sale. Egyptian Museum, Cairo.

Various Styles

Kufic is the name given to the style seen in Figure 418, and the term is somewhat generalized to cover differing types of scripts: Kufic-Basran and Makkan-Madinan, named after towns in the Arab sphere founded in the second century of our era. The similarity between Arabic and Syriac scripts is striking, both using descending verticals and holding to a horizontal base line with groups of connected letters.

The introduction of alien writing is sometimes paralyzing to novices. In a fine article on Arabic scripts in *Alphabet 1964*, Walter Tracy explains: "In the contemplation of a foreign script we are at first hampered by inhibition that is almost prejudice: the letters are not only strange—they seem *unreal*." Similarly, many people feel that musical signs represent a most formidable barrier and fear that reading music must be left to gifted folk. Arabic, however, is not hard to master. The pen's nib is cut at an angle. As seen from the top, the right corner is forward, and the angle declines from the horizontal about 25 degrees (more or less). Given a specimen of writing or an alphabet, one can begin to put letters together and drift along until the style commences to sink in. We saw in Figure 400 a student work executed after a few hours of practice. It is a copy of an original Arabic work. It does not matter that the student was ignorant of literary content, though it is obviously sensible to

prefer such knowledge if it is available. The student was able to open a window on a highly developed writing tradition. And when one observes the manner in which other peoples write, critical attitudes toward our own traditions come easier. We cannot expect biologists to formulate ideas about writing—it is up to us, the artists.

In formal book hands Arabic was fairly conservative in the centuries following Mohammed. This is apparent in the Koran fragment of Figure 418, where the Kufic inscription style weighs on the penman. This example dates from the eighth century. Such inhibitions are not seen in the document of sale in Figure 419, dated A.D. 854, which possesses the real spirit of Arabic writing. Again street writing pushes its way into official documents and book hands, leaving a permanent mark on the graphic qualities of Arabic writing. It is cursive, and full of ligatures—whole words are tied together.

Remember that Arabic, like the Aramaic from which it derives, is written from right to left. The original 22 consonants of early Semitic writing have been expanded to 28 in the Arabic alphabet. Persian, Urdu, Kurdish, and

421. Naskh hand dated 1187. India Office Library, London.

420. The Arabic alphabet according to Walter Tracy in *Alphabet.*
Left column: *alif, ba, ta, tha,*
jim, ha, kha, dal, dhal, ra, zay, sin, shin, sad;
right column: *dad, ta, za, 'ayn, ghayn, fa, qaf, kaf,*
lam, mim, nun, ha, waw, ya.

some other tongues that make use of the Arabic signs use a few more letters. The alphabet explains itself in Figure 420, and as can be seen, some letters are executed differently depending on whether their position in a word is initial, medial, or final. Writers of Arabic do not separate words at the end of a line as, regrettably, we do. As a result, strokes of letters are sometimes stretched out to make lines even, or *justified* in proper terminology.

Because of religious prohibitions there is little imagery in Arabic manuscripts in the early centuries of the tradition. Esthetic needs thus had to find expression in the writing itself. Decoration in books, as in architecture, rugs, and so on, was based on geometry, for the same reason. The Persian area was an exception to the rule, and in other areas the Arabic script can be seen in secular documents containing marvelous illustrations dating from the thirteenth century and later. See the Notes and Bibliography for a few books on this tradition in illustration.

The principal styles in Arabic writing are Kufic, Thuluth, Naskh, and Nastaliq. We have seen an example of Kufic. Thuluth was used in writing the Koran and other works of a deserving nature. It is a tall and elegant hand. Naskh is the name of the classical Arabic book hand, and most of the local variations are based on this style. Nastaliq (now commonly called Farsi) uses a unique slant and a wider-cut pen, giving strong graphic content

422. With color added, Arabic manuscripts may present a brilliant visual feast. Egyptian Museum, Cairo.

to thick and thin strokes. This script is associated with Persia.

Meant for reading, the Naskh hand is disciplined and therefore capable of bearing a considerable burden of elaboration. An early Naskh hand is seen in Figure 421, dated 1187. It is graceful but conservative, and modern typefaces tend to revert to this kind of script.

Arabic writing has sign weaknesses similar to our own. Only 15 of the Arabic signs are genuinely distinctive in shape, so dots are used to distinguish the various letters that may cause confusion. Then too, dashes are used to express vowel sounds missing in the Semitic consonant alphabets. When these signs are included in an alphabet that also includes flourishes, the effect is like a piece of embroidery, as in Figure 422, dated 1299.

The distinguished character of Arabic writing is so marked, and there are so many local variations of it, that it would take a book of considerable length to reproduce the principal styles and local variations. The elegance of Arabic penmanship is seen in Figure 423, a page from a Persian Koran dated 1211.

Scribes in the Arabic sphere enjoy playing games with the alphabet. They enjoy making symmetrical designs with letters, delight in making involved decorative titles, and excel in forming visual puns in which letters are

used to create animals. An example of this sort of play is seen in Figure 424. This seventeenth-century Persian work spells *dove* in both graphic and letter form, serving as the calligraphic signature of a tribal chieftain.

A Live Tradition

Arabic, a living language, is spoken by some 90 million people, with about 30 million speakers in Asia and 60 million in Africa. It is the official language of a number of countries in the Near East and northern Africa, and many of the 450 millions who profess the Mohammedan faith have some knowledge of Arabic through sacred literature. The calligraphic tradition, enjoying 1200 years of life, is still spritely. In some countries newspaper headlines are still written by hand, because large type fonts are not yet available. With its ligatures, dots, and vowel signs, Arabic was not the easiest hand to convert to types, and the skilled scribe is still important in the culture of the Arabic areas. A few books of facsimiles are listed in the Notes and Bibliography, and it is hoped that readers will find them available, since the Arabic tradition in calligraphy, decoration, and bookmaking is truly outstanding in the world. Most of the examples reproduced here were executed on paper, since the Arabs had knowledge of papermaking before its use in Europe.

Speakers of modern Hebrew, *ivrit*, are few in numbers today. In 1948 the state of Israel was established in its old homeland, and Hebrew was designated as an official tongue along with the indigenous Arabic. The peoples who came to the new nation spoke in divers tongues but tended to possess language skills, and as of this date more than a million inhabitants can use Hebrew, which is not yet half of the population. Other speakers of Hebrew reside in our several communities. These are religious personnel and scholars who have kept the tongue alive through the centuries. In larger population centers Jews support schools for the teaching of the ancient tongue to the young people, with mixed results, as in the teaching of any language. The author's interest in the Hebrew script was sparked by a student who had attended a Hebrew school and who knew the signs of the alphabet with their subtleties.

Previous to the establishment of a modern nation, which has fixed on reviving Hebrew as a national tongue (for the religious faithful as well as agnostics), Jews were united in faith but not in language, speaking and writing the language of the country in which they resided. Chinese Jews speak and write Chinese. In recent centuries European Jews, isolated for various reasons, came to speak a language called Yiddish, based on German of the middle Rhine area liberally spiced with Slavic and Hebrew words and written in Hebrew signs. Yiddish was and is a kind of international language of Jews of European origin, and was the language of the large number of Jews who came to the United States in the earlier part of the century. Why all this background? Well, perhaps some readers confuse religion and language in this particular case. Similarly, Catholics hear a good deal of Latin from time to time, but knowledge of the tongue resides in the clergy, scholars, and teachers. It is clear that our interest in Hebrew writings and scripts bears little relation to the number of speakers of the language in present times.

The earliest Hebrew writing, called Old Hebrew, comes from the Phoenician-Canaanite variety of early Semitic, c. 1100 B.C. and is very similar to it because of the close relationship of the peoples. A few records on stone predate 1000 B.C., and there are some business records on *ostraca* (documents written in ink with crude pens on broken ceramics) dating from the middle of the ninth century. Clear writing in Old Hebrew can be seen in the Lachish letters discovered in 1938 in that city, and they reveal the thick-and-thin characteristics of the reed pen. The Lachish letters may date from the destruction of the city by Nebuchadnezzar's army c. 587 B.C. Aside from the pen characteristics, a number of the letters were curved on descending strokes. This old writing of the Hebrews did not survive, however, in the mainstream of history. Exile doomed the Old Hebrew tongue, and Aramaic took its place. Old Hebrew survives in the script of the Samaritans, a rare sect. Samaritan writing is seen in Figure 425, a manuscript dated 1258, now in the British Museum.

425. Samaritan writing. British Museum, London.

The classical Hebrew alphabet is taken from the Aramaic of Figure 413. Called square Hebrew, it became standardized during the second and first centuries B.C. Because there is a remarkable stability in the writing of Hebrew through the centuries, the modern alphabet is reproduced in Figure 426.

אבגדהוזחטיכלמנסעפצקרשת

426. The 22 Hebrew letters as presented by The Monotype Corporation. Derived forms are not presented. While pen letters differ markedly, this is a fair interpretation of European square Hebrew except for *lamed*.

The Dead Sea Scrolls

Before 1947 Hebrew manuscripts predating the Christian era were very few. But in that year the first of the Dead Sea scrolls were discovered by an Arab shepherd named Muhammad the Wolf. Muhammad and another shepherd entered a cave near Qumran, located in the northwestern region of the Dead Sea in Palestine, and there they came upon some ceramic jars. One of the jars contained seven large dessicated leather scrolls wrapped in linen. One of the scrolls, 24 feet in length, carried the complete text of the Book of Isaiah, almost identical with the version found in the Hebrew Bible.

About three hundred caves have been explored since 1947, and eleven of these have yielded fragments from every book in the Old Testament except the Book of Esther. Some of the copies, the manuscript of Daniel for

427. Writing in the Dead Sea Scrolls. © The Bialik Institute and the Hebrew University, 1954.

example, are thought to follow the original writing (c. 165 B.C.) by only fifty years. The Dead Sea scrolls represent one of the greatest single manuscript discoveries.

The tale of the Qumran manuscripts will be inscribed in history books to come. Already tangled beyond any hope of truth, the story begins with the attempt of the two Bedouins to sell the "Cave I" documents. Merchants in Jerusalem showed one of the documents to the Syrian archbishop residing in the Convent of St. Mark. The latter observed that the writing was not in Syriac but Hebrew and sent the merchants away to find the shepherds, with an offer to buy their holdings. After some months the two were located and directed to the monastery, where the monk on duty, knowing nothing of the proceedings, sent them away, as they were "rough-looking Bedouins who had with them some very dirty rolls, several wrapped in dirty cloth with a black substance on them." The metropolitan (an ecclesiastical primate) heard about this development at lunch and turned to one of his merchant friends, who reported that the Bedouins had negotiated with a Jewish merchant but had become suspicious and had returned to Bethlehem. The merchant went after them and persuaded one of them to leave the scrolls in his shop. The other departed to seek his fortune elsewhere.

Thus the original findings were split up. The four scrolls acquired by Archbishop Samuel were brought to

New York by him and were sold in 1955 to General Yigael Yadin for $250,000. In an interesting sidelight, Menahem Mansoor reports in his excellent textbook on the Dead Sea scrolls that the United States tax court held that the $250,000 was subject to the capital gains tax. There is much more to the story, but the other Bedouin sold his three scrolls to E. L. Sukenik, the distinguished scholar at the Hebrew University of Jerusalem. General Yadin was Sukenik's son, so the two parcels from Cave I are now reunited at the Hebrew University of Jerusalem.

The square Hebrew script of the Dead Sea scrolls is seen in Figure 427, from Sukenik's notes and portfolio study published in Jerusalem in 1954. The one ascender, *lamed* or *L*, stands out, and this feature marks many Hebrew manuscripts, although many contemporary type designs hold this ascender down to save space.

Hebrew in the Middle Ages

Hebrew manuscripts after the famous Dead Sea scrolls simply do not exist until the seventh and eighth centuries of our era, and the dating of these scraps is uncertain. One of the earliest confirmed dates is 916. As mentioned, Hebrew writing enjoyed a certain continuity of form. Cursive tendencies must have intruded on the formal square Hebrew, because cursive tendencies are seen when the script emerges from the darkness after a rough date of

וַיֹּאמְרוּ הִנְנוּ כְּחַסְתָלָחֶם עֲשׂוֹת מִשְׁמַעְתָּךְ"

יראה בְּרֹזֶב וְאוֹפֶן וְאַלְפֵי שִׁנְאָנֶיךָ"
 לַהַב חֲנִית וְאוּד חֲצִי שְׁנוּנֶיךָ"

יראה מַלּוֹן כִּפָּה וּרְכִיבַת רַגְבֶּיךָ"
 נְסִים מַגְּעָרָתָךְ זִי נָמֶשְׁק גְּבִיךָ"

יראה סַלֵּל הַכֶּלֶךְ וְנַחֲלַת שִׁפְרָתָךְ"
 עֲמֹךְ כְּסָר לְכָב יִכָּוֵן לְקִרְאָתָךְ"

יראה פְּקִיד שַׂר וְכָל שׁוֹפֵט"
 צֵאוּ יֵרֵד הַיּוֹם וְיִשְׁפֹּט"

יראה קָנוּי וְקָנוּ עָרֵעַר וְלַגֵּיוֹנוּ"
 רֹכַה וְעַלְמָה חֲלָשׁ וְתוֹפֵשׂ פְּגִיוֹנוּ"

יראה שָׁכֵן וְנֵפוֹת וְכָל פְּלָכִים"
 תִּתְרוֹמֵם לַעַד מֶלֶךְ מַלְכֵי הַמְּלָכִים"
 לִכְבֹד וְתִמְלֹךְ עַל כָּל בִּיחוּד" כַּכָּתוּב עַל יַ־
 נְבִיאָךְ וְהָיָה יְיָ לְמֶלֶךְ עַל כָּל הָאָרֶץ בַּיּוֹם הַהוּא יִהְיֶה יְיָ

וכן תֵּן פַּחְדָּךְ יְיָ אֱלֹהֵינוּ עַל כָּל מַעֲשֶׂיךָ וְאֵימָתֶ־
 עַל כָּל מַה שֶּׁבָּרָאתָ" וְיִרָאוּךָ כָּל הַמַּעֲשִׂים
 וְיִשְׁתַּחֲווּ לְפָנֶיךָ כָּל הַבְּרוּאִים וְיֵעָשׂוּ כֻלָּם אֲגֻדָּה אֶחָת
 לַעֲשׂוֹת רְצוֹנְךָ בְּלֵב שָׁלֵם כְּמָה שֶׁיָּרַעְנוּ יְיָ אֱלֹהֵי־
 שֶׁהַשִּׁלְטוֹן לְפָנֶיךָ עֹז בְּיָדְךָ וּגְבוּרָה בִּימִינָךְ וְשִׁמְךָ
 נוֹרָא עַל כָּל מַה שֶּׁבָּרָאתָ" וּבְכֵן תֵּן כָּבוֹד־
 וַיֹּאמְרוּ תְּהִלָּה לִירֵאֶיךָ וְתִקְוָה לְדוֹרְשֶׁיךָ וּפִתְחוֹן ז

428. A Hebrew manuscript. Bodleian Library, Oxford, England.

429. Syrian square Hebrew. Bodleian Library, Oxford, England.

These two examples show how square Hebrew survived. Local habits could give the letters a flavor of the area, but the basic shapes of the signs remained unchanged.

Another style of Hebrew writing is called rabbinical. Here the strong top line is bent and makes an arc with the downstrokes. While some cursive Hebrew writing can be rather wild, particularly in areas influenced by Arabic writing, the general trend of the rabbinical style is conservative. That seen in Figure 430 is a Babylonian Talmud dated 1335. As one might guess by its black and crowded aspect, this was executed by a German scribe. This too is straightforward pen writing but seems to exhibit the sharp cutting action of a quill in contrast to the reed of the previous figure. While some of the letters touch one another, there is no real attempt to form ligatures. It seems that the Hebrew signs preclude this kind of adventure.

Marcel Cohen's *La Grande invention de l'écriture* (Paris, 1958) contains a number of personal letters written in modern Hebrew characters. These are worth seeing for their variety. Even in the most personal kinds of scripts, letter signs are separated. Books such as *Hebrew through Pictures* by Richards, Weinstein, and Gibson, give a written version of the alphabet; but individual writers may execute some letters in differing form, depending on background.

Square Hebrew, whether seen in inscriptions or typeface, was and is a calligrapher's alphabet. It has elements of genuine lasting quality, as befits the tradition. Graphically these qualities reside in strong vertical and horizontal elements combined with fine slow curves. Readers should try this alphabet. As observed, it is not easy to do well, but it is interesting to place a hand into the stream of history.

1000 B.C. But cursive writing failed to make any permanent mark on the formal square Hebrew, which became solidly entrenched in the late Middle Ages and the Renaissance period and remains so today despite talk of reform. The Talmud prohibits tampering with the signs of writing.

Since Hebrew was written in all of the countries of Europe and the Near East in the late Middle Ages, it took on some local stylistic variations, but these nowhere disturbed the basic structure of the alphabet. The square Hebrew seen in Figure 428 is French and dates before 1471. Initial strokes go right and down, and in this example there is some double stroking to gain a decorative effect. In the first line the ascender of *lamed* is given a flourish, and it is seen with its peculiar flag in lines below. There is no doubt considerable influence from French black letter in detail. The canted nib cut used to execute square Hebrew gives the script strong horizontal strokes and strong design qualities.

A sturdy square Hebrew from Syria is reproduced in Figure 429. This probably dates near to that seen in Figure 428. Here the writer gives the reed pen a strong voice in the proceedings. On seeing an example of this kind, an observer is tempted to describe the character of the writer. It is written with authority, even with some grace, but it has little time for nonsense.

430. German rabbinical style dated 1335. Vatican Library, Vatican City.

An eighth-century inscription from India.

Chapter 15 Aramaic Moves East

In the graphic displays of Figures 42 and 413 we observed that the
Semitic alphabet, invented or developed in the second millennium B.C.
in the areas adjoining the eastern shore of the Mediterranean, became
established in several cultures that were related in language but differed
in economic and religious ways of life. The Phoenicians, living on the
shore of the Mediterranean, moved west in boats, explored the area to
Gibraltar and beyond, persuaded Greek speakers to use the Semitic
alphabet, and left remnants of their passing in Sardinia, Spain, and
elsewhere in the Mediterranean. Phoenician colonization of the African
shore was more successful — in spite of Rome's domination of Carthage —
and numerous peoples in North Africa still use languages and scripts
related to Phoenician and Punic.

THE ARAMAEAN PENETRATION INTO ASIA

Canaanites, Hebrews, and other cultural groups using variations of the original Semitic alphabet were at the time destined for a local history, and the eastern flow of the alphabet depended on vigorous Aramaic merchants, who opened trade routes followed by missionaries. Through these missions and through trade, versions of the Aramaic alphabet spread to the east into central Asia in a flow beginning in the first millennium B.C. Some of these developments lay hidden until the twentieth century. The notable expeditions of Sir Aurel Stein into Chinese Turkestan beginning in 1900 shed new light on the ancient writing of the area. Several countries sponsored expeditions into the area, and these also brought back samples of the writing.

Sogdian Writing

The Sogdians were a people living in an area east of the Caspian Sea and spreading eastward into northern India and Mongolia. These people spoke an Indo-European language but adopted a version of the Semitic-Aramaic alphabet for writing, just as the Greeks took the Phoenician signs. From A.D. 500 to 1000 Sogdian was the international language of central Asia, as French was in a later day. An undated sample of Sogdian calligraphy is reproduced in Figure 431, a Buddhist text written on paper. Its resemblance to Aramaic is obvious. Later examples resemble the Syriac, which points to the influence of Nestorian missionaries and Nestorian calligraphers. The Nestorian church was a relatively powerful sect banned for heretical beliefs in the fifth century. As shown in our example, the calligraphers were very good.

A related script, the Uighur, used by a powerful Turkic people who created an empire in central Asia in the eighth century, also shows strength and sophistication in the

432. A document from the Mongol era. Bibliothèque Nationale, Paris.

writing. Mongolian scripts followed Uighur signs and method, that is, from the top down and with columns reading from left to right. The method of reading and writing is presumed to have been influenced by Chinese, although the latter arrange columns in the opposite direction. At any rate, the example of Figure 432, dating from the seventeenth century, shows an expert pen writing, still with a Syriac base but with Chinese overtones. These and other writings in Mongolia are based on Semitic alphabets and the pen and are not to be confused with Chinese writing and the brush. In principle and method the differences are great. Mongolian manuscripts could be quite striking. That seen in Figure 433 was executed in black and various shades of gold.

The Mandaean Script

The Mandaean alphabet also stems from the Aramaic, although the origins of it are obscure. A Gnostic sect, the Mandaeans have lived in the Mesopotamian Valley since the first millennium B.C. According to Diringer's account, the principal religious work, the Book of Adam, is a group of extravagant ravings. Scarcely mentioned in texts on contemporary languages, the Mandaean people are practically extinct, with a few thousand souls living in the marshes at the juncture of the Tigris and Euphrates rivers. The sample seen here, Figure 434, is one of the oldest in Europe, dated 1560. It is written from right to left and resembles Syriac scripts in the way the signs center on a base line.

431. Sogdian writing on paper. British Museum, London.

433. Mongolian religious document. British Museum, London.

434. Mandaean writing. Bibliothèque Nationale, Paris.

Manichaean Writing

Manichaean writing is named for Mani, or Manichaeus, who founded a religion in A.D. 247. This cult, a peculiar blending of Christian and Zoroastrian doctrines with an intermixture of much of the mysticism of Gnostic sects, succeeded in inscribing its name on the stones of history. From the third to the thirteenth century it was one of the strongest and most broadly sown of all religions, and it gave the Christian faith its most serious competition in its formative years, with southern Europe the battleground. St. Augustine was a follower of it for ten years but became disillusioned. In the sixth century Justinian, insisting on complete uniformity, decreed the death penalty for the practice of Manichaeism. It faded out in Europe but survived in Asia until shortly after the thirteenth century. As scribes, Mani and his followers were very good indeed.

Other Derivatives

Palmyra was an ancient city in the Syrian desert east of Tripoli in Lebanon. An oasis with natural wells, it became important in trade between Syria and Mesopotamia, and enjoyed a period of prosperity lasting over half a century. Toward the end of its prosperous era its chief was a power in the Roman east. It finally gave way to Roman power in

A.D. 272. The writing was derived from Aramaic, and remaining records are on stone. Curiously, Palmyrene inscriptions have been found in North Africa, on the Black Sea, in Hungary, in Italy, and in England, where the Free Library of South Shields owns an important Latin-Palmyrene bilingual piece.

Pehlevi (or Pahlavi) was an Indo-European language that, like the related Sogdian, used an Aramaic alphabet. Alexander the Great had carved out an enormous empire stretching from Greece to India in the fourth century B.C. Successors to Alexander split the empire into three parts. The largest of these parts, excluding Greece and Egypt, stretched from the Aegean to India and is known as the Seleucid empire. This shaky edifice fell as Rome moved in from the left of the map. A new dynasty, the Parthian, filled the vacuum in northern Iran, and spreading west, held fast against the Romans in the Mesopotamian Valley. European overlords were not again seen until World War I. Parthians held sway in the area until A.D. 220, when they were overcome by a stronger group of Persians. Thus Pehlevi survived in several varieties until the big move by Islam in the seventh century. Deriving from Pehlevi was the Avesta, or Zend, script used in the sacred Zoroastrian literature. The Avesta script is still used among the Parsis of India and Iran.

Armenian and Georgian are other non-Semitic lan-

guages deriving from Aramaic. Armenian, very much alive, is spoken by Armenians in Asia Minor and perhaps by a few aging Armenian persons in the United States. It is written left to right. Georgian, too, is alive. Residing in the southern Caucasus since the seventh century B.C., Georgians represent a physical identity of some note in a changing world. It will be remembered that Stalin was a Georgian. Those who wish to follow these alphabets are advised to consult the Notes and Bibliography.

SOUTH ARABIC INSCRIPTION LETTERS

It will be noted from Figure 42 that South Arabic writings stem from the Phoenician-Canaanite writings fairly early in the alphabetic story. The fertile strips facing the Dead Sea and the Indian Ocean became the location of powerful agricultural and trading centers toward the end of the second millennium B.C. King Solomon obtained some of his fringe benefits from this area, and his visitor, the queen of Sheba, while enjoying a frank and open discussion with the king on undisclosed topics, left him with quantities of spices, gold, and precious stones. This speaks of the wealth of the kingdoms in southern Arabia.

South Arabic was the early Semitic alphabet expanded to 29 letters. It exists on stone, and many of these examples can be seen in volume 4 of *Corpus Inscriptionum Semiticarum*. We are not privileged to see any of the pen writing because it did not endure, but there are hints of it on the stones. But if inscription letters tend to be stiff, South Arabic makes the most of it. This can be seen in the Louvre example of Figure 435. Given the texture of stone, the angular letters can be quite pleasing. In Figure 436 the sculptor has cut away the ground and left the letters in relief, a rather unique approach.

Considering the fact that the kingdoms of southern Arabia were trading centers, it is a curious truth that the

436. South Arabic writing on stone. *Corpus Inscriptionum Semiticarum.*

script did not move from its home base. Some inscriptions have been found in northern Arabia, and it did cross the Dead Sea into neighboring Africa. This development led to the rise of Ethiopic scripts, which remain today. All of the other South Arabic alphabets dissolved with the civilization.

Ethiopic scripts, written from left to right under Greek influence, were remarkably conservative. To this day, formal pen writing and typefaces reflect the vertical orientation of the inscriptions just seen. The example of Figure 437 dates from the seventeenth century. There are times when truth must be brusque, and here it is obvious that Ethiopic is one of the strangest pen hands of all time.

437. Ethiopic writing. Vatican Library, Vatican City.

435. South Arabic inscription. Louvre, Paris.

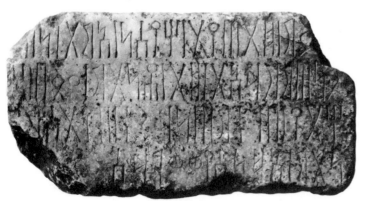

310 *Writing: A World Art*

438. A Kharosthi Inscription from Turkestan. *Kharosthi Inscriptions.*

THE WRITING OF INDIA

India is a multilingual country. Perhaps no geographical or political entity has ever enjoyed or suffered a greater proliferation of the spoken tongue. In Britain, after the conquest of 1066, Latin, Anglo-Saxon, and French were competing tongues in the principal centers of the islands, but there were many speakers in Ireland, Wales, and Scotland who understood none of these languages. The fusion of languages that we call English became the dominant language, and speakers of older tongues were forced to become bilingual, although it is said that there are still a few who do not speak English. By sheer weight of number of speakers, English became the principal tongue in the United States. Early Spanish-speaking peoples have given us a flavored group of words like *palaver, calaboose, pinto, vamoose, padre,* and *coyote,* to mention a few. But these Spanish speakers, too, had to learn English. Waves of immigration brought Germans, Irish, Italians, Jews, Swedes, Poles, Norwegians, Czechs, Armenians, Greeks, and Basques to the States; and all of these bands left their marks in bilingual settlements, now in decline. Perhaps the largest group of foreign speakers in the United States was that which used Yiddish, a composite language used by the Jewish population of central Europe. Speakers of Yiddish congregated in New York and other large metropolitan centers, where a generation ago the number of speakers was well over two million. A familiarity with Yiddish terms, rich in sound and colorful in meaning, is found in the large city centers, and in the show-business milieu of the last fifty years. Yiddish speakers decline in numbers yearly, a fact deplored by many.

Ancient History

In India there is no dominating tongue to swallow immigrant speech. There are in India 14 principal languages, not counting English. A linguistic survey of India shows 179 languages stemming from these 14, with 544 dialects.

A villager in India can get on a train, travel for a few hours, and find himself in an area with speech so foreign that he must find a bilingual interpreter to help him out.

One of the principal splits in Indian languages goes back into history. In the second millennium B.C. Indo-Aryan peoples related to the Hittites, Medes, and Persians moved through mountain passes into India. These tall, fair-skinned peoples met the shorter and darker native Dravidians in the central part of the subcontinent and drove the latter south. Thus the invaders from the north established roots for ten of the principal languages of India, while four have their basis in the Dravidian civilization. The northern tongues of India are Assamese, Bengali, Gujarati, Hindi, Kashmiri, Marathi, Oriya, Punjabi, Sanskrit, and Urdu. In number of speakers Hindi leads, with at least 165 million, and Bengali is used by 85 millions. Some odd notes: paired languages, closely related, may have an east-west geographical division; Urdu, a variation of Hindi, is used by Moslems who use Arabic signs and write from right to left; Pakistanis, separated politically from India after Britain's rule ended in 1947, are separated geographically with a linguistic split, Urdu being used in West Pakistan and Bengali in East Pakistan. Ghandi spoke Gujarati.

Indic writing first appeared in the third century B.C., during the reign of Asoka (272–231 B.C.). Leader of a great empire, Asoka turned away from his success in military endeavors to embrace the arts and religion. In his reign, Asoka's edicts were committed to stone. These are stiff and angular in outward form but furnish a valuable inference of literacy for the area and period. Following the Asoka inscriptions two forms appear, Kharosthi and Brahmi. Kharosthi was used in the northwestern regions of India from the third century B.C. to the fourth century of the Christian era and in central Asia until the eighth century. An example of this writing is seen in Figure 438, discovered by the first Stein expedition into Chinese Turkestan and published in *Kharosthi Inscriptions* (Oxford,

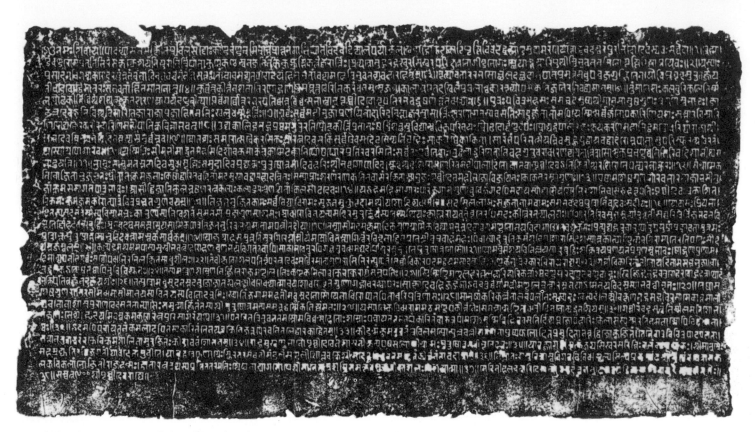

439. A Sanskrit inscription. *Epigraphia Indica*, Government of India Press, Calcutta.

1929). Although the language is not central to later developments in India, the script, or vehicle for the language, exhibits some interesting features. It is pen-written on wood, oriented in direction from right to left, and shows a closer affiliation to Aramaic scripts than to other Indic writings. It is assumed that variations of the Aramaic signs and method reached India through trade routes. Of these Semitic origins the languages and scripts of India show scarcely a trace today, and many well-educated Indians believe that writing was an indigenous development. Figure 438 shows a considerable flair with the pen, and Ahmad Hasam Dani, a respected authority, assures us that the base culture gave honor and respect to the art of writing.

Sanskrit and Devanagari

Sanskrit is the name given to the ancient classical Indo-European language of India. By the fifth century B.C. it was the literary tongue of learned people and of a religious hierarchy. The four sacred books of the Brahman religion, the Vedas, are preserved in Sanskrit. Scholars polished and preserved the language and implemented its sounds with a highly sophisticated set of vowel signs appended to consonant signs. There were 35 consonantal signs, aided by 14 vocalic signs. Sanskrit gradually gave way to vernacular speech, and after A.D. 1000 it became a second tongue of the learned, in the same way that Latin became the second tongue of the learned in areas associated with France, Italy, Spain, and so on. Knowledge of Sanskrit is thinly spread over India today, but this knowledge serves to hold the Indian languages together.

Sanskrit as a language has been rendered through a variety of scripts or alphabetic forms, but it is most closely associated with a script called Devanagari. The forms of Devanagari are seen in the inscription style in Figure 439, dating from the twelfth century. It was originally incised in stone, and what we see here is an ink rubbing taken from the surface, a procedure that reverses values. Letters in the original are about ½ inch in height. In form, the letters reflect two arts: the stiff method of the stone-cutter balanced by curves from pen letters. It is obviously an excellent form for inscriptions because the vertical and horizontal strokes give the piece a quality of dignity, while the curves keep it alive visually.

Pen letters using Devanagari forms and expressing Sanskrit authorship are observed in Figure 440, a page

from a sixteenth-century manuscript in the Freer Gallery in Washington, D.C. The pen is cut wide at the tip and the letters are crowded; but it appears that individual differences in the letters are preserved more carefully than in the black letter of northern Europe. The basic alphabet consists of almost fifty unique signs, and ligatures of consonant and vowel add to this total. If this seems excessive, it should be remembered that the experimental alphabet used in England to teach the elementary grades needed 44 signs to express the sounds heard in common speech. Pens used for this memorable script are canted, or skewed, at the nib as seen from the top; the left corner is high, with the right corner lower. Perhaps a 20-degree angle would suffice. Some of the larger type houses have converted the Devanagari script to types. Because of the architectural qualities inherent in the script—a constant repetition of vertical and horizontal strokes—careful design in type seems to preserve some of the essential qualities traditional in pen-written and inscribed versions. One of these faces can be seen in the large catalog produced by the Mergenthaler Linotype Company. In England the Monotype Corporation furnishes an excellent version of Devanagari.

Our next presentation, Figure 441, is that of a few lines of Sanskrit poetry written by an Indian teaching in a college in the eastern part of the United States. This was executed in rapid manner to demonstrate that the Devanagari script is not always a matter of strict interpretation. The indentation on the left reveals that the lines are written from left to right. Our calligrapher's pen did not have a metal well for holding ink, and his dipped pen ran out of ink quite rapidly. Thus it is evident that the strokes in the horizontal line are made from left to right, and in each character this horizontal stroke is the first to be executed. This offhand version exhibits only a few pen lifts, and the use of the reed pen usually requires more than seen here. Otherwise the writer is often going against the "grain" of the pen. The novice is reminded here that when working with a reed pen, the number of lifts depends on the surface. On smooth paper or carefully prepared skin surfaces a writer can avoid pen lifts; but if the surface is a "toothed" paper (which is the case in Fig. 441), it is difficult to push the pen against the rough surface. Carefully prepared quill pens, steel pens, or fountain pens can reduce the number of pen lifts. This means that the nib must be carefully honed on the corners to reduce the incidence of friction with a rough writing surface. This aside, the number of pen lifts is also a matter of individual preference. In personal handwritten letters some individuals use more pen lifts than others.

Other Indian Scripts

Our next example, Figure 442, exhibits another script of northern India, a Brahma-kanda translated into Assamese. It was executed in 1836 and now resides in the British Museum. Assamese is spoken in the northeast section of India, and the number of speakers—at least six million—would in most countries be a very substantial portion of the population. In view of India's population, the speakers of Assamese are a small number. A family relationship with Devanagari can be seen in Figure 442, with signs hanging from a top line. There is an obvious curving of the strokes, and the pen is cut finer at the nib, which gives a more monoline content.

440. Page from the *Story of Kālaka*. Freer Gallery, Washington, D.C.

441. An informal example of Sanskrit writing showing how the top line may become continuous. Author's collection.

442. An Assamese document; the original is almost four times this size. British Museum, London.

443. South India script, 8th century. *Epigraphia Indica*, Government of India Press, Calcutta.

There are four principal languages spoken in southern India, in an ancient division of that country along cultural and ethnic lines. The languages associated with the Dravidians are Kanarese, Malayam, Tamil, and Telegu. The number of speakers does not compare with the number using Hindi or Bengali but is large nonetheless. Speakers of Tamil number at least 18 million.

An ancestor of the modern Kanarese and Telegu scripts is seen in Figure 443. This example, a rubbing, dates from the eighth century and was incised in copper. The decorative qualities of the script are obvious enough. Of course this commentary does not include any of the technical matters in regard to the basic differences in Indian languages. In visual qualities the southern alphabets differ from the northern in two important respects: the horizontal line is omitted, and the characters feature more curves and loops.

In Figure 444 we observe a Sinhalese manuscript from the island of Ceylon. An Indo-Aryan migration to Ceylon occurred in the fifth century B.C., and the language shows northern roots but has been heavily influenced by the Dravidian peoples living on the island. Some of these speak Tamil and employ the Tamil script. Ceylon became converted to Buddhism in the third century B.C., and this event has been of paramount influence in the literature of the island. Figure 444 is a Buddhist document.

In outward form the script is typical of the writings from southern India and southwest Asia, full of curved

forms and contrasting sharply with the majestic strokes of the Devanagari already seen. The method of bookmaking is ancient and prevalent in this part of Asia. In the present example the writing is executed on strips cut from palm leaves. In the book from which it is taken the leaf measures 22½ inches in width and 2½ inches in height. Surfaces are very thin, stiff, flexible, and smooth, as the fine penwork demonstrates. There are some four hundred leaves in the book of Figure 444, and both sides of the leaves are used for writing. Each side, or page, would yield about 56 square inches, or a western format of 8 by 7 inches. As can be observed, a great many characters can be crowded into the space of one leaf, so the document is lengthy in terms of reading time. With illuminated wooden covers our example is 6½ inches thick. Two holes were made in all the leaves and the wooden covers and were used to hold the "book" together. This method of bookmaking remained important in the area after the introduction of paper and can be compared to the importance of papyrus in the Middle East and Europe. Like papyrus, the leaves darken with age. Reproduction of older specimens presents very formidable problems.

The Brahmi writing of the Asoka period eventually influenced writing in eastern Turkestan, Burma, Siam, Cambodia, Bali, and central Sumatra. Modern scripts in these areas are associated with the languages and scripts of southern India. In Figure 445 we observe a Burmese document originally executed in 1858 with gold on ivory. The script, expressing Pali, the ancient language of Buddhist literature, accentuates the curved forms of southern India. Many pen-written documents emanating from the area seem to be written entirely in a series of circular forms, most curious to the uninitiated.

A Sample from Tibet

The writing seen in Figure 446 is Tibetan and is part of a pen-script title used in a contemporary dictionary. In terms of language, Tibetan is not intimately connected to the languages of India; but cultural connections led to the use of an Indian script for Tibetan literature in the

Below: 444. Sinhalese document. Rare Book Room, University of Wisconsin.

Bottom: 445. Burmese Writing. British Museum, London.

446. Author's copy of Tibetan writing.

seventh century. Speakers of Tibetan are quite few, but Tibetan religious centers have served as bastions of learning for many centuries. Tibetans are excellent calligraphers, as the example of Figure 446 demonstrates. The example is described as being "with head" and maintains a square geometry along the top line. This style is used as a formal script. A "headless" version is used for ordinary purposes, while a special decorated script is used for documents of prestige.

With the proliferation of scripts suggested here, it is obvious that other sources are needed for a full review. But it is interesting to note that the idea of the alphabet swept across southern Asia and might have spanned the Pacific from west to east if the inhabitants had not run out of land. In more recent times Russians have brought their version of the alphabet to Alaska.

Poem by Emperor Hui-tsung. National Palace Museum, Tǎi-chung.

Chapter 16 Chinese Calligraphy

Many of the ancient writings of the Near East baffled generations of scholars. Where connections, between living languages and ancient signs had been cut there seemed few clues, and many distinguished teachers tried in vain to penetrate the veil for one. Often a brilliant guess would bring out the name of a town or ruler. The scholar would publish his results, and a dozen colleagues in various countries would retreat to their studies and try again. Dramatic successes in decipherment, the stuff we like to read about, were etched against a background of bleak failure for many involved in the pursuit of ancient languages and scripts. In contrast, ancient Chinese writing did not have to be deciphered. A living language with an unparalleled continuity, Chinese needed only a reinterpretation as scholars traced the changes in signs backward in time.

Chinese writing made its appearance in the middle part of the second millennium B.C., during the Shang dynasty (1765–1123 B.C.). The earliest records were incised on bones of animals, such as the scapulae of cattle, deer skulls, or on the breastplates of tortoises. These "oracle" bones, of which some hundred thousand have been discovered, are identified with any number of subjects, such as births, deaths, hunting expeditions, and the like; most of them, however, deal with ancestor worship and enterprises needing the intervention of the divinity. The vocabulary of the Shang writers has been estimated at twenty-five hundred words. It was at this time that the principles of Chinese writing were established. Signs exhibited abstractions of parts of the human body, animals, and objects, and some of these had already become unrecognizeable to the uninitiated. Word signs were combined to form new meanings, as in the case where the signs for *broom* and *girl* meant 'matron' or 'lady.' Phonetic signs were already used to qualify meanings. A wide river might be designated by the logogram for *water* followed by a sign for the sound of running water—a low-pitched sound. The same logogram might be followed by the sign for *Kung*, water flowing but higher in pitch, indicating a narrower stream. In Chinese there is no official syllabic system for spelling foreign names. I. J. Gelb points out that *Roosevelt* could be spelled *Lo* (practically a nickname or code) or put together with word signs of a close phonetic content, as in *Lo-ssu-fu*. A word like *telephone* can be pieced together with logograms and phonetic signs to read *te-li-feng,* but if the word persists in the language a new approach may be taken and *telephone* can be designated by signs meaning 'electricity talks.' With Greek and Latin prefixes and suffices we can piece together words such as *parliamentarianism*, a meaningless word. The Chinese, using what is essentially a monosyllabic system of communication, would no doubt find a simpler word.

The Chou dynasty succeeded the Shang dynasty in 1122 B.C. Dates for the earlier Western Chou period are 1122–771 B.C. At this latter date the capital was moved, and the Eastern Chou period terminated in 256 B.C. Artistic remnants of the Chou culture center around a technology for casting bronze, which technique leans heavily on skills with clay. Three of the Chou bronzes, all utensils, are magnificent works of art. One basin is 25 inches in diameter; a large bell is 27½ inches in height. While most of the Chou bronzes possess inscription writings of modest length, one huge three-legged vessel contains an inscription of 497 characters. Figure 15 showed writing taken from an early Western Chou bronze. This writing dates from the eleventh century B.C.

and already seems to possess a kind of calligraphic elegance. It cannot be said that this single reproduction represents the state of letter production for the time. Some of the inscriptions take on a very geometric form. It was a period of experimentation in written forms, undertaken in a period of political experimentation and fragmentation. In writing, this period of experimentation is confirmed by scholars who have counted 49 different configurations for *yang*, the sign for sheep.

A sharply increasing vocabulary augmented the problem, and one court historian who lived in the reign of Emperor Hsuan (827–788 B.C.) made an attempt to codify existing signs into a standard set of nine thousand characters. The effort proved unsuccessful but is remembered by the term *chou wen.* The diversification of method in writing in the Shang and Chou periods is reflected in the engraved process of the oracle bones, the relief and engraved processes of the bronzes, and the engraved manner of early "stone drum" inscriptions. Engravings in stone became a tradition in Chinese writing that continues to the present day.

Political unity came to the Chinese peoples in 221 B.C. with the short-lived Ch'in dynasty. The first emperor ordered a reform of written forms, and his prime minister Li Ssū worked out the first set of signs that helped unify the method of Chinese writing. The writing that appears before the time of Li Ssū is categorized by the title *ta chuan* and his reform characters are referred to as *hsiao chuan*, sometimes previously called "small seal style" or "lesser seal style." Of the stone inscriptions commemorating the deeds of Shih Huang Ti, the first Ch'in emperor, only two survive, and these are reported to be in a very poor condition. In the tenth century a man named Hsu Hsuan made a study of Ch'in writings and executed a copy of one of the tablets in wood. This memorial is called *I Shan Pei* after the I mountain in Shantung province. The copy is generally respected as capturing the essence of Li Ssū's reform characters, and a part of this work is reproduced in Figure 447. In graphic form the script is a monoline version, holding cursive forms into an imaginary square and imposing a symmetry of content wherever possible. Apparently this discipline has been central to the control of Chinese writing in terms of letter arrangement in the subsequent centuries. Chinese writings are read beginning at the top right character and working down the column, with the eye shifting up and to the left to catch the first character in the next line.

In relation to Western books, Chinese introductory material is found, as in books in Hebrew, at the back, and the conclusive signs, indicating authorship and ownership, equivalent to the Western colophon, or signature,

447. Copy of *I Shan Pei*. Chiang Yee,
Chinese Calligraphy.

appear at the lower left in any body of Chinese writing. These geometric signs of authorship, contrasting in form with familiar brush calligraphy, are derived from ancient inscription signs like the *hsiao chuan*. They are executed in relief, charged with ink, and stamped into the design.

The disciplined inscription forms thus live on in Chinese writing traditions. Moreover, many contemporary Chinese calligraphers practice the ancient letters in much the same way that we study Latin uncial. In either case, the purpose is twofold: to understand the past and to become complete calligraphers.

LI SHU

While the *hsiao chuan* script, backed by a powerful central government, is believed to have been helpful in the codification of Chinese signs, its stiff inscription style could not cope with the increasing flow of paper work produced by the Ch'in bureaucracy. A faster script was needed. Chinese writers ascribe the formation of a new script to

one Ch'êng Miao. For some unrecorded offense, this citizen languished in jail for ten years and during the time experimented with a new set of characters for writing. Emperor Shih Huang Ti is said to have been pleased with the script, and Ch'êng Miao was released from jail and rewarded with a civil service position as censor. The new script, called *li shu*, contained about three thousand characters and was executed with a brush. The sinuous curves seen in *hsiao chuan* were reinterpreted into a system of vertical, horizontal, and angular brush strokes, which are the basis of Chinese writing. *Li shu* was adopted as the clerical method of this dynasty, while *hsiao chuan* was reserved for more formal documents.

BRUSHES AND PIGMENTS

The brush has been the principal tool of Chinese writing, and its use goes back to the Shang dynasty and the times of the bone and shell scripts. Chinese historians record that the brush was invented by a contemporary of Li Ssū, but modern archeological discoveries have proved them in error. A pottery fragment found among oracle bones has brush marks on it, and in 1954 a grave dating from the Period of the Warring States (468–221 B.C.) produced a brush. It is now believed that brush writing and brush drawing were fairly prevalent in the centuries preceding Ch'êng Miao and his *li shu* script. Although experiments were made in utilizing reeds and bamboo for writing purposes, the true Chinese writing brush is made of hairs and is always pointed. A dozen different animals have loaned their hair to the brushmaker's craft. Brushes made of the hair of rabbit, deer, and goat appeared in the Han dynasty (succeeding Ch'in). Some brushes were made with an inner part or core of rabbit or deer hair and an outer layer of hair from goats. One scholar listed 36 different varieties of brushes that could be identified according to the materials used. As one might guess, brushmakers have been highly respected artisans in the history of Chinese calligraphy, and the care and handling of brushes has given rise to a considerable body of commentary. A book published in 1966, *Chinese Calligraphers and Their Art* by Ch'en Chih-mai, highly recommended for its rich text and fine reproductions, contains a good essay on brushes. In this splendid production the author states that refinements in the art of brushmaking included making brushes from the whiskers of mice.

To continue with technical matters, some kind of black ink was probably used in the Shang dynasty, and a red pigment made of cinnabar appeared early. Soot or lampblack was no doubt concomitant with the earliest stages of Chinese writing, since it is a natural product of fire. Pine

wood was used as a source for this pigment by the end of the second century A.D., and ink sticks (pigment with a binder) were developed in the second or third century.

Writings on silk go back as far as 700 B.C.; but most of the important technical work that made silk an important carrier of Chinese calligraphy began in the Han dynasty.

THE ORIGINS OF PAPER

Papermaking, a Chinese development, resulted in a major vehicle for Chinese brush writing. It is well known that the development of the craft of papermaking is not only central to the dissemination of Chinese literature through brilliant calligraphers, but is of prime importance in the communication arts of Western civilization. A few notes on this are appropriate. Expeditions in the twentieth century have uncovered some outstanding collections of paper manuscripts. The second Stein expedition discovered the largest collection in 1907 at Tun-huang, a town established toward the end of the first century A.D. on the northwestern frontier of China. At this site, in a sealed library, the Stein expedition discovered over twenty thousand manuscripts in paper rolls, many of which were in a perfect state of preservation. Most of the manuscripts were in Chinese, but some were in Sogdian (Fig. 431), Sanskrit, and Tibetan, with a sprinkling of other scripts of central Asia. One book of selections from the Old Testament was executed in Hebrew. This massive collection is now divided among several museums and a number of private collections. The British Museum acquired some seven thousand rolls dating between A.D. 406 and 995. Later efforts obtained three thousand rolls for the Bibliothèque Nationale in Paris, while the Chinese library in Peking received almost ten thousand rolls. Most of the solid evidence about Chinese papermaking stems from these discoveries and from collections of original manuscripts. In the years when knowledge of the Semitic alphabet was moving east along trade routes, knowledge of papermaking sifted westward along the same trails. The Arabs picked up the art and introduced it in Europe, where it provided the principal writing surface, crowding out the use of skins in the late Middle Ages. In Renaissance times only the wealthy could sponsor literature written on skins, and printing on vellum is rare. The process of papermaking is a subject of renewed interest in colleges and universities today, and no doubt printers and printmakers will make more use of original handmade papers in years to come.

Paper is assumed to have been developed after A.D. 100. The exact method of early papermaking is still in doubt, but early papers seem to be made up of raw vegetable fibers and rags. Raw fibers used were those of mulberry, laurel, and China grass mixed with rag fibers made from flax and hemp. Some early papers contained the remains of old fish nets and tree bark, and many other plant fibers were tried. The British Museum's collection of papers contains sixty examples from the early centuries of papermaking, each with a different composition. Contemporary Chinese papermakers furnish any number of beautiful papers with elegant textures provided by remnants of vegetation. Western artists sometimes purchase these papers and then wonder what to do with them. Some papers contain exotic entities like butterflies, and these are indeed curious and challenging. The practice of sizing, or saturating paper with a mild vegetable glue plus a starchy material like rice flour, began in the T'ang dynasty (A.D. 618–906). With the perfecting of this process papers could be thin, smooth, even of texture and color, and receptive to the brush-stroked sign.

BRUSH WRITING

The great art of brush writing came to eminence in China during the Han dynasty, which succeeded the Ch'in. Dates of the Han dynasty are these: Western Han, or Former Han, 206 B.C. to A.D. 23; Eastern Han, or Later Han, A.D. 25–220. One of the monuments of this period is the great inscription of Confucian classics. A part of this inscription is seen in Figure 448, a rubbing from one of the remaining fragments. Confucius (551–479 B.C.), one of the great innovators in Chinese thought and culture, gave rise to a large body of literature. In 213 B.C., Li Ssŭ suggested that earlier literature be burned in order to ensure the supremacy of the edicts and pronouncements of the Ch'in dictatorship. Many documents were destroyed by this act of censorship, and others were destroyed in the peasant revolution of A.D. 206, when the imperial palaces were burned. Scholarship and writing were on the increase throughout the Han dynasty, and Confucianism was recognized as state doctrine in the second century of our era. A new edition of Confucian classics was completed in A.D. 175; the books were committed to stone during the next eight years by a legion of specially trained carvers. The example in Figure 448 represents a part of one stone out of some 46. It is believed that the seven classics of Confucian learning contained about two hundred thousand characters.

No one now believes that the brush-drawn calligraphic models were the work of one man; they are assumed to be by a team or succession of calligraphers expressing the *li shu* script of the time. The particular version of *li shu* we have just seen is termed *pa-fên*, the formal script of the

448. Han brush calligraphy as copied in stone.
Ta-lu tsa-chih, Vol. X, No. 5.

Eastern Han, or Later Han, dynasty. Celebrated calligraphers begin to appear by name in this era. Ts'ai Yung, a specialist in the *pa-fên,* is also credited with a personal style of writing accomplished by dragging the brush over the surface at high speed and thus creating strokes streaked with the white of the paper. The Chinese call this *fei po,* or "flying white." Other individual styles were also extant, as can be seen by the historical record of Figure 449. Chinese records contained few examples of Han brush writing until the modern scientific expeditions of Stein, P. K. Koslov, and the Sino-Swedish expedition headed by Sven Hedin. Hedin's group discovered the largest single collection of Han documents in 1930. The discoveries were so numerous that even today no complete commentary on the scripts used in them is available. That seen in Figure 449 was uncovered by Stein's group and is part of a group of 77 tablets connected by hemp string. Recorded on them is an inventory of weapons. They were executed in the years A.D. 93–95, and make up the first complete Chinese "book" in existence. Of the thousands of Han records discovered in this century, most are written on bamboo or wooden strips, principal vehicles for writing before the development of

paper and the perfecting of silk. Many Han "slips" show a cultivated hand, clear enough to be read by contemporary Chinese two thousand years after their execution. The example in Figure 449 shows the vigor and spirit inherent in the Chinese calligraphic tradition, although it was not written by a professional. The formal *li shu* script of Later Han is deliberate and elegant, but the period is noted for its bold inventiveness, which laid the basis for the creative brush scripts that were to follow.

The most revered genius of Chinese writing is Wang Hsi-chih (A.D. 307–365). His stature has been compared to that of Michelangelo, Beethoven, and Shakespeare. Wang Hsi-chih came from a distinguished family. His father was an official in the lively Tsin dynasty (A.D. 265–419) and a calligrapher. Two uncles of this aristocratic family were also skilled writers. The young Wang Hsi-chih was tutored for a time by a lady named Wei Fu-jên, who came from a long line of calligraphers. For a time the youth emulated the writing style of the tutor but later mastered *hsiao chuan, li shu,* and contemporary variations, in a model of Chinese practice—mastering older styles. This

449. List of weapons, c. A.D. 94. *Academia Sinica.*

Left: 450. Writing by Chung Yu admired by Wang Hsi-chi. Collection of Tai Liang-mo, Peking.

Right: 451. An original by Wang Hsi-chih. Ch'en Chih-mai, *Chinese Calligraphers and Their Arts.*

fits the Chinese pattern of veneration of traditions but also serves to teach mastery of the brush. One of the calligraphers most admired by the mature Wang Hsi-chih was a statesman and scholar named Chung Yu (A.D.151–230), one of the line of rulers in the Later Han period. An example of writing attributed to Chung Yu is seen in Figure 450. The stone from which the rubbing was taken is quite worn and therefore some of the original quality of the piece is lost. Chung Yu was master of the *chên shu* script, which has been described as possessing a fine balance between strength and pliability. An original by Wang Hsi-chih follows in Figure 451, executed in small *chên shu* in A.D. 348. The full work was intended as a model for sons in the family. The works of Wang Hsi-chih have served as writing models for generations of calligraphers up to the present time. The short strokes are not mere blobs but show a subtlety of contour much admired by later calligraphers.

Strokes and Composition

Although there have been historical exceptions, most Chinese calligraphers hold the brush in a vertical position, so that it is free to move in any direction. The thumb is held vertically in alignment with the brush, and the fingers curl around the other side. One writer explains it this way: "Empty the fist, make the fingers firm, level the wrist, keep the brush upright." While a great majority of the strokes are made in a downward direction, some require an initial upward movement, resulting in a hook or blob. A manual of eight basic strokes is familiar in Chinese annals. This goes back to Wang Hsi-chih, who is said to have propounded the theory that the eight strokes in the character *yung* (meaning perpetual) were basic to the creation of all the characters in the standard script, *chên shu.* In Figure 452 we see a filled-in drawing of the character *yung*, the first word in Wang Hsi-chih's spon-

taneous masterpiece of calligraphy, *Lan T'ing Hsü*, the most celebrated masterpiece of Chinese calligraphy. The original is lost. The desperate search for it is related in Ch'en Chih-mai's recent book *Chinese Calligraphers and Their Art*, published by the Melbourne Press. There are at least 117 extant copies of the document, the best of which are by noted calligraphers who copied the original.

The eight strokes embodied in Figure 452 involve certain difficulties that must remain with scholars of Chinese calligraphy. In the past and today many more brush strokes are needed to delineate the numerous characters found in Chinese writing.

In terms of composition, Chinese characters are executed within an imaginary square. As regards number of strokes involved, the pictographic Chinese scripts exceed the number of strokes used in Latin uncial and derivatives, and in Hebrew, Devanagari, and Arabic.

Judging from the measured and stately documents from the Han dynasty, it would seem that Chinese calligraphers recognized that if certain rules were not followed, the brush, which was used in painting as well, could run wild. A useful device, that of dividing the square into nine equal and smaller squares, seems to stem from calligraphers of the T'ang dynasty (A.D. 618–906). Yen Chên-ch'ing (709–785) was one of four great calligraphers associated with T'ang calligraphy, and he is considered to be the most widely respected of all. His work was marked by a personal style of strength and power held in bounds. In Figure 453 a contemporary teacher has selected

453. Characters from Yen Chên-ch'ing, *Yên t'i cĥeng k'ai lin mu tzu t'ieh.*

452. Author's sketch from woodcuts attempting to reproduce Wang Hsi-chih's feathered terminals.

characters from the writings of Yen Chên-ch'ing to demonstrate how the master used certain basic strokes. In Chinese writing there are two fundamental strokes, which travel from upper left to lower right. The strokes have been interpreted in many ways, of course, but on the left we see the standard stroke and on the right the flatter version, or "swimming fish." In the example of Figure 453 Yen Chên-ch'ing's characters are fitted to the nine-square system, purporting to show that the master's script followed this plan of composition.

To Western viewers Chinese writing is an elegant form of brush art without much sense. Certainly our system of serifs, initial and terminal strokes, would be difficult to explain to an Oriental calligrapher. But Chinese characters can obviously be broken down into a number of specific strokes. Ch'en Chih-mai's recommended book gives a summary of a 32-stroke method initiated by Fêng Wu in the Ch'ing dynasty (A.D. 1644–1911). No doubt

individual teachers or schools would insist on more or different characters or perhaps on both, since teaching methods vary.

Another honored calligrapher was Chao Mêng-fu (1254–1322). This artist, a descendant in a line of emperors of the Sung dynasty (A.D. 960–1276), was caught in the Mongol invasion that inaugurated the Yuan dynasty (1277–1367). Chao Mêng-fu was a sensitive intellectual of great talent. When Kublai Khan's Mongol army finally subdued the last followers of the house of Sung, Chao Mêng-fu was thrown out of his job and spent a ten-year period of privation. A young man at this time of change, he finally accepted a position as court calligrapher in the new regime, when many of his friends chose the honor of oblivion. A collaborator in the modern sense of the term, Chao Mêng-fu turned to the Buddhist religion and a fabulous career of hard work. He is said to have created ten thousand characters in a day, in a career that remained alive until his last years, terminating at the age of sixty-eight. Honored in his own time, Chao Mêng-fu's contribution has been revered by the Chinese for his devotion to antiquity and the sinuous grace he imparted to the art of calligraphy. In Figure 454 we see a number of selected characters from the writings of Chao Mêng-fu, taken from

454. Characters from Chao Mêng-fu, *Chao Mêng-fu shu Miao-yen ssŭ chi.*

a contemporary writing manual. In Chinese tradition, many classic examples of writing, admired for literary content, calligraphic excellence, or both, were and are incised in stone. In the process of transfer something is undoubtedly lost, not because of any intent on the part of the stonecutters, who seem to have been exceedingly skillful, but because carvers cannot interpret all the subtleties seen in the encounter between the brush and paper. Rubbings reverse the original pen-written values in terms of black and white, and in Figure 454 these are reversed again to obtain a black sign. But Chinese calligraphers insist that strokes must have "bones," and this quality comes across in Figure 454. The reader will notice a series of four dots in the center top character. They are seen again in the left column, next to the bottom square. When Chinese readers see a sequence of four dots it is assumed that the character has some connection with the word *fire*. A series of identical round dots would suffice to communicate meaning, but Chinese calligraphic traditions insist that the four dots be executed with a degree of finesse. The dot on the left should be executed with an upward stroke, the two middle strokes should show a peak to the right, with the right dot exhibiting a downward inflection. And notice the character in the lower left square. Our calligrapher is faced with ten horizontal strokes as he completes the figure, and see how beautifully he descends, giving each stroke its own life. A careful scrutiny of the characters will show how the Chinese calligraphers obey the rules and create something unique at the same time.

Important Calligraphers

In order to pick up developing styles we go back to the T'ang dynasty. The T'ang court was said to be gay and lively, featuring spirited performances by painters, musicians, and dancers. Important figures in calligraphy—Yen Chên-ch'ing, Ou-yang Hsün, Ch'u Shui-liang, and Liu Kung-ch'üan—stood to the side of exciting new developments in the arts. Steeped in Confucian doctrine, these great men generally followed a practice of developing elegance in a conservative tradition in the formation of letters. A manuscript by Ch'u Shui-liang shows a clarity and delicacy that is almost too fragile to live.

But there were other kinds of people practicing calligraphy in the T'ang period. Earlier practice had produced a style called *hsing shu*, which was a compromise between the *li shu* of the Han period and later cursive writing. In *hsing shu* the brush is given considerable liberty, strokes are rounded, and the number of lifts is reduced. The cursive tendencies increase in a style called *ts'ao shu*, and characters may be written with great rapidity and be

455. Writing by Huai-su. Palace Museum, Peking.

models of Yen Chên-ch'ing of the T'ang era. Yet it is an elegant piece of calligraphy.

It is hoped that this brief look at the Chinese tradition in writing will encourage a few beginners to pursue the art. Our institutions of higher learning offer an increasing range in Far Eastern studies, and the areas of science attract larger numbers of Chinese-speaking people as time proceeds. The chances of discovering a person able to demonstrate some phase of the Chinese writing arts is better than fair.

456. Writing attributed to Ch'ien Lung. Author's collection.

connected. As in Roman cursive, exuberant Chinese writers often exceeded the legibility limit and were condemned and admired on separate counts. The wild calligraphy of the T'ang dynasty has been credited to two "drunken geniuses," Chang Hsü and Huai-su. Chang Hsü was frequently inspired by strong drink and often wrote while in that condition. The all-out flying brush, executed with the greatest speed possible, is called *k'uang ts'ao* by the Chinese. Huai-su, a Buddhist monk, was devoted to the major art of calligraphy and the minor art of drinking. For a time he studied with Chang Hsü and shared his teacher's defect of writing while under the influence. A charming line in *Chinese Calligraphers and Their Art* describes the calligrapher as appearing to write as if he were watching "the sudden outbreak of a violent storm when birds fly out of the woods and the startled serpent seeks shelter in tall grass." We see an example of the gifted monk's writing in Figure 455.

Cursive writing is thus an integral part of the Chinese tradition, as it is in the West, and seems equally vulnerable to criticism. It is admired when well done, but beginning students must learn the more conservative *li shu*, or clerical, style before attempting the others.

It is certainly permissible to leave terminology to those more expert and admire Chinese calligraphy on its merits as graphic endeavor that delights the visual sense. The example in Figure 456 is attributed to Ch'ien Lung, an eighteenth-century emperor in the Ch'ing dynasty, which preceded the modern Republic of China, dating from 1912. Emperor Ch'ien Lung is not an admired figure, and critics point out that his writing falls short of the

Chinese Calligraphy 325

A LOOK AT JAPANESE CALLIGRAPHY

Expert calligraphy is also much admired in Japan, where the technical approach shows a family relationship with the calligraphy of China. Indeed the styles of Japanese writing are derived from the Chinese, but through the years Japanese calligraphers have developed different ways of handling certain strokes. The brush skills required in Japanese calligraphy are quite imposing.

Japanese is not a logographic language but syllabic in nature, and the phonetic pattern of Japanese is quite unrelated to Chinese. The basic set of syllables numbers fifty, and while the total number of characters for all purposes is several hundred, with perhaps a hundred used in newspaper composition, obviously the Japanese writer has fewer characters to learn than a Chinese writer. If our minuscule and capitals are considered as separate graphic entities, then the Japanese learn only a few more signs than we do in the West.

Many peoples in the Far East drew on Chinese characters for signs expressing different qualities of speech. The Japanese may have borrowed the Chinese signs as early as the fourth century A.D., but the first known example of Japanese writing dates 712 and is called the *kojiki*. Chinese characters were adapted to stand for the basic sounds in Japanese, but other native inventions were added. These developments were underway in the eighth and ninth centuries. To untrained eyes, early Japanese writing will look like Chinese except for certain curved forms used to indicate phonetic changes. The Japanese use two sets of signs, both derived from Chinese scripts. *Hirigana* developed out of the Chinese cursive *ts'ao shu*. A separate development resulted in the *katakana*, a more angular script taken from the formal *chên shu* writing of the mainland. The forms of *hirigana* are those in general usage, while *katakana* is employed in spelling foreign words.

Many Japanese calligraphers of the early periods of Japanese writing were trained to write in Chinese. This is seen in Figure 457, a Buddhist document called a *sutra*, always written in Chinese. Our excerpt is taken from a long scroll about 23 feet wide. The writing surface consists of 15 sheets of hemp paper. Scribes who copied the work were employed in a *sutra* copying bureau and executed the writing in A.D. 734. It is considered a national treasure. In style the writing seems to stem from the Han period, but certain initial and ending strokes differ, and it would seem that there are departures from the strict Chinese code of permissible strokes. But we must leave these matters to better judgments before this commentary is condemned by both Chinese and Japanese callig-

457. A sutra in Chinese. Nezu Art Museum, Tokyo.

raphers. Perhaps it is safe to say that the script is crisp and incisive.

In Figure 458 we observe the hand of Daitó Kokushi, a highly honored Zen priest who traveled and studied in a wide area. In this case our example, in Chinese, was executed on silk in 1322. The brush work is indeed impressive. Critical commentary on calligraphic specimens originating in China and Japan sometimes equates calligraphic quality with personal characteristics. One respected Chinese writer makes this comment: "His writing shows him to have been a tall, thin, handsome figure." Western critics are less inclined to this form of analysis, relegating it to the status of phrenology yet wondering if there is not a hidden ounce of truth in it. The writing seen in Figure 458 is praised by a Japanese critic in this way:

458. Chinese writing by Daitô Kokushi. Nezu Art Museum, Tokyo.

459. Japanese cursive. Nezu Art Museum, Tokyo.

There is something peculiarly fine in his handwriting, the free, bold strokes of his brush so well expressing the versatility and resourcefulness of his mentality, while the whole is etherealized, as it were, by his high spiritual attainments—a perfect combination of polished art and refined spirit has found expression in his brush strokes.

Now when we consider the printed pages of Nicolas Jenson, which are not to be duplicated by any means known to man, perhaps our rhetoric of praise has been too thin.

The cursive tradition in Japanese writing is seen in Figure 459, dated around 1172 and typical of the poetry scripts of the period. This example was written by Fujiwara-no Toshinari in Japanese. Thus the basic Chinese characters used by the Japanese are written in a kind of shorthand cursive of a type already observed. Again the brush work shows a superlative skill in manipulation, which stands for pride in the calligrapher. The spontaneous qualities seen in Chinese and Japanese writings are truly the result of long and careful training, which eventually results in personal style.

CODA

When Arab speakers were turned back at Tours, France, in 732, Christianity was assured its future in the West. In such pivotal face-to-face encounters there is so much at stake that historians do not have the time to remind us that had Martel's soldiers failed, we might now be writing an Arabic script. And the vigorous and hungry Vikings of the North also had a hand in shaping the language and script patterns of the English-speaking peoples. In 911 Charles the Simple, king of France, gave Normandy to the Viking leader Rollo in exchange for Rollo's conversion. Rather than sacking the continent at random, the Vikings settled in to become French and furnished the spirit for new adventures, which led to the Norman invasion of England in 1066. Years later, when the swords and helmets were still rusting in the ground, the changes in language, implemented by foreign scribes walking on safe ground, began to penetrate to the level of country people, who had to learn a new word for eggs.

In contrast, the question of language and script in a given area was not always decided by armed might. Buddhist power resided in the persuasive qualities of individuals, and their efforts helped to shape the languages and scripts now used in southeast Asia. In another kind of peaceful exchange, a language or set of signs might travel along a trade route, as with Aramaic, with one camel driver teaching another.

Sometimes a language seems to travel via scripts of necessity, signs scratched quickly with little thought of elegance. But when a population of literate people has had sufficient time to develop a literature, the script usually exhibits a parallel sophistication and may reach a point of high art, as seen in the scripts that carry Arabic and Chinese. In these we see centuries of preparation, with the calligraphic artists struggling against the irons of legibility to create feasts for the eye and finding receptive readers who need and enjoy the visual play. In this book we have attempted to open a window on some of the developments in the esthetics of visual language, and in this sense it is hoped that readers will enjoy reading about languages and looking at scripts.

But viewing for pleasure and participating are quite different kinds of activity, and the greater rewards reside in involvement and in creative acts. For some there will be the satisfaction of performing a stroke as well as Arrighi's, and in the arts action is not to be denied. The way to approach the art of calligraphy is to decide right away to be successful. And as a student becomes sufficiently skilled with the pen to turn out his first good piece, another reward will be forthcoming: He will understand the scripts of history much better.

Notes and Bibliography

This is not a formal annotated bibliography. It departs from the usual bibliographical format of alphabetical listings in order to correlate the text more closely to the pertinent publications than is generally the case. The following notes and entries are organized first in regard to subject matter; that is, they are listed in related groups corresponding to discussions in the text proper. Within this framework importance usually supersedes other considerations. In some instances the date of publication is even more important than the author's name, and so a chronology of publication dates is maintained where necessary. Publishers are given where it has been possible to obtain the necessary information.

CHAPTER 1 SIGNS AND MEANING

Alphabetic Development

Basic accounts of the development of alphabetic writing can be found in *The Universal Jewish Encyclopedia* and in the *Encylopedia Britannica*.

A Study of Writing. I. J. Gelb. Chicago: University of Chicago Press, 1963. A noted scholar of the Hittite civilization and language presents the best account of the development of writing available in English. There is also a paperback edition.

Voices in Stone: The Decipherment of Ancient Scripts and Writings. Ernst Doblhofer. London: Souvenir Press, 1961; Toronto: Ryerson Press, 1961. A fascinating story of the decipherment of ancient scripts; reliable and informative.

The Alphabet. David Diringer. New York: McGraw-Hill, 1953. A standard source for many years. Contains the needed pictorial matter, and this offsets its somewhat confusing manner of organization. Two other works by Diringer are *The Story of Aleph Beth.* London: Lincolns-Praeger, 1958, which provides a very readable account of the development of alphabetic writing; and *Writing.* New York: Praeger, 1962, a fine distillation of Diringer's earlier works in which the clarity is markedly improved.

"The Art of Writing," *The UNESCO Courier,* March 1964. Reprints, available from the UNESCO Publications Center in New York, may be found useful in the classroom.

The Art of Writing. Paris: UNESCO, 1965. Related to an exhibition. An excellent source book with fine notes and illustrations on all the important families of writing. Can be obtained from the UNESCO Publications Center, New York.

La Grande invention de l'écriture. Marcel Cohen. Imprimerie Nationale (Librarie C. Klincksieck), 1958. No translation available, but the pictorial material and its organization are excellent.

Notices sur les caractères étrangèrs. Charles Fossey. Paris: Imprimerie Nationale de France, 1948. Not available in translation but has excellent alphabetic charts on ancient and modern Oriental writing.

Die Schrift. Hans Jensen. Gluckstadt and Hamburg: Verlag von J. J. Augustin, 1935.

Histoire de l'écriture. James G. Fevrier. Paris: Payot, 1948. Not available in English, but the volume is respected by scholars.

The History of the Alphabet. Isaac Taylor. New York: Kegan Paul, Trench, Trubner and Co., 1899. Dated but valuable.

The Story of the Alphabet. Edward Clodd. London: George Newnes, Ltd., 1900. Dated but valuable.

Semitic Writing. G. R. Driver, London, Eng.: Oxford University Press, 1948. A fine, well-illustrated account of Semitic writing from pictograph to alphabet by a noted Oxford scholar. Recommended to every student.

The Alphabet. Martin Sprengling. Chicago: University of Chicago Press, 1931.

The Triumph of the Alphabet: A History of Writing. A. C. Moorhouse. New York: Henry Schuman, 1953. An excellent account of the development, transfer, and spread of alphabetic writing.

Language. Leonard Bloomfield. New York: Holt, Rinehart and Winston, 1935. Important for the connection it shows between writing and speech.

Ancient Writing and Its Influence. B. L. Ullman. New York: Longmans, 1932. A fine account by a noted scholar of the adaptations and changes in alphabetic writing in the Greek and Roman line. The illustrations are limited in format and scope, but each is thoughtfully chosen.

Primitive Communication

Four Hundred Centuries of Cave Art. Henri Breuil. Montignac: Centre d'études et de documentation prehistoriques, 1952.

The Cave of Altamira. Henri Breuil. Madrid, Tipografica de Archivos, 1935.

The Lascaux Cave Paintings. Fernand Windels. New York and London: Viking, 1950.

Historical and Statistical Information Respecting the History, Condition, and Prospects of the Indian Tribes of the United States, Part I. Henry R. Schoolcraft. Philadelphia, 1851.

Pictographs of the North American Indians: A Preliminary Paper. Garrick Mallery. Washington, D.C.: Bureau of Ethnology, Smithsonian Institution, 1886.

Picture-Writing of the American Indians. Garrick Mallery. Washington, D.C.: Tenth Annual Report of the Bureau of Ethnology, 1893. Mallery's volumes are important to the study of writing and of the Indians of the United States.

Die Felsbilder Europas. Herbert Kühn. Stuttgart: W. Kohlhammer, 1952. In other words, *The Rock Pictures of Europe*.

Egyptian writing

Papyrus Reisner I. William K. Simpson. Boston: Museum of Fine Arts, 1963. Hieratic pen-written documents from the Middle Kingdom.

A Family Archive from Siut. Edited by Sir Herbert Thompson. London: Oxford University Press, 1934.

The Wilfour Papyrus, Vol. 1 *(Plates)*. Edited by A. H. Gardiner. London: Oxford University Press, 1941. Monumental reproductions.

Pre-Phoenician Greek Materials

Cretan Pictographs and Prae-Phoenician Script. Arthur Evans. London: Oxford University Press, 1895.

Scripta Minoa. 2 vols. Arthur Evans. London: Oxford University Press, 1909–1953. Evans also wrote *The Palace of Minos at Knossos*. 4 vols. London: Macmillan, 1921–1936.

Mycenae and Tiryns. Henry Schliemann. New York: Scribner, Armstrong and Co., 1878. Very exciting for engravings of artifacts.

The Decipherment of Linear B. John Chadwick. Cambridge, Eng.: Cambridge University Press, 1958.

CHAPTER 2 THE ALPHABET TO ROME

"The Antiquity of the Greek Alphabet." Rhys Carpenter. In *American Journal of Archaeology*, XXXVII, 1933.

"How Old is the Greek Alphabet." B. L. Ullman. In *American Journal of Archaeology*, XXXVIII, 1934.

"The Early Alphabetic Inscriptions from Sinai and Their Decipherment." W. F. Albright. In *Bulletin of the American Schools of Oriental Research*, CX, 1948.

"New Light on the Early History of Phoenician Colonization." W. F. Albright. In *Bulletin of the American Schools of Oriental Research*, LXXXIII, 1941.

"The Greek Alphabet Again." Rhys Carpenter. In *American Journal of Archaeology*, XLII, 1938.

"The Alphabet in Italy." Rhys Carpenter. In *American Journal of Archaeology*, XLIX, 1945. Contains a well-reasoned account of the transfer of the Greek alphabet to Roman soil.

"Notes on the Early Greek Writing." Franklin P. Jones. In *American Journal of Philology*, LXXVII, 1956.

"The Diffusion of the Greek Alphabet." R. M. Cook and A. G. Woodhead. In *American Journal of Archaeology*, LXIII, 1959.

The Local Scripts of Archaic Greece. Lilian H. Jeffery. Oxford, Eng.: Oxford University Press, 1961. A long discussion of the usage of the alphabet in Greek-speaking areas, with some well-reasoned arguments on the manner and time of the transfer of the alphabet from Phoenician traders.

Imagines Inscriptionum Atticum. Johannes Kirchner. Berlin: Gebr. Mann Verlag, 1948. Good collotype reproductions of Greek inscriptions from the earliest known to those of the Christian era.

Inscriptiones Graecae. Otto Kern. Bonn: A. Marcus and E. Weber, 1913. One of the best sources on Greek inscription writing, with many excellent photographs.

Specimina Codicum Graecorum Vaticanorum. Franchi de Cavalieri and Johannes Lietzman. Bonn: A. Marcus and E. Weber, 1910.

Books and Readers in Ancient Greece and Rome. Frederic G. Kenyon. Oxford, Eng.: Oxford University Press, 1951. A short, scholarly, and interesting commentary. See also Kenyon's *Ancient Books and Modern Discoveries*, Chicago: The Caxton Club, 1927.

Athenian Books in the Fifth and Fourth Centuries B.C. E.G. Turner. London: H. K. Lewis and Co., Ltd., 1952. Based on an informative lecture at University College, London.

Roman Writing

"The Alphabet in Italy." Rhys Carpenter. In *American Journal of Archaeology*, XLIX, 1945. Contains an interesting account of the transfer of the Greek Alphabet to Roman soil.

La scrittura Greca in Italia. Stelio Bassi. Cremona: Stabilimento Tipografico Società Editoriale "Cremona Nuova," 1956; and *La scrittura calligrafica Greco-Romana.* Stelio Bassi. Cremona: Stabilmento Tipografico Società Editoriale "Cremona Nuova," 1957. Both trace the development of writing forms from Greek through Roman times to the third century A.D. Well-illustrated and unexcelled in terms of visual coverage. Readers will have no trouble picking off important dates.

An Introduction to Greek and Latin Palaeography. Edward Maunde Thompson. London: Oxford University Press, 1912. The justly famous work that traces Greek and Roman manuscript hands through the Middle Ages. It excludes the carved alphabets. A more recent edition is available from Burt Franklin (New York, 1960). In this edition the line work and text matter are unimpaired; but the original halftones have been recopied, and the technical problems have not been solved, so that many plates that were adequate in their day are now seriously marred by blackening. Although the new edition is a good effort, readers should try to get the original.

Corpus Inscriptionum Latinarum. Theodore Mommsen. Berlin: G. Reiner, 1863. A long series on all Latin texts from the first appearance of the language to the sixth century. A standard source for all scholars.

Exempla Scripturae Epigraphicae Latinae. Emil Hübner. Berlin: G. Reiner, 1885. One of the great sources on Latin writings carved in stone. Modern scholars believe Hübner's methods included some misrepresentation, but it is hard to find a better source for the calligraphic origin of Roman inscription writing.

Roman Lettering. L. C. Evetts. New York: Pitman, 1938.

Introduction to the Study of Latin Inscriptions. James C. Egbert. New York: American Book Co., 1896.

Latin Epigraphy. John Edwin Sandys. Cambridge, Eng.: Cambridge University Press, 1919. Other works by Sandys should also be investigated.

Inscriptiones Latinae Selectae. Herman Dessau. Berlin, 1892–1916; reprinted 1954–1955. If this is not available, look for other works by Dessau.

Inscriptiones Latinae Christianae Veteres. 3 vols. Ernst Diehl. Berlin: Weidman, 1924–1931.

"Contributions to the Palaeography of Latin Inscriptions." Joyce S. Gordon and Arthur Gordon. In *University of California Publications in Classical Archaeology*, Vol. III, No. 3,

1957. An excellent study of the methods of Roman writing.

Album of Dated Latin Inscriptions. Arthur E. Gordon and Joyce S. Gordon. Berkeley: University of California Press, 1958–1965. See especially Volume I, *Rome and the Neighborhood, Augustus to Nerva;* and Volume IV, *Indexes.* Enlarges the readers' view of these periods and provides a source for slides, a fortunate result of scholarship.

De caratteri di Leopardo Antonozzi, Vol. I. Rome, 1638. Contains a careful study and reproduction of the Trajan column letters and is the only Renaissance publication devoted to the letters of a single monument. This book can be found in five libraries: Bibliothèque Nationale, Paris; Kunstbibliothek, Berlin; Columbia University, New York; Victoria and Albert Museum, London; Newberry Library, Chicago. A facsimile edition would be most welcome.

The Trajan Capitals. Frederic W. Goudy. New York: Oxford University Press, 1936.

Letters Redrawn from the Trajan Inscription in Rome. Edward M. Catich. Davenport, Iowa: Catfish Press, 1961. A detailed analysis of the Trajan letters based on studies at the site. Contains 93 plates and appropriate notes. Photographs of the site are not informative. Has photographs of the cast in the Victoria and Albert Museum.

Paléographie Romaine. Jean Mallon. Madrid: Consejo Superior de Investigaciones Cientificas, Instituto Antonio de Nebrija de Filologia, 1952.

L'Écriture latine de la capitale romaine à la minuscule. J. Mallon, R. Marichal, and C. Perrat. Paris: Arts et Métiers Graphiques, 1939. An excellent source book of facsimiles.

Manuel de paléographie latine et française. Maurice Prou. Paris: A. Picard, 1924. Another fine facsimile source.

Lateinische Palaographie. Franz Steffens. Berlin and Leipzig: Verlag von Walter de Gruyter and Co., 1929. Very good. Has examples going into the Middle Ages. Earlier editions may be available.

CHAPTER 3 MISSIONARY AND MONASTERY

Alphabetic Development

The writing of the Middle Ages has attracted many scholars, and facsimile editions began to emerge in the second half of the nineteenth century. Quality of reproduction is uneven; but date of publication is not a reliable index of quality, and many of the older facsimile editions exhibit the historic hands of the Middle Ages in superb fashion.

Basic Sources

Historical Atlas. William R. Shepherd. New York: Barnes and Noble, 1964. The ninth edition of a classic reference work that traces the flow of ethnic groups and centers of power in the Middle Ages.

Thought and Letters in Western Europe: A.D. *500 to 900.* Max L. W. Laistner. London: Methuen, 1931. An excellent account of scholarship and literature before and after the decline of Roman power.

An Introduction to Greek and Latin Palaeography. Edward Maunde Thompson. London: Oxford University Press, 1912.

Codices Latini Antiquiores. E. A. Lowe. Oxford, Eng.: Oxford University Press, 1934. Eleven volumes in a 12-by-17½-inch format. The classical source on Latin book hands to A.D. 800. Almost every manuscript existing appears in reproduction. Lowe's notes are important.

Chartae Latinae Antiquiores. 3 vols. Albert Bruckner and Robert Marichal. Olten and Lausanne: Urs Graf-Verlag, 1954–1963. Designed in a generous format, this production is a companion to *Codices Latini Antiquiores* and exhibits the legal, or charter, hands of the Anglo-Saxon period. Contains superb reproductions of Latin cursive writing.

Legacy of the Middle Ages. C. Crump. Oxford, Eng.: Oxford University Press, 1926. E. A. Lowe's essay "Handwriting" appears here.

Palaeographia Latina. 6 vols. W. M. Lindsay. London: Oxford University Press, for St. Andrew's University, 1922–1929.

The Descent of Manuscripts. A. C. Clark. Oxford, Eng.: Oxford University Press, 1918.

Notes on the Development of the Latin Script from Early to Modern Times. Stanley Morison. Cambridge, Eng.: Cambridge University Press, 1949.

Paléographie des classiques Latins. 2 vols. E. Chatelain. Paris: Hachette, 1884–1900.

La scrittura delle cancellerie italiane. Vincenzo Federici. Rome: P. Sansaini, 1934. Some 113 plates on Italian scripts from Roman times to the seventeenth century; a rich survey.

Facsimilies of Manuscripts and Inscriptions. Series 1 and 2. Edited by E. A. Bond, E. M. Thompson, G. F. Warner, F. G. Kenyon, and G. P. Gilson. London: Palaeographical Society, 1873–1894. A series of large volumes with beautiful reproductions.

Manuel de paléographie recueil: Facsimiles d'écritures du Ve au XVIIe siècle. Maurice Prou. Paris: Alphonse Picard et Fils, 1904. An excellent source book. Other facsimile editions by Prou may be available.

Sources for Latin Book Hands

Codex Vergilianus qui Palatinus Appellatur quam Simillime Expressus. R. Sabbadini. Paris, 1929. A facsimile of a famous Vatican manuscript (1631) written in the rustic-capital style.

Picturae Ornamenta Complura Scripturae Specimina Codices Vaticana 3867. Edited by F. Ehrle. Rome, 1902. A facsimile of another Vatican manuscript, Codex Romanus, written in the rustic-capital style.

Fragmenta et Picturae Vergiliana Codices Vaticana 3225. Edited by F. Ehrle. Rome, 1899, 1930. A facsimile of a rare manuscript using rustic capitals.

Codices Vergiliani qui Augustus Appellatur Reliquiae. Edited by R. Sabbadini. Turin, 1926. The most famous of the Vatican Latin manuscripts (3256) featuring the square-capital, or quadrata, style.

Sources for the Uncial Book Hand

Uncialis Scriptura Codicum Latinorum. Emiles Chatelain. Paris: H. Welter Rennes, 1901. With 100 handsome plates, this may be the best facsimile edition devoted to uncial manuscripts.

Il codice evangelico K della Biblioteca Universitaria Nazionale de Torino. C. Cipolla. Turin, 1913. An early uncial manuscript.

Histoire romaine de tite live: réproduction réduite. H. Ormont. Paris, 1907. A classical uncial manuscript written in Italy. The reproduction is reduced in scale.

Monumenti paleografica Veronesi. 2 vols. E. Carusi and W. M. Lindsay. Rome, 1929–1934. Facsimiles of writings held in Verona featuring uncial and early minuscule hands.

Specimina Codicum Latinorum Vaticanorum. F. Ehrle and P. Liebart. Bonn: A. Marcus and E. Weber, 1912.

Corpus Extravagantium Codicum, I. A. Amelli and G. L. Perugi. Rome, 1922; Turin, 1930. A facsimile edition of the uncial hand in transition to a minuscule hand.

Exempla Codicum Latinorum Litteris Maiuscule Scriptorum. K. Zangemeister and W. Wattenbach. Heidelberg, 1876, 1879. Excellent facsimiles of uncial manuscripts.

The Bodleian Manuscript of Jerome's Version of the Chronicle of Eusebius. J. K. Fotheringham. Oxford, Eng.: Oxford University Press, 1905. A manuscript in the early uncial style.

English Uncial. E. A. Lowe. Oxford, Eng.: Oxford University Press, 1960. Fine reproductions of the early uncial writing in Anglo-Saxon territory and of late uncial styles. Lowe's notes are indispensable to the understanding of this development.

Sources for Celtic Writing

Book of Kells, Codex Cenannensis. Bern: Urs Graf-Verlag, 1951. Facsimile of the fabulous masterpiece of Celtic writing and illuminating in full color reproduction with a volume of notes.

The Book of Kells. Described by Sir Edward Sullivan. London: The Studio, 1933. Has 24 color plates.

Early Irish Minuscule Script. W. M. Lindsay. Oxford, Eng.: Oxford University Press, 1910.

Facsimiles of the National MSS of Ireland. 5 vols. Edited by J. T. Gilbert. Dublin: Public Record Office of Ireland, 1874–1884.

The Annals of Inisfallen. Royal Irish Academy. Dublin: Williams and Norgate, 1933. A facsimile edition of a manuscript detailing events in Ireland from 1100 to 1321. The script is vigorous, a pleasure to study.

Senchas Mār, Facsimile of the Oldest Fragments. Dublin: Stationery Office of Saorstat Eireann, 1931. A collotype facsimile of manuscripts pertaining to ancient Irish law. Strong calligraphy c. 1300.

The Antiphonary of Bangor. F. E. Warren. London: Henry Bradshaw Society, 1893–1895. Celtic writing c. 680–691; an important manuscript.

Sources for Anglo-Saxon Writing

Codex Lindisfarnensis. Olten and Lausanne, Urs Graf-Verlag, 1956. Another superb facsimile edition of a monumental manuscript exhibiting the Celtic tradition as passed to Anglo-Saxon hands.

Historia Ecclesiastica Gentis Anglorum (Bede), C. Plummer. Oxford, Eng.: Oxford University Press, 1896. The famous chronicle of the English.

Facsimiles of Ancient Charters in the British Museum. London: British Museum, 1873.

Sources for the Scripts of Central Europe and the Carolingian Period

Le Cabinet des manuscrits de la Bibliothèque Impériale. L. Delisle. Paris: Imprimerie Impériale, 1868–1881. After the first of three volumes the title changes to *Le Cabinet des manuscrits de la Bibliothèque Nationale.* Early book hands of the French area are included.

A Survey of the Manuscripts of Tours. E. K. Rand. Cambridge, Mass.: Medieval Academy of America, 1929. The Tours scriptorium was influential in the Carolingian reform.

Monumenta Germaniae Historica: Auctores Antiquissima. Berlin, 1877. *Scriptores Rerum Merovingicarum.* Hannover and Leipzig, 1885.

Monumenta Paleographica: Denkmäler der Schreibkunst des Mittelalters. A. Chroust: first series, Munich, 1902–1906; second series, Munich, 1911–1917; third series, Leipzig, 1927–.

Scriptoria Medii Aevi Helvetica: Denkmäler Schweizerischer des Mittelalters. 10 vols. A. Bruckner. Geneva: Roto-Sodog, 1935–. Facsimiles of writing from the Swiss area.

The Script of Cologne. Leslie Webber Jones. Cambridge, Mass.: Medieval Academy of America, 1932. Carolingian scripts from Cologne c. 819–890, with 100 plates.

Pontificum Romanorum Diplomata Papyracea Hispanie Italiae Germaniae. Rome: Vatican Library, 1928. An enormous facsimile of a script used for ninth-century diplomatic exchanges. Demonstrates late use of papyrus.

Terentius, Codex Vaticanus Latinus 3868. Leipzig: Otto Harrassowitz, 1928. A facsimile of plays from a ninth-century manuscript employing the Carolingian minuscule. The illustrations are interesting.

Sources for Spanish Calligraphy

Paleografia Española. Zacarias Garcia Villada. Madrid: Publicaciones de la ''Rivista de Filología Española,'' 1923. The scripts of Spain in all styles. Contains 67 plates.

Exempla Scripturae Visigoticae. P. Ewald and G. Loewe. Heidelburg: Gustav Koestler, 1883. Has forty plates showing the development of manuscript styles in Spain.

CHAPTER 4 WRITING IN THE LATE MIDDLE AGES

The Beneventan Script. E. A. Lowe. Oxford, Eng.: Oxford University Press, 1914.

Scriptura Beneventana. E. A. Lowe. Oxford, Eng.: Oxford University Press, 1929. Two expositions of the independent script of southern Italy.

Black Letter Text. Stanley Morison. Cambridge, Eng.: Cambridge University Press, 1942. The best study on the development of this historic style of northern Europe and England.

Early English Manuscripts in Facsimile. Edited by Bertram Colgrove *et al.* Copenhagen, London: Rosenkilde and Bagger, 1958. The English versions of the Carolingian minuscule.

English Manuscripts in the Century after the Norman Conquest. N. R. Ker. Oxford, Eng.: Oxford University Press, 1960. Native styles in transition. Valuable notes with an explanation of runic characters in Anglo-Saxon writing.

Facsimiles of Biblical Manuscripts in the British Museum. F. G. Kenyon. London, British Museum, 1900.

Autotypes of Chaucer Manuscripts. London: Chaucer Society, c. 1888. Very large and beautiful reproductions of the Chaucer manuscripts of the fifteenth century. Notes by F. J. Furnival are marked by irreverent wit.

English Vernacular Hands from the Twelfth to the Fifteenth Centuries. C. E. Wright. Oxford, Eng.: Oxford University Press, 1960.

Chevalerie Vivien. Raymond Weeks. Columbia, Mo.: University of Missouri, 1909. French legends written in the thirteenth century. Facsimiles in a bold hand.

La Pecia. Jean Destrez. Paris: Jacques Vautrain, 1935. Many facsimiles of hands of the thirteenth and fourteenth centuries.

Facsimilés d' écriture du XIIe au XVII siècle. Maurice Prou. Paris: Alphonse Picard et Fils, 1904. Very good reproductions of business and legal transactions in the late Middle Ages.

Central European Manuscripts in the Pierpont Morgan Library. New York: Pierpont Morgan Library, 1958. Ninety plates of pre-Renaissance manuscripts with notes and a bibliography.

Antichi manoscritti. Ernesto Monaci. Rome: Martelli Tipografo Editore, 1881. Beautiful facsimile pages of book hands and cursive writing before the Renaissance.

Scriptura Latina Libraria. Joachim Kirchner. Munich: Rudolf Oldenbourg, 1955. A good review of the scripts of the Middle Ages. Most important, 28 alphabets are reproduced at the back of the book.

The Origin and Progress of Writing. Thomas Astle. London: J. White, 1803. Fine engraved copies of the decorated letters of the Middle Ages. In its time it was the best review of medieval manuscript hands, and it is still useful.

Monumenta Epigraphica Christiana in Civitate Vaticana. Angelo Silvagni. Rome: Pontificum Institutum Archaeologia Christianae, 1953. Photographs of inscription forms from Roman times to the twelfth century. These volumes show what was happening to inscription letters between the time of Roman power and the late Middle Ages.

"The Paleography of Latin Inscriptions in the Eighth, Ninth, and Tenth Centuries in Italy." Nicolette Gray. In *Papers of the British School at Rome,* Vol. XVI (New Series, Vol. III). London, 1948. Has a useful bibliography.

Decorative Alphabets and Initials. Alexander Nesbitt. New York: Dover, 1959. This work took a lot of digging, and Nesbitt's sources are listed.

CHAPTER 5 RENAISSANCE AND CHANGE

Inscription Letters

La Roma antica di Ciriaco d'Ancona. Christian Huelson. Rome: Ermanno Loescher and Co., 1907. Some 50 reproductions of fifteenth-century illustrations on ancient Roman architecture and inscriptions.

A Corpus of Italian Medals of the Renaissance before Cellini. George Francis Hill. London: British Museum, 1930.

Renascence Tombs of Rome. Gerald S. Davies. London: J. Murray, 1910. Alinari can probably furnish prints of any inscription reproduced in Davies' volume.

"Sans Serif and Other Experimental Inscribed Lettering of the Early Renaissance." Nicolette Gray. In *Motif 5.* 1960. Shows styles that lost out in the classical revival.

"Trajan Revived." James Mosley. In *Alphabet 1964.* London: James Moran Ltd., 1964. An excellent article documenting the victory of the classical inscription letters in Renaissance times and beyond.

Krásné Písmo. František Musika. Prague: Státní Nakladatelství Krásné Literatury, 1958. An important review of written forms, including reproductions of many important alphabets. Luca della Robbia's inscription letters are among those pictured.

The Humanistic Scripts

The Origin and Development of Humanistic Script. B. L. Ullman. Rome: Edizioni di Storiae Litteratura, 1960. Gives the best explanation of the development of our minuscule, or lower-case, alphabet from late Carolingian models. There are 70 reproductions.

The Humanism of Coluccio Salutati. B. L. Ullman. Padua: Antenore, 1963. Deals with one of the strong Humanists who was influential in the development of the new writing of the Renaissance. Has 19 plates.

The Life of Poggio Bracciolini. William Shepherd. London: Longman, Rees, Orme, Brown, Green, and Longman, 1837. The story of Poggio, who, as a calligrapher, began using a revised Carolingian script in 1400.

The Renaissance. George Clarke Sellery. Madison, Wis., University of Wisconsin Press, 1950. Background on the meaning of "Renaissance" in terms of ideas and literature.

The Chancery Hand and Italic

Humanistic cursive writing came to be known as Chancery cursive late in the fifteenth century and as Italic in England. Chancery cursive was one of the principal hands featured in the first wood-cut writing manuals printed in Italy in the sixteenth century, and this development can be followed in the Notes and Bibliography of Chapter 6.

Renaissance Handwriting. Alfred Fairbank and Berthold Wolpe. London: Faber, 1960. The development of Humanistic cursive, with excellent notes and 96 well-selected plates. An indispensable source.

The Script of Humanism. James Wardrop. Oxford, Eng.: Oxford University Press, 1963. Covers aspects of Humanistic scripts between 1460 and 1560, with particular stress on the gifted calligrapher Bartolomeo Sanvito.

The Handwriting of the Renaissance. Samuel A. Tannenbaum. New York: Columbia University Press, 1930. Shows the vernacular hands of the period. Pages of writing are accompanied by transcripts. A valuable bibliography is included.

Deutsche und Lateinische Schrift in den Niederlander 1350–1650. A. Hulshof. Bonn: A. Marcus and B. Weber, 1918. Local scripts of the Netherlands area. Entrenched remnants of the writing of the Middle Ages.

Constructed Letters

Some of the constructed alphabets of the Renaissance exist in manuscript form and were not printed in their own time. Other efforts were printed, but most of these editions are almost as rare as the manuscripts. This list is chiefly devoted to modern editions concerning Renaissance constructed letters. Those interested in calligraphy are indebted to Giovanni Mardersteig, head of the world-renowned press Officina Bodoni for some of the best scholarship and printing in this area of study. A facsimile production uses photographs of the entire page, thumbprints and all, while black-and-white reproductions use only printed or drawn content and omit the background. See notes for Chapter 6 for further references to Roman capital alphabets.

Lines of the Alphabet. John Ryder. London: The Stellar Press and The Bodley Head, 1965. An illustrated review of facsimile editions devoted to constructed letters, with the names of books and authors needing modern productions.

Felice Feliciano Veronese: Alphabetum Romanum. Edited by Giovanni Mardersteig. Verona: Editiones Officinae Bodoni, 1960. A facsimile devoted to Feliciano's effort c. 1460. A facsimile of the constructed alphabet of Felice Feliciano has been made by R. Schone, Berlin, 1872.

The Moyluss Alphabet: A Newly Discovered Treatise on Classic Letter Design. Damiano da Moille. Introduction by Stanley Morison. Paris: J. Holroyd-Reece, 1927. A Mardersteig production of a set of capitals designed by Damiano da Moille of Parma and printed c. 1480. Set in Poliphilus on Arches paper.

Fra Luca de Pacioli of Borgo S. Sepolcro. Edited with notes by Stanley Morison. New York: The Grolier Club, 1933. Printed by the Cambridge University Press, with typography by Bruce Rogers, this edition of Pacioli's alphabet is something very special.

De divina proportione di Luca Pacioli. Giuseppina Masotti Biggiogero and Franco Riva. Verona: Editiones Officina Bodoni, 1956. A Mardersteig production. Pacioli's alphabet of 1509, with test in Bembo type. Leonardo da Vinci's *I corpori regulari* is included.

Luminario. G. B. Verini. Translated by A. F. Johnson; edited by Philip Hofer and Stanley Pargellis. Cambridge, Mass., and Chicago: Harvard College Library, 1947. A redrawn version of Verini's alphabet of Roman capitals, first published in 1526. Features an introduction by Stanley Morison. The original edition has large, open, lowercase types not seen in this translation.

Of the Just Shaping of Letters. Albrecht Dürer. New York: The Grolier Club, 1917. An edition of Dürer's constructed capitals, first published in 1525. A translation is provided. This elegant book was printed by Emery Walker and Wilfred Merton in London.

The Construction of Roman Letters by Albrecht Dürer. Albrecht Dürer. New York: Bruce Rogers, 1923. A short introduction by Rogers is included, but Dürer's original text has been omitted.

Albrecht Dürer: Antika-Alfabetets Versaler. Albrecht Dürer. Copenhagen: C. Volmer Nordlunde, 1958. Nordlunde is the distinguished leader in Danish printing. A translation is furnished, with text and constructed letters on facing pages.

On the Just Shaping of Letters. Albrecht Dürer. New York: Dover, 1965. This modestly priced edition is a copy of the 1917 Grolier Club edition.

Champ Fleury. Geofroy Tory. Translated by George B. Ives. New York: The Grolier Club, 1927. The famous work first published in Paris in 1529. Features constructed capitals in Part 3. The English translation makes this a very significant volume.

Champ Fleury. Geofroy Tory. Edited by Gustave Cohen. Paris, 1931. This is known as the Bosse facsimile. The text is not in English.

Johann Neudörffer d. "A" der grosse Schreibmeister der deutschen Renaissance. Albert Kapr. Leipzig: Otto Harrassowitz, 1956. Neudörffer's alphabet of 1660 is reproduced in a facsimile with the background cut away.

Johann Neudörffer und seine Schule im 16 und 17 Jahrhundert. Werner Doede. Munich: Prestel Verlag, 1957. Neudörffer constructed Roman capitals c. 1540. Later this alphabet was engraved in slightly altered form and published in Nuremberg in 1660.

La Réforme de la typographie royale sous Louis XIV, le Grandjean à Paris. Paris: Librairie Paul Jammes, 1961. An attempt by Philippe Grandjean (1665–1714) to codify the Roman capitals into a very strict format.

A Book of Type and Design. Oldřich Hlavsa. New York: Tudor, 1960. An excellent survey containing constructed alphabets by Feliciano, Da Moille, Pacioli, Tory, and Pierre Le Bé.

CHAPTER 6 WRITING MASTERS: BRILLIANCE AND DECLINE

Bibliographical Sources

A Catalogue of Italian Writing Masters of the Sixteenth Century. A. F. Johnson. London, 1950. This bibliography first appeared in the Journal *Signature*. Parts of it appear in *Three Classics of Italian Calligraphy.* Edited by Oscar Ogg. New York: Dover, 1953.

Bibliografia delle arti scrittorie e della calligrafia. Claudio Bonacini. Florence: Sansoni Antiquariato, 1953. One of the principal sources of information on the books of the writing masters.

Diccionario de caligrafos españoles. Emilio Cotarelo y Mori. Madrid: Tip. de la "Revista de Arch. Bibl. y Museos," 1916. Rather complete coverage of important calligraphers in Spain. Pedro Díaz Morante, a seventeenth-century expert, receives 42 pages. The reproductions are not even fair.

Bibliographie Deutscher Schreibmeisterbucher von Neudörffer bis 1800. Werner Doede. Hamburg: E. Hauswedell, 1958. Excellent for notes and facsimiles on writing manuals emanating from the German-speaking areas. Excellent.

The English Writing-Masters and Their Copy Books 1570–1800. Ambrose Heal. Cambridge, Eng.: Cambridge University Press, 1931. The master volume on the subject, with numerous reproductions. Stanley Morison provides an outline on the development of handwriting.

American Writing Masters and Copybooks. Ray Nash. Boston: The Colonial Society of Massachusetts, 1959. A history and bibliography through Colonial times.

Handwriting and Related Factors 1890–1960. Virgil E. Herrick. Washington, D.C.: Handwriting Foundation, 1960. With 1754 entries, this volume covers many aspects of handwriting, including some manuals by latter-day commercial experts.

Calligraphy 1535–1885. Carla Marzoli. Milan: La Bibliofila, 1962. Notes on 72 writing books issued from Italy, Spain, France, and the Netherlands. Has careful work, numerous reproductions, some new material, and an introduction by Stanley Morison.

A Handlist of the Writings of Stanley Morison. John Carter. Cambridge, Eng.: Cambridge University Press, 1950. Privately printed. The late Stanley Morison was such a prolific scholar that a catalog of his writings would be very useful.

Facsimiles and Reproductions

The Calligraphic Models of Ludovico degli Arrighi Surnamed Vicentino, Montagnola, Switzerland: Frederic Warde, 1926. Arrighi's *La operina* and *Il modo de temperare le penne* in facsimile without translation. Production by Mardersteig with notes by Stanley Morison. Printed privately for Frederic Warde, using

his Arrighi types. Arrighi's two books have also been reproduced by Tidens Förlag (Stockholm, 1958). The translation appears as footnotes.

La operina. Arrighi. Copenhagen: Grafiske Højskoles, 1959. Collotype reproduction with a translation written in Danish in Arrighi's style by Bent Rohde, a leading calligrapher in Denmark.

The First Writing Book: Arrighi's Operina. 4th ed. John Howard Benson. New Haven and London: Yale University Press, 1963. A black-and-white version of the original edition, preceded by Benson's calligraphy in English, which follows Arrighi line for line. An elegant book that neophytes should try to acquire. Available at a modest price in paperback.

Three Classics of Italian Calligraphy. Edited by Oscar Ogg. New York: Dover, 1953. The writing books of Arrighi, Tagliente, and Palatino in black-and-white renditions from originals in the Newberry Library. An introduction by Oscar Ogg and a bibliography by A. F. Johnson are included. Reasonably priced.

Lo presente libro insegna la vera arte dello excellente scrivere. Giovanni Antonio Tagliente. Introduction by James Wells. Chicago: The Newberry Library, 1952.

Eustachio Celebrino da Udene. Edited by Stanley Morison. Verona: Editiones Officinae Bodoni, 1929. Celebrino's small treatise was called *Il modo d'imparare di scrivere lettera* and was printed in 1525. A Mardersteig facsimile.

The Instruments of Writing. Translated by the Rev. Henry K. Pierce. Newport, R.I.: Berry Hill Press, 1953. A translation from Palatino's writing book of 1540, with reproductions of original woodcuts. Part of Arrighi's method of cutting a pen is included.

The Treatise of Gerard Mercator. Edited by Jan Denuce and Stanley Morison. Verona: Editiones Officinae Bodoni, 1930. A Mardersteig facsimile, featuring Mercator's version of italic writing in woodcuts.

Arte subtilissima. Juan de Yciar. Oxford, Eng.: Oxford University Press, 1960. A facsimile of Yciar's writing book of 1550 (the first appeared in 1548). This is one of the great writing manuals. A facsimile was first published by the Lion and Unicorn Press, Royal College of Art, London, 1958. A translation by Evelyn Shuckburgh is provided.

Das Schreibbuch des Urban Wyss. Edited by H. Krenzle. Basel: Henning Oppermann, 1927. A facsimile of the original Wyss manual of 1549 titled *Libellus Valde Doctus,* printed in Zurich.

Wolffgang Fugger's Handwriting Manual. Edited by Harry Carter. Translated by Frederick Plaat. London: Royal College of Art, 1955. This facsimile was taken from a later edition of Fugger's manual and differs from the Kapr version in some important details.

Wolfgang Fuggers Schreibbuchlein. Edited by Albert Kapr. Leipzig: Otto Harrossowitz, 1958. Has an Introduction in English by Fritz Funk. Fugger (c. 1515–1568) was a pupil of Neudörffer, the great master of the pen. He was also a printer and his large manual of 1553 in Nuremberg shows this. The 1958 version uses collotype reproduction throughout and is a splendid production.

A Newe Booke of Copies 1574. Edited by Berthold Wolpe. Oxford, Eng.: Oxford University Press, 1962. First published by the Lion and Unicorn Press, Royal College of Art, London, 1959. The original was by Thomas Vautroullier, a scholar and printer who printed the first writing manual to appear on English

soil, by John de Beau Chesne and John Baildon in 1570. The notes are valuable and the black-and-white reproductions show the prevalent book hands.

Andres Brun, Calligraphy of Saragossa, Some Account of His Life and Work (also called *The Writing Book of Andres Brun, 1583*). Henry Thomas and Stanley Morison. Verona, Editiones Officina Bodoni, 1928. A Mardersteig facsimile of surviving sheets of two manuals by the Spanish master, one published in 1583 and the other in 1612.

Les Écritures financière et Italienne-Bastarde, Louis Barbedor, Paris, 1647. Louis Barbedor. Basel, c. 1940.

Survey Material

Meister der Schreibkunst aus drei Jahrhunderten. Peter Jessen. Stuttgart: Julius Hoffman Verlag, 1923. The 200 reproductions of writing master efforts make this a most important volume, almost indispensable.

Penmanship of the XVI, XVII and XVIIIth Centuries. Lewis F. Day. London: B. T. Batsford, c. 1911. Day died in 1910 and the volume was finished by Percy Smith. There are 112 well-selected items in black and white. The Bibliography is also valuable. Day also wrote *Alphabets Old and New, Lettering in Ornament,* and other volumes on writing.

The Universal Penman Engraved by George Bickham, London, 1743. New York, Dover, 1941. A copy of the original featuring reproductions of all the great writing masters of England in the first half of the eighteenth century. A unique presentation of an era in which more is discerned than the writing.

Vieilles Écritures. A. De Bourmont. Caen, 1881. Official cursive writing of the fifteenth, sixteenth, and seventeenth centuries in a large collotype reproduction.

Geschichte der abendländischen Schreibschriftformen. Hermann Delitsch. Leipzig: K. W. Hiersemann, 1928. A great survey that begins in Rome and ends in London in 1709. Many writing masters are included.

Handwriting in England and Wales. N. Denholm Young, Cardiff: University of Wales Press, 1954.

The Handwriting of English Documents. Leonard Charles Hector. London: E. Arnold, 1958. Fine notes on writing surfaces, inks, pens, papers, and formats. Scribal habits of abbreviation are also documented. Thirty pages are devoted to illustrations.

English Court Hand A.D. 1066 to 1500. Charles Johnson and Hilary Jenkinson. New York: Ungar, 1967.

The Later Court Hands in England. Hilary Jenkinson. Cambridge, Eng.: Cambridge University Press, 1927. An earlier work, *Palaeography and the Practical Study of Courthand.* Cambridge: Cambridge University Press, 1915, may prove instructive in this area of writing.

Reflexiones sobre la verdadera arte de escribir. Domingo Servidori. Madrid, 1789. The first great production devoted to the study of the writing masters in several countries. Servidori was the first genuine critic in these areas. Most of the great writing masters are illustrated.

Arte de escribir. Torcuato Torio de la Riva. Madrid, 1798. Another fine volume setting critical foundations.

CHAPTER 7 THE HERITAGE OF GUTTENBERG, JENSON, AND GRIFFO

Type, its invention, development, and practice, is an enormous

field in terms of bibliography. The subject is historical, technical, critical, and esthetic. If technical matters are the warp of printing, personal preference is the weft, and this bibliography, like others of its kind, reflects personal views.

There is no intention here to cover the technical aspects of typesetting or the development of presses. The principal concern is with historical aspects, facsimiles, and a few sources that might prove useful to any group of people actively engaged in printing.

The Invention of Printing in China and Its Spread Westward. Thomas Francis Carter. New York: Columbia University Press, 1925; revised by L. Carrington Goodrich. New York: Ronald Press, 1955.

Early Movable Type in Korea. Won-Yong Kim. Seoul, Korea: Eul-yu Pub. Co., 1954. The story of abortive and successful efforts to manufacture movable types in the Orient. Successful attempts predate Gutenberg.

Specimen Pages of Korean Movable Types. Melvin P. McGovern. Los Angeles, Damison's Book Shop, n.d. A deluxe edition of the early Korean types printed on Oriental papers.

Five Hundred Years of Printing. S. H. Steinberg. Baltimore: Penguin, 1961. An interesting and reliable history at a reasonable price.

Four Centuries of Fine Printing, 1500–1914. Stanley Morison. New York: Barnes and Noble, 1960.

The Typographic Book, 1450–1935. 2 vols. Stanley Morison and Kenneth Day. Chicago: University of Chicago Press, 1965. Has 378 plates.

Printing Types: Their History, Form, and Use. Daniel Berkeley Updike. Cambridge, Mass.: Harvard University Press, 1951. First printed in 1922, this work has become a classic. There are 367 well-chosen illustrations.

The Book: The Story of Printing and Bookmaking. Douglas Mc-Murtrie. New York, Oxford University Press, 1948.

A History of the Printed Book. Edited by L. C. Wroth. New York: Limited Editions Club, The Dolphin No. 3, 1938.

Type Designs: Their History and Development. Alfred Forbes Johnson. London: Grafton and Co., 1934.

Gutenberg to Plantin. George Parker Winship. Cambridge, Mass.: Harvard University Press, 1926.

West European Incunabula. Konrad Haebler. Munich: Weiss, 1928. See also Haebler's *Geman Incunabula* (1927) and *Italian Incunabula* (1928).

Early Humanistic Script and the First Roman Type. Stanley Morison. *The Library*, Series IV, Vol. 24, 1943.

The Story of Incunabula. Konrad Haebler. New York: The Grolier Club, 1933.

Early Printed Books to the End of the 16th Century. Theodore Besterman. Geneva: Societas Bibliographica, 1961. Contains bibliographies.

Early Venetian Printing. Ferdinando Ongania. New York: Scribners, 1895.

Notable Printers of Italy During the Fifteenth Century. Theodore Low De Vinne. New York: The Grolier Club, 1910. An influential study dated in its details but good in substance. Type designs attributed to Claude Garamond were actually the work of Jean Jannon at a later date.

Calligraphy and Printing in the Sixteenth Century. Christopher Plantin. Antwerp: The Plantin-Moretus Museum, 1964. Plantin, a Frenchman, settled in Antwerp in 1549 and established a great printing house. One of his memorable works was the great Polyglot Bible in eight volumes (1568–1573). The recent work is an interesting dialogue by this great publisher. Front matter by Stanley Morison and Ray Nash.

The Printed Books of the Renaissance. E. P. Goldschmidt. London: Cambridge University Press, 1950.

Facsimiles

Faksimile-Neudruck: der Sweiundvierzig Zeiligen Bibel der Johannes Gutenberg, Mainz 1450–1453. Leipzig: Insel-Verlag, 1913. A facsimile of the famous 42-line Bible.

Die Buchkunst Gutenberg und Schöffers. Paul Gottschalk. Berlin: Paul Gottschalk, 1918. Eight facsimiles from first editions.

Bible Latin c. 1450–1455, Mainz. New York: H. W. Wilson & Co., 1940. Twenty-five facsimiles of Gutenberg's 42-line Bible.

Peter Schoffer of Gernsheim and Mainz. Hellmut Lehman-Haupt. Rochester, N.Y.: L. Hart, 1950. In a foreclosure of 1455 the bulk of Gutenberg's presses and types went to Schoffer. This book has 19 facsimiles.

Knihopis Československých Tisků. Prague, 1925. Reproductions of Czechoslovakian pages printed before 1500.

Fabulas de Esopo: Reproduccion en facsimile de la primera edicion de 1489. Madrid: Real Academia Española, 1929. The typeface is a rotunda, very well done, undoubtedly by one of the early German printers in Spain. Woodcuts of these historic fables are quite interesting.

The Dictes and Sayings of the Philosophers. William Caxton. London: Elliot Stock, 1877. A nineteenth-century facsimile of the first book printed in England in 1477. No doubt this will be as hard to find as the original.

Bodoni, Giovanni Battista, 1740–1813. E. P. Goldschmidt. London: Cambridge University Press, 1950.

Manuale Typografico. G. B. Bodoni. 4 vols. Parma: Franco Maria Ricci Editore, 1965. A joint effort with the Biblioteca Palatina and the Museo Bodoniana.

Manuale tipografico del cavaliere Giambattista Bodoni Parma, Presso la vedova, 1818. London: Holland Press, 1960. A facsimile of one of the great type manuals of history. A few libraries have the original posthumous publication.

Nineteenth-century Typography

The nineteenth-century is at once the most exciting and alarming period in the history of typography. Reform typography that started about 1900 is still continuing. The New York Public Library possesses an outstanding collection of nineteenth-century typography. Some of this material has been published and may be available.

Nineteenth Century Ornamented Types and Title Pages. Nicolette Gray. London: Faber, 1938. An invaluable contribution to the study of the period by a distinguished scholar.

"American Wood Type." Rob Roy Kelly. In *Design Quarterly*, LVI, 1963. The entire issue is devoted to wood type, and the author, a leading authority, could honor the trade with a book. The Walker Art Center in Minneapolis is responsible for this distinguished quarterly.

Book Typography 1815–1965 in Europe and in the United States of America. Edited by Kenneth Day. Chicago: University of Chicago Press, 1966.

Olde Type Faces at the Tri-Arts-Press. New York: Tri-Arto-Press, n.d. A catalog of typefaces from the Frederic Nelson Phillips

Collection. These were originally cast from 1870 to 1920.

"A Check List of 19th-Century Type Specimen Books." Ralph Green. In *New England Printer*, April 1952. Has a few typographical errors but is informative.

Title Pages and Decorative Letters

One Hundred Title Pages 1500–1800. A. F. Johnson. London: Lane, 1928.

Decorative Initial Letters. A. F. Johnson. London, The Cresset Press, 1931.

Decorative Alphabets and Initials. Alexander Nesbitt. New York: Dover, 1959. A veteran teacher and writer contributes a valuable effort full of visual delights. Part 3 is devoted to the nineteenth-century. Reasonably priced.

200 Decorative Title-Pages. Alexander Nesbitt. New York: Dover, 1964. Fine material. Available at a reasonable cost.

Illustrated Historical Surveys

Illustrated historical surveys on type design and contemporary compilations of type styles have been greatly improved in recent years. These are suggestions for a classroom reference shelf.

An Introduction to the History of Printing Types. Geoffrey Dowding. London; Wace and Co., 1961. Clear and bright with fine notes and illustrations.

Alphabet in Type. Alfred Bastien and Catherine Aklin. West Drayton, Eng.: A. J. Bastien, 1958.

A Book of Type and Design. Oldřich Hlavsa. New York: Tudor, 1960. Written by a well-known Czechoslovakian designer. It has been translated, and the notes are very helpful. An outstanding effort. It should be noted that the publications emanating from Europe lean heavily on European type designs and are thus especially useful to interested Americans.

ABC of Lettering and Printing Types. 3 vols. Erik Lindegren. New York: Museum Books, 1965. Lindegren, a brilliant Swedish designer, has written three distinguished volumes, of which volumes B and C are useful in the present context.

Type. Rudolf Hostettler. Switzerland: Teufen AR, 1958. A selection of 80 important typefaces obtained with the cooperation of established European foundries.

Specimen Books

Art Directors Work Book of Type Faces. J. I. Biegeleison. New York: Arco, 1965. A veteran teacher in a well-organized display of types. The showings are large, so students can compare details of design; the notes are brief and to the point.

Type and Typography: The Designers Type Book. Ben Rosen. New York: Reinhold, 1963. A volume of 440 pages exhibiting more than 1000 fonts.

Graphic Arts Typebook. New York: Reinhold, 1965. Two of six projected volumes. Book I is devoted to 24 serif faces; Book II exhibits sans serif faces and a miscellany. Styles are shown in differing weights and with various leadings. These examples are printed by lithography; the types will look a little different when printed letterpress on handmade paper.

Type Specs. New York: Type Specs Co., 1962. With a format of 17 by 11 inches and with over 500 pages, this is one of the most comprehensive and useful specimen books ever assembled.

Type and Lettering. William Longyear. New York: Watson-Guptill, 1961. A very useful review by a veteran teacher.

Typesetting Methods

The original typesetting method of Gutenberg is still practiced. Individual letters are picked from a *case* and placed in rows on a *composing stick,* and then individual lines are massed together by hand. In catalogs, types manufactured for this method are labeled *handset* or *foundry.* American Type Founders makes a specialty of foundry type.

A method used by the Ludlow Typograph Company features special machinery. In this method matrixes are lined up by hand in a unique casting stick. This stick is then locked into a mechanism containing molten type metal, and the entire line is cast in type-high letters spaced the same way the matrixes were spaced. If a printer has the *Ludlow* equipment, his type catalog should give an indication of it. This equipment is generally used to form one line or several lines of type in *display* sizes and is not used to set text material of the kind seen in this book.

The explanation of the *Monotype* system of casting is found in its name—one piece of type is cast at a time. Each individual piece of type is cast in a fraction of a second and moves out on a belt. In this method an operator works at a keyboard machine, reading the text and pressing keys. This operation results in a punched tape like that used in player-piano mechanisms. The alphabet and elements of punctuation (period, comma, and so on) are held in a large matrix. The tape informs the casting machine which letter is to be cast next, and the matrix moves to put that particular letter into position for casting. Monotype casting machines can be programmed to print repeats of any line or to turn out question marks by the billion if supplied with enough metal. Type catalogs issued by printers who have Monotype machinery might indicate this in the catalog by a small printed word—Mono or Monotype—accompanying a type sample.

Linotype, another method of type production, involves the casting of one line of text at a time. In this method a keyboard operator triggers a matrix for letter *A* and so on, and these are then joined. When the line is finished, the operator presses a key and the line of individual matrixes, locked together, is moved into a casting position and cast in type-high relief and automatically joins the lines already completed. This method has been the backbone of newspaper and book production for a half-century. The Intertype Company features a similar method of type production.

Printers of small jobs will set type by hand and buy foundry type from ATF and other firms who sell type. Larger printing firms may have Linotype, Ludlow, and Monotype machines, as well as cases of handset foundry type. If a catalog is not clear, the printer should be asked what he has in the way of equipment for typesetting. The larger Linotype companies usually do not carry the Monotype designs in their Linotype catalog.

The only way really to understand typesetting machines is to go to a newspaper office or a printing firm and see them in operation. A few weeks of typesetting by hand will augment the learning process.

Photosetting equipment has been in use now for more than ten years. In this process alphabets are projected on photosensitive plates for use in lithography or gravure printing. The Lanston Monotype Company can furnish a booklet concerning the functions of one of the photosetting machines in use today.

The 1967 *Penrose Annual* contains an article on photo-composition by Klaus F. Schmidt.

Type Manufacturing Firms

Listed below are some of the important firms who manufacture and sell type. These firms publish type catalogs that may be useful in explaining the differences between Old Style Roman and Modern Roman fonts. Then too, neophyte printers will need a gradual acquaintance with the range or proliferation of type designs. Although not documented, type catalogs carry the imprint of history; many of the styles found in them were designed by brilliant figures of past generations, although, roughly speaking, few designs created as long ago as 1900 remain in the printing repertoire. Most designs based on the past have been reworked.

American Type Founders, 200 Elmira Avenue, Elizabeth, N. J. Specialists in foundry type.

Lanston Monotype Company, 3620 G Street, Philadelphia, Pa.; branches in Toronto, New York, Chicago, Atlanta, and San Francisco.

Mergenthaler Linotype Company, 29 Ryerson Street, Brooklyn, N. Y. Their specimen book of Linotype faces is 2½ inches thick, costly, and difficult to procure. Some of their smaller publications may serve as well.

Intertype Company, 360 Furman Street, Brooklyn, N. Y.

Ludlow Typograph Company, 2032 Clybourn Avenue, Chicago, Ill.

Typefounders of Chicago, 1100 South Kostner Avenue, Chicago, Ill. They have foreign language fonts and some European designs, including Centaur, Bembo, and Palatino.

American Printing Equipment and Supply Company, 42–45 Ninth Street, Long Island City, N. Y. This firm carries a line of wood type in large sizes.

Monsen Typographers, Inc., 22 East Illinois Street, Chicago, Ill.

Mackenzie & Harris, Inc., 659 Folsom Street, San Francisco, Calif.

Foreign Type Houses

For technical reasons, types manufactured in Europe cannot be used in the United States. Type designs that cross the ocean either way must be recast to conform to type-high and shoulder-to-paper measurements. The exchange of ideas between the United States and Europe involves only England, the Netherlands, and Germany; and these ties, starting anew in the twentieth century, are reflected in commercial enterprises that exhibit some common views on the subjects of esthetics and legibility.

The divisions of the Monotype Corporation in the United States and England are closely aligned. Important German designs are promoted in the United States by Bauer Alphabets in New York. Typefoundry Amsterdam is represented in New York by Amsterdam Continental Types and Graphic Equipment, Inc. No survey books can reveal the flavor and intent of European type design, and thus European type catalogs are the principal source of our knowledge of these developments.

The Monotype Corporation Limited, 43 Fetter Lane, London W. C. 4. A sponsor of many fine designs, this firm has pub-lished some excellent essays, which are available at a reasonable cost.

Stephenson Blake & Company, Ltd. The Caslon Letter Foundry, Sheffield, England. A fine catalog explains the lineage which goes back to William Caslon I (1720–1794).

Lettergieterij, Joh. Enschedé en Zonen, Haarlem, Holland. This distinguished type house features a catalog of such excellence that it is a model of type usage. As a teaching guide it is better than most texts.

Typefoundry Amsterdam, Amsterdam, Holland.

Bauersche Giesserei, Frankfurt am Main, West Germany. A distinguished type house with its own distinguished history. Dr. Konrad F. Bauer and E. R. Weiss are among those who contributed to its great reputation.

D. Stempel A G, 6 Frankfurt am Main, West Germany. This firm took over the designs of the famous Klingspor institution. Small catalogs are available from Amsterdam Continental in New York.

C. E. Weber Schriftgiesserei, Immenhofer Strasse 47, Stuttgart, Germany.

Johannes Wagner Gmb H, Romerstrasse 35/37, Ingolstadt, Germany. This southern German firm has a connection with Castcraft of Chicago.

Berthold Type Foundry, 43 Mehringdamm, Berlin S. W. 61, West Germany.

Ludwig & Mayer, Hanauer Landstrasse 187–189, Frankfurt am Main, West Germany. Has numerous catalogs.

Haas'sche Schriftgiesserei A G, Munchenstein, Switzerland.

Fonderies Deberny et Peignot, 18 Rue Ferrus, Paris, France. Requests may bring folio material exhibiting sharp and elegant designs unavailable elsewhere.

Fonderie Olive, 28 Rue Abbé-Feraud, Marseille, France.

Società Nebiolo, Turin, Italy. Designs by this firm are embedded in the new graphics of Italy. Aldo Novarese, in response to the resurgence of interest, offers Eurostyle, a new sans serif alphabet.

CHAPTER 8 MORRIS, DADA, AND BAUHAUS

The Books of William Morris, Harry B. Forman; London: F. Hollings, 1897.

The Life of William Morris. John Williams Mackail. Oxford, Eng.: Oxford University Press, 1950.

The Kelmscott Press and William Morris, Master Craftsman. H. Holiday Sparling. London: Macmillan, 1924.

William Morris, Designer. Gearald H. Crow. A special number of *Studio* edited by C. G. Holme, London, 1934.

The Typographical Adventure of William Morris. London: William Morris Society, 1958. An exhibition catalog.

William Morris and the Kelmscott Press. Providence, Rhode Island, Brown University Press, 1960. An exhibition catalog.

Private Presses and Their Books. Will Ransom. New York: Bowker, 1929. There is a pitiable lack of scholarship—historical, esthetic, or any other—in this area of cultural importance.

Journal of the Printing Historical Society. Edited by James Mosley. St. Bride Institute, London.

Private Press Books. Edited by Roderick Cave, David Chambers, and Peter Hoy. Pinner, Eng. A periodical of great interest.

Printing for Pleasure. John Ryder. London: Phoenix House, 1955.

Any attempt to list important books issued by private presses is quite beyond the scope of this text. Yet there are several publications that perhaps owe their existence to the revival of interest in fine printing, and these could benefit students of printing.

The Oxford Lectern Bible. Oxford, Eng.: Oxford University Press, 1935. One of the monumental publishing efforts of this century. The Smithsonian Institute has a copy printed on special paper. The Bible features Centaur types by Bruce Rogers, which were designed in a 22-point size but recast on a 19-point body. Booksellers may be able to provide a page from this publication at a modest sum. Novices should try to get a solid page of type to see why Centaur is a classic among modern book faces.

Aventur und Kunst. Konrad F. Bauer. Frankfurt am Main: Bauer-sche Giesserei, 1940. An illustrated chronological history of printing. The pages are set in a modified black letter and are beautiful to see. The house of Bauer was rich in talent, having such a brilliant type designer as E. R. Weiss, and a good bit of this went into *Aventur und Kunst.*

The Alphabet and Elements of Lettering. Frederic W. Goudy. Berkeley: University of California Press, 1942. First published in 1918 by Mitchell Kennerly in New York. Subsequent revisions and additions are seen in the 1942 edition. Not all Goudy wrote is well-liked; his book on the Trajan letters is not widely admired. However, most historical examples of letter structure are Goudy interpretations, for Goudy's genius lay in his ability to draw alphabets and see them come through the technical processes of conversion to type and work well on the page. If this amazing knack is discernible at all, perhaps this volume will reveal it. It is also available in a Dover reprint (New York, 1963). Some of the details of Goudy's life can be absorbed in *Behind the Type.* Bernard Lewis. Pittsburgh: Carnegie Institute of Technology, 1941.

Typologia. Frederic W. Goudy. Berkeley: University of California Press, 1940. Studies in and comments on type design, legibility, and so on.

Pi: A Hodge-Podge of Letters, Papers and Addresses Written during the Last Sixty Years. Bruce Rogers. Cleveland and New York: World, 1953. A distinguished career recorded in the form of personal comment, including the travail of Rogers' part in the publication of the Oxford Lectern Bible. See also *Bouquet for B.R.* New York: The Typophiles, 1950, limited-edition tribute to Rogers with remarks written out in a dozen hands; and *The Works of Bruce Rogers: A Catalog of an Exhibition Arranged by the American Institute of Graphic Arts and the Grolier Club of New York.* New York: Oxford University Press, 1939. Several of Rogers' sketches are shown, with a list of 768 productions in which he was involved.

Liber Librorum. Stockholm: Bror Zachrisson, 1955. In celebration of the 500th anniversary of the Gutenberg 42-line Bible, leading printers in the various countries were invited to design and print part of Genesis. The result is a beautiful portfolio edition, featuring differing type styles, papers, and formats. A very useful publication for classroom discussion.

Books and Printing. Paul A. Bennett. Cleveland: World, 1963. A group of essays.

Art Nouveau. Edited by Peter Selz and Mildred Constantine. New York: The Museum of Modern Art, 1959. The section on graphic design by Alan M. Fern is pertinent in this fine review.

Calligrammes. Guillaume Apollinaire. Paris: Club du Meilleur Livre, 1955. Poetry in French. The Calligrammes of 1913–1916 are reproduced at the end.

Guillaume Appollinaire, 1880–1918, Vol. 1. Prague: State Publishing House of Fine Arts and Literature, 1965. Shows the full range of Apollinaire's wit and invention.

An Anthology of Concrete Poetry. Edited by Emmett Williams. New York: Something Else Press, 1967. Here the new typographic poetry takes off from Apollinaire.

Schrift. Fritz H. Ehmcke. Hannover, 1925. The state of letter structure in the first two decades of the century are well described in illustration, including some Art Nouveau type designs.

Dada Gedichte. Zurich: Verlag die Arche, 1957. A small book featuring the typography of Hans Arp, Hugo Ball, Tristan Tzara, and many others.

Kurt Schwitters. New York: Marlborough-Gerson Gallery, 1965. A catalog of a retrospective exhibition, with good reproductions and an excellent biographical review, giving clues on Schwitters as a writer and typographer.

Die neue Typographie, Jan Tschichold, Berlin: Vergriffen, 1928. Written when the author was still imbued with the Bauhaus spirit.

Bauhaus 1919–1928. Edited by Herbert Bayer, Walter Gropius, and Ise Gropius. New York: Museum of Modern Art, 1938. Reissued by C. T. Branford (Boston, 1959).

CHAPTER 9 CALLIGRAPHY IN REVIVAL

A number of fine performers in the area of pen calligraphy have been involved in the design of types. There is no attempt here to segment the whole talent into its separate parts. In a general way the entries here follow the text, except for the first group of books which deserve special emphasis.

The New Handwriting. M. M. Bridges. London: Oxford University Press, 1898. The poet Robert Bridges and his wife were among the first people of influence to implement the Morris ideal through personal action.

Writing and Illuminating and Lettering. Edward Johnston. London: Pitman, 1906. The most influential book of the revival. Still in print.

Manuscript and Inscription Letters, for Schools and Classes and for the Use of Craftsmen. Edward Johnston, with plates by Eric Gill. London: J. Hogg, 1911. A folio publication reissued by Pitman (London, 1946).

Lettering. Graily Hewitt. London: Seeley Service and Co., 1930; Philadelphia: Lippincott, 1930. A superb volume based on research work on techniques by a distinguished leader in the London revival. Reprinted in 1954.

Pen and Graver. Hermann Zapf. New York: Museum Books, 1952. An edition in English of *Feder und Stichel.* A superb piece of book production featuring the works of the contemporary master calligrapher Hermann Zapf. Printed on Fabriano paper with Zapf's Palatino types.

The Calligrapher's Handbook. Edited by Cecil Mortimer Lamb. London: Faber, 1956. Eleven essays by well-known students of Johnston and other experts on a variety of technical subjects pertaining to calligraphy and bookmaking, such as pigments, inks, skins, papers, gilding and binding. There are 50 illustrations. Advanced students will need this book.

Calligraphy and Palaeography. Edited by A. S. Osley. New York: October House, 1965. A collection of 27 essays presented to Alfred Fairbank on his seventieth birthday. Many of the better scholars and calligraphers have made valuable contributions: B. L. Ullman, Berthold L. Wolpe, Philip Hofer, Ray Nash, Lloyd Reynolds, Nicolette Gray, Bent Rohde, Paul Standard, and others. A fine volume and much needed in any library, though a little too highly priced for most students.

Calligraphy Today. Heather Child. New York: Watson-Guptil, 1964. The notes starting with William Morris are brief but good. Has many excellent reproductions of the best contemporary calligraphers and those of the revival. Child is one of Britain's leading calligraphers.

Edward Johnston. Priscilla Johnston. London: Faber, 1959. An admired biography of this distinguished leader.

Autobiography. Eric Gill. London: J. Cape, 1947. Gill, a master craftsman, was also a unique individual in a long line of strong Britons endowed with odd crosses between conformity, eccentricity, and genius.

Sculpture: An Essay on Stone-Cutting. Eric Gill. Ditchling, Sussex Eng.: St. Dominic's Press, 1924.

Letters. Edited by Walter Shewring. New York: Devin-Adair, 1948. Offhand messages to friends, converted to type, with a few examples of Gill's skilled calligraphy.

Eric Gill: His Social and Artistic Roots. Edward M. Catich. Iowa City: The Prairie Press, 1964. The Society of Typographic Arts, Chicago, sponsored a comprehensive showing of Gill's work at the Newberry Library. Catich delivered the remarks and these are the basis for this text, a limited edition.

Eric Gill, Twentieth Century Book Designer. Sister Elizabeth Marie, I.H.M. New York: Scarecrow, 1962. A review of Gill's sources and work in illustration and typography. Excellent on Gill, but not well printed.

An Essay on Typography: Eric Gill. London: Dent, 1960. On a popular level Gill is better known through inscription renderings of the Roman letter. Gill's type designs were notable in their own time and in his native country.

Continental Figures

Unterricht in Ornamentaler Schrift. Rudolf von Larisch. Vienna: K. K. Hofund Staatsdruckerei, 1940. The eleventh edition of this pioneer work in Europe, with over 50 reproductions.

Beispiele Kunstlerischer. Edited by Rudolf von Larisch. Vienna: Staatsdruckerei, 1902–1926. In three volumes featuring various continental penmen. Vol. 2 has 35 plates; Vol. 3 has 37.

Kuntschrift und Schriftkunst. H. Busch and H. Crossman. Dusseldorf: M.-Gladbach, B. Kühlen, 1927. German lettering with 196 examples.

Titel und Initialen für die Bremmer Presse. Anna Simons. Munich: Verlag der Bremmer Presse, 1926. Work accomplished by the celebrated German calligrapher for the Bremmer Press.

"Lettering in Book Production," Anna Simons. In *Lettering of Today,* Geoffrey Holme, London, 1937. A special and outstanding edition of *The Studio,* with articles by Alfred Fairbank and Percy J. Smith.

Anna Simons Festschrift. Edited by Fritz H. Ehmcke, Munich: Verlag der Corona, 1934. Tribute to one of the century's pioneer calligraphers, with contributions by Johnston, Morison, Von Larisch, and others.

Alphabets. Imre Reiner. St. Gall: Zollikofer, 1947. A small book on historically important hands by a leading European designer of letters.

Johnston, Larisch, Koch: Drei Erneuren der Schreibkunst. Otto Hurm. Mainz: Int. Gutenberg-Gesellschaft, 1956. By a very skilled German calligrapher.

Rudolf Koch. Oskar Beyer. Kassel and Basel: Bärenreiter Verlag, 1953. An excellent book on the great German master, featuring many reproductions of his work. In German.

The Book of Signs. Rudolf Koch. New York: Dover, 1955. A reprint of an older work on the graphic symbols of history, with 493 examples originally executed by Fritz Kredel, a product of Koch's workshop.

Schriften, Lettering, Écritures. Walter Käch. Olten: Verlag Walter, 1949. A contemporary German master explains cursive and drawn letters in three languages.

Schriftvorlagen für Schreiber, Buchdrucker, Maler, Goldschmeide, Stickerinnen und andere Handwerker. Berthold Wolpe. Kassel: Bärenreiter Verlag, 1934, 1947. A small volume by the German-trained English scholar and designer.

Hermann Zapf, Calligrapher, Type-Designer, and Typographer. Cincinnati: The Contemporary Arts Center, Cincinnati Art Museum, 1960–1961. A catalog for an exhibition.

About Alphabets: Some Marginal Notes on Type Design, Chap Book 37. Hermann Zapf. New York: The Typophiles, 1960.

Manuale Typographicum. Hermann Zapf. New York: Museum Books, 1954. One hundred typographic arrangements in sixteen languages. German edition published by Georg Kurt Schauer, Frankfurt.

The ABC of Lettering and Printing Types. Vol. A. Eric Lindegren. New York: Museum Books, 1964. Volume A, *Lettering,* applies here.

Recent English Writings

"Writing and Lettering." M. C. Oliver. In *Fifteen Craftsmen on Their Crafts.* London: The Sylvan Press, 1945. Many artists in Britain studied with Oliver or one of his students.

Civic and Memorial Lettering. Percy J. Smith. London: A. & C. Black, 1946.

A Book of Scripts. Alfred Fairbank. Harmondsworth, Eng.: Penguin, 1949; revised 1950, 1952. Short but full of interesting material by the distinguished student of Hewitt who centered on the italic style and recreated it in calligraphy and scholarship.

A Handwriting Manual. Alfred Fairbank. Leicester: Dryad, 1932; revised 1954. See also Fairbank's *Woodside Writing Cards* (1932); *Barking Writing Cards,* later; *Dryad Writing Cards* (1935); and the *Beacon Writing Books.*

Written by Hand. Aubrey West. London: G. Allen, 1951. A small review featuring a number of cursive hands.

Sweet Roman Hand. Wilfrid Blunt. London: J. Barrie, 1952. A small volume devoted to italic and other cursive hands.

Modern Lettering and Calligraphy. Edited by Rathbone Holme. London and New York: Studio Publications, 1954.

Calligraphy and American Letter-Form Traditions

American Writing Masters and Copybooks. Ray Nash. Boston: Colonial Society of Massachusetts, 1959. This illustrated volume goes through Colonial times and includes a bibliography.

Fraktur: The Illuminated Manuscripts of the Pennsylvania Dutch. Frances Lichten. Philadelphia: Free Library of Philadelphia, 1958. Bearing on one of the best collections of its kind.

Gravestones of Early New England. Harriet M. Forbes. Boston: Houghton Mifflin, 1927; New York: Da Capo, 1967.

Early New England Gravestone Rubbings. Edmund Vincent Gillon, Jr. New York: Dover, 1966. Has 195 plates; instructive, touching, and hilarious.

"New England Gravestone Rubbings." Ann Parker and Avon Neal. In *Craft Horizons*, July/August, 1963. A hint on the technique of obtaining good rubbings from relief works.

Lettering. Thomas Wood Stevens. New York: Prang, 1916. Has 108 reproductions of alphabets and sample pages. A review of an era, featuring work by Dwiggins, Goudy, Oz Copper, and others.

On the Technique of Manuscript Writing. Marjorie Wise. New York: Scribner, 1924. The need for this kind of book in the United States is expressed by the sale of 19,000 copies as of 1942.

Handwriting for the Broad-Edge Pen. Frances M. Moore. Boston: Ginn, 1926. One of the earliest and most successful books on calligraphy published in the United States. Moore was a student of Hewitt in London.

The Anatomy of Lettering. Warren Chappell. New York: Loring & Mussey, 1935. A short study by a distinguished leader in American letter design who studied with Koch in Germany. The work was motivated by Koch's death.

Calligraphy: Flowering, Decay and Restoration. Paul Standard. Chicago: The Society of Typographic Arts, 1947. A small, well-written story by one of the elder statesmen among calligraphers in the United States. Some bibliographies mention an edition by the Sylvan Press in 1948.

Elements of Lettering. John Howard Benson and A. G. Carey. New York: McGraw-Hill, 1950. This does not have everything a teacher might desire, but it is a useful and respected publication.

The Book of Oz Cooper. Chicago: Society of Typographic Arts, 1949. A project by the Society of Typographic Arts, filled with Cooper's drawings, lettering, and Americana writings. Cooper's wit is engaging. There are handwritten passages by Ray DaBoll, with commentary by Goudy, Dwiggins and others. Cooper is known through types bearing his name, but this volume uncovers a rare human being.

Rules of Civility. George Washington. New Haven: Lewis Glazer, 1952. Calligraphy by Robert Gillam Scott, with illustrations by Leo S. Sloutsenberger. Work with the quill pen.

The First Writing Book: Arrighi's Operina. Edited by John Howard Benson. New Haven: Yale University Press, 1954. Mentioned again for Benson's calligraphy in the front matter and for his English version of Arrighi's pages.

Calligraphics—Hands and Forms. New York: Typophiles, 1955. Foreword by Paul Bennett, with 25 samples of writing by as many expert American calligraphers. For some reason this is not as successful as might be wished.

Salter: A Third of a Century of Graphic Work. George Salter. New York, 1961. A catalog for an exhibition, featuring the calligraphy and graphic designs of one of the best calligraphers the United States has produced.

Am Wegesrand. Fritz Kredel and George Salter. Frankfurt am Main: Bauersche Giesseri, c. 1962. A unique collaboration between one of Rudolf Koch's students (and collaborators) and the distinguished American calligrapher Salter on a promotional piece. Kredel, who with Koch produced the distinguished *Blumenbuch* in the 1930s, has worked in the United States for many years.

State of the Sky, December 1958. James Thomas Mangan. Phoenix: Acorn Press, 1958. Designed and written by Ray DaBoll, one of the skilled veterans of United States calligraphy.

The Art of Fine Lettering. Sister Michaeline Lesiak, O.S.F. Notre Dame and London: University of Notre Dame Press, 1965. Notable for its technical notes.

Exhibition Catalogs

Calligraphy—The Golden Age and Its Modern Revival. Portland: Portland Art Museum, 1958. A brief survey of historical examples. Illustrations from the revival era and contemporary times up to the date of publication. A fine museum and a fine teacher and calligrapher, Lloyd Reynolds, make this a valuable study.

Calligraphy and Handwriting in America 1710–1962. Caledonia, N.Y.: Italimuse, 1963. The exhibition was compiled by P. W. Filby of the Peabody Institute Library in Baltimore. Examples from American writing manuals, Dwiggins, Benson, and contemporary figures. Reproductions by Meriden Gravure. Italimuse is a company that publishes a number of small manuals on italic writing, and good pen points and fountain pens are available through them.

Two Thousand Years of Calligraphy. Baltimore: The Walters Art Gallery, 1965. A comprehensive study parallel with an exhibition sponsored by several institutions in Baltimore. Good notes lead to a section on contemporary calligraphers. There are about 200 reproductions in this excellent review, and every teaching studio should have it. The type used is Bembo, and the reproductions are by Meriden Gravure.

Artists and Popular Calligraphers

Schrift und Bild. Frankfurt am Main: Typos Verlag Frankfurt am Main, 1963. In other words, *Art and Writing.* Based on a monumental exhibition at Baden-Baden and Amsterdam to show how modern artists have used letters. The best source known. Available from the Something Else Press, New York.

Love and Joy about Letters. Ben Shahn. New York: Grossman, 1963. Shahn was an apprentice to a firm of lithographers and learned to do the precise work on stones. This sense of craftsmanship never left him. The barriers between calligraphy, typography, drawing, and color seem to dissolve in Shahn's work. It is a beautiful book and every reader ought to see it.

Lettering by Modern Artists. New York: Museum of Modern Art, 1964. Notes by Mildred Constantine. A catalog on a fine exhibition.

Graffiti. Brassaï (Gyula Halász). Stuttgart: Chr. Belser Verlag, 1960. An impressive photographic study of wall etchings and popular calligraphy. A very moving book.

CHAPTER 10 GRAPHIC DESIGN AND THE ALPHABET

"Basic Alphabet." Herbert Bayer. In *Print*, May/June 1964. A brief review of the alphabetic reform long advocated by this distinguished designer.

ABC of Lettering and Printing Types, Vol. C. Eric Lindegren. New York: Museum Books, 1964. Volume C is a historical review, beautifully designed and illustrated, with valuable material on the movements under consideration.

Typography: Basic Principles. John Lewis. New York: Reinhold, 1964. A small, well-illustrated book on influences and trends in typography since 1900.

Lettering Today. Edited by John Brinkley. New York: Reinhold, 1965. First published by Studio Vista, London, this is an excellent survey and reference work on contemporary letter usage. There is an introduction and four sections, each written by a leading authority.

Typography. Aaron Burns. New York: Reinhold, 1961. An essential book on contemporary practice by one of the strongest exponents of a new role for typography. A big and handsome effort.

Typographic Directions. Edited by Edward M. Gottschall. New York: Art Directors Book Co., 1964. Designed by Herbert Lubalin, this excellent work demonstrates how typography is combined with contemporary images in advertising. The reproductions are poor, but the ideas come through.

Alphabet 1964. Edited by R. S. Hutchings. London: James Moran, 1964. Contains a number of valuable articles, including "Television Typography," by Brian Innes.

Letter Design in the Graphic Arts. Mortimer Leach. New York: Reinhold, 1960.

Lettering for Advertising. Mortimer Leach. New York: Reinhold, 1960.

d/a, Vol. LI, No. 4, 1965. Published by the Paper Makers Advertising Association, Westfield, Mass. This particular issue is devoted to articles on typography, including "Computer Typography" and "Typomundus 20," a report on a 1965 exhibition sponsored by the International Center for the Typographic Arts in New York. Slides from the Typomundus 20 exhibition are available through ICTA. A review of this momentous exhibition can be found in *Graphis*, Vol. XXI, No. 121, 1965.

Design with Type. Carl Dair. Toronto: University of Toronto Press, 1967. The late veteran teacher and printer gives an excellent text, which should be examined by all students of typography and its role in modern communication.

Typography. Emil Ruder. New York, Hastings, 1967; Teufen, Switzerland: Arthur Niggli, 1967.

CHAPTERS 11 and 12 STRUCTURE AND LABORATORY EXPERIENCE

There is no specific list of publications narrowly devoted to the structure of letters, nor are there any manuals that outline or suggest laboratory problems. Other parts of the Notes and Bibliography list books that should be useful to designers of letters. For advanced techniques concerning pen calligraphy, books by Johnston and Hewitt and those edited by Lamb and Osley should be consulted. Listed here are those publications that should be useful to any studio application. The second group of publications has several sources known to be available at a reasonable cost. A number of survey volumes follows.

A Development and Lineage Theory for the Roman Alphabet. Edward M. Catich. A chart available from Mohawk Paper Mills, Inc., Cohoes, N.Y.

The Roman Letter. James Hayes. Chicago: Donnelley, 1951. An excellent short review of letter development from Roman times to the Renaissance by the best calligrapher in the Chicago area. A reprint appears in *The Donnelley Printer*, Fall, 1966.

Roman Lettering. London: Victoria and Albert Museum, 1958. A fine group of alphabets, including the Trajan letters and those of Cresci.

A Book of Sample Scripts: The House of David, His Inheritance. Edward Johnston. London: Victoria and Albert Museum, 1966. This is the outstanding manuscript left by Johnston, completed in 1914. This inspirational work is available in the United States through British Information Services in New York.

Scriptura Latina Libraria a Saecalo Primo usque ad Finem Medii Aevi. Joachim Kirchner. Munich: R. Oldenbourg, 1955. The back matter contains a valuable review of European pen hands from Roman times to the Renaissance.

The Development of Writing. Hs. Ed. Meyer. Zurich: Graphis Press, 1964. A short review of historic pen hands that is quite valuable in spite of its mixture of methods of representation.

Reasonably Priced Books

A Study of Writing. Ignace J. Gelb. Chicago: University of Chicago Press, 1963.

"The Art of Writing," *The UNESCO Courier*, March, 1964.

The History and Technique of Lettering. Alexander Nesbitt. New York: Dover, 1957. Nesbitt's recreations of historic styles are often "copied" or "freely copied" from existing manuscripts, but his interpretations are admirable and can be trusted.

Three Classics of Italian Calligraphy. Edited by Oscar Ogg. New York: Dover, 1953.

The First Writing Book: Arrighi's Operina. Edited by John Howard Benson. New Haven and London: Yale University Press, 1955. Now available in paperback.

The Alphabet and Elements of Lettering. Frederic W. Goudy. Berkeley: University of California Press, 1942; New York: Dover, 1963.

On the Just Shaping of Letters. Albrecht Dürer. New York: Dover, 1965.

Decorative Initials and Alphabets. Alexander Nesbitt. New York: Dover, 1959.

A Book of Signs. Rudolf Koch. New York: Dover, 1955.

Five Hundred Years of Printing. S. H. Steinberg. Baltimore: Criterion, 1959.

Typography: Basic Principles. John Noel Claude Lewis. London: Studio Books, 1963; New York: Reinhold, 1964.

Survey Volumes

Die Schrift. Hermann Degering. Berlin: Verlag von Ernst Wasmuth, 1929. This survey volume has 240 plates featuring European developments in letter usage from Roman times.

Hoffmanns Schriftatlas. Alfred Finsterer. Stuttgart: Julius Hoffman, 1952. A large format with 210 pages devoted to historical examples. Excellent.

Deutsche Schriftkunst. Albert Kapr. Dresden: Verlag der Kunst, 1959. Another large format with numerous reproductions of historical styles.

Storia della stampa. Piero Trevisani. Rome: Raggio, 1953. A large review of written and printed forms with many fine reproductions.

Alphabets: A Manual of Lettering for the Use of Students, with Historical and Practical Descriptions. Edward F. Strange. London: Strange, Bell, and Sons, 1898. Has 200 illustrations.

Treasury of Alphabets and Lettering. Jan Tschichold. New York: Reinhold, 1966. This is a translation of *Meisterbuch der Schrift,* Ravensburg: Maier, 1952.

CHAPTER 13 GREEK CALLIGRAPHY

In the Middle Ages some scribes wrote texts they could not read. It is not a recommended procedure, but the writing traditions in Greek, Hebrew, and Arabic are important. In the past, lack of source material has inhibited classroom participation in foreign scripts. The publications listed here may help reduce this difficulty to some degree.

Introduction to Greek and Latin Palaeography. Edward Maunde Thompson. London: Oxford University Press, 1912. Recent reprints are not as good as the original edition.

Dated Greek Minuscule Manuscripts to the Year 1200. Kirsopp and Silva Sake. Boston: American Academy of Arts and Sciences, 1934. A series of facsimile volumes showing Greek scripts over a long period.

Proben aus Griechischen Handschriften und Urkunden. Franz Steffens. Trier: Schaar and Dathe, 1912. Has 24 plates.

Codex Alexandrinus. 5 vols. London: British Museum, 1909–1957. A facsimile in reduced size.

The Codex Sinaiticus and the Codex Alexandrinus. Notes by H. J. Milne and T. C. Skeat. London: British Museum, 1963. A publication on the origins of the two great uncial Bibles held by the British Museum.

The Palaeography of Greek Papyri. Frederic G. Kenyon. London: Oxford University Press, 1899. Twenty facsimiles and a table of alphabets.

Veröffentlichungen aus der Papyrus-Sammlung. Munich: Der K. Hof-Und Staatsbibliothek zu München, 1914. Volume I, *Byzantinische Papyri,* has 37 huge collotype plates on some of the wildest Greek cursive to be seen anywhere.

CHAPTER 14 ARAMAIC MOVES EAST

Corpus Inscriptionum Semiticarum. 5 series. Paris: Académie des Inscriptions et Belles-Lettres, 1881–1951. A continuous series devoted to Semitic scripts. Thousands of collotype reproductions and, within the limitations of the title, the best source known. Features carved letters.

Specimina Codicum Orientalium. Eugene Tisserant. Bonn: A. Marcus and E. Weber, 1914. A fabulous source book. There are 80 plates on Samaritan, Hebrew, Syriac (several branches), Mandaean, Arabic, Ethiopic, and Coptic scripts. The item closing the volume, Codex Polyglottus, is a manuscript in five languages. Features pen calligraphy.

Semitic Writing. G. R. Driver. London: Oxford University Press, 1944. An excellent source on the origin of Semitic scripts.

Aramaic Documents of the Fifth Century B.C. G. R. Driver. London: Oxford University Press, 1954. The author is a well-known scholar. Some very clear facsimiles.

Aramaic Incantation Texts from Nippur. James Alan Montgomery. Philadelphia: University of Pennsylvania Museum, 1913. An interesting book on earthenware bowls acquired by the University of Pennsylvania Museum.

Aramäische Papyrus und Ostraka aus Elephantine. Eduard Sachau. Leipzig: Generalverwaltung der Königlichen Museen zu Berlin, 1911. A great find of fifth century B.C. Aramaic documents found on an island in the Nile River. Has facsimiles.

A Brief Course in the Aramaic Language. George M. Lamsa. New York: Aramaic Bible Society, 1961. Alphabetic characters cut from an old manuscript.

Armenische Palaeographie. Franz Nikolaus Finck. Tübingen: K. Universitätsbibliothek zu Tübingen, 1907. Good for getting an idea of what Armenian calligraphy looks like.

Catalogue of the Ethiopic Manuscripts in the British Museum. W. Wright. London: British Museum, 1877. Thirteen plates on this unique script.

Documents de l'époque mongole des XIII et XIV siècles. Prince Roland Bonaparte. Paris: Prince Roland Bonaparte, 1895. Fifteen large intaglio plates on Mongol pen scripts, Chinese and Indian inscriptions.

Tocharische Sprachreste. Emil H. Sieg and W. Siegling. Berlin and Leipzig: W. de Gruyter, 1921. Many reproductions of scripts from central Asia.

Die Soghdischen Handschriftenreste des Britischen Museums. Hans Reichelt. Heidelberg: C. Winter's Universitätsbuchhandlung, 1928. Reproductions of the vigorous Sogdian script.

Die Chinesichen Handschriften und Sonstigen Klinfunde Sven Hedins in Lou-Lan. August Conrady and Karl Himlys. Stockholm: Generalstabens Litografiska Anstalt, 1920. Some reproductions of Asian writings derived from Hedin's Swedish expedition.

Scripts of India

Kharosthi Inscriptions. Edited by A. M. Boyer *et al.* London: Oxford University Press, 1929. A script derived from Aramaic and important in the development of writing in the north of India. Shows pen letters written on wood.

Indian Palaeography. Ahmed Hasan Dani. London: Oxford University Press, 1963. A readable account of a difficult subject.

Epigraphia Indica. Calcutta: Government of India Press, 1888 – . A long series featuring rubbings of ancient Indian inscriptions, some strikingly beautiful.

Specimens of Calligraphy in the Delhi Museum of Archaeology. Maulvi Zafar Hasan. Calcutta: Archeological Survey of India, 1925. Has 103 reproductions on 13 plates.

CHAPTER 15 SYRIAC, ARABIC, AND HEBREW

Writing Arabic. T. F. Mitchell. London: Oxford University Press, 1958. For beginners who want the Ruq'ah version of Arabic. Has notes on whittling the pen and holding it.

The Rise of the North Arabic Script. Nabia Abbott. Oriental Institute Publications Vol. L. Chicago: University of Chicago Press, 1939. An account of the modest origins of Arabic writing styles that were to become world renowned.

Arabic Palaeography. Edited by Bernhard Moritz. Cairo: The Khedival Library, 1905. Has collotype reproductions by the famous Max Jaffe of Vienna. The richness of this amazing twenty-pound portfolio volume on Arabic scripts and book covers is almost unbelievable.

Catalogue of Arabic Papyri in the John Rylands Library, Manchester.
D. S. Margoliouth. Manchester: University of Manchester
Press, 1933. Marvelous cursive writing in 40 plates.

Specimens of Arabic and Persian Palaeography. A. J. Arberry.
London: India Office, 1939. Black-and-white reproductions
covering many varieties in Arabic scripts. Very informative.

*Die Arabischen, Persischen, und Turkischen Handschriften der
Universitätsbibliothek zu Uppsala.* 2 vols. Karl Vilhem Zetter-
stéen. Uppsala: Almquist and Wiksell, 1930–1935.

A Monograph on Moslem Calligraphy. M. Ziya-al-Din. Visva-
Bharati Studies No. 6. Calcutta: Visva-Bharati, 1936. This has
163 illustrations of various styles.

Inscriptions arabes d'Espagne. E. Lévi-Provençal. Leiden and
Paris: E. J. Brill, 1931. The role of Arabic script in architec-
ture may be seen in 185 examples. Photographs reproduced
in collotype by the famous house of E. J. Brill.

Calligraphers and Painters. Washington, D. C.: Smithsonian Insti-
tution, 1959. A treatise on various phases of the calligrapher's
art by Qādi Ahmad c. 1606. No illustrations but enjoyable and
instructive reading.

Islamische Schriftbander Amida-Diarbeker XI Jahrhundert. Samuel
Flury. Basel and Paris: Frobenius A. G., 1920. Has some repro-
ductions in the text and 14 plates.

Oriental Manuscripts of the John Frederick Lewis Collection. Mu-
hammed Ahmed Simsar. Philadelphia: Philadelphia Free
Library. 1937. A descriptive catalog with 48 illustrations.

"Mediaeval Arabic Bookmaking and Its Relation to Early Chem-
istry and Pharmacology." Martin Levey. In *Transactions of the
American Philosophical Society,* Vol. 52, No. 4 (New Series),1962.
Recipes and procedures are explained in an important paper.

Initials and Miniatures of the 9th, 10th and 11th Centuries. Archer
M. Huntington. New York: DeVinne Press, 1904. From a col-
lection in the British Museum. There are many reproductions
in color, but only 350 copies were printed.

Eski Yazilari Okuma Anahtari. Mahmud Yazir. Istanbul: B. Cum-
huriyet, 1942. Investigates Turkish letter formations; has 104
plates.

Album de paléographie arabe. Georges Vajda. Paris: A. Maison-
neuve, 1958. This volume covers Arabic scripts from 11 dif-
ferent geographical areas. There are 94 plates. An excellent
source book.

Hattat. Hafir Osman Efendi. Istanbul: Ibrahim Horoz Basimevi,
1949. A small monograph on a famous Turkish calligrapher
of the seventeenth century. Biographical notes are in English.

"The Flourishing Reed, Arabic Scripts." Walter Tracy. In
Alphabet 1964. London: James Moran Ltd 1964. An excellent
short article with a lot of substance.

Hebrew

The Dead Sea Scrolls. Menahem Mansoor. Leiden: E. J. Brill,
1964. Available from Wm. B Eerdmans, Grand Rapids, Michi-
gan. Has no reproductions but may satisfy a curiosity. There
are many publications on the subject presuming knowledge.
Prof. Mansoor explains what the Dead Sea Scrolls are and
why they are important. Library subject catalogs should re-
veal some sources with reproductions.

Hebrew through Pictures. I. A. Richard, David Weinstein, and
Christine Gibson. New York: Pocket Books, 1954. The signs
of the alphabet are put in an order and a student can see how
words are formed.

Hebrew Alphabets: 400 B.C. to Our Days. Reuban Leaf. New York:
Reuban Leaf Studio, 1950. Has helpful black-and-white repro-
ductions worked out of manuscript styles.

The Book of Jonah. Philadelphia: The Jewish Publication Society
of America, 1953. Has woodcuts by Jacob Steinhardt with
calligraphy by Franzisca Baruch. A handsome piece of work.

Fragments from the Cairo Genizah in the Freer Collection. Edited
by Richard Gottheil and William H. Worrell. New York: Mac-
millan, 1927. A potpourri of Hebrew writing with some free
cursives. There are 102 reproductions.

Vorlesungen über die kunde Hebräisher Handschriften. Moritz
Steinschneider. Leipzig: Otto Harrassowitz, 1897.

Facsimiles of Hebrew Manuscripts in the Bodleian Library. Ad.
Neubauer. London: Oxford University Press, 1886. Hebrew
writing from many areas seen in a large format.

Hebrew Illustrated Bibles of the IX and X Centuries. Moses Gaster.
London: Harrison & Sons, 1901.

*Catalog of Hebrew Manuscripts in the Collections of Elkan Nathan
Adler.* London: Cambridge University Press, 1921. A volume
on a collection of 4200 Hebrew manuscripts, with 52 pages
devoted to reproductions.

The People and the Book. Compiled by Joshua Block. New York:
New York Public Library, 1954. Documents of an exhibition
pertaining to the background of 300 years of Jewish life in
America. The reproductions are not of the highest quality
but the content is very interesting; for example, there is a
page from the first book written by a Jew in North America,
printed from the first complete font of Hebrew types in the
American colonies. Primarily a bibliography, this volume is
informative and fascinating.

The Kaufmann Haggadah. Budapest: Hungarian Academy of
Sciences, 1957. A facsimile in full color of an important manu-
script in the Oriental Library of Sciences. Only 720 copies
printed.

Corpus Codicum Hebraicum Medii Aevi. Ejnar Munksgaards For-
ley. Edited by R. Edelmann. Copenhagen: E. Munksgaards
Forlag, 1956. A series devoted to the reproduction of important
manuscripts in Hebrew. Notes are in English with many re-
productions by lithography.

CHAPTER 16 ORIENTAL CALLIGRAPHY

Written on Bamboo and Silk. Tsuen-Hsuin Tsien. Chicago: Uni-
versity of Chicago Press, 1962. A very interesting story on
the development of Chinese writing. There are notes on
brushes, inks, and the development of paper.

Chinese Calligraphy. Lucy Driscoll and Kenji Toda. Chicago:
University of Chicago Press, 1935. A good book on fundamen-
tal aspects of Chinese writing.

Chinese Calligraphy. Chiang Yee. Cambridge, Mass.: Harvard
University Press, 1955. Has a number of plates and 155 illus-
trations in the text. A good introduction to Chinese callig-
raphy.

The Six Scripts, or the Principles of Chinese Writing. Tai Tung.
Translated by L. C. Hopkins. Cambridge, Mass.: Cambridge
University Press, 1954.

Chinese Calligraphers and Their Art. Ch'en Chih-Mai. Melbourne:
Melbourne University Press, 1966. This beautiful volume is
available through Cambridge University Press in New York
City.

Chinese Art. W. Speiser, Roger Goepper, and Jean Friberg. New
York: Universe Books, 1964. Includes a fine section on callig-
raphy by Roger Goepper.

Index

Page numbers printed in italic refer to illustrations

PHOTOGRAPHIC CREDITS

References are to figure numbers unless otherwise indicated.

Alinari, Florence (138, 148, 150, 151, 152)
American Museum of Natural History, New York (35, p. 3)
Donnelley, R. R. & Sons, Chicago, Ill. (61, p. 107)
Los Angeles County Museum, Calif. (p. 239)
Marlborough-Gerson Gallery, New York (267)
Monotype Corporation Ltd., London (214)
Nelson, Robert, Madison, Wis. (317)
Newberry Library, Chicago, Ill. (222, 239)
Oxford University Press, London (162)
Phaidon Press, London (11)
Toomey, W. J., London (153)
Tscherny, George, New York (12, 313, 314)
Weege, Bill, Madison, Wis. (311b, 319)